GOTHIC

Architecture · Sculpture · Painting

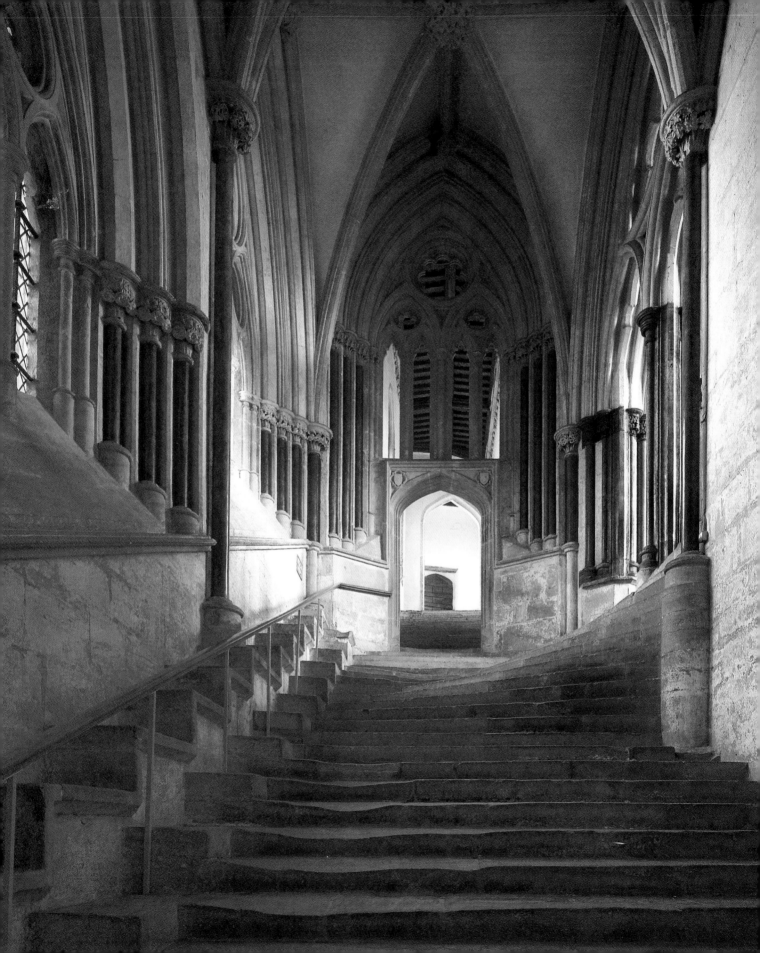

GOTHIC

Architecture • Sculpture • Painting

Edited by Rolf Toman

Photography by Achim Bednorz

h.f.ullmann

FRONT COVER:
Assisi, Upper Church of San Francesco, 1228-53
Interior view
Photo: © 1990, Photo Scala, Florenz

BACK COVER:
Lausanne, Notre-Dame Cathedral
begun last quarter of the 12th century
Painted columns and arch
Photo: Achim Bednorz

Frontispiece:
Wells Cathedral
Steps to chapter house

© 2004 Tandem Verlag GmbH
h.f.ullmann is an imprint of Tandem Verlag GmbH
Original title: Gotik
ISBN 978-3-8331-1038-2

Project coordinator and producer: Rolf Toman, Espéraza; Birgit Beyer, Cologne; Barbara Borngässer, Paris
Photography: Achim Bednorz, Cologne
Diagrams: Pablo de la Riestra, Marburg
Picture research: Barbara Linz, Sylvia Mayer, Cologne
Cover design: Carol Stoffel

© 2010 for this English edition: Tandem Verlag GmbH
h.f.ullmann is an imprint of Tandem Verlag GmbH
Special edition

Translation from German: Christian von Arnim, Paul Aston, Helen Atkins, Peter Barton, Sandra Harper
English-language editor: Chris Murray
Managing editor: Bettina Kaufmann
Project coordinator: Jackie Dobbyne
Proofreader: Shayne Mitchell
Typesetting: Goodfellow & Egan Publishing Management, Cambridge

Overall responsibility for production: h.f.ullmann publishing, Potsdam, Germany

ISBN 978-3-8331-6007-3

Printed in China

10 9 8 7 6 5 4 3 2 1
X IX VIII VII VI V IV III II I

If you would like to be informed about forthcoming h.f.ullmann titles, you can request our newsletter by visiting
our website (**www.ullmann-publishing.com**) or by emailing us at: newsletter@ullmann-publishing.com.
h.f.ullmann, Birkenstraße 10, 14469 Potsdam, Germany

Contents

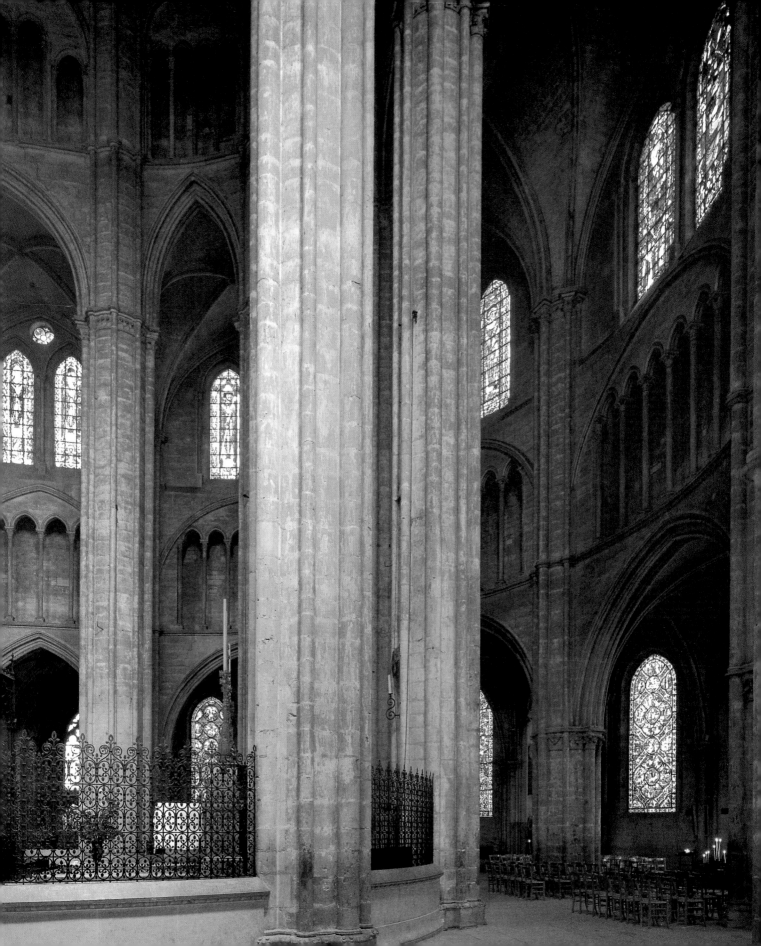

Chartres, Cathedral of Notre-Dame,
begun after the fire of 1194
View from the south

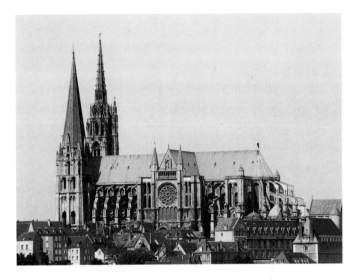

Rolf Toman

Introduction

"Anyone making their way to Chartres can see from a distance of some thirty kilometers, and with many hours of walking still ahead, just how this city crowns the area solely through the great mass of its cathedral with its two towers—it is a city-cathedral. It was a busy city throughout the Middle Ages because of its cathedral, and today the town is an image of what a cathedral town once was. And that was? It was a world which lived through and with its cathedral, where houses huddled below the cathedral and where streets converged at the cathedral, where people turned from their fields, their meadows, or their villages to gaze at the cathedral… The peasant might inhabit a lowly hut and the knight a castle, but both shared in the life of the cathedral to the same extent and with the same feelings during its long-drawn-out construction over the centuries, during its slow rise… Everyone without exception shared the common life of the cathedral. No man was imprisoned in his own poverty at night without being aware that outside, whether near or far, he too possessed riches."

In this observation from his *Open Diary 1929–1959*, the Italian writer Elio Vittorini expresses a common longing for an ideal world, an intact world in which meaning is implicit. The 19th-century Romantics (Victor Hugo, François René Chateaubriand, Friedrich Schlegel, Karl Friedrich Schinkel, John Ruskin, and many others) were also deeply moved by the sight of Gothic cathedrals, and the Romantics' intense vision of the spirituality and transcendent character of the vast and soaring spaces of Gothic cathedrals has lasted to the present day. It is apparent, for instance, in the noted 20th-century scholar of Gothic Hans Jantzen (from whose *The Gothic of the West* this introductory quotation from Vittorini has been taken), who is still part of the Romantic tradition. This is evident in such characteristic assertions that in Gothic architecture "something solid is being removed from its natural surroundings by something incorporeal, divested of weight and made to soar upwards," as well as by his famous analysis of the "diaphanous structure" of the Gothic wall and his talk of "space as a symbol of the spaceless." The theme is always the transcendent.

This aspect of the Gothic cathedral was also important to the scholar Hans Sedlmayr, who shortly after World War II published his celebrated study, *The Emergence of the Cathedral* (1950). Sedlmayr was attempting to offset the darkness of his own time with the shining light of the cathedral, which he saw as a complex and multifaceted work that marked a high point of European art. Just as Jantzen had "discovered" the diaphanous wall structure, so Sedlmayr, turning his gaze upwards to the vaults, identified what he called the "baldachin system" of Gothic cathedrals (the vaults looking like a canopy supported by slender columns). But alongside all the structural analysis and the metaphysical interpretation, Sedlmayr added another

element: his book on cathedrals is closely linked, in date and in philosophy, with his ultra-conservative work on cultural criticism, *Art in Crisis: The Lost Center* (1957, original German 1948), whose dubious racial and ideological underpinnings are unmistakable.

The affinity between conservative cultural criticism and an inflated reverence for Gothic has a long tradition in Germany. That Gothic lends itself to ideology in this way is closely connected with the long-standing belief that Gothic, in contrast to Romanesque, is the true German style. Based on an error, this appropriation of Gothic was, in the final analysis, "founded in the art theory of the Italian Renaissance, which had considered medieval art in general to be an essentially 'German' or—which comes to the same thing—Gothic style, from which the new Renaissance art of Italy had now finally liberated itself. As late as around 1800, equating Gothic with German was a *topos* of European culture, one that was scarcely questioned. From this there arose in Germany a national enthusiasm for everything Gothic, in which people thought they saw the greatest achievement of their forebears… But then art history, which was just emerging as a discipline, quickly established that Gothic, especially the Gothic cathedral, was one of the original achievements of Germany's arch-enemy of the time, France. This bitter recognition led to a change of attitude in the evaluation of the German Middle Ages" (Schütz and Müller).

The reason for this disillusionment lay in thinking in terms of national superiority, an error from which even some art historians were not immune. It is astonishing—and important to remember—just how stubbornly this brooding over the ethnic origins of Gothic persisted. Such views can be detected even in Sedlmayr's book on cathedrals, though they are more subtle than the ones in circulation

7

in Nazi Germany, and seemingly expressed in more civilized terms. In Sedlmayr's summary of his deliberations on the origin of the Gothic cathedral we are told: "For the complete structure of the cathedral, the north Germanic ('Nordic') element provided the structural component, the skeleton, as it were. The so-called Celtic ('Western') element provided the 'Poetic.' And the Mediterranean ('Southern') element provided the fully rounded, human component... Historically these elements did not appear simultaneously during the construction of the cathedral, but in this sequence... The third element, however, was already in play from the beginning but initially superimposed on the others and largely ineffective. Only after 1180 does it flourish, determining the 'classic phase' of the cathedral, but from as early as 1250 onwards it was firmly suppressed again. The 'classic' cathedral is thus one of the most magnificently successful fusions of the characters of three peoples. In art it creates 'Frenchness,' and in this very fusion is European in the highest sense." Today this biological, ethnic, and racial delving or—as Wilhelm Worringer named and practiced it—this delving into "the psyche of mankind" in order to explain the "essence of the cathedral" is considered obsolete.

A major obstacle in our attempt to understand the art and life of the Middle Ages is the difficulty of putting ourselves into the intellectual and emotional world of the men and women of the period. The decisive barrier to our understanding is presented by medieval Christianity, which, embracing every aspect of life, completely determined the thinking and feeling of the period. Today we are even farther away from this aspect of medieval life than the Romantics were. This difficulty was noted by Sedlmayr in his afterword published in 1976 in a reprint of his book on cathedrals. For Sedlmayr there was no point in saying "We must look at the cathedral through the eyes of medieval people" because these people would inevitably be an abstraction. Instead, he suggested "looking at the cathedral through the eyes of its builders, with the eyes of Suger and his architects." This was a clearcut task and methods could be developed to achieve it. Even if Sedlmayr's optimism is not something we can fully share, it is this approach we have taken here; and we can begin by turning our attention to the origins of Gothic and the central role played by Abbot Suger of St.-Denis. On this, at least, art historians are in agreement.

Abbot Suger of St.-Denis: The Beginnings of Gothic

Gothic is of French origin. It emerged around 1140 in the small kingdom, which already bore the name Francia, that occupied the area between Compiègne and Bourges, and that had Paris, the royal city, as its center. The territory on which the most impressive cathedrals in the new Gothic style were to be built in quick succession was insignificant compared with present-day France, and the power of the French king—though not the prestige—was still slight. His political and economic power took second place to that of the dukes of Normandy, who were at the same time kings of England, and also to

that of his neighbors to the southwest and east, the counts of Champagne. What distinguished him from the other feudal lords, however, and gave him greater authority, was the sacred character conferred on him when, at his coronation, he was anointed with holy oil.

This potential was something which Suger of St.-Denis (ca. 1081–1151), one of the leading figures of France in the 12th century, knew how to exploit. Although of humble origin, he was a childhood friend of Louis VI from the time of their common monastic upbringing in the abbey of St.-Denis, and he was a confidant, advisor and diplomat in the service of both Louis VI (1108–37) and Louis VII (1137–80). When Louis VII and his queen took part in the Second Crusade from 1147 to 1149 he appointed Suger his regent, a role Suger performed extremely well. As the monk Willelmus, Suger's biographer, reports, from that time on Suger was known as "the father of the fatherland." He made the strengthening of the French monarchy his life's work. Aware that the temporal power of the French king was greatly restricted, he knew that it was vital to increase the monarchy's spiritual prestige. Suger's efforts were aimed at exactly this.

When he became abbot of St.-Denis in 1122, Suger, along with all his other tasks, doggedly pursued his dream of restoring the abbey's former prestige by renovating the long-neglected fabric of the church. The church had already been a royal burial place under the

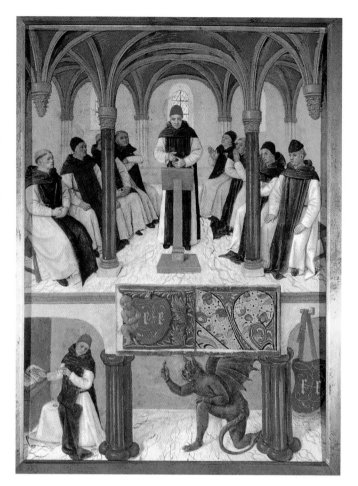

St. Bernard teaching in his monastery,
from *Book of Hours of Étienne Chevalier*,
ca. 1450–60
Chantilly, Musée Condé

Merovingian dynasty, and under the Carolingians it had enjoyed the prestige of being one of the most important churches of the realm.

It was here, at a place important because of its historical significance, that Abbot Suger, through the work on his abbey (1137?–44), became the initiator of a new spatial order for church building. For the first time, and along with other innovative measures, he and his architect closely united elements of Burgundian architecture (the pointed arch) and Norman architecture (rib vaults). By doing so, he became, in effect, the "creator of Gothic."

That this act, so important in art history, did not take place in a political vacuum, and that it was at once religiously, aesthetically, and politically motivated, is made clear in more detail in the first contribution in this book, on the beginnings of Gothic architecture in France (see pages 28–115). There Bruno Klein sets out the social, cultural, economic, and technical conditions that made it possible for Suger and his architect to create a new church architecture—an "architecture of light"—that was to raise the observer "from the material to the immaterial." It made it possible, a little later, for innovative architects, developing Suger's new concept of sacred architecture, to create the great Gothic cathedrals.

Between 1180 and 1270, the end of High Gothic, about 80 cathedrals were built in France alone. And this was just the urban episcopal buildings, not including the far more numerous restorations of other types of church such as abbeys and collegiate and parish churches. It was in these cathedrals and episcopal churches that the new Gothic architecture found characteristic expression. Appearing first in the French crown lands (the Royal Domain centered on Paris) and then wider afield, the cathedrals were highly visible demonstrations of prestige and power. Their spread went hand in hand with the expansionist policy of the French monarchy during the late 12th and 13th centuries. Indeed some historians believe that the building of Gothic cathedrals was one of the key factors in the ascendancy of medieval France in Europe, achieved largely under King Philippe-Auguste (Philippe II, 1180–1223) and extended under Louis IX (St. Louis; 1226–70). From the 1220s other countries in Europe (in England it had been as early as around 1170) adopted the "French style", usually, but not solely, because it represented the latest in building technology. Gothic architecture became a European style.

Abbot Suger and St. Bernard

A portrait of Abbot Suger of St.-Denis is provided by the art historian Erwin Panofsky, who wrote a fascinating study of the relationship between medieval art, philosophy, and theology entitled *Gothic Architecture and Scholasticism* (1951). In most of his writings Panofsky is concerned with grounding art history in intellectual history. This is his approach to Abbot Suger. All the same, in his book on Suger and St.-Denis he brings the abbot of St.-Denis to life as an individual: "A fierce patriot and a good householder; a little rhetorical and much enamored of grandeur, yet thoroughly matter-of-fact in practical affairs and temperate in his personal habits; hard-working and companionable, full of good nature and *bon sens*, vain, witty, and irrepressibly vivacious." Suger was certainly able to enjoy life, and was in particular keenly sensitive to the radiance and wonder of beautiful things.

In all this, and in particular in his love of beautiful things, Suger differed greatly from another major figure of his time, St. Bernard of Clairvaux (1090–1153). The great Cistercian abbot, the fiercest polemicist and the most powerful and influential monk of the 12th century, saw monastic life as one of strict obedience and, as far as personal comfort, food, and sleep were concerned, of extreme self-denial. Filled by missionary zeal, he became passionately involved anywhere monastic life, liturgical practice, or religious attitudes were, in his opinion, lacking either in strictness or in a concentration on essentials. He acted with great severity against the theologically unorthodox. Even Abbot Suger, who, though certainly in favor of discipline and moderation, was decidedly against the "monkish virtues" of abject submissiveness and asceticism, could not be indifferent to the views St. Bernard had about St.-Denis, for St. Bernard exercised a great influence on the pope. It had certainly not escaped St. Bernard's attention that there were times when things at St.-Denis, which was so linked to the French monarchy, were not as they should have been: "Without hesitation or pretense they render unto

Caesar the things which are Caesar's. But they do not render unto God the things which are God's with the same conscientiousness." Admittedly in 1127, in the sixth year of Suger's office as an abbot, Bernard congratulated his more worldly *confrère* on having successfully "reformed" the abbey of St.-Denis. But, as Panofsky observes, "this 'reform,' far from diminishing the Abbey's political importance, invested it with an independence, prestige and prosperity that permitted Suger to tighten and to formalize its traditional ties with the Crown." What caused St. Bernard to show more tolerance toward conditions at St.-Denis than he usually showed toward monasteries that did not meet his exacting standards? What caused him to treat Abbot Suger with far greater consideration than he usually showed toward those with whom he disagreed? Panofsky concludes that there was a tacit agreement of interests by the two potential opponents: "Realizing how much they could hurt each other as enemies—one the advisor of the Crown... the other the mentor of the Holy See and the greatest spiritual force in Europe— they decided to be friends."

The opposition of Abbots Suger and Bernard can also be seen in the character of the renovations at the abbey of St.-Denis. Abbot Suger had a great passion for sacred pictures and for all kinds of church decoration, for gold, enameling, and precious stones, indeed all kinds of beautiful gleaming objects, and he was especially fond of stained-glass windows. Bernard, on the other hand, condemned such decoration, not because he was unreceptive to its charm, but because he saw in such things a distraction from pious thoughts, prayer, and meditation. In the case of the Cistercian monasteries and churches being built in large numbers everywhere in Europe in the 12th and 13th centuries, this meant that the builders had to adopt a style that observed the numerous rules and regulations inspired by St. Bernard's austere aesthetics. Nevertheless, the expanding Cistercian order played an important role in the spread of Gothic throughout Europe, for it was receptive to the technical improvements of Gothic principles of construction, and was itself often innovative, for example in techniques of hydraulic engineering developed for the monasteries established in remote valleys.

Peter Abelard

In order to counter the view that the people of the Middle Ages lack a distinctive individuality, we can now, in this panorama of medieval culture, look briefly at another of Abbot Suger's contemporaries, a man who also endured a problematic relationship with St. Bernard, and who in fact came into direct conflict with him: the philosopher Peter Abelard (1079–1142).

In his book *Scholasticism*, a lively introduction to medieval philosophy, Josef Pieper gives us a thumbnail sketch of the scholar. "Peter Abelard... was still only a boy when he attended the famous Roscelin's school of philosophy. He was barely twenty when he went to Paris and, after two or three years of studying, himself opened a

school of philosophy, at first on the outskirts of the city. At the age of twenty-nine he marked the success of his school by moving it to Paris itself, situating it in what is today the university quarter. In 1115 he was head of the cathedral school of Notre Dame—all of thirty-five years old. Shortly afterward he met Héloïse. Abélard himself relates in his autobiographical *Story of My Adversities* (*Historia calamitatum*) how out of sensual passion rather than love he set about seducing this girl, his pupil. After she had had a child by him, they were wed in secret." The sequel was the cruel revenge of Heloïse's guardian, who had Abelard beaten and then castrated. The famous, confident professor had to take refuge in a monastery. St.-Denis took him in. This famous love story—which cannot be followed up here— did not end there. Héloïse went into a convent, but we know from their letters that the two lovers preserved a remarkable spiritual friendship for the rest of their lives.

In Abelard we meet an early representative of a new type of scholar, the professional thinker or intellectual. He makes his appearance with the rebirth of the towns in the 12th century, first as a master in the schools and then, in the 13th century, as a professor in the universities. In his study of the early years of the University of Modena, which was founded at the end of the 12th century as one of the earliest Italian universities, the Italian scholar Giovanni Santini writes: "The birth of the 'intellectual' as a new sociological type presupposes the division of labor in the town, exactly as the rise of the university institutions presupposes a common cultural sphere in which these new 'cathedrals of knowledge' appear, flourish, and can freely debate with each other."

Abelard played a decisive part in the development of Paris as a center of lively philosophical and theological debate. Here medieval scholars found ample opportunity to sharpen their intellectual weapons. Abelard himself was the most important spokesman of his age in the perennial debate over universals, one of the main themes of medieval philosophy, and with his dialectical work *Sic et non* he was, together with John Scotus Erigena (9th century), and Lanfranc and Anselm of Canterbury (both 11th century), one of the founders of scholasticism. The dominant form of thinking and exposition in medieval philosophy and theology, scholasticism involved reaching conclusions by means of the lengthy exposition of arguments and counter-arguments (*sic et non*), leading finally to a "determination" by the master. Thus Abelard was one of those who laid the foundation for the later "cathedrals of ideas" of high scholasticism just as Abbot Suger, through the rebuilding of his abbey church, became the joint initiator of the construction of Gothic cathedrals. As we have already mentioned Panofsky's *Gothic Architecture and Scholasticism*, perhaps we should point out here that such parallels can sometimes be drawn rather too hastily and often do not survive close scrutiny.

Abelard's thinking, strongly marked by the separate philosophical discipline of logic, can be understood, in its critical, antidoctrinaire tendency, as an early attempt at a medieval Enlightenment. It often

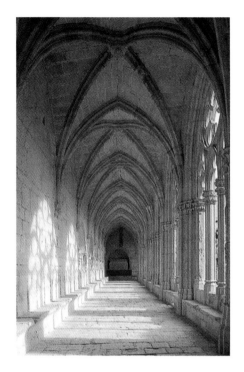

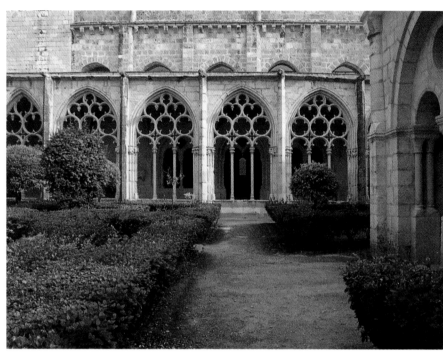

shows more concern with the human than the theological. An example of this is when, on the question of ethics, he emphasizes that there can be no sin without a conscious evil intent. In following our own conscience we may err, but we cannot for that reason be deemed guilty; we acted in good faith.

On the question of the relationship between faith and reason, a vital issue at the time, Abelard adopted a remarkably progressive position, arguing that only unprejudiced scholarly understanding ought to determine faith. Abelard, in other words, was an early representative of the urban intellectual, his beliefs consistent with Christian belief, but his mind open and enquiring.

The Dominance of Faith over Reason

For some, however, Paris was the modern Babylon, a city of reprehensible pleasures and intellectual pride. St. Bernard, the fiercest opponent of Abelard, called out to the Paris teachers and students: "Flee from the midst of this Babylon, flee and save your souls. All of you, fly to the cities of refuge where you can repent for the past, live in grace in the present, and confidently await the future [that is, in the monasteries]. You will find much more in forests than in books. The woods and the rocks will teach you much more than any master."

Here an attitude quite the opposite of Abelard's is being expressed. The abbot of Cîteaux took up a very different position in the front-line of Christianity. As Jacques Le Goff writes: "That rural man, who remained a medieval and foremost a soldier, was ill-suited to understand the town intelligentsia. He saw only one course of action against the heretic or the infidel: brute force. The champion of the armed Crusade, he did not believe in an intellectual crusade. When Peter the Venerable [the last great abbot of Cluny, who died in 1155] asked him to read the translation of the Koran in order to reply to Mohammed in writing, Bernard did not respond… That apostle of the reclusive life was always prepared to fight against innovations he deemed dangerous. During the last years of his life he essentially governed western Christian Europe, dictating his orders to the pope, approving military orders, dreaming of creating a Western cavalry, the militia of Christ; he was a great inquisitor before his time."

St. Bernard hurled the words quoted above against the "false teacher" Abelard who, sensing the spirit of Christianity in Greek philosophy, saw in the philosophers Socrates and Plato Christians before Christianity. Bernard was not convinced: "By making Plato into a Christian you are only showing that you yourself are a heathen."

Abelard was often prepared to challenge such warriors; he was even prepared to enter into a public debate with St. Bernard. But though he was confident enough for such a debate, and considered himself superior to the great abbot in intellectual astuteness, he was hopelessly inferior to St. Bernard in the politics of power. He was

11

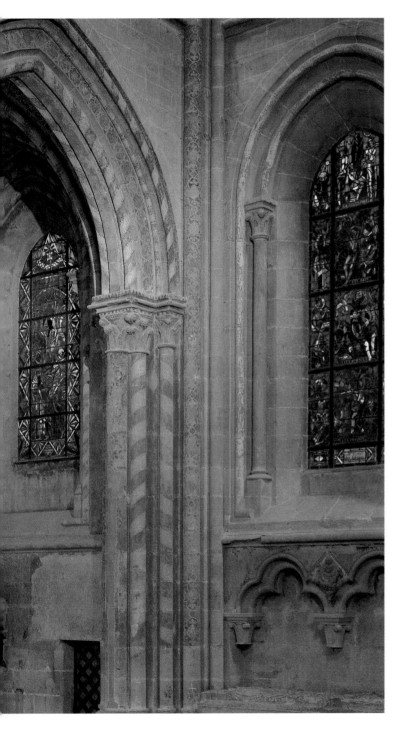

never given the chance for a confrontation in which he could have fought with the weapons of his own choice. The night before the planned debate, Bernard passed to the assembled bishops a document representing Abelard as a dangerous heretic. By so doing, he deftly transformed the occasion from a debate into a trial in which Abelard had to establish his innocence. All Abelard could do was challenge the competence of the assembly and appeal directly to the pope. In the event, the bishops passed a mild judgment on the alleged heretic and sent the case to Rome. Bernard learned of this and so was able to intervene and present his own point of view forcefully. The "dispute" ended with a condemnation of Abelard by the pope, and his books were burned at St. Peter's. Abelard sought refuge at Cluny, where he was taken in with great kindness by the abbot, Peter the Venerable. This abbot succeeded in having the excommunication imposed on Abelard in Rome quashed, and even brought about a reconciliation between Abelard and Bernard. Abelard died in the monastery of St.-Marcel in Châlons-sur-Saône.

The dispute between Abelard and Bernard can be seen as representative of a much broader conflict. It was an early skirmish in the long war between understanding and faith, reason and authority, science and the Church, a conflict that began in the High Middle Ages and was resolved only in the 18th century, when the German philosopher Immanuel Kant (1724–1804) separated belief in God from knowledge of the world. The defeat of Abelard by the influential abbot, and, above all, the way the defeat was brought about, illustrates a marked imbalance of power, an imbalance that began to change only at the beginnings of the modern period. The example of Galileo (1564–1642), who was summoned before the Inquisition because of his support for the Copernican theory and there made publicly to deny the theory, shows how long-drawn-out the process of intellectual emancipation was.

During the 13th century, when the universities emerged as the new power in the towns and cities, and scholasticism reached its height, science (at this early stage still lacking both method and objectivity) was unable to develop a new world-picture liberated from the bonds of Christian dogma. In his *Intellectuals in the Middle Ages* (1957), Jacques Le Goff sketches the rise of the universities in their early stages. At first they had to assert themselves by battling against ecclesiastical forces, above all against the local bishops, then against secular forces, above all the royal houses, their ally now being the pope. The final stage was to win far-reaching independence from the papacy. For a long time during the Middle Ages the Church clamped down on free and independent thinking, and so secured its own position and power for centuries.

Approaches to the Interpretation of Gothic Cathedrals

For a long time the study of Gothic architecture took little note of cultural and historical circumstances of the kind briefly considered above. Following the adoption of Gothic by the Romantics, there

developed a new line of interpretation inspired by Viollet-le-Duc's ten-volume *Dictionnaire raisonné de l'architecture française* (1854–68), which considered the development of the Gothic cathedral from a structural and technical point of view, an approach encouraged by the development of iron construction during the 19th century. Essentially an engineer's perspective on Gothic, this approach has been continued by several 20th-century writers (notably Victor Sabouret and Pol Abraham), though without the creation of such succinct interpretative concepts as Jantzen's "diaphanous wall" or Sedlmayr's "baldachin system." The scholar Otto von Simson follows Jantzen's and Sedlmayr's formal and analytical tradition of interpretation, a tradition pioneered by Franz Kugler in his studies of the Gothic cathedral in his *Handbook of Art History* (1842) and his *History of Architecture* (1856–59). But von Simson also, more importantly, draws on Panofsky's interpretation of Gothic in terms of intellectual history. Taking his lead from Panofsky's 1946 lecture on the relationship between Gothic architecture and scholasticism, in which Panofsky discusses Abbot Suger's understanding of the role light was to play in his new church, von Simson gives particular emphasis to the way in which the spiritual concept of light determined the development of the Gothic cathedral. He expanded his approach in 1956, when, as a reaction to Sedlmayr's *The Emergence of the Cathedral*, he published *The Gothic Cathedral: Origins of Gothic Architecture and the Medieval Concept of Order*. Since then there have been many attempts to interpret the precise significance played in the building of cathedrals by the light streaming in through their stained-glass windows, all of these interpretations deriving from remarks Suger himself made. A recent example is Michael Camille's chapter "Heavenly Light" in his book *Gothic Art* (1996).

Abbot Suger described the rebuilding of his abbey church in two short works, *Libellus de consecratione ecclesiae Sancti Dionysii* (*A Brief Account of the Consecration of the Church of St.-Denis*) and *De rebus in administratione sua gestis* (*Work Done Under His Administration*), written about 1145–50, justifying his project as a work pleasing to God. It is in these two accounts that Suger mentions the particular importance of light, developing an aesthetic of the ascent from the material (light from the windows, and precious stones) toward the spiritual (the light of God). Suger speaks of the *lux mirabilis*, the wonderful light, and of the *sacratissimae vitrae*, the most sacred windows. Panofsky believed that these and other statements by Suger were to be interpreted in the spirit of the neoplatonic philosophy of light. It was clearly this approach that laid the foundations for von Simson's interpretation of the "metaphysics of light." Several art historians followed him. But in recent years, in view of the weakness of other conclusions reached by von Simson, his ideas on this topic have lost much of their persuasiveness.

Thus Günther Binding, for example, who among other things has closely studied medieval building practice, in his essay "The New Cathedral: Rationality and Illusion" (1995) considers it misleading

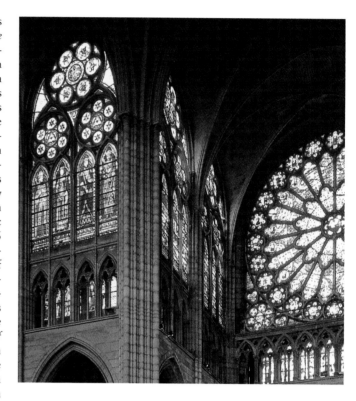

"to understand Gothic architecture as a reflection, or more precisely as the representation, of a supernatural reality." Moreover, he does not agree with von Simson's view that Suger sought "to lead visitors to the new sanctuary on to the religious experience that art had revealed to Suger himself," nor with his claim that "the design of his church, Suger's creation of Gothic form, originated in that [religious] experience." Binding thinks that such faulty interpretations stem from the fact that von Simson, and Panofsky before him, took individual statements in the sources out of context, or interpreted them in ways that were wrong, or at least biased. Pointing to the fact that a long time before Suger the buildings described in scripture—Noah's ark, the tabernacle of Moses, the temple of Solomon, Ezekiel's vision of the new kingdom of God, and the New Jerusalem of the Apocalypse—already possessed symbolic value for medieval patrons, he concludes that "the sources used selectively by Otto von Simson cannot establish a 'theory' of a new cathedral, namely of the Gothic choir of St.-Denis. They neither created nor founded the Gothic cathedral, but are clearly to be assigned to the realm of the *artes* (academic disciplines) and theology, and interpreted in the traditional way known long before the 12th century. That also goes for the attempts of Erwin Panofsky... to establish an analogy between Gothic architecture and scholasticism."

For Binding the cathedral "is first and foremost the place of the divine epiphany and of structured ritual." He regards the change in architectural construction occurring between 1190 and 1235 as "dependent on an economic development in the course of the second half of the 12th century, and also on the greater number of skilled and available workers resulting from that development." Binding does not, however, restrict himself solely to economic and technological conditions, for he summarizes his analysis with the observation that the Gothic element of the new church was "a masterly and harmonious blend of construction, illusion, rationality, and theology."

Social and Economic Aspects of the Emergence of Gothic Architecture
In the chapter "God is Light" in his book *The Age of the Cathedrals*, the French historian Georges Duby examines Suger's architecture as what he calls the abbot's "monument of applied theology". The new architecture created by Suger, he argues, is a hymn of praise to the Son of God. In the book as a whole he develops a broad-ranging approach to the Gothic cathedral. His book is essentially a historical sociology of artistic creation that attempts to set the cathedrals firmly within their specific social and intellectual context. We have already seen that 12th-century towns were developing into cultural centers, and that it was there that Gothic took root. The Gothic cathedrals were some of the most exquisite fruits of this emergent urban culture, the universities of the 13th century some of its most important institutions.

It is in this context of this rebirth of towns that Duby views the art of the cathedral: "Throughout the twelfth and thirteenth centuries [towns] grew both larger and more animated, while their outlying districts stretched alongside the roads. They were lodestones drawing wealth. After a long period of obscurity they became the principal centers, north of the Alps, of the most advanced culture. But for the time being virtually all of their vitality still came from the surrounding fields. Most of the manor lords decided at this time to shift their places of residence to the city. Henceforth the products of their estates converged in the cities. In those cities, the most active traders were the wheat, wine, and wool merchants. Thus, although cathedral art was urban art, it relied on the nearby countryside for the major factor in its growth, and it was the efforts of countless pioneers, clearers of land, planters of vinestocks, diggers of ditches, and builders of dikes, all flushed with the successes of a flourishing agriculture, that brought cathedral art to its fulfillment."

Duby reminds us that the new cathedrals arose in a society "whose ideal of sanctity was still a monastic ideal and was to remain so for some time to come," a fact illustrated above by the examples of the forceful personality of St. Bernard and the energy of the Cistercian order. Alongside the Cistercians, who in many respects were still representatives of the old rural order rooted in land ownership, there appeared in the first third of the 13th century the mendicant orders, the Franciscans and the Dominicans. With the mendicants a new type of order arose, one that was clearly distinguished from the older

communities belonging to a monastery, or to the chapter of a cathedral or seminary; their members were certainly bound to the order for life by their vows, but not to a particular monastery. The new orders demanded not only that individual monks should swear a vow of poverty, but also that their monasteries should be free of all possessions. The (male) members of the order spent their time in work, study, and pastoral care, and survived by begging for alms. As mendicant and preaching orders, the Franciscans and Dominicans concentrated on the towns. In the 13th century the great churches of the mendicant orders, built in a very simple style, were usually spacious hall churches, mainly in the Gothic style. These aisleless churches were intended to hold the largest possible congregations for the sermons that were such an important part of the mendicants' approach to their vocation. These churches were to have a significant impact on the urban development of the Middle Ages (see page 243).

The mendicant orders also played an important role in combating the numerous heretical sects. From the point of view of

Christian orthodoxy, the greatest danger came from the Cathars, who had spread over a wide area of southern France (see pages 116–117). In Languedoc, where most of the Cathars lived, St. Bernard had already tried in vain to persuade the heretics to change their ways. Attempts at conversion by force, with Cistercian assistance, followed. Dominican preachers at first tried to use persuasion rather than force of arms. The Franciscans and Dominicans, in Duby's words, "knew how to make the broadest spectrums of men listen. They appealed to what men were most sensitive to, spoke in everyday language, avoided abstract notions, and made use of striking images. Into their sermons they worked different kinds of anecdotes, depending on the social status of their public. Already they had begun to use the appeal of theatrics in conjunction with the propaganda by showing the first miracle plays. And whereas art, until then, had been a form of prayer and homage, in praise of the divine glory, the new urge to persuade and convert now made it a means of systematically edifying the laity."

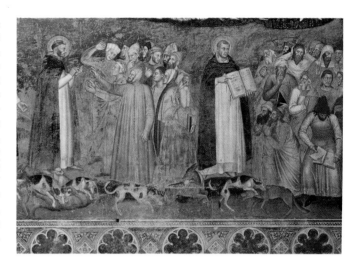

So it is not surprising that the Franciscans and the Dominicans, who were regularly in dispute with each other over the most effective ways of being persuasive—and finally engaged each other in philosophical and theological controversies, as well as in struggles for influential positions within the Church—played a revolutionary role both in the development of painting and in the teaching of philosophy and theology. Some of the greatest medieval philosophers were Dominicans (Albertus Magnus, Thomas Aquinas) or Franciscans (Bonaventura, Duns Scotus). But it was the Dominicans who, as a result of their growing closeness to the papacy, became the crusading guardians of Christian orthodoxy. They did not shrink from the use of force. As the main agents of the Inquisition, with its "practice of justice," they were responsible for one of the darkest chapters of medieval ecclesiastical history.

Recent works (in French and German) on Gothic art and architecture include, to name just a few, Alain Erlande-Brandenburg, *Gothic Art* (1983), Dieter Kimpel and Robert Suckale, *Gothic Architecture in France 1130–1270* (1985), Willibald Sauerländer, *The Century of the Great Cathedrals 1140–1260* (1990), Alain Erlande-Brandenburg, *Triumph of Gothic 1260–1380* (1988), Albert Châtelet and Roland Recht, *The End of the Middle Ages 1380–1500* (1988) and the works by Günther Binding and Michael Camille mentioned above. Of course, all such works rely on countless studies in formal analysis, intellectual history, iconography, and economic and social history. This is precisely their advantage over older works. In the light of the ever-increasing number of specialized studies, however, it is becoming more and more difficult for new studies to venture an overview of Gothic art and architecture of the kind offered in this book.

Of the works mentioned above we can look briefly at just one, a work that stresses the social and economic aspects of the subject:

Kimpel and Suckale's *Gothic Architecture in France 1130–1270*, which has succeeded in establishing itself as a standard work on Early and High Gothic architecture in France. The authors base their work on the thesis that "the area where Gothic began and expanded until 1200 corresponds exactly to the crown lands of France. As late as 1270 the masons' lodges of the crown lands are the real centers of innovation." They write of "the dynamic character of the style and of the social system supporting it," and thus indicate that they consider political and social factors to have been equally important in the rise and spread of Gothic. It is typical of their approach that they also look closely at the first 25 chapters of Abbot Suger's account books for his building work, in which he mentions several historical and economic aspects of his architectural projects that have until now been largely ignored by art historians (see page 28).

The multifaceted nature of the approach used by Kimpel and Suckale becomes clear in their first chapter, where they use the cathedral of Amiens as an "introduction to the study of the Gothic cathedral." Alongside the architectural history and the detailed descriptions of form and function, they attempt a reconstruction of the original appearance of the building, examine the early stages of building work, and discuss the building's patrons and its functions.

In this connection they analyze the complex web of relationships between the bishop (who took the initiative for the new building), the cathedral chapter, the people (the citizens), and the king (and other founders), and consider the role of each of them in the new building of the cathedral. In brief, they see both the politics and the building work as motivated by the shared interest of the king, the bishop, and the citizens "in keeping down the tyranny of the feudal nobility. In model form we have before us the coalition that determined this epoch and its architecture."

Further close studies of the master builders, the stonemasons, their tools and their lodges, the constructional knowledge of the architects, and so on strengthen the impression that the authors are essentially concerned with the elucidation of the social and economic factors in the building of the cathedrals. At the beginning of the 1980s there was certainly a need for an emphasis on such facets of medieval building, though it cannot be denied that the authors are also governed by a specific ideology. All the same, they also pay attention to formal, aesthetic, and iconographic factors. On the age-old controversy as to whether the building technology or the "idea" came first in the building of the cathedrals, the authors take up a middle position. "We would like to admit openly that in our opinion Gothic form would never have arisen without technical and constructional innovations; but we do not by any means regard Gothic architecture as merely an early form of engineering. It can be fully understood only in terms of the dialectical relationship of aesthetic and constructional, political and religious, economic and intellectual trends."

This many-sided approach is also the approach taken in the present volume. It is a reflection of changing fashion in art history,

however, that in this volume there is no discussion of "dialectics," and that the perspectives used, in contrast to those of Kimpel and Suckale, have again shifted firmly in the direction of a comparative analysis of form.

Gothic and Renaissance

"The Gothic cathedral of the 13th century can clearly be seen to differ from the Romanesque of the 12th in many respects: pointed arch instead of round arch, buttress system instead of wall mass, diaphanous, space-defining walls instead of thick walls pierced by windows, openwork tracery instead of walls with stepped and niched surfaces, and above all the creation of one unified space rather than the mere addition of spatial units which had been usual until that time." Günther Binding describes these characteristics in detail, and adds to the list more elements which as a whole make up the medieval masons' repertoire, including the elements which contribute to the breaking-up of the exterior of the building such as gables, pinnacles, finials, and crockets. (The reader can find these and other elements belonging to the vocabulary of the Gothic cathedral illustrated on pages 18–27. Terms not explained there can be found in the glossary.)

On the subject of the relationship of the Gothic cathedral to other types of Gothic church, such as the Cistercian monasteries partly marked by Gothic, the churches of the mendicant orders, and the Gothic hall churches of Poitou, Sedlmayr has shown that their participation in Gothic "morphology" can be traced back to a confrontation with the Gothic cathedral. "From the Gothic cathedral these 'Gothics' (if we can use this term) adopt individual forms like the pointed arch, the shape of the vault, the clusters of shafts, the rose window, and the radiating chapels in the choir, but give them a new meaning each time in their new setting... It is not 'the' Gothic, therefore, which produces the Gothic cathedral, but the cathedral that produces the Gothic."

After discussing the beginnings of Gothic, we can conclude by briefly looking at the relationship between Gothic and Renaissance. Since Gothic is identified with the end of the Middle Ages, and Renaissance with the beginning of the modern age, it is not surprising that there is such extensive debate over the precise point of transition between the periods. At the heart of the discussion was (and still is) the very concept of the Renaissance, for it is according to a particular concept of the Renaissance that the suggested transition dates stand and fall. "After the threshold of the new age had been linked for a long time (and unalterably, as it seemed, to the age of the great discoveries around 1500), there finally emerged in history and literary studies a genteel 'revolt of the medievalists,' helped along by constant research into specific details, which was directed against the antithetical separation of the two ages. Much that is generally seen as characterizing the Renaissance can already be seen in the late Middle Ages, and likewise some medieval phenomena could be pursued far

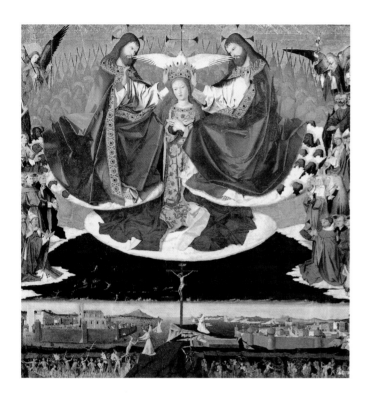

Enguerrand Quarton
Coronation of the Virgin, 1453
Painting on wood, height 183 cm
Villeneuve-lès-Avignon, Musée de l'Hospice

into the modern age… So today we understand by the threshold of the modern age not so much a sharp dividing line around 1500, but rather a gradual transition which took place between the outside dates of 1300 and 1600" (Norbert Nussbaum, 1994).

Art history can also provide convincing objections to the idea of a clear dividing line between the Middle Ages and the Renaissance. A century passed before Gothic established itself as a style across the whole of Europe; it was a gradual process. The same could be argued for the end of the Middle Ages. Features which are today considered characteristic of the Renaissance are already heralded here and there in late medieval art, sometimes in isolation, earlier in some regions, later in others. In Germany, where Renaissance art developed exceptionally late and not nearly as distinctively as in Italy, the Gothic art of the Middle Ages lived on into the 16th century. Equally, the depictions of architecture suggesting spatial depth in the works of Giotto, widely seen as a seminal figure in the development of the Renaissance, do not make him a "Renaissance" artist. Even Jan van Eyck, for all that is new in his painting, does not immediately leave all traces of the Middle Ages behind. It was with good reason that the Dutch historian Johan Huizinga, in his great cultural and historical work *The Waning of the Middle Ages* (1919), challenged the overhasty classification as "Renaissance" everything in late medieval art

that showed signs of novelty. In his essay "The Problem of the Renaissance" (1920) Huizinga outlined the development of the Renaissance way of thinking from Vasari to Voltaire, Michelet, Burckhardt, and others, concluding that "the contrast between the Middle Ages and the Renaissance, still a basic postulate, was not sufficiently defined." Writers and scholars, he argued, had based themselves again and again on a vague conception of medieval culture and had referred to this as a crude contrasting backdrop to the Renaissance. The concept of the Renaissance, identified with individualism and worldliness, was finally exhausted by an all too broad extension of its meaning: "There was not a single cultural phenomenon of the Middle Ages that did not fall under the concept of the Renaissance in at least one of its aspects."

One of these aspects, in the sculpture and painting of the closing years of the 14th and 15th centuries, is the realism that is often seen as the hallmark of Renaissance art. Flemish realism, for example, was emphasized in 1905 by the Belgian art historian Gevaert as the principal characteristic of the Renaissance in the north. This emphasis appeared again more recently in Heinrich Klotz's *The Style of the New* (1997). For Klotz, the Renaissance began in Dijon in Burgundy: "The first great monument of the early Renaissance is the sculpture portal of the Carthusian monastery of Champmol. The work created by Claus Sluter was so incisively new that its date, 1390–1400, seems hardly credible." Nevertheless, Sluter's sculptured portal has been included in the present volume (see page 320), alongside other works which some art historians ascribe to the early Renaissance. This is equally the case with the paintings of Jean Fouquet, Nicolas Froment, Jan van Eyck, and early Netherlandish painters up to Hieronymus Bosch. Like the *Coronation of the Virgin* by Enguerrand Quarton (see left), they are regarded here as works on the threshold between Gothic and Renaissance.

Quarton, in the markedly different scale of his figures, shows himself to be clearly indebted to the Middle Ages. On the other hand, in his details, such as in the small figures of the judgment scene at the lower edge of the picture, and in the views of the town, we can detect a keen pleasure in realistic representation that makes it entirely appropriate to present his work again in a forthcoming book on the Northern European Renaissance, to be published in this series.

Pablo de la Riestra

Elements of Religious and Secular Gothic Architecture

Basilica

The basilica type of church is constructed with a nave and at least two side aisles, the nave and aisles being separated by arcades. The nave is higher than the aisles so that it can be lit by its own source of light, the clerestory. If a high nave is not lit with upper windows in this way, the church is referred to as a pseudo-basilica.

The considerable height of the Gothic basilica nave is as a rule supported on the outside by buttressing (Reims), though not always (Magdeburg). Basilicas can have up to six aisles (Antwerp).

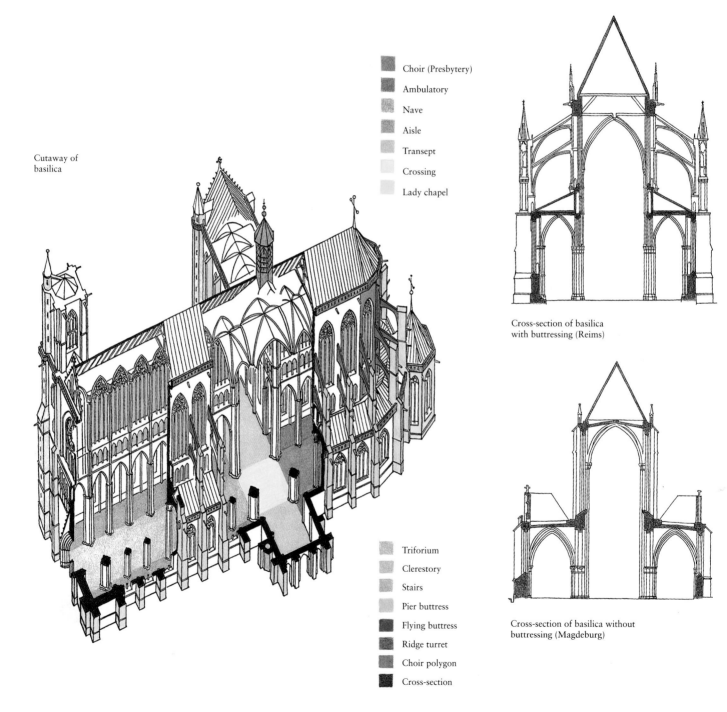

Cutaway of basilica

Choir (Presbytery)

Ambulatory

Nave

Aisle

Transept

Crossing

Lady chapel

Triforium

Clerestory

Stairs

Pier buttress

Flying buttress

Ridge turret

Choir polygon

Cross-section

Cross-section of basilica with buttressing (Reims)

Cross-section of basilica without buttressing (Magdeburg)

Choir

Ambulatory

Aisle

Nave

Gable

Transverse pitched roof

Stairs

Pier buttress

Clerestory

Cross-section

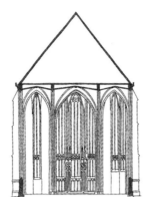

Hall Church

This type of church has aisles that are as high, or nearly as high, as the nave. The hall church usually has a nave and two aisles, the nave receiving its light indirectly from large windows in the aisle walls. If the nave is higher than the side aisles, the church is referred to as a stepped hall church. Hall churches can have as many as two aisles on each side of the nave (St. Peter's, Lübeck). Since the aisles support one another, there is no need for external buttresses.

Cross-section of hall church

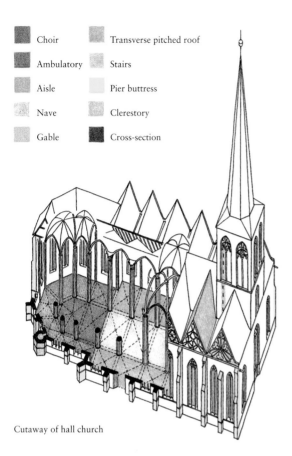

Cutaway of hall church

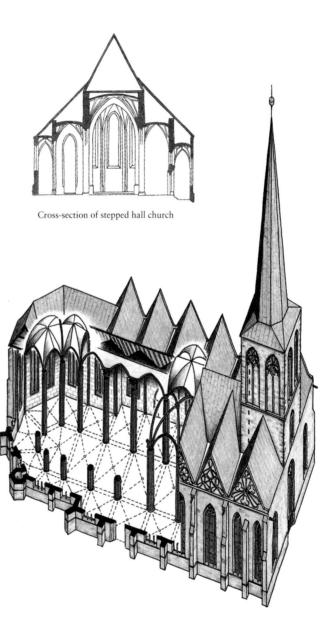

Cross-section of stepped hall church

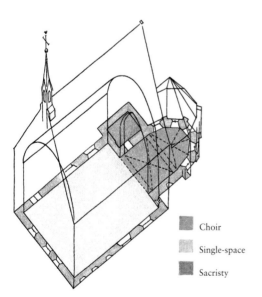

Choir

Single-space

Sacristy

Two-celled church (hall construction), (Nuremberg, St. Klara)

The single-aisle church is a non-centrally planned single-space church

Centrally Planned Church

In contrast to basilicas and hall churches, which are constructed along a horizontal axis, centrally planned churches are designed around a single central point. Centrally planned churches are round or polygonal (from hexagonal to any number of angles). A church built on a Greek cross plan (with four equal arms) is also considered to be centrally planned.

Church Façade
(Marburg, St. Elisabeth)

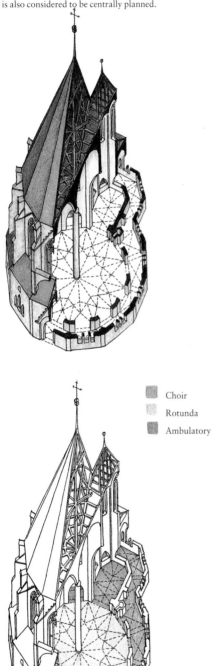

Choir

Rotunda

Ambulatory

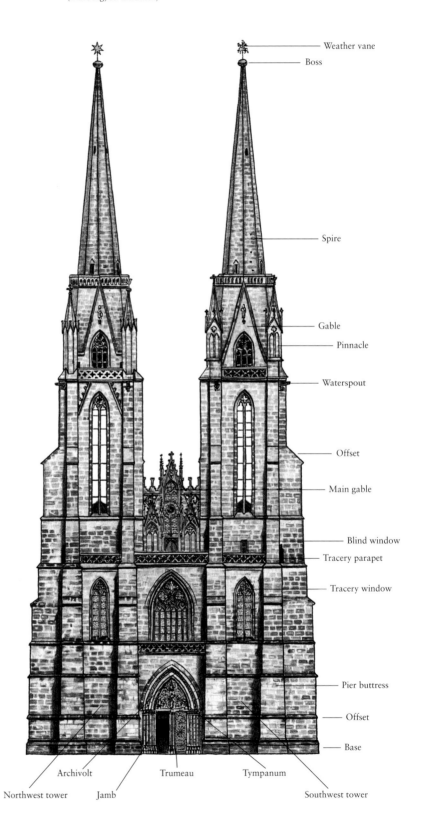

Weather vane

Boss

Spire

Gable

Pinnacle

Waterspout

Offset

Main gable

Blind window

Tracery parapet

Tracery window

Pier buttress

Offset

Base

Archivolt

Northwest tower

Jamb

Trumeau

Tympanum

Southwest tower

20

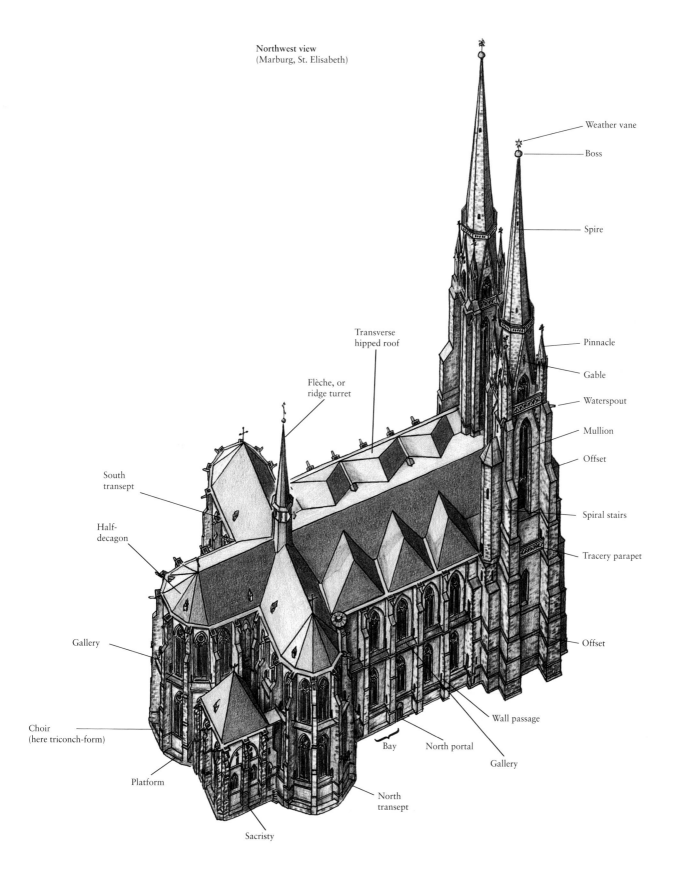

Northwest view
(Marburg, St. Elisabeth)

Weather vane

Boss

Spire

Transverse
hipped roof

Pinnacle

Gable

Flèche, or
ridge turret

Waterspout

Mullion

South
transept

Offset

Spiral stairs

Half-
decagon

Tracery parapet

Gallery

Offset

Choir
(here triconch-form)

Wall passage

Platform

Bay

North portal

Gallery

North
transept

Sacristy

21

Vault

A vault is a curved ceiling or roof made of stone or brick. In Gothic architecture ribs were used in place of roof hips. The ribs can be part of the load-bearing structure or purely decorative. In terms of their form, a distinction is made between cross rib and reticulated or stellar vaults (see below).

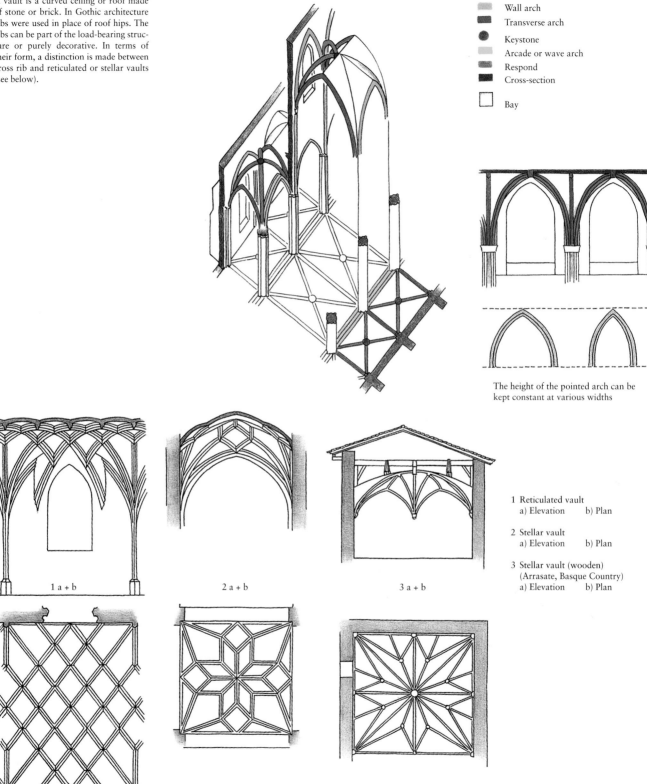

Cross (or diagonal) rib
Wall arch
Transverse arch
Keystone
Arcade or wave arch
Respond
Cross-section

Bay

The height of the pointed arch can be kept constant at various widths

1 a + b

2 a + b

3 a + b

1 Reticulated vault
 a) Elevation b) Plan

2 Stellar vault
 a) Elevation b) Plan

3 Stellar vault (wooden)
 (Arrasate, Basque Country)
 a) Elevation b) Plan

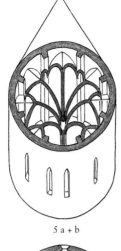

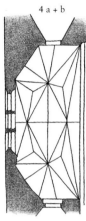

4 a + b

5 a + b

6 a + b

7 a + b

4 Cell vault
 a) Elevation b) Plan

5 Umbrella vault
 a) Elevation b) Plan

6 Hanging keystone
 a) Early Gothic b) Late Gothic

7 Dome vault
 a) Elevation b) Plan

Tracery
Tracery is a decorative system of slender, intersecting stone bars which form a geometrical or flowing pattern in Gothic windows. Originally developed only for dividing the crown of large windows, it became increasingly intricate and was later used not only on windows but also on wall surfaces, gablets, gables, etc. The basic forms of tracery are the foil (trefoil, quatrefoil to multifoil) and the vesica, an oval with a pointed head and foot, which occurs only in Late Gothic architecture. Window tracery usually consists of a crown *couronnement* supported by mullions.

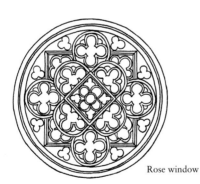

Rose window

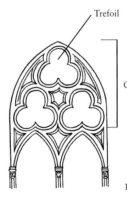

Trefoil

Crown

13th century

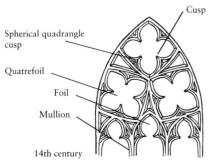

Spherical quadrangle cusp

Quatrefoil

Foil

Mullion

Cusp

14th century

15th century

23

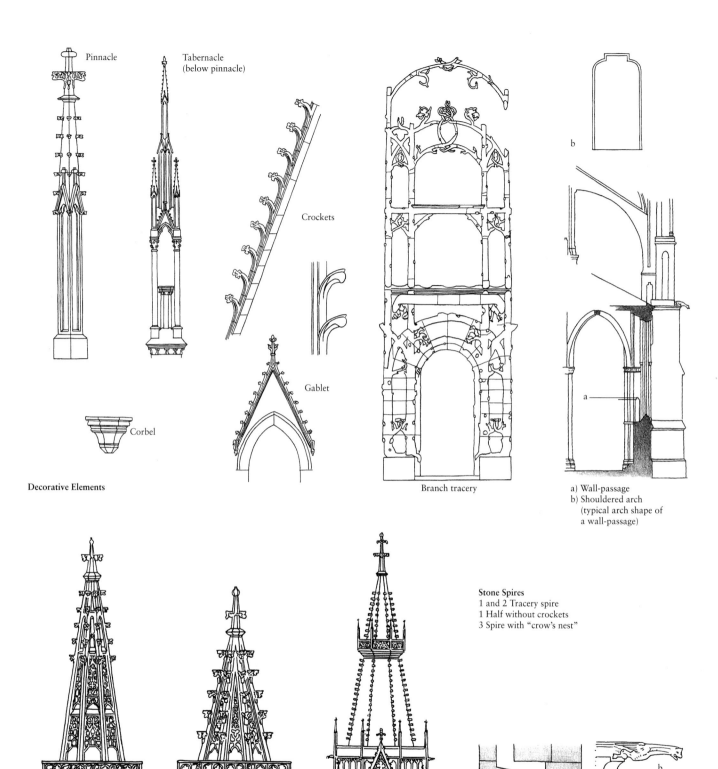

Pinnacle

Tabernacle
(below pinnacle)

Crockets

Gablet

Corbel

Decorative Elements

Branch tracery

b

a

a) Wall-passage
b) Shouldered arch
(typical arch shape of
a wall-passage)

Stone Spires
1 and 2 Tracery spire
1 Half without crockets
3 Spire with "crow's nest"

1

2

3

b

a

Waterspout a) Longitudinal
cross-section of a pier buttress
b) Gargoyle

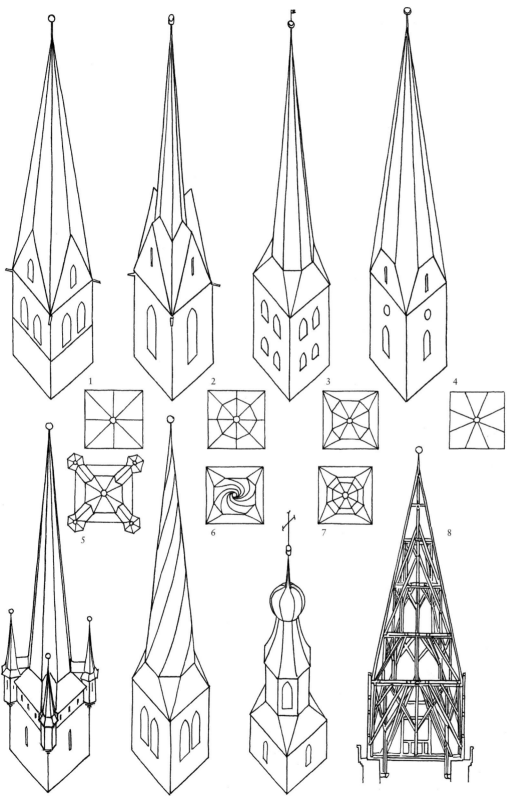

Wooden Spires
(with associated gables)

1 Octagonal spire on four triangular gables

2 Octagonal needle spire on four triangular (offset) gables

3 Octagonal spire on three inverted triangle and four trapezoids

4 Octagonal spire on four trapezoid gables

5 Octagonal spire with four corner spirelets

6 Twisted octagonal spire

7 Octagonal spire with onion dome

8 Wooden structure of a spire

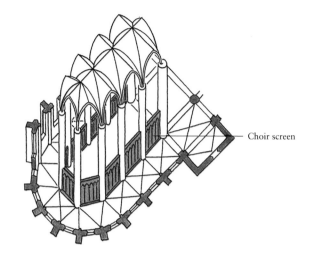

Rood Screen and Choir Screen
The rood screen is a dividing wall between the choir and the nave, its purpose being to separate the monks and clergy in the choir from the laity in the nave. In many cases the rood screen is extended by arcades placed in front of it so that a low "transverse building" arises in front of the presbytery. Below rood screens there are sometimes altars. The top of the rood screens could serve as a platform, for singers for example, usually set behind a tracery parapet.

Choir screens are low walls that separate the choir from the ambulatory. In polygonal choir screens these walls are occasionally pierced or even constructed with railings.

Rood screen

Choir screen

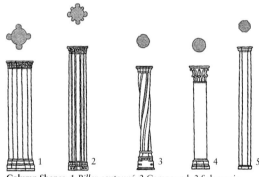

Column Shapes: 1 *Piller cantonné* 2 Compound 3 Salomonic 4 Round 5 Octagonal

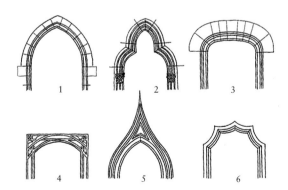

Arch Shapes: 1 Pointed 2 Pointed trefoil 3 Basket 4 Segmental 5 Ogee 6 Curtain

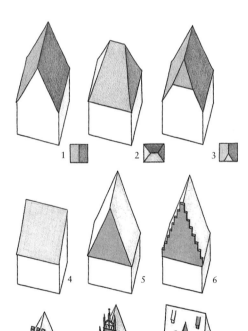

Roof and Gable Shapes

1 Pitched roof

2 Hipped roof

3 False hipped roof

4 Monopitch roof

5 Triangular gable

6 Crow-step gable

7 Crennelated stepped gable

8 Stepped gable with finials

9 Dormer windows

Timber-frame Construction

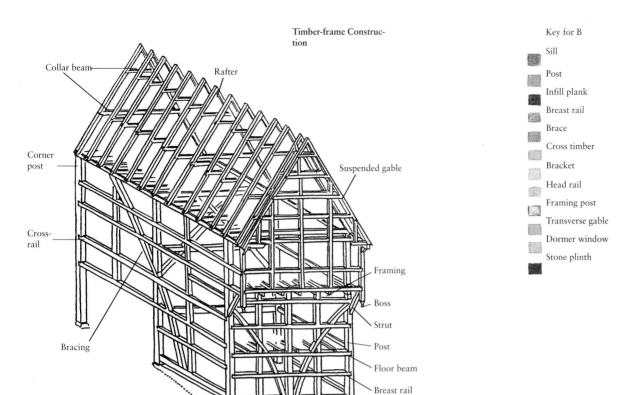

Collar beam

Rafter

Corner post

Cross-rail

Bracing

Suspended gable

Framing

Boss

Strut

Post

Floor beam

Breast rail

Stone plinth

Brace

A

Key for B

Sill
Post
Infill plank
Breast rail
Brace
Cross timber
Bracket
Head rail
Framing post
Transverse gable
Dormer window
Stone plinth

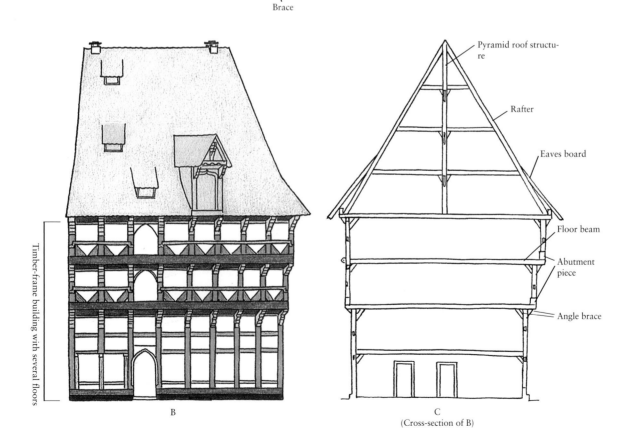

Timber-frame building with several floors

B

Pyramid roof structure

Rafter

Eaves board

Floor beam

Abutment piece

Angle brace

C
(Cross-section of B)

27

Bruno Klein

The Beginnings of Gothic Architecture in France and its Neighbors

The Political and Architectural Background

It can be argued that the foundation stone of Gothic architecture was laid on July 14, 1140. For it was on that day, a few kilometers to the north of Paris, that the rebuilding of the choir of the Benedictine church of St.-Denis was begun at the instigation of Abbot Suger. A work of the highest artistic achievement, the choir harmoniously integrates the elements and motifs we now consider characteristically Gothic, and thus effectively established the basis for the emergence of the style. The choir's importance in this respect is undisputed. But the building of the choir should not be seen in isolation. It was part of social, political, and philosophical developments that had begun several decades earlier. Moreover, it owes its pre-eminence in architectural history to the energy and skills of its patron, Abbot Suger of St.-Denis (ca. 1081–1151), the man whose remarkable ambition and vision led to its creation.

In considering the significance of St.-Denis it is necessary to bear in mind two important historical factors. First, since the 10th century this region of northern France had, like others, witnessed a gradual improvement in trade and commerce which led to a steady growth in both population and prosperity. Second, by the time St.-Denis was begun, in the early part of the 12th century, the French monarchy, at least within the Royal Domain around Paris, had become far more secure. A friend and advisor to both Louis VI (1108–37) and Louis VII (1137–80), Abbot Suger played a decisive role in this consolidation of royal power. This allowed him to reclaim, either through negotiation or through force, the monastic lands that had been appropriated by local barons. It was when he had accomplished this, as he writes in his own record of his achievements, *Work Done Under His Administration*, that the abbot began to restore the abbey church. This church not only formed the center of the monastery and its estates, but also, as we shall see, played a key role in the establishment of the French monarchy.

It is important to remember that the rebuilding of the choir of St.-Denis would never have become so significant in the history of architecture had it not drawn upon the recent architectural innovations in the Île-de-France, the region around Paris controlled directly by the monarchy. Admittedly the Romanesque architecture of the region was not as rich and varied as that of Burgundy or Normandy, but nevertheless during the second quarter of the 12th century new and distinctive architectural trends had begun to emerge. Suger himself had already started a new façade for the western end of the church of St.-Denis. Though not strictly Gothic, this façade fits perfectly into the context of architectural renovations taking place at the time in Paris and the surrounding areas. So the choir of St.-Denis should be seen not as the entirely novel starting point of Gothic, but rather as the major catalyst for a movement that had begun a few years earlier.

This can clearly be seen in the use of rib vaults, which were to become one of the most important features of Gothic architecture. The technical and aesthetic possibilities of this vaulting system

St.-Germer-de-Fly (Oise),
former Benedictine abbey church,
second third of 12th century
Exterior from the southeast (below)
Choir (bottom)

appear to have been recognized shortly after 1100 in several parts of Europe, notably in north Italy, in Speyer in the Upper Rhine, and also in Durham in England, from where it found its way into Normandy. The architects of the Île-de-France learned of it there and used it around 1140, for example in the church of St.-Étienne in Beauvais, on the border with Normandy. At about the same time the interior space immediately behind the façade of the Cluniac priory at St.-Leu-d'Esserent on the Oise was given rib vaults. And in the abbey church of Notre-Dame in Morienval, which was probably renovated shortly after the reception of the relics of St. Annobertus in 1122, this new style of vaulting was installed in a particularly original way. Here the exterior wall of the apse is split into two layers, between which is a narrow space spanned by rib vaults. This space is much too narrow to form a linked choir and ambulatory, like the later one in St.-Denis. Modeled on the double-layered wall of a Norman apse, this split wall may well have been constructed simply to strengthen the apse, which stands on sloping ground. Whatever the reason, the important point is that even before St.-Denis was built there had been experiments with rib-vaulted choirs. This is significant because it shows that builders in the Île-de-France were more willing to experiment than builders in Normandy, where until that time rib vaults had been constructed exclusively for rectangular areas. The use of rib vaults in choirs with complex ground plans and irregular bays opened up undreamed-of possibilities in the articulation of architectural space.

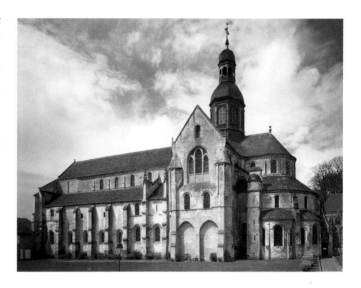

An early example of this can be seen in the Benedictine abbey church of St.-Germer-de-Fly, on the border between the Île-de-France and Normandy. In 1132 the monks had succeeded in regaining the relics of St. Germarus, an event that led to an increase in the number of pilgrims visiting the church, and that even moved the English king, Henry I, to donate timber for the building work. During this period the power of the local barons was being curtailed by the French kings, who thereby strengthened not only their position, but also that of abbeys like St.-Germer, which had large areas of land at their disposal. By the 1230s therefore, the Benedictines of St.-Germer felt confident enough to have their church magnificently restored. They built a galleried basilica that has a nave with two side aisles, an aisle-less transept, and a choir with an ambulatory and radiating chapels (see right). The exterior of the buildings boasts no lavish decoration, yet the overall architectural conception is all the more subtle for that. Sometimes linked and sometimes separate, the stories have their own individual character, a character determined mainly by the relation-ship between window and walls and by the different kinds of buttresses. The radiating chapels, with their rhythmic succession of closely aligned windows, clearly dictate the motifs of the next story: the smaller windows reappear in the gallery story, the larger ones in the nave. The result is that light streams onto the high altar both from the sides and from above, and the extensive choir, with its tight aureole of chapels, confirms the belief that a religious service held here should be celebrated with great solemnity.

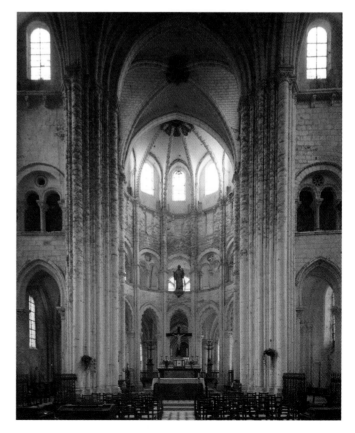

Paris, former Cluniac priory
of St.-Martin-des-Champs, before the mid
12th century
Choir (left)
Ambulatory (right)

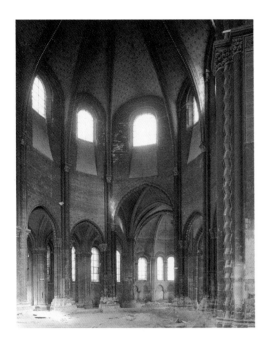
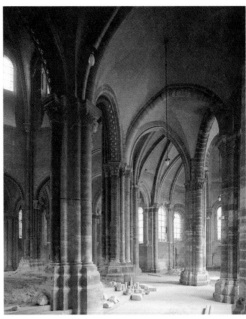

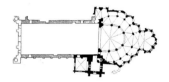
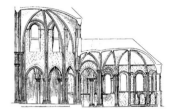

St.-Martin-des-Champs,
Ground plan (top)
Elevation of choir (above)

The interior demonstrates more clearly than the exterior just how much this building is indebted to the architecture of nearby Normandy. Motifs such as the zigzag arches in the arcades, the continuous shafts, and the rib vaulting clearly derive from there. Yet no church in Normandy at this period would have displayed such a sharp contrast between the boldly protruding clusters of shafts and the deeply recessed wall between them, or between the supporting framework and the panel walls. Here and there it seems as if the master builder responsible was handing this contrast almost playfully. The profiles of the arcade arches, which are part of the wall, seem to disappear behind the shafts, and the open passage in front of the clerestory indicates that the wall there has been reduced to a thin membrane. There are passages in the same position in Romanesque Normandy, but they are always situated inside an extremely thick wall, never in front of it, open to the air.

The calculated play of opposing shapes can also be seen at many other points in St.-Germer-de-Fly, for instance in the arcade arches of the apse, where a round profile appears to stretch between zigzag curtains, or in the clerestory, where round-arched windows are set in niches with pointed arches. Taken as a whole, then, the architecture of this church demonstrates a newfound freedom in the use of the traditional repertoire of forms. Indeed, the innovative way in which this repertoire is handled suggests that the master builder consciously distanced himself from it in order to create something completely new. This striving for innovation, this willingness to experiment, is characteristic of the beginnings of Gothic.

Apart from the buildings already mentioned, which all lie to the north of Paris, the architecture of the capital city itself was also responding to these new ideas. This can be seen, for example, in the choir of the important Cluniac church of St.-Martin-des-Champs (see above), which was begun under Prior Hugo, who held office between 1130 and 1142. At first sight the ground plan of St.-Martin-des-Champs is difficult to understand, since it lacks any symmetry or clear geometrical structure. There was an attempt to combine two different forms, a choir with diagonally arranged chapels whose apses increase in length, and a choir with an ambulatory. Thus this building consists of a semicircular apse surrounded by an irregular ambulatory with a succession of chapels. These, on the south side at least, protrude in telescopic fashion farther and farther eastwards, and in so doing seem to overlap. The chapels are arranged not around a common central axis, as was usual, but staggered one behind the other in a parallel line. This pattern, which was started on the south side, was meant to be carried out on the north side as well but there radiating chapels were constructed instead and the symmetry of the building was destroyed.

A glance at the vaults indicates that this choir was designed to be longitudinal rather than centralized. Rib vaults, which always mark the most important areas, are found only along the central axis over the inner choir, over the axial chapel, and over the bays between them. The remaining areas are spanned by groin vaults or domes. The axial chapel is also given special consideration. It is bigger than

30

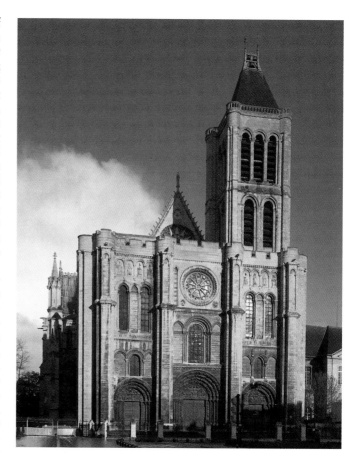

all the rest and its external walls spread out to make a clover-leaf ground plan. Inside, this chapel looks like a domed room with a modern rib vault, though the rib vaulting is used for decorative rather than structural reasons. Here the technical possibilities of the vaulting system remain almost deliberately unexploited, for the windows do not, as at St.-Germer-de-Fly, stand up high in the vault webs, so that they almost disappear into the vaulting. Instead, situated lower down, they encircle the chapel like a uniform ribbon of light underneath the huge web of the vault. Both St.-Germer and St.-Martin show a greater emphasis on the windows, with the walls between the windows and the wall supports beginning, as it were, to dissolve. In St.-Martin the windows, along with their deeply profiled surrounds, are arranged like pieces of jewelry midway between the base of the wall and the vault. All in all then, in St.-Martin there is no uniform design, but an enrichment of the repertoire of forms through the accentuation of one single motif, the window. And as at St.-Germer-de-Fly, it was through the choir once again that the desire for innovation was expressed, the highest architectural subtlety achieved.

The abbey church of St.-Pierre-de-Montmartre in Paris, probably rebuilt after the conversion of the monastery into a Benedictine convent in 1133, still demonstrates, in spite of considerable later alterations, the separation of load-bearing piers and thin "skeletonized" walls that was very modern at the time. Even so, the building is less important architecturally than politically. For St.-Pierre stands on "Martyrs' Mount" (Montmartre), on which, according to legend, St. Dionysius (Denis) and his companions were executed. Thus the building became the martyrium of St. Dionysius, one of the places which, for the medieval mind, was the site of an important event in the story of salvation. Adelaide, the wife of King Louis VI, wished it to be her last resting place. This decision was the real reason for the reform of the monastery and the rebuilding of the church. In this she was following the example of her husband's family, for French kings were traditionally buried at Dionysius' burial place, the abbey church of St.-Denis. Dionysius was the patron saint of the Capetians, the French royal family. This development, which the Church was forced to accept from 1133 at the place of his martyrdom, was something it could not refuse to accept at his grave only a little later.

Innovation Through Variation: The French Monarchy, St.-Denis, and Abbot Suger

In the early 12th century the French kings were, compared to other rulers, at best only moderately important. Their inherited lands, moreover, were surrounded by the territories of much more powerful French rulers. They were distinguished, however, by their grandiose ambitions: they saw themselves as the rulers of all France, their claim based on their inheritance of the imperial authority of Charlemagne who had been crowned Frankish king in St.-Denis in 754. His grandson, Emperor Charles the Bald, was later buried there. Just how important the maintenance of this Carolingian tradition was is clearly

shown in Abbot Suger's decision to begin the renovation of St.-Denis with the restoration of the memorial to Charles the Bald. It was not only the French and Merovingian kings who were buried there: St.-Denis also housed the tomb of the patron saint of France, Dionysius (Denis). During the Middle Ages this supposed first bishop of Paris was confused with Dionysius the Areopagite, a follower of the apostle Paul, to whom the extremely important writings of Pseudo-Dionysius (probably written in Syria about 500 AD) were attributed. It was in these influential writings that the theory of celestial hierarchies was expounded, according to which a king was to be seen as God's representative on Earth. For the advocates of this theory the restoration of royal power was not an end in itself, but an integral part of God's divine plan of salvation, in which the kings of France had an important role to play. Just how close a link was sought between sacred tradition and the French monarchy at this time became clear when at the dedication of Suger's new choir Louis VII himself carried the remains of St. Dionysius from the old crypt to the new upper choir.

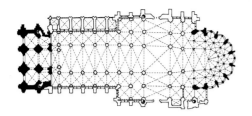

St.-Denis (Seine-
St.-Denis),
former Benedictine
abbey church
Ground plan

OPPOSITE:
St.-Denis (Seine-St.-Denis),
former Benedictine abbey church
Ambulatory, 1140–44

The abbey church of St.-Denis therefore played a complex and important role for the French monarchy in terms of national policy. The architecture of the church was an expression of the two ideological strategies pursued for the restoration of the monarchy in the 12th century. The first involved reaffirming ancient traditions in order for the French monarchs to establish themselves as direct descendants of the legitimate royal house, and prove themselves worthy successors of that line. The second involved introducing new ideas in order to supercede the events of the immediate past. In other words, the new (politically and architecturally) was seen as a means of acknowledging and restoring the past. Gothic architecture, as it began at St.-Denis, was to provide a tangible expression of this concept.

Suger did not rebuild the whole of his abbey church at once. He started with the westwork (see page 31). Though this suffered considerably in the 18th and 19th centuries (the north tower had to be demolished after being unsuccessfully restored), it still bears witness to the feeling of a new departure in the 1130s. It stands on a ground plan two bays deep and three bays wide. Its three new portals provide an easy entrance into the old church, and in addition conceal several chapels deep in its upper stories. This new front, the narthex of which is fitted with thick clustered piers and a new-style cross-ribbed vault, gives the clear impression from the outside that its architecture was seen as symbolic. With battlements topping the façade, which is given rhythmic and sculptural emphasis by mighty buttresses, the building looks as if it could be a triumphal gate or a castle. It can be read both as a clear expression of the worldly power of the abbot of St.-Denis, and as a triumphant symbol of the newly strengthened monarchy. The rich sculptural decoration of the portals, together with the original bronze doors provided by Suger himself, explanatory inscriptions, and the constantly reappearing motif of the number three on the wall of the façade, make this westwork the portal of the Heavenly Jerusalem.

Broadly similar features can be seen on the old façade of the abbey of St.-Étienne in Caen, the burial place of the dukes of Normandy and of the English king William the Conqueror, whose successors were the chief enemies of the French monarchy. But at St.-Denis this older style is surpassed both as architecture and as symbolism. Suger's new west façade was more than just an improvement of a Norman model; it was also a recreation of a Carolingian westwork, by means of which an important local tradition was acknowledged.

Even before the completion of this west end, Suger felt "carried away" (to use his own words) to start work on the restoration of the choir of his church. This he was able to realize in the very short space of time of 1140 to 1144 (see opposite). The direct symbolic references are less evident here than in the façade, but on the other hand the architecture is of a far higher quality. If the new crypt and ambulatory, within which the crypt of the earlier building is enclosed, still display simple Romanesque shapes, then the new choir above them is so highly filigreed that the upper parts threatened to collapse in 1231 and had to be replaced. There is hardly any wall surface to be seen in the ambulatory, where slender columns bear the weight of the vaults. By contrast, the area occupied by the windows, which reach almost to the floor, is all the larger, flooding the area with light. Instead of the earlier simple ambulatory there is now a double ambulatory in which both aisles are separated by elegant monolithic columns that support the rib vault as if it were weightless. The vaults of the outer ambulatory are integrated into the chapel vaults, so that a single, unified space is created.

The elements used in this choir, such as the Burgundian pointed arches and the Norman rib vaulting, are not new. What is so striking is their combination. Suger and his unknown architect used them in order to create a sanctuary that is the crowning glory of the whole church, a sanctuary that spoke as forcefully to the simple, uneducated visitor as it did to the abbot, who could bring to it a sophisticated allegorical interpretation. The fact that Abbot Suger had wanted to bring ancient columns from Rome to build his new choir, which adjoined an old nave that according to tradition had been dedicated by Christ himself, allows us to see the beginnings of Gothic architecture, a style widely regarded as new and non-classical, in a new light, as an attempt to restore older traditions. At the same time, the new choir and façade had to contribute to the contemporary relevance of the historic nave. Solely in terms of political intention, the old and the new mutually strengthened one another and, in the words of the abbot, "were brought together into one greater unified whole."

In carrying through his plans for the rebuilding of St.-Denis, it is clear that Abbot Suger drew upon classical theories of rhetoric in which he found both theoretical justification and practical implications for his rebuilding. Thus *variatio* (variety), one of the basic skills of rhetoric, was achieved through combining different building parts. The theory that there are different styles appropriate for different subjects could have been a stimulus for the difference in styles between the crypt underneath and the choir above. Similarly, *aemulatio* (emulation) was understood to involve the creation of something new from some highly respected model from the past (in this case the old nave of St.-Denis with its columns), a worthy exemplar that provided the measure of the new.

The Gothic architecture of St.-Denis was not simply a development of Romanesque. It was, rather, the result of ambitious attempts to create something new through a critical examination of the past. Admittedly the innovative architecture of the 1130s was a precondition for these developments. Yet the abbey of St.-Denis alone, so important for the French kings, and dominated by the intelligent and energetic Abbot Suger, was the place where all the conditions seem to have been met for taking the decisive step in the creation of the Gothic style.

Architecture in the French Provinces

The practice of combining the old and new in architecture was of course much older. Like Abbot Suger, Carolingian and Ottonian builders had already made use of classical architectural in their buildings. In

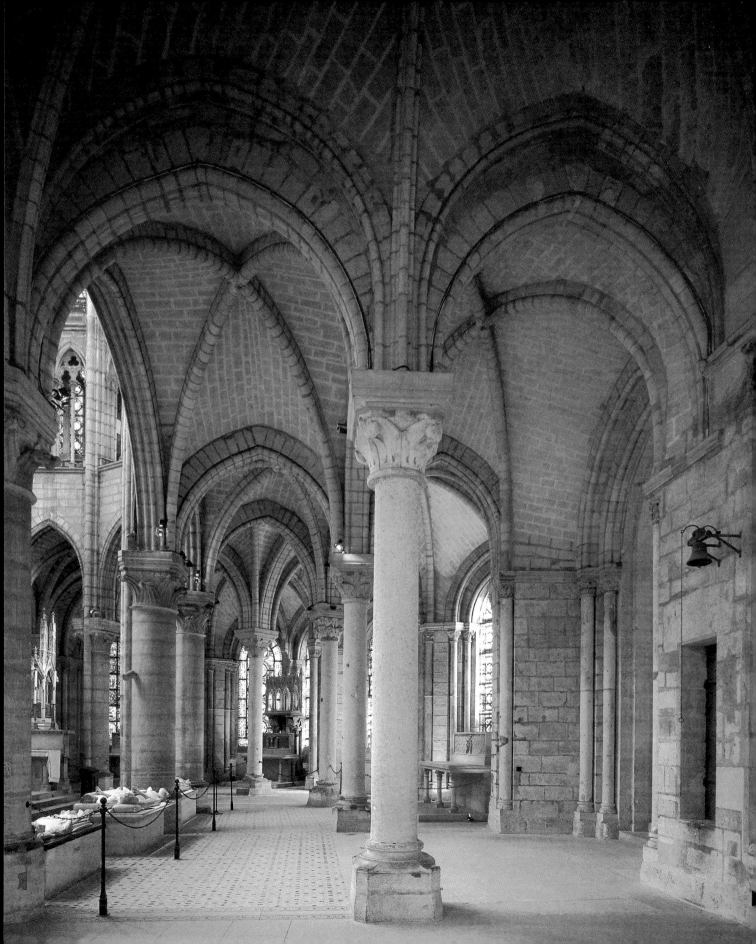

Angers (Maine-et-Loire),
Cathedral of St.-Maurice
Nave (below), mid 12th century
Ground plan (right)

fact that it was in Angers, in the middle of the 12th century, that the religious architecture of the region began to experiment with rib vaulting, a form previously unknown there. It was no coincidence that this took place against the political background of the unification of Toulouse in the south of France and Normandy on the Channel through the marriage in 1152 of Eleanor of Aquitaine and Henry Plantagenet of Angers.

At St.-Denis and Angers the old and the new were boldly juxtaposed. In various forms of regional architecture, by contrast, they were combined in such a way that the reuse of the old alongside the new was almost impossible to detect. In the cathedral of Le Mans, also situated in Plantagenet territory, a third way was followed. Here there was an attempt to integrate the old into the new in a way that was at once visible but not too bold (see opposite).

Originally built in the late 11th century with a flat roof, the church had burnt down several times, the last time being in 1137, when it was decided to vault the nave in stone. In the course of this work the whole clerestory of the nave was rebuilt, while the old arcade area below was largely left alone as it carried the weight of the existing aisle vaults. The uniformity of the row of arches was destroyed by the installation of the new responds to support the nave vault, for these heavy responds rise from every second columnar pier. The remaining piers were also renewed, but largely in their original form. We can clearly see above the new, pointed, rhythmic arcade the old round arches still running along the wall, behind the new piers. A slight difference in the color of the stone emphasizes the contrast between the older and the newer parts.

The building of a stone vault to withstand fire does not in itself explain why such an expense was incurred at Le Mans. Totally demolishing the old parts of the central nave would certainly have been cheaper than the technically complicated approach of retaining the arcade where the piers were replaced. This leads us to suppose that at Le Mans they did not want to remove the evidence of restoration, but, on the contrary, almost wanted to display it in order to make the history of the building more evident and comprehensible. The solution is intelligent and aesthetically convincing. If we look upwards along the length of the nave from the side aisles, we see a cathedral that has acquired a more modern appearance. The huge canopy-like rib vaulting installed, perfectly supported by its new piers, is a symbol of architectural luxury, as are the blind triforium and the deep windows with their many columns. The reason for this considerable extravagance could be that for the princes of the house of Plantagenet the cathedral of Le Mans—like St.-Denis for the French kings—was to become a dynastic monument. Among its most important supporters was King Henry II of England, who had been baptized in this cathedral in 1133. His parents, Matilda, heir to the English throne, and Geoffrey Plantagenet, Count of Anjou and founder of the house of Plantagenet, had married there in 1128, and it was there, in 1151, that Geoffrey had been buried. In 1152, as we

addition, among religious buildings almost contemporary with the newly built sections of St.-Denis there were several that also used modern Norman rib vaulting. The cathedral of St.-Maurice in Angers (see above) was renovated in this way under Bishop Mormand de Doué (1149–53). Its internal walls remained the same but disappeared almost completely behind new blind arcades that have pointed arches and huge piers. Here the vaults stretch over mighty transverse arches and diagonal ribs that rise up so high that the keystone does not lie at the same height as the apexes of the transverse and blind arches, as was usual, but considerably above them. So the old type of aisleless church, widely known in southwest France, with rows of domes set one behind the other, was transformed into a rib-vaulted frame with bays in the Norman style. One could argue whether this is enough to make Angers a truly Gothic building, particularly as its basic structure remains traditional. But the issue of how to categorize the cathedral stylistically is less important than the

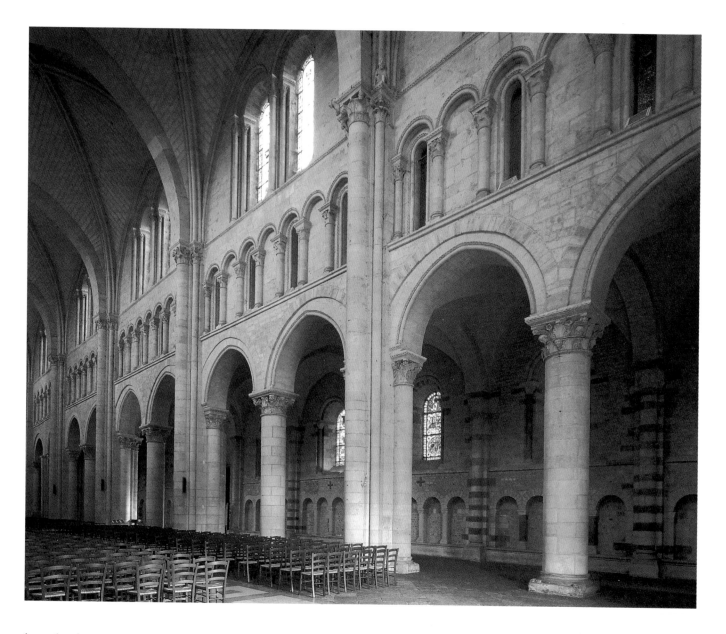

have already seen, Henry married Eleanor of Aquitaine, the divorced wife of the French king Louis VII, which made the Plantagenets the greatest territorial lords in France. Two years later, in 1154, Henry could finally ascend the English throne. All this happened during the years when the cathedral of Le Mans was being rebuilt (it was finished in 1158).

Thus Le Mans, like St.-Denis, shows that the architectural traces of the past could be considered valuable, and that reviving the past could create new perspectives for the future. The comparison of the two buildings also explains why St.-Denis would subsequently become the more attractive of the two. For apart from the fact that it was easier to extend the existing parts of St.-Denis than it was to carry out the restoration work at Le Mans, the choir of St.-Denis did not have the enormously thick walls Le Mans had. This meant that it was easier for Abbot Suger and his architect to use the columnar piers

of the old nave as a motif for the new building. In other words the character of the new choir of St.-Denis was determined solely by slender elements such as columns, shafts, and ribs. In the restoration of Le Mans, by contrast, the massive Romanesque walls were the starting point for the innovations, so that everything became even more heavy and massive.

The Impact of St.-Denis

In the early 1150s, not long after the choir of St.-Denis had been completed, the little cathedral of Senlis, also to the north of Paris, was begun (see page 36). Its style clearly shows the influence of the innovations at St.-Denis. Though the interior, which has been rebuilt several times after being gutted by fire, is now overwhelmingly in the Late Gothic style, the building still possesses its original ambulatory and choir with monolithic columns and radiating chapels. Its ground

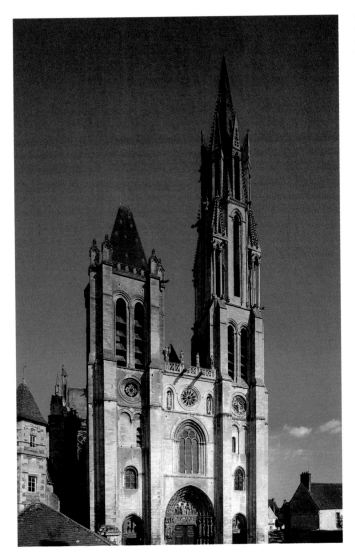

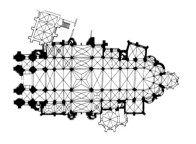

sturdy columns with tall capitals were used. Classical in their proportions, they had both an aesthetic and a practical function, being usable in all parts of the inner choir. This meant that there was no longer the awkward gap between the structure of the straight side walls and the rounded apse of the choir. In addition, this stylistic unity of the choir is strengthened by identical clusters of tall responds that stretch from the piers to the vaults. Because of this unity, visitors often fail to notice that the outside responds in the choir's apse and on the straight walls support quite different arches and ribs; they see only the harmony and structural logic of the choir, which at the time must have made a highly effective contrast with the roof of the nave, which was still flat.

The inside elevation of the choir of St.-Germain-des-Prés has three stories: in contrast with the two-storied nave, it was given an extra story, the triforium. The triforium arches were sacrificed in the 13th century when the clerestory windows were lengthened in order to make the church lighter. This modification can still be seen on the exterior because the roof above the side aisle is flatter today than it was originally, so that now the old lower sill of the window jambs appears to hang in the middle of the wall. The flying buttresses were never changed, however, so that St.-Germain-des-Prés today possesses the oldest surviving flying buttresses on a Gothic church.

The interior of the building also shows how well the architect was able to give formal expression to the significance of different parts of the church. If the walls of the side aisle are still largely smooth and fitted only with round-arched windows, then the windows of the choir's chapels have pointed arches, which are then emphasized in the clerestory by responds and decorated archivolts. Similarly, there is a gradation in the size in different parts of the church. Therefore even in Paris itself, as in St.-Denis, the rhetorical theory of different styles appropriate for different subjects must have been taken into consideration. In fact St.-Germain-des-Prés cannot be understood at all if it is not seen as a reflection of St.-Denis. For here too the fact that only parts of the church were rebuilt can hardly be put down to mere thriftiness, but must be seen as part of a well-thought-out undertaking. At that time the monastery was trying, alongside St.-Denis, to assert itself as the traditional royal burial place by renewing the memorial foundations and gravestones of the Merovingian kings who were buried there.

Tradition and Innovation in the Churches of Reims

It was clearly in those buildings that had close links with the French monarchy that there was a characteristic merging of old and new. This is well illustrated by the cathedral of Reims, in which the French kings were crowned and anointed. There too an old nave had been provided with both a façade and a choir in the new style. Unfortunately nothing remains of this today for the cathedral was replaced in the 13th century by a completely new building.

By contrast, the abbey church of St.-Remi in Reims, despite being badly damaged during World War I, is still one of the most impressive

plan clearly reveals a style founded upon that of St.-Denis, even if the chapels are separate and not merged with the vaults of the ambulatory. Although this cathedral was constructed in one stage, its creators did not take the opportunity to build a more modern façade, one which would stylistically match the choir. Instead they built a copy of the west façade of St.-Denis. So the west end of Senlis is two bays deep, just as if it ought to be joined to an older nave, as at St.-Denis. In other words, the cathedral of Senlis, though a completely new building, simply adopts some of the juxtapositions of different styles found at St.-Denis, even though at St.-Denis these had been the result of a changing approach to the building's design.

At about this time the Benedictines of the abbey of St.-Germain-des-Prés in Paris rebuilt their church. The 11th-century nave was retained, as was the old west tower, though this was given a modern sculptured portal. As at St.-Denis, at St.-Germain-des-Prés only the choir with its radiating chapels was completely rebuilt (see opposite, left and top right); this was consecrated by Pope Alexander III in 1163. In the apse, instead of the normal slender monolithic piers,

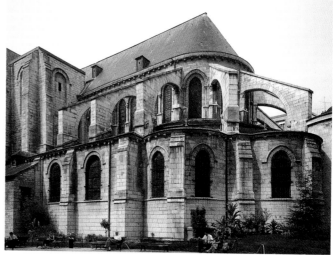

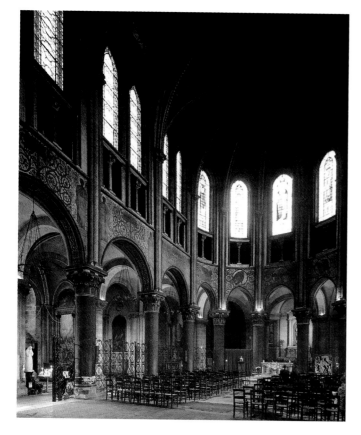

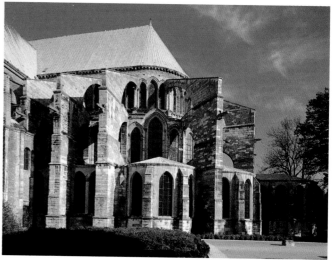

examples of this characteristic combination of architectural styles from different ages. It was in this church that the monks kept the holy oil, supposedly delivered by angels, that was used to anoint French kings. In addition, the church housed the tomb of St. Remigius (Remi), who had used this angel-brought oil to baptize Clovis I, the king who thereby became the founder of the kingdom of France. Remigius and Dionysius played a similarly important role in the development of the French monarchy.

The rebuilding of the abbey church began in the second half of the 1160s with the west façade (see page 38, right). The original upper part no longer exists, but the surviving two lower stories provide us with a clear idea of the new façade of the 1160s, which was built between two older side towers. From these outer towers inwards there is an increase in the wealth of the motifs, the depth of relief, and the light provided by windows. Characteristically, the main portal is framed by two classical columns from which slender shafts rise, a motif that reappears in the interior of the church. Monolithic columns were also placed in front of the piers of the 11th-century

nave in order to receive the clusters of slender responds that support the newly installed Gothic vault. Just as at Le Mans, the impression created is that of being in a church that has been built inside a much older one. In the completely new choir the motifs of the nave are adopted again, particularly in the wide arcades and the tall gallery openings, which are divided into two arches. As at St.-Germain-des-Prés, a continuous row of mighty piers surrounds the whole inner choir. Out of them rise clusters of shafts, which join those between the gallery arcading to create a virtual forest of round slender shafts. The triforium and clerestory are linked with the help of slender mullions, the clerestory becoming a light filigree. Even the number of arches increases from bottom to top in characteristic sequence: one arch in each bay of the arcade, two in the gallery, and three in both the triforium and clerestory.

The link between the ambulatory and radiating chapels is a particularly original achievement (see page 38, top left). Here at Reims the chapels are laid out in a circular pattern so that they just touch the ambulatory, quite the opposite of the arrangement at St.-Denis,

Reims (Marne), former Benedictine
abbey church of St.-Remi

BELOW:
Ambulatory and chapels of the choir,
begun under Abbot Pierre de Celles
(1161–82)

BOTTOM:
Nave, 11th-century, rebuilt and
vaulted in the second half of the
12th century

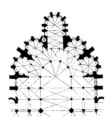

Ground plan of choir (left)
Façade (below), first half of
11th and second half of
12th century

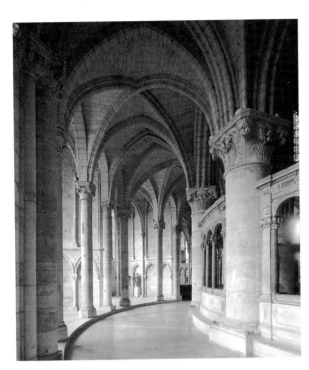

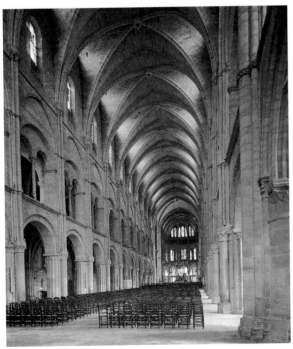

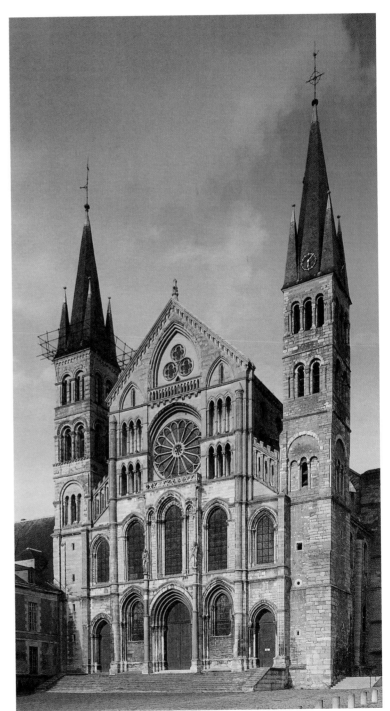

Châlons-sur-Marne (Marne),
former collegiate church of
Notre-Dame-en-Vaux
Choir (bottom), late 12th century

where both are drawn together under one vault. Where these two spatial elements meet, slender monolithic columns, the familiar motif of the church, rise up and support the vaults of the ambulatory and the chapels. On the remaining sides, the chapel vaults are supported by even more slender monolithic responds which stand in front of the wall. The impression created is that the chapel vaults are canopies that stand independently.

The exterior of the choir (see page 37, bottom right) puts all older buildings into the shade. Here we can see the already familiar decorative gradation from top to bottom. We can also clearly see that this monumental construction is composed almost solely of windows set between minimal sections of wall. The choir is supported by thin yet strong buttresses and flying buttresses which, leaving a clear view of all the windows, stand like proud witnesses of an elegant mastery of the balance of forces.

The choir of the collegiate church of Notre-Dame-en-Vaux in Châlons-sur-Marne (see right), about 40 kilometers (25 miles) southeast of Reims, shows considerable affinity with St.-Remi, notably in its elevation and in the arrangement of its radiating chapels. The precise chronological relationship of the two buildings has not been completely determined, but St.-Remi may well have supplied the model for Notre-Dame-en-Vaux. Certainly the combination of different building styles, demonstrated in such exemplary fashion at St.-Remi, was attractive to the builders of the smaller collegiate church because there had been continuous building there during the 12th century, always to different plans. Not until the successful integration of the ambitious Reims pattern, in which inconsistency of style was the order of the day, could this lack of uniformity finally be accepted in a building characterized by constant changes of plan. In addition, the canons of Notre-Dame-en-Vaux had only just become wealthy, and so the idea of documenting the venerable history of their church by preserving its various styles could not have come at a better time.

As a result, Notre-Dame-en-Vaux can be seen as an imitation of those churches in which differences of architectural style were used to demonstrate a venerable past. But it also marks the end of the development of this stylistically heterogeneous Early Gothic type of church, in which the new had been developed out of a critical reappraisal of the old. Admittedly, there were later "composite" churches of this kind, but on the whole during the second half of the 12th century there was a marked shift towards stylistically more uniform churches, though of course these had had always existed alongside the "composite" type.

The Gothic Cathedral

The Emergence of a New Form

During the 12th century, the cathedral of Sens, situated to the southeast of Paris, was the seat of the archbishop who was "Primate of Gaul" and to whom even the bishop of Paris was subordinate.

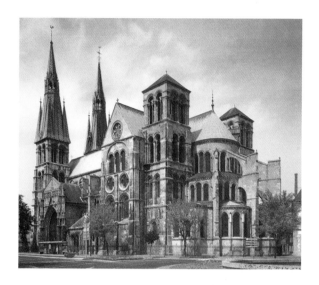

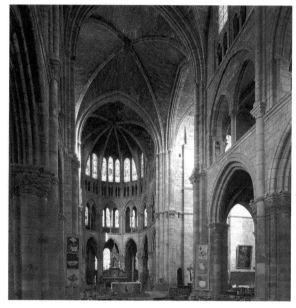

Though built at around the same time as St.-Denis, the cathedral of Sens is of great simplicity, particularly as it originally had no transept and only a single rectangular chapel at the apex of the ambulatory. The three-storied elevation (see page 40, left) is similar to that of Le Mans, but the walls are considerably thinner. This can be seen clearly at the capitals of the double columns that separate the huge bays beneath the sexpartite vaults. Above each pair of columns a single

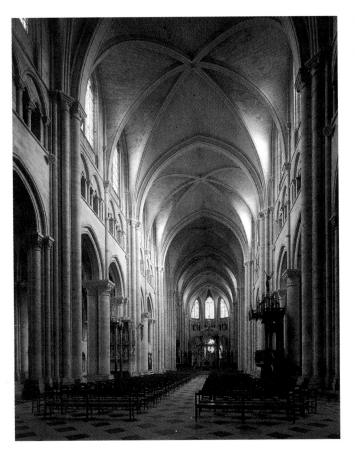

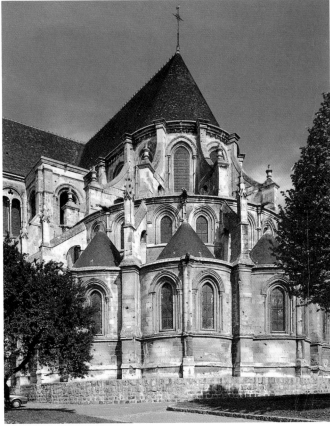

broad abacus protrudes far into the nave, seemingly without anything to support it, while the wall of the nave stands squarely over the free space between the double columns, almost as if the architect, with a touch of playfulness, wanted to show off just how light and thin his nave wall was. Rising from these double columns, and stretching right up to the vaults, are slender shafts that do not engage with the wall behind. Because of this, the main piers are all the stronger, and bear the burden of the vaults' weight. The lateral webs of these vaults originally came much lower, as the windows beneath were smaller than those that exist today. The vaults must once have looked like canopies on poles. Though lacking the subtlety of the much smaller St.-Denis, the cathedral of Sens provided an elegant alternative to the architectural extravagance of Le Mans.

The choir of the old cathedral of Noyon (see above, right) was built after a fire had caused extensive damage to the church in 1131. Whether it was begun before or after Sens cannot be clearly established. It may well be that the external walls of its radiating chapels

were constructed even before those of the choir of St.-Denis, in other words before a change of plan led to the creation of a new wealth of shapes. Nevertheless, it can be assumed that there is some connection between a transfer of relics carried out in 1157 and the completion of the inner choir, since it displays some similarities with the choir of St.-Germain-des-Prés in Paris, which was consecrated in 1163. The cathedral possesses four stories (see page 41, left), an arrangement that had already been accepted in older churches, above all in the cathedral of Tournai, which had long had close links with Noyon. A succession of slender monolithic columns surrounds the apse, as at Senlis and at St.-Denis. The arcade arches look as if they are carved out of the wall, while in the gallery story they are much more richly profiled. For the decoration of the building in general, and in particular for the construction of the responds, shaft rings play a more important part here than in any other church built before this date. The lowest rings divides the section of respond between the capitals and the first stringcourse roughly in the middle; the next rings lie exactly at the same height as

Noyon (Oise), Cathedral of Notre-Dame
Choir, probably begun mid 12th century

Noyon (Oise), Cathedral of Notre-Dame
South transept

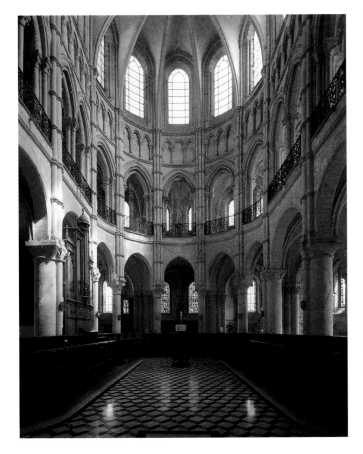

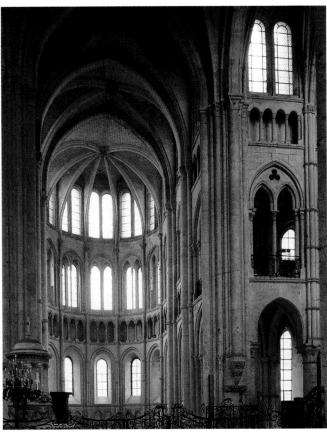

this stringcourse. Higher up still, the shaft ring occurs quite independently of other features, which makes the responds seem as if they are rising up completely detached from the wall.

This tendency to separate wall and vertical supports, only hinted at in the choir, is developed more fully in the transepts which, unusually, terminate in an apse (see above, right). There the wall consists of several layers. In front of this hollowed-out wall stand simple responds which, rising with a rhythmical movement through the shaft rings and capitals, become increasingly free of the walls. In addition, the capitals supporting the vault are so low that the pointed windows of the second tier look as if they are being drawn up into the vaults. This subtle delicacy in the layering of the wall is taken up again in the nave of the cathedral, though the main architectural decoration was clearly reserved for the liturgically more important eastern parts. Nevertheless, though the individual elements are arranged harmoniously, the cathedral of Noyon does not form a unified whole, as the various changes to the design can be clearly seen.

A close-to-perfect unity of the whole emerges only with the cathedral of Laon, whose architect borrowed a great many forms from Noyon. The building was started in 1160 and the most important parts were completed shortly after 1200. The cathedral, an important pilgrimage center, was originally a galleried basilica with an ambulatory and a long transept. Both the west façade and transept façades were to be accentuated by double towers, but this plan was executed fully only on the main, west, façade; a further tower rises up over the crossing. The result is that the building's distinctive silhouette is visible from far away, since the Cathedral of Notre-Dame at Laon stands on a hill overlooking a broad plain.

Alternating clusters of five and three responds are placed in front of the four-storied internal main walls (see page 42), each shaft of a respond corresponding to a rib of the sexpartite vault. These responds, unlike those at Noyon, intersect the stringcourses at regular intervals, dividing the responds into sections that seem to be uniform modules. Two of these sections of the respond lie between

Laon (Aisne), Cathedral of
Notre-Dame
Nave and choir, begun ca. 1160,
extension to choir completed
ca. 1220
Ground plan (right)

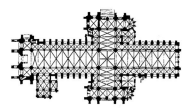

the pier capital and the stringcourse of the gallery. Three more are needed to reach the triforium, whose height is equal to one further section of respond. On two pairs of piers west of the crossing the responds are even taken right down to floor level, so that the building in this section is constructed entirely in "respond modules." The many monolithic respond shafts correspond to the large number of small columnar shafts in the gallery, triforium, and clerestory, even to the ribs of the vault. As a result, the interior seems richly but not excessively decorated. Instead of running out of control, the decoration, being a logical and coherent articulation of the architectural space, integrates fully with the building's structure.

Unlike St.-Denis in Paris and St.-Remi in Reims, the cathedral of Laon gains its dignity not through the contrast of differing parts, but through the creation of a building that forms a coherent whole both in structure and in decoration. The builders and the architect in Laon remained loyal to this principle when shortly after 1200 the short choir, started 40 years earlier, was pulled down again in order to build a final, much larger and longer, choir. Its style matches that of

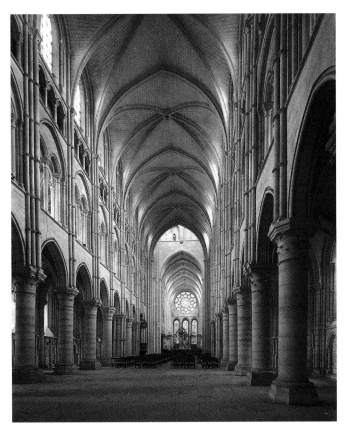

the older parts of the church perfectly. In other words, an architectural style already decades old was repeated, despite the fact that in the meantime architectural styles had long since taken a different course. We can only speculate on the reasons for the demolition and rebuilding of the choir. Did the rich and distinguished cathedral chapter of Laon consider the old choir too small? Or did it worry that pilgrims, high up in its gallery, were able to walk around their exclusive meeting place? Certainly in the new choir the gallery that once ran along the east wall has been blocked off.

There may well have been aesthetic reasons for the rebuilding, since the length of the extended choir corresponds approximately to that of the nave, so that both parts of the building now extend almost symmetrically from the crossing. In addition, the large rose window above the three lancets in the new east façade is a mirror-image of the rose window of the west façade. As both transept façades already had rose windows before the new building work began, the addition of this rose window on the east façade meant that from the crossing a huge circular window could now be seen in all four directions. In other words, the alterations to the choir greatly increased the unity of the interior of the building.

The west front of Laon (see opposite), built in the last years of the 12th century, represents a remarkable achievement in Gothic architecture. Here the structure of the older two-tower façade is consistently reflected inside the building with the result that, for the first time, a façade is integrated into the body of the building, no longer standing in front of it as an independent block. At the same time, the west front exhibits a strong sense of rhythm and three-dimensional form: the portals jut out like triumphal arches, and the windows above the portals, dominated by the rose window in the center, are deeply set back. Moreover, the towers develop logically from the lower part of the building, and no longer appear to be merely added on, as at St.-Denis. This was possible because the architect of Laon's west front concealed the front buttresses so skillfully that it is hard to see that they begin by the portals and continue upwards between the windows. And so at Laon a completely different picture emerges from Senlis, where the buttresses dominate the façade from the ground up to the towers. The west front of Laon was so highly valued by contemporaries that it was imitated over and over again. The medieval artist Villard de Honnecourt included it in his famous sketchbook as early as the 1220s, claiming it had the most beautiful towers he had ever seen.

To the buildings with four-storied elevations we have already looked at (St.-Remi in Reims and the cathedrals of Noyon and Laon), we can now add, as the youngest member, the cathedral of Soissons (see page 44), where a four-storied south transept was built soon after building land was donated in 1177. It is here that filigree work reached its height, for instead of the ground-floor arcade having a single arch per bay and the gallery two (the usual arrangement), both levels have three extremely slender arches set between the main piers.

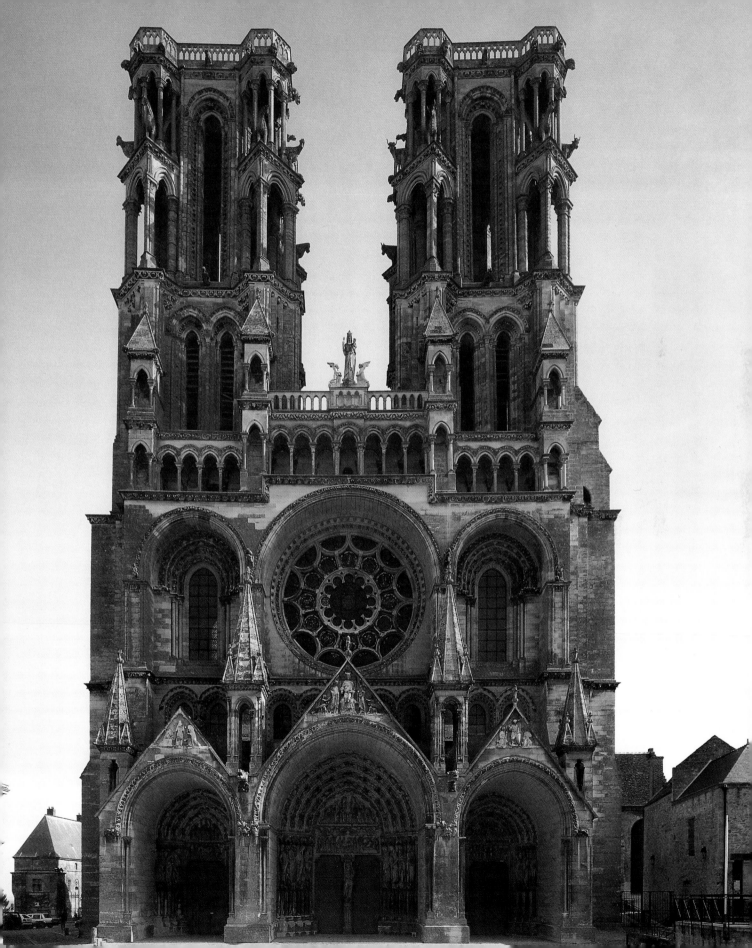

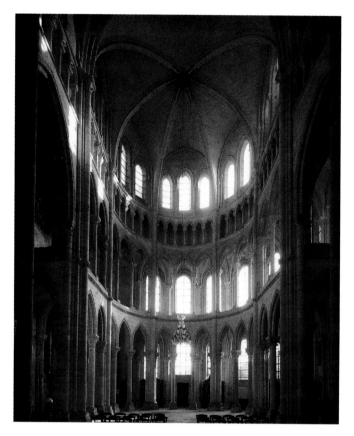

This resulted in a considerable reduction of wall surface in the spandrels of the arches, so that the building appears to consist only of responds and arches. The increase in the number of triforium arches to six per bay, and of the clerestory windows to three, as at St.-Remi, also contributes to the disappearance of the walls. Here it was easy to do without responds having rhythmically placed shaft rings (as at Laon), since with this fragile-looking architecture the concern is not with the structural function of the decorative scheme, but with the articulation of spaces that flow into one another. In addition, piercing external walls with windows, a feature pursued to an extreme here, opened up the building's space by pushing its boundaries outwards.

Soissons represents one of the high points of Early Gothic architecture, but it would be wrong to regard this building as the conscious goal of a deliberate stylistic development. Contemporary projects included buildings that reflect trends completely at variance with those of Soissons. The leading example is the Cathedral of Notre-Dame in Paris. After a lengthy period of planning, during which time individual parts of the old structure may already have

been rebuilt, Pope Alexander III could officially lay the foundation stone for a completely new building, a building which can in a sense be regarded as the prototype Gothic cathedral. This is not because it was the first cathedral in the Gothic style (Sens and Senlis are earlier) but because here for the first time there was an attempt to construct, in the new style, a monumental building that was characteristic of its type and yet unique. With a length of 130 meters (426 feet) and a height of 35 meters (115 feet) to the vaults, Notre-Dame in Paris far exceeds the usual size of a Gothic cathedral. No wonder that in order to realize the project, the building control regulations of an entire district had to be changed! Yet for the cathedral of a capital city, situated close to the residence of the increasingly powerful kings, all this was not considered excessive.

Notre-Dame is a basilica with galleries and double side aisles, an arrangement previously found only in such eminent buildings as the abbey church in Cluny and St. Peter's in Rome. This alone indicates the privileged position of Notre-Dame, particularly as Gothic churches with double side aisles were the exception later. Separated by huge columns, the double aisles of the nave become a double ambulatory in the apse. The problem of the ambulatory spreading out in an ever-increasing radius was solved by doubling the number of columns and by setting triangular vaults against each other, with the result that the whole ambulatory of Notre-Dame displays an even regularity of shape.

Similarly, the arcades in the main nave also have a series of uniform columns, as at St.-Germain-des-Prés, resulting in the rhythm between the straight and rounded parts of the choir remaining unchanged. This is all the more astonishing as the nave of Notre-Dame has sexpartite vaults, which elsewhere are always linked by stronger or slender piers in alternation, according to the changing number of vault ribs. Above the piers rise uniform clusters of slender responds, always in threes, making no allowance for the fact that each cluster has to correspond to a different vault profile. This irregularity is disguised in a way similar to that used at the start of the choir apse at St.-Germain-des-Prés: the three responds of one cluster support two wall ribs and a transverse rib; the three responds of the next cluster support two diagonal ribs and a transverse rib, and also (out of view) two wall ribs. Only in this way was it possible to build a row of completely uniform arches, galleries, and windows, and it was only in this way that the most elegant proportions could be achieved.

The huge webs of the sexpartite vaults, which are much larger than the more closely spaced ones of a quadripartite vault, correspond to large areas of wall. In other words, the builders of Notre-Dame did not aim for a total opening up of the wall surface (as in the south transept of Soissons), but for an effective contrast between a recognizably thin and flatter wall on the one hand, and slender responds (without shaft rings) and vault ribs on the other. Originally this effect was even more striking since the wall surface above the gallery was larger, the area above being broken only by rose windows

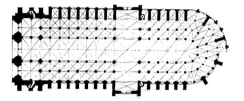

Paris, Notre-Dame
Ground plan, with
the 13th-century
chapel extensions

with modest-sized openings. This arrangement was not to last because the cathedral was too dark; as early as the 13th century the windows were enlarged and in the 19th century Viollet-le-Duc remodeled them around the crossing.

In the nave of Notre-Dame a new architect added some variations to the contrasting system of wall and supports. The galleries, which now possess three openings, are no longer supported at the sides by round shafts but by flat pilasters. These contrast with the responds in the nave, which, even more slender than those in the choir, consist of tall, monolithic shafts no longer flush with the wall.

The theme of the flat wall is adopted again in the west front of Notre-Dame (see below, right), which goes back to the type used at Laon, but with a quite different character. Because the towers at Notre-Dame, unlike those at Laon, stand above double side aisles, they are wider and more stable, so that the buttresses do not have to protrude very far. Moreover, they almost sink into the wall of the first story, which was pulled forward so far that the portals are set deeply into them and do not protrude, as at Laon. It creates the impression of

looking at a triumphal arch with a royal gallery, a line of statues representing all the French kings, which demonstrates the historical continuity and authority of the monarchy. Nowhere else in medieval architecture does a royal gallery display a succession of monarchs, here shown in close array, quite so impressively. This effect could be achieved only because the builders of Notre-Dame, unlike the builders of Laon, avoided the rhythmic intensification of the façade decoration as it moves towards the center. Only in the upper stories and towers, where delicate shapes appear, does the impact decrease without detracting from the sublime overall impression.

How powerful an impression Notre-Dame in Paris made can be seen from the collegiate church of Notre-Dame in Mantes, situated almost on the border between the French Royal Domain and Normandy, which then belonged to England, and for this reason was particularly important for the French king. It was probably begun around 1160, according to an old design, with slender monolithic piers in the apse and alternating supports. This plan was soon modified to reflect the architecture of Notre-Dame in Paris. Thus we

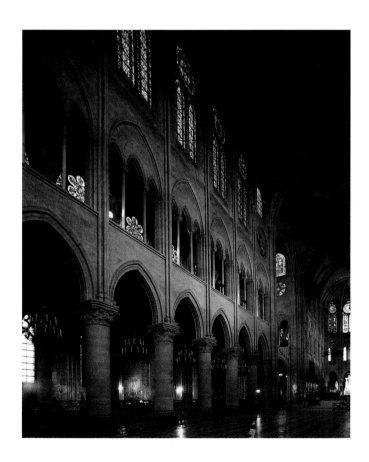

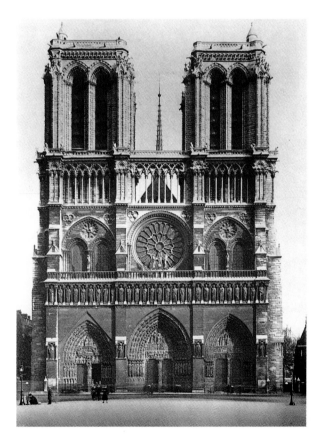

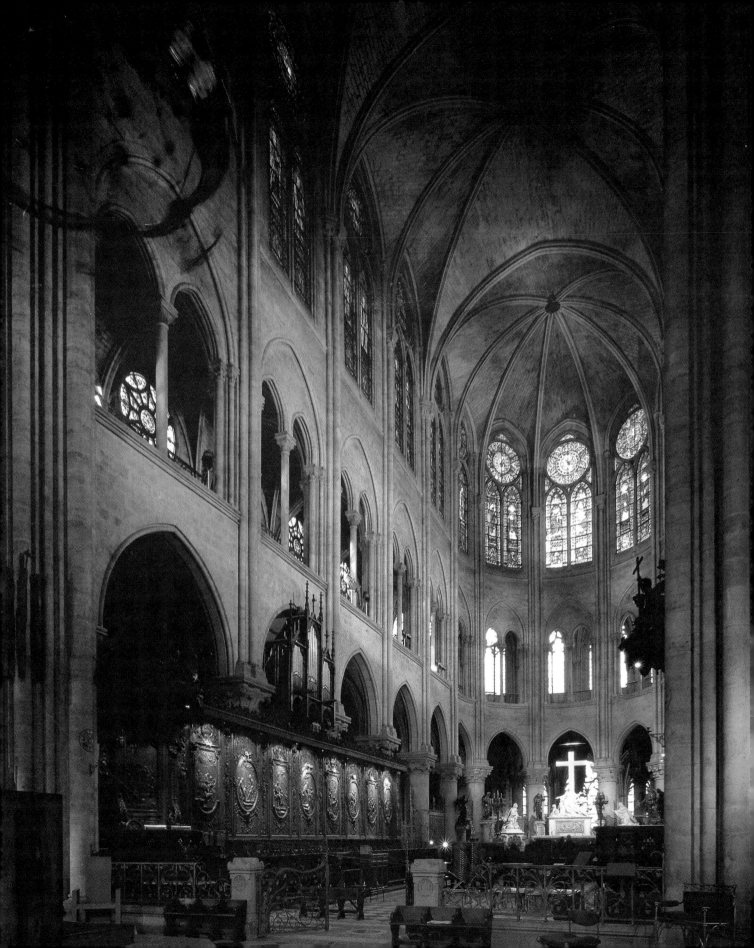

OPPOSITE:
Paris, Cathedral of Notre-Dame,
begun 1163
Choir

Paris, Cathedral of Notre-Dame
Nave vault

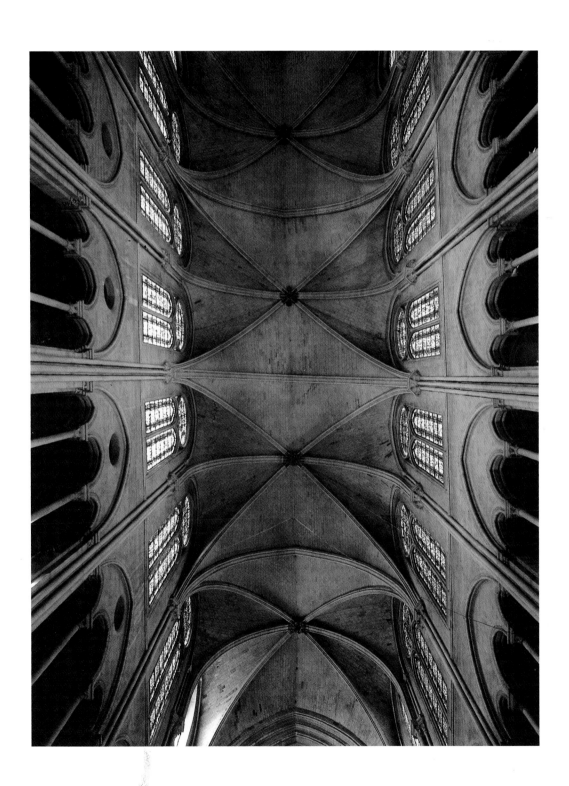

BELOW:
Mantes (Yvelines), former collegiate
church of Notre-Dame
View from northwest, begun
towards 1200

CENTER:
Nave and choir, ca. last third of
12th century

RIGHT:
Braine (Aisne), former Premonstratensian
abbey church of St.-Yved, begun towards 1190
Ground plan (right)
Choir and crossing (below, right)

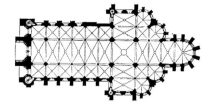

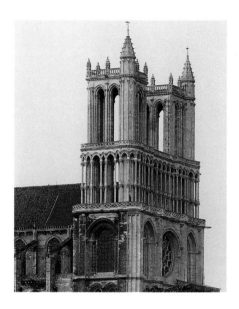

find here once again the thin membrane-like expanse of flat wall, an elevation with no triforium, and giant vault webs (see above, center), while slender clusters of responds rise up to contrast with the wall surface. On the west front of Mantes (see above, left) plans from Laon and Paris appear to have become confused since this façade, though less powerful than the façade of Notre-Dame in Paris (through the influence of Laon), takes its consistent horizontal emphasis from Paris—though it is not clear whether Notre-Dame of Paris preceded Notre-Dame in Mantes or vice versa.

Mantes is an example of the growing acceptance, after the last third of the 12th century, of several specific types of church building, evidently considered exemplary. Highly individual designs did not disappear as a result, yet Gothic architecture at this time seems to have become increasingly systematic, even standardized. An example of this trend is the abbey church of St.-Yved in Braine. Situated near Laon and Soissons, Braine was the royal seat of the duke of Dreux, the brother of the French king, whose future wife must have encouraged the building of the church shortly before 1200. The church, which since that time has served as a burial place for the dukes of Dreux, is certainly not a building in the same class as a cathedral. It was not the resting place of the first family of the land, and for this very reason it was built in a style that is impressive in its simplicity, a style reached by simplifying the rich vocabulary of forms found in Laon cathedral. Thus instead of four stories there are only three, the gallery being omitted. The nave does not have the subtlety of alternating clusters of responds, and these responds are not divided into rhythmic lengths by shaft rings. In place of an ambulatory, as existed in Laon at the time, Braine possesses an original choir with diago-

nally placed side chapels (see above, right). Like Laon, the church also has an open crossing tower and, until its destruction in the 19th century, a west end that was very like that of its model.

A comparison of the cathedral of Laon and the abbey church of Braine is particularly instructive because it demonstrates how medieval architects could adapt a great model purely by simplifying it, and in doing so reshape it into something new. Since there are in this region other churches in which similar features are to be found—Braine has a virtual twin in the abbey church of St.-Michel-en-Thiérache—Laon appears to have functioned as a life-size "model-building kit" during the last years of the 12th century.

The Stylistic Diversity of Gothic Cathedrals Around 1200

Around 1200 a series of very different versions emerged out of this model-building kit. With the rebuilding of the choir at Laon there was a return to the older style of architecture we have already mentioned, with all its wealth of detail. Exactly the opposite happened at Soissons. Instead of continuing with the rebuilding of the cathedral in the subtle style of the existing four-storied transept, the patrons took another path and built the new choir and nave in the style used in the abbey church of Braine, with its three-storied elevation and fewer responds (see opposite, bottom). In spite of this, the stories of Soissons Cathedral are higher on the whole than those in Laon Cathedral, higher even than those in its own former transept. A reduced number of stories on the whole meant a considerable gain in height. For the first time in Gothic architecture the arcade and clerestory have approximately the same dimensions, a feat achieved by extending the window area and raising the vault.

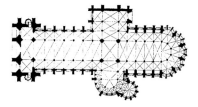

Soissons (Aisne), Cathedral
of St.-Gervais-et-Protais
Choir, ca. 1190–1212 (below)
Nave and choir (bottom)
Ground plan (left)

The trend towards simplicity can be seen on the exterior too (see right, top), a fact which becomes particularly clear when it is compared to St.-Remi in Reims (see page 37, bottom right). With their rhythmically ordered arrays of buttresses, the exteriors of both choirs are largely alike, even if Soissons has one story less. Yet at Soissons there is not the dynamic relationship between window openings and buttresses that there is at Reims, just as there is little variety in the ornamental decoration from floor to floor. It was not the subtle addition of detail that was to create such an effect in Soissons, but the standardized, sculpturally modeled mass of its masonry.

The new aesthetic of simplicity and monumentality apparent in the choir at Soissons was radically different from the aesthetic of detail and subtlety illustrated by the older transept (see page 44). There is a good deal of evidence to show that when the choir was being built, those in charge of the rebuilding intended to tear down the old transept in order to rebuild it in the new, more monumental style. That it is still standing, even though its pendant on the north side was replaced during the rebuilding, is due solely to a lack of funds. As a result, Soissons represents the exact opposite of Laon. Instead of expanding the cathedral of Soissons in the old style, as had happened at Laon, those in charge decided to throw out the old in favor of the new. Though the medieval restorers of both cathedrals employed very different means, their intentions were the same: to create completely uniform buildings, buildings, moreover, whose past was not easy to read.

In Chartres, the most significant Marian shrine in France, a monumental building in the new style of Soissons was begun after a fire in the old cathedral in 1194. Even if the crypt and west front of the earlier church had survived and could be used again, they were not conspicuously cherished as venerable "relics." By the end of the 12th century there was a growing desire to build completely new buildings rather than to preserve as much of the old as possible. This is made clear in the stories and legends that grew up around the devastating fire and the rebuilding it brought about. Initially the fire was seen as a catastrophe, largely because it was thought that the precious Marian relics had been lost along with the church. When these relics were discovered unharmed, the mood changed completely, and the fire was interpreted as an expression of the Virgin's desire for a new and more beautiful church. When we consider that Abbot Suger, some 50 years earlier, had had so many scruples about rebuilding his old church, and had had such a deep respect for its stones that, to use his own words, he "buried them as true relics," it is all the more surprising to see that in Chartres the Mother of God was seen as the destroyer of her own church. Can it be concluded from this that the new Gothic architecture of the French Royal Domain had become so highly respected in the meantime that using it no longer needed any justification?

In its basic structure, the interior of Chartres Cathedral is difficult to distinguish from that of Soissons. With their huge increase in height, the arcades and clerestories, separated by the triforium, are approximately the same height (see page 50). Yet Soissons and Chartres, in

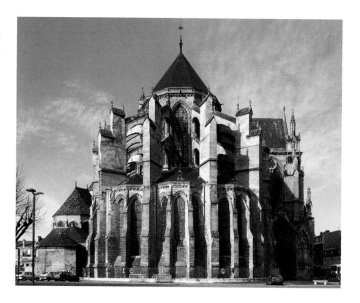

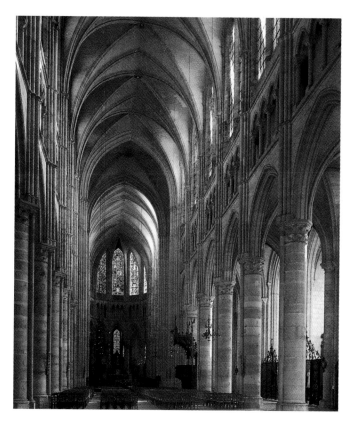

49

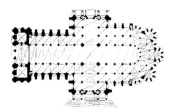

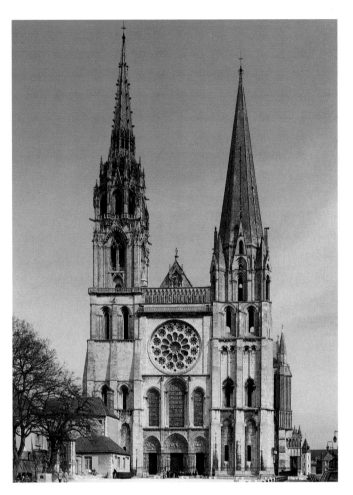

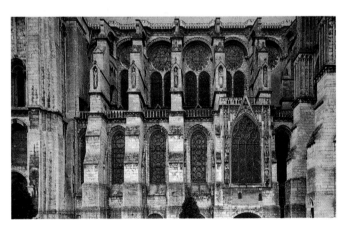

spite of this similarity, are unmistakably different. This can be seen in almost every single comparison of motifs. For example, the columnar piers at Soissons, in spite of their great height, are nearly as slender as those at Laon, and they are accompanied by only one slender respond. In Chartres, by contrast, the piers are more than twice as thick and are surrounded by four responds, which are themselves almost the average size of the main piers in Soissons. A pier in Chartres is a maximum of 3.70 meters (12 feet) thick; a pier in Soissons is barely 1.40 meters (4.6 feet) thick. This great difference in the piers cannot be put down to a difference in the height of the buildings: Chartres is only a little taller than Soissons. The explanation lies in the fact that the builder of Soissons, in order to make it taller than other cathedrals, merely lengthened the piers. The builder of Chartres, on the other hand, made them far larger, and therefore stronger. Here we touch on an essential feature of the innovations at Chartres: this cathedral was not only the largest Gothic cathedral built up to then, but also the most awe-inspiring, even in its smallest detail. And so Chartres, in spite of the height of the vault, which is even higher than that of Notre-Dame in Paris, appears neither too immense nor even too airy, but heavy and very powerful. At the same time, it is not without subtlety: the shape of the piers alternates between octagonal and round, with round responds attached to octagonal pier core and vice versa. Since these differences continue in the clusters of responds leading right up to the vault, the whole wall of the main nave has a subtle, almost imperceptible rhythm.

From the outside, too, Chartres looks like an incarnation of monumental architecture (see bottom, left). The enormous buttresses of the nave primarily demonstrate strength and only secondarily serve to stabilize the building and support the vault. In the choir (see page 54, right) this buttressing becomes somewhat lighter, though it does not change its basic structure. It is clear that the architect knew that he was doing more than was structurally necessary, otherwise he would not have tunneled so thoroughly into the inner buttresses of the ambulatory with wall-passages that are invisible to the observer, and that make a mockery of the massive size that is put on show.

Chartres is so full of architectural quotations that it is almost a synthesis of older types of Gothic buildings. As in Notre-Dame in Paris, for example, there is a double ambulatory in which, as at St.-Denis, every other chapel that adjoins it is combined under one common vault with the ambulatory bay (see ground plan above). Yet the size of the ambulatory at Chartres, with its mighty columns, makes it difficult to recall the width and ease of the ambulatories in Notre-Dame in Paris and at St.-Denis. In the same way, the motif of the front at Laon cathedral appears twice at Chartres, not however in the west, where the old façade had to be only slightly modified when it was rebuilt, but in the transepts. Here the wall surfaces dissolve almost completely into lancets and enormous rose windows (see pages 52–53). Similarly, the porch above the west portal was turned into a richly shaped and richly sculptured triumphal arch.

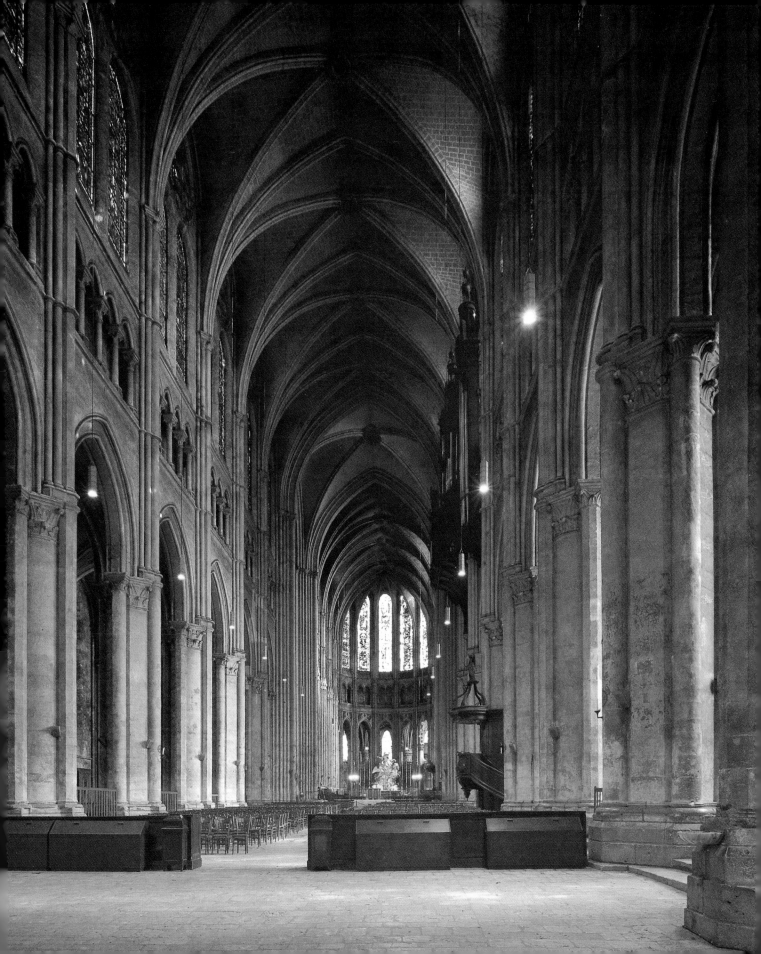

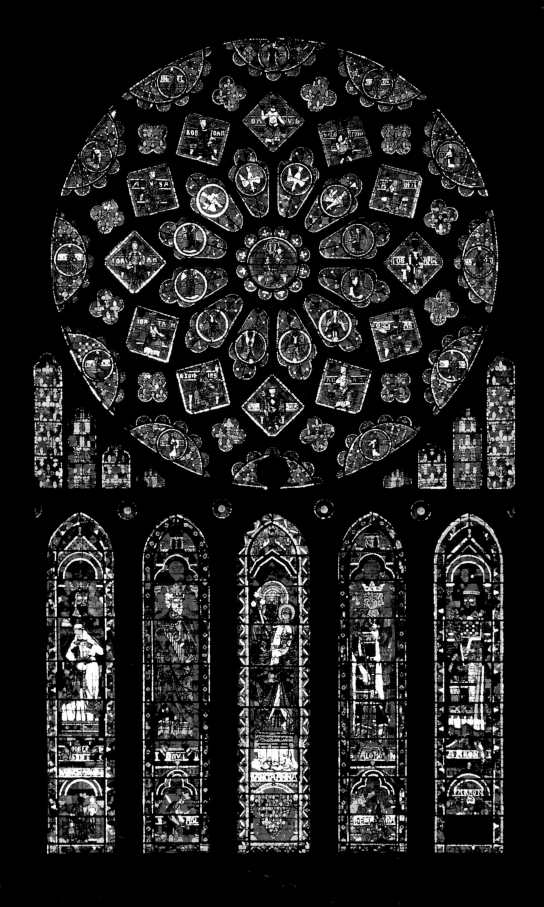

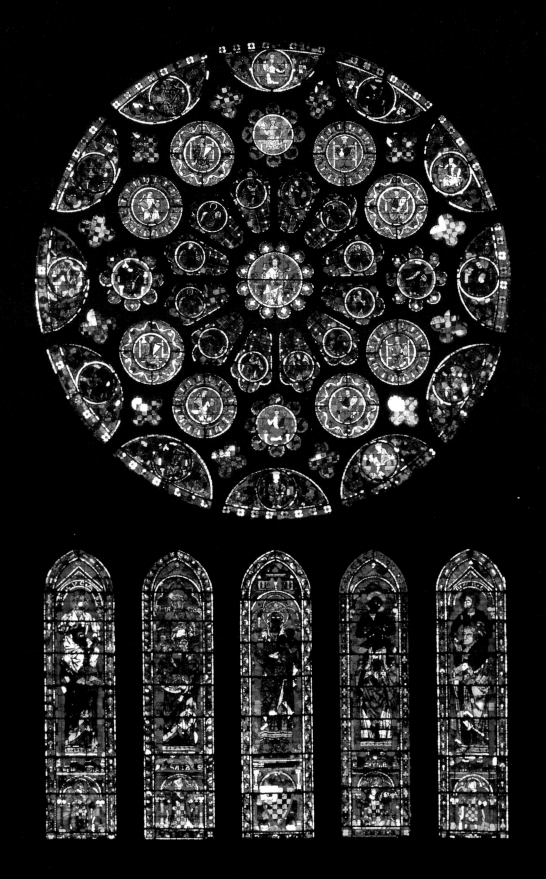

PREVIOUS PAGES:
Chartres (Eure-et-Loir),
Cathedral of Notre-Dame
North rose window (page 52)
South rose window (page 53)

BELOW:
Chartres (Eure-et-Loir),
Cathedral of Notre-Dame, built
after the fire of 1194
Ambulatory (left)
Choir (right)

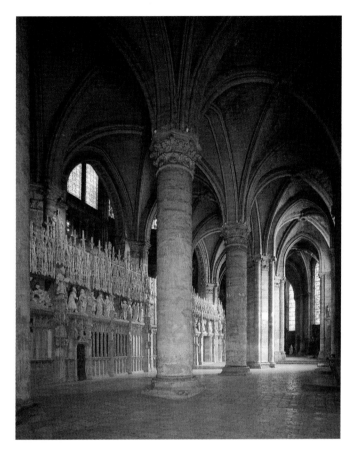

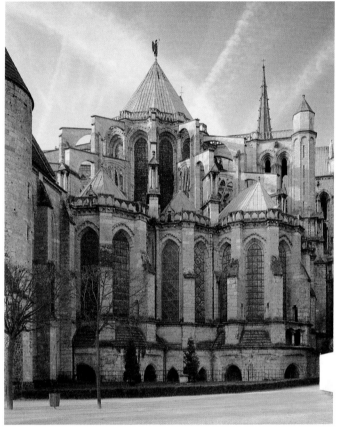

Castle Architecture and Chartres

There can be no question that the architect of Chartres had an excellent knowledge of contemporary church architecture, especially that found in the area around Laon. Yet the innovations in the distinctive military architecture of the day could not have escaped his attention, for it was an architecture in which massiveness—stressed again and again at Chartres—was an integral feature. Even individual motifs seem to have been inspired by it, too. One example is the strange passage at the base of the Chartres choir connecting the polygonal area formed by the chapels to the semicircular inner structure, a passage which is structurally superfluous (see above, left). This motif, which gives the impression that it has been carved out of the solid mass of stone, only serves the purpose of drawing one's attention to the enormous strength of the walls. It had a practical function only in fortified towers—and that is precisely where it comes from. The towers of the castle of Fère-en-Tardenois, built in 1200, demonstrate a similar comparable change in style between its lower areas and upper floors (see page 57).

The motif of enormously strong walls was not the only link between Notre-Dame and the castles of the period, some of the most important and innovative projects built under the French king Philippe-Auguste (1180–1223). Much more important was the fact that these castles, like the cathedrals and abbey churches, had a symbolic as well as practical function: often their apparent strength was far greater than their real ability to defend. The best example of this is at Château Gaillard (see page 56), a fortress that the English king Richard the Lionheart (1189–99) had built to block the Seine on the border between Normandy, which then belonged to England, and the French Royal Domain. This powerful, and above all very expensive, construction was begun in 1196 and completed in the very short time of one year, yet as early as 1204 it was captured by Philippe-Auguste after a long siege. Behind an outer castle, which blocks off the only natural entrance, the circular main castle rises up, appearing to consist solely of a row of closely aligned towers. It is dominated by the keep with several floors from which, on the outside, spur-like

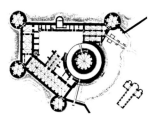

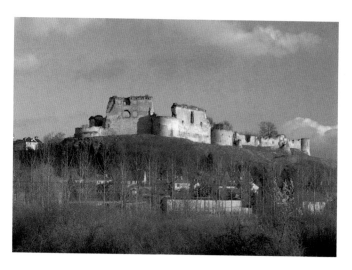

brackets protruded to support the battlemented parapet above, whose shapes contrasted dramatically with those of the main castle. The design was of course determined above all by military needs, but it is clear that the design was also meant to demonstrate the supposed strength of the fortress.

The structure of the castle of Coucy (see right, top and center), built around 1225–42 and situated centrally between the three episcopal towns of Noyon, Laon, and Soissons, is somewhat more complex, as is that of the enormous castle in Angers, built at roughly the same time (see right, bottom). Coucy-le-Château was not a purely defensive building. It was also the seat, closely connected with a small town, of the powerful dukes of Coucy. Enguerrand III, who had it built, was trying to increase his power by exploiting the unstable political situation at the beginning of the reign of Louis IX (1226–70). The king was still a minor and so his mother, Blanche of Castile, was acting as regent. The castle is an expression of the duke's ambition. In contrast to Château Gaillard, at Coucy the keep stands not on the outermost point of a cliff but on the line between the main and the outer castle. It therefore looks both into the far distance and towards the inhabitants of the town, who had to take their tribute payments there. As the keep was to provide living accommodation for the family, it had three large, heated rooms lying one above the other. With their ribbed vaults, these rooms look like chapels, but they must have been very dark because of the tiny windows. The keep at Coucy, in other words, combines church and military architecture.

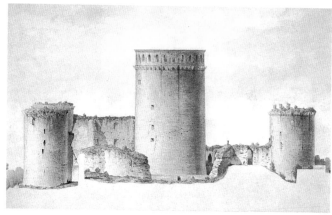

In Angers, by contrast, the military function dominates entirely. Here it was Blanche of Castile who ordered the building of the castle, in order to be able to defend the royal family against ambitious barons such as Enguerrand. The fortress was originally even more impressive since its towers, which now rise to over 50 meters (165 feet) above the moat, originally stood even higher. The absence of a keep shows that this complex was meant as a fortification to house a garrison, and not as a royal residence.

As the examples of Château Gaillard and Coucy show, castle architecture during this period was often less practical than poetic (if we can use this word in connection with their military function). Their builders, such as Richard the Lionheart in the case of Château Gaillard, often did not know how to distinguish clearly between practical function and symbolic value. From a modern pragmatic point of view this may seem astonishing. But medieval wars and battles were themselves in large part ritualized and symbolic events. Nevertheless, the comparison of castle and church architecture can clearly demonstrate that a purely rational account of sacred architecture, in general or in detail, is totally inappropriate, since even the very practical military architecture of the period was sometimes not entirely "rational."

Now to return to Chartres. The architect of the cathedral was not necessarily a military architect, yet he clearly knew that this form of architecture offered a range of ideas with which he could bring about

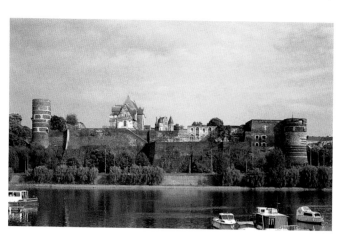

Château Gaillard (Eure),
castle, 1196–97, captured
and destroyed 1204, from west

Fère-en-Tardenois (Aisne),
castle, ca. 1200

St.-Quentin (Aisne), former
collegiate church of St.-Quentin,
begun ca. 1200
Ground plan (right)

St.-Quentin (Aisne), former
collegiate chuch of St.-Quentin
Nave and choir

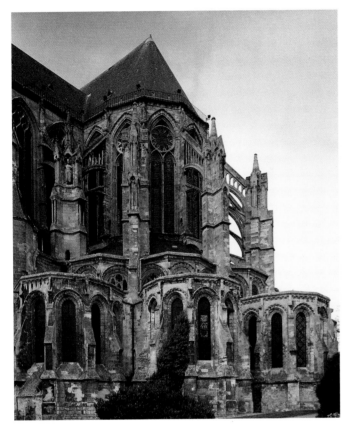

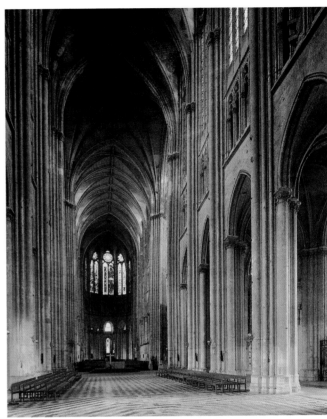

what he wanted to achieve—or at least what he had been commissioned to carry out. And since Chartres, as the most important French place of pilgrimage, was more significant than Soissons, he had to surpass Soissons. A simple increase in size was not enough: he chose a "grander" style that bore a close affinity to castle architecture.

Soissons and Chartres are thus to be perceived as alternative forms of the Gothic cathedral with very different styles. The fact that the architect of Chartres departed from the guidelines Soissons had supplied does not detract from his achievement in the least. Out of these guidelines he created something quite new that surpassed everything that had gone before it. He could simply have built a cathedral like the roughly contemporary collegiate church of St.-Quentin, in the diocese of Soissons (see above). All the possible types of building and stylistic elements of earlier architecture are combined in this collegiate church, and it is the imaginative combination of these, rather than the overall impression, that was innovative. So at St.-Quentin (a collegiate church could be as big as a cathedral) there is an ambulatory with separate chapels, as at St.-Remi in Reims, that ends with diagonally

placed chapels, as at St.-Yved in Braine. Not only these models, from before 1200, were adopted. At St.-Quentin the builders appear to have carefully considered the latest architectural trends so that they were able to integrate into their designs innovations of a much later date such as those of the cathedrals of Amiens and Beauvais. For this reason the architecture in St.-Quentin is not poor; it took good ideas from several sources. For us the value of St.-Quentin is that it provides a clear and instructive example of a contemporary alternative to Chartres, created at the very moment when a certain standardization in Gothic architecture was being reached. In St.-Quentin the builders were happy simply to combine familiar architectural forms and motifs. It was at Chartres that a new greatness was achieved through the creative refashioning of the familiar.

The Impact of Chartres and the Development of Alternatives
Chartres set a high standard in Gothic church architecture, a standard that, it must have seemed, could not be surpassed. All the same, Gothic architecture had by no means reached its peak; it is probably

only because the building of the cathedral proved to be so lavish and costly that it could not be outdone. The only way to surpass Chartres, using its own methods as it were, was to restore the cathedral of Reims. This fitted in well with current political needs, for it was here that the archbishops of Reims consecrated the French kings, and the current archbishop had to decide what could be done to make the cathedral measure up to the importance of a major occasion so steeped in tradition. When the old cathedral burnt down in 1210, it had to be rebuilt with great speed. King Philippe-Auguste was already in his late forties, so the coronation of his successor had to be reckoned with (people at that time rarely lived past 50). And in fact the successive coronations of Louis VIII in 1223 and Louis IX in 1226 took place in the middle of a building site.

Just how great an impression the cathedral at Chartres had made can be gauged from the fact that the new cathedral of Reims broke away from some local architectural traditions. Like the church of St.-Remi in the same town, the old cathedral had incorporated several buildings from various ages. The new cathedral was to be more uniform. Reminders of local architectural tradition find expression mainly in the unusually short choir, which had the effect of making the new nave seem even longer (see page 60).

However, the coronation ceremony may also have been a decisive factor in this, for the largely unchanged distribution of space meant that the coronation could unfold with the same elaborate ceremonial. So, instead of becoming involved in the complex architectural portrayal of history, as had been usual in Reims until that time, the builders of the new cathedral followed the pattern of Chartres.

The achievement of Chartres is not diminished at Reims, since the Chartres pattern is further enriched by details taken from local architectural tradition, for example, the building of an interior passage in front of the windows on the ground floor and the linking of the triforium and clerestory in the chevet by means of a continuous mullion. The use of such quotations, to which more could be added from churches nearby or farther afield, is really nothing more than an embellishment of the overall character of Chartres. At most they express, somewhat awkwardly, the builders' desire for some historical references, for the architectural traditions employed in their new cathedral could not be exactly the same as those used in Chartres Cathedral.

But there are also important and visually striking motifs that outstrip those of Chartres. The intricate rose windows on the clerestory windows in Chartres, for example, are replaced in Reims by a form of tracery that here makes its triumphant entrance into Gothic architecture. For this fine bar tracery in the window openings permitted an increase in the surface of stained glass and, along with that, its decoration. Tracery was also technically much easier and therefore quicker to make than the individually shaped rose windows of Chartres (see pages 52–53), as it could be prepared piece by piece with the aid of templates. This planning method was new at the time

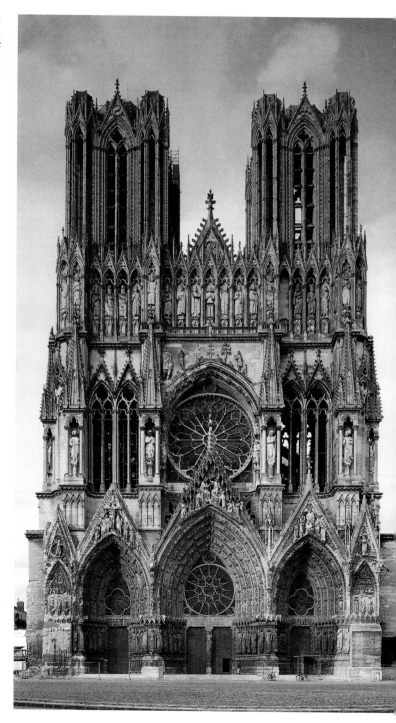

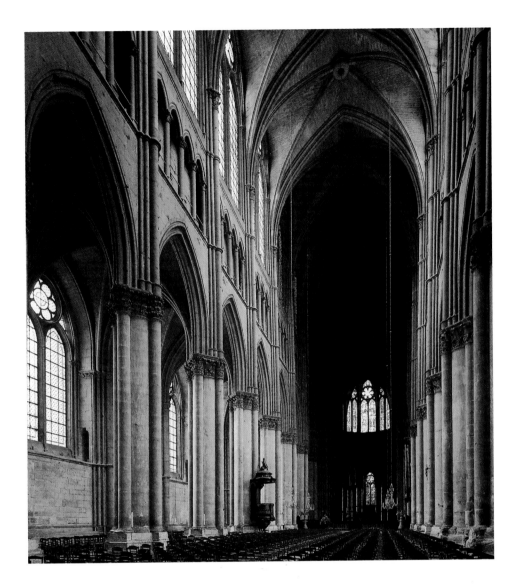

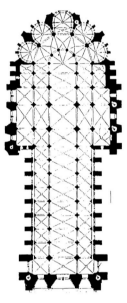

Reims Cathedral, ground plan

and it is certainly no coincidence that the oldest precise architectural sketches that have come down to us, in Villard de Honnecourt's so-called stonemasons' lodge book, are of Reims Cathedral itself and the other churches in the area.

The Reims architect also broke away from Chartres in the construction of the choir. This was made considerably easier since at Chartres the crypt of the earlier building had been integrated into the foundations, which was not necessary at Reims. Instead, a building emerged with a solid outline similar to that of Soissons, yet with considerably more lavish decoration. Tall arcading with pointed arches crowns the radiating chapels, and at the top of the buttresses tower mighty tabernacles with giant carved angels. This motif is continued on the entire exterior of the cathedral, which appears to be guarded by the heavenly hosts (see opposite). Here too the model was Chartres Cathedral, where there are niches with statues in the mighty buttresses of the nave, but in Chartres they are much too small to transform the buttresses into sculptural niches and so disguise their true structural function.

Where Chartres supplies only technical solutions, Reims displays a great wealth of motifs in its detail. For example, in the uniform decoration of the capitals, Reims uses highly individual decorative designs that attempt to imitate natural foliage as closely as possible. As a result, the principle that the height of capitals is determined by the diameter of the shafts, a principle that goes back to classical times, is here ignored for the first time in Gothic architecture. So at Chartres the mighty arcade piers are topped by high capitals, and the thinner shafts at the side by consistently lower ones. In the oldest parts of Reims, by contrast, the capitals of the slender columns are made as high as those of the massive pier cores until finally, in the later part of the cathedral, the capitals are like continuous friezes that run uniformly across the pier cores and responds.

Reims' attempt to surpass Chartres had finally to remain an unfinished experiment, for the expense of further improvements was too great. The architectural future was not to be based on the luxury buildings of Chartres and Reims, even though their motifs had already passed into the general repertoire of Gothic architecture. It

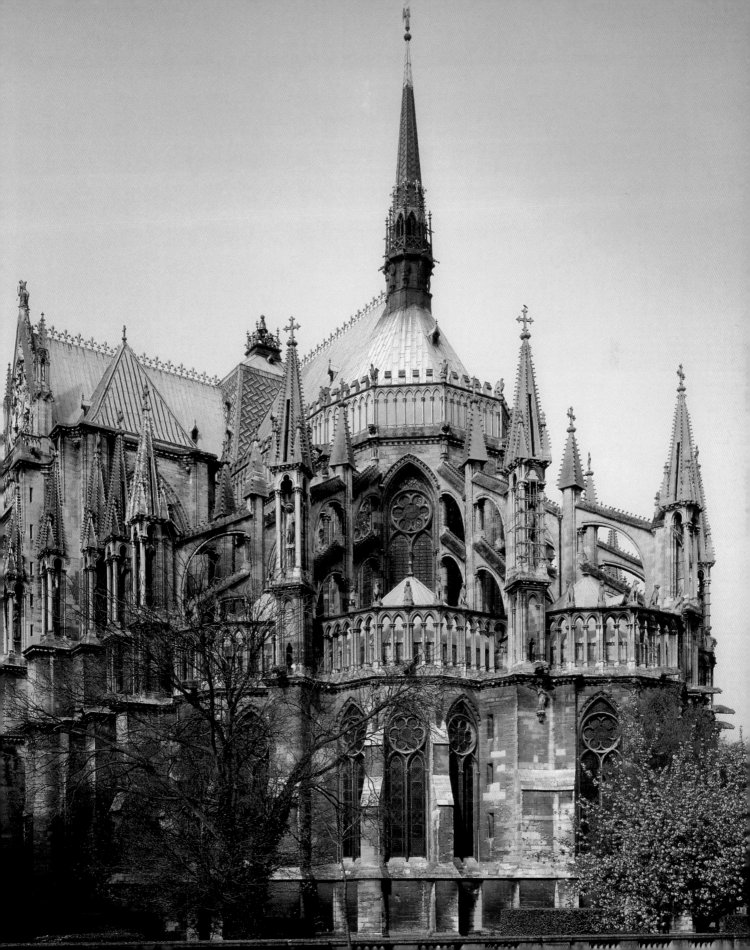

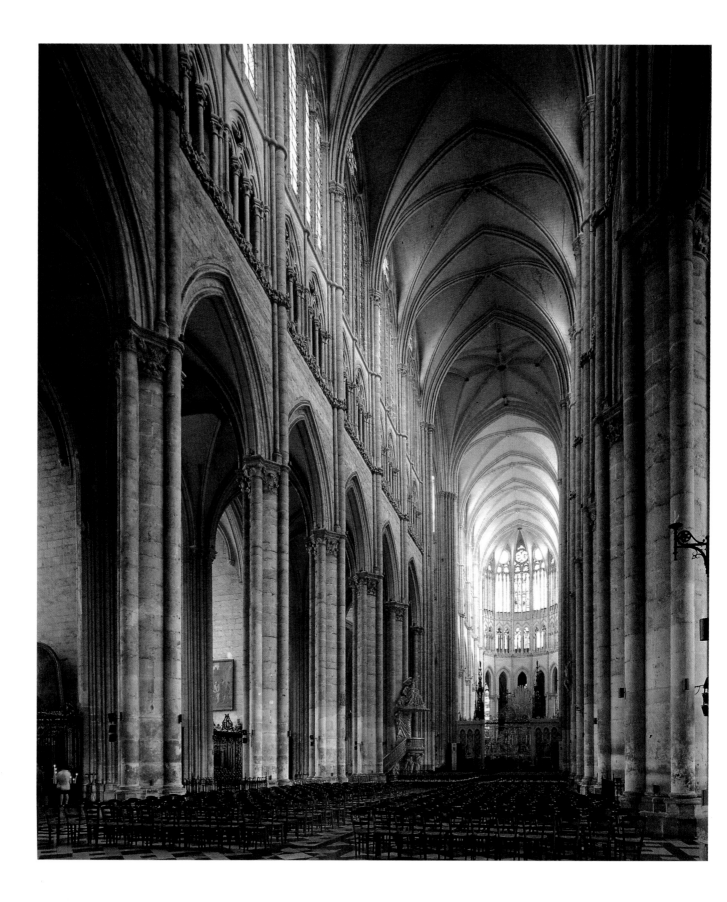

Amiens (Somme), Cathedral of
Notre-Dame
West front (below)
Ground plan (left)

was to be based on the technically much more elegant and less costly model of Soissons, to which Chartres and Reims themselves had indeed been indebted.

Thus the first architect of Amiens Cathedral did not attempt to match the extravagance of Chartres and Reims. A fire in the old cathedral, consecrated in 1152, had provided the opportunity for a completely new building, which was begun in 1220 under Bishop Evrard de Fouilloy. Robert de Luzarches is known to have been the first architect and master builder, followed by Thomas de Cormont and his son Renaud, who in 1288 completed the first maze on the cathedral floor, of which only a copy remains today. This maze was made to remind people of the most important people and dates in the building's history. The succession of sparkling architectural achievements in Amiens must have begun with the drawing up of a precise building plan establishing the future development of the building, since the old cathedral only covered the site of the new nave. East of that, where the future choir was to be built, was the city wall, to the west stood St. John's Hospital, and on the site of the planned north transept stood the church of St.-Firmen. Therefore, when the foundation stone was laid, the land to be built on was not yet available, and did not even belong to the patron.

This situation was not unique in medieval building, but it was unusual, as at Amiens, to have to start in the middle of the cathedral, in the south transept to be precise, in order to be able to construct the façade, choir, and north transept at some uncertain date in the future. Nevertheless, the huge building was erected quickly between 1220 and 1288. As a result of this rapid progress, the course the building was to take remained unclear for several years, largely because it was being reconstructed on the basis of differences in the decoration of the nave and choir. In the event, these differences turned out to be the result of a uniform plan that assigned differing styles to these parts of the building.

Only as a result of this perfect planning, which went hand in hand with a rationalization of building techniques, was it possible for Luzarches to build in Amiens a cathedral even larger than those of Chartres and Reims. The key factor here was his decision to avoid simply stacking large blocks of masonry one on top of the other. Instead of imitating the enormous pier masses of Reims and Chartres, he chose the slender Soissons piers, which structurally were completely adequate, and yet at the same time he adopted the system of four slender shafts used at Chartres (see opposite). What the Amiens supports lacked in volume they gained in height, so the total expense cannot have been much more than in the older cathedrals. In the choir the architects of Amiens even dispensed with the rear wall of the triforium, until then an integral part of this feature, so that this story, which had always been dark, now seems to be brightly lit, and visually merges with the richly designed tracery of the clerestory windows.

The arcades and clerestories at Amiens, in contrast to those at Soissons, Chartres, and Reims, are not of the same height, for the

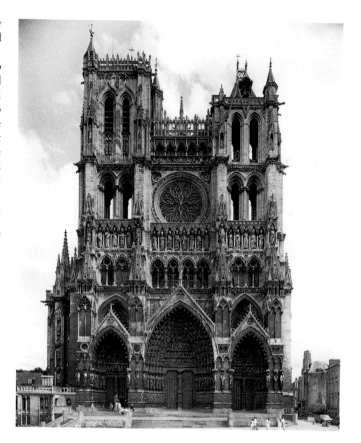

arcade alone equals the combined height of the triforium and clerestory. As a result, hardly any fixed points are offered at eye level to anyone entering through the west portal. The slender supports carry the walls of the nave, which are divided above the arcades by a strongly pronounced leaf-patterned stringcourse, into seemingly inaccessible regions. At the same time the long, sheer, and tunnel-like nave appears to push the choir into the far distance so that the interior of Amiens looks its most impressive from the main portal. This can be regarded as a remarkable achievement, as the building was begun at a quite different place.

What is more, the first architect of Amiens must have incorporated the observer's viewpoint into his plans in a way previously unknown. The west front (see above), in front of which during the Middle Ages the houses were packed together so closely that the façade could not be seen as a whole, is really no more than a thin wall in front of the church, quite lacking the heavy monumentality of Laon, Paris, and Chartres. Even more impressive is the perfectly situated portal, which at eye level offers only small reliefs, the characters

Amiens (Somme), Cathedral of
Notre-Dame, begun 1220
Choir

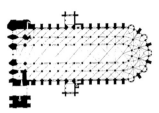

OPPOSITE:
Bourges (Cher), Cathedral of St.-Étienne,
begun late 12th century
View from southeast (top)
Nave (bottom left)
Side aisle (bottom right)
Ground plan (left)

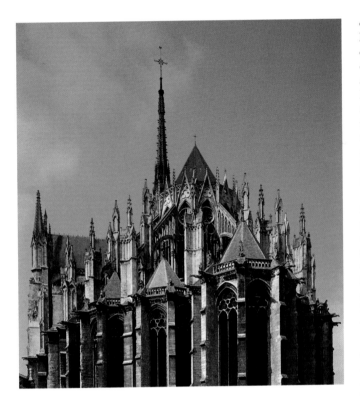

offer a completely uniform view (see opposite). This impression is heightened by the use of steep flying buttresses, which, being very thin, do not conceal the main body of the building. In addition, Bourges has double side aisles, like Notre-Dame in Paris and the Romanesque abbey church of Cluny, from where it also borrows the staggered height of the side aisles as they move toward the nave. The outer side aisles are the usual height, but the inner ones soar above them and have their own window story (see opposite, bottom right). Their monumental arcades correspond with those of the nave and bear the weight of the triforium and the nave clerestory. Thus the building at ground-floor level is of an enormous width, while the triforium and clerestory, as at Amiens, are transported upwards into inaccessible heights.

The structure of the piers in Bourges is highly original, since it negates the classic theory of support and load. The piers do not end at the capital, but run on up into the vault, a segment of their round core protruding from the wall. This creates the impression that the cathedral consists essentially of rows of gigantic cylindrical piers onto which the walls and the vault have been placed. This impression is strengthened by the fact that the shafts at Bourges are particularly slender, so that much of the pier core remains visible between them. In the apse, moreover, the vault webs are forced down between the windows, suggesting that the whole vault is a thin membrane.

Although the proportions of Bourges are untypical of the Gothic architecture of northern France, Bourges Cathedral quickly became influential there, particularly in Picardy. The increased spatial effect in Amiens Cathedral is likely to have been inspired by Bourges, though it is impossible to be certain about this.

However, we can be sure that this is the case with the cathedral of Beauvais, begun in 1226. The town was once one of the richest in France (this is difficult to imagine now because of the extensive damage caused during World War II), though the growing importance of Paris was making Beauvais an increasingly provincial center. In spite of this, one of the most ambitious of all Gothic cathedrals was to be built there, one that was based, moreover, on the most magnificent models. For this reason the spatial structure of Bourges was adopted, with its staggered aisles, which increase sharply in height as they move toward the center. As we have already seen, this was also the case at the collegiate church of St.-Quentin in Picardy.

At the same time, the building has such a close affinity to Amiens, begun only a few years before, that it is sometimes difficult to establish which cathedral influenced the other. Since the height both of the ambulatory and of the inner side aisles of Beauvais exceeds that of the chapels and the outer aisles, it was still possible to build a triforium and a low window story (see page 66, right), as at Bourges. Because of this, a vault of unusual height for northern France was built in the inner ambulatory, resulting in the arcades of the choir being much steeper than they would otherwise have been. This effect is heightened through the arches in the chevet being narrower than those at Bourges. This was originally different at the sides of the choir

and scenes from the story of salvation above it being much more deeply recessed than in the earlier buildings. They force the faithful observing the portal from below to use the same worm's eye view that they will have to adopt in the interior when viewing the architecture.

On the exterior of the choir (see above), as at Reims, the wealth of forms intensifies considerably from bottom to top. The simple buttresses higher up between the chapels become richly decorated, finely fashioned constructions, out of which flying buttresses with openwork arches leap up to the wall of the main nave. There decorated gables (one for each bay) intersect the sill of the eaves, creating a cluster of pointed gables that seem to imitate the façades of the Holy City. This gable motif also appears in the interior of the choir above the triforium arches, where it makes absolutely clear that this is the high altar before which the bishop and chapter gather. Even though the citizens of the rich city of Amiens played an important role in the rebuilding of the cathedral, its architecture does nothing to make them feel included—in fact, the opposite.

The cathedral of Bourges is a possible model for the opening up of space at Amiens. Architecturally Bourges, begun at the same time as Soissons and Chartres, presents a radical alternative to these buildings. First, there is no transept, so that both the interior and the exterior

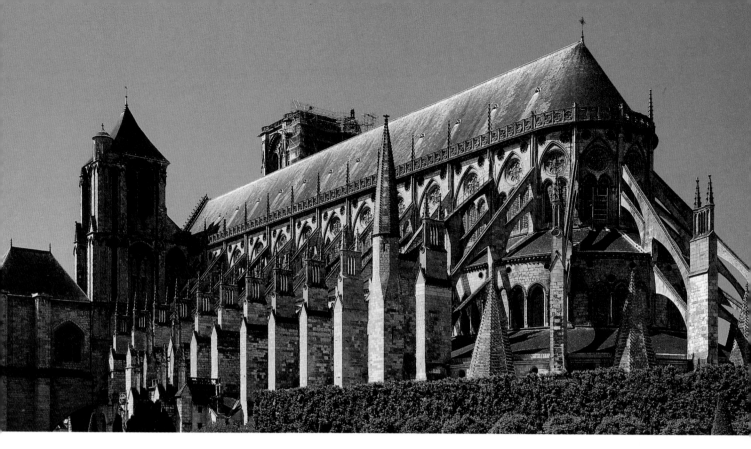

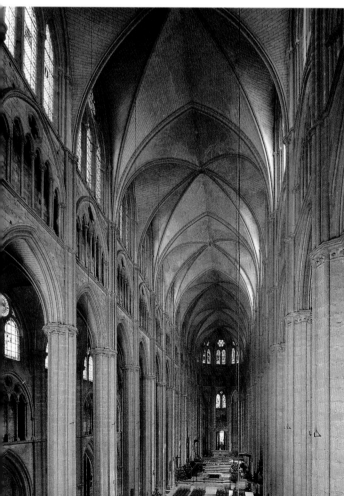

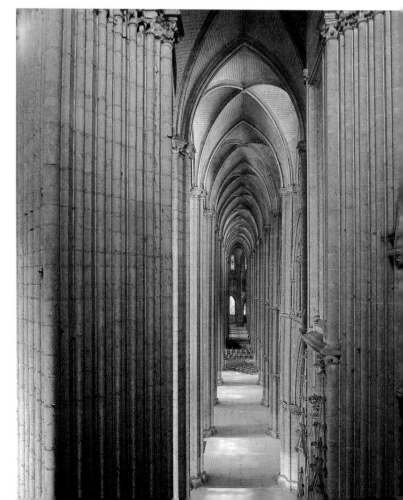

Beauvais (Oise), Cathedral of St.-Pierre
Choir, begun 1225, restored 1284 and
1573 after collapse

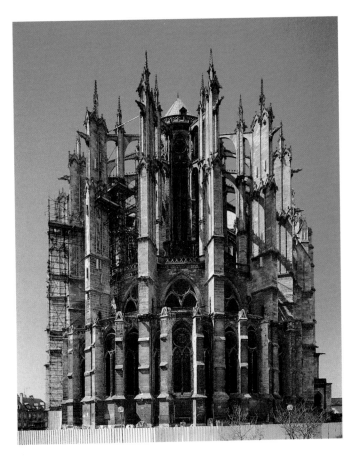

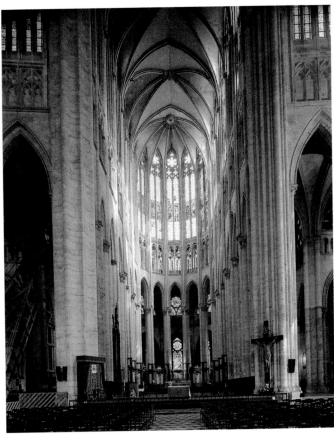

of Beauvais, where the arcades adopted the same width as the Bourges model—in fact, even wider. How the clerestory of Beauvais looked in the past is not known, for around the middle of the 13th century, when the building was far enough advanced for these parts to be begun, there was a change of plan. A filigreed, light-filled triforium with extremely elongated windows above it was erected, so that the interior space finally reached the record height of over 48 meters (157 feet). In 1272 this choir was ready for use but twelve years later, in 1284, it collapsed.

The reasons for this catastrophe are not entirely clear. Certainly it was not just the height. Mistakes may have been made in the construction of the buttresses. The building has still not settled down even today, resulting in more and more costly methods of support being necessary, even though during the rebuilding after 1284 the number of piers was doubled. Since the choir polygon itself had survived the collapse with no damage, the pattern of its closely aligned arches could be applied to the rest of the building, and a new

pier was placed in the center of each side arcade. Admittedly this meant that the cathedral lost the original openness of its interior, but it gained an even greater impression of height because of the tighter sequence of bays.

In the 16th century, after the completion of the transept, work was started not on the nave but on a monumental crossing tower. This too was to prove catastrophic. In 1573, after its completion, the tower collapsed and caused extensive damage. In the choir's first vault you can read the date 1575, the year in which this vault was rebuilt for the second time. After that it was never completed and the building has remained unfinished to this day.

Even if the precise technical reasons for the first collapse are not known, it has nevertheless been established that it would not have happened without the change of plan just mentioned, whereby Beauvais was to become a cathedral with an enormous clerestory in the style of Soissons, Chartres, Reims, and Amiens. The building would have conformed to the standard designs popular in northern France for

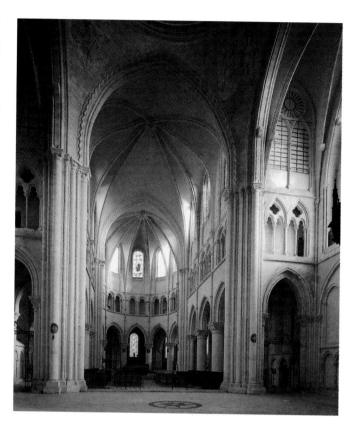

Provins (Seine-et-Marne), former
collegiate church of St.-Quiriace,
after 1157
Choir

churches of this size, and the spatial disposition borrowed from
Bourges would have been made far less significant. Thus the lofty,
subtly merging spaces above the ambulatory and chapels finally acted
only as a backdrop for raising the inner choir to colossal heights.

There are numerous reasons as to why around the year 1200
Bourges (see page 65) was the only cathedral that demonstrated
such an unusual style of French Gothic. Certainly, as the church of
a large and eminent archbishopric in the center of France, it was an
extremely important building politically, for which the best was
only just good enough. As we have already seen, it also adopts a
succession of architectural themes from such important buildings as
Notre-Dame in Paris and the abbey church at Cluny. Many details
indicate that the architect came from that area of northern France
around Laon and Soissons in which there was a highly developed
architectural culture. But all this does not really explain why
Bourges looks so different in every respect from the Gothic
churches not only of the Île-de-France, the region so central to the
origins of Gothic style, but also the churches in the neighboring
regions of Champagne and Picardy. Could the unique character of
Bourges Cathedral be explained by the fact that Bourges lies some
distance from the political and architectural center of the region,
and so the architect was free to experiment more freely? This ques-
tion will always invite speculation, without there ever being any
clear answer. Yet it allows us to turn our attention finally to those
Gothic buildings that were constructed at the end of the 12th
century and the beginning of the 13th century outside the confines
of the heartland of the birth and development of Gothic, where, as
we have seen, the great abbey churches and cathedrals had set the
standard over and over again.

Gothic Architecture in Champagne and Burgundy

The dioceses of Reims in Champagne and of Sens, which extends into
Burgundy, belong, for geographical and political reasons, to the
heartland of Gothic. Around these centers, which, seen from Paris,
lay on the periphery of the Royal Domain, architectural originality
was apparent from an early date. For from here the builders looked
not only to the Early Gothic of the Île-de-France, but also to the
contemporary Romanesque architecture of Burgundy. Here churches
could be built whose architecture, though at times highly original,
would later also acknowledge the wellspring of Gothic.

An example of this is the church of St.-Quiriace in Provins (see
above), founded in 1157 by the Count of Champagne. Provins was
one of the four towns famous for their champagne fairs, where Euro-
pean merchants gathered regularly. Situated within the diocese of
Sens, the building echoes certain basic characteristics of the cathedral
of Sens, notably a three-storied elevation and the contrast between
boldly protruding main piers, which bear the weight of the vault, and
very slender columnar supports. But the architect of Provins went
further: he fitted the triforium of his church with many more shafts

than Sens Cathedral had, and he decoratively reshaped the heavy
transverse arches with the help of a bold zigzag motif. For the
impression of space, however, the alteration to the vault is especially
important. In Provins the vault is not six-part, as at Sens, but eight-
part, resulting in a construction that is far more decorative because of
the correspondingly greater number of ribs. Since the church in
Provins is much smaller than the cathedral in Sens, the decorative
elements of the architecture have a much greater impact in the church
than in the cathedral, where their effect is subdued by the vast space
of the cathedral interior.

The abbey church of the Cistercian monastery of Pontigny lies
about the same distance from Sens as Provins, but in a southeasterly
direction, and is thus almost in Burgundy. Of the five mother abbeys
that were once the center of an order active throughout the whole of
Europe, Pontigny is the only one surviving today. All the others
(Cîteaux, Clairvaux, Morimond, and La Ferté) were victims of the
French Revolution and its aftermath. During the whole of the second
half of the 12th century Pontigny was a building site, for soon after
the whole church was completed, the east choir, only a few decades

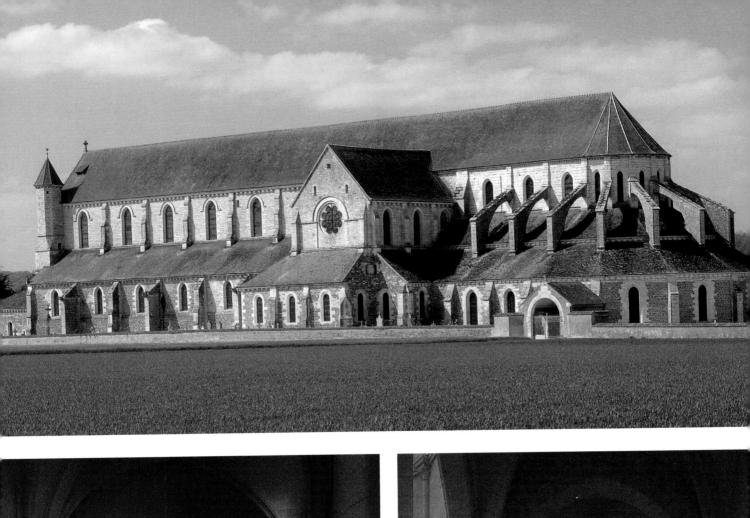

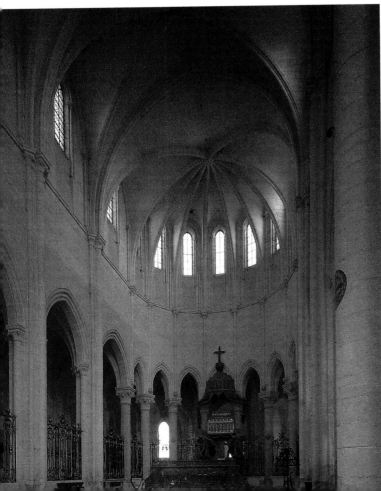

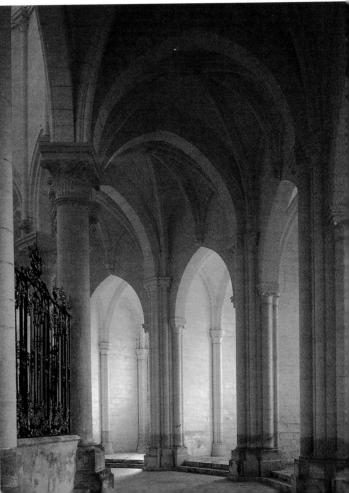

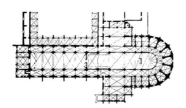

Vézelay (Yonne), former Benedictine
abbey church of Ste.-Madeleine, last third
of 12th century
Ground plan of choir (right)

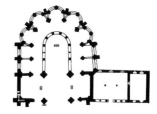

old, was pulled down in order to make way for a larger new building (see opposite). This was necessary to give the increased number of priest-monks the opportunity to read the daily mass, a rule prescribed by the Cistercian order.

The date the choir was built is unknown, yet from its style it is thought to have been constructed in the last quarter of the 12th century. It displays unusual luxury for a church of the Cistercian order, in which excessive expenditure on architecture was prohibited. Because of the regularity of the ground plan, the seven radiating chapels correspond to the seven sides of a polygon. The high number of chapels, necessary because of Cistercian practice, meant that the church has more chapels than any cathedral of the day. Pontigny's apse is composed of seven sides of a fourteen-sided polygon and an additional half-bay (five sides of a ten-sided polygon was standard). As a result, there are more columns and windows, whose profiles, along with the ribs of the choir's vault, make the high choir an extremely elaborate construction. In architectural terms, all this was necessary because there were elaborate rib formations in the ambulatory and flying buttresses on the outside, but theologically the building can hardly be described as an expression of Cistercian modesty.

It is evident how rich the monks of Pontigny, despite their vow of poverty, actually were, since they were able to complete their church in the course of a few decades, and then immediately rebuild it, while the much smaller church of St.-Quiriace, by contrast, was never completed.

At around the same time Pontigny was being built, a new choir was being built in the church of Ste.-Madeleine in Vézelay in Burgundy. Vézelay was at that time a much visited pilgrimage town, where the relics of St. Mary Magdalene were kept. Not until 1270, when other Magdalene relics were found in St.-Maximin in Provence, and declared authentic by the pope, did the pilgrimage to this church decline, causing Vézelay to sink into a deep sleep.

The Gothic choir in Vézelay (see right), just like the choirs at St.-Denis and St.-Remi in Reims, contrasts with an older, and in this case Romanesque, nave whose light-filled goal the choir appears to be. The choir not only defines the interior space but also contributes to the impressive outline of the church as a whole, which, because it stands on the highest point of a hill overlooking Vézelay, is visible from far away. The interior is so subtly designed that it requires detailed analysis. First, Vézelay's choir, like that at Provins, adopts the three-storied elevation of Sens Cathedral, even down to the subdivision of the shafts by shaft rings. The motif of the double piers also appears again, though only once, on the north side, while opposite there is only a single slender column. This characteristic asymmetry is as playful as it is disturbing in its ability to direct the visitor's gaze toward a specific point. Slender double columns are the thinnest supports of this choir, and they stand in the very place where in most other churches the strongest piers are to be found, that is, between the straight side walls and the polygon. By doing this, the architect of Vézelay solved the problem of the transition between these various parts of the east end of a church, a difficult

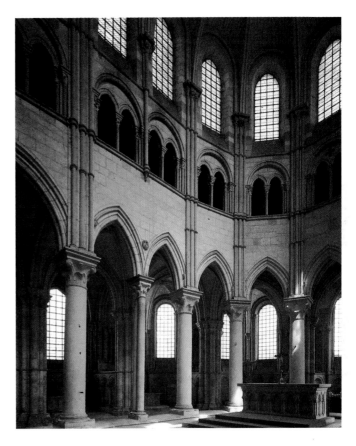

problem to overcome architecturally. His solution was not only novel but also contrary to every design that had been used up till then, particularly those used at Sens and Provins.

In addition, the problem in Vézelay is thought through from the vault, which is designed as a succession not of similar constructions, but of compartments of the same size. Sexpartite, quadripartite, and polygonal vaults follow each other in succession over the chevet without the dissimilarity of their structure being obvious since they all have the same narrow webs. The transverse arches are just as strong as the ribs and no thicker, as they would otherwise be, and so they do not visibly separate the individual vaults from each other, but, together with the ribs, look like part of one uniform three-dimensional architectural decoration.

Along with several other effects, the architect of Vézelay heightened the impact of this richly structured vault area even more. He did not lift the apex of the wall arches above the windows to the height of the vault keystone, as was usual. Also against common practice, he started the vault at the upper stringcourse of the triforium. Both of

OPPOSITE:
Auxerre (Yonne), Cathedral of St.-Étienne,
begun 1215
Exterior (top)
Nave and choir (bottom left)
Axial chapel of choir (bottom right)

these devices help to transform the vault from a dominant architectural structure resting squarely on the walls into a magnificent canopy. When the setting of the vault is taken into account, the function that is served by the strange pair of slender double and single piers becomes clear for it can now be seen that they mark the actual boundary of the bay, while one would expect this to be the function of the much stronger piers close by. In other words, the construction of the bays in the arcade area and vault do not match, a notable deviation from the common structural principles to date of Gothic architecture.

At Vézelay much greater emphasis was placed on visual than on logical consistency. This is also illustrated by the fact that the wide interval between the adjacent piers is divided with the help of slim supports, so that the arches rising above them become as thin, and above all as low, as those in the actual chevet, whose construction is extended out to the side walls as a result.

It is apparent from the ambulatory and the radiating chapels that the architect of Vézelay in effect designed the ground plan and the upper areas as two separate entities. At ground level there is a simple ambulatory with deep individual chapels. At window height, however, their dividing walls fall away and they open onto each other at the sides so that a plan of Vézelay at this level is similar to that of St.-Denis, where quite shallow chapels adjoin a double ambulatory and where they are incorporated under the same vaults as the outer ambulatory. Thus at Vézelay the two most important alternative designs current at that time (a double ambulatory with shallow chapels, and a single ambulatory with deep chapels) exist both alongside and overlapping each other. The choir provides a good example of how in the last years of the 12th century, even with a good knowledge of Île-de-France Gothic, it was possible to build in very different styles.

Just as the architect of Vézelay found a solution for the structural unity of wall arcading and vault, so his colleague in Auxerre a few decades later separated the wall and the structural elements. The restoration of the cathedral choir, begun in 1215, essentially echoes the pattern of Chartres with its three-storied wall elevation (see opposite), though it is smaller than its model. Admittedly the same scale was not even attempted—quite the opposite, since the load-bearing elements (piers, responds, and triforium shafts) were made far more slender. The columnar piers of Auxerre, even in comparison with those of Soissons, in turn much more delicately constructed than those of Chartres, are markedly thin. In order to prevent the individual clusters of shafts from protruding too far (and not solely because of their large number), the shafts of the wall ribs stand not in front of the wall, but in box-like niches set within the wall. This idea was not essentially new, of course, since the axial chapel at St.-Remi in Reims was designed in the same way, but it was only at Auxerre that this system was used consistently throughout the building.

In addition, at Auxerre, the top of the window niches end in such a way that they form independent box-shaped voids between the vault and the glass of the windows. The technical finesse and intentional delicacy of the design find their best expression in the axial chapel of the choir (still unchanged today), where the vault is installed like a freestanding canopy (see opposite, bottom right). The two columns in the opening of this chapel give the impression of being two of the canopy's poles.

The nave of the parish church of Notre-Dame in Dijon (see page 72, right), which was constructed mainly in the second quarter of the 13th century, displays an acceptance of the architectural forms of Auxerre Cathedral that fall short of a precise imitation of the building type. Thus the dimensions are considerably smaller, as is normal for a parish church, and consequently the clerestory is shorter. In addition—and unlike Auxerre—the building has uniform columnar piers that are combined with a rhythmically constructed sexpartite vault. Notre-Dame in Paris provides the foremost example of this contradictory pier-vault combination. There, uniform clusters of three responds, climbing to the semi-darkness of the vault area, merge with alternating rib formations. The architect at Dijon solved the problem of matching responds and vault ribs in exactly the opposite way. Because the number of ribs changes at the springing of the vaults, the number of corresponding responds below also changes. One pier has three responds, the next one, and so on along the length of the nave. As a result, both vaults and responds lend a rhythmic structure to the space. This is emphasized by the row of uniform columnar piers, the triforium arcades, and the clerestory windows, which, as at Auxerre, are set in niches. Thus two different sequences overlap here. To accentuate this, the architect set the groups of three responds below the transverse rib of the vault so far apart that the wall between them is still visible. This feature can be seen especially clearly at the springing of arcade arches, whose profiles continue behind the responds.

In addition, the motif of the side aisle walls of Auxerre is taken up again, with several windows of equal height aligned within each bay. Grouped together in threes, they refer to the triforium, which is similarly divided into three, and allow the whole clerestory to appear to be broken up by a series of small, equally sized lancet windows. This motif also emphasizes the uniformity and closely spaced sequence of the nave wall, which heightens the contrast with the wide wall arches of the vault.

On the façade (see page 72, left), unique in French Gothic architecture, the motif of rows of arches superimposed on each other is taken up again. This highly impressive showpiece wall, decorated with relief galleries and tight rows of carvings which project horizontally, towers up over finely constructed portals.

Even if the buildings in the southeast of the Île-de-France, that is to say, mainly in Burgundy, were built with some knowledge of that central region's cathedral architecture, it nevertheless seems that its architects maintained a certain independence. The elegant solutions that they found—separating the ground and upper stories at Vézelay,

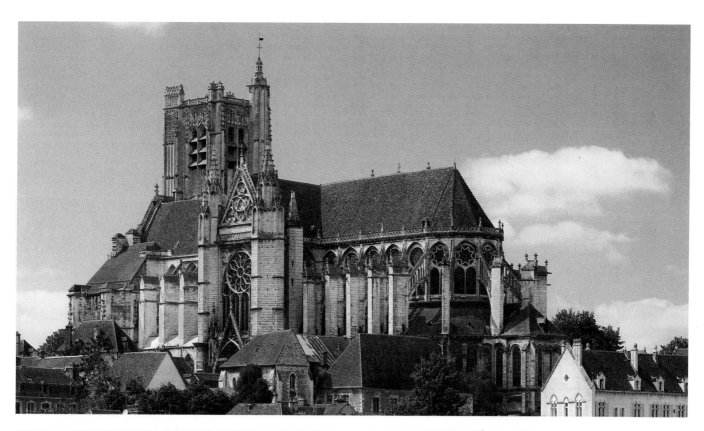

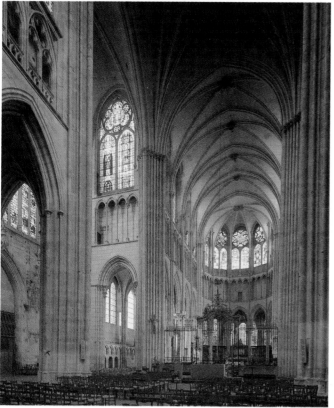

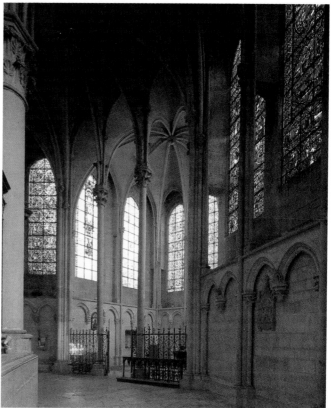

Dijon (Côte-d'Or), parish church of Notre-Dame,
second quarter of 13th century Façade

Dijon (Côte-d-Or), parish church of Notre-Dame
Nave and choir

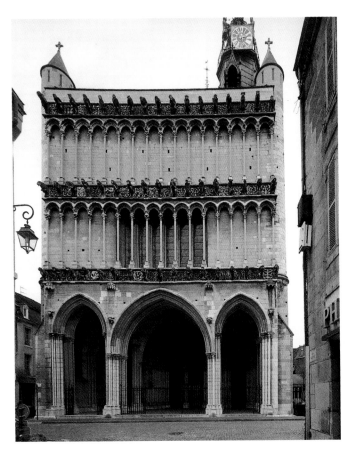

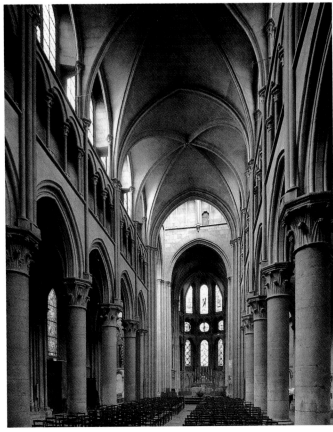

slimming down the load-bearing structures in Auxerre, and varying the rhythm between the various layers of wall in Dijon—were to have a marked influence on the architecture of Paris from the mid 13th century onwards.

Gothic Architecture in Normandy

Surprisingly, scholars and historians have not given the Gothic architecture of Normandy anything like the same attention the contemporary architecture of the Île-de-France or Burgundy has received, despite the unquestioned quality of buildings there. The knowledge of Early Gothic in the Île-de-France had quickly spread throughout Normandy and the surrounding areas. The Gothic style was already being used when Normandy still belonged to the English crown, before it was conquered by the French king Philippe-Auguste in 1204. So in Lisieux, for example, rebuilding of the cathedral had begun in the 1150s, imitating the elevation of Laon fairly closely, but without the triforium.

The architecture of the choir in St.-Étienne in Caen, the burial place of William the Conqueror, is quite different and far more original. At the end of the 12th century the old apse was replaced by a modern choir with an ambulatory (see opposite, top). The epitaph inscribed in the new building tells us the name of the architect, Guillelmus. While the ground plan obviously refers to that of St.-Denis, since the chapels added to the ambulatory open into each other, the decorative elements appear to derive chiefly from Canterbury Cathedral. But the architecture of the old church also played an important role, since the structure of its stories (arcade, gallery, and clerestory) was preserved in the new choir. What is perhaps even more important, the *mur épais*, the thick Romanesque walls so typical of Normandy, was also retained. Because of this, the piers and arches in St.-Étienne are much stronger than those in contemporary churches of the Île-de-France, and so can be decorated with large numbers of shafts and profiles.

A characteristic of this *mur épais* was the potential to split the wall into several layers one behind the other. Guillelmus was clearly

TOP RIGHT:
Caen (Calvados), former Benedictine
abbey church of St.-Étienne
Choir, begun around 1200,
Ground plan of choir (left)

BOTTOM:
Coutances (Manche), Cathedral of
Notre-Dame, 1180,
Ground plan (right)

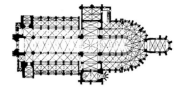

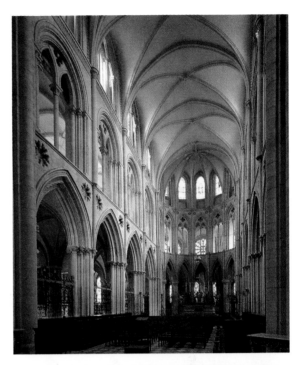

keen to exploit this feature, for he pierced the spandrels of the arcades with rosettes that seem to open up a view into the core of the wall, and in front of the clerestory windows he built a stepped arcade. The construction of walls conceived as layers becomes particularly clear at the piers in the chevet. Here the piers are made up of two columns placed one behind the other, with one appearing to carry the inner layer of the main nave wall, the other carrying the back wall.

This motif goes back to the Early Gothic cathedral of Sens and buildings based on it, such as Canterbury. Here, however, this "double Norman column" is much more decorative, perhaps even more playful, than its forerunners. The rounded abaci above the capitals, which make each one of the double columns appear detached, are characteristic of this arrangement. At Sens they are drawn together under one common, rectangular abacus.

Along with round bases and abaci on the capitals, the double columns in the chevet of St.-Étienne were favorite motifs of Norman Gothic. They are found again in the choir of Coutances Cathedral, and after about 1180 were gradually renewed from west to east (see right, bottom). In contrast to the façade, which was only slightly altered, the nave was so extensively restored that it is hardly possible to see that a large part of the Romanesque walls have been retained there. The elevation is similar to that of the choir of St.-Étienne in Caen, yet a more logical connection between the disposition of the walls and vault was arrived at through the three powerful responds rising up right from ground level and linking with the diagonal and transverse ribs. In Caen this pier motif appears only at the start of the choir's apse. On the other hand, on the straight side walls this pattern begins above ground level as slender responds, then becomes more pronounced at the height of the stringcourse beneath the gallery until it finally turns into the richly profiled cluster of ribs in the vault.

The choir of Coutances, probably begun around 1220, presents a completely new building. Its side aisles were transformed into a double ambulatory and its chapels made less deep, and constructed so that they share a common vault with the outer ambulatory, as at St.-Denis, Caen, and Chartres. Yet at Coutances (but not in these other three buildings) the side aisles are not of equal height, but increase in height as they move toward the nave, as at Bourges. A three-storied elevation appropriate to a nave (with arcade, tribune gallery with blind arcading, and clerestory) is found only in the inner side aisle of the choir, while the central nave, with just an arcade and a clerestory, is almost spacious in its simplicity. The traditional Norman *mur épais* is split into layers right through, so that the structural devices inside are completely separate from the external walls and windows.

In the apse, the familiar motif of the double columns, taken from St.-Étienne in Caen, is employed with this division of the walls, so that even the clustered piers in the straight parts of the choir are split. In consequence, it looks as if they consist of two supports fused

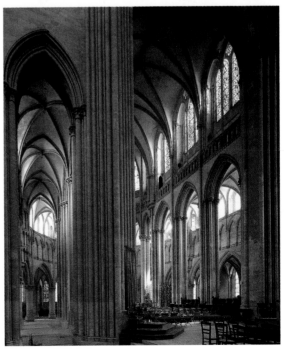

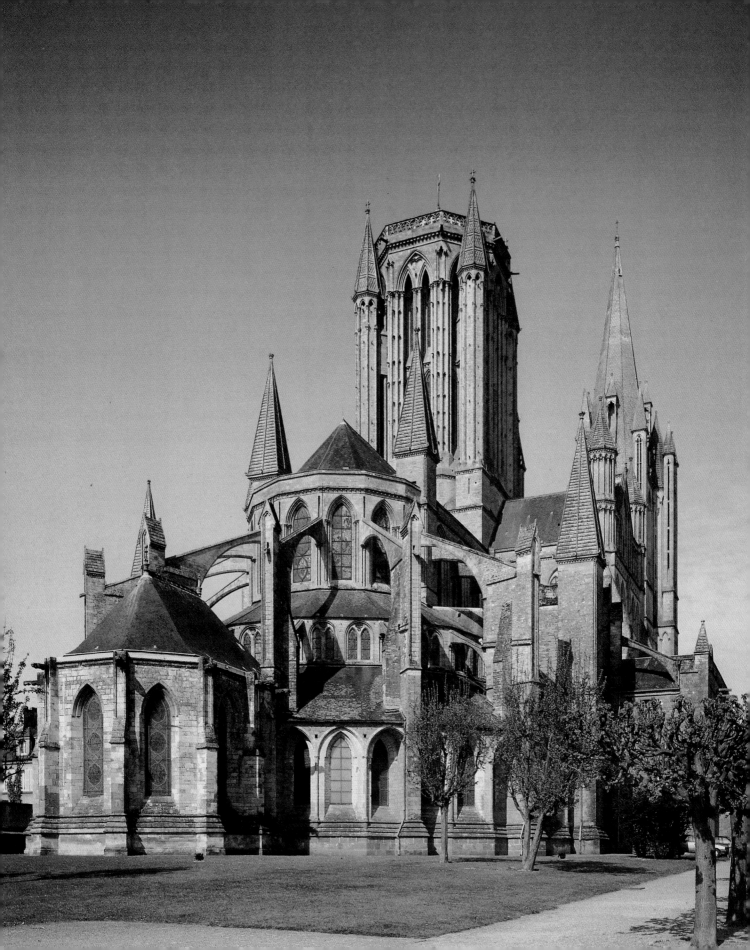

Bayeux (Calvados), Cathedral of
Notre-Dame
Choir, ca. 1230–45

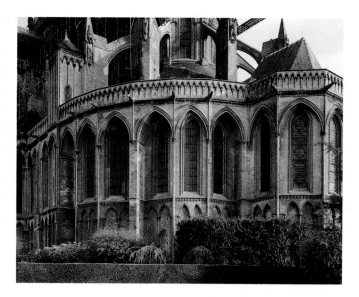

together, the front arcade supporting the nave vault, and the back arcade supporting the vault of the side aisle.

The exterior of the choir at Coutances (see opposite) is characterized by a sharp contrast between the protruding stories and the huge buttresses, which in effect are gabled walls. Along with some stairway towers topped by stone turrets, they lead the eye up to the crossing tower, which not only dominates the exterior of the cathedral but creates a unique impression when seen from the inside. It rises above the richly profiled crossing arches like a huge, yet delicately constructed, light-filled lantern. After this crossing tower was built, the towers of the façade were made higher. In other words, the restoration which was carried out during the mid 13th century ended at the west end of the cathedral, where it had begun about 70 years before.

Bayeux Cathedral (see right) can be described as the younger sister of Coutances, since in style they both follow the extension to the choir at St.-Étienne in Caen. The rebuilding of Bayeux began with the choir (about 1230–45), whose rich architectural decoration stands in marked contrast to that of Coutances. All the piers, with the exception of the double columns in the chevet, which were taken from the church of St.-Étienne in Caen, are surrounded by a host of filigree shafts, and the soffits of the arches develop into a variety of profiles. An area of capitals with square, octagonal, or round abaci forms the link between piers, arches, and vaults in a way which had never been used before.

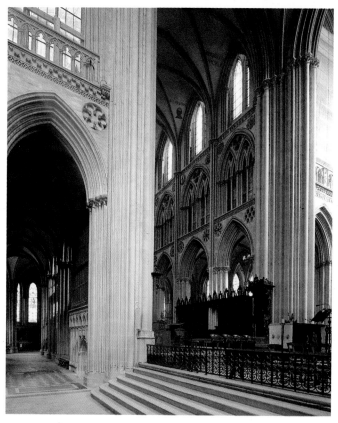

On the transept façades, which were constructed in the third quarter of the 12th century, this pleasure in rich decoration joins forces with a formal vocabulary borrowed from contemporary Rayonnant architecture of the Île-de-France. A comparison of the exteriors of Bayeux and Coutances demonstrates that the architect of one cathedral was working, in essence, with an array of decorative details while his colleague, by contrast, was trying to achieve his effect through the contrast of massive blocks of masonry.

At the Merveille (the marvelous), built between 1210 and 1228 on Mont-St.-Michel (see page 76), both trends can be seen. After the conquest of Normandy by the French king Philippe-Auguste, Mont-St.-Michel was no longer merely an abbey situated in the middle of the Anglo-Norman kingdom. It was now a French outpost on the border with England formed by the Channel. It was rebuilt at the time in an extravagant way.

Storerooms, accommodation for the various guests to the abbey, and a cloister had all to be integrated into one building, for which there was really no more space on the steep cliff alongside the church. Therefore strong substructures were built, which lend a fortress-like appearance to the building. Behind this external view, a series of rooms are hidden away, increasing in elegance from the lower level to the top level.

The cloister at the very top is Mont-St.-Michel's masterpiece (see page 76, right). From the unvaulted ambulatory visitors look into the

Mont-St.-Michel (Manche),
Merveille from the north
Watercolor by E. Sagot, between
1862 and 1869 (below)

Cross section of the "Aumônerie"
of the Merveille (right)

Mont-St.-Michel (Manche),
Benedictine abbey
Cloisters in the Merveille, built
1210–28

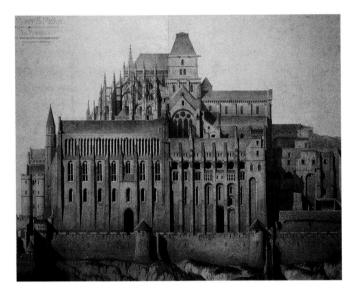

base of a side aisle vault which had already been built but had then been abandoned after a change of plan. At any rate, the rich profiling of the central nave piers and the arcade arches can be seen as typical of the region, since these would have been impossible without the tradional *mur épais*.

By contrast, the architecture of the choir, with its repertoire of motifs borrowed from "French" Gothic, is much more severe. As in the choir of St.-Étienne in Caen, there is no trace of the desire to decorate wall surfaces and profiles. Yet there is an even greater affinity with Île-de-France Gothic, since the choir shows a three-storied elevation, unusual for Normandy, with an arcade, triforium, and clerestory.

Similarly, the passage in front of the main nave windows, which is found everywhere else in this area, is missing. However, some consideration is given to the older parts of the church, for the separation of the stories lifts the height of the stringcourses in the nave. The ambulatory too, with its three protruding chapels (the middle one was rebuilt from 1302), must be seen as a repetition of the corresponding structure of the earlier 11th-century building.

inner courtyard through two arcades set against each other. The narrow space between these rows of arches is spanned by a slender vault whose rib profiles cross over each other in parts like interwoven branches. Perhaps this was an attempt to imitate nature, for the many rosettes of leaves in Norman architecture found in the spandrels of the arcades are unusually rich in their variety and in their carving. Since the capitals of the thin columns, which would normally carry some leaf decoration, have remained undecorated, there is here a deliberate contrast between the "pure" architecture of the columns and the arcades on the one hand and the architecture of the vault areas, with their naturalistic motifs, on the other.

If the buildings already mentioned represent the independence of Gothic architecture in Normandy, then others reveal a fluctuating relationship of close affinity to, and distance from, "French" Gothic. One of these is the archiepiscopal cathedral of Rouen, which had already been continually extended and rebuilt in the 12th century. There are still traces from this period to be seen on the façade. When a fire ravaged the town and cathedral in 1200 and made a new building necessary, things did not progress in a logical way. Before the nave was finished in 1237, to a plan by Jean d'Andeli, a much more modern-looking choir was consecrated, which is linked to the architect Enguerran.

The nave (see opposite) gives the illusion of having four stories, but in the side aisles it is clear that there is no vault between the arcades and the gallery. Where the vault springing would have come in a standard design, there is only an unusual formation of detached shafts. There is some dispute as to whether the function of these shafts is purely to add a decorative feature or to conceal the

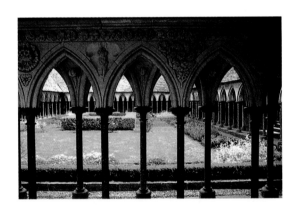

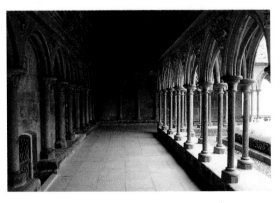

Rouen (Seine-Maritime), Cathedral of
Notre-Dame
Nave and choir, begun after
fire of 1200

Le Mans (Sarthe), former Cathedral of
St.-Julien,
Choir, built between 1217 and 1254
(centre and below)

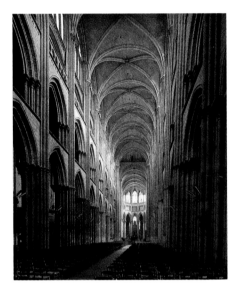

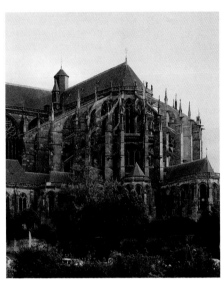

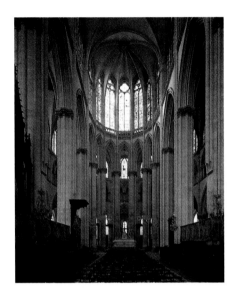

The crossing tower (whose roof was destroyed by lightning in 1822, and as a result was renewed in cast iron up until 1876) is once again typical of buildings in Normandy of the 12th and 13th centuries. The closeness to characteristic forms of the region becomes even clearer in the façades of both transepts, even though from 1280 a completely new kind of decoration, in the Parisian Rayonnant style, was incorporated.

In Rouen, therefore, styles of different provenance were combined in a unique way. Additionally, traditional and modern types of architecture were employed, so that the cathedral is, in essence, characteristic of Normandy. While patrons in the areas where Gothic first emerged wanted either to juxtapose the old against the new or to build uniform churches in a "pure style," their Norman colleagues obviously took delight in permanently—and in fact often unnecessarily—modifying building plans, without sparing too much thought for uniformity or purity of style. The results were highly original buildings that are never monotonous.

A particularly noteworthy example of this is the choir of the cathedral of Le Mans, whose nave has already been mentioned in connection with Early Gothic (see above, center and right). Like Normandy on its northern border, the city of Le Mans, in the department of Maine, had fallen into the hands of the French monarchy in 1204, along with the rest of the English king's French possessions. A few years later, in 1217, King Philippe-Auguste allowed the cathedral chapter to pull down the city wall in the place where it wanted to build a particularly large new choir. Because the ground sloped away at that point, some costly foundation work was needed at first, but the choir was nevertheless ready to be started in 1254.

It follows the pattern of the choir of Bourges Cathedral, whose aisles increase in height from the outside to the center, but instead of the tiny chapels of its model, a circle of large and particularly deep chapels adjoins the outer ambulatory of the choir (see above). These belong to the older parts of the cathedral extension. Because of their angularity and their strongly constructed buttresses, they demonstrate a number of similarities with the architecture of Soissons. As a consequence, it has now been widely accepted that the original architect of Le Mans came from there.

His successor (to whom the remaining parts beneath the clerestory of the central nave have been ascribed) must have been brought from nearby Normandy. For not only did he employ a succession of motifs typical of that region, such as the twin columns in the chevet and the richly profiled arches, but he also designed the elevation of the inner choir ambulatory in a way similar to the choir ambulatory in Bayeux, with arcades, gallery, and clerestory. The décor in the spandrels of the gallery arches appears to have been produced by those same sculptors who had just finished work on Mont-St.-Michel (see page 76) in 1228.

The upper story of the nave was begun before the middle of the century by yet another architect, who brought with him the Île-de-France style, which at that time was modern. This can be seen particularly clearly in the window tracery, which once again takes up the forms of the Ste.-Chapelle and the chapels built onto the north side of Notre-Dame in Paris.

But in spite of all these differences in style, the original choir of Le Mans seems on the whole far more unified, largely because the overall plan was obviously always respected and variety was looked

Le Mans (Sarthe), former Cathedral
of St-Julien
Ambulatory, built after 1217
Ground plan of choir (right)

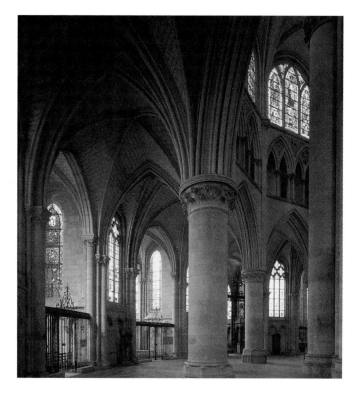

for only in the details. Admittedly the choir, simply because of its dimensions, differs from the 12th-century nave, but without disregarding it. Visitors entering the west portal are greeted by an impressive view, one that steadily increases in splendor as they move along the nave.

Le Mans is perhaps the perfect example of a Gothic cathedral that combines not only styles from different periods, and different regional styles, but in addition various building types without looking completely heterogeneous and confused as a result. It is no coincidence that from the middle of the 13th century onward the style emerging in this cathedral came to be seen as exemplary throughout Europe.

Gothic Architecture in the West of France

Patrons and architects in the west of France, in contrast to those in other regions, operated not only independently of the architectural developments of the Île-de-France, but largely in ignorance of them. Even though individual forms might be adopted, for example in the tracery of the windows, no attempt was made to imitate the "classic" Gothic cathedral, with its basilica-like elevation, ambulatory, and radiating chapels.

In Poitiers, a town that had several Romanesque churches possessing an ambulatory, the cathedral remains a cuboid in which the nave and its two side aisles end in the east at the same height (see opposite, left). Probably begun as early as the 1150s, construction was advanced in 1162 by an endowment from the English king Henry II and his wife, Eleanor of Aquitaine. Three parallel, extremely shallow apses are cut into the straight continuous east wall, so that not only are ambulatory and radiating chapels missing but there is no real hint of a chevet. Instead, the dominant impression, inside and outside, is of great unity of structure and space, especially as it is a hall church, its nave and side aisles being of approximately equal height.

This design resists any strong differentiation between the different parts of the building, a feature which in other regions was an important aspect of Gothic architecture. Even the older hall churches, frequently found in the west of France, which had provided the model for Poitiers, do not exhibit such equal naves and side aisles as does the Cathedral of St.-Pierre.

The interior walls copy an elevation traditional in Poitou, with tall wall-arcading above which rise shallow wall niches with large windows. As in the cathedral of Angers, the vaults rise up dome-like towards the center, but west of the two choir bays—from which point on the cathedral nave is also made higher—they are divided only by very slender ribs. These ribs divide each vault into eight parts, since not only do they stretch across diagonally (as is normal), but they also run between the apexes of the transverse ribs and wall arches. This means that only half of the ribs can be extended downward by responds.

Thus a curious discrepancy arises between the piers, whose powerful half-shafts correspond to the arches between the vaults, and the vaults themselves, which are stretched between them like narrow sails. The structural connection between piers and vault thereby becomes relatively weak. This can be interpreted as another negation of the then current principles of Gothic architecture. In the course of construction, which lasted far into the 13th century, building work underwent several changes of plan. But it was only right at the end of this period, during the building of the west façade, that the cathedral of Poitiers managed to respond to yet another style of Gothic architecture.

Thus the portal area has a similar structure to the one in Bourges, while the rose window, which dates from as late as the second half of the 13th century, is modeled on that of Notre-Dame in Paris. In Normandy, which became French in 1204 along with Poitiers, the Gothic style of the Royal Domain had arrived long before that date. Its significance in the west of France, by contrast, remained slight, even for quite a long time afterwards.

This is also true of St.-Serge in Angers, where the architect constructed a double-aisled rectangular choir with a protruding axial chapel (see opposite, right). Thin vault webs rising up to the center

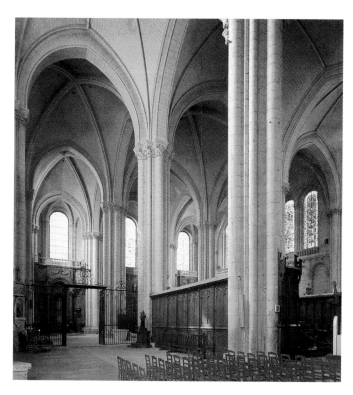

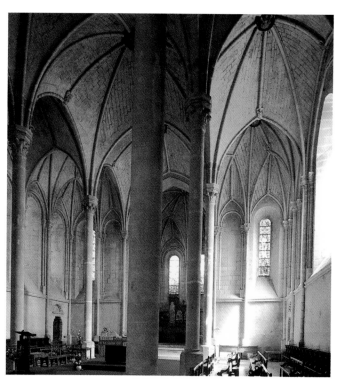

support each other, so that additional buttressing is unnecessary. As the main bays already possess the Angers-style eight-part vault, the number of ribs at the end of the choir and in its corners is further increased. This richer disposition not only fulfils a decorative purpose but also serves to carry the thrust of the vaults vertically, especially at the edge of the building. Since the diagonal thrust of the vaults is reduced, the piers in the choir could be radically slimmed down; under a greater lateral thrust they would soon have collapsed.

Thus the choir of St.-Serge became one of the most filigreed Gothic halls. Its structure can be explained only by the regional tradition of rib vaulting which had begun in the middle of the 12th century in Angers itself with the building of the cathedral. Here the influence of the Gothic of the French crown lands played only a marginal role at most.

Rayonnant Gothic

New Building Practices and Stylistic Innovation

Up to the beginning of the 1220s, a large number of Gothic ecclesiastical buildings, from cathedrals to parish churches, had been constructed in the Royal Domain and the adjoining regions. This lively building activity had also led to technical progress. The "dismembering" of the wall and support system in a building such as Notre-Dame in Paris is therefore not only the result of aesthetic considerations, but also the product of advances in building technology. In this respect, the architects of the 13th century had at their disposal a much greater wealth of experience than their older colleagues had had. Building methods were also rationalized to a greater extent: shaped stones were no longer individually carved but were produced in series, which reduced costs and speeded up the building work. The whole building process could now be better planned, something which affected not only the general organization of work, but also the architecture itself (see pages 154–155).

The most important tool in this advance was the architectural sketch, which improved greatly in only a short time. Developing from large grid plans staked out on the building plot with the help of ropes and posts, which could offer only general indications about the plan of the church, the first small-scale plans appeared about 1220, drawings scratched with a compass and straightedge onto a plaster base or walls. Even if at first these plans showed only individual, easily drawn geometrically details like rose windows, before long they began to illustrate complete ground plans.

About 1220–30, builders and architects took the decisive step of making small-scale sketches on parchment. With this method, all the larger and smaller shapes could be copied and reproduced in order to give precise advance details to sculptors and masons. The celebrated "lodge-book" of Villard de Honnecourt dating from this time (see right) gives an overview of the various functions and types of architectural drafts. Villard, it is true, was probably not an architect, but his manuscript, which shows people, animals, machines, furnishings, carvings, and many more things apart from churches, demonstrates that in the great cathedral lodges of the period plans and details must have been of great interest. He himself drew sketches in Cambrai, Laon, Reims, Chartres, and Lausanne, and even in Hungary.

This new architectural practice of drawing on parchment also made it possible to make a provisional sketch on a sheet of parchment, and thus to experiment with new ideas by illustrating them. Moreover, these sketches were simple to transport, so that architects, without having to travel themselves, could keep abreast of developments elsewhere. Whatever was currently being built in Paris, for example, could quickly become known elsewhere and so influence developments far and wide. The old limitations, determined largely by the mobility of the individual architect or mason, were being overcome. Yet another consequence of the development of architectural

drawings was that the buildings, at least partially, conformed to what could be represented by a draftsman. Gothic architecture after the final quarter of the 13th century often looks as if a series of different plans have been laid on top of one another like stage-sets.

The Gothic architecture built after the 1220s in France is called Rayonnant, after the sunburst rays of the delicate rose windows of the period. Thanks to technical innovations, the shapes in window tracery had become richer and more filigreed, the complicated designs for them being sketched beforehand on parchment. Nevertheless, despite their increasingly complex structure, they still appear two-dimensional.

Throughout Europe there were attempts to imitate these rose windows. They appear on buildings that otherwise have nothing at all to do with French architecture. This touches upon another important point. In the whole of west and central Europe during the 13th century, even outside the French crown's domains, which had grown considerably in the course of time, people were beginning to regard French culture, and especially the Parisian court style of St. Louis (Louis IX), as a model. They were trying to imitate not only the fashion, ceremonial, and poetry of France, but also its architecture. Gothic was thus a European style by the middle of the 13th century at the latest. Admittedly, it was not every style of Gothic that was favored in this way; it was largely the Parisian variety. The fame of this style of Gothic was such that an architect could be appointed

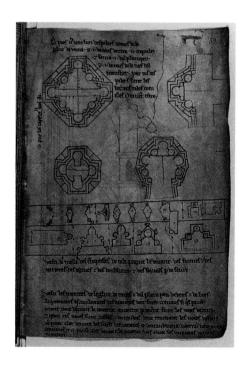

St.-Denis (Seine-St.-Denis),
former Benedictine abbey church
Nave with choir and transept

St.-Denis (Seine-St.-Denis),
former Benedictine abbey church
Rose window of transept, after 1231

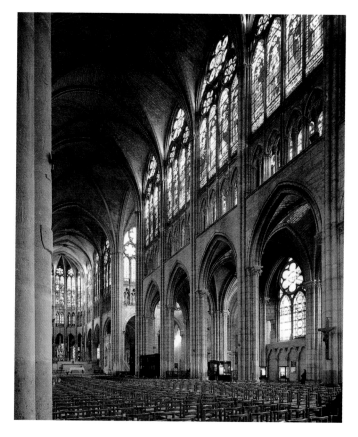

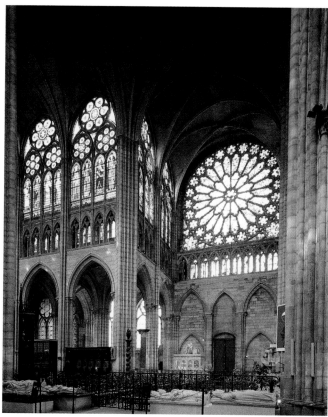

master mason on a project solely on the basis of his claim to have studied the latest architecture in the French capital, even if he was at best an average product of the school of Parisian Gothic.

Naturally there is no precise point at which Rayonnant can be said to have begun. Even Early Gothic had not begun all at once, but had developed gradually until it became a phenomenon that could be perceived by contemporaries as something distinctive. For that reason, many characteristics of Rayonnant Gothic can already be observed in the cathedral of Amiens, which integrates the old and the new in equal measure.

The French Court and Its Milieu

Perhaps it is no coincidence that once again one of the first buildings in the new style was the abbey church of St.-Denis, which as early as the 12th century, under Abbot Suger, had played such an important role in the development of Gothic. In 1231 Abbot Eudes Clément ordered a further reconstruction, perhaps because the upper parts of the Suger building were already in danger of collapse, but perhaps

also simply to acquire at long last a completely modern church (see above). At any rate, the ancient and hitherto spared Carolingian nave was now sacrificed, though the ambulatory of Abbot Suger's choir was preserved.

The unknown architect first strengthened the series of the choir's inner piers, which he replaced, in a complicated procedure, without affecting the arcades and vaults resting on them. In doing so he took into consideration the older parts of the choir not only stylistically but also aesthetically, retaining in principle the shape of the old columnar piers and merely placing some shafts in front of them. In the rest of the church, supports with a cruciform ground plan were used exclusively. Their core, however, is hardly visible because it almost completely disappears behind the shafts. In this way the earlier round piers in the arcades of the nave were dispensed with for the first time in St.-Denis. Previously they had been either single columns or *piliers cantonnés* (columns with individual engaged shafts). Abandoning these had far-reaching consequences, since until then the capital had broken up the pier. Now the clusters of shafts

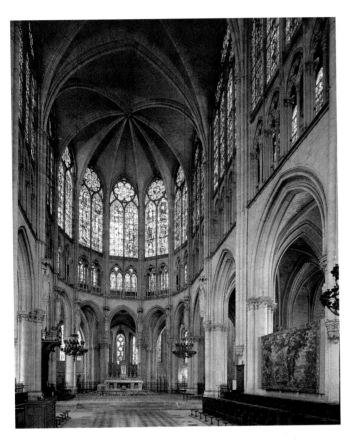

could run continuously from ground to vault. In addition it had become superfluous to make a structural distinction between the piers of the arcade and those of the crossing or tower, which had always been powerful cruciform piers with continuous clusters of shafts. This new type of support system therefore served the unifying trend vertically as well as horizontally, in the succession of bays. Its development marked a radical departure in architecture, for it signified a rejection of the system of the columnar arcade which ultimately goes back to antiquity.

In once again using the old columnar piers in the choir, the architect of St.-Denis was respecting the unity of Suger's ambulatory and radiating chapels. At the same time, he was indicating that this was an older part of the building, to be clearly distinguished from the modern parts. It is a matter of speculation whether the new pier structure was in fact devised precisely to illustrate this contrast.

The merging of the piers into their adjacent responds allowed an appropriate structure for the upper parts of the nave. Thus the delicate lit triforium and the clerestory windows are linked by continuous

mullions. In this way the relief form of this area develops logically from the clusters of responds. The unity of form in the upper story is further enhanced in the later parts, in the nave completed in 1281 (see page 81, left). Here the mullions of the clerestory windows are lengthened, pushing the crowns higher and causing the apex of the windows to reach the same height as the capitals of the vault alongside them. This also means that in the clerestory the responds and the mullions reach the same height. Though this solution is aesthetically convincing, it contradicts the architectural principle that had previously applied to the windows of the transept and choir. Here in St.-Denis it was not the upright lancets in the lower area of the windows that are the important parts of the tracery, but the crowns above them, with their powerful sexfoil tracery, in which the larger pattern of the enormous transept rose windows is continued. The center point of the transept rose window therefore also lies at about the same height as the lower sexfoils in the crowns of the clerestory windows. It is in fact the rose windows of the transept façades (see page 81, right) that set the standard for the whole of the church's clerestory, since they completely fill the space between the triforium and the apex of the vault, which, because of this, could not be higher or lower anywhere else. But since the diameter of the rose windows also coincides with the width of the transept, the transept is therefore responsible for the overall proportions in the other parts of the church. This is no coincidence: it is precisely there, in the transept, that the burial place of the French kings was to be established. New statues for the tombs were carved in the 1260s. The new, or rather remodeled, St.-Denis was intended to underline the significance of the church as a royal burial place. For this purpose the transept was widened and provided with double side aisles, something which had never happened before. Above the outer side aisle bays, towers were intended to rise up in order to make the position of the tombs recognizable even from the outside (these, however, were never finished). The rose windows link the exterior with the interior space, which they dominate completely.

The style of St.-Denis is evident in the upper parts of the choir of Troyes Cathedral (see left). This had to be renewed after a storm in 1228 severely damaged the church, which had been under construction since the early years of the century. The dates for St.-Denis and Troyes cannot be far apart as the buildings are very similar in places; it is hard to decide which church preceded the other. But the logic of internal building suggests that St.-Denis, in which the task of planning was much more complex than in Troyes, came first. Moreover, before the remodeling of St.-Denis there had already been initial attempts at restoring the architecture in the area around the abbey church, while this was not the case in Troyes.

The new-style architecture of St.-Denis, in which the richness and elegance of construction is combined with Burgundian wall structure, was transferred during the 1230s to a smaller building, the royal chapel of St.-Germain-en-Laye situated to the west of Paris (see opposite). Here all the walls are split into layers. The base of the

walls recedes behind a delicately profiled arcade, and all the
windows, including the west rose window (which has since been
filled in), are set in niches that are finished off at the top in a straight
line and glazed in the spandrels, which lie just behind the vault webs.
The separation of inner and outer layers is thus strikingly displayed.
Finally, the architect has even devised a stylistic difference between
the glazed exterior shell and the inside shaft and vaulting system. The
window tracery, because of its large number of ornate crowns,
contrasts with the smooth shafts in the interior. Of course this sort of
thing only made sense in a small chapel, where the windows are
nearer to the observer than is the clerestory in a basilica. At that time,
the architect could reckon on an attentive observer who was in a
position to perceive and appreciate such subtleties.

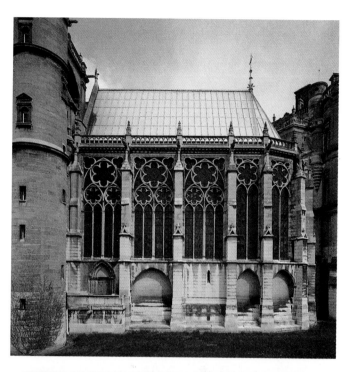

The patron of St.-Germain-en-Laye, King Louis IX, will have
noticed these subtleties, but he probably considered them too extrav-
agant for his most important church building, the Ste.-Chapelle in
Paris (see pages 84–85). Consecrated in 1248, it must have been
mainly constructed in the first half of the 1240s. As tall as many an
older cathedral, it rises up in the middle of the royal palace like a
stone shrine—which is in effect what it is, for it was built to house
what was thought to be Christ's crown of thorns, acquired from the
Byzantine emperor Baldwin II. This relic, which was brought to Paris
in 1239 in solemn procession, served to increase the sacred prestige
of the French kings, who had for a long time, after all, been anointed
with oil supposedly brought straight from heaven. As an allusion to
the royal crown, the crown of thorns was an unmistakable symbol.
When the king was paying reverence to the crown of thorns, holding
it aloft on the platform of the Ste.-Chapelle, he was standing like
Christ among the apostles, whose statues are attached to the piers. In
addition, angels in the spandrels behind the statues of the apostles are
celebrating a divine service. To those witnessing the ceremony, it must
have seemed as if the king was standing at the center of an earthly
representation of the Heavenly Jerusalem.

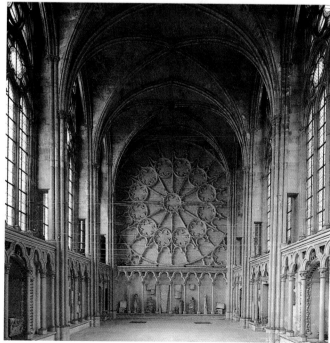

It would have been ill-advised to design such a politically impor-
tant building as the Ste.-Chapelle only according to the latest Parisian
architectural fashion. Its timeless or eternal significance would be
expressed much better by an appropriate "classic" architecture.
Therefore it is no coincidence that the analysis of the building struc-
ture, which can be applied so successfully to the other examples of
Rayonnant architecture, is inappropriate for the Ste.-Chapelle. At
least this is the case with the upper chapel of the church, while the
lower chapel of the building, two-storied in the style of palace
chapels, is an extremely complicated structure. Supporting the floor
of the upper chapel is the lower vault, which is supported by thin
columns standing well away from the walls (see page 84). Delicate
tracery arches divert the vault's lateral thrust onto the outside walls.
If this vault had extended from wall to wall, then its arches would not
only have become wider but also so high that they would have had to
begin almost at ground level.

Paris, Ste.-Chapelle,
former royal palace chapel,
consecrated in 1246
Lower chapel
Ground plan (right)

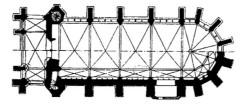

OPPOSITE:
Paris, Ste.-Chapelle
Upper chapel

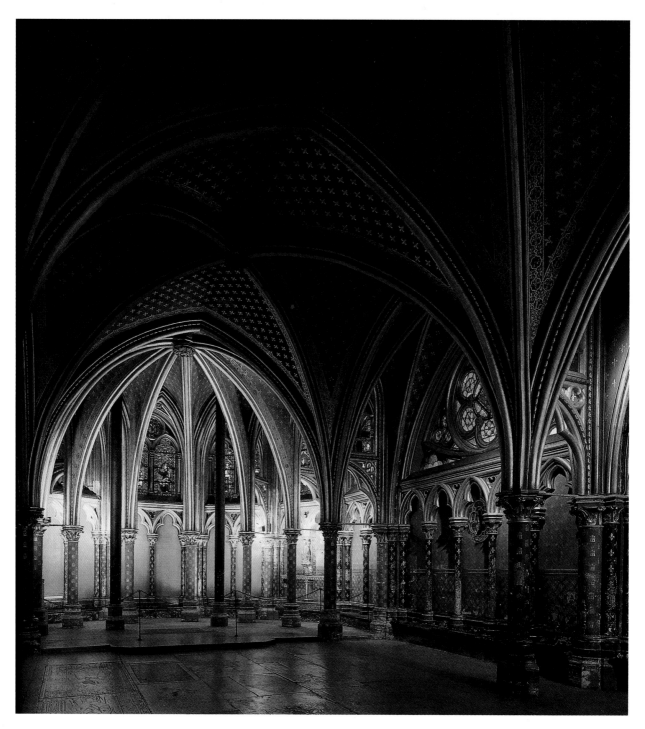

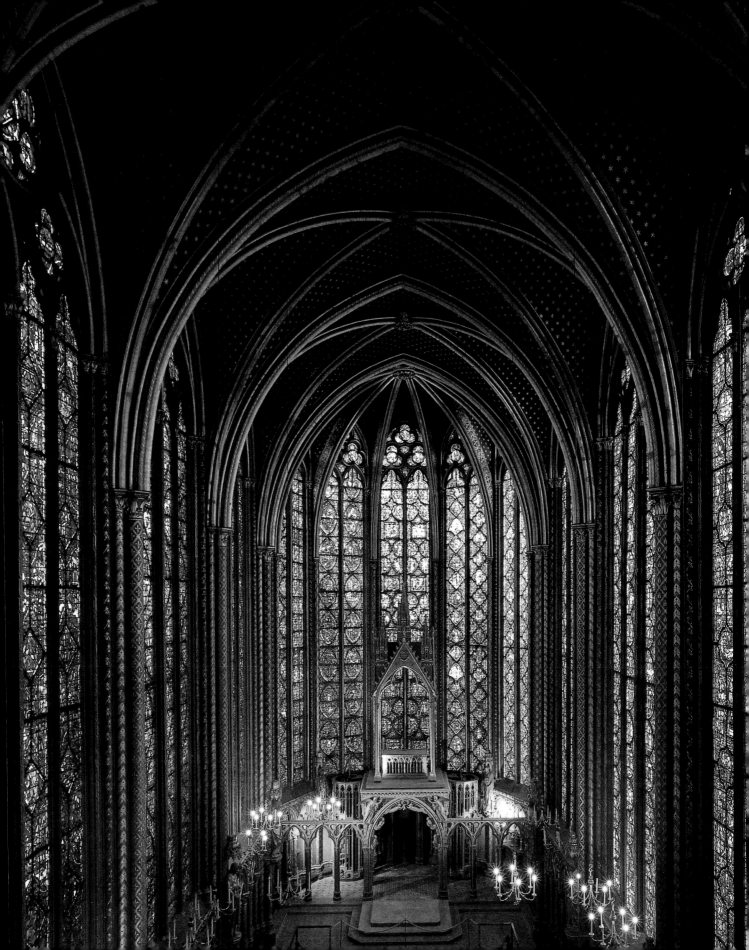

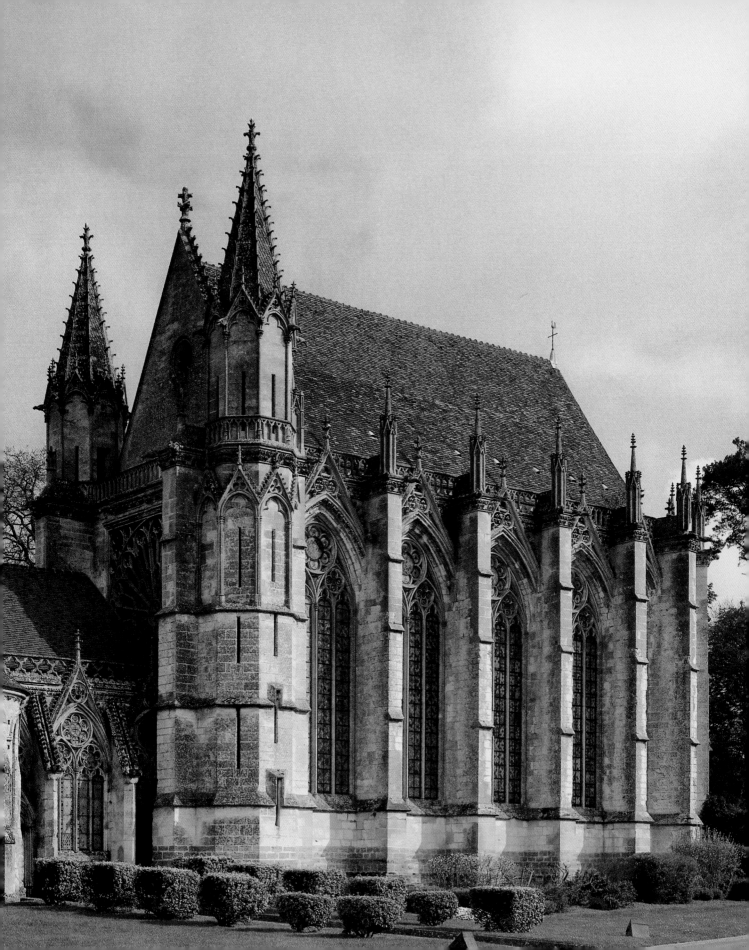

OPPOSITE:
St.-Germer-de-Fly (Oise), former
Bendictine abbey church
Marian chapel, ca. 1260–65

St.-Germer-de-Fly (Oise), former
Benedictine abbey church
Passage between chevet and
Marian chapel (left)
Marian chapel
(right), ca. 1260–65

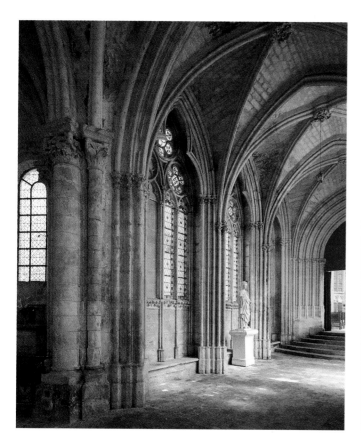

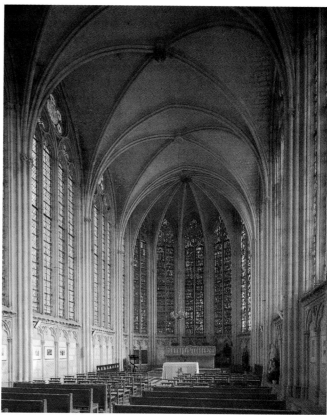

The structural engineering of the upper church is no less sophisticated, but by contrast with the lower chapel, the means employed to carry out the task, mainly a complex system of tension rods and ring armatures, are cleverly concealed. The architect had to forgo any overt demonstration of his ability in order to make the upper chapel appear both simple and elegant (see page 85). The wall is completely translated into shallow wall arcading and very tall, narrow windows, each of which has an unobtrusive crown. Slender responds of varying sizes support the vault with its high springing. This architecture is painted all over in the colors and motifs of the royal coats-of-arms, while the vault webs portray a starry sky. Despite major restoration, the present colors are probably close to the original scheme, in which intricate glazing in strong red and blue tones predominated.

There is a connection between the appearance of St. Louis himself, who never showed himself in an extravagant light either in his actions or in his clothes, and the architecture of the Ste.-Chapelle, which is devoid of fashionable detail. Neither a reassertion of the out-of-date, nor a *retour à l'ordre*, the Ste.-Chapelle set the standard

for "classic" Gothic for a long time. Outside France, where an attempt was made to imitate the French monarchy, it became a standard for Gothic buildings; within France, in contrast, the trend was for less majestic buildings since nothing could really compare with the Ste.-Chapelle.

Thus the Marian chapel of the abbey church of St.-Germer-de-Fly (see opposite and above), constructed in the early 1260s, can be interpreted as a miniature, and above all less steeply soaring, version of the Ste.-Chapelle. Outside, nevertheless, it is decorated somewhat more richly and elegantly, notably in the filigreed gables and the richly worked cornices. This is also true of the connecting passage to the old church, which makes the extension far more than just a new axial chapel. In this miniature piece of architecture, the décor discloses its full effect because here the buttresses are not so dominant. The expenditure on decoration is also evident in the windows, since in the crown of the windows, instead of the quatrefoils used in the Ste.-Chapelle, larger cinquefoils were used, window apex and gable being drawn together into one single feature. In the interior of

this connecting passage the double-layering of the wall, avoided in the Ste.-Chapelle, also reappears, and the piers display far more shafts than is necessary; they seem to develop from the richly profiled soffit of the chapel portal. The cusped arcade arches produce a rhythm of their own that does not correspond to that of the window tracery. In contrast to this, the interior of the chapel itself looks smoothed out, for the responds do not protrude boldly. The original painted decoration will have emphasized this effect. The architect of the Marian chapel of St.-Germer-de-Fly knew very well how to create decorative, three-dimensional, and graphic effects, and how to apply them in a sensitive and subtly differentiated way.

For this architecture, rich in nuances, the two transept façades of Notre-Dame in Paris, constructed around 1250, were the model. These new façades had to be built because around 1220–30 work was started on constructing chapels between the buttresses of the cathedral, chapels that overshadowed the old façades. The name of the architect of the older north façade, Jean de Chelles, who before his death also laid the foundation stone for the south façade (see opposite, top), is known to us thanks to an inscription which his successor, Pierre de Montreuil, put into the base of the later façade. This south façade largely follows the model of the older north façade, but with a number of subtle differences. For example, the tracery of the rose window becomes even more intricate and finely detailed. Although its appearance has altered after several restorations, it still shows why on his gravestone its creator Pierre de Montreuil was given the scholarly title of *doctor lathomorum*, "doctor of stone-masonry."

The Individuality of Architecture and Architects

With Jean de Chelles and Pierre de Montreuil we encounter the first Paris architects known to us by name. In Amiens there is the cathedral master builder Robert de Luzarches and his two successors, Thomas and Regnault de Cormont. In the maze of Reims Cathedral (which has since disappeared) the architects Jean d'Orbais, Jean de Loup, Gauches de Reims, and Bernard de Soissons were represented, and in Reims we can still see the gravestone of Hugues Libergier (see right), the architect of the abbey church of St.-Nicaise, which was demolished during the French Revolution. Thanks to documentary evidence, Gauthier de Varinfroy is known to us as the master builder of the cathedrals of Meaux and Évreux. It is hardly a coincidence that none of these names is mentioned before the second half of the 12th century, and that only then did the younger master masons erect monuments to their deceased predecessors, as happened in the cathedrals of Amiens, Paris, and Reims.

Obviously the leading architects of the period were no longer regarded merely as capable craftsmen but were greatly admired for their organizational skills and, above all, for their creativity. In art history, therefore, it is precisely for this period that attempts are being made to ascribe an oeuvre to individual artistic personalities not primarily on the basis of written sources, but on the identification of

each architect's "artistic signature." For that is exactly what these architects were doing: trying to create a recognizable individual style that would enable them to be distinguished from their colleagues. The theoretical concept for this was *aemulatio* (emulation), competition with a recognized model. Pierre de Montreuil was doing just this when, in the building of the transept façades of Notre-Dame in Paris, he named his predecessor Jean de Chelles, and modified his own architecture on the basis of the other man's example. In all this it was no longer the patron of the work who provided the impetus for the competition between architects, as had still been the case only a few decades before, but the architects themselves.

The patrons were losing control over their projects because architectural specialization was increasing. The profession of the individual architect was emerging. The architect could now achieve a high social position, as is clearly shown by the fact that he could erect monuments to himself and his deceased colleagues in the guild of architects. The remembrance of individuals across several generations, a practice seen in the ever-increasing number of architects' inscriptions, had until then been the preserve of the nobility and the higher clergy. Regnault de Cormont, who laid the maze on the floor of Amiens Cathedral, in which his own name also stands next to those of his predecessors, probably went the furthest in this respect. This monument, looked at from the entrance, lay immediately behind the tombs of the bishops of Amiens, who had been the first to commission the Gothic cathedral. The maze placed the bishop and the master mason of the cathedral on the same level.

This growing stress on individual architects was first confined to the main centers (Paris, Amiens, Reims). Nevertheless, it is clear that

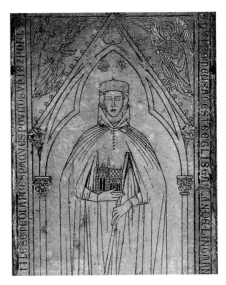

Reims (Marne), Notre-Dame Cathedral
North transept, gravestone of the architect Hugues Libergier, from the abbey church of St.-Nicaise, begun by him in 1231 and demolished during the French Revolution

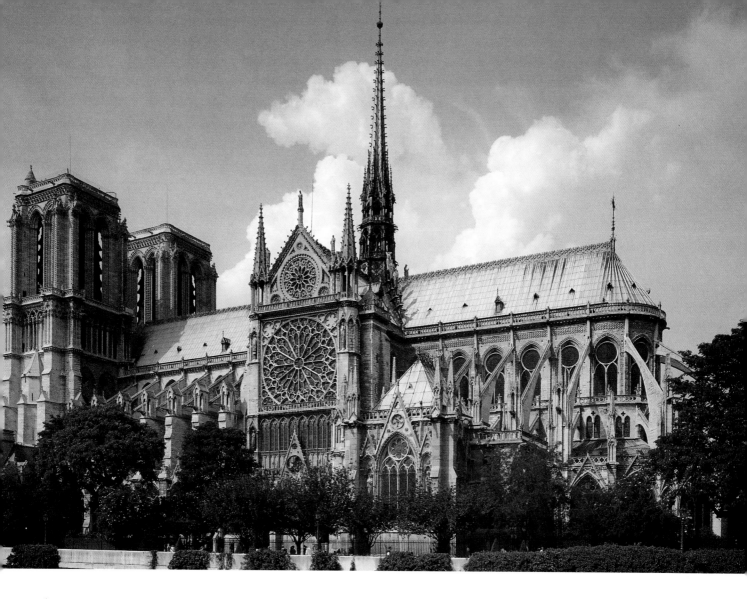

in other areas too architects had become increasingly self-confident and independent figures who were capable of creating works of the highest quality and originality, though usually without having the opportunity to bequeath their names to posterity. The pilgrimage church of St.-Sulpice-de-Favières (see right) is a perfect example of the way the new architecture of the capital was being adopted after the middle of the 13th century. The principle of free-standing wall-arcading at ground level, the niches in front of the windows, the tracery, and the shape of the piers are all clearly realized through the models of St.-Denis and St.-Germain-en-Laye. On the other hand, the choir polygon, glazed in its three tiers, is an entirely independent creation.

The master mason of St.-Urbain in Troyes went still further in this respect. The building is so original that one would dearly love to know the name of the architect. He has been identified by some as the Johannes Angelicus named in one source, and turned into a modern-sounding Jean Langlois. But the source in question describes him only as *magister operis* ("master of the project"), in other words the administrator of a masons' lodge, which means in effect that the identity of the architect of St.-Urbain is still unknown.

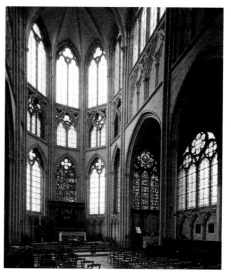

St.-Sulpice-de-Favières (Essonne), parish church Choir, mid 13th century

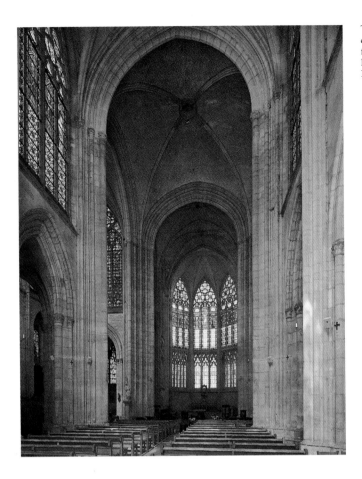

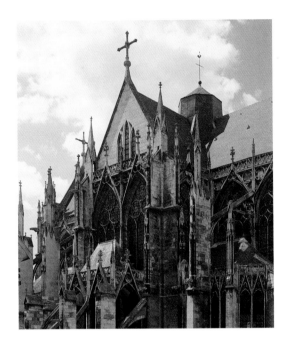

Troyes (Aube), former collegiate
church of St.-Urbain,
founded 1262 by Pope Urban IV
Interior (left)
Exterior of the transept (below)

OPPOSITE:
Carcassonne (Aude),
St.-Nazaire
Cathedral
Choir and transept, begun ca. 1280

The church was founded in 1262 by Pope Urban IV at the house where he was born and the choir and transept were constructed in the years immediately following (see above). Outstanding among the building's features are the membrane-like walls that are so thin that they give the impression they are not solid walls but fabric stretched between the buttressing. There are always several layers placed one behind the other. In the lower story of the interior, the discrepancy between the inner and the outer layers of wall (hinted at cautiously in Notre-Dame in Dijon and in the Marian chapel of St.-Germer-de-Fly) is logically extended to all parts, so that the free-standing tracery at the front never corresponds with the window tracery behind. There is no hint of a triforium or a wall area rising over the roofs of the side aisles. Instead, the clerestory windows are extended downwards as far as possible.

The exterior of the building seems to be resolving into three elements: structurally necessary buttressing, decorated glass surfaces required for structuring the interior space, and decoration. Nowhere else is there such a wide space between clerestory and buttresses. At times it seems as if the windows and vaults are stretched over the architectural frame, just like the fabric of a vast tent. The decoration, particularly the gables, mostly stands independently in front of the wall, which is largely reduced to load-bearing elements. This is also the case with the filigreed transept porches, the thrust of which is diverted in a completely unusual way onto buttresses standing freely in front of them.

At Troyes the architecture was broken down in a unique way by displaying its basic elements (the space boundaries, the supports, and the decoration) independently. From this it can be seen what self-confidence an architect could develop in his profession at that time whenever he had received such an extraordinary—in this case papal—commission.

For the same reason, however, the building was also bound to remain unique, since it went radically beyond the aesthetic of the age. That architecture in other places remained more conservative does not therefore mean that it was poorer, but that patrons and architects were not in such an exceptional and fortunate situation as those at St.-Urbain in Troyes, and had to satisfy the more complex needs of a church's many users.

Thus the choir and transept of the cathedral of Carcassonne in southern France (see opposite and page 92, top), although probably planned only around 1280, are closer to the architectural concepts of the Ste.-Chapelle than they are to those of St.-Urbain. Admittedly the pier profiles and the tracery are carved, following fashion, a little more distinctly than in the Ste.-Chapelle, but the luxury of the layered wall of St.-Urbain is not repeated. As there was not much space at his disposal, the architect linked the choir to a series of chapels and opened the choir and chapels through to each other at the sides. This resulted in one huge continuous space whose merged sections are bounded only by fine free-standing tracery and open-work wall panels.

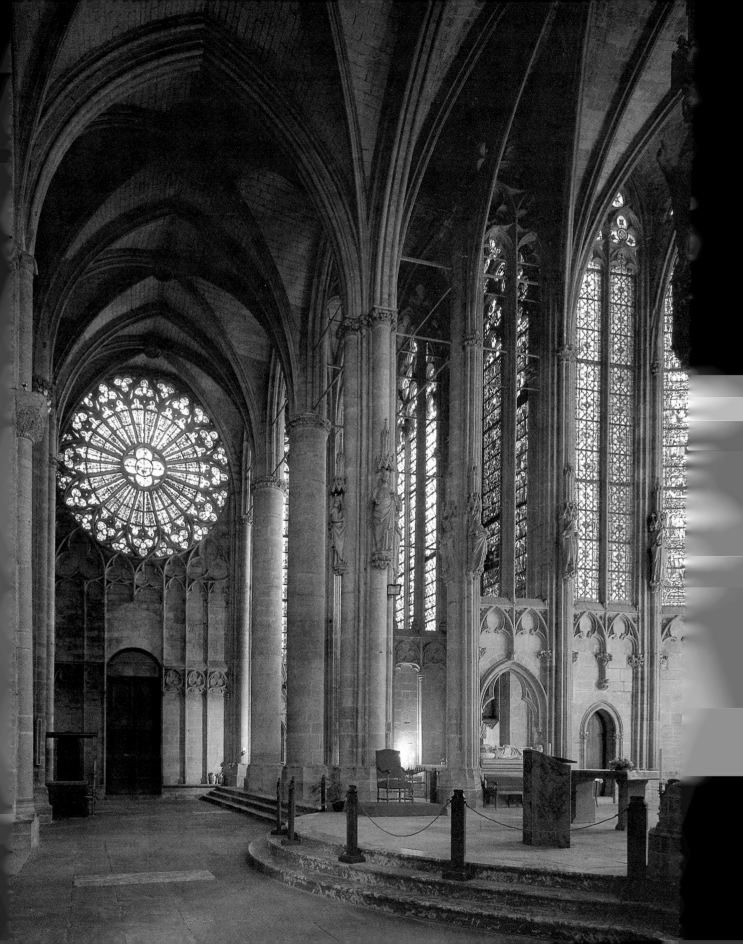

Carcassonne (Aude),
St.-Nazaire Cathedral
Choir and transept, begun towards 1280
Ground plan (right)

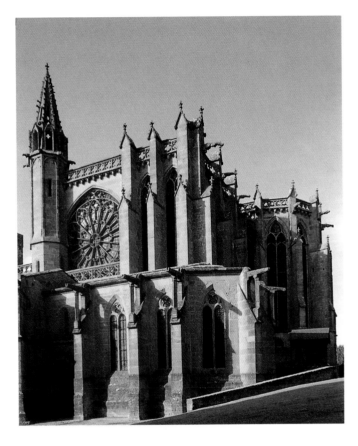

1248. Its architect was Jean Deschamps. The wall elevation of the interior follows the classic three-tiered form (with arcade, dark triforium, and clerestory), but it is combined with the modern pier type from St.-Denis. The motif of the gabled triforium derives from the choir of Amiens.

But the innovations in this cathedral in the middle of France become clear precisely in the comparison between the triforium and clerestory there and at Amiens. For instead of linking both stories to each other by means of continuous window mullions, and without giving up a stringcourse between them, Jean Deschamps simply placed the triforium into the clerestory window area. The triforium is part of the window tracery, and it is of secondary importance whether the tracery is glazed or open, transparent or not.

Technically it would have been a trifling matter to open up the triforium in Clermont-Ferrand since above the side aisles there are no pent roofs, whose slope would otherwise cover the triforium, but flat terraces, above which the whole clerestory, including the triforium, rises up freely. Therefore the reason for not allowing the triforium to disappear could only be an aesthetic one. It was probably preserved because it was separated from the clerestory windows by a series of richly carved, visually dominant gables. These gables, together with their individual lancets, form a basic module that remains constant, appearing frequently in the individual windows, with variations according to the width of the bay.

Unusually, the individual window is not defined as a leftover space between two piers, but as an independent element composed of the basic module just mentioned. This had the advantage that in each case these outer strips of window are always of the same height, which means that the lower part of the crown is situated at exactly

Viewed from the older nave, the choir looks like a glassed-in shrine, its windows a wall of bright light. This filigree architecture is structurally so daring that it could be stabilized only with the aid of a complicated system of invisible tension rods.

Carcassonne is evidence that Gothic architecture after the middle of the 13th century was no longer a local style limited to the Île-de-France and the surrounding area. Outstanding buildings were now considered models worthy of emulation regardless of where they were built. Thus the canons of the cathedral of Narbonne, also in southern France, justified the new construction of their cathedral by arguing the need to imitate the "noble and grandly executed churches… in the Kingdom of France." And for that reason the main focus of building activity in France was now moving increasingly to the periphery, because, after all, in the heartland of Gothic most cathedrals, abbeys, and priories had been begun in the new style long ago, even if they were not yet completed.

An example of the spread of Gothic beyond its original area of influence is the cathedral of Clermont-Ferrand (see right), begun in

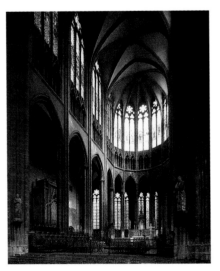

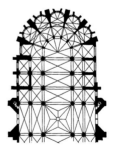

Clermont-Ferrand
(Puy-de-Dôme),
Notre-Dame Cathedral
Choir, begun 1248
Ground plan of choir (above)

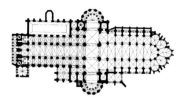

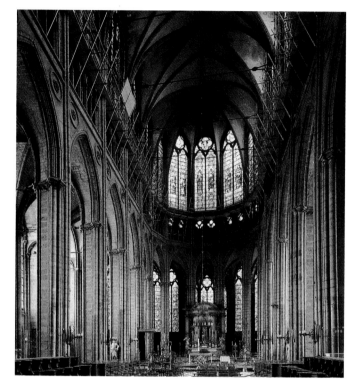

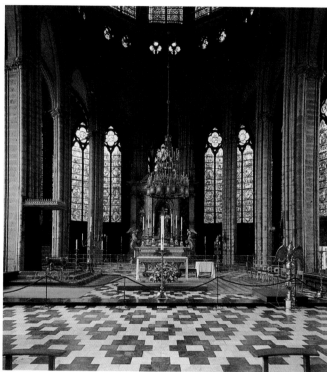

the same height in all parts of the choir, which was not the case in older buildings. This meant that the impression of a unified choir clerestory could be achieved. In the narrow wall areas of the choir polygon two of these modules fit exactly between the piers every time, yet in the straight bays a narrow strip of wall still remains free alongside each of the window areas, which at Clermont-Ferrand consist of three lancets.

This does not mean that Jean Deschamps departed from the principle of the dissolving of the wall into supports and windows, or even that he inaugurated a new aesthetic of the wall, as has often been claimed: he merely resolved in a totally new way the problem common to every choir, that of the complicated transition between the straight and polygonal parts. As we have already seen in the analysis of the church of Ste.-Madeleine in Vézelay, this problem could lead to highly original solutions.

The anonymous architect of the choir of Tournai Cathedral, which was constructed between 1243 and 1255, also had to concern himself with the problem of linking the different parts in this area of the church (see above). Like his colleague at Clermont-Ferrand, he took the strips of window in the chevet as his point of departure for the windows in the remaining parts of the upper story, but instead of

adding a strip of wall to them at the edge, he split the two strips in the middle by an additional, very narrow, extra lancet, repeating this design in the triforium.

Since in Tournai he was not building a completely new cathedral but was merely extending the old Romanesque building with a new choir, the architect had little space at his disposal for the choir. Therefore he chose the ground plan of the cathedral of Soissons, which requires only a small area for the choir. Thus the straight chapels are situated flat between the buttresses while the radiating chapels, to save space, are drawn together with the ambulatory under one vault.

In Tournai, however, the chapels are no longer independent spaces, but instead are parts of an area created by the undulating exterior wall of the ambulatory, an arrangement that creates an unusually spacious impression. With their large areas of window, the chapels must originally have seemed like a glazed backdrop behind the arcades of the inner choir. In order to make this view possible, the arcade piers were made appropriately thin—too thin, in fact, for they soon had to be strengthened and the impression of space was lost.

San Galgano, former Cistercian
abbey church, begun ca. 1224
Nave

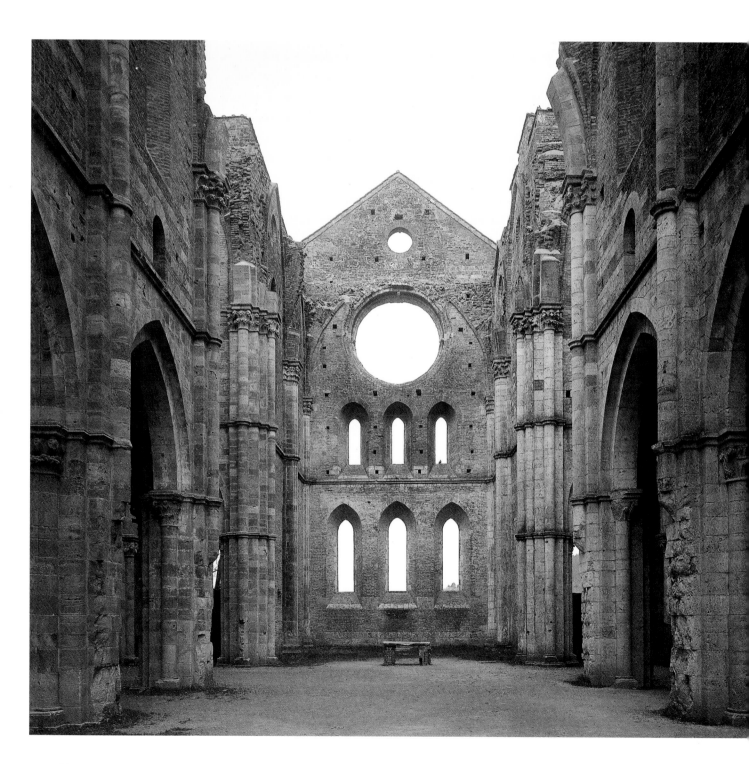

Early and High Gothic Outside France

Gothic as a French Export

It is no coincidence that Tournai stands at the end of an account of the development of Gothic architecture in France. For this town was no longer situated within the Kingdom of France, but was now within the borders of the Holy Roman Empire. All the same, the influence on the town of French politics and culture was decisive, especially as German was never spoken in Tournai. Consequently, The cathedral of Tournai can certainly be regarded as belonging directly to French Gothic, which is equally true of other buildings in the frontier areas of France.

In any case, it is only with difficulty that the spread of Gothic in the late 12th and early 13th centuries can be represented as coinciding with the political frontiers of the time. Normandy, for example, still belonged *de jure* to France, but when the first Gothic buildings were built there it was under English rule and the French king could not exercise any rights there *de facto*. Early Gothic is therefore very similar on both sides of the English Channel. The first country outside France in which this style was taken up and quickly achieved an independent form was indeed England, whose Gothic is therefore treated in a separate chapter in this book. In France's other neighbors, whose history was not so closely bound up with the mother country of Gothic, the assimilation of the new style came about differently.

In the following pages the spread of Gothic will be discussed in the phase in which it can still be viewed as a French export, before it took root and underwent completely independent transformations in the countries of adoption. This does not mean that the first Gothic buildings outside France are being labeled as merely derivative, particularly as none of them as they stand could have been built in France. All the same, the wish of the English king Henry III to put the newly built Ste.-Chapelle in Paris on a wagon and transport it to London reveals that French buildings were widely regarded as pointing the way forward. This admiration of French architecture varied in intensity from country to country, and ended at very different times in its various places of adoption.

The Beginnings of Gothic in Italy

Among France's neighbors, it was Italy that was the least receptive to the early forms of French Gothic. Thus, in marked contrast to other European countries, there is not a single Italian cathedral or large church from the 12th or 13th century that is wholly based on the French model. In Italy, the new style was first of all spread mainly by the Cistercians, not in the version known from the Île-de-France, but in a variant based on Burgundian Late Romanesque. This led to only minor modifications of Italian native architectural style, especially as the rib vault was already common as an important structural element of Gothic architecture in northern Italy from the early 12th century.

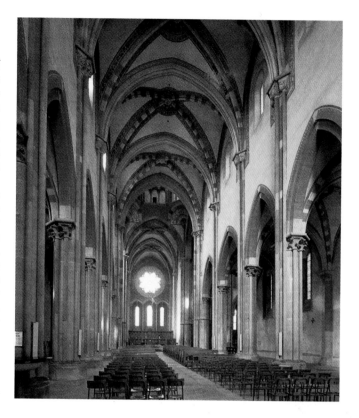

The period of the true adoption of Gothic architecture from France was, for the reasons already given, brief and had already ended soon after the middle of the 13th century, when quite independent buildings were constructed in Italy, buildings that have little more than the name Gothic in common with their counterparts in France.

The ruin of San Galgano in Tuscany (see opposite) is typical of the many Gothic Cistercian churches in Italy. Begun about 1224, the building still shows the cruciform piers with the three-quarter columns in front, typical of Burgundian Romanesque. All the same, from the ground plan up it is an extremely logical transplantation of the French pattern for a Cistercian church. Thus it is virtually only the materials—brick and travertine—which point to Italy.

One of the few churches that show a quite definite relationship to the Gothic of the northern French type is Sant'Andrea in Vercelli, founded in 1219 by Bishop Gualo after his return from England as papal legate, and consecrated as early as 1224 (see above and page 96). The building was admittedly far from finished at that point, but it must have progressed rapidly because the bishop was able to place a substantial income from an English abbey at the disposal of his foundation. The adoption of Gothic building forms, unusually

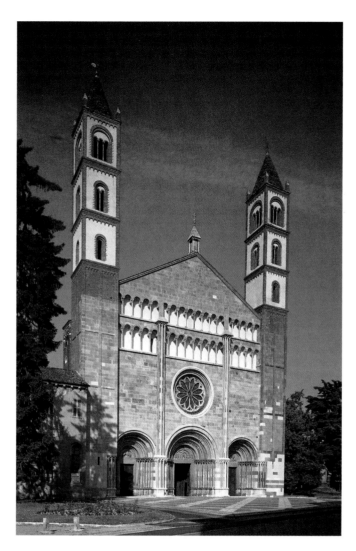

Vercelli, Sant'Andrea,
founded 1219, dedicated 1224

specific for Italy, is certainly connected with the fact that the church was run by canons from the Paris abbey of St.-Victor.

Thus the ground plan already indicates a style of building that is characteristically French, with a nave and two side aisles, transept, and staggered apses, a form that is found for example in St.-Vincent in Laon, and in St.-Yved in Braine. The shape of the piers, unusual for Italy, with the columns closely surrounded by shafts, is derived from the side aisles of the nave of Notre-Dame in Paris. However, the unusually small clerestory windows are already an indication of how far the building is from French Gothic, especially as it was begun around the same time as the cathedral of Amiens. From the outside, the church is built entirely of brick, which is typical of northern Italy, with a flat blind screen façade with dwarf galleries and flanked by twin towers rising from a rectangular ground plan. All these features had been known in Italy for over a century. Sant'Andrea clearly demonstrates that a complete adoption of Gothic building types and forms was out of the question in Italy; such an adoption, if it was attempted at all, depended on specific conditions.

The Beginnings of Gothic Architecture on the Iberian Peninsula

The appropriation of Gothic on the Iberian peninsula proceeded in a considerably more varied manner than in Italy, beginning earlier and lasting longer. The reason for this was that the connection with France had always been closer geographically and, above all, politically. As early as the 11th century, the age when Christian Spain was beginning to emerge from Arab domination (until 1492 Spain had to grapple with Muslim rule in the southern part of the peninsula), the orientation toward French culture had been an important means of reintegrating Spain into the Christian west. The French monastery of Cluny, closely connected with the Holy See in Rome, played an important part in this, just as in reverse the gigantic church of Cluny was constructed by means of Spanish money extorted from the Arabs. Along the pilgrims' way to Santiago in Galicia, French culture played a particularly important role, because on the *camino francés* (French road) there were not only very many pilgrims from France but also a series of towns settled completely or partially with inhabitants of French origin. It is therefore no coincidence that the first signs of the adoption of French architecture and sculpture can be recognized in the cathedral of Santiago itself.

In the west of the church, where building began in 1168, the main portal (the Portico de la Glória, completed in 1188), the rib vaulting and the whole conception of the design show that the architect, Master Mateo, was familiar with artistic trends of the day in France, especially in Burgundy. Admittedly all the French elements there are transformed in such an original way that it is difficult to describe the Portico de la Glória as Gothic, let alone French.

This is true also of a whole series of other buildings from Catalonia in the east to Galicia in the west, for example the Cistercian churches of Moreruela, Santes Creus (see page 11), and Poblet, and also the cathedrals of Salamanca and Lleida. Their architecture, which combines traditionally Spanish elements, such as powerfully constructed piers, with rib vaulting inspired by French models, could have led to the emergence of an original variant of Gothic on the Iberian peninsula at an early date. But working against this possibility was the fact that all the kings of the different kingdoms of Spain were always concerned to be in direct contact with French culture, which in the field of architecture led to more and more new waves of Gothic being adopted.

In Ávila in Castille, which had been an archbishopric only since 1142, the rebuilding of the cathedral was probably begun in the 1170s. Characteristically, this happened at a time when King Alfonso VIII (1158–1214), still a minor, was temporarily residing in the town after the separation of the kingdoms of Castille and León, which occurred in 1157. This cathedral was such an ambitious project that in order to construct its ambulatory (see opposite, left) the mighty town wall, finished only a few decades before, had to be broken through. This would have been unnecessary had they decided on a less lavish east end of the church, namely one with an apse of the

Ávila, Cathedral of San Salvador, last
third of 12th century
Ambulatory (below)
Ground plan (right)

Las Huelgas (Burgos), former
Cistercian convent church, early
13th century
Choir and transept

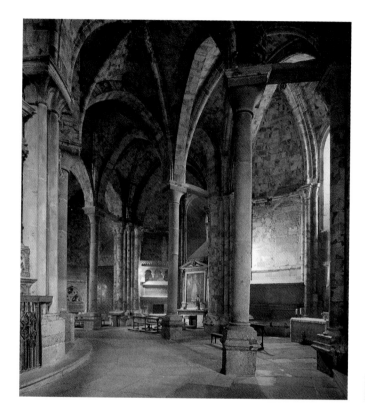

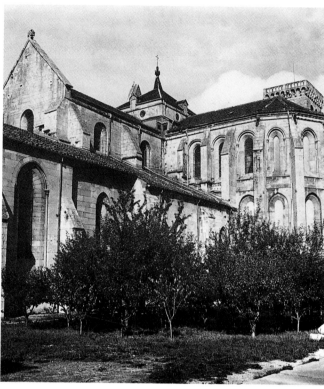

form usual in Spain. But instead they even constructed a double ambulatory with radiating chapels, the center of which, hardly by chance, lies exactly on the line of the old town wall. At the time there was only one model for this east end in Europe, namely St.-Denis, which contained the tombs of the French kings and the national patron saint, Dionysius (Denis). It can be assumed that Ávila too was intended as a "royal" building, differing from everything hitherto constructed in Spain, and at the same time comparable to one of the most modern and sophisticated royal churches in Europe.

At the same time, it was clear from the start that in Ávila an exact replica of St.-Denis was impossible, because the excessive opening up of windows, so important for the French abbey church, was the one thing which could not be imitated: the choir, being a part of the town wall, could hardly be opened to the outside. But that probably did not matter either, because the integration of the Ávila choir into the town wall makes the king's involvement quite clear: he alone was responsible for decisions on the demolishing or rebuilding of town walls. Therefore a subtle interplay between a heavy exterior and a filigree interior, with slender columns, responds, and rib vault, characterizes the ambulatory of Ávila, whose architect is named as

Master Fruchel. The appropriation of Gothic was in this case highly selective and only of short duration, as the other parts of the choir already show a repertoire of exclusively traditional Spanish forms.

In 1183, Alfonso VIII, who had already been involved in Ávila, founded, in front of the city gates of Burgos, the Cistercian monastery of Las Huelgas, which served as a royal residence. The church, which dates only from the early 13th century (see above, right), shows that patrons and builders were still basing themselves on French architecture, although the reception of Gothic had in the meantime become much more complex than it had been at Ávila. For example, the building imitates French models from the region around Laon in almost exact detail while some of the rather more complicated vault shapes allow us to conclude that the Gothic architecture of the Loire region was also known.

In the cathedral of Cuenca, too, the chevet, which originally consisted of a polygonal main apse and lower side apses, increasing in depth towards the axis, imitates building types and forms of Laon, perhaps also those of Braine. The influence of the buildings in that region was at the same time spreading in France itself, shown by its reception in such varying places as Bourges, Chartres, and Le Mans.

Alcobaça, former Cistercian
abbey church, from 1178
Panteão Real (left)
Choir (right)

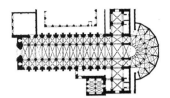

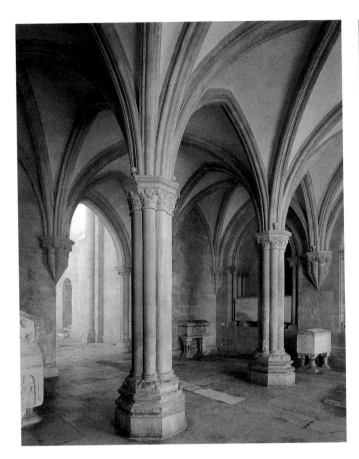

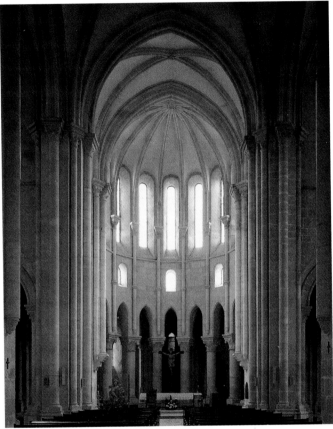

Some of the motifs characteristic of this architecture, such as the shafts set into the window reveals, or the buttresses that are continued above a wide water channel merely as narrow strips of wall, even recur on the well-room of the Portuguese Cistercian monastery of Alcobaça. And since the well-room cannot have been begun before the 1220s, it is to be assumed that large parts of the church had already been completed earlier, for usually the extension to the cloister began only when the church could be used for religious services. Unfortunately it is necessary to approach this powerful, extremely impressive building by way of marginal notes such as these, since there is not yet a satisfactory account of its history.

The monastery had been founded in 1153 by the first Portuguese king, Afonso I Henriques (1139–85). The original church was replaced from 1178 by the present new building (see above and opposite). Construction, however, progressed slowly as the monks had to abandon Alcobaça again temporarily because of an attack by the Moors. Consequently several building phases can easily be distinguished. For example, at the fourth nave bay from the crossing, there is an interruption in building typical of many Cistercian churches, since the first things to be completed were the east parts necessary for priest-monks—the high altar, the side altars, and choir stalls. A consecration recorded as taking place in 1223 may be associated with the completion of this building phase. After that, at least two further building phases followed for the remainder of the nave, until the final consecration in 1252.

A precise architectural history categorization of Alcobaça is difficult because whereas the church reveals itself from its ground plan to be an almost exact copy of Clairvaux, St. Bernard's church, its later construction cannot be so simply classified. This is true of its unusually high choir (see above, right). The choir is, by contrast with a Cistercian church like Pontigny (see page 68), modern for its time, its comparatively long windows suggesting the influence of cathedral design, but all the same, it is covered by a rather old-fashioned, dome-like vault. In contrast to this basilica-style choir, the nave and transept

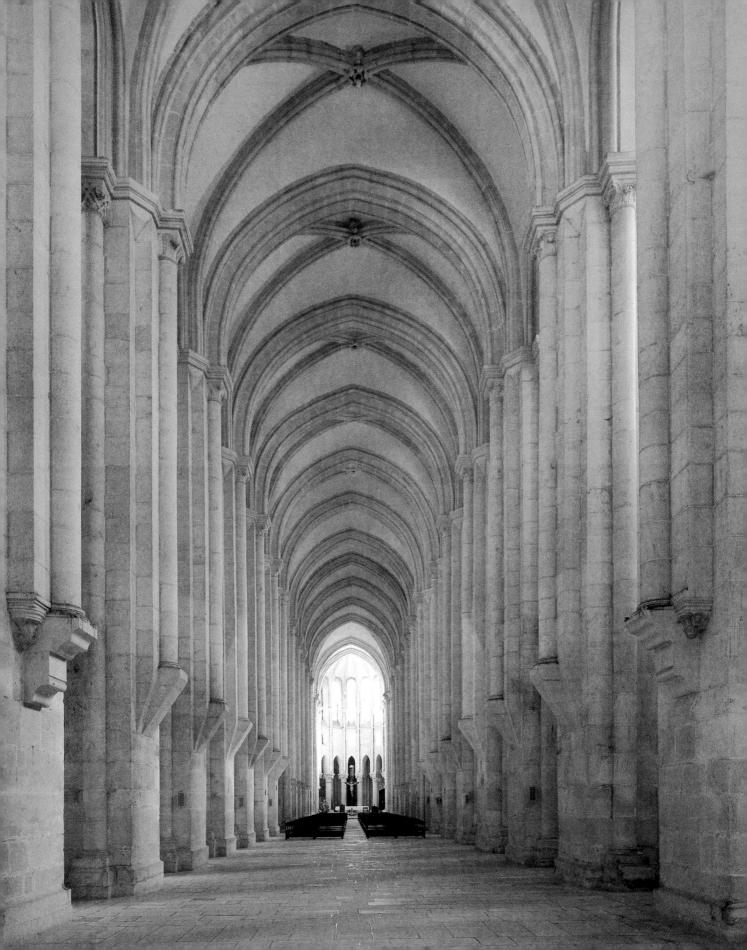

are halls with cross-ribbed vaults and with aisles about as high as the nave, for which there were no models in Cistercian architecture.

No satisfactory explanation for the introduction of this unusual building type has been found. Perhaps we can imagine that in Alcobaça, as in Spain around 1200, the builders who were working there were familiar with the Gothic of Picardy, and especially of western France, where there were hall churches such as the cathedral of Poitiers (see page 79, left). But the bays here are much wider, while the distance between the mighty piers of Alcobaça, collared off at the bottom in true Cistercian style, is so narrow that a view through into the side aisle becomes almost impossible.

At any rate it is clear that in general the imposing church of Alcobaça pays no attention to the Gothic of the Île-de-France, even if individual details show that the builders were well acquainted with it. Instead, the building tends to give the impression of an exaggeration of a Burgundian Cistercian church from the third quarter of the 12th century. In other words it does not reflect a fashion, it represents a type. Since this church could not have been constructed in such

dimensions without some royal involvement, its architecture also reflects royal interests and aspirations.

It was only after the 1220s that Gothic cathedrals were constructed in Spain for which the most modern French episcopal churches served as direct models. It is true that before that there were churches in Spain in the Gothic style, in Cuenca, for example, but these were based only on elements of the new Gothic style, not modeled on the Gothic cathedral. At Burgos in 1229, Bishop Mauricio, a confidant of the Castilian king, Ferdinand III (1217–52), laid the foundation stone for his new church, the choir of which could already be used by 1230 (see below, left).

Originally this basilica, which has a protruding aisleless transept, also possessed an ambulatory with sexpartite vaults and small chapels, like the cathedral of Bourges. The motif of the columnar pier surrounded by slender responds stems from there, too; the core of the pier is continued in front of the main nave wall. Motifs like the high triforium surmounted by blind arches derive from the model of the French cathedral, as well as the vault webs in the choir polygon

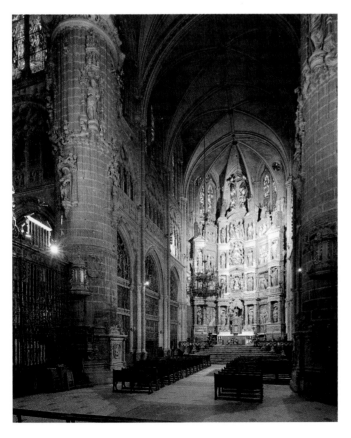

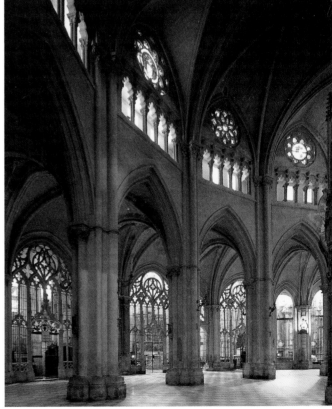

RIGHT:
León Cathedral, begun 1255

BELOW:
Toledo Cathedral,
begun ca. 1222–23
Exterior and ground plan

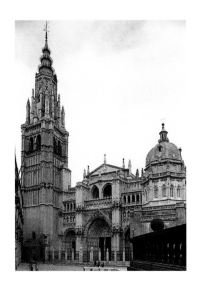

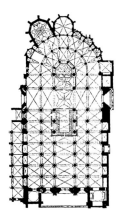

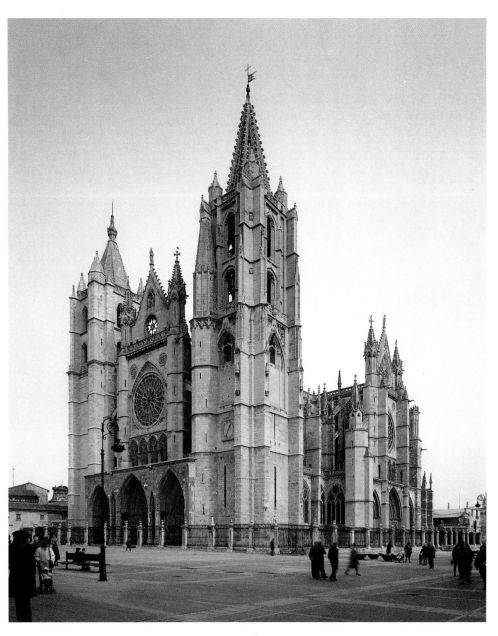

penetrated by small oculi. But Burgos is not a copy of Bourges, since the Spanish cathedral has only single side aisles and for that reason it was not possible to repeat the sequence of two side aisles increasing in height toward the nave.

This did occur, however, in the construction of the archiepiscopal cathedral of Toledo, begun immediately after Burgos and based essentially on the same French model. In accordance with the status of the Archbishop of Toledo, who was Primate of Spain, this cathedral is the largest 13th-century building in Spain. Apart from its nave and double side aisles, it can also boast an aisled transept, thereby surpassing both its French model and its Spanish sister-church in Burgos. In addition, the double ambulatory (see opposite, right) possessed a further circle of radiating chapels, formerly with

15 alternately rectangular and semi-circular chapels, a record for Gothic cathedrals. In order to create the connection between the piers of the inner choir, six in number, and the 18 corners of the radiating chapels, a complicated sequence of vaults was used in which, starting from the center, behind each pier there is a triangular vault framing a large rectangular one.

The Toledo master mason (whose name was Martín) could not adopt the Bourges system here, but based himself instead on the outside ambulatory of the recently started choir of the cathedral of Le Mans. The motif of the triforium in the inner ambulatory, which is crowned by a rosette, had already occurred in numerous smaller churches in the area around Paris, in which, as here in Toledo, the clerestory was too low for lancet windows.

101

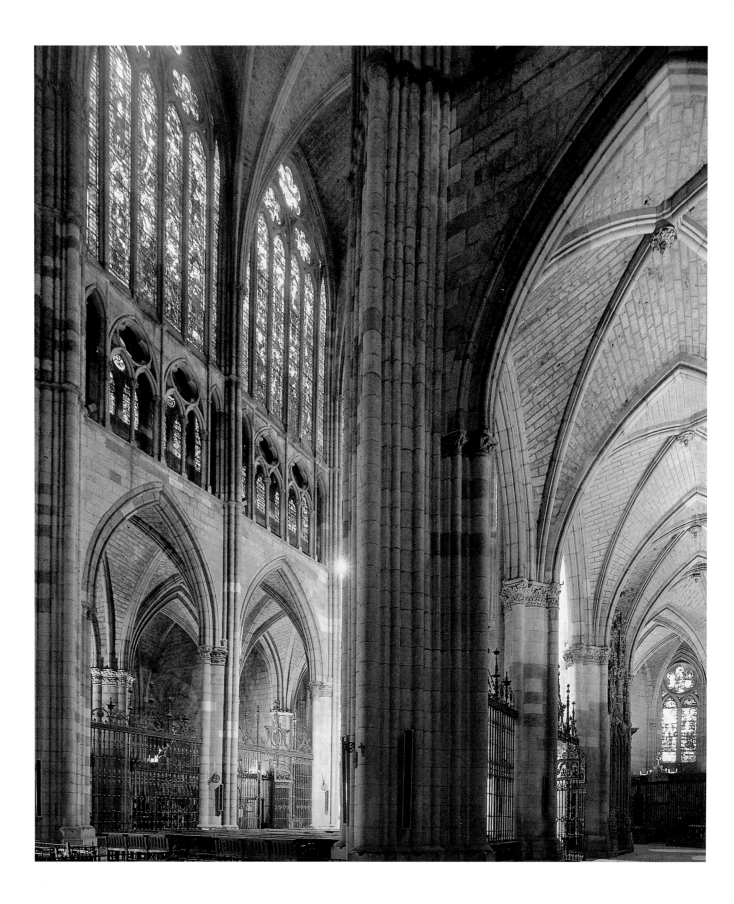

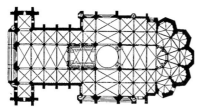

The archiepiscopal cathedral of Toledo can be seen not only as a slightly modernized version of the pattern of Bourges, but also as an attempt to integrate the latest French architecture over its whole range, while at the same time continuing to take account of Islamic elements. This building was clearly aiming to be seen as the religious center of the whole Iberian peninsula, and to be at least the equal of cathedrals outside Spain, if not their superior. It is no surprise that such an ambitious building project could be brought to a conclusion only at the end of the 15th century.

The cathedral of León, begun about 1255, represents a further step in the Iberian appropriation of French Gothic. The choice of models is in this case not as arbitrary as at Toledo, but it is almost only royal buildings of France that are adopted. The ground plan of the choir resembles that of Reims, while the layout of the west and transept façades, with their towers standing freely at the side next to the central aisles (see page 101, right), follows the model of the transept façades of the royal tomb of St.-Denis. The extreme delicacy of the interior and the large tracery windows (see opposite) must similarly go back to St.-Denis, although the elegance of the execution suggests that the Ste.-Chapelle may have served as the model. The pier type can be described as the link between the *piliers cantonnés* of Reims and the continuous rib clusters of St.-Denis.

León Cathedral was therefore to unite elements that in France were divided among several buildings important to the monarch. At the same time, this claim could be displayed only formally because the cathedral of León was not a royal coronation church, the tomb of a particularly important national saint, or the home of a politically important relic.

At that time a further enlargement was planned to the already very large cathedral of Santiago, which, as the burial place of St. James, was one of the most important pilgrimage destinations, and which since the beginning of the Reconquista (the reconquest of Spain under the Christian banner) had been considered one of the principal centers of Christian Spanish identity. The plan was for a choir extension in the Paris style, which with its total of 19 chapels would have put even Toledo in the shade. Finally, Parisian Rayonnant architecture was also the model for the extensions to the cathedral of Burgos carried out about 1260 to 1280. In these buildings a particular connection with King Alfonso X (1252–84) can be demonstrated. Like the French kings a hundred years before, he wanted to create a centralized state based on the person of the monarch. He failed in this, however, because of the resistance of the nobility, who plunged the country into civil war.

The influence of French Rayonnant architecture in Castille can therefore be regarded as an attempt, through architecture, to make royal claims that were not in fact realizable. Therefore it did not result in a broad adoption of Gothic forms in a clear and definitive way, as was the case at Toledo. The forms taken were those of an exclusive "royal" French Gothic, which in France itself was no more

than one of many possible versions. The failure of the policies of Alfonso X was therefore a heavy blow for the further reception and expansion of Gothic in Castille. Gothic would become successful again only later in Aragón and Catalonia, because in these areas there was no excessive concentration on a small circle of French models, which meant that architectural development could be more independent and more varied.

The Beginnings of Gothic Architecture in the Holy Roman Empire

The First Encounter

The Holy Roman Empire was politically and culturally still a highly heterogeneous entity at this time. Between its individual parts there existed at best a loose association. At the moment when, for various reasons, Gothic architecture in France began to be of interest to potential patrons in the Empire, the Empire extended from Sicily over wide areas of Italy and up to the North Sea and the Baltic. The Emperor, whose task it was to hold this empire together, had real power only in certain regions. His power had not been enforceable in northern Italy, for example, since the 12th century.

In the area north of the Alps, which is to be discussed here, a distinction must be made between the areas in the east, and those in the west, which today belong predominantly to France. In the latter, where French was spoken, Gothic architecture can hardly be distinguished from that which arose in the neighboring French regions. In the eastern areas, by contrast, an early adoption of individual elements of Gothic architecture took place, though without the buildings concerned being mistakable for their models. It was not until the second half of the 13th century that Gothic become the norm there, and it was only after this time that an independent style of Gothic architecture began to emerge in Germany.

How wrong it would be to take as a starting point merely political frontiers, whether real or the accidents of history, is shown by the case of the cathedral of Lausanne, situated on Lake Geneva. The diocese was part of the archbishopric of Besançon and therefore was oriented toward the west, not only in terms of geography but also in terms of ecclesiastical politics. Nevertheless, it is astonishing that already during the building of the cathedral (begun about 1160–70), a Gothic ambulatory was constructed that at this time was very unusual in the region, an ambulatory vaguely reminiscent of the cathedral of Sens. When after a change of plan the inner choir was finally begun, the builders of Lausanne looked even farther west: the three-storied wall elevation (see page 104), which has a real triforium and a recessed clerestory, shows astonishing similarities to that of Canterbury Cathedral (see page 125), where the originals of many other forms at Lausanne can also be found.

It is true, therefore, that after Canterbury Lausanne is the oldest Gothic cathedral outside France. Perhaps that is why at Lausanne the consistency and order that characterizes the architecture of the heart-

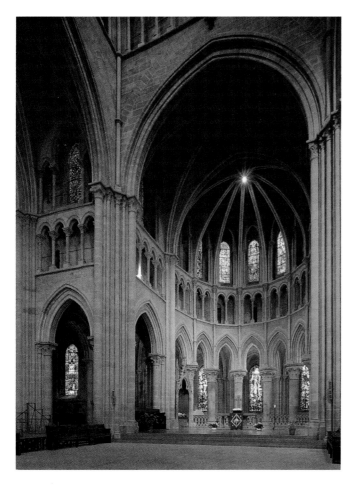

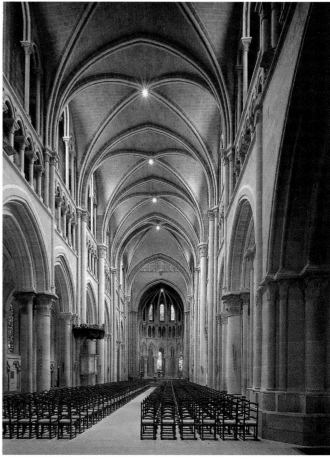

land of Gothic is largely ignored. In French Gothic, for example, there is not a single church in which such different piers stand next to each other as they do in Lausanne. On the other hand, the building was clearly of interest to French architects: Villard de Honnecourt, passing through the area, studied the rose window in the south transept and made a free copy of it. Above all, Lausanne was to become important later in the French part of Burgundy, since the cathedral, as one of the first Gothic buildings, boasted a two-layered clerestory. Today the painting of the interior, still largely preserved, gives Lausanne Cathedral a special place in the study of Gothic architecture (see page 12).

An important contribution to the spread of Gothic architecture was made by the Cistercians, whose tightly organized and centralized order had its home in Burgundy. In the German Cistercian monasteries there was at first no complete adoption of French Gothic

architecture, but a mixing of regional traditions with modern elements. Thus the church at Maulbronn in Swabia is still entirely Romanesque, but is surrounded by monastic buildings demonstrating increasing Gothic influence: the porch of the church, constructed towards 1220, possesses a vault with ribs that all have round arches. Since the diagonal, blind, and arcade arches are all of different widths, their diameter is also different, and therefore they all begin at different levels.

In the somewhat later refectory (see opposite), with its two aisles, the pointed arch is admittedly already used, which would have made it possible to position all the vault springings at the same height, but the architect sacrificed this possibility in the interests of unity. With their red ribs, some curving outwards and some richly ornamented, the vaults form a contrast to the completely smooth, light brown walls. In the middle of the room the vaults are supported by seven

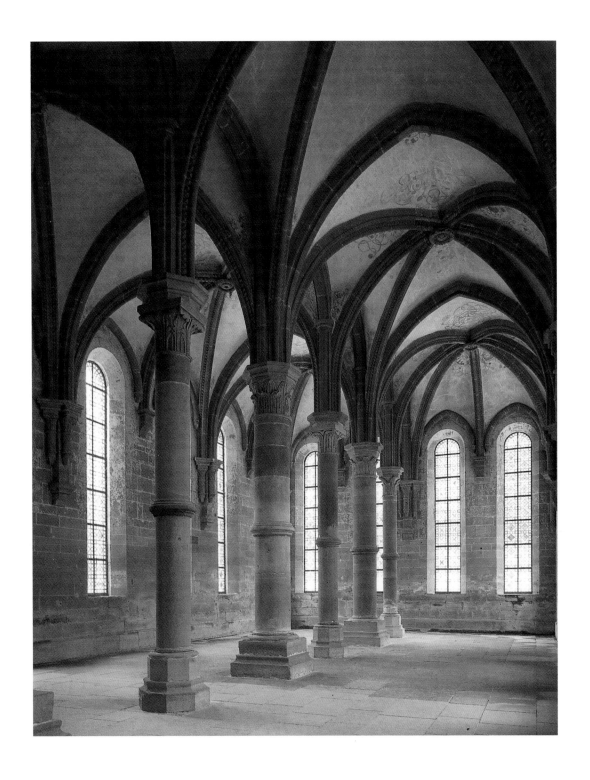

Magdeburg Cathedral
Choir, with re-used antique columns
from the earlier Ottonian building

columns that make up the main, richly varied decoration of the room. According to the number of ribs carried, the columns are either thick or thin; square plinths correspond with octagonal capitals and vice versa, and the square abaci even have further octagonal ones laid on top of them.

The architecture at Maubronn must have been seen to be so advanced for its time in Germany that the workshop there was also engaged in places farther afield. That this should happen at a Cistercian monastery, as in Walkenried in the Harz, is hardly surprising, but that it should have played a part in the new building work at Magdeburg Cathedral requires comment. The rebuilding of the cathedral began in 1209, the old cathedral having been destroyed by fire in 1207. As usual, the rebuilding began with the construction of the ambulatory and its radiating chapels. But in Magdeburg neither their structure nor their forms are really Gothic. It seems that the patron, Archbishop Albrecht II, who had studied in Paris, had an idea of how a Gothic cathedral should look, but could not communicate this precisely to the builders. Moreover, there may have been a lack of skilled architects and builders to realize the project.

Only with a second building phase, when the choir gallery, the so-called bishop's ambulatory, was built did a truly Gothic character appear. It was this part of the cathedral, with its columnar piers and corresponding rib vaults (see below, right), that was built with the participation of the Maulbronn workshop. Astonishingly, however, even in this building phase the wall supports, which had already been started in the inner choir, were broken off so that columns from the old cathedral could be used. These were antique columns that Emperor Otto I, under whom the Magdeburg archbishopric had been founded in 968, had appropriated from Italy to bestow on his cathedral a certain air of nobility. Their renewed use in the Gothic cathedral was a clear reference to the tradition of the archbishopric, its founder, and the first cathedral. However, the old cathedral's historical value was totally rejected by Archbishop Albrecht II, who, against much opposition, had his new cathedral built over the old one but at an angle, so that it was impossible to re-use the original foundations and the walls resting on them.

Magdeburg therefore shows in an exemplary way how complicated the reception of Early Gothic was in the Holy Roman Empire.

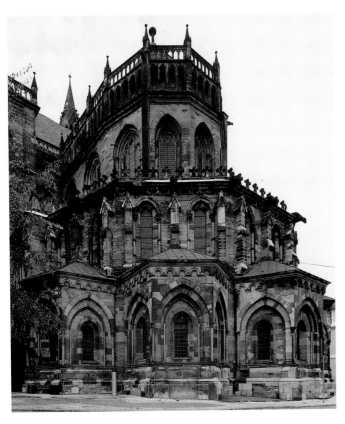

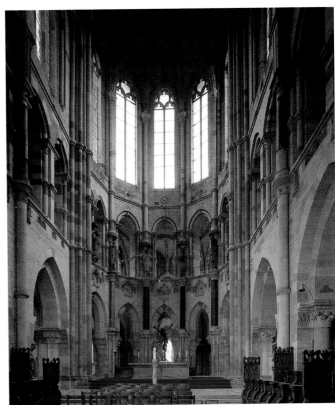

Cologne, former collegiate church of
St. Gereon
Ten-sided tower, 1219–27

For while the initial idea of building a modern, Gothic cathedral could be executed only in stages (which is why only the clerestory of the choir with its tall windows, completed in 1266, reflects French architecture) the new cathedral was once again linked to tradition through the integration of the re-used columns. Such changes in composition are clearly illustrated by Magdeburg Cathedral, which creates an impression of architectural patchwork when compared with the Gothic buildings of France, where an equally radical but nevertheless elegant juxtaposition of old and completely new parts had taken place.

Completely different from Magdeburg is St. Gereon in Cologne, where there is a conscious contrast of old and new (see right). Here a centrally planned building dating from the 4th century had been constantly extended since the second half of the 11th century, with the result that this historic heart had in the end become the lowest and most unsightly part of the whole church. When finally the church was rebuilt in the 1220s, the problem the builders faced was that of how to turn this Early Christian heart of the church into its center without losing it entirely in the rebuilding. The builders solved this problem by leaving the historic circle of niches on the ground floor alone and building a new Gothic structure there whose lower stories match those of the old structure. In this way, by having a French Gothic extension built on top of its older church, St. Gereon became increasingly modern from outside to inside, and from bottom to top.

In the interior, the only really modern (Gothic) element, which goes beyond the formal Romanesque canon that had been the norm until then in Cologne, is the upper story of the central structure. Its high windows and dome of ribs show a similar tracery pattern to that of the cathedral of Soissons. On the outside, even buttresses were added, though they are much too high to take the lateral thrust of the dome. Apart from that, a small gallery that is still quite Romanesque crowns the whole building. Thus St. Gereon is not an entirely Gothic building, but one in which individual Gothic elements were used like set pieces in order to enshrine the old heart of the building.

The Systematic Development of Gothic in the Holy Roman Empire

Churches in which the Gothic style came to be applied systematically which were built after the 1230s stand out against the background of these early examples. It is striking that most of these new buildings were constructed in the archbishopric of Trier, to which belonged the three Lorraine dioceses of Toul, Verdun, and Metz, still at that time situated within the boundaries of the Empire. Since they bordered directly on Champagne, and were predominantly French-speaking, it is not surprising that they were particularly receptive toward the new French architectural ideas. Unfortunately the art and architecture of this whole region have not been widely studied, and the treatment in art history of the Gothic architecture of Lorraine or the Moselle region cannot compare with the detailed studies of, for example, Burgundian Gothic. There are signs that Gothic in this area came

Trier, former cathedral church
of Our Lady, begun in the 1220s
Interior
Ground plan (right)

OPPOSITE:
Trier, former cathedral church of
Our Lady
View from east

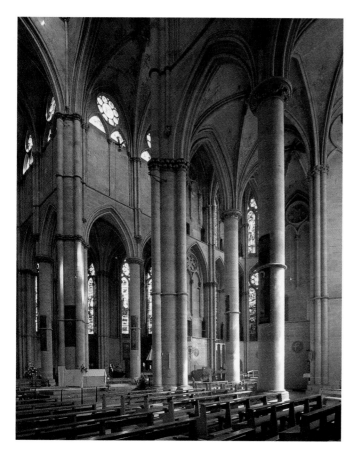

ground story is formed by the arcades that open onto the chapels while the shallower upper story consists mainly of windows glazed just at the top, only those in the chevet and at the ends of the arms of the cross being completely glazed. The impression created is that the interior is divided into two spatial areas. In the lower region there is a very light effect spreading in all directions, while in the upper region, which is open in the shape of a cross, it is much darker. Both areas are linked to each other through the motif of double windows.

Just how precisely the significance of the individual spatial areas is calculated is shown by the shapes of the piers, whose size is reduced from inside to outside. Those of the crossing, above which a further tower rises up, are constructed as *piliers cantonnés*, followed by slender columnar piers between the arcades, while on the exterior walls there are only thin clusters of responds. The sills of the windows are continued as stringcourses around the piers in order to re-emphasize, particularly on the ground floor, the way in which all the spatial areas are united.

Almost all the individual motifs of the Liebfrauenkirche in Trier can be traced to French models. Thus the stringcourse over the piers, the passages in front of the windows, and the tracery patterns are modeled on these features in the cathedral of Reims, although it can be assumed that the cathedral of Toul, begun shortly before, served as a mediator. But the way in which these forms are connected to each other in an almost mathematical way is completely un-French, even if we cannot overlook the fact that it was the rational formal vocabulary of French Gothic that made the systematic architecture of Trier possible. Finally, it is clear that the Liebfrauenkirche is, as it were, pinned in between two quite traditional poles: the ground plan was determined by the earlier building and so the church ended up with a crossing tower completely devoid of Gothic forms. To compensate for that, the church makes a tactful gesture toward the forms of the neighboring cathedral, which is superior in status. Therefore both churches seem not to be in competition, but to complement each other, though admittedly the older cathedral marked out the framework for the development of the Gothic architecture of the Liebfrauenkirche.

Stylistically very closely related to Trier, even if not situated in that diocese, is the church of St. Elisabeth in Marburg, which was constructed from 1235 above the grave of St. Elisabeth of Thuringia, who had died in 1231 and had just been canonized. Elisabeth was in two respects a "modern" saint. First, she had devoted herself to poverty and to the care of the poor and sick. Second, as a princess serving the poor, she had set an example of deep piety by breaking deeply entrenched social barriers. The fact that she was a woman meant that she was perhaps better placed to express her piety in this way. It also meant that, since her cult combined elements both of the courtly love tradition and of popular Marian devotion, she quickly became extremely popular.

Both the Teutonic Order, who were the patrons of the church, and Elisabeth's brother-in-law, Count Conrad of Thuringia, had political

first to Toul, which was nearest to France, as well as to Trier, the metropolitan center. It is not possible, however, to see a clear advance of Gothic from west to east. The development of Gothic within the archdiocese has to be seen in terms of a complex web of relationships between the various patrons, and also between the buildings themselves.

The Liebfrauenkirche (Church of Our Lady) in Trier was constructed for the cathedral chapter next to the cathedral, replacing an old central building on the same spot. The new Gothic church takes up the basic form of the older church, with the result that the arms of the cross formed by the nave and transept are of the same length, though the new choir protrudes a little more to the east (see opposite). The ground plan of this choir is based on the five sides of a ten-sided figure, whereas the other arms are based on the five sides of an eight-sided figure, with low diagonal chapels attached to their sides to link the arms together. A tower rises above the crossing. The unusual ground plan, built according to local tradition, demanded an equally unusual elevation, with only two stories (see left). The tall

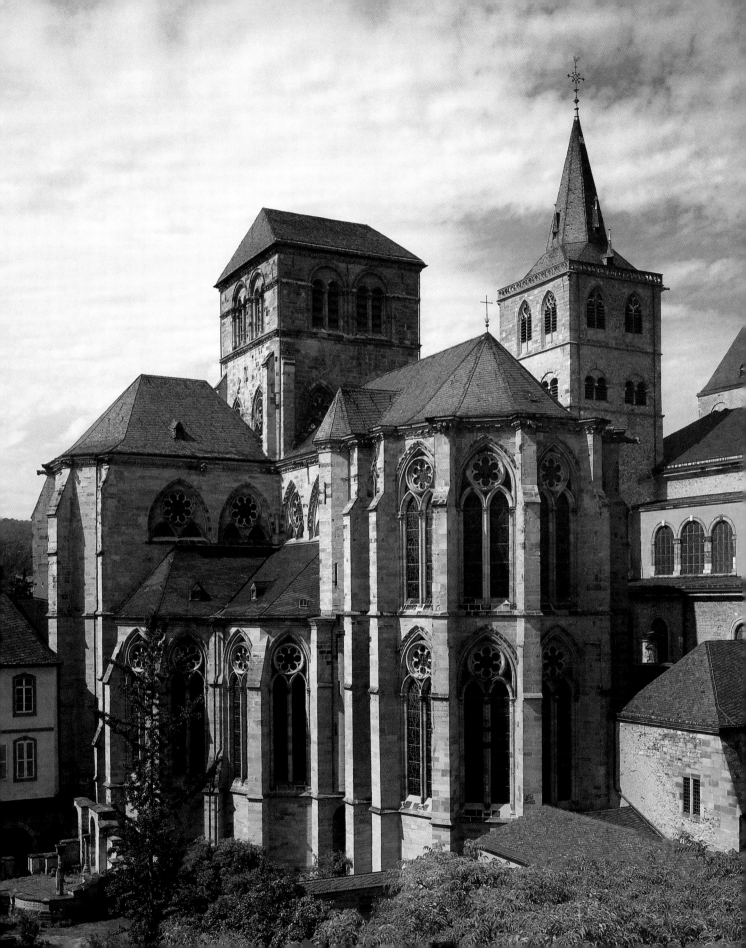

Marburg, former hospital and pilgrimage
church of St. Elisabeth, begun 1235
Ground plan (right)

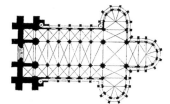

Marburg, former hospital and pilgrimage
church of St. Elisabeth
Interior looking west

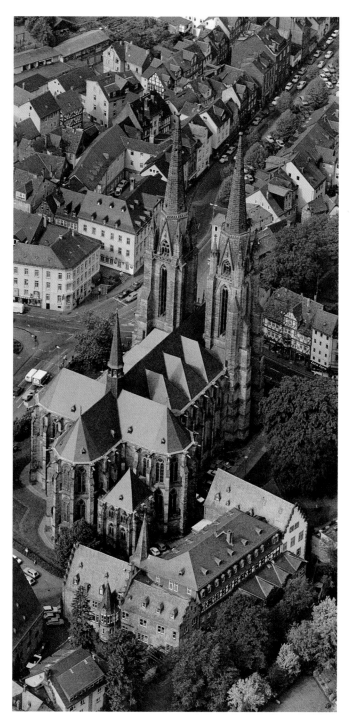

and territorial ambitions. Thus both, exploited her cult for their own purposes and made her their patron saint. The Marburg church was to promote the cult of Elisabeth and give it a center, and in so doing was to satisfy the requirements of all the interested parties.

The building is composed of a nave of the hall church type, which has a twin-tower façade. The ground plan is of the three-conch type (see above), characteristic of Rhineland Romanesque. In the central church, the Teutonic Order was responsible for the service while in the southern conch the counts of Thuringia maintained their family tombs. It was they who assumed responsibility for the protection of the patron saint of their house, as she was entombed in the northern conch. The functions of such buildings with three conches had never before been so precisely defined as they were at Marburg. For whereas in the older architecture there were magnificent unified spatial areas spreading out to the sides, in Marburg three choirs of similar type were actually added onto each other. This possibility of spatial disposition was precisely what the older three-conch type of building did not offer because the eastern apse, which was only an

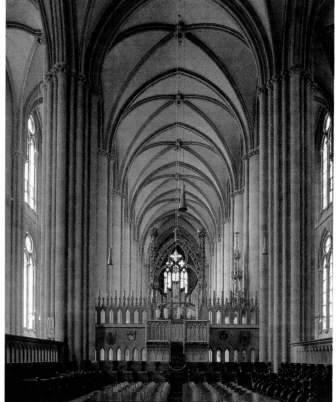

annex of the central crossing, was too small. In Marburg, this older building pattern was combined with the form of the new Gothic long choir, for which Trier was the model.

The three-part choir in Marburg set the standard for the rest of the building. But since the wall of this east end, with its two rows of windows, could be transferred to the nave only if continuous exterior walls were present there too, the main body of the building was constructed as a hall church (see opposite, right). In this type of building the nave and side aisles are the same height, so that the exterior walls can be at the same height as those of the choir. A basilica form, in which the outer walls of the side aisles are lower that those of the nave, could not be used. It was not necessary to invent this form for the Marburg nave since the design of the hall church had long been in use. It was here adapted to the form of the Gothic choir through the use of a sequence of narrow bays. Thus the closely aligned piers concealed the side aisles completely and nothing remained of the spaciousness of the older Westphalian halls.

It seems that at Marburg, Gothic architecture served the same purpose it did at Trier, namely that of adapting a traditional building type to contemporary needs in a modern way. In doing so, the builders were not able to make a complete break with tradition. They tried, rather, to utilize tradition. An example of this is the way in which, at the time the church was built, a golden shrine for St. Elisabeth was created, adopting once again the basic type of the older Marian shrine in Aachen, but slightly modernized. What distinguishes this phase of French-inspired Gothic architecture in Germany is the fact that Gothic was made to new and different ends, and was not used solely to build larger, more beautiful, and "better" churches than before.

It was only in the 1240s that the new cathedral in Metz, southwest of Trier, was begun (see right). One of the major problems in the Cathedral of St. Etienne was the fact that space was limited at both ends. The choir and the transept in the east could therefore be constructed only much later, between 1486 and 1530. For the planned lengthening of the church towards the west, the highly original solution was found of incorporating into the new building the seminary church of Notre-Dame-la-Ronde. The unusual position of the towers, in the middle of the nave, still reveals today where the cathedral originally ended. The building was probably intended to be a little lower, as the low arcades indicate, but after a change of plan it was then adapted to the most modern French architecture. In this way it received not only an unusually tall, light-filled triforium, but also gigantic clerestory windows. All the same, these parts of the cathedral do not give the impression of being out of proportion, because they are delicately formed and covered by sharply pointed vaults. The cathedral of Metz marks a turning point in the Gothic architecture of the Holy Roman Empire because there is no originality in the way it was remodeled. The builders were happy just to bring it into line with French models.

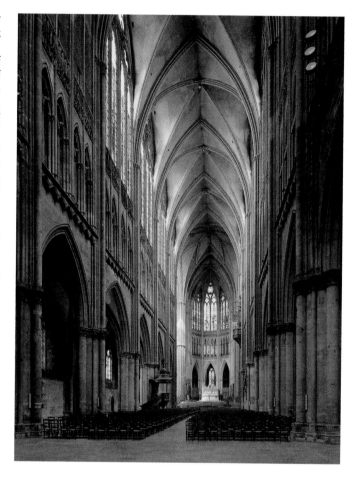

In the Benedictine abbey church of St.-Vincent in Metz, begun in 1248, the regional variant of Gothic in Lorraine can be seen more clearly, as this building was not subject to any change of plan aimed at bringing it into line with French models. Thus it copies the two-storied elevation of the cathedral of Toul, as well as its apse, which is glazed with a continuous row of large windows. Though its walls are not quite so filigreed as the upper wall areas of the cathedral of Metz, the building is an important example of how adaptation to the French models at first proceeded cautiously until, in the same town, with the change of plan for the cathedral, a decisive step was taken towards a structurally more daring style. In a sense the town of Metz was therefore a testing ground for Early Gothic architecture in the Holy Roman Empire, preparing the way for a far more complex reception of Gothic than had occurred at Marburg or Trier.

Another important center was Strasbourg. Here around 1240, immediately after the completion of the cathedral choir and transept

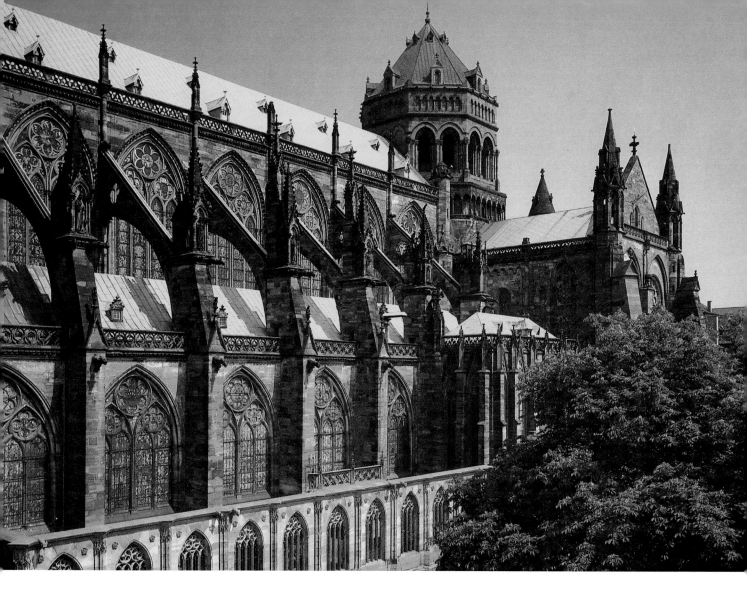

in the Late Romanesque style, a new Gothic nave was begun (see above and opposite, left). This demonstrates a perfect control of the latest French forms. Even if at first sight the stylistic break between the various parts of the building seems complete, the transition was quite subtle. The most recent parts of the transept already demonstrate the same profiles as the new nave, which leads to the conclusion that the same architect was working in both parts of the cathedral. Moreover, the nave also takes the older parts of the church into consideration: it continues to use the foundations of the earlier 11th-century building, the reason it is unusually wide. Its height had to acknowledge the existing crossing, whose dimensions could not be exceeded, at least on the outside. Thus the nave has unusual proportions for a Gothic cathedral: the width of the nave at Reims is 30 meters (98 feet) and at Strasbourg 36 meters (118 feet) while the height of the nave at Reims is 38 meters (125 feet), at Strasbourg 32 meters (105 feet). Nevertheless the Strasbourg architect constructed the most modern building of its time in Germany, its forms largely based on the new building work at St.-Denis which had begun a few years before. From there the cathedral borrows features such as

the pier with the continuous shaft, the glazed triforium, the window tracery, and, in the side aisles, walls with niches and blind wall arcading. These motifs were not, however, copied exactly from St.-Denis. They were also partially influenced by the style of even more modern buildings, such as the cathedral of Châlons-sur-Marne. Details such as the unusually high number of shafts (16) surrounding the piers, however, are completely new.

Thus the architecture of the Strasbourg nave not only adopts French Gothic seamlessly, it even goes a step beyond it. But unlike at Trier or at Marburg, Gothic architecture here is not modified by being blended with traditional regional elements. Rather, its development continues in line with the most up-to-date tendencies of architecture in France itself.

This is also true of the façade of Strasbourg cathedral (see page 201), which was begun shortly after the completion of the nave in 1275. Here the famous wall grilles of the flamboyant building of St.-Urbain in Troyes are taken to extremes through "tracery harps," so that in the portals, for example, three layers are staggered one behind the other: at the front the decorated gable, behind it a screen

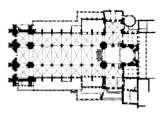

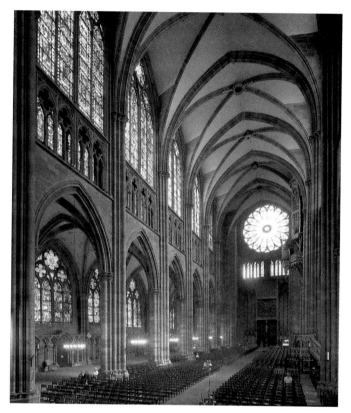

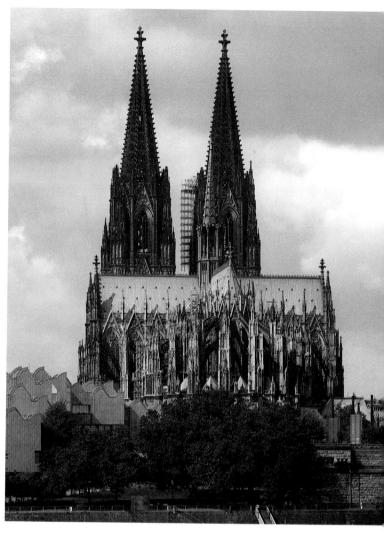

of tracery, and only then the actual wall. Even the gigantic rose window in the middle of the façade stands out from the background by virtue of the fact that the spandrels are free-standing circles of tracery in front of the rose.

With this façade a change in trends in the Gothic architecture of Strasbourg becomes apparent. If the nave is still geared toward French buildings of a classic, measured style, then in the façade there is a marked shift toward something new and quite extraordinary. In its dimensions, too, this façade far outdoes the earlier parts of Strasbourg Cathedral, with the result that from outside it seems to form the focal point of the whole cathedral. It is no coincidence that it was begun at a time when Strasbourg was prospering economically and its citizens had won the freedom of the city from the bishop (the city council had taken over supervision of the building of the cathedral). Contemporary chronicles were already praising the building as a sign of a new Golden Age. What part Erwin von Steinbach, first named in documents in 1284, had in the planning of this façade, is still in dispute. There is no doubt, however, that the façade has to be regarded as the highly original work of an outstanding artistic personality.

What Strasbourg was for the Upper Rhine, Cologne was for the Lower Rhine, for it was there in 1248 that the foundation stone was laid for a new cathedral. There had been plans for it already under Archbishop Engelbert (1216–25) since in contrast to the cathedrals of the archbishops in Mainz and Trier—and even in contrast to some lower-ranking episcopal churches—the existing cathedral, dating from the Carolingian and Ottonian eras, had become hopelessly small and old-fashioned. The ambitions entertained by the people of Cologne can be judged by the scale and lavishness of a Late Romanesque shrine for the relics of the Magi, politically important within the Empire. It is not only the largest of all the shrines, it was also their culmination. Similarly, the new cathedral was also to be the culmination of everything that had gone before.

The attempt has constantly been made to link the adoption of the French Gothic style for Cologne Cathedral with the political orientation of the archbishop of the time, Konrad von Hochstaden. In doing so, too little attention is paid to the fact that in order to express his position, and that of the Cologne seminary, the powerful archbishop had to choose the most exacting models for his cathedral. His

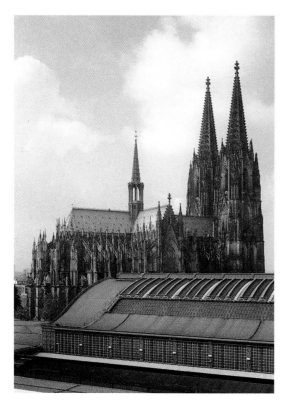

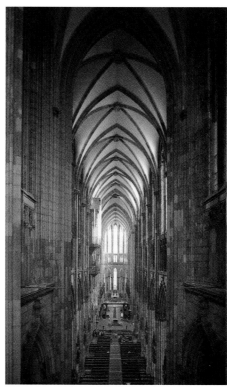

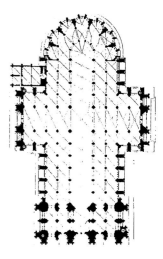

cathedral had to be in the French Gothic style: a gigantic building in the Late Romanesque style would certainly have excited some attention in the town and its surroundings, but hardly in the Empire, and certainly not outside it.

At the same time, however, it becomes clear that in Cologne no extravagant building in the style of Strasbourg's west façade could be allowed. It had to be a classic cathedral (see above and opposite). The French king had also rejected an all-too-individual and modernistic style when building the Ste.-Chapelle, consecrated in 1248, so it is not surprising that it was precisely the style of the Ste.-Chapelle (that of the cathedral of Amiens, which had been the model for Ste.-Chapelle) that was adopted in Cologne.

In Cologne, therefore, the architects built a cathedral modeled essentially on Amiens. Where in Amiens there was still some formal uncertainty, a classic solution was chosen for Cologne. Instead of the *piliers cantonnés*, in which a break between upper and lower story was unavoidable, the patrons chose a clustered pier of the St.-Denis kind, but not on a cruciform ground plan. They had to be on a round plan, for which the piers between the side aisles of the choir in Amiens served as a model. Since in this shape of pier a much better relation between the responds and the ribs could be achieved, the large continuous capitals of Amiens could be dispensed with, so that there is only a single capital between respond and rib. The light triforium of the Amiens choir was also adopted, but its somewhat weak gable motif was replaced by a much more elegant triforium inspired by Beauvais, blended with openwork spandrels in the manner of the transept façades of Notre-Dame in Paris. Thus at Cologne the clerestory reaches the same height as the arcade (just as at Soissons, Chartres, and Reims) and is no longer as low as the one

in Amiens, and the nave is somewhat higher than that at Soissons, Chartres, and Reims. Moreover, Cologne Cathedral has double side aisles, like the choir, so that each of the towers sits squarely on four side-aisle bays instead of being in effect only a false front, as at Amiens. This meant that a monumental west façade could be built, the plan of which, however, was only ready and fully worked out towards 1300.

When the choir of Cologne cathedral was consecrated in the year 1322, the first part of the building of the cathedral had been completed. Such a development would not have taken place in France: in the very active world of French building, drawing a line under earlier developments and creating the "perfect" cathedral would have been unthinkable. The artistic aim in Cologne, by contrast, was to achieve perfect architecture, free from any hint of creation by a particular individual.

For that reason the first cathedral architects, the masters Gerhard, Arnold, and Johannes, were not the stuff of legends, like their Strasbourg colleague Erwin von Steinbach, whose style clearly reveals highly individualistic tendencies. The personal signature of the architect was to become important again only some decades later, and not in Cologne's attempt to build the ideal Gothic cathedral.

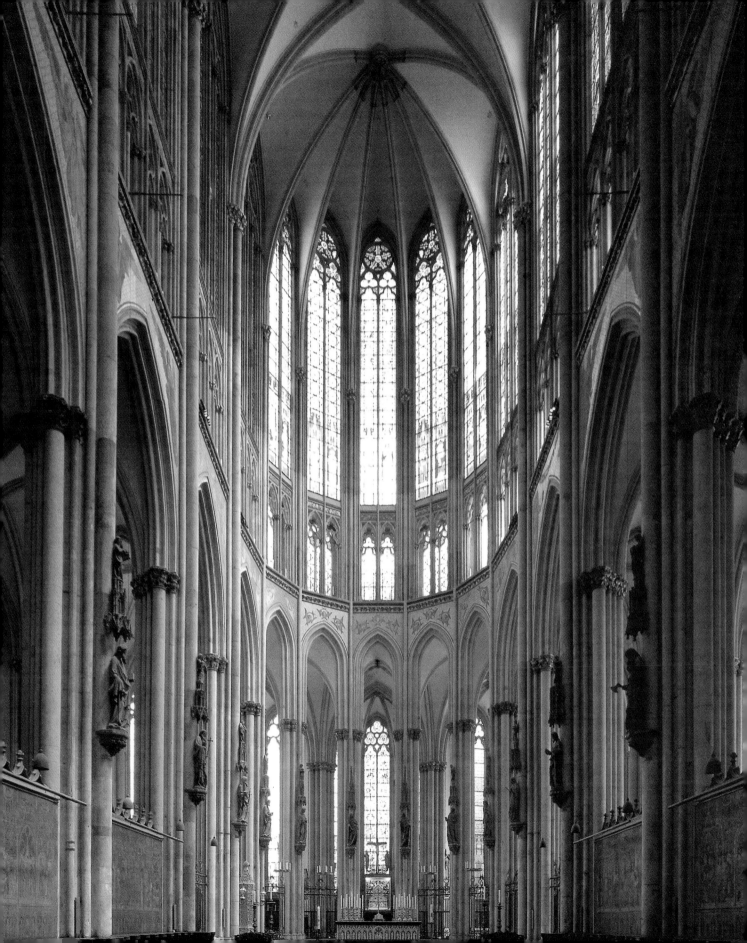

Barbara Borngässer
The Cathar Heresy in Southern France

Montségur, Peyrepertuse, Quéribus, Puivert... the Cathar castles of southern France cling to the gray-brown rock like eagle's nests. The relics of an age deeply shaken by the religious crises that afflicted the south of France during the 12th and 13th centuries, they are symbols of the sufferings of a religious sect ground down by the millstone of European history. A story that began with a simple desire for reform ended with the brutal and systematic eradication of "heretics." Thousands of people died, many of them burnt at the stake, and whole towns, such as Béziers in 1209, were burnt and plundered, Cathars and non-Cathars alike dying at the hands of the French soldiers. Crusaders and the infamous Inquisition, initiated by the pope and the French kings in rare unanimity, left behind them scorched earth and drove clergy as well as laity into flight, hiding, and exile.

Even today the historical categorization of the Cathars is difficult—utopian thinkers, church reformers, heretics? The range of labels that have been attached to the nonconformists of the south is a broad one. What did the Cathars want? What was it that drove them into a dispute with the Church which had such far-reaching and tragic consequences, which turned reformers into martyrs? Everything had begun with clearly justified criticisms of the Catholic clergy. Similar criticisms were heard in many parts of Europe during the 12th century. But with others (for example the wandering preachers and mendicant orders) this desire for reform became successfully integrated into the Church and utilized for propaganda. With the Cathars, by contrast, it drifted into heresy and thereby, in the eyes of both Church and state, made the Cathars guilty of betraying the Christian faith.

The Cathars' faith involved a radical commitment to the principles revealed in the Gospels, a ban on killing (connected with abstention from meat), total sexual

abstinence, and commandments to work and to fast. Their world-picture was oriented toward dualism: to the idea that the world, deeply flawed as it was, could not be the work of a single creator and therefore included within itself two antagonistic principles. There existed the "good," the realm of the spirit, which had been created by God, and, in fierce opposition, the "bad," which was identified with the physical world and seen as the creation of Satan. A similar philosophical concept was in fact already in existence in late antiquity in the philosophy of gnosticism: human beings are composed of two antagonistic parts, since their souls are divine, but their bodies earthly and corrupt. For the Cathars, the only escape from this dilemma was to vanquish evil by becoming "pure" in mind and body through the strict observance of the precepts of the New Testament.

The name Cathar, derived from the Greek *katharos* ("pure"), indicated the striving for a simple, purer way of life (the term Albigensian arose later in relation to Albi, the main center of the sect). The path of the Cathar believer striving for this inner purity led through baptism (*consolamentum*), to the status of a *parfait*,

Fanjeaux (Aude)
Wheel cross, 13th century

"a perfect one." This spiritually enlightened person, a sort of priest, was to be shown deep respect by the believers, who were to ask him for the *melioramentum*, the blessing, with a triple bow.

These beliefs, which may sound quite harmless to us, contained explosive potential: with the acknowledgment of only one sacrament, baptism—which moreover was newly interpreted—the Cathars struck at the fundamentals of Catholic dogma. But another belief proved even more explosive. Since the earthly sphere belonged to the Devil, the normally effective deterrent of the Church, the threat of eternal damnation, was gravely weakened. In the face of the "daily experience of hell," the concept of the Last Judgment held no fear for the Cathars. Accordingly, they were hardly prepared to perform the usual ritual of indulgences or to pay church taxes. So it was not only the beliefs of the Church that were challenged, but its structure, practices, and institutions. The Church felt it had to act.

Heresy, however, was only one aspect of the bloody conflict that the Cathars unwittingly provoked. What proved disastrous was their link with the rulers of the area who wished to resist the expansion of French power in the south. For a long time questions of faith had not been the main concern: the fertile lands at the foot of the Pyrenees, in Languedoc, and in Aquitaine, had long been a problem for the French crown. The historical and cultural orientation of the peoples of the Languedoc area linked them with the empire of Aragón, which from Barcelona controlled the Mediterranean, rather than with the Île de France far to the north. When the question of the religious nonconformists in the south had first arisen, the French were happy to leave the solution to the pope. However, in 1208 the papal legate, Pierre de

Castelnau, was killed near St.-Gilles. The circumstances in which he died are not clear, but his violent death increased the tension of the situation sharply, and prepared the way for a war that was launched by Pope Innocent III as a crusade against heretics. Into this "holy war" rode the northern French feudal lords, created crusaders for the event, who had been promised forgiveness for their sins (and the possessions of the heretics). As early as 1209, Béziers and Carcassonne were conquered under dubious and brutal circumstances; in 1210 the fortresses of Minerve, Terme, and Puivert fell. In Minerve, it seems, 140 Cathars leapt voluntarily into the flames at the stake.

Under the leadership of Simon de Montfort, the "crusaders" pressed on through the countryside, murdering and

Puivert (Aude), 14th century

Puivert (Aude), 14th century
Corbel figure of a musician

Peyrepertuse (Aude), early 12th–end 13th century

Quéribus (Aude), 11th–13th century
View from the fortress

Quéribus (Aude)
Hall of Pillars, late 13th century

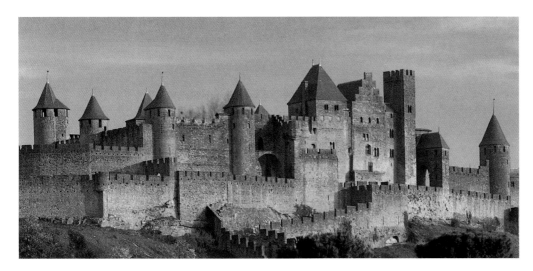

Carcassonne
La Cité, begun in 1228, restored in
the 19th century by Eugène Emmanuel
Viollet-le-Duc

Carcassonne, St.-Nazaire Cathedral
Relief with scenes of a siege,
first half of the 13th century

burning. In 1211 they took Lavaur, fought around Castelnaudry, and laid siege, ineffectively, to Toulouse. In 1213 the first round of the conflict came to an end at the castle of Muret, when Pere II, king of Aragón, was killed in a skirmish and his troops withdrew. French control of the south was assured for the moment. Simon de Montfort died during the renewed battle for Toulouse in 1218, and his son, who had taken over as military leader, was let down by the pragmatism of the crusaders—promised an indulgence for 40 days of military service, they returned home to northern France immediately this time was up, which coincided exactly with the siege of Toulouse!

For a short time at least the Cathars and their political supporters were able to draw breath. They did not have long. In 1223 Louis VIII came to the French throne, a tireless campaigner determined to extend his empire to the Mediterranean. In 1226 he invaded the south again and embarked on a bloody campaign of conquest that ended in 1229 with the capitulation of Count Raymond VII of Toulouse in Meaux.

The political situation in the south of France was thereby clarified and the independence of the region lost once and for all. The conflict with the Cathars, however, smoldered on, with the result that Pope Gregory IX set up an institution that was long to demonstrate the power of the Church: the Inquisition. The Dominicans were given the responsibility of organizing the Inquisition, its sole function being to combat heresy. Their ultimate weapon was the stake, used selectively but nonetheless effectively.

The Cathars had withdrawn to inaccessible fortresses since the Treaty of Meaux. The names of the castles of Fenouillèdes, Puilaurens, Peyrepertuse, and Quéribus stand for the legendary resistance of their occupants to the overwhelming power of the Church rebels whose only weapon was their "purity of

soul." The most striking example of this resistance is provided by the fall, in 1244, of Montségur, the "secure mountain" that had defied the royal army for over a year. Eventually the supposedly impregnable fortress, into which 400 to 500 men, women, and children had withdrawn, fell through treachery. The occupants were given a stark choice: to recant their "errors" or to be burnt at the stake. Two hundred Cathars kept the faith and died in the flames. According to tradition, only four *perfecti* succeeded in fleeing; it is said that they took the legendary

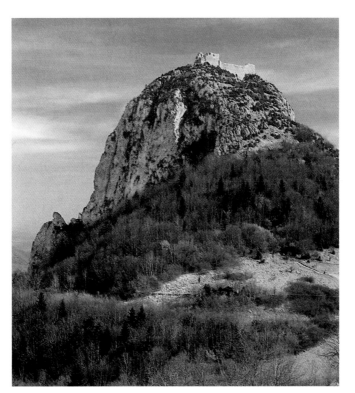

treasure of the Cathars into safety and concealed it in a place still unknown.

Since that time, facts and legends have been constantly intertwined in literature about the Cathars. Woven into the bare historical facts were romantic stories of the heroic struggle for freedom and independence, of ardent anticlericalism and anti-imperialism. The story of the Cathars became one of myth and mystique. In the 1930s scholars of the composer Richard Wagner, together with equally dubious literary critics, even claimed Montségur as the scene of the Parsifal legend

(contrary to all historical evidence, as the epic was composed decades before the fall of the castle).

Historically, however, the question remains of how a small community with radical claims could bring so many people under its spell, and even inspire some of them to the ultimate sacrifice, martyrdom. Disgust with the extravagant and lax lifestyle of the clergy and a desire for strict morality and firm principles are only part of the explanation. The central question was a different one: how could the world, with all its paradoxes and all its evil, be understood as the creation of a good god? For the Cathars, myths about angels and devils, the fall of Satan, and the transmigration of souls provided more convincing explanations of a troubled and problematic existence than did the relatively abstract concept of the sacrificial death of Christ, or the dry dogma of the Catholic Church. Cathar preachers knew exactly how to bring such concerns and spiritual longings vividly to life through imagery. They interwove Bible scenes with folk legends until the former, now unrecognizable, portrayed the battle between Good and Evil in the most compelling stories and images. Cathar preachers were able, in other words, to move deeply and convincingly those who had long since turned their back on an ineffectual established church.

Myths became an integral part of Cathar beliefs and left a deep mark on their everyday life. Perhaps for that reason it is not surprising that the Cathars themselves have become part of a myth.

Montségur (Ariège)
"Le Pog" (The Rock) with the fortress
of 1204

Ute Engel

Gothic Architecture in England

The History of England in the High and Late Middle Ages

England was one of the first countries to adopt the Gothic architecture of France during the second half of the 12th century, a major factor in the new style's reception being the close historical links between the two countries. In 1154 Henry II (1154–89) came to the English throne. He was of the French Plantagenet dynasty and so was able to expand English territory on the continent by adding his native area in the west of France. England had been united with Normandy since the Norman Conquest in 1066. To these territories were added the possessions of Eleanor of Aquitaine in the southwest of France when she divorced the French king in 1152 to marry Henry. As a consequence, England ruled over the whole of the western half of France during the second half of the 12th century (a greater area of France than the French king himself ruled).

But this was soon to change. Henry's son King John (1199–1216) quickly lost Normandy and most of the territories in western France through his clashes with the French crown and the pope. In 1259, under Henry III (1216–72), Poitou was also lost, with the result that England was left only with territories in the south of France; direct links with France were largely lost. In the course of the 13th century, as a result, an independent English national consciousness was born. The English nobles still spoke French, of course, but a variety of their own which during the 14th century gradually merged with Anglo-Saxon (Old English) to form the English language.

Under Edward III (1327–77) conflict with France broke out which led to the Hundred Years' War, fought on and off from 1339 to 1453. In spite of initial success, England finally lost all its French possessions, old and new, with the sole exception of the town of Calais. The power of the English kings was weakened and only with the Tudor king Henry VII (1485–1509) was real political stability restored. His son Henry VIII (1509–47) implemented the Reformation in England, which came to a head with the dissolution of the monasteries. This affected countless cathedrals too, of which half were administered not by canons but by Benedictine monks. The crown took over Church property and founded several abbeys again as additional diocesan seats. The age of the English Renaissance began.

Distinguishing Features of English Architecture: Salisbury Cathedral

The history of medieval England was deeply marked by the centuries-old conflict with France. This rivalry is clearly reflected in the development of Gothic architecture: right from the beginning the English chose to follow an independent path. Conscious of their traditions, as far as possible they preserved their Anglo-Norman building methods, which had developed from 10th- and 11th-century Anglo-Saxon architecture, and also the Norman architecture introduced by the conquest of 1066. During the whole Gothic era it was mainly those features compatible with Anglo-Norman principles that the English adopted from the wealth of French architectural forms. Not even once was the system of French Gothic accepted as a

Salisbury Cathedral
View from northeast, 1220–66
Ground plan (bottom)

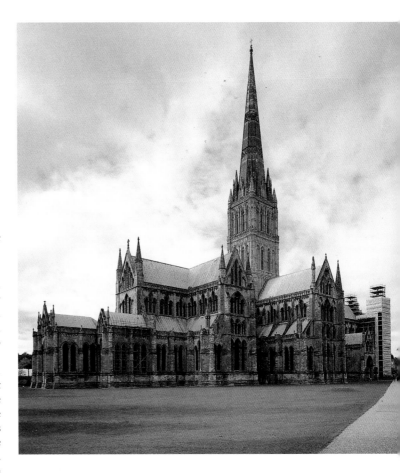

whole, as it was in Germany, for example, in Cologne Cathedral; it was always modified to suit English building traditions. And so there arose in England an independent variant of Gothic architecture whose common features we can look at more closely in Salisbury Cathedral, one of the most significant examples.

Salisbury was begun in 1220, the same year as the cathedral of Amiens, and was also completed shortly after Amiens, in 1266. Yet the differences between them could hardly be greater. Salisbury, unlike Amiens, is not situated in the town center and so surrounded by other buildings, but is on the edge of the town in a spacious cathedral precinct. North of the cathedral there was originally a free-standing clock tower in the style of an Italian campanile. To the south is a cloister surrounded by a high polygonal central building, the chapter house. Such polygonal or round chapter houses are unique to England, the earliest example being built in Worcester around 1110.

The ground plan of Salisbury Cathedral is made up entirely of rectangles. A large extensive transept divides the building in the middle (see right). On the exterior this crossing is marked by a tower. Out of the eastern half a second, smaller transept rises up. Behind that the choir is made up of a number of buildings that become lower as we move eastwards: a high choir, a rectangular ambulatory, and a low eastern chapel. This regular layout fits in with the medieval liturgical divisions of the cathedral. Only the nave was accessible to the laity; to the east of the great crossing, a choir screen (*pulpitum*) separates the choir area reserved for the clergy from the nave. Between the two transepts were the choir stalls for the canons. East of the smaller transept was the sanctuary with the high altar. More altars stood in the eastern side aisles of both transepts. The ambulatory led to the east chapel, the retrochoir, which was dedicated to the Holy Trinity. In addition, this room was used for the adoration of the Virgin, a particularly strong observance in England. Separate Lady Chapels, in which the clergy celebrated a daily Marian mass, were common from the late 12th century. These chapels were mostly built at the east end of the church as a retrochoir, and less frequently on the north side of the choir.

The countless new choirs in English Gothic are almost all rectangular. Polygonal choirs with an ambulatory and radiating chapels, as built in France, are rare. In the second half of the 12th century two types of rectangular choirs developed in England, according to region. In the south and west, the Salisbury version, which has a low ambulatory and protruding retrochoir, is more widespread. In the north and east, on the other hand, the dominant type is a church in which the whole of the choir area ends in a flat end wall, the nave staying at its full height throughout its length. This results in a flat east façade. Within these large unified rectangular spaces the individual areas are divided by barriers.

On the exterior of Salisbury there is none of the open buttressing so impressive in French buildings. The present-day flying buttresses are later additions. The original buttressing in Salisbury is hidden

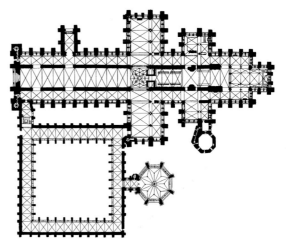

Salisbury Cathedral
View looking east

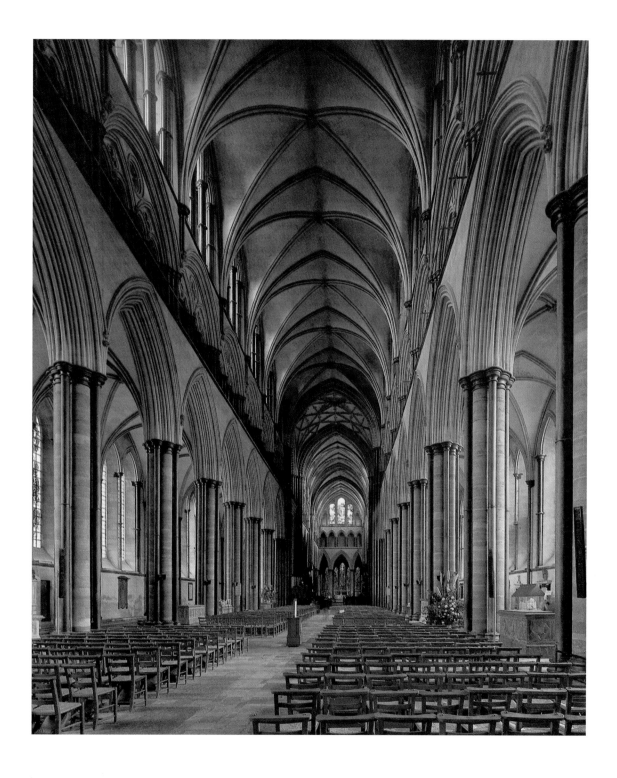

under the roofs of the side aisles, a typical English solution that is linked to Anglo-Norman traditions. There are two reasons for this hidden buttressing. For one thing English Gothic buildings are relatively low. The nave of Salisbury is 25.6 meters (84 feet) high, that of Amiens 43.5 meters (143 feet) high! For another, right until the end, the English kept up the Norman building method of the *mur épais*, the thick wall. That means that they built extremely powerful walls which could be split into several layers and tunneled through with galleries and passages. Both of these features made it possible to construct main nave vaults of stone with low flying buttresses or with no buttressing at all. And so they were completely the opposite of the technically much bolder French Gothic style with its dizzy heights and skeletonized walls.

However, English Gothic cannot in any respect be seen as a more modest version of the French. On the contrary: whatever English architecture may have lacked in height, it made up for in length and artistic decoration. Old St. Paul's Cathedral in London, for instance, attained a length of 179 meters (588 feet). Reims, on the other hand, was only 139 meters (456 feet) long. In addition, English Gothic architecture is much richer and more sophisticated in its love of detail and materials than French Gothic. It seems clear that English patrons were concerned that their architecture should have as many bays as possible, and that it should be as resplendent as possible. Perhaps this situation reflects the general prosperity of the English economy in the Middle Ages, in particular the extraordinary wealth of the medieval Church in England (in the 13th century 12 of the 40 most prosperous bishoprics in Europe were to be found in England). Thus in England Gothic architecture was not seen as a technical challenge, but as a decorative system in which walls, vaults, and glass could all be richly ornamented.

In Salisbury, as in English buildings generally, this love of decoration can be seen particularly well in the interiors (see opposite). If one looks eastwards along the nave in Salisbury Cathedral, then first of all it is the richness of architectural materials that stands out clearly. Light limestone contrasts with the slender *en-délit* shafts, sills, and capitals of a dark, gleaming marble-like substance. This is the so-called Purbeck marble, a sedimentary limestone from the south of England that can be polished like marble. It became increasingly popular in England from the 12th century. If we add the colorful painting of arch profiles and vaults, and fine stained-glass windows, then English buildings must have had a gloriously colorful and costly appearance.

The piers in Salisbury have complex shapes and are surrounded by many *en-délit* shafts. They often change shape from bay to bay and, as a result, demonstrate English inventiveness merely in their fashioning. These piers bear huge arches with stepped profiles of a richness that cannot be found anywhere in France. This great variety of profiles is a result of the English tradition of using the Norman *mur épais*, which in this way is concealed by being reduced to a series of slender, decorative lines. The piers are not connected to the vault responds, which begin only at the middle story. This truncation of the responds, which sit on corbels in the form of small carved heads, is again characteristic of English Gothic. Shafts and vault responds are not linked together as one common structure, as in French Gothic. The piers are conceived as independent units within the architecture, in effect as pieces of sculpture to be seen from all sides. In the middle story at Salisbury the Anglo-Norman preference for galleries lives on. The spandrels of the arches are richly decorated with leaf patterns and rosettes. Even the clerestory above is decorated with a motif typical of English Romanesque, the stepped triple arcade. The wall at this point is in two layers and a passage is squeezed between the inner wall and the outer wall.

Most of the great churches of England were not built at one time and according to a single unified plan. They were often built bit by bit and, true to the old Anglo-Saxon tradition, always retained a part of the earlier building—better to add a few new parts then to tear down a much-respected old building and start again. Thus many of England's Gothic buildings contain fragments from different ages, with bits of very different plans often standing side by side. In the course of the following overview of the development of Gothic architecture in England, we will frequently encounter the co-existence of several buildings within a single structure.

Early English, Decorated, Perpendicular: The Main Periods of English Gothic

English Gothic architecture can be divided into three main periods, which do not correspond exactly to the Early, High, and Late Gothic familiar to those who live in Continental Europe. The terminology of English Gothic was established in 1817 in the book *An Attempt to Discriminate the Architectural Styles of English Architecture* by Thomas Rickman, and has proved valuable even today. Each of the three periods begins with an adoption of a French Gothic feature which is then transformed by being made to conform to local architectural traditions.

Early English describes the first period, from roughly 1170 to 1240. To this early stage belongs the choir of Canterbury Cathedral, which was started by a French architect from Sens and used elements from Sens, St.-Denis, and other buildings of French Gothic. The second period, from roughly 1240 to 1330, is known as the Decorated period. This begins with the restoration of Westminster Abbey, which mostly derives from the cathedral of Reims. Finally, the Perpendicular period marks the last and longest period of English Gothic, roughly 1330 to 1530. Although it has its roots in the French Rayonnant style, Perpendicular was the English style least influenced by French Gothic.

Roche, ruins of the Cisterican abbey church
Transept and choir from the west, 1165–70

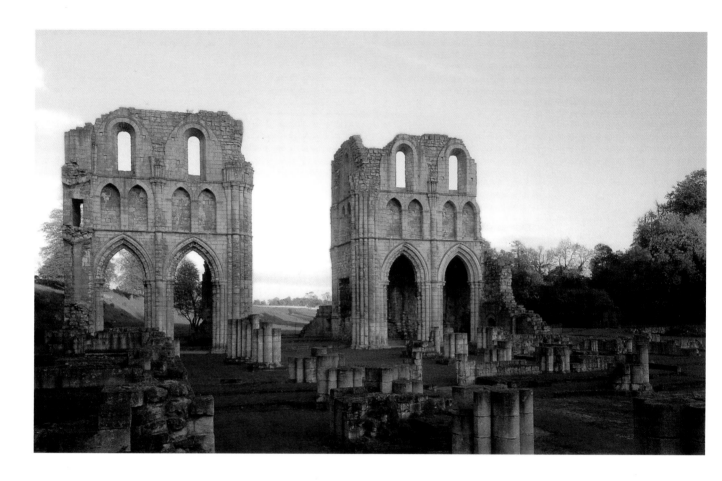

The Beginnings of English Gothic: New Elements Amid Anglo-Norman Tradition

From the middle of the 12th century there was a flourishing artistic exchange between England and France. New elements such as the pointed arch, cross-ribbed vaults over the nave and aisles, and delicate, slender shafts now occasionally appeared in the rich vocabulary of English Late Romanesque. The use of rib vaults was particularly significant. In England they had been developed around 1100, in Durham Cathedral, but had been used mainly in the vaulting of side aisles.

The Cistercians played an important role in the adoption of French ideas, as was the case in other European countries too. Almost all their buildings in England survive only as ruins. The abbey church of Roche (see above), for example, built between 1165 and 1170, closely follows the patterns of northern France, above all that of Picardy. The pointed arch dominates, and the piers are composed of keel-shaped, sharp-edged shafts, some of which climb right up to

the springing of the vault in the clerestory. The building had cross-ribbed vaults throughout. Particularly conspicuous is the tall triforium with its pointed blind arcading.

Of even greater significance in the development of Early English Gothic was the succession of episcopal patrons. Having close contact with the Continent, they were able to initiate the adoption of innovations from France in their ambitious building projects. Most prominent of all was the Archbishop of York, Roger of Pont l'Évêque (1154–81). Soon after taking up office he had the choir of his cathedral rebuilt, but this has been destroyed and is known to us only from excavations. A smaller version has survived in the cathedral of Ripon (see opposite, top), constructed according to Roger's plans and dating from between 1160 and 1175. In the choir, early French Gothic buildings like Noyon or Laon are copied in an amazingly faithful way. Clustered piers with slim proportions carry a sharply pointed arcade and a nave wall unusually thin for England. The responds begin on their own corbels directly above the piers, and

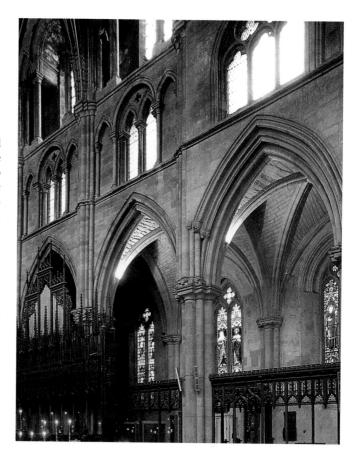

Ripon Cathedral (former collegiate church)
West bays of choir, looking northwest, ca. 1160–75

BOTTOM:
Worcester Cathedral,
Nave, west bays, looking northwest, after 1175

with their five shafts refer completely naturally to the cross-ribbed vault, planned from the beginning but built only later, in wood. The triforium, glazed at a later date, is also constructed according to French tradition. Twin lancet windows with a shared mullion are flanked by two blind windows with pointed arches. This motif was soon afterwards adopted in other buildings in the north of England, including Byland Abbey and Tynemouth Priory. In the clerestory, Ripon, with its triple arcades and passage, returns to the Anglo-Norman tradition.

The south of England was destined for an exchange of ideas with France across the Channel. The influences of French Early Gothic can be seen particularly well in the buildings of Henry of Blois (1129–71), Bishop of Winchester; a good example is the St. Cross Hospital in Winchester. In the west of England, on the other hand, an original variety of Early Gothic architecture developed. It appears for the first time in the two west bays of the nave at Worcester Cathedral (see right, bottom), but is admittedly still heavily mixed with Romanesque traditions because this was a repair to an older part of the building after a tower collapsed in 1175. And so in Worcester we can still see a particularly massive *mur épais*, a high gallery whose rear wall is an integral part (as in a triforium), and the already familiar clerestory with passage. Yet the new elements are unmistakable: pointed arches alongside round arches, vertical clusters of responds which protrude from the piers and which support the ribbed vault (renewed later), and, above all, the break-down of the piers, arcades, and supports into many slender shafts and profiles. The middle story, with its several layers of wall staggered behind each other and its sculptured rosettes, is particularly lavish.

The Impact of Canterbury Cathedral on English Gothic

During the 1170s Canterbury was a name on everyone's lips. Archbishop Thomas à Becket (1118–70) was murdered in the middle of his cathedral by King Henry II's men in 1170. A pilgrimage to his grave was quickly established and as early as 1173 Becket was canonized by the pope. Only one year later, in 1174, Canterbury Cathedral burnt down (some people believed that this was no coincidence). The rebuilding of the choir led to one of the most sensational building projects England had seen for a long time. Although the monks of the cathedral monastery, in typical English fashion, at first wanted to retain as much of the burnt-out shell as possible, they were receptive toward new ideas and held an architectural competition. A Frenchman came out the winner: William of Sens. Gervase, one of the Canterbury monks, wrote an account of the building work right up to the completion of the choir in 1184, and his account constitutes one of the most important sources of information about the construction of medieval buildings.

The French architect managed to set the new building in the old perimeter walls and to lengthen the choir eastwards (see page 125).

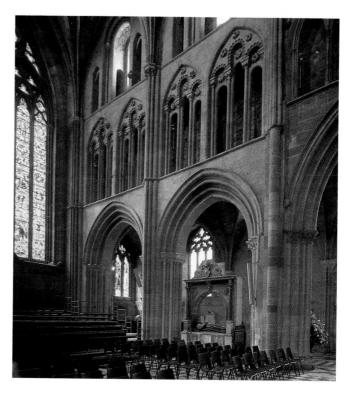

Canterbury Cathedral, Trinity Chapel
Stained-glass window with scenes from
the life of St. Thomas à Becket

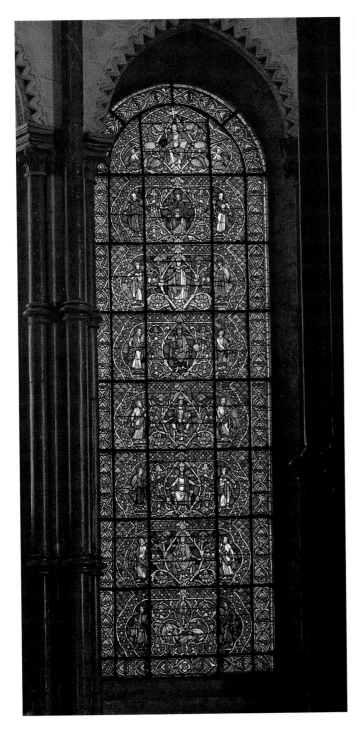

In so doing, there arose in Canterbury the first of the many Gothic choir extensions in England. Yet in other respects the monks were uncompromising. The Romanesque crypt had to be retained and this predetermined the distance between the piers in the choir above. Their shape was to alternate, as in the earlier building, between round and square. The height of the nave could not exceed the height of the old nave, and there also had to be the traditional clerestory passage. Under these conditions William of Sens created, as best he could, a French cathedral in the style he knew from his own country.

In the first part to be built, the monks' choir in the west, he made the piers as thin and tall as possible in order to create slender, soaring proportions. He designed the double arcades of the gallery in the pattern of Sens, even if everything turned out to be much more crowded because of the narrow spaces between the piers. In addition he changed a large number of the *en-délit* shafts, which he had carved out of the dark marble in fashion in northeast France. A fourth story, a French-style triforium, was not possible because of the low height. William constructed the vault in the French style as a sexpartite ribbed vault, but supported it with only quite flat flying buttresses. In the eastern transept and the sanctuary he began to experiment even further, above all with more Purbeck marble shafts around the piers. Their magnificent gleam had obviously fired his clients with enthusiasm. But then disaster struck. In 1178 William fell from the scaffolding and had to return to France. Another master mason of the same name, an Englishman this time, completed the project.

The most unusual parts of Canterbury were built under the English William: the Trinity Chapel, which spreads out beyond the altar into a semicircular apse with an ambulatory and ends with the Corona, which in turn is an almost circular axial chapel. Both parts were to serve the cult of St. Thomas à Becket. His shrine was placed in the Trinity Chapel, raised up high above the whole church; the relic of his head was in the Corona. The splendor of the new building is concentrated in these parts: the double columns in various colors of marble and the enormous stained-glass windows which tell of the saint's miracles in color (see left). The architecture displays even more innovations: the gallery is altered into a true French triforium and on the external walls long slender shafts break away from the wall to create a skeletal effect.

Although the new choir of Canterbury was built under special circumstances, it was nevertheless extremely influential and determined the development of English architecture for at least the next 75 years. One reason for its power of attraction was certainly the flourishing cult of relics. The veneration of St. Thomas à Becket triggered a flood of pilgrimages to the relics of the English saint. All the larger churches tried to promote their own saint and to display their relics as effectively as Canterbury did St. Thomas à Becket's. This led to the large number of new choirs which were inspired by the new style of building in Canterbury, choirs which mark the first phase of English Gothic.

Canterbury Cathedral
Choir looking east, 1174–84

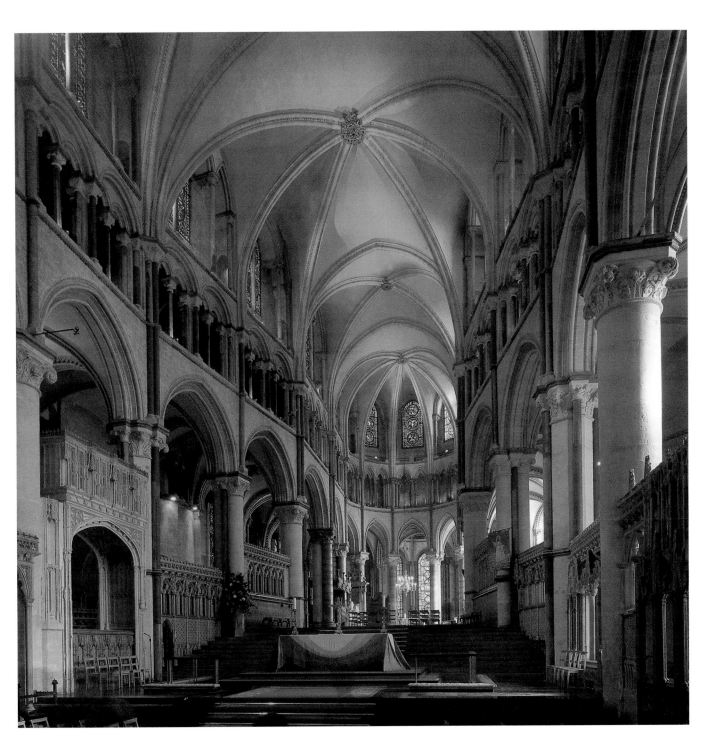

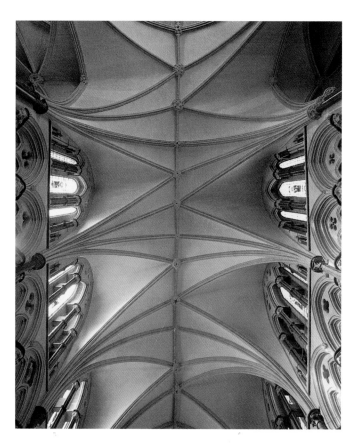

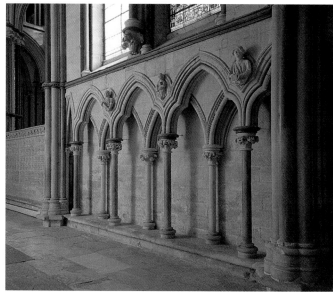

Lincoln Cathedral, St. Hugh's Choir
Main nave vault with the "crazy vaults"
by Geoffrey of Noiers, 1192–ca.1210

Lincoln Cathedral, St. Hugh's Choir
Southern side aisle with the syncopated
double-layered blind arcading by
Geoffrey of Noiers

Early English Gothic: Three Different Styles

Lincoln and the North

One of the first large buildings to follow Canterbury was the cathedral of Lincoln, rebuilt from 1192 after an earthquake. Like Canterbury it had two transepts, an ambulatory with (originally) a separate axial chapel, a three-story elevation, and (originally) a sexpartite rib vault. But each of these elements was now upgraded. It appears that the master mason of Lincoln wanted to use every architectural form possible and to avoid repeating himself. So Lincoln Cathedral became a testing ground which enriched the capabilities of English Gothic in an undreamed-of way. Architects would draw on its repertoire of forms for generations to come.

Especially unusual is the first section to be built, the choir, which was named after its patron, Bishop Hugh of Avalon. It was constructed until about 1210 by a master builder named Geoffrey (his place of origin, Noiers, leaves it unclear whether he was English or French). In comparison with Canterbury, the whole of the new building, both inside and out, is rich and varied and served up such surprises as shafts whose capitals are decorated with crockets. Two inventions in the Lincoln choir turned out to be particularly momentous and made it justly famous: the syncopated double-layered blind arcading in the side aisles (see above, right), and the so-called "crazy vaults" of the high choir (see above, left). In the choir Geoffrey increased the sexpartite vault of Canterbury to eight parts per bay. He subdivided it, but not symmetrically: the ribs lying diagonally opposite are split and meet east and west of the middle of the bay. The result is that an elongated lozenge stretches diagonally from one corner of the bay to the other. Two other ribs from opposite sides of the bay spring up to meet each of these points of intersection and so form a curving Y-shape. A rib runs along the entire length of the ridge to bind the vault together longitudinally. This complex construction is the first large-sized, richly decorated rib vault of Gothic architecture and clearly demonstrates the pioneering spirit of its designer. A contemporary chronicler compared it to the wings of a bird.

In the nave of Lincoln Cathedral another no less talented architect summed up the experiments of his predecessor (see opposite). The Purbeck marble shafts of the piers in the generously proportioned space are different between one pair and the next. The decoration of the building is of the highest quality. Capitals and consoles are decorated with English stiff-leaf decoration, in which the buds intertwine and the flowers and leaves appear as if blown by the wind. The vault provides the high point once again. A prominent longitudinal ridge leads the eye eastwards. From each vault-springing seven ribs rise up like a fan, each one meeting its counterpart at the ridge rib. The "crazy" ideas of St. Hugh's choir are systematized and increased in intensity. The transverse and diagonal ribs are given additional ribs known as triple ribs, or tiercerons. The innermost ones meet at the short transverse ridge ribs and create a star-shaped outline. Probably completed before 1237–39, this is Europe's first recorded star vault, even though when the ceiling is looked at as a whole the star pattern is not very pronounced. By contrast, the borders of the bays seem to melt away and the ribs come together from the side walls to form a large, bold pattern.

Lincoln Cathedral
Nave looking east, ca. 1220–40
Ground plan (below)

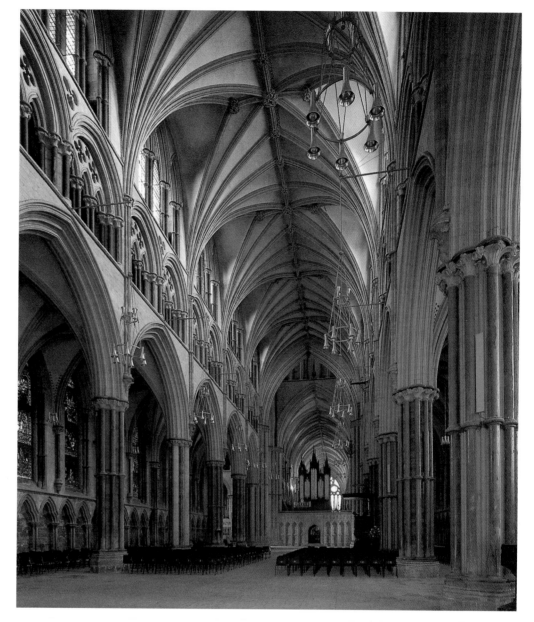

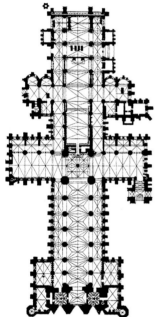

The direct inheritors of the innovative ideas in Lincoln are found in the north of England, where from around 1200 there was a building boom which included cathedrals, collegiate churches, and monastery churches in equal numbers. There was real competition in the rebuilding of choirs. Northern English Gothic used the colorful *en-délit* shafts only sparingly since Purbeck marble from the south coast of England was hard to come by. The supports were mostly designed as clustered piers. Patrons often did without stone vaults, being content with wooden ceilings. A particularly important theme in the buildings of the north were the fronts at the east end of the choirs and on the transepts. Since the nave walls were continued at full height right up to the east walls, in the north of England there arose a series of impressive soaring flat east fronts. Several rows of

long lancet windows were placed above one another as, for example, at the Benedictine abbey in Whitby (see page 129). The lower lancets match the height of the arcade arches of the nave, the middle ones the gallery and clerestory; the upper row decorates the gable. The greatest of these northern English showpiece fronts is the northern transept of York Minster, which was built around 1234–51. Above the wall arcading, five particularly tall and slender lancet windows rise up, taking up almost the whole height of the end wall; these are the famous "Five Sisters" (see page 128).

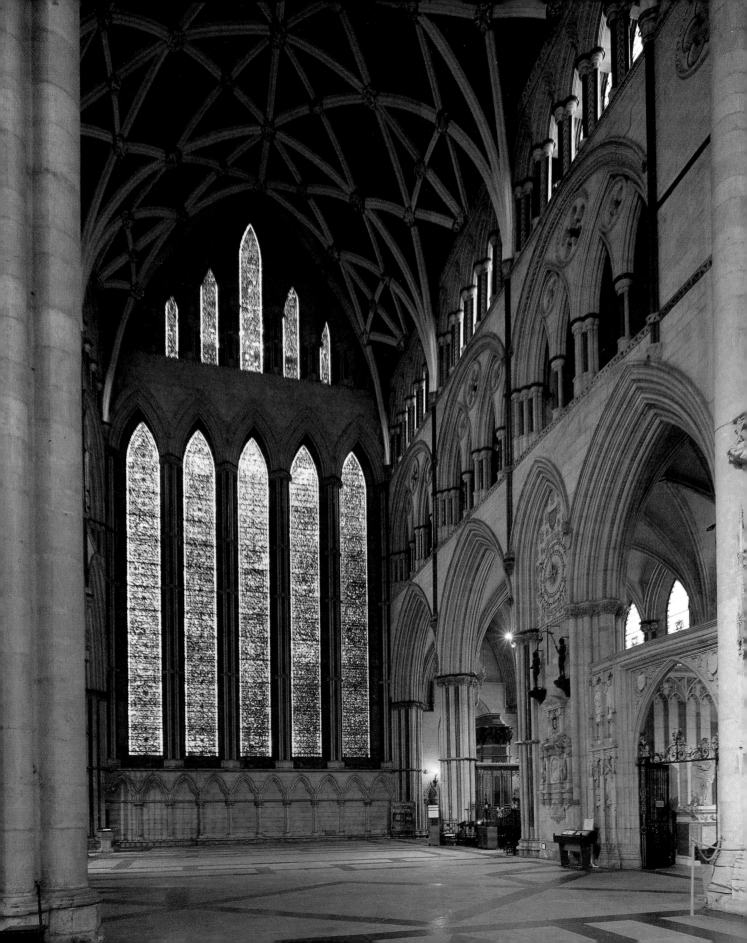

OPPOSITE:
York Minster
North transept looking northeast,
ca. 1234–51
The "Five Sisters" are among the tallest
lancet windows in England. The vault in
York is built of wood. Characteristic of
north of England Gothic is the gallery
consisting of four openings under one large
arch, as in the choir at Whitby (see right).

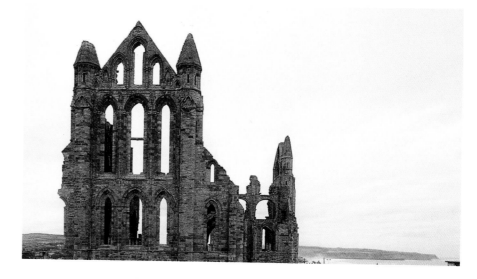

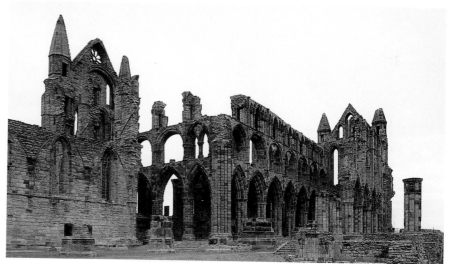

Whitby, ruins of the Benedictine abbey
church
East front (top)
Interior looking northeast (center)
Interior of the choir looking northwest
(bottom)

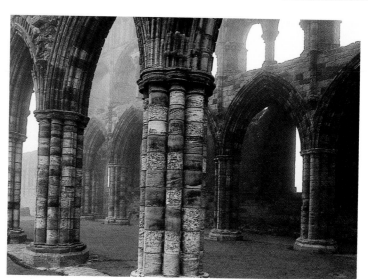

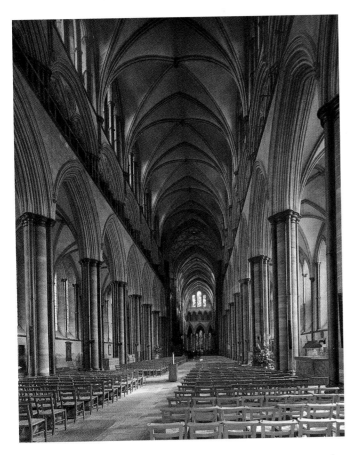

according to their liturgical significance. In the choir the piers have eight shafts and are of different shapes; in the nave, on the other hand, they are uniform and have only four marble shafts. Salisbury's restraint in its formal language can be seen most clearly in the vault: unlike Lincoln, Salisbury has a conventional quadripartite cross-ribbed vault. The original grisaille glazing lent further credence to the balanced character of this architecture. The Trinity Chapel in the east (see opposite) reaches the height of elegance as a bright chamber whose vault is supported by slender marble columns.

During the first half of the 13th century such simplicity became the hallmark of a whole group of buildings in the south of England, including the choirs of the Templar Church in London and the Priory Church in Southwark (London) and the chapels in the bishop's palaces of Canterbury and Lambeth (London). They are characterized by slender piers, large windows, and a preference for open hall-like spaces. The episcopal patrons of these buildings came from an influential circle of clerics around the Archbishop of Canterbury, Stephen Langton, who was an important promoter of church reform. One of these clerics, Richard Poore, became Bishop of Salisbury (1217–28), carrying out a liturgical reform which, on account of its clarity and practicability, was an example for many English churches. The same sense of order also appears to be expressed in the architecture of this group of buildings around Salisbury Cathedral.

Wells and the West

The architecture of the west of England took a completely different path. An individual architectural language had already emerged here around 1175. It can be seen, for example, in the west bays in Worcester Cathedral. Though there is no rich decoration with marble or en-délit shafts in the churches built in this style, they nevertheless stand out because of their finely nuanced designs.

The high point of Gothic architecture in the west of England is Wells Cathedral, which was begun around 1180 (see page 132). Its architecture consists of clear but delicate linear elements set between plain walls. The long rows of uniform piers in the nave are entirely surrounded by thin shafts, in clusters of three, that support the corresponding ribs of the stepped-profile arcade arches. The stories are separated clearly from each other by horizontal stringcourses. The middle story is very much shallower than earlier examples in English Gothic, and with its uniform sequence of closely spaced arches this gallery is clearly based on the French triforium. The unusually high clerestory windows have no accompanying openings. The steeply pointed cross-ribbed vault rests on short responds which hardly interrupt the horizontal layering of the stories. The variety is amazing, both in the wealth of the architectural forms, and also in the richness of the particularly exquisite stiff-leaf capitals, on which all kinds of human and animal figures romp around.

A fire in 1184 made it necessary to rebuild the abbey church of Glastonbury, situated quite close to Wells. In the 12th century Wells,

Salisbury and the South

In the south of England at the end of the 12th and the beginning of the 13th centuries, several important building projects were embarked upon in the wake of Canterbury. They include rebuilding work at the cathedrals of Rochester and Chichester, and the construction of the retrochoir at Winchester (see page 151). The most important building of the Early English style, however, is Salisbury Cathedral, at which we have already looked. Salisbury is the only great building in English Gothic that was constructed according to an overall plan on virgin land. The earlier building had had to share space with a royal castle on a cramped hill-top site. The new building, on the other hand, could be built down in the valley, literally on a greenfield site. Right from the beginning it appears to have been designed as a counter to the lavish and experimental architecture of Lincoln. And so Salisbury Cathedral is characterized by its great regularity and simplicity (see above). The individual parts of the building are only very subtly distinguishable from one another

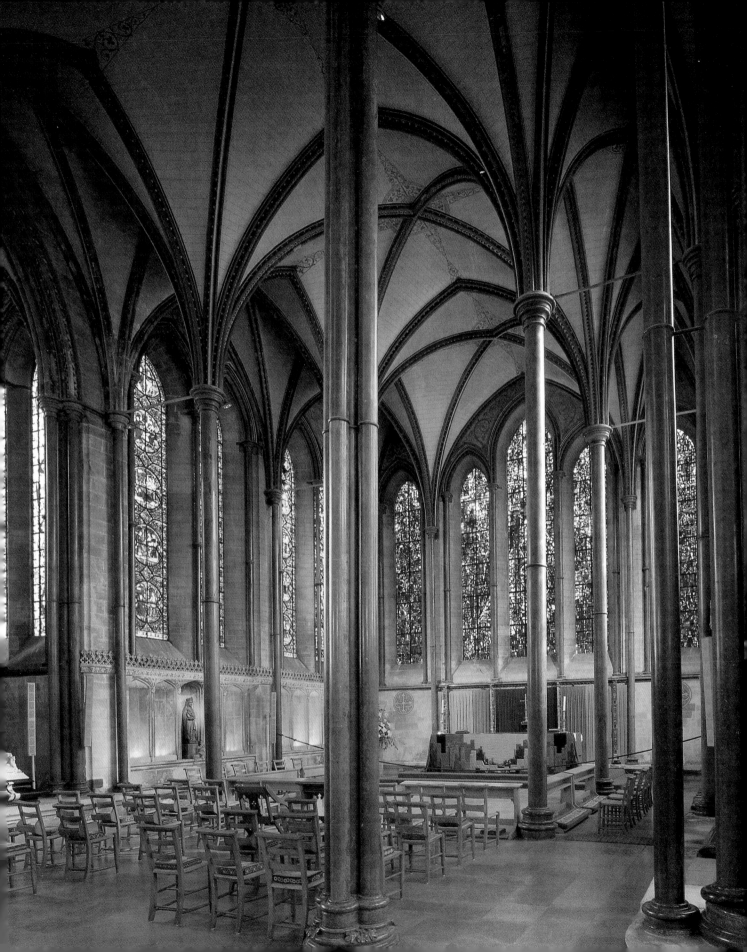

Wells Cathedral
Nave looking east,
ca. 1180–1240
The scissors arches from ca. 1338
support the tower.

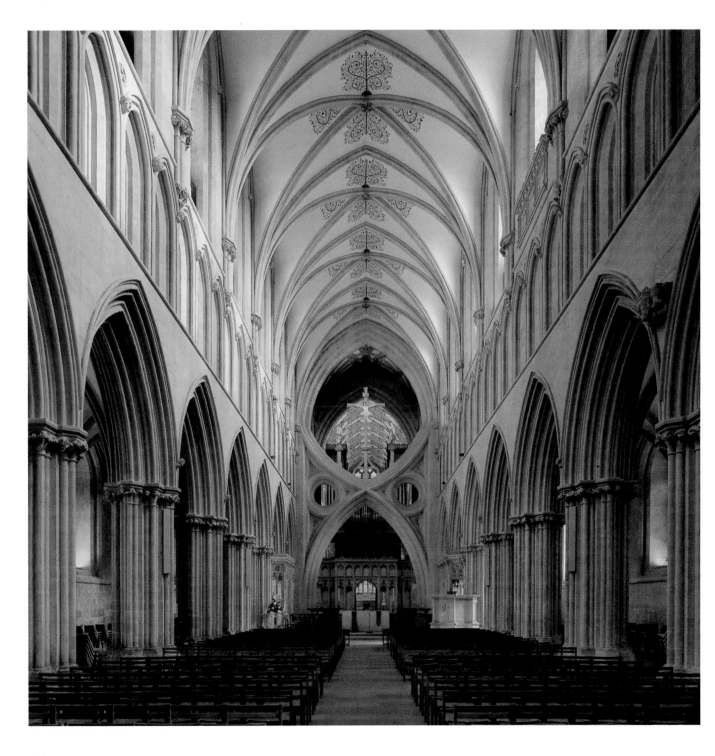

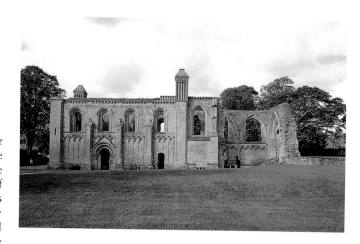

Glastonbury, and Bath were competing with each other for supremacy in the region and to be the seat of a bishopric, a dispute which was settled in the 13th century in favor of Wells. The competition between the canons of Wells and the monks of Glastonbury can be seen in their building projects. While Wells represented a new style of Gothic formal language, Glastonbury represents a careful attempt to modernize the old. The historical background makes it understandable. Glastonbury was one of the oldest and richest abbeys in the country. Its separate Lady Chapel, the *vetusta ecclesia* (old church), was even said to have been founded by Joseph of Arimathea. Now, in the face of competition from the recently founded Wells, the monks wanted to express these venerable traditions in their architecture.

The greatest splendor was reserved for the Lady Chapel, the heart of the abbey and its showpiece (see right, top and center). The small rectangular building is completely surrounded both outside and inside by finialed arches, and decorative motifs such as zigzags and rosettes are everywhere. The whole building was painted and given stained-glass windows. In spite of this love of Late Romanesque decoration and the consistent use of round arches, Gothic innovations were also included, for example *en-délit* shafts made of a bluish marble-like stone (almost all lost today), French-style stiff-leaf capitals, triangular gables above the portals, and cross-ribbed vaults.

Thus Glastonbury, with its attempt at reconciling the old with the new, and Wells, with its distinct modernity, represented two basically different concepts of how an important church building should look. And yet they were built only 10 kilometers (6 miles) apart, at exactly the same time, with building materials from the same quarry, a particularly telling illustration of how medieval patrons and master masons could choose between different formal languages or styles.

It was a different situation again with Worcester Cathedral, where a new choir was built from 1224 (see right, bottom). Worcester had recently been honored. It had long housed the remains of the Anglo-Saxon bishop Wulfstan, who was canonized by the pope in 1203, and in 1216, in accordance with his wishes, King John was buried in the cathedral. There was a desire to build something that would reflect this new status architecturally.

The Gothic style of the west of England was shown off to advantage only on the exterior of the building and in the side aisles. Apart from that, the cathedral revealed the gloriously colorful raiment of the Early English style in finely balanced variations that combine the structural simplicity of Salisbury with the decorative delights of Lincoln. Individual motifs such as the triforium, with its remodeled arches, are clear examples of this. But the structure of the choir as a whole, which has a soaring east wall and monumental groups of lancet windows in the end walls, follows north of England patterns. By choosing stylistic elements from all the regions of the country, the patrons obviously wanted to make it clear that Worcester was a royal burial place.

Peterborough Cathedral (former Benedictine
abbey church)
West façade, ca. 1180–1238

A Unique Feature of Early English: The Screen Façade

English Gothic also went its own way in the construction of west fronts. Only relatively seldom do we see the twin-towered fronts so common in France. In their place English cathedrals and monastery churches were content with a simple straight façade, or else they competed with each other in the construction of lengthy showpiece fronts, the so-called screen façades.

Such a façade is only indirectly connected with the nave opening up behind it. The façade extends across the whole building, and the towers are either set back at the sides, or rise up from just behind the wall of the façade.

West-end portals play no particularly noteworthy role in English architecture. In contrast to French portals, they cower insignificantly in the lower areas of the façade and are not decorated by sculpture. One reason for this is that, since Anglo-Saxon times, the main entrances to English churches lay at the side, mostly on the north, where a lavishly decorated porch marks the portal (probably as a protection against the inclement English weather!).

The most beautiful English screen façade is to be found at Wells (see opposite). At the dedication of the cathedral in 1239 it was still

not complete. The towers stand at the side of the nave and boldly protruding buttresses divide the building vertically. Several rows of blind arcading, one above the other, run across horizontally. Statues are spread over the whole façade: they consist of reliefs on the surfaces of the spandrels, life-size figures of saints on the buttresses, and, enthroned above them all, Christ presiding over the Last Judgment. The whole story of Christian salvation unfolds on this gigantic wall of pictures. In addition, the façade was used in the liturgy at the great religious festival processions. Singers and musicians stood on passages behind concealed openings so that the whole façade would begin to resound and became a speaking tableau of the Heavenly Jerusalem.

The Gothic screen façade constructed on the west transept of Peterborough Cathedral is a complex design with huge arched openings (see above). It was based both on a Romanesque façade with monumental portal niches and on a Roman triumphal arch. The church proudly displays its portals as the gates of Heaven, which lead into the church as into the place of eternal salvation. The towers stand back behind the gigantic arches, and statues are found only in the gables high above.

Wells Cathedral
West front, ca. 1230–40
The towers were completed ca. 1400.

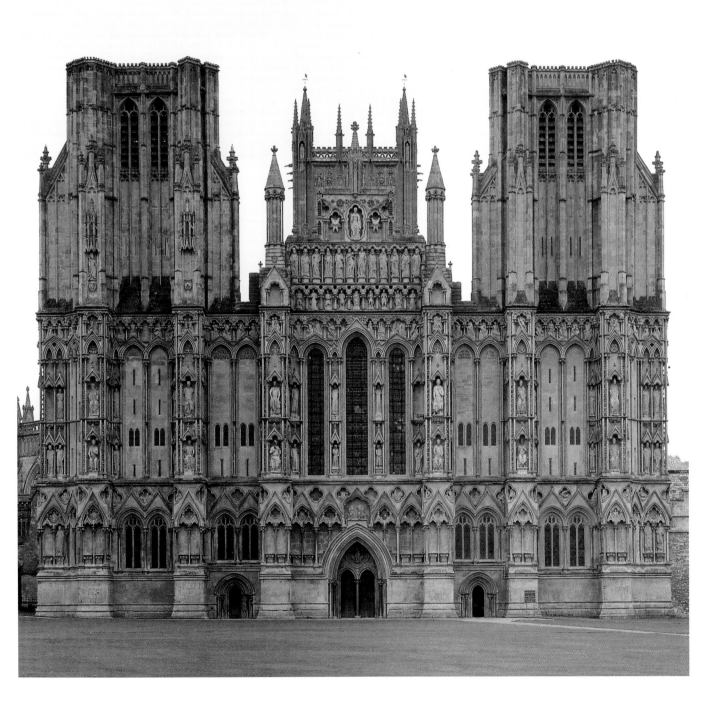

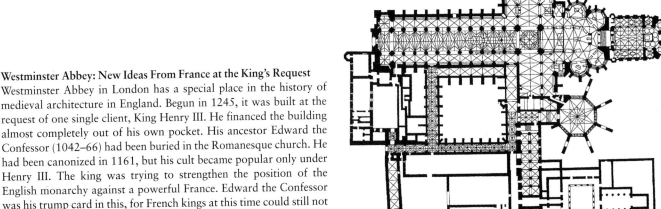

Westminster Abbey: New Ideas From France at the King's Request

Westminster Abbey in London has a special place in the history of medieval architecture in England. Begun in 1245, it was built at the request of one single client, King Henry III. He financed the building almost completely out of his own pocket. His ancestor Edward the Confessor (1042–66) had been buried in the Romanesque church. He had been canonized in 1161, but his cult became popular only under Henry III. The king was trying to strengthen the position of the English monarchy against a powerful France. Edward the Confessor was his trump card in this, for French kings at this time could still not produce an official saintly ancestor.

The rebuilding of Edward's burial place was therefore a part of major political endeavors to enhance the status of the English royal house. The new Westminster Abbey was not only to be one of the most splendid churches of Christendom but it was also, even more importantly, to stand comparison with the great French cathedrals. In this way, Westminster Abbey became the most French of English Gothic church buildings.

The king employed an architect by the name of Henry of Reyns. Once again the name is puzzling: is Reyns a village in England, or Reims in the Île-de-France? Was Henry perhaps an Englishman who had studied in the masons' lodge in Reims? Or was he, like William of Sens, a Frenchman who had to adapt himself to English building practices? In spite of various restrictions, the master mason Henry created a French-style polygonal choir whose apse formed five sides of an octagon, an ambulatory with radiating chapels (see opposite, left), and an aisled transept. The elevation, with its soaring arcade, shallow middle story, and high clerestory, is also in keeping with French models (see opposite, right).

The most striking feature of the choir is its height. No English religious building had reached 32 meters (105 feet) until then; Reims was 38 meters (125 feet) high. In addition, there is in Westminster an element which had been completely unknown in English Gothic architecture until that time: tracery in the gallery and a thin-walled clerestory, which now had no wall-passage. Large rose windows with openwork spandrels decorate the transept façades. Outside, a system of flying buttresses supports the walls of the high nave.

The most important French model for Westminster was, as the name of the master builder may well imply, Reims Cathedral, although in the middle of the 13th century its architecture had already been superseded by the innovations of the Rayonnant style. But for Henry III the political significance was what counted: Reims was the cathedral for the coronation of French kings and Westminster was to fulfil this function for the English monarchs.

Henry the master mason was also acquainted, however, with the latest developments in Amiens and Paris. In Paris he and his patron were particularly impressed by the Ste.-Chapelle, which the French king, Louis IX (1226–70), later St. Louis, had built specially for the relic of Christ's crown of thorns. The characteristic tracery windows of spherical triangles in the Lower Chapel of the Ste.-Chapelle are found again in the gallery of Westminster Abbey. The rich interior decoration of the Paris chapel also appears to have inspired the builders of Westminster, who decorated the entire surfaces of the walls of the abbey church with small carved rosettes (diaper work), which they gilded and painted. They placed figures everywhere, on the corbels, on the spandrels of the blind arcading, and on the end walls of the transepts. Westminster Abbey was one of the most magnificently decorated buildings of the Middle Ages. It was in effect a vast reliquary enclosing the shrine containing the bones of Edward the Confessor.

In spite of this close connection with French Gothic architecture, on close inspection Westminster Abbey, like Canterbury Cathedral before it, remains an English building. Individual French elements were selected, but immediately merged with English traditions. Thus the middle story is not a triforium, as one would expect in a French High Gothic cathedral, but a gallery in the English style. The typically Anglo-Norman double layering is also in evidence here, as there is double tracery in the openings going into the gallery space. The supports of the arcade arches follow the pattern of the French *pilier cantonné*, yet they are made entirely of Purbeck marble, and their shafts, like the piers in the nave of Salisbury, are *en délit*.

This blend of English and French Gothic makes Westminster Abbey a truly eclectic monument, a fact that can be explained only by the clear aims of its royal patron. English tendencies increased in the course of the building process. Henry of Reyns was succeeded in 1253 by the master mason John of Gloucester, and the latter in 1260 by Robert of Beverley. Under them the piers in the nave received additional shafts and the vault acquired tierceron ribs. At the dedication in 1269, the choir, the transept, and the four eastern nave bays of the abbey, as well as large parts of the splendid decoration, were complete. After the death of the royal patron in 1272, however, the building was left unfinished. The nave was completed after 1375, and the west front as late as the 18th century.

London, Westminster Abbey
Choir and nave, looking east, 1245–69

London, Westminster Abbey
Nave, looking southwest, ca. 1258–69
The nave was completed after 1375.

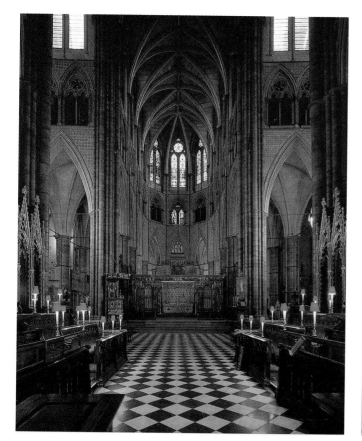

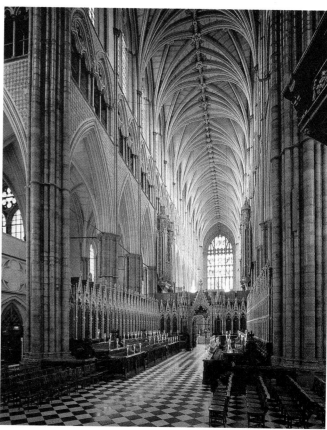

The Decorated Style: Decoration, Tracery, and Vault

With Westminster a new era in English architectural history began. It embodied so many new ideas that English builders were able to draw on them for almost a hundred years. Admittedly they quickly returned to traditional English building methods and practices, such as the thick, double-layered walls, but nevertheless Westminster had opened up new possibilities for the decoration of church buildings. The most influential feature proved to be the tracery, with which one could cover not only the windows but now also the walls. In addition came the idea of closely linking architecture and sculpture to form a total work of art. Before long the vault was also included in the total effect and came to be artistically fashioned with the rib formations already developed in Lincoln. Thus the Decorated style, as its name suggests, brought innovations primarily in the area of the decoration of every available architectural surface. In the process two variants of the Decorated style developed in parallel, distinguished by the forms of their tracery. The geometrical style in the Westminster tradition

remained close to the geometrically constructed tracery of the French Rayonnant style, while at the same time the curvilinear style of tracery (also called flowing tracery) explored, on the basis of the new keel or talon arch (the ogee arch), the possibilities of a flowing, sweeping design.

The Impact of Westminster

During the second half of the 13th century the momentum generated by Westminster helped to create a large number of new buildings. Individual elements such as the rounded triangular windows are quoted in Hereford and Lichfield. Westminster's chapter house, completed under Henry of Reyns, served as a model for the one at Salisbury in the 1260s and 1270s (see page 138). These two central buildings were both built as exquisite glass cages in which all the wall surfaces are transformed into vast windows. The central mullion in Salisbury is so fine that it is hardly possible to see it against the light of the window. Sculpted reliefs in the spandrels of the lower wall

137

Salisbury Cathedral
Chapter House, looking north,
1260s/70s or after 1279

OPPOSITE:
Lincoln Cathedral
Retrochoir, known as the "Angel Choir,"
looking northeast, 1256–80
The base for the reliquary of St. Hugh's
head can be seen on the left.

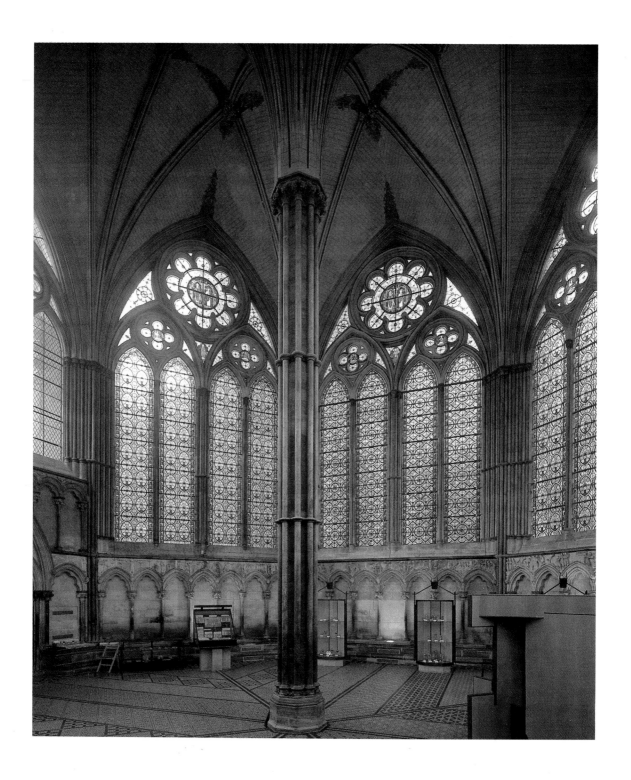

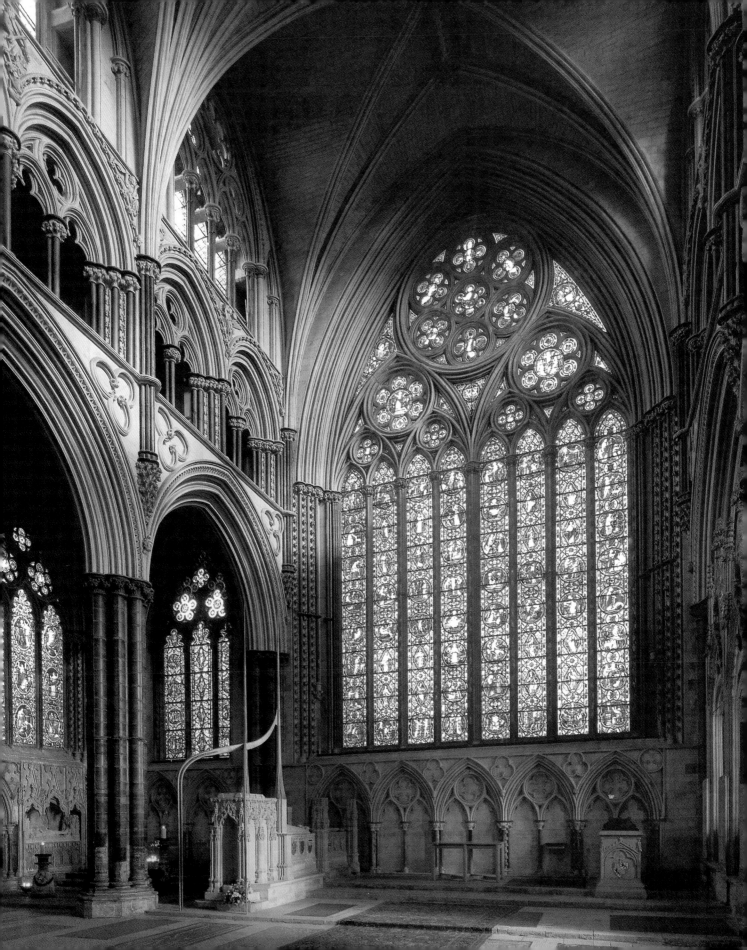

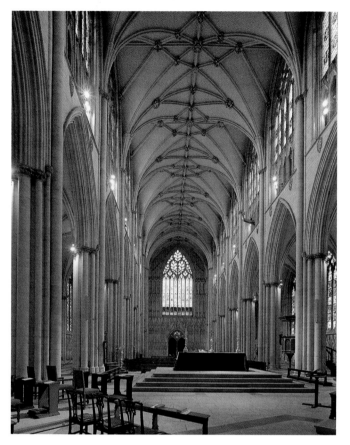

York Minster
Nave, looking west
1291–ca. 1340

Particularly French: York

A new campaign, also completely under the spell of geometrical tracery, was started for the rebuilding of York Minster in the last quarter of the 13th century. In the chapter house and its vestibule the tracery patterns follow with unusual closeness models of the French Rayonnant style, especially those of St.-Urbain in Troyes. The French character of the architecture is intensified in the nave, which was built from 1291 (see left). The reason for this must lie in the person of the patron. Archbishop Jean le Romeyn (1286–96) had been professor of theology at the University of Paris, and so in the nave at York we find the only English example of the skeletal, thin-wall structure of French Gothic.

The high arcade arches are sharply pointed, and the gallery is replaced by a triforium and linked with the clerestory windows by continuous vertical shafts. Both are placed close up to the interior face of the wall and have no wall-passage. Yet another motif from France can be found in the triforium, namely arches that are framed by crocketed gables, that is, so-called gabled arcades. This motif was used on the niches and canopies used for displaying statues, and was eventually transferred to large-scale architecture on French Rayonnant portals. The change from geometric to curvilinear tracery can be seen particularly clearly in the large west window of York Minster, which was glazed in 1339. Foils appear to unfurl like leaves on a stem and in the center of the crown a large heart shape is formed out of ogee arches.

The Creativity of the Southwest

Another center for the Decorated style was southwest England during the last quarter of the 13th century. In several buildings in this region it is possible to see a move away from purely geometric style and the evolution of unusual and distinctive solutions, especially in the interior design.

The first of these buildings was Exeter Cathedral, which was renewed from east to west from around 1280, all in one phase. The interior of this relatively small-proportioned building is dominated by the low-springing vault that appears to consist almost entirely of ribs (see opposite, top right). The vault of Exeter's nave is the most elaborate tierceron vault in England. The number of ribs has increased from the seven used in the nave at Lincoln to eleven. The arcades and the numerous clustered piers with stepped profiles closely match this tight rib formation. In Exeter, even the traceried windows are fashioned in a particularly rich style, with each pair of windows differing from the next.

From 1316 to 1342 the master mason Thomas of Witney, one of the most creative men of his time, was working in Exeter. Thomas was responsible for the completion of the nave, the building of the west front, and the furnishing of the choir. In the detailed architecture of the furnishings, especially the bishop's throne and choir screen of 1315–24, he introduced several important innovations. The most

arcading, which tell stories from the Old Testament, demonstrate the great love that age had for decoration.

Between 1256 and 1280 the choir in Lincoln cathedral was extended eastwards. In the new box-shaped space, the so-called Angel Choir (see page 139), the reliquary of Bishop Hugh, who had now been canonized, had to be installed in a fitting manner. All the window openings and galleries of the choir are filled with geometrical tracery.

The great variety of forms here goes much further than in Westminster Abbey. In Lincoln they combined for the first time the traditional English flat east end wall and the new element of tracery. This resulted in large groups of vertical strips of traceried windows in the east of the church as a counterpart to the windows of the west front. Even the costly wall decoration at Westminster is shown off to advantage in Lincoln. Blind tracery covers every available surface. Reliefs decorate the spandrels of the gallery with the singing and music-making angels who gave this choir its name.

BELOW:
Exeter Cathedral
West front, 1329–42 (with alterations
from the mid-14th and 15th centuries)

Exeter Cathedral
Nave, looking east, ca. 1310
At the bottom can be seen the choir
screen (1317–24) by Thomas of Witney
and on the left, in the triforium, the
singers' gallery.

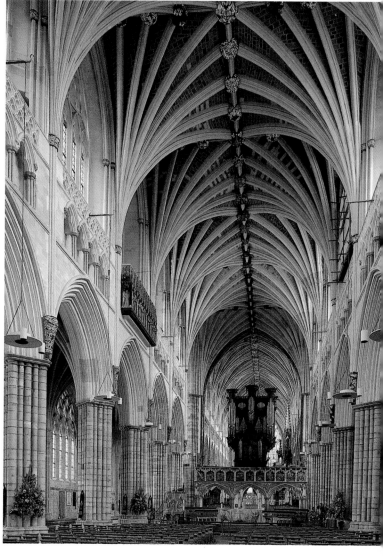

significant are the ogee arches in various styles, which we can see in
one of their earliest expressions in the choir screen, and the new
lierne rib structure in the vaults of the choir screen passage. The
lierne is an additional rib on the cross-ribbed vault that (unlike the
tierceron) is not connected to the vault springings. With liernes it was
possible to design even more intricate vault patterns.

Like Thomas of Witney, many architects of the period were happy
to experiment with new shapes in small-scale architecture before
transferring them to large buildings. Thomas of Witney had learned
of liernes and ogee arches shortly before his work at Exeter in an
important English building project which has since been destroyed,
namely the double chapel of St. Stephen in the royal palace of
Westminster. The chapel was begun in 1292–97 under the court
master mason Michael of Canterbury, but it was not finally
completed until 1320–26.

The west front at Exeter (1329–42), with its large central window,
in which the transition between geometric and curvilinear tracery is
signaled, represents the flat end façades which are so typical of Late
Gothic in England (see below). The most unusual element, the blind
sculptured showpiece façade, is a later addition from the middle of
the 14th and 15th centuries and illustrates the survival of the early
Gothic screen façade.

Meanwhile, in nearby Bristol, one of the most original buildings
of Late Gothic in Europe was being built (see page 142). The
Augustinian monks of the cathedral started the restoration with the
choir, which was to serve as the burial place of the powerful Berkeley
family; it was completed in 1332. This is a hall church, unusual for
England. Here a brilliant master mason whose name we do not know
created a new and unique interpretation of the hall church form. The
wide nave opens into the narrow side aisles through tall, wide arches.

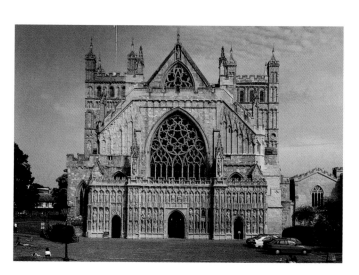

The vaults are placed at right angles to the nave, like the barrel vaults
in early Cistercian churches. The bays of the side aisles are spanned
by four small cross-ribbed vaults which are supported by transverse
arches that are much lower than the arcade arches of the central
nave. The spandrels of these arches, however, are openwork, and
terminate horizontally in a battlement-like frieze. Above the vaults is
an open space. Whole vault webs are missing, which means that an
open view into the neighboring bays is provided so that the
transverse arches of the side aisle in Bristol look like linked bridges.
The inspiration for this unusual design could have been the lower
chapel of the Ste.-Chapelle in Paris. The Bristol master took this
highly original approach to the vault to an extreme in the little
anteroom of the Berkeley Chapel, where he omitted all the vault webs
and allowed the ribs to hang freely in the air.

The master's unrestrained originality is shown in other ways too.
The central nave piers merge into the arcade arches without a break.
There are no capitals and imposts here, one of the earliest examples

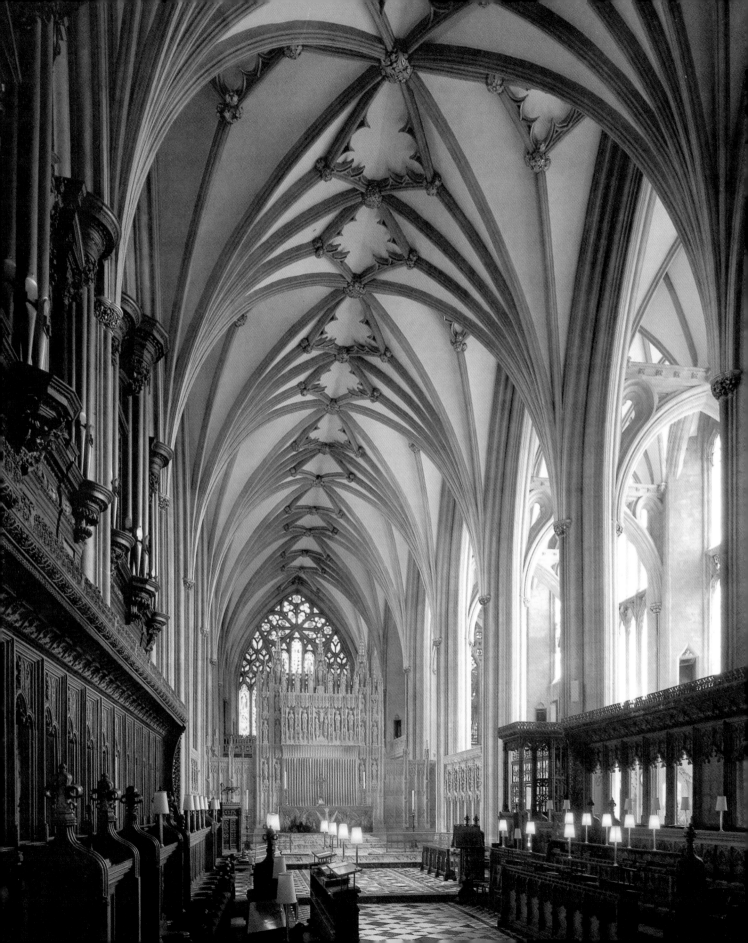

OPPOSITE:
Bristol Cathedral (former Benedictine
abbey church of St. Augustine)
Choir looking east, 1298–ca.1332

Wells Cathedral
Chapter House, looking south, 1290s

of this feature in European Gothic. The wavy profiles (ogee molding) of the piers are just as novel. The central nave vault begins as a tierceron vault but meets at the vault ridge in a row of large lozenges formed of liernes. In addition, the liernes are decorated like tracery with cusps suspended from the surface of the vault. But the most unusual feature of the cathedral is the unknown Bristol master mason's treatment of the architectural furnishings, especially on the Berkeley family tombs. Ogee arches are piled precipitously on top of each other and inverse multifoil arches form frames reminiscent of Islamic architecture.

A third building in southwest England also demonstrates the dynamism of this region in the early 14th century: Wells Cathedral, which we have already mentioned in connection with the Early English style. In the 1290s an octagonal chapter house was built, one of the most beautiful in England (see right). It was completed before 1307. Unlike the chapter houses of Westminster or Salisbury, its basic form is not the glass cage but instead the richly decorated vault. Like a palm-tree, the sturdy central column supports the expansive dome of the vault on which countless closely packed tierceron ribs stretch upwards.

The vault at the end of the new choir at Wells is also worthy of attention. It begins in the east of the Early Gothic choir with the Lady Chapel, which is lower than the choir's nave but higher than the ambulatory. Thomas of Witney, who is already known to us from Exeter, had been active there since 1323. The Lady Chapel was completed by 1326.

Unlike all comparable chapels in England, this chapel has a ground plan that is not a rectangle but an elongated octagon. The vault, rising up like a dome, is decorated with a star of ribs. The architect had the task of connecting this octagonal chapel space with the rectangular ambulatory around the choir. His solution was a subtle interpenetration of spaces that would become familiar only much later during the Baroque period. The supports in the ambulatory are arranged in a hexagon whose east side is identical to the west end of the Lady Chapel. Visitors can easily become disorientated in the forest of slender supports east of the choir. Only by looking up at the vault can they see the center of the hexagon, which is distinguished by its star shape.

The choir itself was renovated from 1333 by the master mason William Joy (see page 144, left). The three stories are linked by a pier profile whose wave pattern, familiar to us from Bristol, runs all around the pier. The central area, a kind of triforium, consists of a delicate latticework pattern of vertical bars and ogee-arched gabled arcading containing statues. The bars continue from the rear of the arcade arches to the tracery of the clerestory windows. The finely detailed tracery is the so-called flowing or reticulated tracery, in which the pattern allows itself to go off in any direction it pleases. The clerestory passage leads past slanted window jambs. Their openings are framed by ogee arches that curve outwards towards the

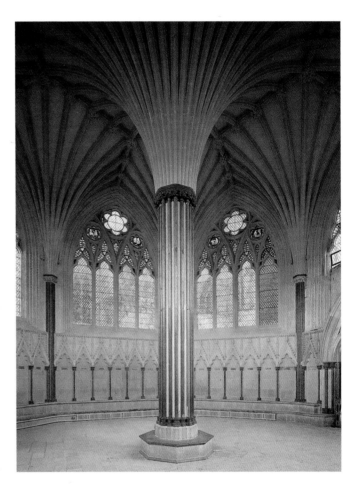

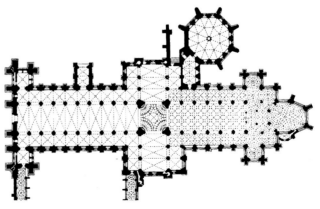

Wells Cathedral, ground plan

Wells Cathedral
Choir looking east. The choir was built
by master mason William Joy from 1333.
The Lady Chapel by Thomas Witney,
completed in 1326, can be seen to the
east through the arcades.

Ely Cathedral
Crossing octagon, 1322–40
The wooden vault and lantern are by the
master carpenter William Hurley.

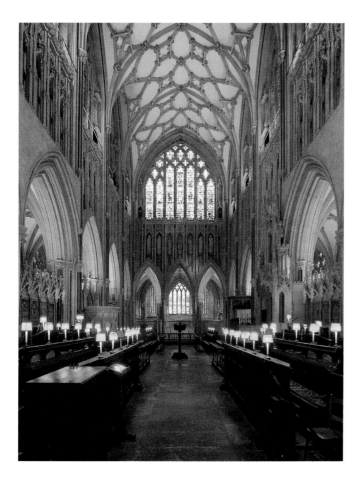

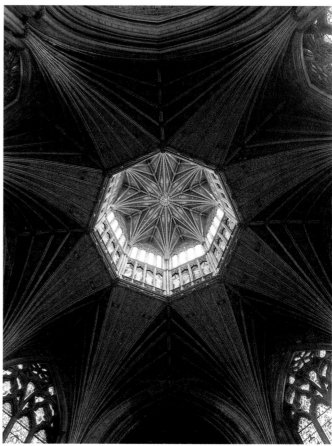

top. Thomas of Witney had introduced this so-called nodding ogee in the bishop's throne at Exeter. Finally, in the vault, the boundaries of the bays almost completely disappear and a mesh of liernes spreads over the whole surface, creating lozenges, hexagons, and stars. Walls, windows, and vaults in the Wells choir are all covered by a filigree web of fine lines.

Necessity the Mother of Invention: Ely

At the beginning of the 14th century, the monks of Ely in the east of England also wanted to have their own church in this splendid new style. In 1321 they began on a small scale with a Lady Chapel to the north of the choir. But the following year a catastrophe made it necessary for the clergy to undertake a much larger building project all in one go. The result of this is one of the most unusual spatial creations of the Middle Ages. On 22 February 1322 the crossing tower collapsed and took the crossing piers and the adjacent bays

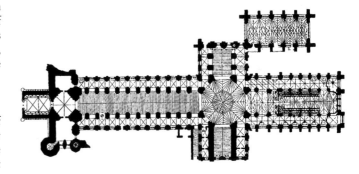

Ely Cathedral, ground plan

Ely Cathedral
Lady Chapel, looking northeast,
1321–ca.1345

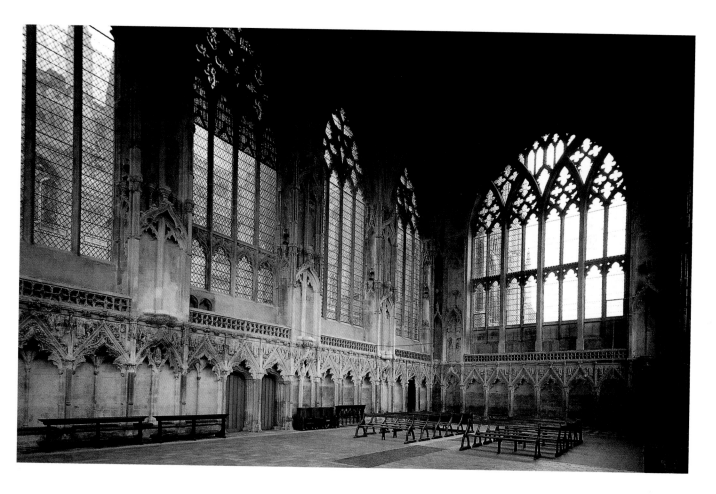

with it. The sacristan, Alan of Walsingham, was given the task of organizing the reconstruction. Possibly it was his own idea not to build the crossing in the old style but to extend it into an octagon (see opposite, right). Light now streams in through large windows, illuminating the central area of the church where the monks' choir stalls once stood. The vault above these windows is spectacular. The huge surface, with a diameter of 22 meters (72 feet), stretches over an ingenious wooden construction, to build which the royal carpenter William Hurley was specially brought from London. Tierceron ribs stretch up from the corners of the crossing and support an octagonal lantern tower that has wide windows and is angled at 45°. The wooden vault, behind which the buttressing is concealed, was painted to look like stone. Outside, the fantastic silhouette of the octagon and lantern, with their buttresses and pinnacles, can be seen from far away, rising above the flat marshland of the surrounding countryside.

The bays next to the choir in Ely also had to be repaired, and they were completed in 1336–37. Here the decoration completely obscures the architecture. Even more richly decorated is the Lady Chapel (see above). The last part to be completed, around 1345, it was consecrated in 1353. Although it has a simple box-like shape, it outdoes everything which had gone before in complexity: the interior architectural forms, ornamentation, sculpture, and (at one time) painting are all subtly interconnected. All the surfaces are covered with finely detailed decoration, the shapes emerging from behind one another and out of each other. The leitmotif is the gabled arcade with its three-dimensional, outwardly curving ogee arches (nodding ogees). Everywhere was sculpture telling the story of the Virgin Mary's life. Everything was once gilded or painted in bright colors. In its original condition, the Lady Chapel at Ely must have been a stunning treasure house, a high point of the Decorated style which could hardly be surpassed.

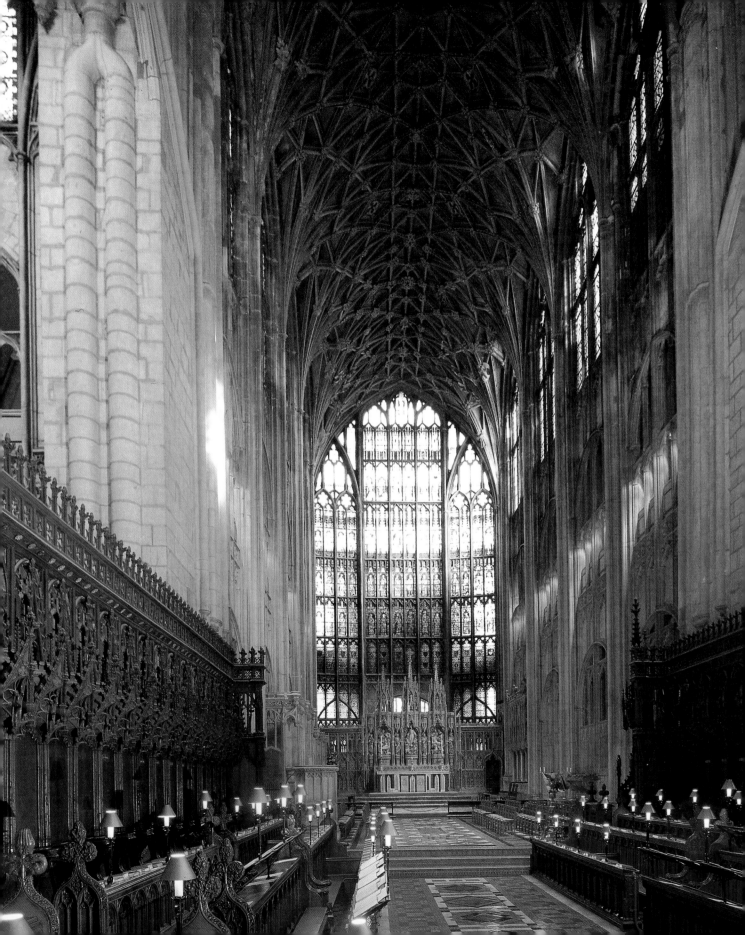

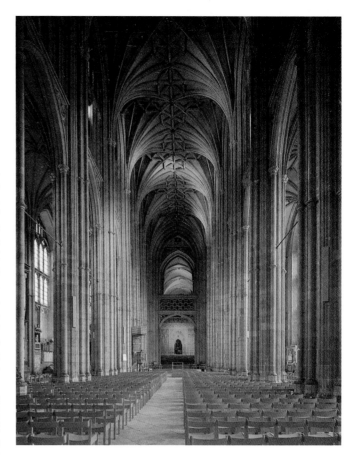

The Perpendicular Style: Reaction to Excess

This extravagant wealth of shapes and details provoked a reaction. This began in the west of England with the abbey church in Gloucester in the 1330s, even as some important works of the Decorated style were still being built. King Edward II (1307–27), who had been held captive in Berkeley Castle by his wife and her lover, and finally murdered, was buried there. Soon afterwards, quite unexpectedly, a pilgrimage was established to his burial place. The pilgrims' donations, along with gifts from his son, Edward III (1327–77), soon made it possible, shortly after 1330, to remodel the old Romanesque basilica, beginning in the south transept. Presumably the royal master mason Thomas of Canterbury, who had overseen the completion of the royal chapel of St. Stephen's in Westminster, was brought to Gloucester. Motifs from the upper chapel there were used again at Gloucester, this time on large-scale church architecture, and so a new architectural style was born. One of Thomas' successors perfected this style in the remodeled choir around 1337–60 (see opposite).

The tradition-conscious Benedictines of Gloucester wanted to retain their old building as far as possible. The master mason satisfied this condition by decorating the central nave walls with a veneer of lattice work of vertical and horizontal lines behind which the old side aisles and galleries were concealed. Only the clerestory was completely rebuilt. The Decorated style is continued in Gloucester in a new formal language: the decoration of every available surface with patterns. Yet in comparison with the Decorated style as used elsewhere, in Gloucester there is a standardization of forms and no longer an ever-changing pattern of shapes. The basic motif is the "panel," a narrow, elongated rectangle of tracery at the top of which a small cusped arch is enclosed. Panels such as this cover the walls, openings, and windows of Gloucester with a symmetrical grid of latticework. Here the order of the regular grid is set against the Decorated style's effusive spirit of inventiveness. A new style of vertical and horizontal lines was born: the Perpendicular.

Within this network individual structural elements create a clearly legible system, with pronounced vertical elements dividing the walls into regular bays. This orderly structure can be seen most clearly in the monumental east window. With a surface area of 185 square meters (1,990 square feet), it is the largest of its day and consists solely of glass and the tracery bars of the panels. Thicker mullions subdivide it into three vertical sections. Even the roof vault, which is covered with a dense mesh of lierne ribs, conforms to the new formal language: accentuating the central axis, three parallel ridge ribs run the length of the roof vault. Although at first sight there may be a danger of monotony with the stereotyped repetition of these rectangular panels, the master builders of the Perpendicular were every bit as successful as their predecessors in articulating the space available. For it was only with the help of paneling that windows whose surfaces were made entirely of glass could be opened up to

such an enormous size as at Gloucester. Here the old Gothic dream of an interior completely flooded with light became reality.

The architectural vocabulary formulated at Gloucester offered numerous possibilities that English architects exploited to the full from the middle of the 14th century. The panel became the standard form of English architecture. It proved to be extremely flexible as it could be copied in any way desired and could be used to cover surfaces of any size. Moreover, in comparison with the large variety of individual shapes in the Decorated style, it was easy to make, and marked a rationalization of the work processes. Paneling was soon used in all areas of architecture and furnishings, large or small, religious or secular. The triumphal march of the Perpendicular may have some connection with the ravages of the Black Death of 1348–49: there were fewer builders available, and the somber and penitential mood of the period meant that survivors turned away from exaggerated luxury.

In the last quarter of the 14th century the Perpendicular style was used for the first and last time in the architecture of great cathedrals. New naves were built at Canterbury and Winchester. The one at Canterbury, built between about 1375 to 1405 (see above), was probably designed by the court's master builder, Henry Yevele, one of the most active and successful architects of his time. The most striking feature of this nave is its verticality. The arcades are particularly tall, the piers slender. The vault supports climb up like drainpipes and, as in the choir at Gloucester, clearly mark the

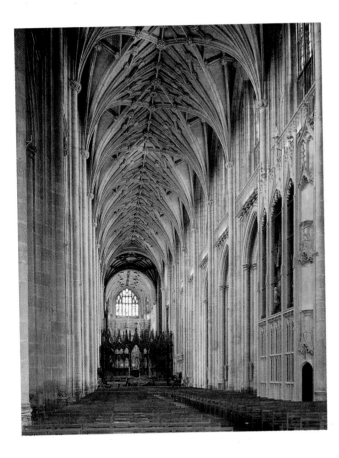

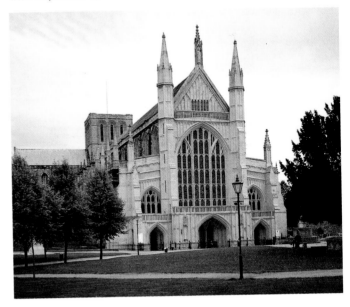

division into bays. A double wave-shaped curved profile (a double ogee) runs in an unbroken line from the piers up to the clerestory windows, uniting the whole main nave wall into one enormous arcade, a motif familiar from the choir at Wells. Contrary to English tradition, the arcade arches are very narrow, with the result that even the wall above with its paneled triforium and clerestory looks like a narrow surface slotted into the huge arcade. The vault is more restrained than the one at Gloucester, which has a dense mesh of ribs. The liernes form a star pattern only at the vault ridge, a feature which accentuates the center of each bay.

In Winchester Cathedral the rebuilding of the nave around 1360 had begun with the west front. One of the last cathedral fronts of England, it was once again built with a flat end wall (see above, right). On this façade the side aisles are separated from the nave by boldly protruding buttresses and pinnacles. The wall and window surfaces between are completely covered with paneling, and the large west window has been designed as a variation of the east window at Gloucester. The porch has Tudor arches. These four-centered arches, which are typical of the Perpendicular style, took the place of the ogee arch of the Decorated style. As a result of the bent angle of the arches, they could be fitted easily into the rectangular grid of the panels.

After the death of the first patron, Bishop Edington, the rebuilding of the Winchester nave was left unfinished in 1366, and it was not until 1394 that work began again (see above, left), under Bishop William Wykeham. He was one of the most influential men of his time and an important patron of the arts. He employed as his master mason William Wynford, who like Yevele had served in the royal household. To save money, Wynford did not dismantle the Romanesque nave but artistically remodeled the original fabric of the building instead. The new structures were sculpted out of the old masonry. In this way an architectural style arose which has quite a different character, although it works with the same set of basic shapes. The piers and arcade arches are huge. A parapet above the arcades hides how far the wall above it has moved back. Here the nave is characterized not by thin, tightly stretched wall surfaces, as at Canterbury, but by three-dimensional stepped profiles. The high nave vault is extended downwards a long way so that the thrust of the vault can be transmitted to the thick Romanesque wall.

After the naves in Canterbury and Winchester had been built, cathedrals lost their leading role in English architecture. The outstanding building projects of the 15th and early 16th centuries occurred in small-scale church building such as chapels and parish churches and also in the building of Oxford and Cambridge colleges, which were now beginning to develop as important projects. Some of these smaller building projects turned out, at least in part, to be no less spectacular than the cathedrals and monastery churches of earlier times. This is especially true of the magnificent series of royal chapels with which medieval architecture in England comes to an end. Once again the English kings emerged as founders of prestigious building projects. Henry VI (1422–61, 1470–71) laid the foundation stone for King's College Chapel in Cambridge in 1446, Edward IV (1461–70, 1471–83) founded St. George's Chapel in Windsor Castle, and Henry VII (1485–1509) renewed the Lady Chapel at the east end of

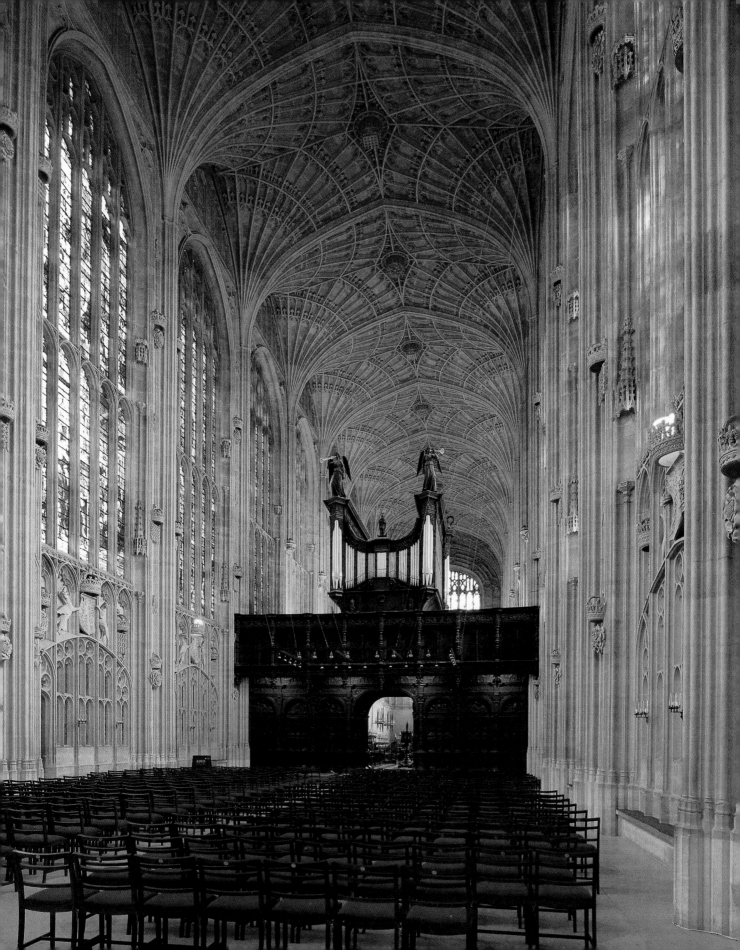

London, Westminster Abbey
Henry VII's Chapel, looking southwest,
1502–09
On the left is the tomb of Henry VII.

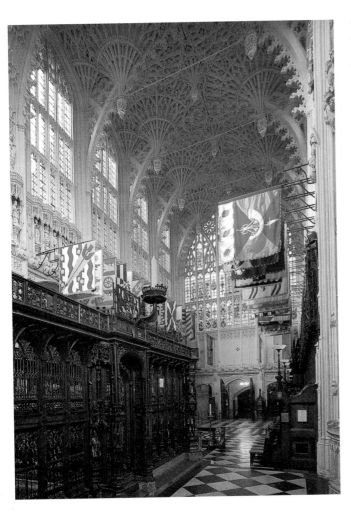

tracery. The fine lines of these lower sections have a vertical emphasis that leads the eye up to the vault. The product of the last building phase at the beginning of the 16th century, this chapel is regarded as the high point in the art of medieval vaulting. Here a technique seen only in England is applied to the monumental span of 12.66 meters (41.5 feet): the fan vault. This form of vaulting had already been developed around 1360–70 in the cloister at Gloucester Cathedral, but until now it had been used only in small buildings. The fan was created by combining the tierceron vault, with its palm-like spread of ribs, with the panels developed by the Perpendicular style. The basic form consists of a series of inverted half-cones that are cut off horizontally at the top and meet at the vault's ridge; they are supported by the transverse arches. Traceried panels are laid on the cones, which taper as they descend. The vertical lines look like the spokes of a window rose. The result is a form that is fine-meshed but nevertheless clearly structured. Having spread over the windows and walls, tracery and paneling had now taken over the vault too. In King's College Chapel, English Late Gothic created a completely unified architectural space that is unrivaled anywhere in Europe.

Looked at from a technical point of view, English Late Gothic fan vaults are a masterpiece. They are no longer composed of separate ribs and webs like traditional vaults, but of individual stone slabs curved into each other. The tracery lines of the panels are carved out of these slabs. The surfaces of the spandrels between the cones are completed by horizontal slabs, which at King's College Chapel weigh 1.5 tons each.

One would imagine that after Cambridge no further improvement could be made. But this was precisely what Henry VII set about trying to achieve. He had the Lady Chapel in the east of the Westminster Abbey torn down for his own burial place, and the choir built by Henry III made twice as long. Both outside and inside, Henry VII's Chapel is composed entirely of intricate panels with hardly any plain wall area left.

Once again the greatest triumph of the interior space is the vault (see left). Here the basic structure evident in Cambridge is almost totally obscured by the rich diversity of forms. The Westminster vault is a fan vault, but combined with large hanging bosses called pendants. The number of cones in the structure has increased and the points of the whole cones in the middle hang spectacularly in midair. The technique which makes this masterpiece possible is well disguised: the transverse arches disappear into the ceiling of the vault, their thrust being transmitted to the external buttressing. This intensifies the weightless impression of the vault, the lines of tracery being carved out of stone slabs, with the actual surface of the vault behind appearing only as a shadowy background.

Medieval art in England comes to an end with Henry VII's Chapel in Westminster Abbey. Henry VII's tomb, made by the Italian Renaissance sculptor Pietro Torrigiano, lies concealed behind a paneled screen in the center of the chapel.

Westminster Abbey between 1502 and 1509, the chapel now bearing his name. As all three chapels were intended to serve as royal burial places, they reached cathedral proportions.

King's College Chapel (see page 149) is an integral part of a college that Henry VI founded in Cambridge in 1441. After the death of the founder in 1471, the work made slow progress. Only when Henry VII took up the initiative again in 1508, and left the means for the completion of the building project in his will, was it finally completed, in 1515.

This chapel is the epitome of the Perpendicular style. The walls are now almost completely translated into glass. Only at the bottom is there any remaining solid wall, and this is covered by a grid of

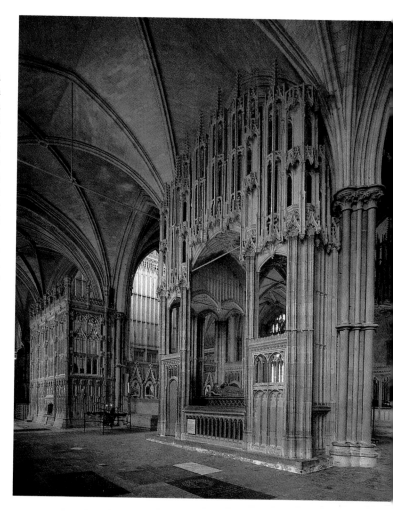

Winchester Cathedral
Retrochoir, looking northwest with the chantry chapels of Cardinal Beaufort, died 1447 (in front), Bishop Wayneflete, died 1486 (to the right in the background), and Bishop Fox, died 1528 (left). In the niche in the base of this chapel the skeleton of Fox is depicted.

Three Special Building Types of the English Late Middle Ages: Chantry Chapels, Parish Churches, and Castles

The English Chantry Chapel

Finally, we can look briefly at three building types that played a special role in English medieval architecture. The first is the requiem chapel, known as the chantry chapel. In the course of the 14th century, and especially after the Black Death, there emerged a need for a stronger expression of religious faith. Great significance was attached to remembering the dead and to providing for one's own death. According to medieval ideas, the souls of the dead had to rely on the prayers of those left behind in order to reach Heaven from Purgatory. Therefore during their lifetime the faithful paid for masses that were to be read out (and sung) at a particular altar in a particular church after their death, preferably in perpetuity. The word *chantry* is derived from the Latin term for such requiem masses, *cantaria*.

Families that were especially rich could afford to build their own chapel in memory of their dead. This would contain their tombs and an altar. On the Continent these private chapels were mostly built along the side aisles of large churches. In England chantry chapels had since the second half of the 14th century been built as separate little buildings in the middle of the church, mostly as a "stone cage" structure. The idea behind them was simple: the nearer the main altar or reliquary of the church, the better. With the flexible architectural vocabulary of the Perpendicular style, these miniature buildings could best be constructed out of openwork panels.

English chantry chapels developed from the freestanding tombs with lavish canopies that had been constructed for the dead of important members of society since the middle of the 13th century. A high point of this genre is the memorial to King Edward II which was erected about 1330–35 on the north side of the choir at Gloucester (see page 370). With all the lavishness of the Late Decorated style, this tomb is encased by a complex multi-layered baldachin-style piece of architecture composed of ogee arches, buttresses, gabled arcades, and crocketed pinnacles.

In Winchester Cathedral, whose bishops were some of the richest in England, this form of lavishly decorated tomb was gradually upgraded to evolve into the chantry chapel (see right). The two patrons of the new nave made the first move, particularly the self-important Bishop Wykeham. He had his tomb placed under one of the southern arcades and had a chapel erected around it whose wrought-iron work blocked off the whole of the arcade arch (see page 148, left). Small doors led into the chapel, which is complete with altar and retable. Through the traceried panels one can see the recumbent figure of the bishop, who died in 1404. At his feet small carved monks pray for the salvation of his soul. The monument reveals a curious mix of piety and exhibitionism.

Bishop Beaufort of Winchester, who died in 1447, had attained the rank of cardinal and wanted to outdo his famous predecessor. He left behind large sums of money to make alterations to the high altar and reliquary of St. Swithin. In 1476 the shrine was transferred to the Early Gothic retrochoir further east. Beaufort had already reserved a place south of that for his chantry chapel, which has a steeply towering, extremely complex baldachin. The side walls are omitted in the middle in order to reveal the statue of the entombed bishop proudly displayed in his cardinal's robes. His successor Wayneflete (who died in 1486) did not want to take second place to him and occupied the north side of the shrine with his no less splendid chapel. From Winchester, chantry chapels, whether for clergy or laity, spread throughout the whole of England. Many patrons had representations of themselves as skeletons integrated into the bases of their funerary chapels as a *memento mori* for visitors to the church.

The English Parish Church

In Late Gothic England even quite ordinary people left behind
impressive evidence of their piety. English agriculture experienced a
tremendous upturn in the 15th century, with sheep breeders and wool
and cloth merchants in the east and southwest becoming extremely
wealthy. Such citizens often donated their money to the rebuilding
and furnishing of their parish churches, and towns and villages
competed with each other in the creation of the most lavish church.

Suffolk, Norfolk, and Cambridgeshire possess a particularly large
number of splendid parish churches in the Perpendicular style. The
parish church of the Holy Trinity in Long Melford (built around
1460–96) is one of the most impressive of these (see left, top). The
pride of the whole village is expressed in this richly decorated
building. All the exterior walls are covered with inlay work of dark
flint and light limestone (flushwork), which is typical of the area and
is executed particularly skillfully here. Among the most unusual
features of Long Melford church is the inscription that runs round
the whole building. This immortalizes the names and dates of all
those who made donations to the church, and adds a prayer of
intercession for their souls.

In the interior of the parish churches the architects' main interest
lay in the wooden ceilings. Only rarely did English parish churches
have stone vaults. England, a shipbuilding nation, had a preference
for wooden ceilings and became expert at making them, as we have
already seen from the octagon at Ely. One type proved to be
particularly successful in Late Gothic times: the hammerbeam roof,
in which beams protruding horizontally into the space bear segments
of arches which meet at the roof ridge. This structure allowed long
distances to be spanned without intermediate supports. The parish
church of St. Wendreda in March displays a particularly splendid
roof of this kind, built about 1500, in which there are two rows of
hammerbeams on top of each other (see bottom left). It is decorated
with a host of carved angels which are fixed onto corbels, beams, and
the roof ridge. With angels' wings outstretched, the whole ceiling
becomes a lively celestial dwelling place, a particularly successful
presentation of a church as the Holy City and house of God.

The English Castle

Finally, we should look at castle architecture. The most splendid
castles were built under Edward I (1272–1307) in Wales. This king
had conquered the Celtic peninsula to the west of England in 1283
after a long campaign, and now wanted to secure his hold over it
with a line of mighty castles along the north coast. And so, in an
enormous financial and technological show of strength, a total of 17
castles were built, some of which are the most significant in Europe.
The master builder appointed by the king, Jacques de St.-Georges-
d'Espéranches, came from Savoy. Wherever it was possible he gave
preference to a symmetrical layout with several concentric circles of
walls, round corner towers, and gatehouses fortified as bulwarks.

March, St. Wendreda parish church
Nave and hammerbeam roof, ca. 1500

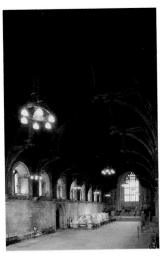

London, Westminster Hall, Houses of
Parliament
Hammerbeam roof (1394–1401) by
master carpenter Hugo Herland

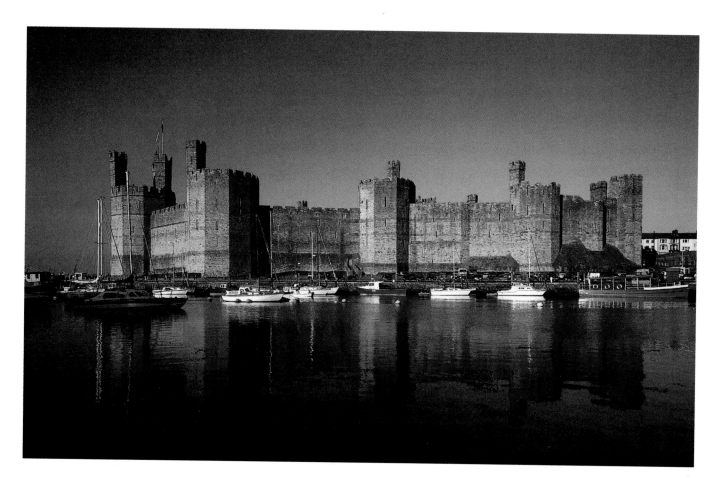

These powerful castles built to the latest military and technical standards were mainly aimed at displaying English strength and superiority to the rebellious Welsh.

This was to be demonstrated to perfection in Caernarvon (see above), where from 1283 a new town was founded outside the castle, which was open only to English settlers. The seat of the English government of North Wales was there. Caernarvon is full of signs of its imperious power. The castle, which has a long ground plan, is situated right on the coast. It has octagonal watchtowers and its masonry is distinguished by narrow strips of red sandstone between light gray limestone. Both the polygonal towers and the striped masonry are motifs adopted from a distinguished model: the late classical 5th-century city wall of Constantinople. The link with the imperial tradition of antiquity was underlined when the English placed figures of eagles on the battlements of the castle: Caernarvon was to be understood as the Constantinople of the north, and Edward I as the Christian ruler of the world.

But in the late Middle Ages the development of secular architecture increasingly went in the direction of domesticity and comfort. The military and technical features moved into the background after the end of the Hundred Years' War between England and France. The hall was the center of life in the castles and country seats of the nobility. These huge rectangular rooms were fitted with increasingly large windows and bays. At one of the narrow ends of the room was the high table, raised on a platform, and at the other end were the entrances to the working areas. These were separated from the body of the hall by a corridor (known as the screen's passage) and a wall, because of the draft. There was often a musicians' gallery high on one wall.

One of the most important preserved halls in England is in the former royal palace of Westminster, now the Houses of Parliament (see opposite, bottom right). Westminster Hall was the only part of the medieval palace to survive the devastating fire of 1834 undamaged. Its exterior walls date from the time of the Norman king William Rufus (1087–1100). Richard II had the hall altered by his master builder Henry Yevele in 1394–1401. Its masterpiece is the wooden ceiling built by the royal carpenter Hugo Herland, one of the first and largest hammerbeam roofs in England, which spans almost 20 meters (65.5 feet).

Hugo Herland's elaborate roof displays the same power of inventiveness that we have seen so often in this review of English Gothic. This originality is the most important characteristic of Gothic architecture in England. French ideas played a role again and again, but their influence never impeded independent development. In all the phases of Gothic, the results are no less remarkable than those in France. The independent paths taken by English Gothic are well worth learning to recognize and treasure.

Christian Freigang
Medieval Building Practice

Until recently, Gothic architecture was largely seen as medieval theology or cosmology expressed in stone. This view totally ignored the fact that in constructing these marvels of architecture medieval builders had to employ a wide range of highly developed skills in both construction techniques and organization. It was because these skills were so highly admired that from the 12th century onwards (and for the first time since classical antiquity) the names and achievements of famous architects began to be recorded.

The rebuilding of Canterbury Cathedral provides a good example of medieval building practice. In 1175 the bishop and chapter summoned William of Sens, obviously a highly respected master mason, from Sens far away in France, to repair the cathedral choir, which had been badly damaged by fire. After the French master mason had assessed the damage, however, he came to the conclusion that a completely new building would provide a safer and also more fitting structure. Using all his powers of persuasion, he was able to convince his patrons to accept his ambitious plan. William proved that his reputation was justified: he not only put the whole plan for this new building into practice, but also devised countless ingenious solutions to technical problems. He was seriously injured, however, by a fall from the scaffolding and had to give instructions from his sickbed. Work came to a halt as craftsmen and the cathedral chapter waited in vain for the master to

recover. Finally he had to return to his hometown and another William, an English master mason this time, succeeded him. We have no record of what happened to either of them after that.

What kind of plans and working drawings would William of Sens, seen here as representative of his many colleagues, have used? The earliest detailed designs and technical calculations we have date from the 15th century. But surviving from the 13th century onwards are portable small-scale architectural drawings which obviously served as the basis for the discussion of new ideas. Two sketches from about 1260 of transept façades for the cathedral of Reims have come down to us in this form. These two drawings clearly served as alternative designs at the planning stage. A century later, in Strasbourg, preliminary sketches for the façade of the cathedral were worked on intensively and some of these large design plans on parchment have survived (see below, right).

Even earlier, around 1230, Villard de Honnecourt filled his famous sketchbook with architectural drawings. Though probably not an architect, but a painter and draftsman from Picardy, he drew existing buildings as accurately as possible and in great detail, particularly the cathedral of Reims (see below, left); he even drew sketches of imaginary buildings.

Attempts were obviously being made to portray large buildings in order to be able to suggest plans to patrons in other towns. After the late 13th century large architectural plans, drawn on several sheets of parchment, become more numerous. Most of the surviving plans

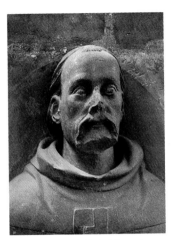

Prague, St. Vitus Cathedral, bust of master mason Peter Parler in the triforium, ca. 1370

were drawn for large building projects in Germany, Spain, and Italy. How legible and accurate these plans are can be seen from the large "Plan F" for the west facade of Cologne Cathedral, drawn around 1300 (see page 202, left). It was on the basis of this detailed drawing that, after a break of 400 years, the cathedral was finally completed in the 19th century. Other impressive examples, as we have just seen, include the design for the west façade of Strasbourg Cathedral.

But medieval architectural drawings were not always working plans for a specific site. The ambitions of the patrons, together with competition between individual building projects, forced many masters to go on paid trips in order to study the "most beautiful" examples of modern architecture, and so find new ideas for their own projects. These trips became common, especially after the 14th century. We know, for example, of journeys made in preparation for the building of the cathedrals of Tortosa and Troyes, and for the collegiate church of Mons in Hainault. Medieval master masons generally moved around a great deal: in 1268 a master mason from Paris was hired for the construction of the Knights' Church at Wimpfen im Tal and in 1287 another Paris master mason was employed to build the cathedral of Uppsala in Sweden. Several French master masons are known to have traveled between various building sites. From the mid 13th century to the beginning of the 14th century, for example, Gautier de Varinfroy and Jacques de Fauran between them are known to have worked at Sens, Évreux, Chartres, Narbonne, and Gerona.

Famous master masons, accordingly, were the most distinguished and highly paid practitioners of their craft. They were entitled to clothing appropriate to their rank and some were given figured gravestones on which their trade was depicted. Just how high-ranking a

medieval master mason could become is illustrated by the first two master masons of the Gothic cathedral in Prague, Matthew of Arras (1344–52) and Peter Parler (1356–99) (see left). Both of them enjoyed the privilege of being buried with figured gravestones in the middle of the new choir of the cathedral. Even more important, both had their portraits carved in the triforium of St. Vitus' Cathedral, along with those of Emperor Charles IV and his family, the first archbishops of Prague, and the building administrators. The master masons obviously ranked among the founders of the new cathedral and were not to be forgotten. Of course not all medieval master masons were so privileged. The majority were craftsmen who had learnt the stonemasonry trade as a basic skill and applied themselves to numerous building tasks—not only churches, but also bridges, fortifications, houses, and so on.

People have often puzzled over what mathematical aids the master masons might have used in planning their buildings. In particular, it was long thought that the basis of their designs was a complex geometrical construction combining circles, triangles, squares, pentagons, and octagons, together with a range of lines derived from these figures. But it is more likely that they used a few simple geometrical shapes and their rotations (an octagon, for example, can be produced by rotating a square), together with a squared grid plan, and a few basic modules. In addition there were absolute measurements like feet, cubits, and fathoms. All the building contracts and descriptions we have refer to measurements such as these.

Before work could begin in earnest, a great deal of preparatory work had to be carried out. The ground had to be leveled off, old building materials often had to be cleared away, the foundations dug, and vast amounts of masonry found. In addition, the builders had to keep a close eye on price and quality. Fetching materials from a long way off or overland was expensive, and so they often decided to have them transported by water. For many parts of the building, like the foundations and wall fillings, poor-quality stone was good enough, but of course this could not be used for highly visible features, such as the costly monolithic shafts used in the 12th century in northern France. For brick buildings, a brickworks had to be set up and the necessary molds made. Large amounts of timber for scaffolding and roofing had to be brought in and treated, so every large building site had its own carpentry workshop. On occasions a master carpenter would direct the whole building process. In addition, the manufacture and repair of metal tools for working on the stone called for a forge. Iron dowels, anchors, and strong clamps to help hold the masonry together also had to be made. All this work had to be efficiently co-

Villard de Honnecourt
Elevation of the nave of Reims Cathedral
Masons' Sketchbook, Paris, Bibliothèque
Nationale, Ms. fr. 19093, fol.3 1v

Strasbourg Cathedral, west façade
Drawing on parchment, between 1365
and 1385, height 400 cm, Strasbourg,
Musée de l'Oeuvre Notre Dame

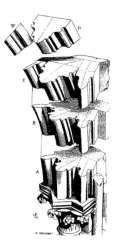

Tas-de-charge vaulting supports, from Viollet-le-Duc, *Dictionnaire raisonné de l'architecture*, 1854–68, vol. IV, p. 93

meant he was then free to put his knowledge to use on other building projects.

The fact that William of Sens was on the scaffolding when he had his accident suggests that this theoretical pre-planning was still not the general rule in the 12th century. But by the mid 13th century such working practices had become more widespread and even gave grounds for complaint. Some observed that, like many a prelate, the head masons merely issued instructions without lifting a finger themselves, and yet were still handsomely rewarded!

For the organization of large-scale building projects, there was a building administration committee, usually affiliated to the cathedral chapter but legally independent. Such committees still exist today in a few cathedrals, such as Cologne and Strasbourg. The office, called the *opus*, *opera*, or *fabrica*, managed the building finances and personnel and concluded contracts with the chief masons. In many cases, as in Strasbourg, the cathedral administration committee had extensive plots of land at its disposal, as well as quarries, and its own sources of income, which made budgeting more flexible. The administrators could hold office for a fixed period

Medieval builders at work, from Rudolf von Ems, *World Chronicle*, ca. 1385, Kassel, University Library, 2° Ms. Theol. 4, fol. 28

ordinated. Even if on average it was somewhat warmer in the Middle Ages than it is today, in the cold winter months building work had to stop as soon as the mortar began to freeze.

An important development in Gothic building practice, however, was that even when the masons stopped building, they continued to work. In the heated stonemasons' workshops, the so-called "lodges," the craftsmen could carry on making a stock of standard-sized stones according to preset patterns. Hundreds of meters of vault ribs, sills, and mullions, all with the same outlines, had to be cut from stone. For many of these parts the masons used templates, which allowed them to mark out the shapes to be cut and later to check the accuracy of their carving. Even the curves of the rib arches could be made in this way. Since these templates either went missing or wore out, there were also large master drawings (often on floors), onto which the important outlines of a building were drawn and permanently scratched. Master drawings of this kind have been preserved in York, for example, and in Clermont-Ferrand and Narbonne.

Templates were a vitally important element in medieval building practice and were even employed in the most complicated areas of Gothic vault construction. This was particularly true in the development of the vault supports into widely splayed out ribs, the use of which solved the extremely complex three-dimensional calculations involved in the so-called *tas-de-charge* building technique (see above) by providing individual templates for the different rib outlines to be fitted together. Basically, a set of templates would be created for each type of vault and then instructions given on their use. This was one of the master mason's most important tasks. Once such standard solutions were found, building work could continue when he was not there, which

or for life, and were accountable to the individual patron. In most cathedrals this was the cathedral chapter, not exclusively the bishop or abbot. Therefore in almost all cases precise accounts would be kept of the building finances. Only a few accounts of this sort have been preserved, notably in Prague, Troyes, Gerona, and

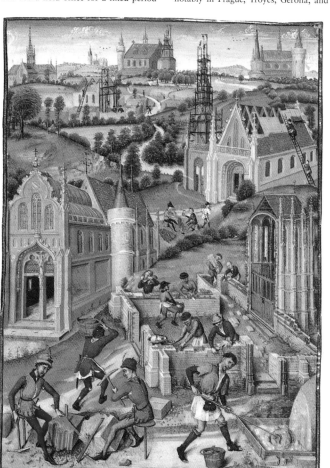

Medieval builders at work, from *Romance of Girart de Roussillon*, Vienna, National Library of Austria

Avignon. They reveal details of prices and wages, periods of employment, and types of contracts.

The turnover of workers was high. This is understandable, for work involved in the construction of a very large building was extremely varied. For the foundations they needed above all numerous unskilled laborers, while to build the walls they sometimes needed only a handful of skilled masons and bricklayers. Moreover, the main sum of money for building came from outside sources and therefore at irregular intervals. Today we would talk of various types of short-term outside funding. This income was gathered from indulgences, special contributions from church offices, votive gifts, collections, and many other sources.

It was not always the plan, of course, to build entirely new buildings. In Le Mans, for instance, the choir was placed alongside the Romanesque nave as an integral part of it. In Toulouse, on the other hand, they built one side chapel after another, while the inner choir was only temporarily finished at half-height and covered with a wooden roof. In Regensburg they proceeded bay by bay and, as protection from the weather, erected a succession of temporary walls.

The masterpieces of Gothic architecture can certainly be seen as expressions both of the power and aspirations of their patrons, and also of the medieval world's faith in the grace of God. But they also clearly reveal that the realization of these beliefs and aims was bound up with a complex network of technical and logistical problems that could be solved only through the application of a wide range of highly developed skills.

Peter Kurmann

Late Gothic Architecture in France and the Netherlands

Church Architecture North of the Loire: Tradition and Innovation

The architectural creativity of France in the period after the building of the great cathedrals of Early and High Gothic is not given the credit it deserves, either in research or in our cultural consciousness. According to long-standing prejudice, after the death of St. Louis in 1270 architects no longer created anything essentially new. At the end of the 19th century Georg Dehio used the term "doctrinaire" to characterize the ecclesiastical architecture of France from about 1270 to 1400. According to him, architects of this period were admittedly capable of achieving remarkable technical feats: the practical experience they had amassed in structural matters had been boldly exploited, and the cutting of stone had never been closer to perfection. But their creations, he argued, were uninspired, their lifeless effects lacking any true originality. In place of creative imagination had come cold intellect and artificial refinement. Was there really a form of Gothic academicism during this period?

It is certainly true that after the rebuilding of the abbey of St.-Denis in 1231 church architecture had reached such a degree of excellence and compositional logic that it could hardly be surpassed. St.-Denis had been transformed into a fine, cage-like structure in which wall space had been reduced to the spandrels in the arcade and in the triforium. The process of unifying the various architectural elements had reached its limit. Thus the shafts in front of the wall carry the front side of the piers on up to the vault, while the tracery of the triforium and the upper windows merge together into one light and uniform background. All the major French buildings of the basilica type after the 1240s are indebted to the newly built St.-Denis. This abbey church set a standard of excellence below which the commissioners of new buildings could not fall. As a consequence, the abbey of St.-Denis brought about a standardization of major ecclesiastical building in France for the next 150 years. It would be wrong, however, simply in view of the formal richness and variety of architectural achievements of this period, to speak of a descent into the doctrinaire, or even the decadent, unless we are to regard refinement and elegance as negative qualities.

The architectural elements that were developed further were mainly the piers and the tracery. The cruciform pier of St.-Denis, with the columns set into the right angles of the cross, was based on the Romanesque pillar. This refinement of an essentially outmoded type of pillar was not destined to succeed. The general development went in the direction of the clustered pier, where the surface of the core was enhanced by the regular alternation of small slender columns and cavettos. The tracery, which in St.-Denis was still composed of four lancets and three round windows, became increasingly complex in the succeeding period. The number of units was increased and, in the crown, complex curves, as well as rounded triangles and rectangles, were introduced in a great variety of combinations.

For the larger episcopal and abbey churches, the principle of the three-storied elevation (that is, a nave with arcades, triforium, and

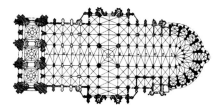

Orléans, Cathedral of Ste.-Croix, begun 1287
Interior (below)
Ground plan (left)

clerestory) remained as a legacy of the "classic" cathedral. But for over 50 years after St.-Denis, no building as large as the classic cathedral was undertaken in the northern half of France. The reason for this was probably the fact that extensive building work had already been carried out: most cathedrals north of the Loire had been renovated fully or partially during the previous hundred years.

When in 1287 the cathedral of Ste.-Croix in Orléans (see right) was begun, it was meant to surpass the classic High Gothic cathedral in its impressive height and breadth. All the longitudinal parts were planned with four aisles, the choir with six bays, and the apse with nine radiating chapels, a record-breaking achievement in architectural luxury since that number had never been reached before. Most of the building work was done between the late 13th and early 16th centuries, though the work has never been completed. Of the original building only the radiating chapels, the exterior walls of the side aisles of the choir, and two full-height nave bays (the middle two of a total of six) are preserved today. Everything else was destroyed by Huguenots in 1568. On the whole the new building, which on account of its consistent adherence to Gothic forms represents an early and outstanding case of historicist architecture, kept faithfully to the character of the two remaining bays of the Late Gothic. Admittedly these date from the 16th century and in individual detail, above all in the composition of the tracery, they certainly deviate from the original late 13th- and early 14th-century choir, which has been lost. In their main features, however, the Late Gothic bays continue the architecture of the original choir. In the radiating chapels, moreover, the builders preserved the original character of the late 13th-century church, which dates back to the Paris architecture of the 1240s.

Right down to individual details, therefore, Ste.-Croix conjures up once again the Gothic of the early 13th century. The large number of very narrow sides of the polygon in the main apse recalls the choir in the cathedral of Chartres while on the outside the buttressing, with its harp-like combination of two flying buttresses, is modeled on the buttressing of the choir at Amiens. The elevation of the nave, in which the triforium occupies a roughly central position between the arcades and clerestory and is not linked to the latter, can be understood as a return to the designs at Soissons, Chartres, and Reims. On the other hand, there are also modern features: the triforium is set in a rectangular frame as at Meaux and Cologne, and in its original arcades Ste.-Croix must have possessed clustered piers. All in all, this testifies to a free selection of elements, a process that from that point on was to be a central feature of Gothic architecture.

The buildings in which there is a consistent development of the architecture of St.-Denis are in Normandy. This area above all, with its regional style strongly indebted to Early English, had long resisted French High Gothic. Yet around 1300 the architecture of the region became one of the finest expressions of the elegant Parisian *style rayonnant*. With the choir of the cathedral of Notre-Dame in Évreux (see page 158, left), a work of exquisite beauty, the renovation of the

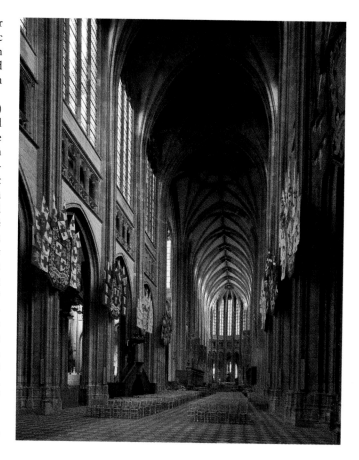

preceding Romanesque building from the early 12th century was completed. It had been substantially damaged by the troops of King Philippe-Auguste in 1195 and 1198 during the conquest of Normandy by the French monarch. As early as the beginning of the 13th century there was talk of rebuilding, but work must have got underway only around 1250. A contract concluded in 1253 between the bishop and canons of Meaux and master builder Gautier de Varinfroy sets down that the latter did not have to work longer than two months per year in the stonemasons' lodge of Évreux. This contract relates to the construction of the triforium and clerestory in the nave, in other words the parts that Gautier built onto the remaining Romanesque arcade area. There is no record relating to the start of work on the choir, which was planned as a completely new building.

With its Gothic stories, the central nave is considerably broader than the original Romanesque nave. Nevertheless, those responsible never thought of demolishing the old nave, as from the beginning

Évreux, Cathedral of Notre-Dame
Choir, begun shortly before 1300
Interior (below)
Ground plan (right)

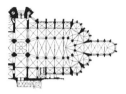

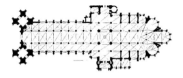

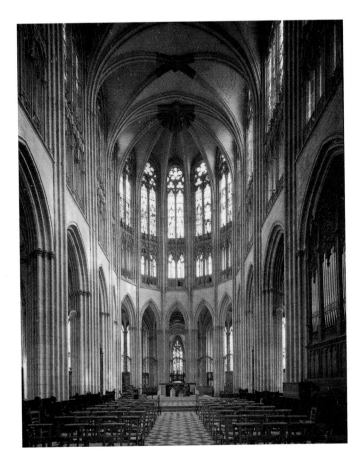

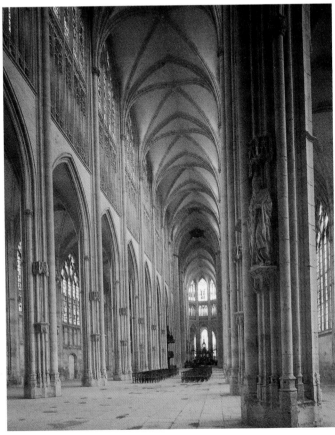

they let the nave walls of the westernmost choir bay meet on the crossing piers. Because of the close positioning of the crossing piers, the view of the choir from the nave is framed very effectively. The arms of the bishops from the period between 1298 and 1310 which decorate the ribs of the high choir vaults have led historians to conclude a date of about 1270 or even 1260 for the start of work on the choir. But why, in that case, do the dedications of altars and stained glass in the ambulatory not begin until the first decade of the 14th century? And why, furthermore, was the glazing of the choir clerestory not begun until the 1330s? These dates suggest that the choir was begun shortly before 1300 and that the bishops' arms on the high choir vault are memorials erected later: they simply recall the two bishops who had begun the building of the choir.

The choir of Évreux proves to be an improved and refined variant of the Rayonnant style of St.-Denis. The Romanesque pillar has become a clustered pier, a single, diagonally set support of a roughly square outline, whose four sides are given a continuous wave of

circular moldings, running in the opposite direction. Every pier profile is meticulously continued as part of a wall support, a vault, or the soffit of an arch. The glazed triforium, the inner arcading of which was altered to Late Gothic almost everywhere, is nearly half as high as the clerestory. This emphasis, unknown in the "classic" cathedral elevation, is perhaps meant to be reminiscent of the high galleries that were part of every large Romanesque church in Normandy. But here this exaggerated passage also has a function in the overall composition. Within the architecture of the Gothic "glass cage," it provides a subtle gradation in the flow of light into the cathedral. While the brightness at the very top streams into the space unfiltered, the high openwork of the triforium subdues it and thereby leads the eye from the clerestory suffused with bright light to the arcade, which is less brightly lit. In St.-Denis, where the translucent triforium merely forms the base of the clerestory, this gradation is less prominent.

The abbey church of St.-Ouen in Rouen, 137 meters (450 feet) long and 33 meters (108 feet) high up to the apex of the central nave

Auxerre, Cathedral of St.-Étienne
Nave, looking west, ca.1320–ca.1400

vault, achieves the dimensions of the gigantic episcopal churches of the High Gothic (see opposite, right). Doubtless the Benedictine monks there wanted to surpass the neighboring cathedral, which is 135 meters (443 feet) long and has a vault height of 28 meters (92 feet). The rebuilding of St.-Ouen was begun in 1318. By 1339 the builders had completed the choir, the exterior walls of the transept, the crossing and the lower story of the tower resting on it, and the adjacent bay of the nave in the side aisle. As everywhere in France during the Hundred Years' War, building proceeded haltingly. The north transept was completed in 1396. Jean de Berneval, who died in 1441, is documented as building the great rose window of the south transept. Only shortly after that, so it seems, were the neighboring clerestory windows added. The nave was built in several stages from the 1450s onwards, and was completed in the first third of the 16th century. The Late Gothic façade, incomplete but highly original, with its towers placed at an angle, received no mercy from the purists of the 19th-century Gothic Revival and had to make way for a sterile piece of work in the years 1846 to 1851.

Despite the many interruptions to the building work, all the architects up to the end of the Middle Ages kept to the original plan of the early 14th century. Only in the window tracery, which in the nave shows the flowing tracery of Late Gothic, is a certain stylistic deviation evident. In the elevation of its nave, the Rouen Benedictine church is related to the choir of Notre-Dame in Évreux, in which the triforium rises up to occupy almost half the height of the area above the arcades. The spandrels of the arcades in St.-Ouen show music-making angels in trefoils painted in grisaille—in other words the builders painted *trompe l'œil* windows on the only remaining section of wall in order to give the impression that the church was made almost entirely of glass.

The apse is built over five sides of an octagon, with the result that, when viewed from the central axis of the nave, only three sides are visible. This end of the choir and the three central, extraordinarily broad, radiating chapels, of which the axial chapel is distinguished by an outer bay, are modeled on those of St.-Nicaise in Reims. Through this model St.-Ouen followed in the wake of one of the classic cathedrals, for St.-Nicaise was a refined version of Notre-Dame at Reims adapted to the dimensions of an abbey church.

St.-Étienne in Auxerre is one of many French cathedrals whose construction slowed down after the choir had been completed before the middle of the 13th century (see page 71). As elsewhere, the construction of the nave and transept took up the whole of the 14th and 15th centuries, during which time the work went at a slow pace because of the economic situation and because of the Hundred Years' War; on several occasions work stopped altogether for long periods. The west front, which the canons began as late as 1547, remained unfinished.

The nave of the cathedral of Auxerre (see right), begun in the 1320s and completed around 1400 with the construction of the

clerestory, was built without any essential changes of plan, and is the equal of the earlier choir. Both of these are masterpieces in their different ways. While the choir enchants by its elegant lightness, the nave impresses through an appearance of unshakable stability. The oblong piers set at right angles to the nave are many times more powerful than the slender piers of the choir. Obviously the architect of the early 14th century had drawn important lessons from the structural damage that made repairs to the choir necessary shortly before 1300.

In the nave the considerable circumference of the piers led to a corresponding thickness of the walls on the ground floor. The arcades with their deep soffits seem to have been carved out from the mass of the walls. Above this robust lower building, pinned between the pipe-like shafts that support the vault, rise the traceried openwork of the triforium and the windows of the upper story, slightly recessed and framed by strong outlines. These upper windows are situated above the triforium on a deep protruding sill. As in the classic cathedral, the triforium and clerestory are thereby clearly separated

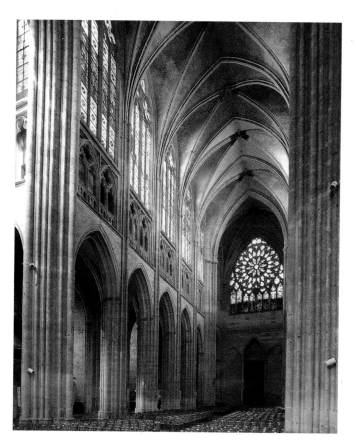

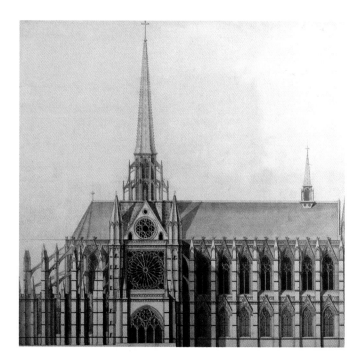

once again. The design of the arcading of the triforium, however, which has two arches per bay, is associated with models of the elegant Rayonnant architecture of Paris dating from the second half of the 13th century. The highly skilled architect of the nave in Auxerre was able to weave all these elements into a new whole that has its own fascinating coherence.

once again. The design of the arcading of the triforium, however, which has two arches per bay, is associated with models of the elegant Rayonnant architecture of Paris dating from the second half of the 13th century. The highly skilled architect of the nave in Auxerre was able to weave all these elements into a new whole that has its own fascinating coherence.

While the nave in Auxerre struck a balance between tradition and innovation, the priory church of St.-Louis in Poissy, destroyed in the French Revolution (1789–99), was given over completely to the past. The elevation of the north side of the nave (see above), prepared by Jules Hardouin-Mansart in 1695, clearly shows how strongly the formal world of the priory was marked by Parisian models from the years 1240 to 1260. The transept façade copied the façade of the Ste.-Chapelle (the original appearance of which the artists Pol de Limbourg and Jean Fouquet captured in their miniatures), and the rose tracery was a repetition of the rose windows of the north front of Notre-Dame Cathedral in Paris. The equal-sized rows of gables in the side aisle windows and in the clerestory evoked both the side chapels of Notre-Dame, as well as the upper story of the royal palace chapel.

As a construction with an ambulatory and seven radiating chapels, but without a two-towered east façade, the priory represented a compromise between cathedral and chapel. The west front will have looked more or less like the smaller sides of the shrine of St.-Gertrude in Nivelles, which on a much smaller scale struck a similar balance between reliquary church and cathedral. The priory was, in effect, a monumental reliquary containing the relics of St. Louis. The formal references to buildings from the time of the royal saint were therefore programmatic. Founded by Philippe the Fair (1285–1314) and begun in 1297, the year in which Louis, at the instigation of his grandson, was canonized, the church and the Dominican monastery connected to it had two purposes: the veneration of the new saint, and the salvation of the founder.

Poissy, Priory of St.-Louis
(destroyed), 1297–1331

BOTTOM:
St.-Thibault-en-Auxois Priory
Choir, ca. 1300
Exterior (left)
Interior (right)

OPPOSITE, LEFT:
Rouen, Cathedral of Notre-Dame
South front, ca. 1300–30

OPPOSITE, RIGHT:
Lyons Cathedral
West front

In complete contrast to St.-Louis in Poissy, though begun only a few years later, the choir of the priory church of St.-Thibault-en-Auxois (see below) is a highly innovative work. It was the result of a building program that from about 1260 onward provided a new choir for the nave and transept, which had been built around 1200. For some strange reason work began with the construction of a costly portal, complete with carved statues, on the north transept, which was seen as the focal point for a pilgrimage that had yet to be established. After the building of two side chapels in the choir in the 1290s, a new chevet was begun that became a showpiece of the *style rayonnant*. Certainly we have here a representative type of chevet frequently chosen in Gothic, one which can be called a "glazed apse," but the obligatory division into ground floor, triforium, and clerestory is re-interpreted here with the greatest ingenuity. Thanks to the blind arcading under the triforium, the ground floor consists of two areas. Moreover, it is treated like the nave of a basilica-type Rayonnant building, with the tracery of the blind arches below and the windows above being linked. In St.-Thibault the actual triforium has a blind rear wall.

Compositionally, the architect thereby achieved two things. First, he prevented the total disintegration of the chevet into a web-like glass cage, and in so doing retained a certain measure of monumentality. Second, by having the triforium blind, he intensified the three-dimensional effect of the glazed passage below, which the casual observer takes for an ambulatory. Thus a high degree of visual illusion is unique to this architecture. Its astonishing character doubtless derives from the desire of the patron to promote a new pilgrimage, to the relics of St. Thibault of Provins.

The church façades planned around 1300 show the broad spectrum of variation in French Rayonnant architecture. In Rouen Cathedral the transept façades, which were built in the early part of the

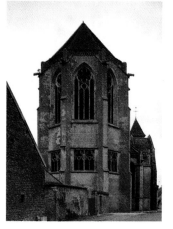

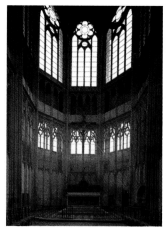

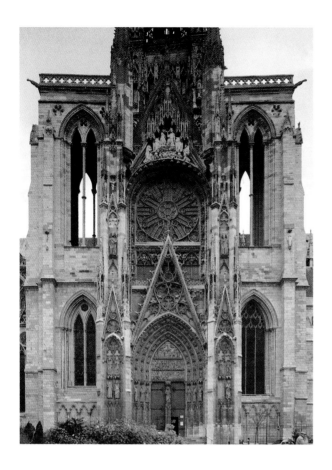

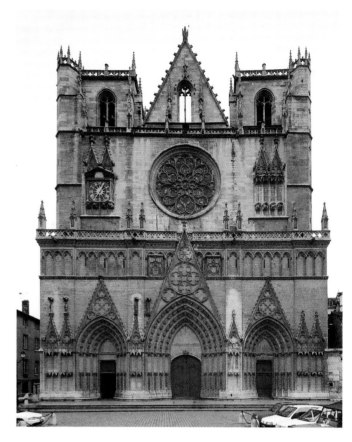

13th century, were out of date, so the central portions of both transept façades were renewed between 1281 and about 1330. The south front (see above, left) is certainly the later one, since in documents from the year 1340 it is called "le neuf portal," or "novissimum portale" (the new portal).

The Rouen façades imitate the two transept façades of Notre-Dame in Paris (see page 89, top) and in each case attempt to adapt to a two-tower façade a model conceived for a transept having a nave without side aisles. The Rouen façades enriched the Notre-Dame model through the development of a more complex pattern of intricate tracery and through the use of sculpture across the whole façade. They also re-interpreted the model by giving greater emphasis to its two layers. At Rouen the front layer consists of the gable of the central portal as well as the tabernacle-like buttress towers that frame it. Higher up, this layer is completed by a gable that stands immediately over the rose window. The back layer is formed by the portal itself, then its tympanum, the triforium tracery, and the rose window. This means that the rose window is set in a shadowy niche, as on the west front of Notre-Dame in Laon. But the rose window's niche is framed by an archivolt with statues, as on the main façade of the cathedral of Reims.

Similarly, the enormous Coronation of the Virgin on the main gable of the Rouen façade is a reference to the west front of Reims, though there the iconic group of figures enlivens the central gable immediately over the portal. A more refined realization of different models is hard to imagine.

Church Architecture in the Southern Half of France: The Adaptation of Northern Models to Local Conditions

During the years the façade of the south transept of Rouen was being built, the west front of Lyons was begun (see above, right). The portal area, with the blind triforium running above it, was constructed between 1308 and 1332, but then building came to a halt. The tier with the rose window was completed only in the 1390s, and the towers were never completed (the surviving lower portions were built in the early 15th century). Nevertheless, the whole façade is executed according to a unified concept, even if this is somewhat simplified in the upper parts. Both in their architecture and in their sculpture, the portals follow the model of both transept façades at Rouen Cathedral. It is probably no coincidence that at Lyons, shortly before the final fall of the town to the French monarchy, they kept to the most modern models of the time from the area around Paris. For the architects of the Lyons façade the motif of the gable, based on both transept façades of Notre-Dame in Paris, was also an important element. Whereas in Paris, however, the chain of gables rises up thin and membrane-like, and detached from the actual wall, at Lyons it appears as part of the façade wall and is treated like a relief. Double-layering effects are eliminated. The extent to which the whole wall is treated as a unified relief is shown by the buttress piers, which have become slim pilasters. The master of the west front at Lyons was obviously tired of playing with the three-dimensional potential of façades, something that was being exploited in a sometimes excessive manner in Parisian-style Rayonnant Gothic.

Bordeaux Cathedral
North front,
ca. 1260–late 14th century
Ground plan (right)

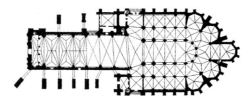

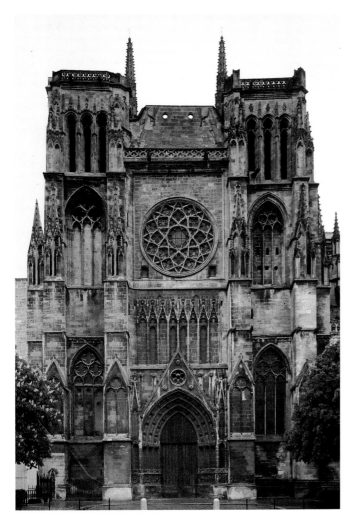

church to the same status as the archiepiscopal cathedrals of Reims and Rouen. As far as the details are concerned, however, the façades, begun shortly before 1300 and, according to tradition, completed under the rule of the English king Richard II (1377–99), adapt in Bordeaux the Parisian *style rayonnant* from the end of the era on which St. Louis had decisively set his seal—even though Bordeaux accommodated itself very well to English sovereignty. These facts warn us to be cautious about hasty interpretations of architectural forms in terms of historical events or political allegiances.

In relation to some cathedral churches in the south of France, such caution has been lacking. Works like the cathedral choirs of Toulouse, Narbonne, and Rodez have been interpreted as a manifestation of a northern French "cultural imperialism." Christian Freigang has shown these interpretations to be erroneous. When these three choirs were begun in the 1270s, victory over the Cathars and the occupation of the region by Louis VIII already lay decades in the past. And when the canons of Narbonne recorded that they wanted "to imitate the noble and grandly executed churches... which have been constructed in the Kingdom of France," they were not affirming that they regarded the cathedral as an architectural symbol of the French kingdom. They were simply recognizing the overwhelming power of the new cathedrals.

In contrast to the cathedrals of Narbonne and Toulouse, that of Rodez (see opposite, left) was almost completed in the Middle Ages, but as a result of a chronic lack of funds the work begun in 1277 was not finished until around 1550. In the first third of the 14th century there was a change of plan which introduced, as its most striking alteration, a type of pier whose shafts merge into the core to form a wave-like curve. This, as well as the blending of the arcade profiles into the wall of the nave, was based on the compositional principle of fusing architectural elements into a compact mass. With this, Late Gothic started to develop in Rodez as early as the beginning of the 14th century.

In the Romanesque period the south of France had already shown a preference in large churches for the simple aisleless church. With the cathedral of Albi (see opposite, right), Gothic architecture created one of the greatest of these churches. The buttresses that line the inside create a continuous row of shaft-like side chapels that almost reach the full height of the vault of the nave. The chevet is formed of radiating chapels also reaching up almost to the height of the main nave, creating a choir of unique beauty.

Unfortunately, everywhere else at the end of the 15th century these "shafts of light" surrounding the great unified space were divided up by galleries and so their impact was seriously impaired. The exterior of the building is largely characterized by the fronts of the buttresses which, protruding as huge cylinders, give the cathedral the appearance of a castle. The obvious assumption is to interpret the fortress-like outer shell of the cathedral as an assertion of Church power intended to impress a town that had long been a hotbed of

The transept fronts of the cathedral of Bordeaux (see above), on the other hand, with their emphatic vertical structuring, are based on classic northern French models. The new Gothic building of Bordeaux was begun in the 1260s with the construction of the choir, whose ground plan is closely modeled on that of the choir of Reims Cathedral. Pierre de Roncevaux, who most likely initiated the new building, had been chancellor at the court of the counts of Champagne before Pope Urban IV imposed him on the canons of Bordeaux as archbishop. It is the ecclesiastical politics of Roncevaux that we see reflected in the ground plan and, especially, in the construction of the twin-tower façades on the transept. With these expensive twin-tower façades Roncevaux raised his metropolitan

Rodez, Cathedral of Notre-Dame,
begun 1277 (below)

Albi, Cathedral of Ste.-Cécile, 1287–ca. 1400
Exterior (below)
Interior (bottom)
Ground plan (below, right)

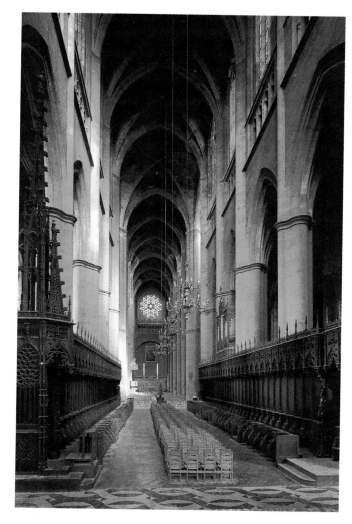

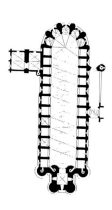

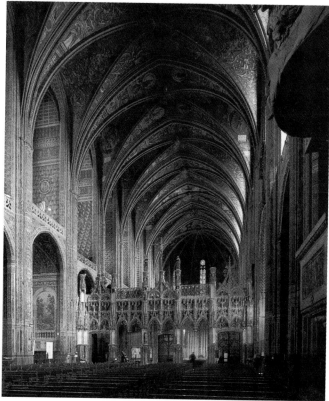

Cathar heresy. A letter of indulgence of 1247 records that the predecessor of the present cathedral had been ruined "by the wars and the heretics." Indeed it was the energetic Bernard de Castanet, Inquisitor of Languedoc and Vice-Inquisitor of the whole kingdom, who, in 1287, on the day after his installation as Bishop of Albi, seized the initiative to build a new church. The choir was completed around 1330. In 1365 the large and clumsy-looking tower, like a keep, was in the process of being built, so that towards the end of the 14th century the nave could be completed.

As we know, one of the main tasks of the Dominicans was that of combating heresy. The order had been founded in 1215 in Toulouse and the general chapter of the order met there every year. In this sense

163

Toulouse, Dominican church
Late 13th century–1385
Interior (below)
Ground plan (right)

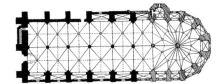

OPPOSITE:
Toulouse, Dominican church
"Palm Tree" detail of vault

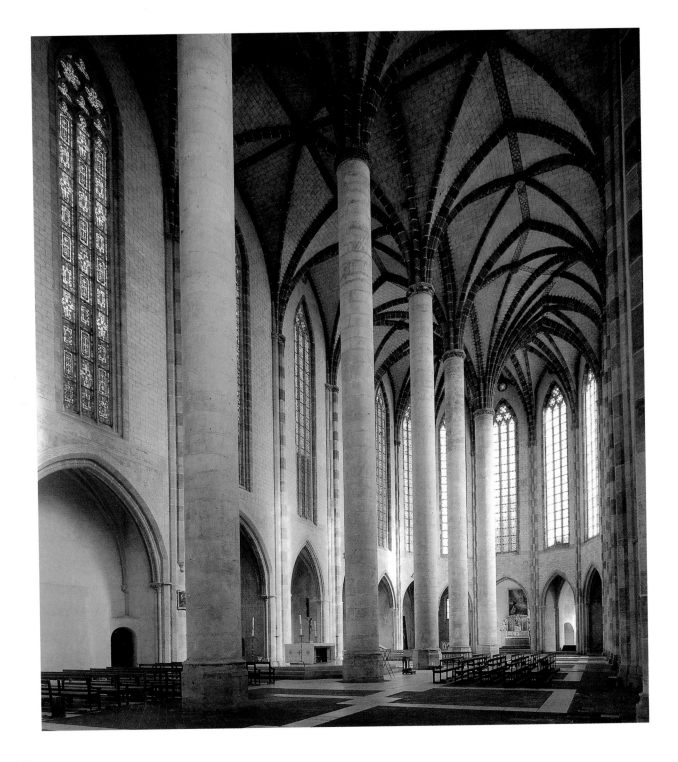

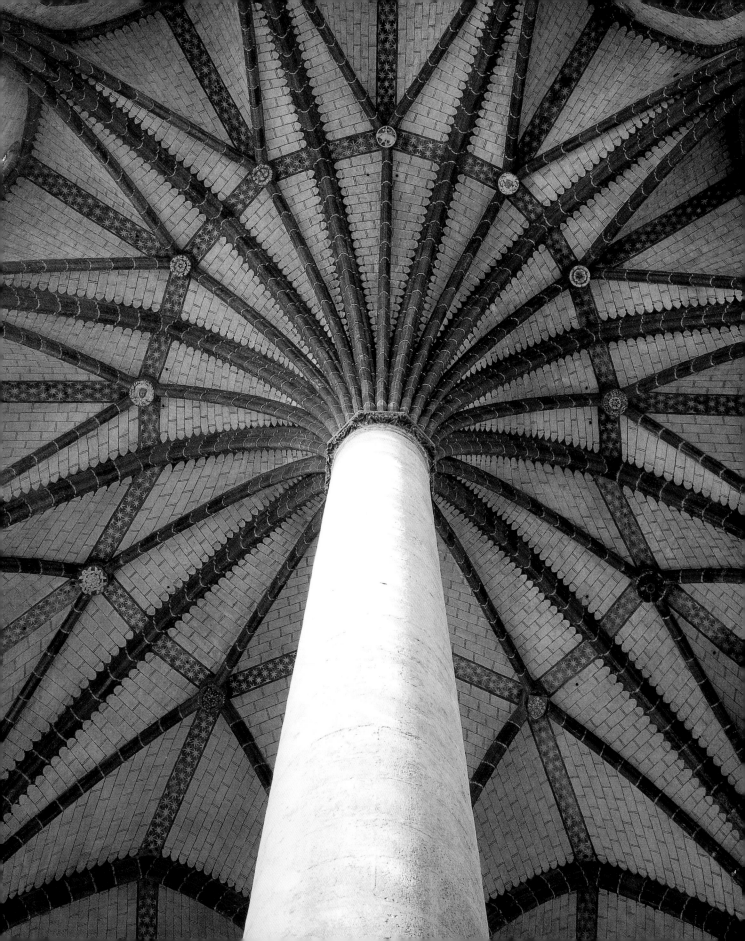

the Jacobin church in Toulouse (see pages 164–65) is the mother church of the order. The French Dominicans had acquired the name "Jacobins" after their first place of assembly in Paris, near a church dedicated to St. James (Jacobus in Latin). Since not a single one of the churches of the mendicant orders has survived in the heartland of Gothic, the Jacobin church in Toulouse is all the more precious.

It is not obvious that it grew in several phases. A first church, begun in 1230 with a double nave, was extended between 1244 and 1263 by two bays and a polygonal apse. This structure was reshaped from the late 13th century into the present-day church, the building being completed at the latest before the dedication in the year 1385. The surprising alignment of powerful columnar piers in the middle of the broad, high space, the magnificent windows stretching up over the low side chapels around the whole building, and last but not least the centered vault of the apse, which from the easternmost pier (popularly called the "Palm Tree") radiates like a star, all create a powerful impression. Here an architectural concept was being developed which, drawing both on Rayonnant shapes and on the two-aisled style frequently employed in the north by the Dominicans, was responsible for the development of the harmonious and monumental church interiors in the south of France.

Court Architecture in the Late 14th and 15th Centuries

We know the names of several artists who from the late 13th century onward worked on commissions from the French king or from members of the royal household. We can hardly describe them, however, as "court artists" in the full sense since the court gave them no commissions that led to the creation of unique or even distinctive buildings.

This changed under Charles VI (1380–1422), however. Although the Paris court had lost much of its cultural pre-eminence, in the closely related satellite courts of the king's uncles, who largely took over the business of government, there developed a love of splendor which had never been known before. Each of these courts attempted to outdo the others. There arose an artistic patronage that required artists to work almost exclusively for these courts and to accommodate themselves to the particular tastes of their patron. One of the king's uncles was Duke Jean de Berry, who had his residences in Bourges, Riom, Mehun-sur-Yèvre, and Poitiers furnished in a princely manner. Part of this involved diverse building schemes, including costly new buildings. His court master mason was Guy de Dammartin, who as a pupil of the royal Parisian architect Raymond de Temple, under whom he had worked at the Louvre.

OPPOSITE:
La-Ferté-Milon, castle, 1398–1407
West side

Guy de Dammartin
Poitiers, ducal palace
Fireplace wall in the Great Hall,
late 1380s

Guy de Dammartin entered the service of the Duke de Berry shortly before 1370, and in Poitiers at the end of the 1380s he restored the Early Gothic palace of the duke's forebears, the dukes of Aquitaine.

The showpiece of this work was the famous fireplace wall with which the narrow southern end of the great hall was newly closed off (see above). The three-part fireplace stands at the top of several steps, like the backdrop of a stage. The gallery above the fireplace was for the use of musicians. A five-part composition of tracery windows with decorated gables fills the upper half of the wall. The fireplace is composed of three separate layers. In the front layer stand the two spiral staircases that overlap the outermost windows. The three middle windows, separated by tall pinnacles, form the second layer. The outermost layer of the wall is defined by glazed lancet windows between which the chimneys rise up. These three chimneys darken the central sections of the three middle tracery windows that form the second layer. Here the play with different wall levels is ingenious. How greatly the patron identified with the monarchy is shown by the statues of Charles VI and Queen Isabelle that stand on the central pinnacles, framed in turn by the statues of the patron and his wife, Jeanne de Boulogne, on the outer pinnacles.

After the Duke of Berry, his nephew Louis, the Duke of Orléans, was one of the most active patrons of this period. Of the half dozen castles that he renovated or constructed during the period from 1392 to his death in 1407, Pierrefonds, which was rebuilt by Viollet-le-Duc in the 19th century, was the most lavish. Louis' intention was not so much to create defendable strongholds as to have comfortable and prestigious residences at his disposal on his visits to his various estates. With Louis d'Orléans, as with Jean de Berry, the step from castle to palace was taken: the fortress had become a country house. This transition is especially evident in the castle of La-Ferté-Milon (see opposite), the building of which stopped in 1407 after the death of the duke. Between the two half-cylindrical, almond-shaped central towers of the west wall a gigantic gateway with a pointed arch opens up. Above this, and situated in a rich architectural frame, is a relief with a theme popular around 1400, the Assumption of the Virgin into Heaven. The use of religious iconography on a castle gateway is very unusual. It is possible that the patron meant his castle to be seen as a secular version of the Heavenly Jerusalem.

After Jacques Coeur, the court banker of King Charles VII (1422–61), had been raised to the nobility in 1441, he had a palace constructed in Bourges that surpasses all town houses of the late Middle Ages (see page 168, left). The west wing of the building, which is in the shape of an irregular quadrangle, has a castle-like extension that uses part of the Gallo-Roman town wall. The east wing and its main portal, on the other hand, create the impression of a palace rich in architectural features. On the roof, a lavish window surmounted by the royal insignia and framed by pinnacles, and, on the staircase tower, the traceried windows of the upper floor stand like elaborate pieces of church architecture. In the canopy above the great entry arch there was originally an equestrian statue of Charles VII. In adorning his house in this way with the royal insignia and the representation of the sovereign, this rich ennobled bourgeois was both demonstrating his fidelity to his employer and placing himself squarely among the members of the nobility. It is no surprise that, in half-open false windows next to the niche with the horseman, the new noble and his lady are watching out for their overlord.

The prestige of the Ste.-Chapelle, constructed by St. Louis, led to some patrons having such a chapel built in their castles or palaces. The indispensable requirement for this was the acquisition of a relic of the Holy Passion. Frequently the Ste.-Chapelle in Paris was also the architectural model, as it clearly was for the Ste.-Chapelle in the castle of Vincennes (see page 168, right, and page 169). King Charles V (1364–1380) began the building of this chapel in 1379, even before he had founded a seminary for it. In 1422, the year his successor, King Charles VI, died, this chapel stood complete apart from the roof, the buttress piers, and the vault; these were added between 1520 and 1550. The Ste.-Chapelle of Vincennes shows in many of its windows, constructed from about 1380 to 1420, early forms of the *style flamboyant*. This name for French Late Gothic is derived from

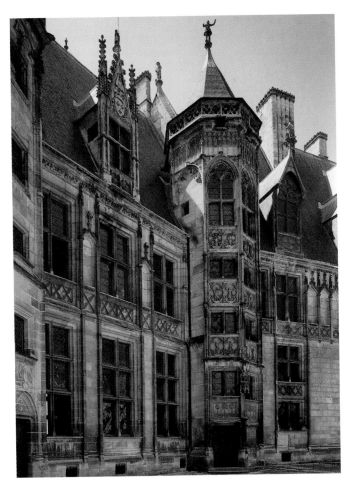

Bourges, Palace of Jacques-Coeur, 1443–53
Inner façade

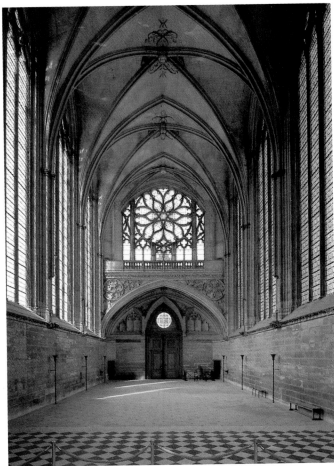

Vincennes, castle chapel, ca. 1375–1550
Interior looking west (Gallery of
Philibert Delorme, 1550)

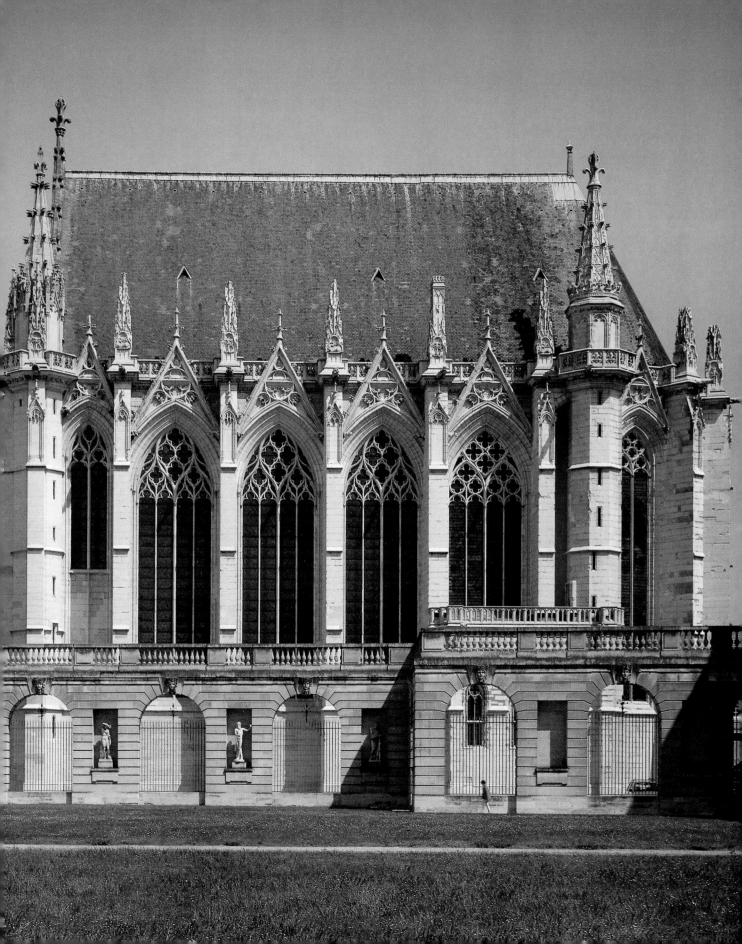

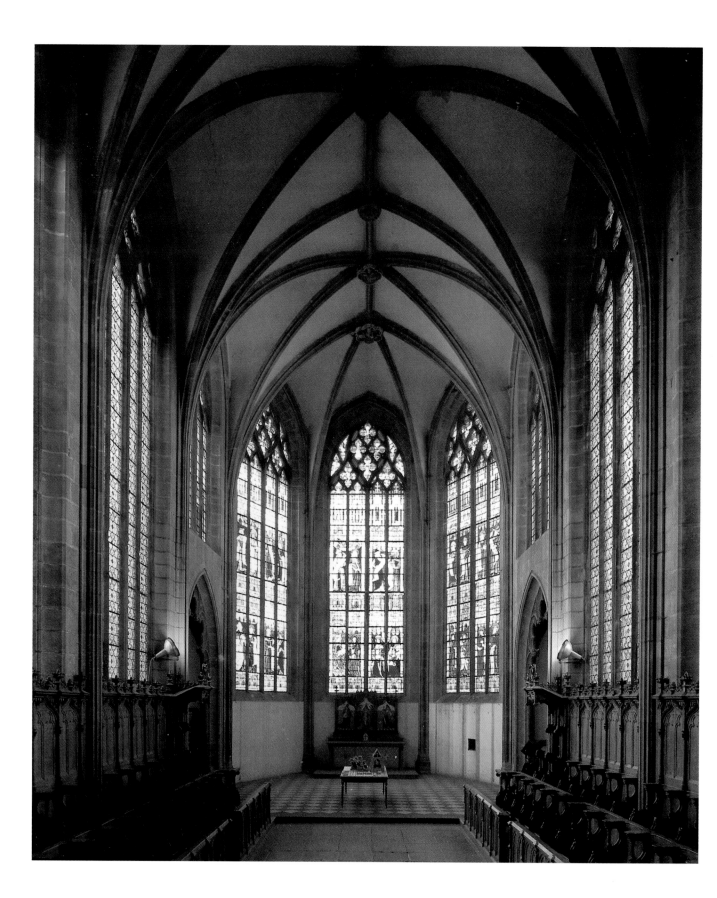

the elaborate patterns of tracery, in which lines flow into each other and are often flame-like in shape. In England, an intricate style of this kind had appeared as early as the late 13th century. Nevertheless, it was not the English occupation of France in the first third of the 15th century that brought about the flowering of this style in France. As the Ste.-Chapelle at Vincennes and the fireplace wall of Poitiers show, the *style flamboyant* had come into fashion in the 1380s.

Duke Jean de Berry also had a Ste.-Chapelle built on the Parisian model in his Auvergne residence of Riom (see opposite); work on it began in 1395. Like its sister in Vincennes, the chapel in Riom consists of only an upper story; in other words it dispenses with the vaulted lower chapel. Because of the somewhat later start to the building, all the windows in Riom now show forms of Late Gothic. Jean de Berry never used the Riom chapel, although it was completed before his death in 1416. Only half a century after the beginning of construction did the heirs of Jean de Berry concern themselves with furnishing the chapel with stained glass.

French Late Gothic After the Hundred Years' War

It is hardly surprising that the architecture of France waned considerably during the first third of the 15th century, the period when the Hundred Years' War was at its most intense and when the English occupied half of France. The realization of large building projects started only after the fortunes of the English were finally reversed in the 1430s. As the country's economy and political structures revived, so in some regions, from around 1450, architecture began to thrive again. Nor did this late flowering of Gothic end when, in the first third of the 16th century, patrons and architects began turning to the forms of the Italian Renaissance.

French Late Gothic was greatly influenced by the construction of large town churches, which were made necessary by a steady growth in the population. The days of the great cathedrals and abbeys, however, was not over yet. There was now further building work at many of them, including those of Troyes, Châlons, Auxerre, Meaux, Toul, Tours, Orléans, Rodez, and Metz. Others, although complete, were remodeled or extended and reached a more up-to-date form. Examples include those at Amiens, Senlis, Sens, Évreux, and Rouen.

In Nantes, however, the gigantic cathedral was totally redesigned and half complete as late as the Late Gothic period (see right). Nantes, which in the 15th century increasingly took over the role of capital of Brittany, wanted to erect a main church appropriate to the town's importance. In 1434 the duke and the bishop together laid the foundation stone of a new cathedral. Building began with the twin-towered west front, which was completed, along with the nave (though not the nave vault), in 1498. But then work came to a halt. Only in the 17th century was the central nave given a Gothic vault and the south transept built and it was only during the period from 1835 to 1891, when the Gothic Revival was at its height, that the cathedral was completed with the building of the choir, together with

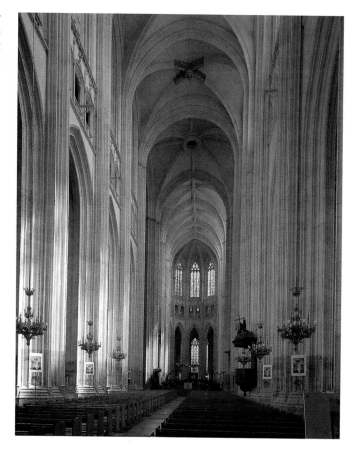

its ambulatory and a newly designed circle of five radiating chapels. Further building in the Late Gothic style was not automatic, for the theoreticians of the Gothic Revival accepted only the forms of the early 13th century. It is a piece of good fortune that the choir of Nantes continues with the repertoire of forms used in the nave, forms which supporters of Gothic Revival thought decadent. In this way France preserved the only Late Gothic episcopal church that, in its overwhelming massiveness, is the equal of 13th-century cathedrals.

Stylistically, the building is representative of Late Gothic. Thus the countless threadlike tori and edges which, alternating with the thin cavettos, determine the surface of the load-bearing structures, run on up into the arches and vaults without any horizontal separation. In accordance with Late Gothic compositional principles, piers, arcade soffits, and vault shafts are fused into single unified masses. Nevertheless the architect understood how to separate the bays clearly from each other, in the spirit of 13th-century Gothic, by designing vaults and shafts as a framework which seems, in

Mont-St.-Michel, abbey church
1446–1500/21
View from the south
Ground plan of choir (right)

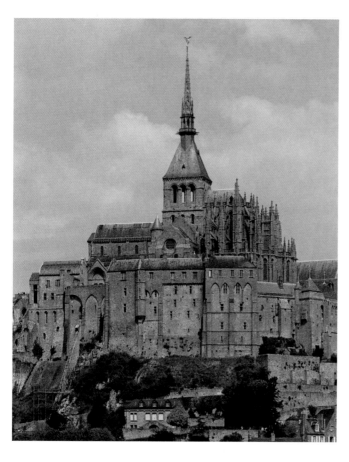

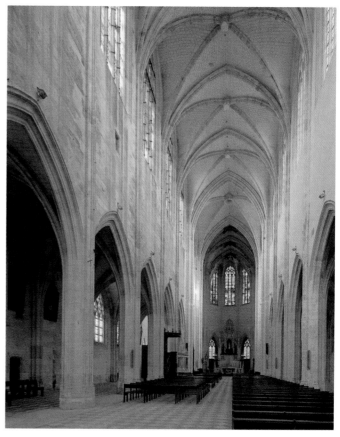

its clear and coherent three-dimensionality, to be quite independent of the walls.

Even the choir of the Abbey of Mont-St.-Michel (see above, left), begun in 1446 but only finished between 1500 and 1521, follows the scheme of the cathedral. With its deep radiating chapels, its high well-lit triforium, its slender vault supports, and its "forest of piers" created by the buttressing, this building proves a translation of the choir of Évreux into the forms of Late Gothic.

Notre-Dame of Cléry (see above, right) was begun in the second quarter of the 15th century and completed shortly after the death of King Louis XI in 1483. Louis gave substantial financial support to the building, raised it to the status of a royal chapel, bought it in 1473, and chose it as his final resting place. The ground plan, with ambulatory but without radiating chapels and triangular vault sections, was influenced by Notre-Dame in Paris. The elevation in the central nave, with vast empty wall surfaces between low arcades and a high clerestory, is that of a monumental parish church.

One of the most significant works from the period of the transition from Late Gothic (which survived a long time in France) to the Renaissance is the nave of the Paris parish church of St.-Étienne-du-Mont, built between 1580 and 1626. With its enormous arcades and low clerestory it repeats in Renaissance forms the layout of the choir, which was built between 1492 and 1540 (see opposite). With pointed arcades cutting into columnar piers, and the "flaming" tracery work of the windows, this nave is still completely indebted to Late Gothic. The enormous heightening of the arcades is reminiscent of the cathedral of Bourges, while the raised gallery in the aisles, which weaves around the smooth pillars like wickerwork, may have been inspired by the cathedral in Rouen. First mentioned in 1541, the unique choir screen, which spans the central nave in a wide openwork arch, is completely in the spirit of the Catholic Church's Tridentine reform of the liturgy, for it allows a clear view of the choir for those attending mass. A stroke of genius is the idea of the two spiral staircases that lead to this choir screen. Winding round the eastern pillars of the

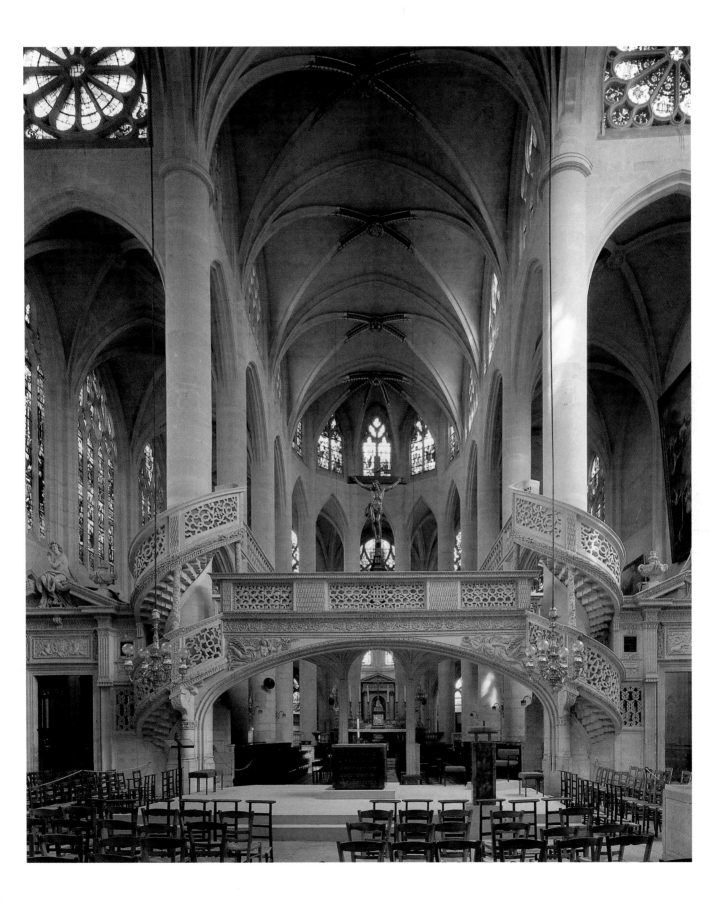

Tours, Cathedral of St.-Gatien
West front, ca. 1440–1537

OPPOSITE, TOP LEFT:
Évreux, Cathedral of Nôtre-Dame
North front, ca. 1500

OPPOSITE, BOTTOM LEFT:
Toul, Cathedral of St.-Étienne
West front, 1460–ca. 1500

OPPOSITE, TOP RIGHT:
Jean Lemoyne
Alençon, Nôtre-Dame
West front, 1506–16

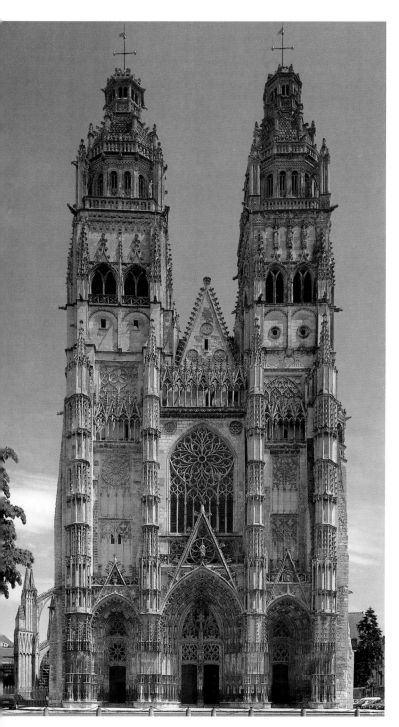

crossing several times, they lead into the gallery surrounding the inner choir.

Those living in the Late Gothic era saw the completion of many churches on which work had been interrupted for a long time. As the luxury of a large main front could normally be afforded only after the completion of the church, the architects of the 15th and 16th centuries were particularly in demand for work on fronts during the Late Gothic era. They often responded brilliantly. One of the earliest fronts of French Late Gothic is that of the cathedral of Tours, on which work was carried out from about 1440 until 1537 (see left). It was only a matter of giving a new finish to a Romanesque twin-towered front. The guiding principle for this embellishment came from the High Gothic fronts of Amiens and Rouen, in which the rows of tall statues in the portal recess, rows that flow around the buttresses, already emphasized the main vertical axes. The openwork gables, the rose window, and the statue niches on the buttresses all give the impression of High Gothic models translated into Flamboyant. The towers, however, introduce a striking contrast. As the center of a region that was open very early to the forms of the Renaissance, a region moreover with many castles, Tours furnished its cathedral front with open-tiered towers whose small crowned domes proclaim the message of the new style far out over the landscape.

Although situated on territory belonging to the Holy Roman Empire, the cathedral at Toul in Lorraine had been closely associated, ever since work on it began in the early 13th century, with the Gothic style of Reims. The west front, completed in the late 15th century, is one of the great achievements of Late Gothic (see opposite, bottom left). Constructed from 1460 until shortly before 1500, according to a unified plan, this west front is also a variation of High Gothic models. More intensively than in these models, however, in Toul the mass of the buttresses is reduced by the angular setting of the side buttresses, which gradually taper as they rise, the result being a unified, rhythmic, and flowing construction. Each tier of the octagonal towers, from top to bottom, is ringed by niches whose tracery is as fine as goldsmiths' work. The huge gables that break up the dividing line of the stories, and especially the large gable above the rose window, deepen the impression of harmonious unity that is especially characteristic of this front.

Normandy has always been a landscape graced with many towers, and it is no wonder that there are Late Gothic examples. During this period, tower foundations that already existed were often completed, as, for example, over the crossing of St.-Ouen in Rouen (see page 177, left). Above the second square story, which belongs to the Early Flamboyant of the 1440s, the octagonal tower constructed under Abbot Bohier (in office 1492–1515) rises like a gigantic crown, surrounded by four corner turrets to which it is connected by elegantly curved flying buttresses. The high octagon that crowns the tower of Notre-Dame in Caudebec-en-Caux, a church begun in 1382, is constructed according to the same principle (see page 177,

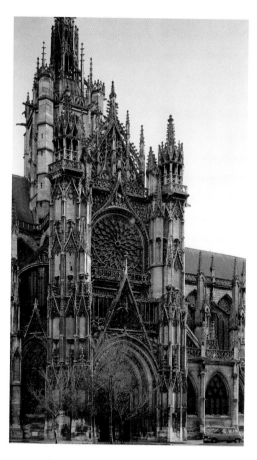

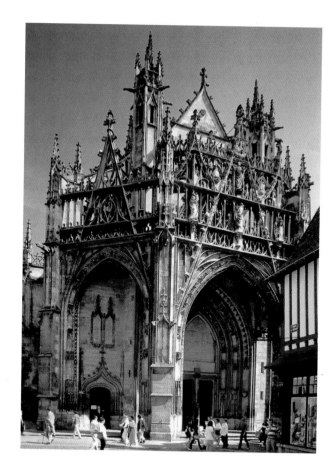

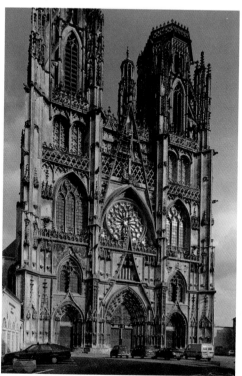

right). Here, however, the number of ornamental turrets is doubled, so that in each case two forked flying buttresses swing out from each side of the polygon. This polygon, begun in 1491, is completed by a spire finished around 1520. Encircled by two crowns, and having sixteen sides as a result of additional changes, the spire is covered in a fine tracery. With such works monumental architecture increasingly approached the "miniature architecture" of the goldsmith.

Although the variations in Late Gothic fronts are enormous, they are almost always new interpretations of older models. The north transept façade of Évreux Cathedral (see above, left), begun around 1500, and a sparkling display of flowing tracery shapes, would not be conceivable without the south façade of Notre-Dame in Rouen, 180 years older. The transept façades of the cathedral in Sens (see page 176), constructed between 1490 and 1517, enable the central rose window, despite its integration into a gigantic tracery window, to return to the prominent position it had lost since the end of the 13th century. On the west side of Notre-Dame in Alençon (see above, right) the porch, which since the 12th century had occasionally been included in Gothic façades, achieves dominance by covering the whole of the end wall. The vaulted front section, crowned by filigree tracery, has the appearance of a gigantic choir screen. This clearly illustrates one of the results of having a free choice of the most varied possibilities, an important concern of Late Gothic. As motifs become interchangeable, less and less consideration is given to their meaning. In Alençon, something normally a part of the "interior decoration" has become a dominant part of the exterior.

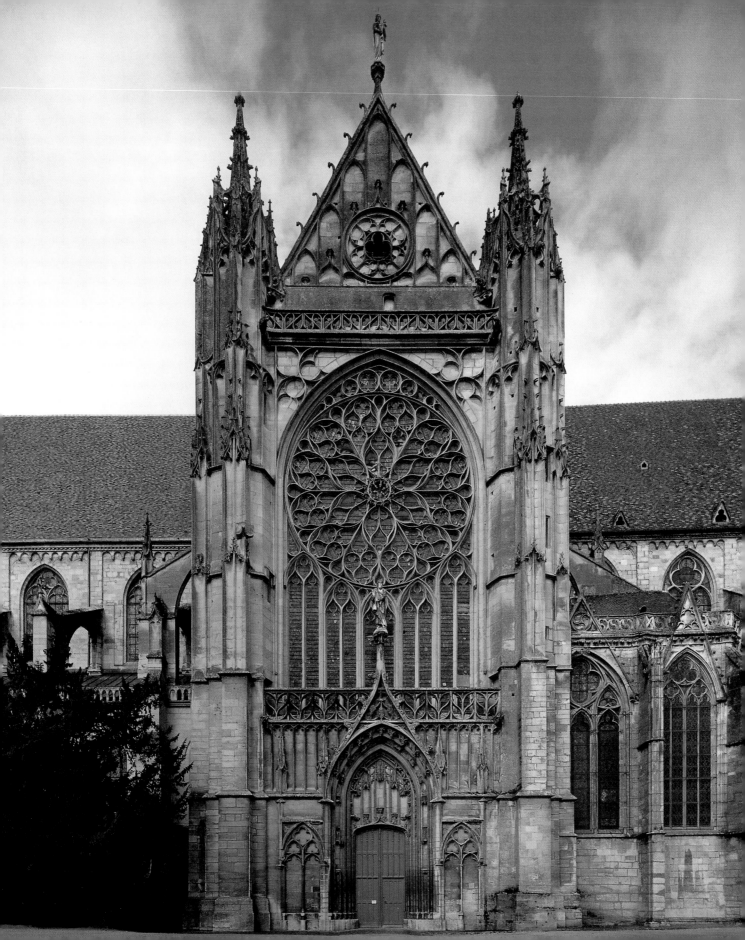

OPPOSITE:
Sens, Cathedral of St.-Étienne
South transept front, 1490–1512

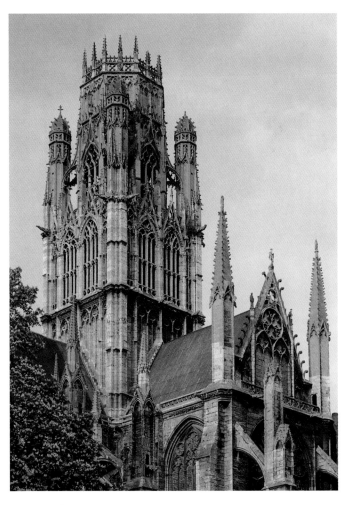

Rouen, St.-Ouen
Crossing tower, ca. 1440–1515

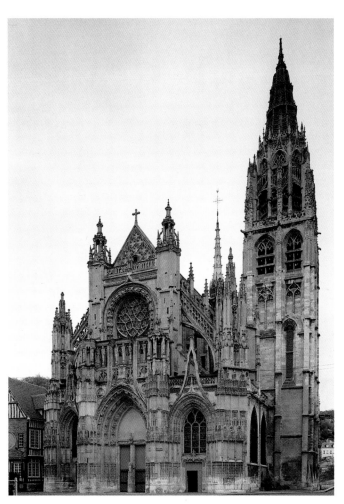

Caudebec-en-Caux, Notre-Dame
Façade with tower
1382–late 16th century

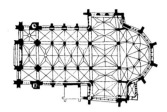

Late Gothic Architecture in the Netherlands: Architecture as an Expression of Civic Self-Confidence

Historically, the Netherlands, or the Low Countries, covered what is now Holland, Belgium, and the northernmost part of France. Throughout the Middle Ages the Netherlands formed a distinctive cultural entity even though it was divided linguistically and politically. Thus the king of France ruled over Dutch-speaking Flanders, while French-speaking Hennegau and Brabant and Holland belonged to the Holy Roman Empire.

The decisive influence on the art and architecture of the Netherlands was the exceptional economic success the area enjoyed during the late Middle Ages, with early forms of industrialization and capitalism developing from the end of the 13th century, particularly in the cloth and wool industries. As part of a developed money economy, the ruling groups in the towns and cities became economically and politically powerful, and through their unprecedented wealth sought to create imposing monuments to their success. These often took the form of fine buildings, secular as well as sacred. In areas where stone was available, this led, from the 14th century onwards, to buildings distinguished by rich architectural ornamentation. In the coastal areas of Flanders and Holland, on the other hand, where there was an absence of stone, a brick architecture was created which in its monumental sparseness reflected on an aesthetic level the somber monotony of the flat landscape.

From the beginning, the Gothic church architecture of the Netherlands was modeled on the major cathedrals in the neighboring regions of France—Artois, Picardy, and Champagne. Thus as early as the beginning of the 13th century the large churches built in the area of the Schelde and Maas were based on the typical French design—a large aisled church with transepts, choir, and ambulatory, whose nave was three stories high (arcades, triforium, and clerestory). This model was nevertheless simplified in one important respect: instead of being supported by *piliers cantonnés*, the arcades are supported by simple round columns. The decisive factor here was probably less the sturdy round column used in many earlier, 12th-century French buildings than the slim pillar-like support which, on the threshold between Early and High Gothic, was used in Soissons Cathedral as well as in some Cistercian churches (for example Longpont and Villers-la-Ville).

A particularly beautiful example of Early Gothic architecture in the Netherlands is the collegiate church of Notre-Dame in Dinant on the Meuse, in what is now Belgium (see above, left). Built between 1227 and 1247, the choir, when measured against contemporary buildings in the heartland of French Gothic, displays some old-fashioned characteristics such as group windows instead of tracery windows and vault ribs that rest on corbels. The triforium, however, with its slim arcades, is similar to those at Soissons, Chartres, and Reims. The slender columns of the arcades in the apse, allowing an unobstructed view of the large windows in the ambulatory (which

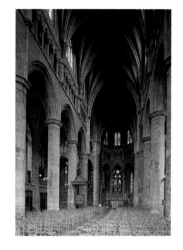

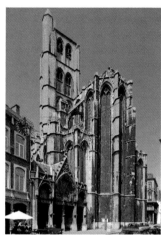

has no chapels), are particularly refined. Here the area behind the choir arcades was translated into an elegant light-filled shell, a characteristic feature of French architecture since Abbot Suger's abbey church of St.-Denis.

The former collegiate church of Mecheln, now a cathedral, was started with the choir in 1342 (see opposite, left). Here a church type was created which was to be repeated many times, a type characterized both by the adoption of the style of 13th-century French cathedrals (though without the two towers at the west front) and by the use, above all in the interior, of a rich decoration consisting mostly of delicate tracery elements. The ground plan of ambulatory with seven radiating chapels and the three-story elevation of the nave followed classic French models.

Particularly in its columns, the collegiate church of Notre-Dame in Huy (see above, right), built between 1311 and 1377, also follows the Soissons example from the late 12th century. But the thin, grid-like triforium arcades, as well as the gallery in front of the clerestory, are probably derived from the regional Gothic architecture of Burgundy. The choir in the form of an apse without ambulatory, as well as the two mighty towers flanking the choir, are reminiscent of 13th-century churches in Lorraine (for example Toul Cathedral and St.-Vincent in Metz). On the outside, there is an impressive east end which provides a clear contrast between the slender soaring windows of the completely glazed choir and the flat square towers, with their ponderous succession of low stories whose windows are for the most part blind.

The strong round columns, the only element of regionalism here, form the solid foundation of a delicate, filigree architecture. A thin, closely interlaced, network of tracery was used to cover the inside of the building with a single coherent layer, which appears not only on the usual elements of the elevation, but also on the spandrels of the

Mecheln, St. Rombaut, begun 1342
Ground plan (right)

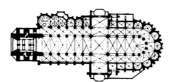

Antwerp, Liebfrauenkirche,
begun 1352
Ground plan (right)

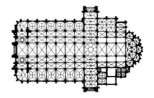

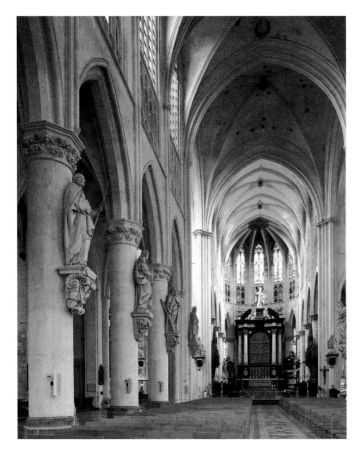

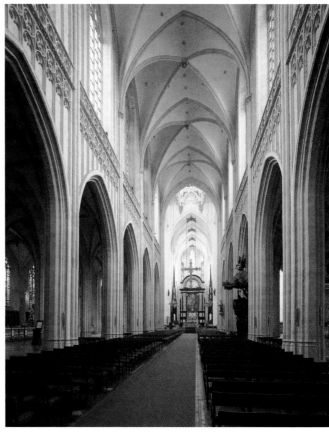

arcades; it veils the triforium and fills the windows of the clerestory and the blind sections of wall alongside.

Such fine latticework, which uses the arch- and foil-shapes of the French *style rayonnant*, here made its first appearance on Continental Europe. In England this decorative principle had been used a little earlier, and with equal consistency, in the reconstruction of the Romanesque choir of Gloucester Cathedral (see page 146), work on which began in the 1330s. Just as at Gloucester, at Mecheln the Romanesque structure was covered with a Gothic filigree net consisting of small units of tracery that spread over the three-part elevation. English influence cannot be excluded. Indeed, the patterns on the arcade spandrels and the sections of wall above them look like enlargements of the wafer motif familiar in English church architecture since the 13th century. In Mecheln, English decorative exuberance and a French basic plan came together in a new unity. The result is the so-called "Brabant Gothic," a style which did not, however, remain restricted to Brabant.

The second large church building in the Brabant style, the Liebfrauenkirche in Antwerp (see above, right), was begun in 1352, its design a reaction to that of Mecheln. Here "stretched bays" characterize the ground plan. In other words, here in Antwerp the usual transversely oblong nave bays used in Mecheln were replaced by bays extended longitudinally. There are no other such examples in basilica construction except in the Mediterranean Gothic architecture of Italy and Catalonia. This arrangement results in a broad hall-like space that stands in marked contrast to space created in the usual Gothic cathedral. In contrast, the ground plan of the apse, with its ambulatory and five radiating chapels, follows the example of Reims Cathedral. The high veil of arcades inserted between the flying buttresses on the outside of the choir chapels is also reminiscent of Reims.

Internally, however, the elevation in Antwerp is divided into just two stories. The arcades are supported by compound piers, not by round columns as at Mecheln, and the overall height of the elevation is accentuated in its middle by a horizontal band of tracery above the

179

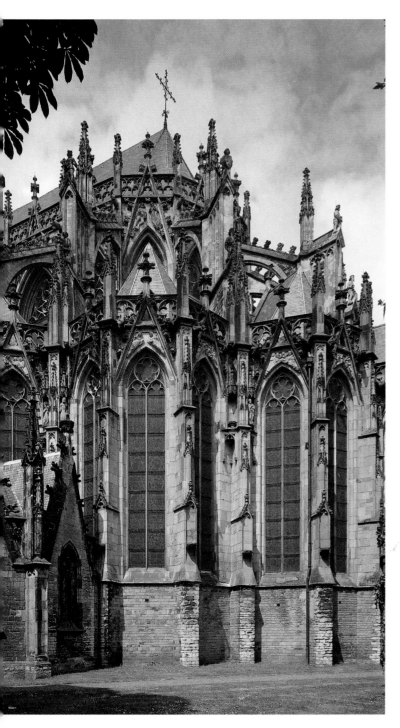

Willem van Kessel
s'Hertogenbosch, St. John,
begun 1370s
Choir

arcades. The windows are positioned in deep niches which are linked in their lowest section by a tunnel-like passageway that runs through the wall. This form of double-layered clerestory wall is of a form that was standard in 11th- and 12th-century Anglo-Norman Romanesque architecture and later was even a feature of English Gothic architecture. The Antwerp clerestory bears comparison with the one in the west end of Wells Cathedral from the 1180s; the same model was also used in the transepts of Chester Cathedral in the 1340s. This form of clerestory does not open up the whole of the space across the bay in favor of stronger wall sections.

As at Mecheln, the areas of the wall above the arches are covered with ornamentation. In contrast to the slightly older example of Mecheln, however, Antwerp includes not just a close-knit pattern of decoration, but also a series of identical lancets that stretch down to the nave arches, their points and rosettes, together with the quatrefoils of the balustrade, forming a clear horizontal band along the elevation. Ultimately this pattern of decoration had also originated in England. The walls of the transept in Chester would need only to be covered with the small decorations and foil forms of the kind dating from between about 1290 and 1330—as originally found, for example, in the window spandrels of St. Stephen's Chapel in Westminster Palace in London—to produce the elevation of Antwerp.

Yet Antwerp Cathedral is anything but an unimaginative copy of English models. Its apse, its buttressing, and its dual tower façade show that it remains deeply indebted to French Gothic architecture. Moreover, the forms taken from English architecture are interpreted in an original way. The decorative lattice placed on the walls, for example, does not become an independent surface hiding the structure of the building. On the contrary, all the decorative elements are subordinate to the important structural elements. This emphasis on structure, together with the hall-like expanse produced by the long bays, produces impressive architecture. The monotony of its forms is intentional. It is evidence of a fundamental attitude which, in the final instance, strives for overwhelming monumentality, something also characteristic of the High Gothic architecture of France.

Brabant Gothic architecture was the only form of European architecture of the 14th and 15th centuries which successfully combined English and French elements in a purposeful way. In Antwerp Cathedral, in particular, this resulted in a work of supreme harmony and balance. Even so, most of the later major buildings of Brabant Gothic architecture followed the three-story classic elevation of Mecheln and did without the double clerestory wall with passageway. Nevertheless, the architects of particularly lavish buildings considered Antwerp to be a model in one respect at least: the use of compound piers rather than round columns. St. John's church in s'Hertogenbosch (see left), begun in the 1370s, was designed to compete with 13th-century models such as the cathedrals of Amiens and Cologne, particularly in the richness of the decoration used on the outside. The figurative decoration of the buttressing and the

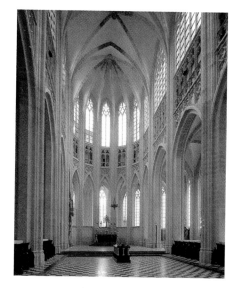 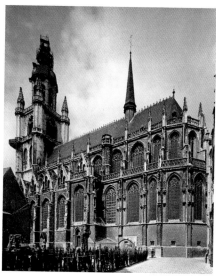 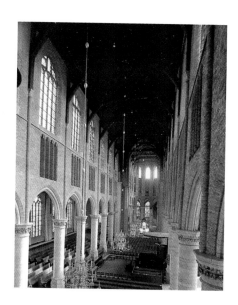

gablets over the windows (now completely renewed but following the original design) is unique.

St. John's church, which is, after Mecheln and Antwerp, the most important creation of Brabant Gothic architecture, became a decisive influence on several subsequent buildings. This is true above all of two collegiate churches: St. Peter's in Louvain (see above, left), where building started around 1400 and the choir was completed no later than 1448, and St. Waudru in Mons, begun in 1450, and in effect a copy of St. Peter's, built 50 years earlier.

Not all lavish Late Gothic buildings in the northern Netherlands were based on a cathedral model, however. The choir of the pilgrimage church of Halle (see above, center), built 1389–1409, is an aisleless church with chapels that are set between the pier buttresses. What looks like an ambulatory from the outside turns out to be merely a row of chapels. But the niches in the clerestory wall and their partial veiling with free-standing tracery latticework clearly show that English examples were once again put to use (a comparable church is that of Bridlington in northeast England, dating from the last quarter of the 13th century).

The choir of the Nieuwe Kerk in Delft (see above, right), erected between 1453 and 1476, also displays this systematic use of niches in the clerestory wall, which has windows only in its upper half. Originally tracery veils covered the blind part of the niches, as can be seen from the traces of fixings in the soffit profile. With its sturdy round columns, ambulatory, and triforium arcades set under the nave windows, the interior of the choir of the Nieuwe Kerk must have been more like the collegiate church in Mecheln at that time than is the case today. The west end of Notre-Dame du Sablon in Brussels, begun in

the second half of the 15th century, also copies the example of Mecheln, while the choir, which was begun in 1400, is still very much in the tradition of the French 13th-century Gothic "glass cage."

As these and many other examples show, real development stopped in the Netherlands around 1350. The deliberately conservative references to the classic High Gothic cathedral found their expression, until the end of the 15th century, largely in an adherence to the French *style rayonnant*. Even the monastery church of Brou near Bourg-en-Bresse (see page 182, left), built from 1513 to 1532, is a conservative building in architectural terms, despite its stellar vault. Designed by the Brussels architect Loys van Boghem, it was commissioned by the Habsburg regent of the Netherlands, Margaret of Austria. Here contemporary Late Gothic architecture is represented primarily by the opulent decoration running wild on the roodscreen, choir stalls, and the famous tombs. There has been little attempt so far to seek an explanation for this backward-looking architecture, but it is clear that the rich patrons preferred to stick to tried and tested models and were not willing to entertain extravagant styles.

It is no coincidence that the Gothic architecture of Brabant mostly rejected the complicated stellar and reticulated vaults which were being built everywhere else in the 15th century. In this respect, the sober middle-class groups ruling the wealthier towns and cities exercised an important influence not only on the parish churches, but also on the urban collegiate churches. In Antwerp and Brussels, the same family names crop up in the lists of the collegiate chapters as in the register of the town magistrature, and in Mecheln and Louvain, the tower of the collegiate church was also the *stadstoren*, or *beffroi municipal*, the place where all important municipal documents were

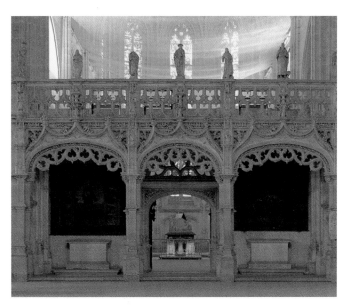

Loys van Boghem
Brou, monastery church, 1513–32
Roodscreen

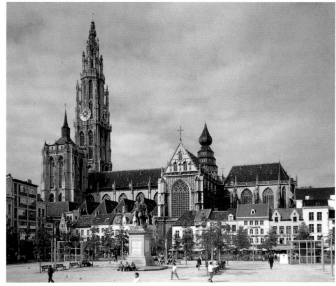

Antwerp, Liebfrauenkirche,
begun 1352

kept. This function coincided with that of being the architectural symbol of the town and its citizens, a fact that helps to explain why the late medieval church towers of the Netherlands became virtual skyscrapers. Since the municipality placed great value on high church towers, façades with two towers tend to be the exception in the Gothic architecture of the Netherlands.

Even in Antwerp, where the large collegiate church of the Liebfrauenkirche was given a huge, five-axis west front with two towers, and was thus built in the manner of the "perfect cathedral," only the north tower was finally built to its full height, in the first quarter of the 16th century (see above, right). It is of outstanding beauty, its delicate structure making it look like a great piece of delicate goldsmith's work. As on a Gothic monstrance, slim pinnacles surround the top two stories, which are linked to the octagonal body of the tower and its transparent crown by delicate tracery bridges.

The character of the Antwerp octagon, as for many other towers in the Netherlands, was established by Utrecht's cathedral of St. Martin (see opposite, bottom left). Begun in 1254 on the basis of the classic High Gothic cathedral (Tournai and Cologne can be quoted in this context), this cathedral was given a huge west tower in the 14th century, which was built in front of the west end. The tower collapsed in 1674. As a single tower 112 meters (368 feet) high, it did not fit into the standard concept of a Gothic cathedral, but it must nevertheless have been highly impressive. Not for nothing was it depicted in the paradisiacal landscape which surrounds the worship of the mystical Lamb of God on the *Ghent Altarpiece* of the van Eyck brothers (see pages 408–409).

The tower of the Liebfrauenkirche in Breda (see opposite, top right), built in 1468–1509, is also indebted to the Utrecht model. Like the Utrecht tower—and almost all other Netherlands towers—it does not have the pierced pyramidal spire that crowns the great towers of German Gothic churches. Since in the Netherlands the towers have several square stories, and are thus proportionately much higher than German towers (see Freiburg Minster, page 200), the octagon is considered to be the real conclusion, even if an onion-shaped wooden dome is placed on top, as in Breda and elsewhere (in Breda the original dome dated from 1509, but the dome was rebuilt with a changed shape after a fire in 1702).

Many of the great church towers of the Netherlands were conceived from the beginning as square blocks. Thus the tower of the collegiate church of Aire-sur-la-Lys (see opposite, bottom right) is by no means an isolated case. Constructed between 1569 and 1634, it imitates the large church towers of the neighboring town of St.-Omer, built in the 15th century, that is, the tower of the abbey church of St.-Bertin, which collapsed in 1947, and the tower of Notre-Dame Cathedral. After being destroyed in war, the upper sections of the tower were rebuilt in 1735–50 in a stylistic mixture of Gothic and Renaissance forms, a combination that must have characterized the tower from the beginning. The tower nevertheless remains indebted in its structure to the principles of late medieval architecture—a good example of appropriate restoration at the time of Louis XV (1715–74).

Gothic secular architecture appeared in particularly magnificent forms in the Netherlands, no great surprise in view of the wealth and political self-confidence of the middle-class groups who governed the

Breda, Liebfrauenkirche, 1468–1509

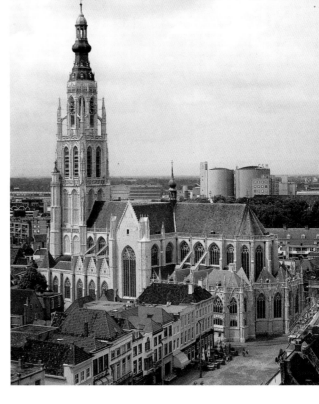

region's towns and cities, groups which played an important role in civic life. Also important were buildings such as hospitals and other charitable institutions.

One of the earliest surviving monuments of this kind is the large infirmary of the Van de Bijloke (in French, de la Biloque) Cistercian abbey in Ghent, dating from 1228–29 (see page 184, left). Its dimensions are 16 by 55 meters (52 by 180 feet), and the wooden vault rises to 18 meters (59 feet). These are the dimensions of a major town church. And as in a work of sacred architecture, the longitudinal walls are pierced with complicated tracery windows while the blind and narrow east wall is covered by monumental murals of the Last Supper and the Coronation of the Virgin, works dating from the mid 14th century. These images were meant to encourage those who were sick or old to partake of the sacrament of the Mass so that they too, like the Virgin, might enter Heaven.

Along with city walls, the large communal building projects of towns in the Netherlands were the "halls" (*hallen*) and town halls. The halls had a dual function as warehouses and as meeting rooms for the community. In addition, they were often also town halls in the modern sense, in other words administrative centers. As the expression

of civic pride often took the widely visible form of huge towers in the Netherlands, these *halletoren*, or hall towers, acquired more or less the same function as church towers and became more and more like them in appearance.

There is no fundamental difference between the cathedral towers of Utrecht or Antwerp and the towers of the Bruges cloth halls or the town halls of Brussels and Arras. The main architectural problem was the same: how to create a harmonic balance between the square base of the tower and the octagonal crown. In Bruges, the cloth hall and the two square stories of the belfry were built in the last third of the 13th century (see page 185). Not until 1482–86 was the tower with the octagon raised by more than a third; until 1741 it was even crowned with a spire.

The construction of Brussels town hall was begun in 1402 (see page 186), along with the base of the tower. The foundation stone of the octagon was laid by Charles the Bold in 1449, work being completed in 1454. In its elegance, this secular building far outstrips contemporary religious architecture. The octagon, divided into three transparent stories, rises up unhindered between the four strong free-standing pinnacles that conclude the base and emphasize its corners. Exceptionally for a Netherlandish tower, it is, like many of the towers on German cathedrals, topped by a tracery spire. With its rows of façade statues, its tracery windows, and, above all, its elaborate tower, whose design was undoubtedly influenced by religious goldwork, in particular tower reliquaries, Brussels town hall comes very close to religious architecture.

The same is true of the tower of Arras town hall (see opposite, right), which was started in the 1450s and completed in the late 16th

century. Although the octagon is more compact than the one in Brussels, it draws on the same source of inspiration. This is evident in the conclusion of the octagon in the form of a stirrup crown. Louvain town hall (see page 187), built in 1448–63, also owes its spectacular appearance to the proximity of secular design in the form of the small-scale architecture of the goldsmiths (though this was largely made for religious use). Since the town hall does without a tower—the tower of the nearby collegiate church acts as communal bell tower—the building was given the shape of a shrine. With its excessive decoration, abundant niches for statues, high-pitched roof, and slim pinnacles on the narrow sides, it does indeed recall the architecturally designed reliquaries that were so popular during the era of High and Late Gothic.

Bruges, Cloth Hall,
last third of 13th century–1486

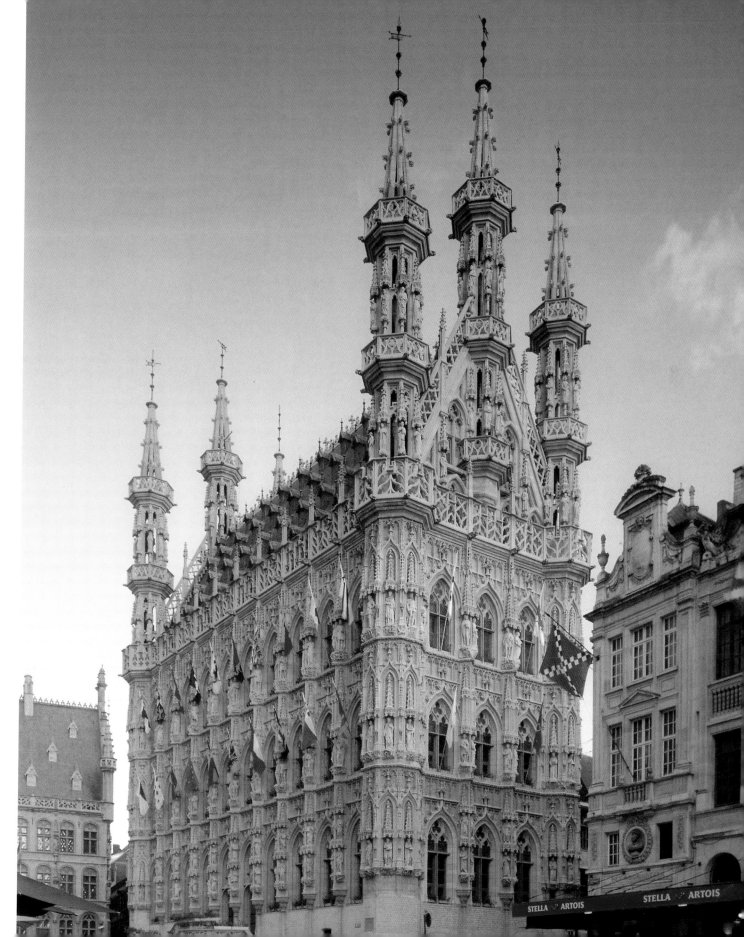

Christian Freigang
The Papal Palace in Avignon

The residence which the popes built in the southern French town of Avignon in the 14th century was then, as it is now, one of the largest fortified palace complexes in Europe. With the arrival of the papacy, the town itself suddenly became an important metropolis, making it the equal of London, Paris, Barcelona, Naples, or Prague.

Church and secular dignitaries had expensive residences built. One of the few remaining examples is the core building of the Petit Palais (Small Palace), at the north end of the large square in front of the Papal Palace. It was the residence of Cardinal Arnaud de Via and served as the bishop's palace after his death in 1335. The town's churches were likewise replaced by large new buildings.

Merchants, diplomats, lawyers, and, not least, artists from all over Europe met in the rapidly growing town, in which Pope Boniface VIII founded a university in 1303. In order to provide protection against the marauding *grandes compagnies* (armies of former mercenaries from the Hundred Years' War, 1337–1453), the city walls were reinforced and considerably extended in the mid 14th century, though, as a telling expression of the new age, gardens and parks were also laid out during this development.

What led to the remarkable transformation of Avignon? In 1274 the pope had been given the neighboring territory of Venaissin (formerly governed by the Counts of Toulouse) at the end of the campaign against the Cathars (see pages 116–117). When Clement V took up residence in Avignon in 1305 on the advice of the French king, following conflict with the German emperor and growing political turmoil in Rome, he was thus also the temporal ruler of neighboring Venaissin. Clement's successor, John XXII (1316–34), Bishop of Avignon, moved the papal government permanently to Avignon, using as his residence the old bishop's palace which was situated to the south of the cathedral of Notre-Dame-de-Doms.

It was not until the papacy of Benedict XII (1334–42) that a start was made on construction of the new imposing papal fortress, with the Palais Vieux (Old Palace), situated to the north, used in place of the bishop's palace. The former consisted of four long wings around an inner courtyard. A further free-standing wing was attached at the southeast corner, and the complex was concluded with the building of the so-called Angel Tower. Clement VI (1342–52) extended

Avignon, Papal Palace, north sacristy of Great Chapel, mid 14th century

Avignon, Papal Palace, papal bedchamber with frescoes, ca. 1343

and regularized the site by extending Benedict's free-standing wing by two blocks, which now formed a further courtyard, the Grand Cour, in the southern part of the palace. Later building work that deserves a mention includes, above all, the laying out under Urban V (1362–70) of the large gardens on the east side of the complex.

Following the return of the popes to Rome in 1377, the anti-popes of the Great Schism continued to use the residence. From the 15th century onwards it was the residence of papal legates. Its contents were plundered during the French Revolution, when the *bastille du Midi* barely escaped destruction. Considerable damage was also done in the 19th century when the fortress was used as a prison and archive. Comprehensive restoration work did not start until 1906.

There are numerous documents relating to the finances of the palace. These refer to many of the craftsmen involved in the development of the Papal Palace. Pierre Poisson from Mirepoix near Carcassonne, for example, was taken on as the master of works; Jean de Louvres, who is thought to have come from the north of France, was employed on the extensions under Clement VI. But few conclusions can be drawn from these documents as to the precise function and historical importance of the building.

With its mighty walls and towers, the Papal Palace is, first and foremost, a formidable castle: in his capacity as temporal lord the pope required real and appropriate protection. But the extensive fortifications were also a means of displaying Church authority. Other examples of this can be seen in the papal fortress in Villandraut in southwest France, in the

town palace of John XXII in Cahors, and in the bishop's palace in Narbonne.

Like most of these residences for princes of the Church, Benedict's palace did not place great value on a strictly regular plan, in contrast to many castles of the French king (such as the Louvre,

Avignon, Papal Palace and cathedral of Notre-Dame-de-Doms
Ground plan

and the castles in Vincennes and Carcassonne). This element of display in the Papal Palace in Avignon is illustrated in particular by those sections of the building constructed under Clement VI. It becomes especially clear in the façade of the large western square, where the large blind arcades in the lower zone are combined with features such as the distinctive towers, cantilevered at half height and crowned with pointed spires, which emphasize the main entrance. Such

towers framing main entrances are found in France in many castles belonging to temporal rulers of this time. Furthermore, it was the measures undertaken by Clement VI that unified the palace complex, giving it a more regular layout based on the two large courtyards.

Overall, the architecture of the Papal Palace is restrained; exquisite finery appears in only a few places. Even if the huge rooms such as the 16-meter (52-feet) wide Great Chapel of Clement VI in the south wing are technical masterpieces of the art of vaulting, the individual structural elements and the tracery profiles mostly remain sturdy and forcefully rounded (see bottom left). This comes as a surprise, particularly in view of the slender pillars and rich inventive tracery in use in southern France at the end of the 13th century. The Papal Palace primarily represents functional architecture that was quickly adapted to the daily

life and ceremonial of the papal court. This represents the real innovation of the building. When the popes returned to Italy at the end of the 14th century, they used the Avignon plans for the new residences that were being created there, eventually even for the extensions of the Vatican Palace.

In the Palais Vieux of Benedict XII, the most important public functions are grouped round the courtyard surrounded by open loggias: the conclave wing in the south and the living quarters of the papal retinue in the west, followed by the papal chapel in the north wing. The Trouillas Tower, situated at the highest point, contained storerooms and coal cellars, food stores, and, above all, the armory. The great kitchen was between the main rooms of the palace in the east wing and the large consistory, above which was the main dining hall. The Curia met in the former, while large formal receptions were held in the latter.

But where were the pope's private chambers? They were in that south-facing extension which, connected to the large dining room, at first contained two smaller assembly rooms, the parament chamber, where ecclesiastical vestments were kept, and the small dining room. Finally, to the south, came the private chambers of the pope in the so-called Angel, or Papal, Tower. Here the pope had his bedroom and his *studium*, his private study. The Angel Tower was an independent unit whose other stories, containing the treasure chamber and library, were linked vertically. These private chambers, which were situated on the periphery of the main building, opened out into successively more lavish rooms culminating in the large dining room. This arrangement was something new and is evidence of a clearly defined

courtly ceremonial employed at the papal court at this time. It was probably based on the model of Catalonian castles, in particular the royal palace of Almudaina in Palma on Majorca.

This ceremonial also involved the building of a loggia overlooking the inner courtyard, another new element in French castle architecture, seen here for the first time. The loggia and courtyard were linked by a broad flight of steps. Under Clement VI, these changed ceremonial requirements were in fact incorporated expansively. Other changes included

extending the private papal chambers by the addition of a giant audience hall and a new papal chapel in the south wing. The link between them was provided by a new and magnificently painted chamber, the famous Chambre du Cerf ("Stag Room"). From the Great Chapel in the upper story the pope would enter a landing which contained the largest and most elaborate window of the palace, the so-called Indulgence Window (restored). A new pope was crowned in an anteroom to the Great Chapel and then, from the so-called Benediction Loggia, he dis-

pensed indulgences and blessings to the large crowd gathered in the courtyard. Visiting dignitaries could approach the pope by means of the broad ceremonial flight of steps. The ceremonial developed at the Majorcan court clearly served Clement VI as the model for this sequence of courtyard, flight of steps, loggia, and court chapel.

The Papal Palace was originally richly decorated, though little of this decoration has survived. Among the most important elements were frescoes by Matteo Giovanetti, who between 1336 and 1368 was the papal court painter. Benedict XII almost certainly called him to Avignon from Viterbo. The fact that an Italian painter, probably from the Sienese school, was employed to undertake such comprehensive painting work is characteristic of a new international appreciation of the arts. English sculptors were working in Avignon at the same time, sculptors from Pisa were working in Barcelona, and in Prague commissions were being given to Italian painters and mosaicists. This phenomenon shows the international fame that outstanding artists enjoyed. The huge frescoes that Matteo and his fellow painters executed in the consistory and the large dining room were unfortunately destroyed in the Middle Ages.

The only works to be preserved are the paintings in the adjoining chapels of St. John and St. Martial and in the private apartments of the pope. The painting of the large audience chamber remained unfinished. The frescoes in the chapels depict the lives of these saints. The most famous of the frescoes are in the Chambre du Cerf, which were probably executed with the help of French painters. These depict the courtly entertainments of falconry, stag hunting, and fishing in the breeding pond (see left), which all seem to be taking place in a light forest where various kinds of tree grow. They create the illusion that the observers are themselves taking part in the scenes.

A similar illusion is created by the murals in the papal bedchamber (see opposite page, bottom right). Here over a painted lower register, which creates the illusion that the murals above are wall hangings, the high walls are completely filled with intertwining creepers and leaves, in between which birds can be made out. Painted birdcages wait to be discovered in the window niches; they are mostly empty, as if awaiting the return of their occupants, now flying in the palace gardens.

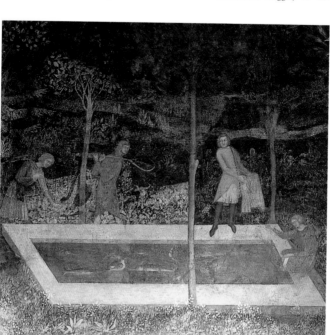

Avignon, Papal Palace
Fishing, detail of fresco in Chambre du Cerf, 1343

189

Pablo de la Riestra

Gothic Architecture of the "German Lands"

The Nature of German Gothic

The Gothic architecture of northern France was not taken up quickly in Central Europe. Once it had become established, however, it became almost indigenous. It is no surprise that Gothic architecture was for a long time thought to be a German creation. Nineteenth-century art history put paid to that idea, but in this cultural area Gothic art continued for some time to be seen as the natural expression of the German spirit.

The character of German Gothic architecture, often misinterpreted for a variety of reasons, is subtle. We might therefore consider a few problems in advance, though without going into too many of the finer points of art history. Gothic architecture did not primarily establish a completely new cathedral form, but rather a vocabulary for the development of a whole visual culture, one that enriched architecture and gave it a new depth. In the Gothic architecture of northern French cathedrals—which cannot of course be seen as the only form of Gothic architecture—the technical and expressive aspects of architecture were developed by each new building. Thus building tasks that had not been very successfully carried out previously, such as the construction of a tower, were solved efficiently and eloquently in Gothic construction. The direct influence of such solutions on German architecture can be seen in the Cathedral in Breisgau. Cologne Cathedral, on the other hand, reveals a more original and independent response to Gothic. Here the choir, though modeled on the choir at Amiens, represents anything but a passive reception of French Gothic, for it refines its model in many points of internal and external construction. This led to the creation of a cathedral choir that is seen as the quintessence of the Gothic choir. At Amiens Cathedral, by contrast, the choir was far less successful, though the nave wall came close to perfection.

Among the other important achievements of Cologne Cathedral are the dual towers of the west front. Designed shortly after the choir, they already represent a marked divergence from French Gothic. Similarly, the huge elevation of the west front (see page 202) is without doubt the most original design of the Middle Ages (it was for financial rather that technical reasons that it was never completed). Likewise, the uncompleted southwest tower, on which building work was resumed in the 19th century, was to be the largest and most daring of all medieval towers.

The relationship of Cologne Cathedral to other church buildings of German Gothic was completely different from the much closer relationship that existed between French cathedrals. No church on German soil follows the Cologne type closely, though many of its elements provided the basis for the creation of diverse and highly original buildings in which quotations from Cologne appeared in new contexts. The double aisles, for example, might be quoted in order to create the effect of a hall church, while the clerestory, columns, tracery, and many other elements were also used, notably in the churches of Minden, Lübeck, Verden, Wetzlar, and Oppenheim.

Of significance here is the fact that, unlike French Gothic architecture, the Gothic architecture of Germany is not fully represented by cathedrals, that is, bishop's churches. Not that there were no Gothic cathedrals built in the Empire—Magdeburg, Strasbourg, Halberstadt, Prague, and Regensburg are examples. But Gothic architecture tended to be used for churches similar to cathedrals in style but not built as cathedrals: Xanten, Aachen, Erfurt, Ulm, Berne, Frankfurt am Main, Vienna, Kutna Horá, and others. Even more common are churches that are built with the dimensions of a cathedral but not in the "cathedral style," such as Lübeck, Rostock, Gdansk (Danzig), Stralsund, Cracow, and Munich, the St. Nicholas churches in Wismar and Stralsund, St. Peter in Riga, St. Martin in Landshut, St. Peter and St. Paul in Görlitz, St. Ulrich in Augsburg, St. Anne in Annaberg, and very many others.

One of the most important problems is the issue of major German cathedrals not built in the northern French cathedral style, a group which includes Lübeck, Verden an der Aller, Schwerin, Augsburg, Wrocław (Breslau), and Meissen. Whether or not any type of church, cathedral or parish church, appears "in the guise of a cathedral" depended on a specific set of circumstances, circumstances that can be explained only on an individual basis. But the fact that so many of these church buildings were not in the cathedral style is itself an important indication that German church architecture points in a different direction from French Gothic. This can be seen in the relationships between the bishop's churches. Just as the power structures in France were increasingly centralized, so religious architecture was increasingly unified (of course this still allowed a great deal of variety in French Gothic architecture). In Germany, by contrast, bishops often enjoyed greater independence, politically and architecturally.

So what we understand today as the architecture of the "German lands" (which was something quite specific, despite regional variations and the discontinuities of political geography) was quite distinct from the architecture of France. This is true even though German church architecture in the Gothic era can at first glance be seen as a simplification of the northern French version. Its forms are generally clearer and its structures fundamentally simpler: many German Gothic churches do not possess a transept, ambulatory, or radiating chapels while, in terms of elevation, many are constructed as hall churches (in which the aisles are as high, or almost as high, as the nave). As hall churches have a self-supporting structure, this means that the buttressing needed for the clerestory of a basilica church (pier buttresses and flying buttresses) is unnecessary. It also means that there is rarely a triforium between the arcade and the clerestory. Even in such an overpowering basilical structure as the cathedral in Magdeburg, which has a tall and clearly defined clerestory, there are no flying buttresses (see page 106). Basilicas such as Ulm Minster and St. Nicholas' Cathedral in Lüneburg were given flying buttresses as late as the 19th century, but more to complete them stylistically than to provide support.

Also largely absent from German architecture are the monumental portals with their elaborate sculpture cycles which played such an important role in French Gothic. The few that do exist, such as Magdeburg or Freiburg, are overwhelmed by the façade. This reveals another important difference between the Gothic art of Germany and that of France. In Germany the portal was denied a central role in the design as a whole but as a consequence German sculpture acquired an extraordinary richness, concentrated on the interior, where it had greater freedom to develop and was far less dependent on specific architectural features. There are a few examples of German portal sculpture, such as the Frauenkirche in Nuremberg or St. Kilian in Korbach, but it is no coincidence that the finest German portal is Strasbourg, the German cathedral closest to France.

But if so many of the characteristics of "true" Gothic are missing, what are the distinctive characteristics of German Gothic architecture? The political and religious objectives associated with Gothic architecture in Germany were on the whole quite different from those determining the building of churches in France. Thus it is unreasonable to point to the absence of specific architectural developments elsewhere, developments not relevant in Germany because of different historical circumstances. One example is the absence of complicated apses with ambulatories and radiating chapels, which occur seldom in the Romanesque architecture of Central Europe and are a rarity in its Gothic architecture. Equally, there are features of German Gothic, such as the double choir, which one would not expect to find in a French cathedral.

Whenever German architects adopted the Gothic architecture of northern France they distanced themselves from it in order to embark on new artistic directions. In doing so, they brought about an extraordinary enrichment of European architectural history. We might even say that in many cases German Gothic architects began where French architects left off.

Thus it is wrong to interpret the various developments of German Gothic architecture as "a particular lack of unity," as claimed by the architectural historian Norbert Nussbaum. We need to look at German Gothic architecture in terms of its own distinctive identity and cultural geography, not at how it deviated from any "standard" form of Gothic but at how it developed historically—and, most significantly for German architecture, where.

This brings us to another issue. Largely because of 20th-century history, the whole question of "German" Gothic is a difficult one for many German historians (of whom this writer is one by academic training, but not by nationality). It is true that the history of the German empire was, as Ernst Schubert has observed, the history of "an empire without a capital," in which diversity was more significant than centralization. The empire lacked the structures necessary for creating a coherent state, in particular, the continuity provided by a clearly defined dynasty. Moreover, it is important to realize that what we understand today as Germany has little or no relevance to

the corresponding concept in the Middle Ages. The modern notion of the nation did not exist, and even concepts like "empire" and "Germany" had quite different meanings.

In looking at the architecture itself, we come to the surprising conclusion that examples of German Gothic architecture are preserved in ten countries: Germany, Austria, Switzerland, Italy (South Tyrol), France (Alsace), Luxembourg, Poland, Latvia, Estonia, and the Czech Republic. In addition, there are more or less isolated enclaves such as Transylvania which must be included at least in part. In Denmark and Sweden, too, Gothic architecture is closely connected with that of northern Germany. If postwar German historians, sensitive to the feelings of their neighbors, refuse to accept the idea of "German" architecture beyond the borders of Germany, for example in Poland and the Baltic, the result is an unjustified diminution of the subject. As Hans Josef Böker has pointed out, it is absurd, when attempting to study the architecture of such areas, to rule out as "somehow inadmissible" the link between, for example, their Gothic brick architecture and that of northern Germany.

Yet another problem is the remarkable diversity and tenacity of local cultures in the German Middle Ages. This, together with the region's profound political fragmentation, has meant that the concept of something specifically "German" is hard to grasp. There are, of course, no simple solutions to these problems of definition. Yet it must be remembered that there were, at least in some regions, cultural frontiers that were clearly visible in the past. Otherwise a north German like Hans von Waltenheym would hardly have made the following remarks in 1474 about the town of Freiburg in Üchtland, which he described as "the most invincible and fortified town which I have ever seen... A merry town, half German and half Latin."

Despite the busy exchange of goods and ideas in medieval Europe, a deep cultural divide did separate German-, French-, and Italian-speaking regions. The question of cultural exchange between German areas and their neighbors such as the Low Countries, the Scandinavian countries, and above all the states in east-central Europe is complex. In the case of east-central Europe in particular, it is not a case of cultural exchange or influence. Here, on the contrary, there were several historical factors that led to the establishment of a German architecture by means of a German presence. These factors include the introduction of Christianity and territorial conquest by the Teutonic Order of Knights, the presence of the Hanseatic League (not only on the Baltic coast), and the numerous communities of German settlers and merchants. Bohemia, now the Czech Republic, was shaped from 1310 onwards by the accession to power of the Luxemburg dynasty. This influence was most marked under Emperor Charles IV (emperor 1355–78), who turned Prague into a major city. For his principal architectural projects, Charles brought the famous architect Peter Parler from Swabia. This period, in which "the periphery became center" (Ferdinand Seibt), was to have a profound impact on the development of European architecture.

So the plural "German lands" in this text is intentional. The singular, if it were more than merely a fiction, is undoubtedly an expression of modern developments and concerns. The glory of the Middle Ages is expressed above all in its variety and ever-changing many-sidedness, a feature which distinguishes that period sharply from our modern world.

Although there is no formula for recognizing the boundaries of German Gothic architecture, a view from outside Germany can be helpful, particularly if this is not from immediately neighboring countries but from further afield. It is significant that the art historian Georg Dehio (1850–1932), the great cataloger of German culture, came from Tallinn in Estonia, that distant Hanseatic enclave whose culture was closely linked to that of the German heartland. It was precisely his view from the periphery that enabled him to develop a sharpened sense of the great variety and vitality of German architectural forms and cultural landscapes, to evaluate them objectively, and to integrate them into a whole.

If there is one thing above all that characterizes the Gothic architecture of central and northern Europe, it is its lack of an inherent classicism, indeed the absence of any reference at all to the classicism of antiquity. In view of the clear desire during the Middle Ages to recreate the Roman Empire in the form of the Holy Roman Empire, this lack of classicism may seem paradoxical. Architecture and visual culture as a whole, even the imperial eagle, that most Roman of motifs, were transformed north of the Alps into something diametrically opposed to the classicism of antiquity. Despite the stated intentions, the result was the creation of a culture that was in effect an independent alternative to antiquity—Gothic art and architecture. It was a culture which, though the most distinct from classical antiquity, was still profoundly European, not least because the initial impulse came from France, but also because most of Europe was integrated into the structure of the Latin Church. For a graphic summary of these differences, we need only to set the Pantheon in Rome next to Freiburg Minster.

It is not my intention to provide a systematic and detailed account of the spread of German Gothic religious architecture and the subsequent innovation in its forms, nor to provide a panorama of a supposed evolution of German Gothic. Since space is limited, it seems more sensible to present a selection of religious and secular examples to illustrate the variety of ideas put into practice and the modernity of the solutions reached, that is, to focus on the specific, and highly original, contribution these regions made to European architecture.

Lübeck and the Baltic

The town of Lübeck played the leading role in the economic organization of the Baltic. Between the 13th and the end of the 15th centuries, it was the most powerful town in that vast geographical area. This preeminence finds clear expression in the architecture of the town. A free town of the Holy Roman Empire from 1226, it was

BELOW:
Lübeck town hall (on left),
mid 14th century
Choir of Marienkirche (on right),
1277–1351

BOTTOM:
Lübeck town hall (foreground)
Marienkirche (left background)

the seat of a weak diocese, the bishop having no temporal power. This meant that the town council consisted solely of wealthy merchants, men made prosperous by the Hanseatic League (*caput et principium omnium nostrorum,* "the head and source of all that is ours"), which was based in the town. There had been no founding act for the League, which developed gradually, and it is not mentioned in documents until 1358, though it had played a key role in the town's prosperity since the 12th century.

Lübeck is built on an almond-shaped peninsula measuring about 2 by 1 kilometers (1.2 by 0.6 miles), the center of which is slightly higher (see page 264, bottom). Six east-facing churches dominate the skyline through their seven large spires, an image of unsurpassed power intended to signal to other towns the futility of any attempts at competition. The construction of the Marienkirche (see right, and pages 194–195) was due to the initiative of the town's merchants, suppliers of capital to, and administrators of, the stonemasons' lodge. The merchants quickly came into conflict with the cathedral chapter over the question of the right to elect candidates to the parish office, a heated dispute that in 1277 caused the bishop to flee to Eutin.

The layout of the town reflects this constellation of power graphically. The cathedral, the bishop's seat, is on the southern edge of the town and has the appearance of being pushed to the sideline. The Marienkirche, on the other hand, rises in the center of the town, the town hall demonstratively at its side, so that together they form an impressive combination. Clusters of little towers and copper spires (see right), which stand like permanent masts and pennants, create the impression of a festively flagged city.

The history of the Marienkirche's development is a reflection of its patrons' energetic striving for monumentality. The previous building, construction of which was already at an advanced stage, was to be a hall church with a single tower. Shortly before the church was finished, this design was rejected in favor of a much larger basilica with two towers. Construction began in about 1277 and was completed in 1351; the towers are 125 meters (342 feet) high, the nave 40 meters (78 feet) high.

In its ground plan and elevation the new church is a French Gothic cathedral, yet these elements were transformed into a completely new style that had very little to do with France. This is not, as is sometimes naively assumed, because it is built in brick. The history of Gothic architecture in the German lands shows that buildings with extraordinarily complex structures can be built from brick (examples include Prenzlau, Neubrandenburg, and Tangermünde). In addition, the brick basilica of another coastal town, the Onze Lieve Vrouwkerk in Bruges, begun just a little earlier than the Lübeck church, is in a completely different style. So the distinctive appearance of Lübeck's Marienkirche is the result of a definite architectural intention, not a mere consequence of the materials used. It appears to be the case only that brick enforces certain shapes on the design. The brick churches built in northern Europe are characterized by absolute clarity of

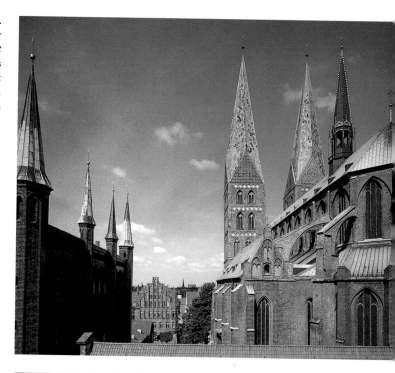

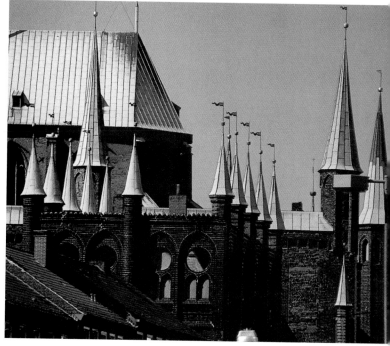

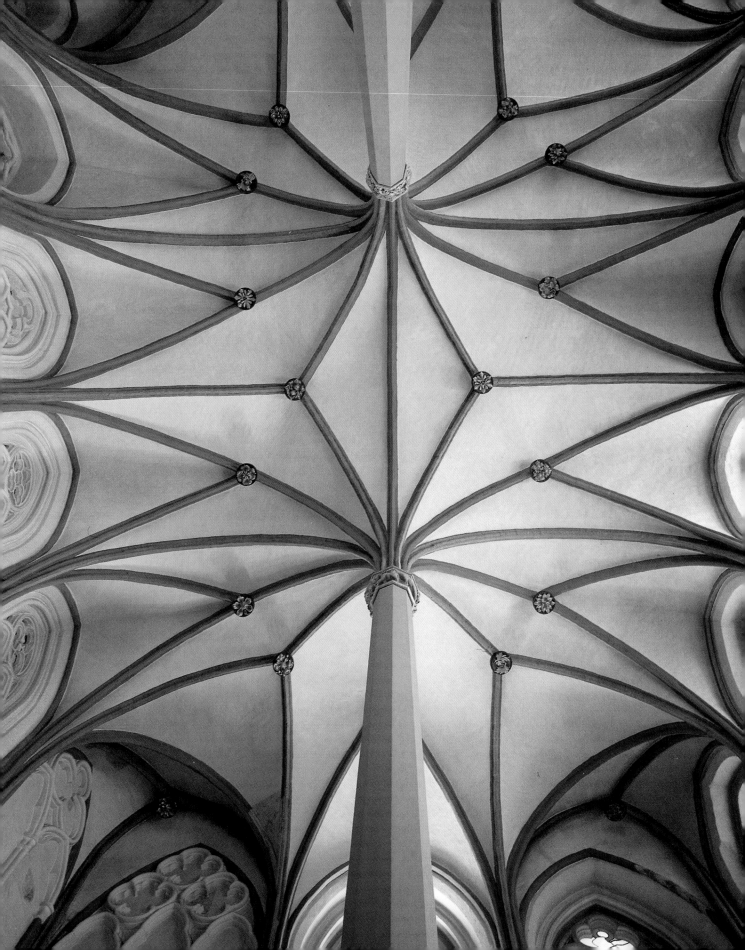

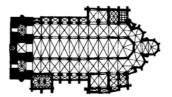

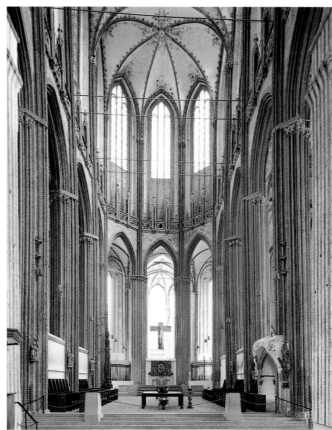

form, tautness, and synthesis. Their architecture exhibits great confidence in the creation of simple, monumental buildings.

The Marienkirche west front rises powerfully. Its towers (see above) are divided by cornices decorated with quatrefoils and end in triangular gables that form part of a helm spire of the kind found on many Romanesque churches in Germany, though here the spire is steeper than, for example, St. Patroklus in Soest. A recurring motif in medieval architecture in the German lands, this form of spire can be found in churches from the Baltic to the South Tyrol, from the Rhineland to Wrocław (Breslau) town hall. The body of the Marienkirche is a wide basilica without transepts, but with an ambulatory and radiating chapels; its wide aisles must be seen as the legacy of the preceding hall church. What is distinctive in the ground plan is that the aisles are wider than the ambulatory and the five-sided polygonal apse was provided with only three chapels (see above, right). Half of the hexagonal vault is part of the chapels, the other half covers the ambulatory. This composition was thought to have come from the

northern French cathedral of Quimper, but according to more recent studies the choirs were built independently. The ground plan of the choir does, however, appear to be a reworking of the hall choir of Lübeck Cathedral. In elevation, it is missing a triforium, which was replaced by an inner continuous gallery with tracery balustrade and pinnacles, in other words external features used here inside the building. The clerestory was designed as a system of deep niches. Those which contain the window openings give the effect of providing the glass "outer skin" of this arrangement, which, for some unknown reason, is called an "aqueduct." Such a structure has its origins in Bremen Cathedral. Similarly, part of the column and shaft profiles, and the division of the windows into three lancets without tracery, can be traced back to Cologne, the latter to the sacristy, consecrated in 1277. The compound piers and many of the vault ribs were painted red, forming a stark contrast to the white walls (see opposite).

Until well into the 15th century the Marienkirche was imitated dozens of times along the Baltic coast as far north as Riga. Not only

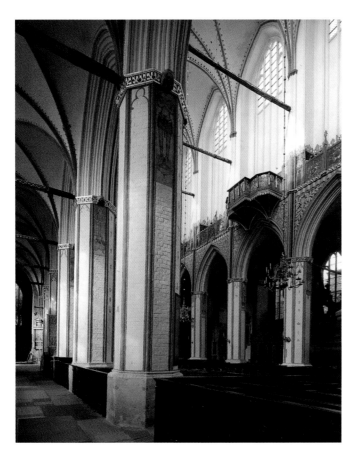

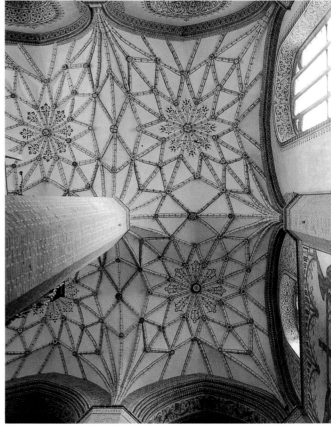

its ground plan and elevation, but also its general aesthetic spread throughout northern Europe as the ideal form of church architecture. One of the first such churches was that of St. Nikolas in Stralsund (see above, left), part of which was built during construction of the Marienkirche. Here again church and town hall arose side by side. In the interior of the church the passage between arcades and clerestory was given a wooden parapet decorated in brilliant colors, as was the clerestory base, the dividing walls, the arcades, and the columns.

This polychrome character deserves special mention because it often determined the interior and the exterior of north European buildings. It was intended to enliven various parts of the building, to complement the iconographic program, and, not least, to provide a better way of "reading" the building. In St. Nikolas the arcade soffits and spandrels were richly decorated and the separation of the stories was marked by a frieze of gilded leaves on a black background. The music gallery, also of wood, dates from 1505.

The Cistercian church in Doberan near Rostock (see opposite), built between 1294 and 1368, exhibits an unprecedented clarity of form. It is also modeled on the Lübeck Marienkirche. Here, however, the ground plan has a pseudo-transept and, due to a rule of the Cistercian order, there is no tower. The transepts, which did not form part of usual church services, were curiously neglected, separated from the nave by a double arcade.

This is not the case, however, at the sister church in Pelplin, where the transept vault, one of the oldest reticulated vaults in German Gothic architecture, is particularly beautiful (see above, right). The transepts at Pelplin are also remarkable for the highly original spaces they create. Their ground plans are square and they are both divided into four bays, the vault being supported by a single octagonal column which reaches up to the height of the vault in a single elegant sweep. In this way the basilica church has in effect been given two vast halls, an inventive and elegant way of extending its space.

Doberan, Cistercian church,
1294–1368
View of pseudo-transept

Doberan, Cistercian church,
1294–1368
Radiating chapels, from east (top)
Choir (center)
View from southwest (bottom)

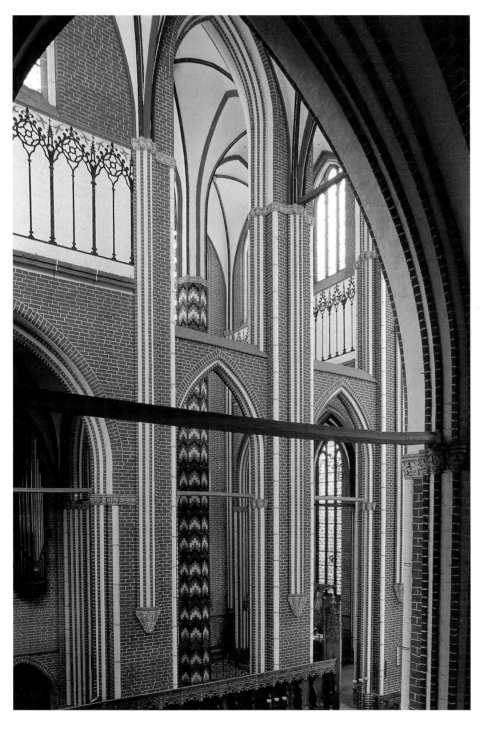

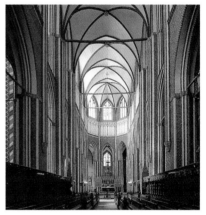

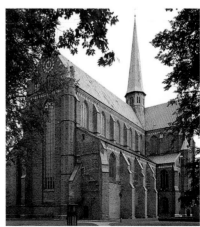

Verden an der Aller, Cathedral,
1274–1323
Choir (below)
Choir ambulatory (bottom)

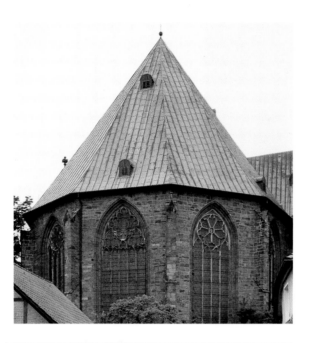

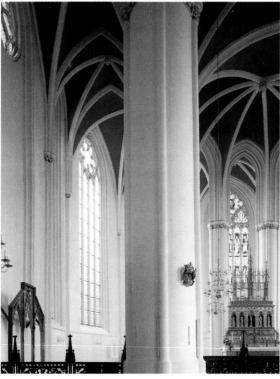

The Development of Late Gothic

A clear move towards Late Gothic architecture was taken by the cathedral at Verden an der Aller near Bremen (see left), a small diocese that, through its cathedral, presented itself as being far more important than it was. The value of the building from the perspective of architectural history lies in the fact that it possesses a polygonal hall choir, that is, a choir which is of the same height in all its parts, a form not seen before. (The hall choir of the Heiligenkreuz church, where work began just a little later, in 1288, was square.) In a certain respect, and by using "Early Gothic means," Verden anticipated the hall churches built by the Parlers, the greatest architects of Late Gothic in the German lands.

The ground plan of the choir displays five sides of a ten-sided figure after a half bay, an arrangement that came, indirectly, from Reims. The arcades are wide, the piers round with slender attached columns. All these are features which appeared for the first time in Germany in the church of St. Elizabeth in Marburg (see page 110), which was modeled on Reims. The hall choir of Verden an der Aller looks from the outside like a massive block that supports a simple roof. Despite this simplicity of form, however, a large pitched roof such as this is much more difficult to construct than several individual roofs, largely because of the length of the beams required, a fact that makes it an important feature. The axis window of the choir polygon displays tracery forms derived from Cologne. In other words, all the architectural elements used in Verden an der Aller had their origin in important cathedrals.

A completely different form of hall choir from Verden an der Aller can be seen in the large Austrian Cistercian church of Heiligenkreuz (see opposite, left). The layout, which had no specific models and no successors, has been variously interpreted as a trio of parallel naves and as a work with a centralizing tendency. The church is built on a square ground plan and has four independent piers. It is the wide distances between these piers, more important in this context than the form of the vaults, that unifies the space of the choir and ambulatory. The grandeur of this architecture suggests that the church may have had links with the Habsburg dynasty. Compound piers are used for the first time in Austria, the tracery motifs in the windows are progressive, and the generous glazing is reminiscent of the Ste.-Chapelle in Paris. The exact start of building is not known. Work was underway by 1288 and the church was consecrated in 1295.

In the second half of the 13th century the lands of the Landgrave of Hesse in central Germany were of great importance. The princely palace was in Marburg. Consecrated in 1288, the chapel of Marburg Castle must be counted as one of the most original buildings of its day (see opposite, right). As a castle chapel, it was probably planned with two stories, though the lower story was never completed as part of the chapel. The chapel anticipated the architecture of the 14th century in three respects: the structure of the sharply pointed buttresses, the ambiguous forms of the window tracery, and the

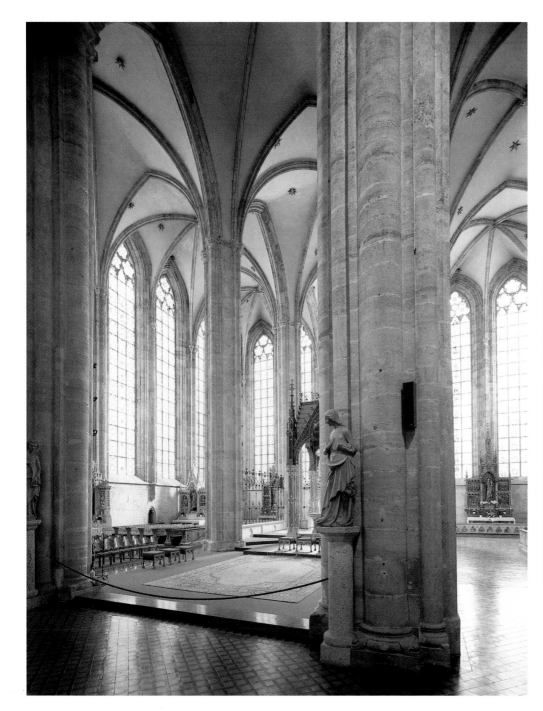

Marburg, castle chapel,
consecrated 1288
View from east (top)
Pier profile in choir (above)

design of the interior, especially the use of stepped profiles. The last of these represents the development of a principle already evident in the choir triforium of Cologne Cathedral (1248–1322). On the outside, spur buttresses rise straight up from the corners of the lower story, becoming more pronounced as the walls slope inwards. When they reach the level of the upper third of the windows they are capped by pronounced off-sets, the buttresses above being much smaller. The angular form of the buttresses is repeated by sharp projections on the eaves. The tracery displays an uncertain design, for the lower ray of the small four-rayed star foil, unusually, shares its contours with the foil lancets below. In the interior of the chapel the areas of wall below the windows are framed by profiles that overlap (see above, bottom right). The divisions between the individual elements, so clearly defined in Early and High Gothic in France, are seen in a completely different way. Though these may seem slight changes, they made an important contribution to the expressiveness of the architecture of

Freiburg Minster
Tower, 1250–1320

OPPOSITE:
Erwin von Steinbach
Strasbourg Cathedral
West façade, started 1277

later periods, particularly in central Germany and the German lands to the south and the east.

Church Towers and the Architecture of the Upper Rhine

The region of the Upper Rhine with Strasbourg as its center developed into a great workshop of Gothic architecture. The cathedral façade of Strasbourg Cathedral (see opposite), first designed by Erwin von Steinbach, is so overpowering that one glance is enough to make one think that this represents the very center of Christendom. The Strasbourg stonemasons' lodge was closely linked with that of Freiburg, a parish church in the form of a cathedral. Freiburg Minster originated at the time the town was governed by the counts of Urach, who had themselves depicted in sculptural form on the front of flying buttresses of the western tower, flanking the open hall in which justice was dispensed.

The tower (see left) is the result of two building phases. The substructure was built in 1250–80, the octagon and spire followed in 1280–1320. When finally completed, it was widely considered to be the most beautiful tower in the world. The influence of the design of Cologne Cathedral façade, the so-called "F Plan," can clearly be seen in its design. The octagon, completely hollow, is supported by triangular corner spurs which, seen in plan, form an eight-point star. The aggressive, angular—and by no means classically Gothic—composition of the tower is given added emphasis by the transition, designed as a twelve-pointed star, between the lower and upper part. The upper part is hollow and so not divided into stories; the pyramid-like spire alone is 45 meters (148 feet) high. It has eight "ribs" and is divided horizontally into eight zones which, completely pierced, have alternating designs of tracery (a novelty in Gothic architecture). The structure of this pyramid was further strengthened by iron pinions hidden in the wall. As if this architectural feat were not enough, the octagon has a spiral staircase which in one sweep reaches a height of 33 meters (108 feet), by far the boldest stair construction of its time.

Even though the tracery spire in Freiburg was completed much earlier than the one in Cologne, it would hardly have been possible without the example of the medieval drawing of Cologne (see page 202), a parchment plan approximately 4 meters (13 feet) high, dated to about 1300. Barely 50 years after this drawing was made, as recent excavations have shown, the foundations of the south tower were completed. In 1411 the tower reached a height of about 50 meters (164 feet). The façade of the cathedral was divided into four stories, of which the four lowest stories have five axes, corresponding to the nave and four aisles, though the façade has only three portals. A fifth story corresponds to the spires of the tower. The subtle transition to the octagonal ground plan starts in the third story. From that level onwards the tower stories are free-standing. The large windows on the third story have a central line that forms the dividing line of the two windows below. It is noticeable that the cornices that divide the stories are unbroken. In contrast, even the older Strasbourg façade

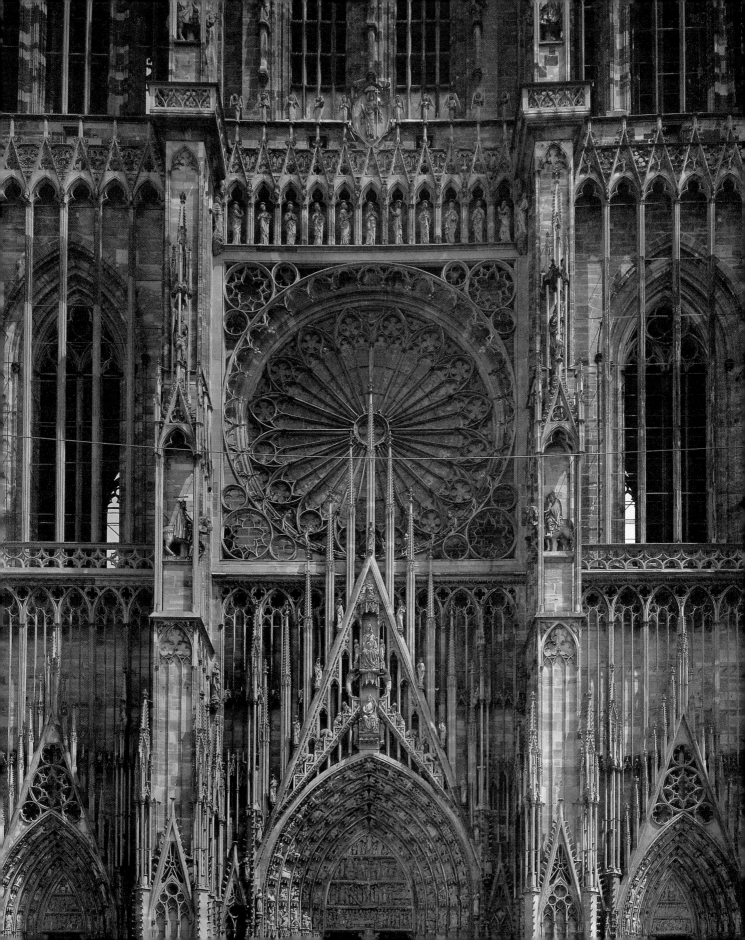

appears modern, for there the continuity of the cornices was not maintained. In Cologne, this archaism serves to restrain the vertical line. Nevertheless, in Cologne there was a shift of focus from the lower façade to the towers, so powerful they dominate everything else. This becomes clear if the façade of Cologne is compared to the façade of Reims Cathedral, to which Cologne can be compared in spite of all its divergences from the French style. The Cologne architect, probably Master Johannes, placed less emphasis on the independence of the portals, which also meant less emphasis on sculpture. A rose window and a royal gallery with the large statues are both omitted. Cologne, in a word, exhibits the complete dissolution of everything which might still have been considered classical Gothic.

It was also the first time that the west end of a church had been accorded such overwhelming importance, conceived, in effect, as a worthy pendant to the complex apse in the east. In 12th- and 13th-century France, all architectural effort was concentrated on the eastern section, since this is where the main altar was situated. As Arnold Wolff has observed, nowhere in Europe were such demands made of architects as in the building of the west end of Cologne Cathedral. The part of the south tower built in the Middle Ages rests on 15-meter (49-feet) foundations. Its elevation displays two free sides (south and west), whose area comes to about 4,700 square meters (5,622 square yards), covered by a network of tracery and columns, partly bonded, partly free-floating. The towers are unique in being set over four bays. By comparison, the towers of Amiens Cathedral cover only half a bay (see page 63). The execution of the second story diverges a little from the drawing in the "F plan." Construction of the tower was interrupted in the 15th century and was concluded only in the second half of the 19th century.

There may be a link between the four-bay structure of the southwest tower of Cologne Cathedral and the Wiesenkirche in Soest, an extraordinarily slim parish church built in green stone (see opposite, top left and center). The architect, Johannes Schendeler, is thought to have started construction in 1331. The ribs of the vault emerge from the piers without the interruption of capitals, and the core of the piers is hollow, which means that they can carry a much greater load—approximately 10 tonnes rests on each. In spite of its marked east-west orientation, and its culmination in a kaleidoscopic apse, the interior creates a single, completely unified, space, largely because of the wide spaces between the piers and the slimness of the columns.

In its delicacy and slenderness, the pilgrimage church of Pöllauberg (see opposite, top right) recalls Soest, which in respect of geography and type is otherwise far removed. There is controversy about the date that construction of the two-aisle hall church, with its

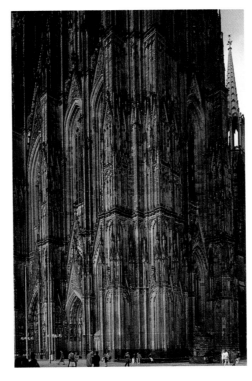

FAR LEFT:
Cologne Cathedral,
parchment plan of west front, ca. 1300.
Height over 400 cm (13 feet)

LEFT:
Cologne Cathedral
Southwest tower, ca. 1350–1410

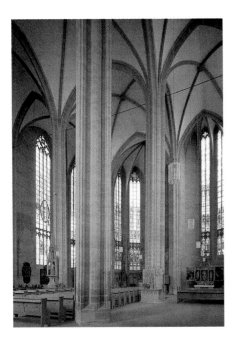

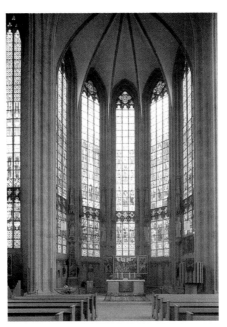

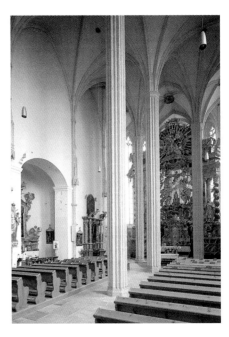

"baldachin" choir supported by four columns, began: some argue for 1339, others 1370. Having no capitals, the two piers in the nave rise straight up into the vault, while the choir piers have slender capitals. Because of the subtle arrangement of piers, the many pilgrims visiting the church could walk around the sanctuary under the "baldachin" created by the vaults in a way possible otherwise only in a centrally planned building. Such expensive compositional means helped to make the choir the unmistakable focus of the design. The lower zone of the inner choir is divided into "niche seating" with delicate arcades and pinnacles.

The church of St. Catherine stands in the small town of Oppenheim, a former free town of the Holy Roman Empire which prospered through the wine trade. The style of the church places it between the Gothic of the Upper and Lower Rhine. Cologne as well as Strasbourg and Freiburg were the major influences. Its architecture can be properly understood against the background of its precise location in the town (as with most historical buildings, of course). Built on a plateau overlooking a vineyard, the church dominates the townscape with its magnificent south side (see right), begun in 1317 and completed about 20 years later. Its complex style, in particular its window tracery, makes it one of the richest examples of Gothic architecture. In contrast, however, the north side, which did not command a fine view, was kept significantly simpler and plainer. The construction of the parish and collegiate church of the diocese of Mainz falls into the same period.

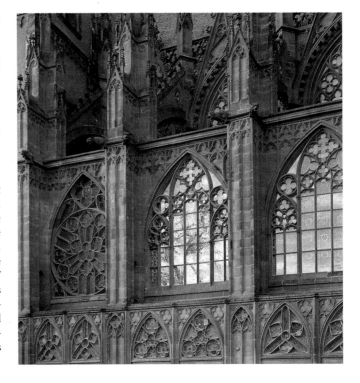

Ulrich von Ensingen
Basle Cathedral, St. George's Tower,
completed ca. 1430

Madern Gerthener
Frankfurt am Main, St. Bartholomew
Tower, 1415–1514

Michael Chnab
Vienna, St. Maria am Gestade
Tower, completed before 1450

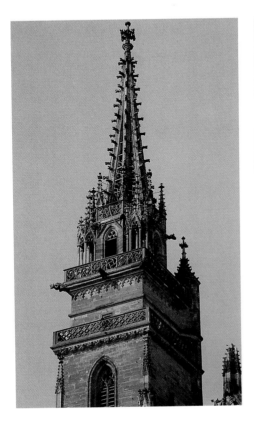

The upper stories of Basle Cathedral are of importance for the spread of German spires in western Europe (see above, left). The tower was completed just ahead of the Council of Basle in 1431, in accordance with a design by Ulrich von Ensingen from Ulm. The enthusiasm of the Spanish bishop Alonso de Cartagena, which led to the commission of similar spires for Burgos Cathedral in Spain, was the result of his visit to Basle in 1435. He must have looked at other plans also, for the Burgos spires have the straight silhouette of the spire of Cologne rather than the slightly curved profile of the more advanced spire of Basle. Ulrich von Ensingen had planned something similar, if on a larger scale, for Ulm. The extension of the tower at Basle, known as St. George's Tower, began in 1421 above a watch-tower with square windows which rises up between two tracery parapets. This section of the tower room came under attack from 19th-century historians, who were unaware that it provided the model for the tower rooms of the important Sebalduskirche in Nuremberg, built in 1482–83. Clearly medieval and 19th-century views of architecture differed greatly.

A free variation of the Freiburg tower octagon was not built until the late Gothic period (in Frankfurt am Main between 1415 and

1514). This is the tower of St. Bartholomew's church (see above, center), based on a design by the architect Madern Gerthener. Here too an octagon rests on a square base, the corner pinnacles of which are linked to it by means of small flying buttresses. The structure is stylistically different from the Freiburg tower. The unconventionally formed dome is a reproduction of the contemporary imperial crown, adopted because it was in this church that the seven Electors of the Holy Roman Empire chose the emperor. This historical fact also explains the form of tower used, otherwise seen only in cathedrals.

The nave of St. Maria am Gestade in Vienna was built in 1398 and the upper stories of its tower (see above, right) were completed before 1450. Its architect, Michael Chnab, created a work in which exotic elements create a refined and aristocratic design. The dome baldachins on the west and south portals appear to be bizarre architectural copies of sculptural works; that these shapes were already known a century earlier in German monumental painting is demonstrated in the *Coronation of the Virgin Among the Apostles* in the monastery church of Altenberg an der Lahn (see page 205, top left). It is likely that they were intended to represent the New Jerusalem. The domed crown of the seven-sided tower is decorated with generous crocketing, a strange

Altenberg an der Lahn, monastery
church
*Coronation of the Virgin Among the
Apostles*, fresco, ca. 1300

Vienna, St. Stephen's
Cathedral

motif that appears to refer to the imperial crown in Frankfurt, but
also to the crown of the Austrian archdukes, introduced by Rudolf IV
(1358–65). As Günter Brucher has observed, the dome-shaped crown
of the tower of St. Maria am Gestade is by no means unique in Euro-
pean Gothic architecture. Similar features can be seen in Frankfurt, in
Pfullendorf, a former free city of the Holy Roman Empire, and on the
tower of the parish church of St. Jacob.

The tower of St. Stephen's Cathedral in Vienna (see right, top) was
completed as early as 1433 as one of two towers originally planned
to flank the choir (the other was never built). The church became a
cathedral in 1469. The "royal" style of the tower goes back to its
patron Duke Rudolf IV, son-in-law of Charles IV in Prague. It is a
virtuoso work of German Gothic architecture, though it differs from
its predecessors in its confused design, which might be described as
impressionistic. The tower can be seen as a huge pinnacle, with none
of the light filigree structure typical of German Gothic towers. The
steep roof of the church is worthy of note, characterized as it is by
geometrical designs in colorfully glazed pantiles. It represents one of
the finest examples of a type which is frequently found in Burgundy
and the Alemanic region.

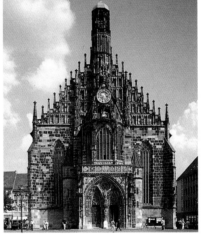

Nuremberg, Frauenkirche
West front, 1350–58

Innovative Ground Plans in the 14th Century

The small church in Greifensee near Zurich (see right, bottom),
perhaps dating from 1425–50, provides an example of the great
freedom of design Gothic plans could achieve. The design was clearly
adapted to the town wall of the small town, the church forming a
quarter circle. The vault system, which rests on a single round
column, is made up of three-rib vaults which together form a stellar
vault. The clever use of such a small area turned it into an original
space. In 1808 there were plans to turn it into a square (a fate the
church was spared, fortunately). The contrast between the freedom
of Gothic architecture and the limitations inherent in classicism is
clearly evident. A section of the fortifications went through the upper
story of the church building. Like many other small medieval
churches of the Holy Roman Empire, it was probably used as a
storage place at some time in its history.

In 1351 the foundation stone of the new choir of the Heilig-Kreuz
Minster in Schwäbisch-Gmünd was laid. This may have been
designed by Heinrich Parler from Cologne, who was working on the
nave of the church in 1330. Heinrich was the father of the famous
Peter Parler, also credited with the plan for this choir. Several innova-
tions appear in Schwäbisch-Gmünd, although there needs to be some
caution with regard to the present shape of the church. The towers at
the beginning of the choir collapsed in 1497 and in the first 20 years
of the 16th century the choir vault was taken down. A further
compact hall choir arose (see page 206, top), its design developing
independently of the choir in Verden an der Aller (see page 198). A
second story emerges from where low radiating chapels begin. The
pier buttresses in the lower story are incorporated into the wall and

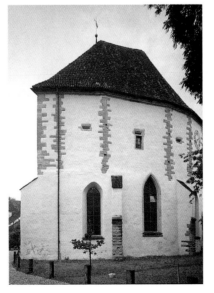

Greifensee near Zurich
Parish church, probably
before 1350
East view
Ground plan (below)

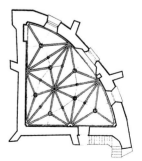

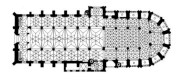

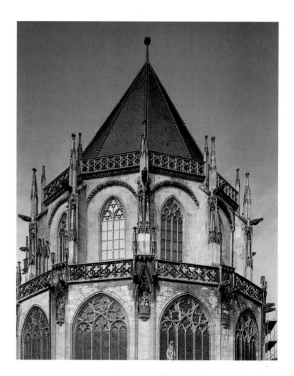

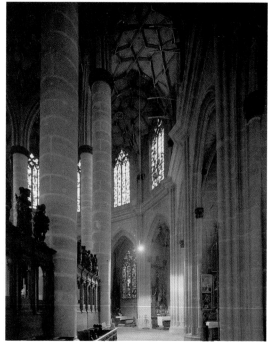

serve to divide the chapels from one another; the piers become visible only in the upper story. The order of these pier buttresses in the lower polygon becomes visible externally through the use of double pilasters, a feature used previously in Marburg and Freiburg im Breisgau. The round arches below the traceried roof parapet also form an important motif. They are designed as flat segmented arches and are given visual emphasis by carved reliefs. They introduce a new aesthetic that placed semicircular arcades into the foreground, a feature subsequently used in several major works of German architecture. The greatest innovation in the choir ground plan is that the inner and outer apse are no longer related to one another. The outer apse, whose plan is seven sides of a twelve-sided figure, contrasts with the inner apse, whose plan is three sides of a six-sided figure. Here the symmetry of older apses was completely abandoned, a revolution that went far beyond the innovations at the cathedral in Verden an der Aller. This arrangement changed the logic of the whole architectural system. The space enclosed by the inner choir is unified by the horizontal stringcourse that runs over the bays, forming a spur in front of every shaft. The columns are cylindrical, following the example of the older nave.

Nuremberg and Prague under Charles IV

Emperor Charles IV of the Luxemburg dynasty (emperor 1355–78), the great sponsor of Prague as an imperial city, also strengthened the position of Nuremberg. He consolidated its importance in relation to other towns of the Holy Roman Empire by staying within its walls 52 times. He supported the construction of the Frauenkirche at the large market (1350–58; see page 205, center, and opposite). That it was intended for important imperial ceremonies is evident from the porch with the balcony as well as from the imperial character of the façade, with its impressive display of coats-of-arms, including those of the Holy Roman Empire, the seven Electors, the town of Nuremberg, and the city of Rome, where the emperors were crowned. In all other respects the outside of the church is quite plain.

The church is a direct descendant of the palatinate chapels, the nearest of which was in the imperial palace in Nuremberg. Having a rectangular ground plan, it is a hall church with two aisles and a tribune for the emperor; its nine bays are supported by four columns. The Frauenkirche is an original Gothic transformation of the Romanesque chapel in the imperial palace, dated to about 1170–80 and built on the orders of Emperor Frederick Barbarossa (1152–90). Tradition has it that on at least one occasion, at the birth of Wenzel, son of Charles IV, in Nuremberg, the imperial insignia and reliquaries were shown to the people from the balcony of the Frauenkirche. From 1423 these so-called "holies" of the empire were kept permanently in Nuremberg and shown publicly each year. A purpose-built wooden platform was used for this rather than the church balcony, which had a symbolic rather than practical function.

The lavish narthex of the Frauenkirche is rich in tracery and has portals on all three sides whose jambs and archivolts are covered

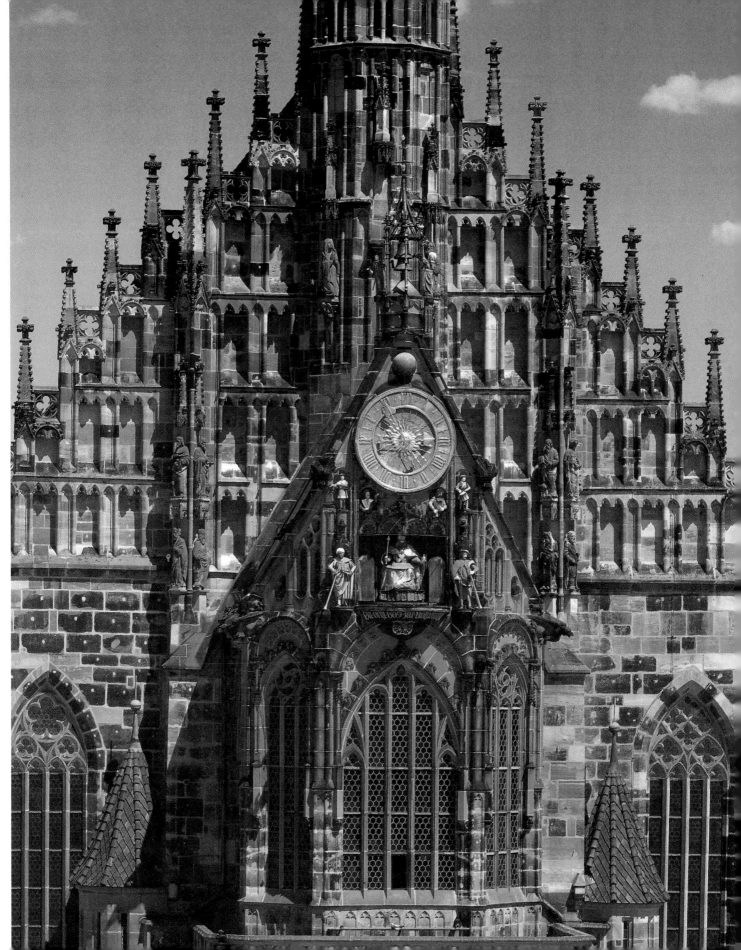

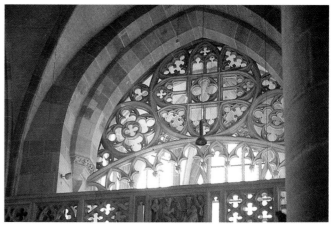

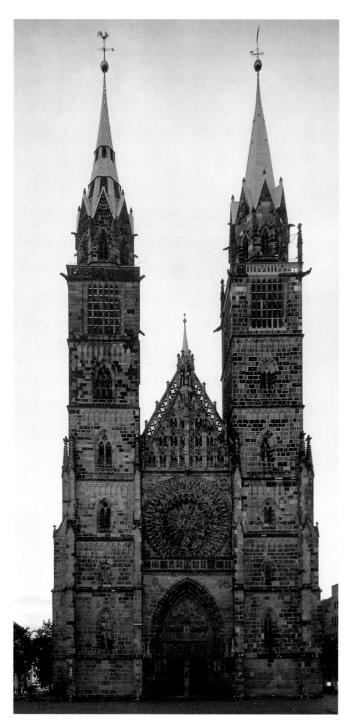

with sculpture (though there are only two archivolts, so that the portals are not so deep as those on French churches). The choir gallery above the narthex is polygonal, which perhaps indicates that it was meant to house a double choir. The pinnacles of the stepped gable and the small octagonal stair tower on the central axis are clear reminders of the secular origins of this façade. The gable is divided into numerous niches which once contained sculpture. The choir loft, which is known as the Imperial, or St. Michael's, Loft, opens onto the nave by means of an arcade whose arches are filled with floating tracery consisting of three rosettes supported by a segmental arch (see above).

The architecture of the Frauenkirche is most likely linked to Peter Parler, the young architect from Schwäbisch-Gmünd who was summoned to Prague at the age of 20 (probably in 1353), long before his buildings in his hometown and in Nuremberg were completed. Not only the style of the sculpture, but also the cubic character of the Frauenkirche, the use of round columns, and the novel use of segmental arches, all allow us tentatively to conclude that this church is typically Parleresque.

Just as the Frauenkirche can be considered a gift from the emperor to Nuremberg, so the neighboring façade of St. Lawrence's church (see left) represents a tribute to the monarch from the people of that district of the city: the coats-of-arms of Bohemia (for Charles IV) and Silesia (for Charles' wife Anna von Schweidnitz) were fixed below the tracery parapet, at the bottom of the rose window. The date building started is not known, but it is clear that buttresses were not included in the first design. The central section of the west façade, with its portal, rose window, and gable, which features a central stairway, were built between 1353 and 1362. The way the two powerful but plain towers flank the elaborate central section is the outstanding feature of this façade. The rose window consists of two planes, an external one with floating radial tracery and an inner one that

Prague, St. Vitus's Cathedral
Lower sections by Matthieu d'Arras
1344–52, clerestory and buttressing
later by Peter Parler

consists of the window itself, which has a diameter of approximately 6 meters (20 feet). The radial tracery creates a sense of movement like a wheel in motion. A new dynamism was created here through the systematic challenging of the traditional forms of Gothic architecture, a process that in German architecture was to take a number of forms. Like all double-tower fronts built during the Middle Ages, that of St. Lawrence is asymmetrical. The partially open copper spire of the north tower was gilded in 1498, work that was paid for by one of the major patrician families of the town, the Imhoffs, whose houses stood opposite.

Prague was elevated to the status of a city in 1255 during the reign of Charles IV (king of Bohemia from 1346, emperor 1355–78). It was effectively a fixed capital of the German Empire. The city's strong links to the German lands, however, went further back. Evidence of this can be found in the 13th century. In 1230 Bavarian settlers established the New Market quarter next to the Old Town, in accordance with the law of Nuremberg, and in 1257 north German settlers founded a settlement (later called the Lesser Town) at the foot of the Hrad hill, governed by the law of Magdeburg. Prague was made an archbishopric in 1344 (until then it had been dependent on Mainz). In the same year the foundation stone for the new St. Vitus's Cathedral was laid (see right, and pages 210–211). Because the house of Luxemburg to which Charles belonged had strong links with France, the cathedral's first architect was Matthieu d'Arras (Matthew of Arras). He designed the ground plan for the choir and built part of the ambulatory and the radiating chapels. He died in 1352 and shortly afterwards, as we have seen, Peter Parler was summoned to Prague. It was Parler who introduced truly modern architecture into church construction. Visiting the cathedral, one gets a powerful sense of how this young architect was able to take hold of a traditional Gothic church and reshape it in accordance with an aesthetic ideal of tremendous innovative power.

A feature of the ground plan is the fact that the vaults are not arranged in bays. This was achieved by dispensing with the longitudinal ridge rib and doubling the diagonal ribs, which now ran in parallel, creating a network of rhombuses, rhomboids, and triangles (see ground plan, page 211). The eye is guided in a zigzag movement from wall to wall. A complete break with the traditional arrangement, in which there was a uniform succession of bays, this makes the space far more dynamic. In cross-section, the vault has a round and unusual pointed profile, the barrel vault being intersected by the transverse vaults that frame the windows. All the ribs are of the same diameter. The elevation of the apse (see page 211, left) is based on that of Cologne, but is of a simpler design, built on five (rather than seven) sides of a ten-sided polygon. The composition also aims for greater clarity by means of the emphatic framing of the windows and the use of a parapet at the lower edge of the roof, reminiscent of the much older one in Reims. The composition as a whole is dominated by vertical elements. A decidedly modern motif is visible on the external pier

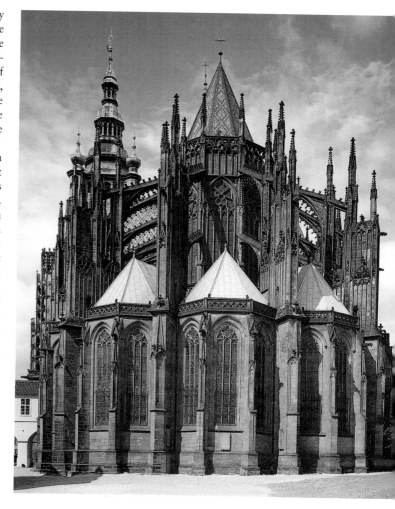

buttresses between the chapels of the ambulatory, where each pinnacle pierces the off-set so that its finial seems to emerge above (see page 210, bottom left). Such subtleties had not been seen before. A complete subversion of convention can be found in the porch of the south portal, built 1367–68. The portal arcade is formed by a richly profiled round arch with baldachins to cover sculpture (see page 210, bottom right and top). But this arcade appears to be half-hidden by free-floating ribs which have no bosses and meet on a projecting trumeau. The fact that the trumeau projects also means that the wings of the door are set at an angle to the wall. Here it is hard to know what to admire more: the ribs "flying" boldly in front of the semicircular arcade, the absence of bosses, or the wrenching of the stone door frames out of the wall. Traditional architectural order has been turned on its head.

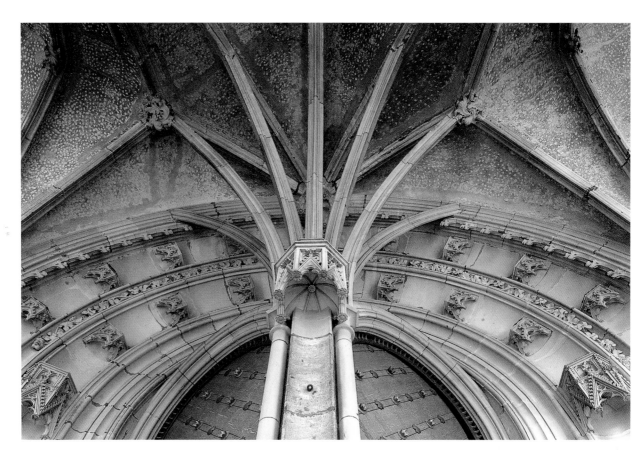

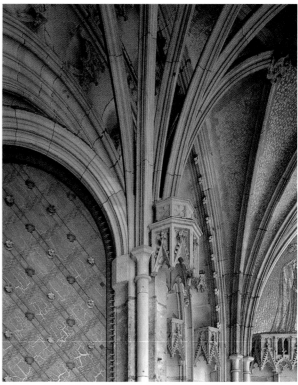

Peter Parler
Prague, St. Vitus's Cathedral,
after 1352
Choir (below)
Ground plan of choir (right)

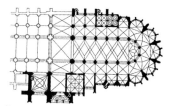

BELOW:
Peter Parler
Prague, St. Vitus's Cathedral
Triforium with portrait busts, 1374–85

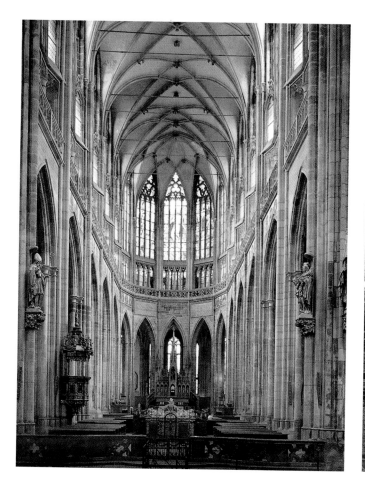

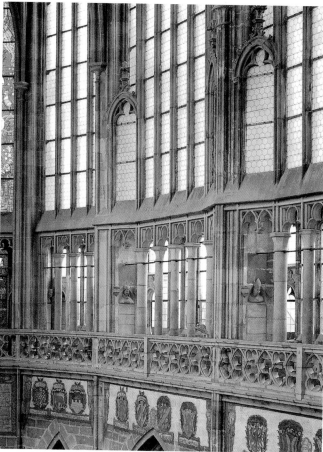

The triforium and clerestory were erected between 1374 and 1385 (see above, right). The triforium has been provided with a parapet filled with tracery, the pattern of which (like that of the windows of the chapel at Marburg Castle) is curiously ambiguous. The front plane of the triforium, formed by the shafts coming from the arcade story below, is linked to the clerestory wall plane by means of small glazed arches. This subtle artifice creates diagonal surfaces that are in fact small windows, in effect, windows within windows. These contain foils and are topped with finials and crockets. A trained eye can see the precise extent to which Peter Parler has drawn on previous motifs in Cologne, Freiburg, Marburg, and Schwäbisch Gmünd. It is also worth noting the gallery of portrait busts set up in the cathedral triforium. Some idealized, others realistic, they include the emperor and his family, archbishops, even the architects Matthieu d'Arras and Peter Parler. This last is significant because it indicates their high social standing.

The Influence of the Parlers

The main parish church in Ulm is the work of the Parler family. Two masters by the name of Heinrich and Michael Parler planned a large hall church which was to be 126 meters (414 feet) long and 52 meters (171 feet) wide. The design changed from hall structure to basilica, however, the nave finally reaching a height of 42 meters (138 feet), which makes it one of the most imposing in Europe (see above, left). The change was the responsibility of the architect Ulrich von Ensingen, known to have worked in Ulm from 1392. In carrying out the work he is sure to have closely followed the instructions of the town council, which acquired the patronage rights to the church in 1395. Among von Ensingen's achievements was the design for the tower, which was to become the highest church tower in the world, reaching 162 meters (over 530 feet). He also designed the vault of the nave, completed before 1471.

Ulrich von Ensingen
Ulm Cathedral
Nave, 1392–1471

Bamburg, Obere Pfarre
View from east, 1392–1431

Hanns Purghauser
Salzburg, parish church
Choir

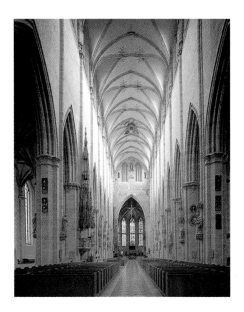 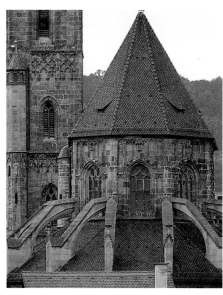 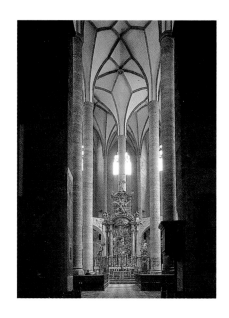

Ulm, despite not being the seat of a bishopric, competed with the largest cathedrals of its time. This is demonstrated not only by its huge dimensions, but also by the use of key cathedral motifs—a choir vault modeled on that of Prague Cathedral, nave piers based on those of Augsburg Cathedral. When the hall became a basilica, the choir remained considerably lower than the nave. Another noteworthy feature of the interior is the use of sharply pointed arches, which greatly increases the impression of upward movement.

The outstanding feature of this church is the handling of light. This was noted as early as 1488 in a description written by a lay brother, Felix Fabri. The earliest surviving record of its kind, it refers to the way light floods into the church, creating "a church without any dark corners." Developing throughout the 15th century, this feature—the filling of a church with bright, clear light—became one of the distinguishing characteristics of German church architecture. French cathedrals such as Chartres, whose dark interiors were saturated with deep colors, were consigned to history. The effect was achieved not by making the windows larger, but by using the new, mostly clear, glazing.

During this time a work which must be described as "Parleresque" was built in Bamberg, the so-called Obere Pfarre, the new choir of which was started in 1392 and completed 39 years later (see above, center). The polygonal apse with ambulatory and chapels displays nine sides of a sixteen-sided polygon, the upper story five sides of an octagon. The bays of the ambulatory are alternately triangular and approximately square or slightly trapezoid. This made it possible to build pairs of parallel pier buttresses that, instead of being placed at the corners, stand at right angles to the wall.

The interesting feature here is the convergence of each pair of flying buttresses at each corner of the polygonal clerestory. Until then, only one flying buttress had gone to a wall corner. The development of this feature meant that in some designs as many as three flying buttresses converge on a single corner (an example is Freiburg Minster, from 1471). The Bamberg flying buttresses also have an angled upper surface, a motif which is taken from the nave of St. Lawrence in Nuremberg. This angle surface appears to call the function of the flying buttress into question, at least visually. The "bend" in the arms of the buttresses allows an open view of the architecture of the clerestory.

During his time in Bohemia, Peter Parler also built the choir of St. Bartholomew in Kolín nad Labem (Kolin an der Elbe; 1360–78). The main feature of this church is that the longitudinal axis of the choir possesses a polygonal ceiling, a motif that was to become a distinctive feature of German Gothic. The significance of the polygonal vault is that it removes the windows from the central axis. This reversal of the basic order of the classic French cathedral occurred in various German churches, though usually with the abandonment of the basilica form of Kolín in favor of a hall church structure. In the hall choirs of the hospital church in Landshut (from 1408; see opposite, below) and the main parish church in Salzburg, built at the same time, a cylindrical column was placed in the middle of the polygonal choir space. This allows several vault elements to converge on the column but blocks the view of the axis window. This changes the perception of the space greatly. Both churches were built by the outstanding architect Hanns Purghauser.

BELOW:
Peter of Frankenstein
Neisse (Poland), St. Jacob
Nave, from 1423

BOTTOM:
Hanns Krummenauer, Hanns Purghauser
Landshut, St. Martin,
1385– ca. 1460

In the Heilig Geist church in Heidelberg (from 1398) and the church of St. Jacob in Neisse (from 1423; see right, top) the wall of the ambulatory is designed as a continuation of the nave walls of the church and is supported by external pier buttress. This church, partly built by Peter of Frankenstein, is dominated by its extraordinary double row of mighty octagonal columns built in alternating layers of brick and dressed stone, creating an overwhelming perspective effect. The impact of the Frauenkirche in Munich (see page 215) is here anticipated in the first half of the century.

The nave of the Franciscan church in the town of Torun (formerly in Prussia, now in Poland), built with internal pier buttresses, anticipates a severe design found in several German Gothic churches. Built in the middle of the 14th century, it was not the first church constructed to this design, which has the immense advantage of leaving the external walls free. The design, known in the 13th century, can be seen, for example, in the choir of Marburg parish church. But in Torun it becomes unprecedentedly powerful. It is difficult to believe that the stark simplicity of this architecture derives from the rules of the Franciscan order. This particular form of severity is not characteristic of the order, and it subsequently appeared more in parish churches than in monastery churches. On the south side there is a niche that reaches from the floor to the vault. The only external ornament is a clay frieze under the eaves. The plain walls are pierced by high windows.

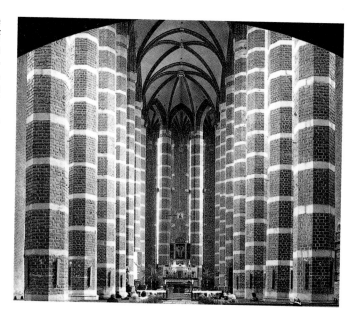

Hall Churches of the Wittelsbach Family

The beautiful Gothic town of Landshut was the residence of the dukes of Lower Bavaria and thus, together with Ingolstadt, Munich, and Straubing, one of the four courts of the Wittelsbach dynasty. Large hall churches were built in all four towns from the end of the 14th century, particularly during the 15th century. The parish and collegiate church of St. Martin (see right and page 214) represents what the architectural historian Erich Stahleder calls "the quintessence of civic pride and princely representation." Its slim tower was built last, completed in 1500.

At 130 meters (427 feet) it is the highest brick tower in the world. It was begun when the architect Hanns Stetheimer (died around 1460) was at work there. The upper stories are today ascribed to Master Stephan Purghauser. The tower is divided in a complex way into multiple blind and open arches, and many of its details are executed in light-colored stone. Its style may indicate a link with the architecture of the Netherlands, a link probably made possible (as their name suggests) by the complex family tree of the house of Wittelsbach von Straubing-Holland-Hennegau. A crown of intertwined ogee arches embraces the spire of the tower, which thus stands in the tradition of the complex and intricate spires of the cathedrals of Ulm, Esslingen, Reutlingen, and Burgos, even if it does not form a "crow's nest."

The interior (see right, bottom) is one of the boldest church spaces in Gothic architecture. Hanns Krummenauer started construction of

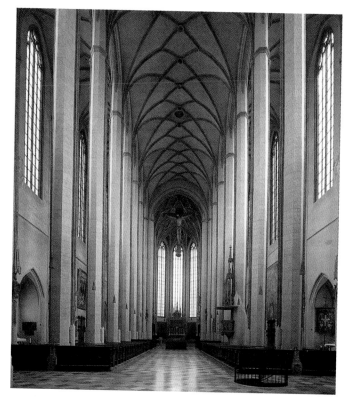

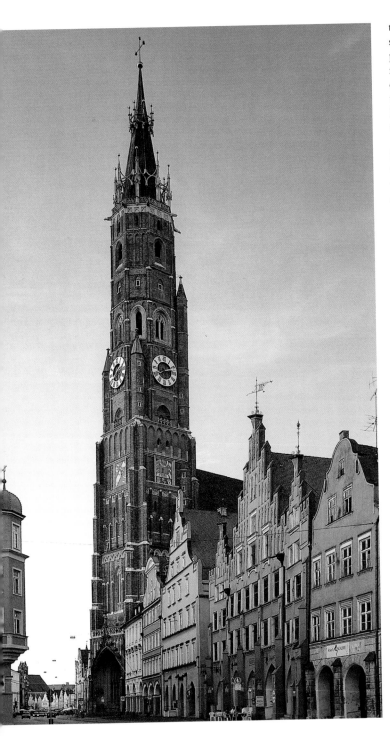

Hanns Stetheimer, Stephan Purghauser
Landshut, St. Martin
Tower, completed 1500

the choir in about 1385, and Hanns Purghauser, already mentioned, succeeded him in the nave. This consists of nine bays and is supported by two rows of ultra-slim piers which, with a diameter of one meter (3.28 feet), reach a height of 22 meters (72 feet). The vault was constructed following the model of St. Vitus's Cathedral in Prague, with each pier having a thin rounded shaft lying against its center line. Low chapels in the aisles were financed by the guilds and wealthy patricians of the town.

The last of the hall churches in the area governed by the Wittelsbach dynasty is the Frauenkirche in Munich (1468–88; see opposite), the largest church building of its day anywhere in Europe, and one of the most advanced in style. There is something bunker-like about the closed exterior of the building: there are no rows of pointed pinnacles on the towers and nothing diverts attention from the compact main body of the building. This is architecture in which all the basic elements of the art of building are allowed to have their say. The design is indeed compact, but the absence of formal richness does not lead to aesthetic impoverishment. On the contrary, it increases the power exuded by the architecture. There are similarities between this building style and 20th-century architecture, much of which is based on the principle of "less is more." The certainty with which this monumental building, with its extreme clarity of form, was inserted into the tight network of houses is astonishing. It remains the undisputed symbol for what Munich was to become. The body of the church displays great simplicity because there are no transepts and it is built as a wide hall structure, with chapels the same height as the nave arranged all around the church. The depth of the chapels is evident from the outside.

The onion domes, erected only in 1524/25, although probably designed considerably earlier, are undoubtedly intended as a reference to what was believed to be King Solomon's Temple in Jerusalem (in reality the Islamic Dome of the Rock). The architecture of the building was known in Germany through the woodcuts in the books *Travels in the Holy Land* by Breydenbach (Mainz, 1486) and *World History* by Schedel (Nuremberg, 1493). An exact sculptural representation of it can be seen in the Pappenheim altarpiece in Eichstätt Cathedral (1489–97). Far from being the first onion domes in the empire, the Munich domes are part of the Late Gothic tradition that probably began with the single tower of Onze Lieve Vrouwkerk in Breda, and progressed through the intermediate stages of the chapel of the Holy Sepulcher in St. Anne in Augsburg (1506) and the church in Rauschenberg near Marburg an der Lahn.

The vast interior of the Frauenkirche is impressive. Modern forms were employed, which means the absence of apparent complexity. The exception is the vault, though in this church the vault does not determine the space. The subtlety of the architectural form is breathtaking. The brilliant Master Jörg von Halspach succeeded in flooding the space with light while at the same time hiding the light sources: the windows are hidden in the niches where the chapels are

Jörg von Halspach
Munich, Frauenkirche, 1468–88
Nave

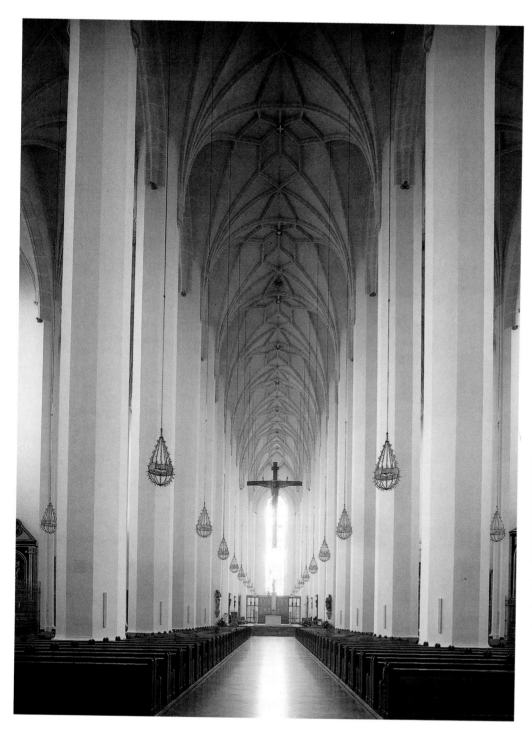

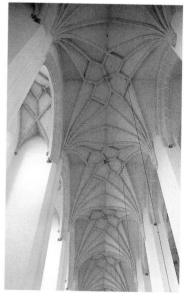

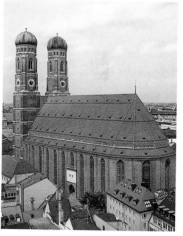

Jörg von Halspach
Munich, Frauenkirche, 1468–88,
onion domes 1524–25
Aisle vault (top)
View from southeast (above)

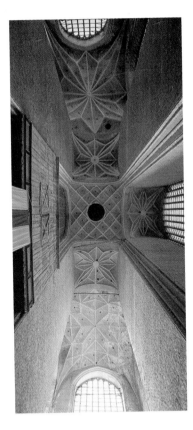

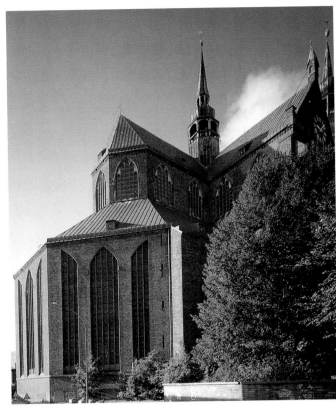

located and are also blocked by the wide columns of the nave. In a sense, we are faced here with a radical reinterpretation of the nave of St. Martin in Landshut (see page 213, bottom), with tower-like supports replacing the slim columns, and the height of the side chapels raised to that of the vault.

Far from being monotonous, as was once claimed, this building is a prime example of the creativity Gothic architecture achieved in Germany, a creativity that emerged at a time when other countries sought to compensate for the loss of originality by adopting the French Flamboyant style, in which constantly repeating structures were overlaid with ever more complex decorative forms. Flamboyant never really took root in Germany.

Late Gothic Architecture in North Germany

The architecture of north Germany was in no way inferior to that of the south, as some have tried to argue by making a spurious causal connection between the artistic production of the area and the political and economic stagnation of the Hanseatic League. The magnificent Marienkirche in Stralsund (ca. 1384–1430/40; see above and opposite) must be seen, despite all the differences due to its basilica form and its dependence on Lübeck, as the source of the austerity of form seen in the Hauptkirche in Munich. All the pier buttresses have disappeared from the fortified exterior, and in order to rescue the clarity of its complex structure, the flying buttresses have been hidden under the transept roofs, to the great advantage of the clerestory. The west end rises like a fortress, its bulk increased by the pseudo-transept, the latter merely the narthex of the church extended to the sides. From the pseudo-transept a huge octagonal tower rises, flanked by four

corner towers, real fortifications with battlement parapets and crenellations. The church is situated in the southwest of the town next to the former town wall. With a spire that soars 150 meters (492 feet), the tower is higher than those of the Lübeck churches, higher even than Heinrich Hülz's Strasbourg tracery spire, which reaches 142 meters (466 feet). The present spire was built in 1708. The novelty of the Stralsund Marienkirche consists in its reversal of the principle of Early Gothic, which the architectural historian Georg Dehio defines as placing all structural elements on the exterior so that the building's construction is not apparent in the interior.

The outside of the polygonal apse (see above, right) must be considered the masterpiece of the church. There are three windows on each side of the polygon—to be precise, a complete middle window and half-windows on the side—which can be read either as an open triptych (if one looks square on) or as half-windows divided by the corners of the wall (if one takes an oblique view point). It is not surprising that this abstract architecture, which plays with visual effects, was not understood in the 19th century when tracery was attached to the windows on the front of the transept and the presbytery was, quite unnecessarily, filled with responds.

Even before 1400, the architect Hinrich Brunsberg began the choir of the grandiose Marienkirche in Stargard (see page 218), a unique example of a brick basilica with triforium. The sculpture niches below the capitals of the piers are also unusual. Here they are successfully integrated into the overall design, whereas in Milan Cathedral, where they were used at much the same time, they became too heavy and cumbrous a feature, particularly as capitals and niches were combined.

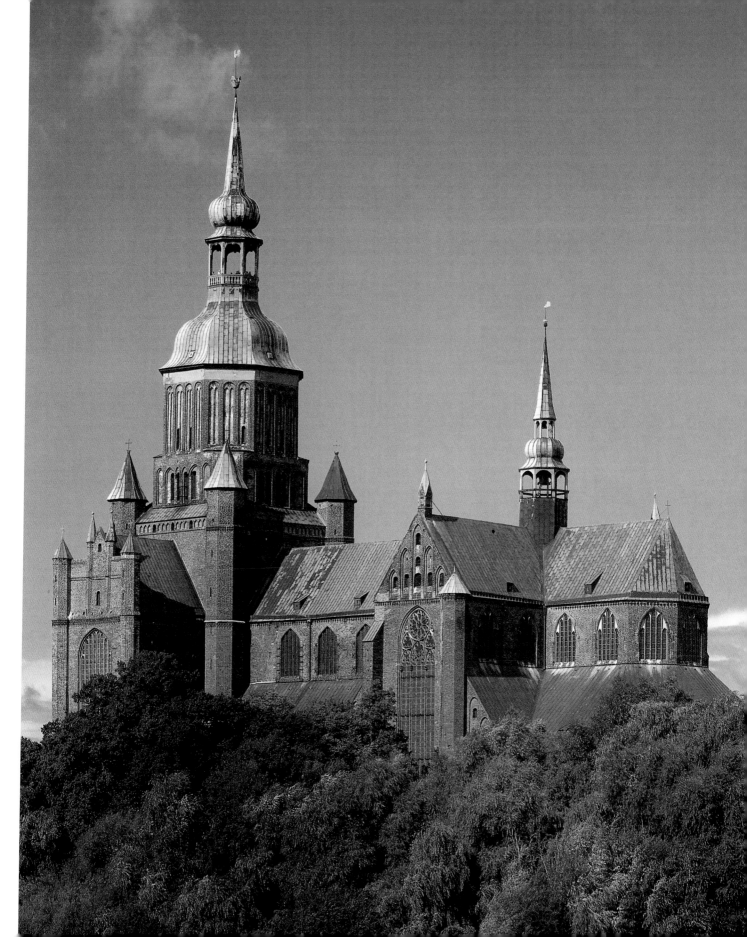

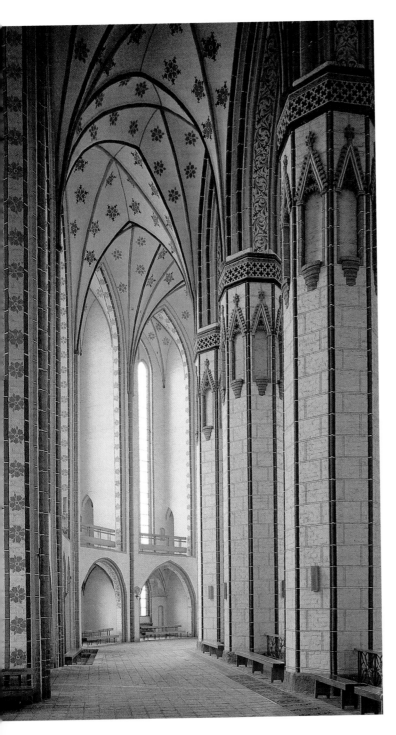

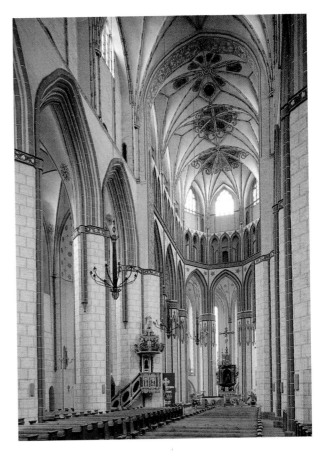

Throughout the 15th century the largest building project north of the Alps was the Marienkirche in Gdansk (Danzig), though it was by no means the last major work of Gothic architecture to be built there (see opposite). When work on rebuilding was completed, the church had an aisled nave, chapels of the same height, a choir, and asymmetrical transepts (two aisles in the north, three in the south). Three characteristics of the church recall the art of the Lower Rhine and the Netherlands: each aisle has its own roof (like the two Franciscan churches in Torun), the portals plus a large window are positioned in an ogival niche, and, finally, the building has a tower with pier buttresses (an element nearly always absent in the brick architecture of German Gothic). There is a special relationship between the Marienkirche and the road network of the town. Portals and roads are all aligned, including the wholly unusual portal in the east wall, aligned with the Frauengasse. Outstanding innovations of the church, worth emphasizing, though they represent only the rebuilding work of the 15th century, include the extraordinary meeting of two windows

Gdansk (Danzig), Marienkirche,
ca. 1343–1502
View from north (below)
Corner windows in southwest corner
of the nave and transept (bottom)

Gdansk (Danzig), Marienkirche
Cell vault

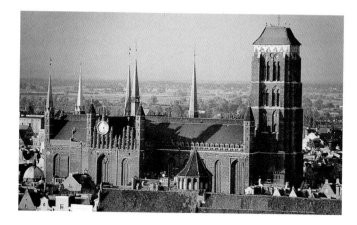

in the corner of the nave and south transept. When the supports were moved to the inside, the corner becomes two half-windows of slightly different heights. When corner windows appear in Gothic architecture (in Spain or Venice, for example) they are nearly always restricted to secular buildings, are quite small, and are invariably on the outside corner, never the inside corner.

The handling of the external wall surfaces, which are bare of ornamentation, is no less brilliant. A continuous cornice stands out as a white line, executed in stone in contrast to the bricks of the wall. Furthermore, the external walls are distinctive in that their corners are beveled so that the walls flow into one another. This means that the slender corner towers (modeled on those of Lübeck), which bring a grand, secular flourish to the cathedral, reflect the natural logic of the building. The vaulting of the interior (see above, right) was largely done in the "cell technique" taken over from the secular architecture of Saxony, as we will see with the Albrechtsburg palace in Meissen (see page 229).

The north aisle of Bremen Cathedral, built as a hall church attached to the Romanesque basilica, must be included among the great late works of north German Gothic architecture. Initiated by Archbishop Johann Rode II (1497–1511), it was completed in 1522, shortly before the Reformation reached Bremen. The reticulated vault, which negates a division into bays, is an unusual feature for a German church, its originality taking it far beyond the vaulting used in the Marienkirche in Gdansk, which, despite its modern forms, was built bay by bay. The architect Cord Poppelken harmonized the old and the new with sensitivity, reusing old capitals and other features of the old cathedral. This utilization of older features went so far that the "aqueduct structure" of the 13th-century south wall was repeated in the north wall, a 16th-century work. This procedure becomes more comprehensible in the light of the almost archaeological approach of some German architects at the end of the Middle Ages, who consciously incorporated older forms in their designs. Examples of such historicism include the tower of

219

BELOW:
Bremen Cathedral
North aisle, ca. 1500–22

BOTTOM:
Brunswick, cathedral of St. Blaise
North aisle, 1469–74

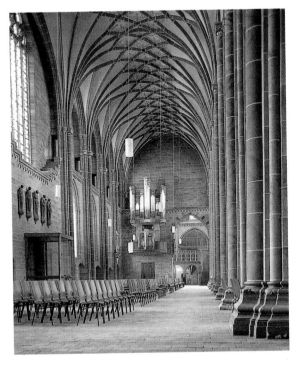

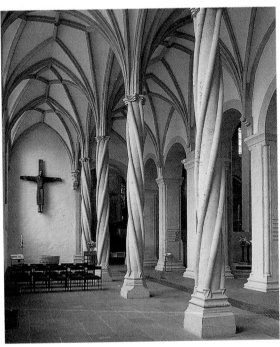

Klein St. Martin in Cologne (1460–86) and the south tower of Osnabrück Cathedral (1505–44).

About 30 years before the north aisle of Bremen Cathedral was rebuilt, the north aisle of St. Blaise collegiate church in Brunswick was also altered in a similar way (1469–74; see left, bottom). No account was taken of the existing Romanesque architecture and in its expressive modernity the double north aisle contrasts strongly with the older building. Long before similar columns were created in the south (Eichstätt, for example, but above all the famous examples in Portugal such as Setúbal and Olivença), round columns were built that each have four winding shafts which climb like vines to their corresponding responds. There were tentative precursors of this form of column in the helical columns of Romanesque architecture, with examples in St. Giles's monastery in Brunswick. The twisting effect is emphasized by the fact that the direction of turn alternates between clockwise and anticlockwise. The layout of the vault ribs changes every two bays.

The church of St. Nicholas in Wismar clearly shows that Gothic architecture in brick could be elaborate, in other words that the severity of some brick buildings was not the result of the building medium itself. The south porch has a 15th-century gable which is richly decorated (see opposite, top left). The glazed clay figures of St. Nicholas and the Virgin are repeated in two main registers as well as in a triangular composition around the central blind rosette, the center of which is a depiction of the face of the sun. For all this figurativeness, the composition still displays an astonishingly neat geometry.

This particular example of elaborate structures in brick architecture was created on a flat surface, but there was also in the north a tradition of building more complicated wall structures that employed tracery, gablets, crockets, and windows with mullions. Such brick gables had their origins in the Marienkirche in Neubrandenburg (ca. 1300). They reached a climax in the 14th century in the church of the same name in Prenzlau (see page 222) and went on to flourish again in the early 15th century in St. Catherine in Brandenburg (see opposite, bottom left).

Stone Secular Architecture

In Stralsund, Lübeck law was established in 1234. Its town hall was built in the 13th century alongside the west façade of the church of St. Nicholas (see page 224, top right). The result was a repetition of the situation in Lübeck, where the Marienkirche and town hall were also closely linked. When the town hall in Stralsund was given its present form, in the 15th century, a façade was built on the northern (narrow) side of the building. Two very different façades in Lübeck had provided inspiration: one at the cemetery of the Marienkirche, from the mid 14th century, and one at the market, built 1440–42. Lübeck also provided models for the covered walk of the arcade, the main story with segmented arched windows, and a "show façade" above, divided by octagonal towers topped with pinnacles. The wall surfaces of the upper façade are divided into blind niches and open-

BELOW:
Wismar, St. Nicholas
Gable of south porch,
15th century

BOTTOM:
Brandenburg, St. Catherine
"Suspended" tracery rosette,
15th century

BELOW:
Neubrandenburg, New Gate
Façade, 15th century

BOTTOM:
Lüneburg, St. John
Tower, 15th century

FOLLOWING PAGES:
222: Prenzlau, Marienkirche, ca. 1325
East view

223: **Hinrich Brunsberg**
Tangermünde town hall, ca. 1420–30

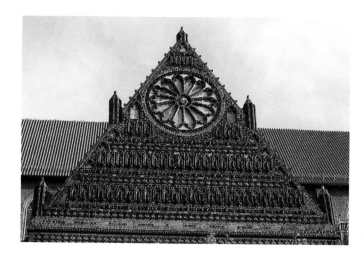

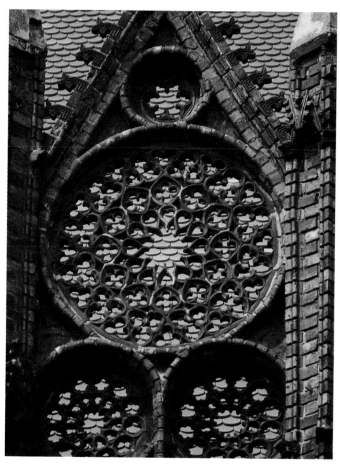

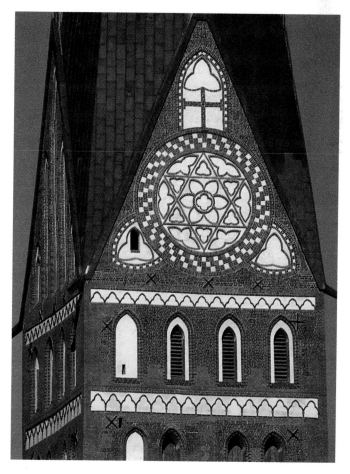

221

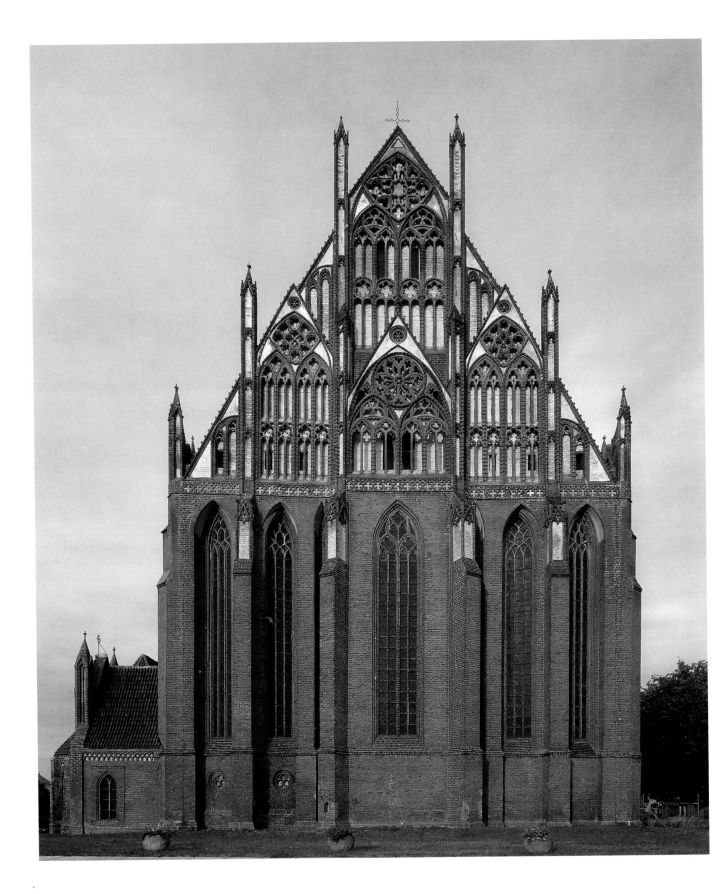

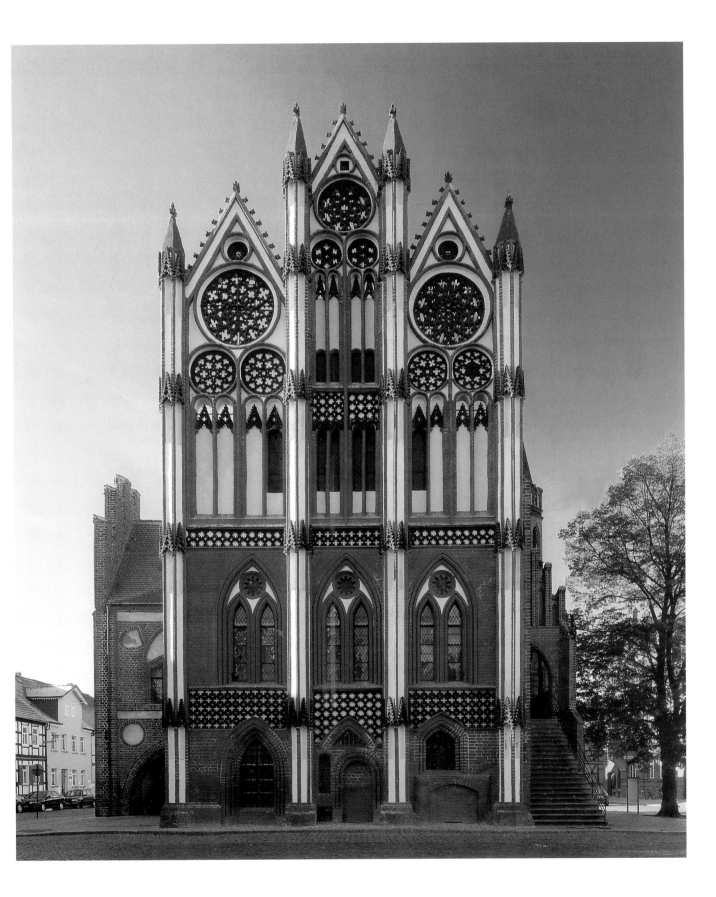

ings, the openings appearing in the free-standing sections of the façade. Behind this wall are just three parallel pitched roofs at half height. The purely representative character of this work is made evident by the openings, which, not laying claim to anything behind, reveal simply open sky.

This motif of pierced gables and slender towers, missing in the Lübeck originals, was used on the façade town hall in Tangermünde, designed by Hinrich Brunsberg (1420–30; see page 223). The only difference is that the rosettes in the oculi in Stralsund are made of copper plate and not, as at Tangermünde, of ceramic tracery. The Altstädter town hall in Brunswick, built 1302–47, must be considered the original model for this gable-and-tower motif.

The external side of the Treptow Gate in Neubrandenburg (see right) is of similar design, with slender dividing towers and pierced gables. During the 14th and 15th centuries, the town succeeded in building the most beautiful town wall in the empire—and in brick! The circular wall, with its four magnificent gates, largely remains a riddle, however. It is a collection of double ramparts and trenches, low gates and gate towers, in which the latter are connected by bridge-like outer courtyards. All four gates are defined as entry points for the town, a Gothic triumphal arch. The element of display gained in significance as the original defensive function of the towers grew less important. Other defensive structures have an aesthetic distinction but Neubrandenburg represents a completely new development for aesthetic effect was the principal consideration. Although the basic design of the gates is a traditional one, the towers above display a compositional freedom and modernity that cannot be found in Gothic civic architecture anywhere else.

The Archdeacon's Residence in Wismar (see top left) provides a good example of a brick crow-stepped gable house from the mid 15th century. In reality, the gable is single level (a type which may have its

origins in Westphalia) but has crenellations like those on houses in Rostock or in the Lower Rhine (for example in Kalkar). The wall on the gable end is divided vertically by blind niches and ornamented with oculi, lancets, and continuous mullions, elements that make up the basic composition of a Lübeck house. The development of a kind of "colossal order" is particularly worthy of note, the gable niches reaching all the way down to the cornice of the ground floor. The ground floor itself remains separated as a "base," the cornice and a geometrical frieze made of glazed clay providing the dividing line. The walls are built of

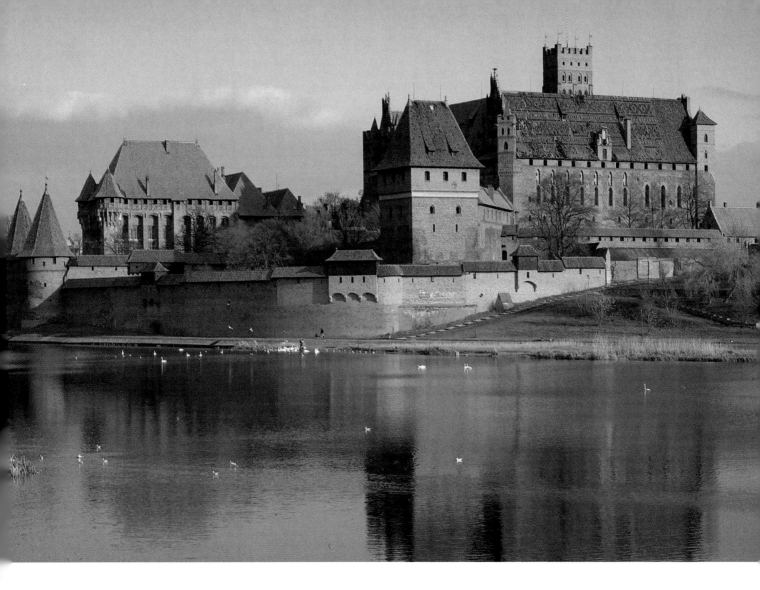

alternating glazed and unglazed layers of brick. A crenellated stretch of wall supported on small arcades runs along the side of the building, a feature that also appears on the church of St. Nicholas in the town. What is noteworthy here is that a unified architectural style has been created, combining sacred, military, and civic forms. The survival of the Archdeacon's Residence provides some compensation for the loss of the grammar school in Wismar, the direct model for this building.

The Marienburg, the main castle of the Teutonic Knights (see above), combines elements of monastic, military, and palace architecture. The foundation stone was laid in the second half of the 13th century. This was the administrative center of the Teutonic Knights, from 1309 the seat of the grand master. Apart from its extensive fortifications, the castle consists of two main parts, the Upper and the Middle Castle, linked by a bridge.

The palace of the grand master, situated at the western corner of the Middle Castle and projecting beyond the wall of the castle, is one of the finest pieces of secular architecture from this period. The main rooms are the Summer Refectory (see page 226, right) and the Winter Refectory. The former, two stories high, features a series of stone cross-windows, which stand between pier buttresses that form niches

for pairs of granite columns, the main load-bearing elements of the structure. The columns continue upwards and end in segmental arches. A crenellated parapet crowns the building. The span of the roof was extended in 1901 in order to protect these valuable architectural elements, though this obscures the architectural origins of the castle, which are the secular buildings of the Rhineland. Two "gatekeeper's lodges," supported by powerfully molded corbels, provide a fitting conclusion to the composition. Links with French architecture have been noted in the motifs for the exterior of the building; the interior owes its origins to Nordic monasteries.

The tower of the town hall in Cologne (see page 226, left) is a unique work of secular stone architecture. If the links to earlier civic architecture in Aachen and the Netherlands are left out of consideration, the work stands as a largely independent creation. This is also true in terms of its relationship with church architecture. From the beginning, the functions of the stories of this tower—described as one of the earliest "high-rises" in Europe—were precisely set out. The town's wine was stored in the cellar. The archives and the financial administration were on the ground floor, the council chamber above, an additional meeting room one story higher, and,

finally, the armory on the fourth and fifth stories. The bell of St. Michael's church was in the spire of the building. All the stories were flooded with light through large cross-windows under ogival arched niches. The restoration of the comprehensive program of 124 sculptures in 1995 revived the tower's original magnificence. Halfway between a castle keep and a town hall, this "tower house" is unique in Gothic architecture.

Exactly one hundred years after completion of the town hall tower in Cologne, the architect Hans Behain the Elder was commissioned to rebuild the town hall in Nuremberg. One of the outstanding talents in secular architecture around 1500, Hans Behain introduced a number of innovations to German architecture, notably the arcaded courtyard, which first appeared in 1509 in a design he created for the Welserhof in Nuremberg. He most probably used as models the courtyards built in Castile by fellow-Germans such as Hans of Cologne and his son Simon (the Casa del Cordón in Burgos, for example). The façade of the council chamber of the town hall (see opposite, left) signals the importance of the council meetings that took place there regularly, council meetings being, as Erich Mulzer has observed, "the key element in the political life of this town of the Holy Roman Empire." Here we are faced by a compendium of what are in fact ecclesiastical elements: walls composed of several layers, tracery parapets behind rows of columns, round gateway arches, all subject to a secular grid design. The way in which the façade connects with neighboring buildings is worth noting. It does so on the ground floor through a stone "diagonal beam" (bottom left of picture) and on the top floor through a bent roof, which is drawn upwards leaving room for the small window of the neighboring building and the rainwater outlet (top right of picture).

Hans Behaim the Elder
Nuremberg town hall, 1514–15
Façade of council chamber

Wiener Neustadt, St. George's Chapel,
ca. 1450

Wiener Neustadt was the imperial capital under Frederick III (1440–93). St. George's Chapel (see below, right), built in the mid 15th century, is situated in the former castle. This chapel, which forms the western gateway to a group of castle buildings, is not only the court chapel but also a meeting chamber. The secular character of the building is so prominent that it is hard to ignore the comparison with Hanseatic courts. Heraldic motifs dominate the whole of the east façade. More than one hundred coats-of-arms blatantly assert the chapel's political function. Below the middle window, surrounded by the coats-of-arms of the Habsburg lands, is a statue of Frederick III, at the very spot where there would normally be the figure of a saint. Only above the window does a figure of the Virgin appear, also on the central axis, but so small and placed so high up that it appears completely insignificant.

Although several German Gothic buildings can be explained from a political point of view, this secular aspect is seldom expressed quite so explicitly as in Wiener Neustadt. St. George's Chapel must, however, be seen as an exception, for the German crown was not a markedly important patron of the arts, certainly not when compared with the Spanish crown.

One of the few buildings for which a direct connection with Maximilian I (1493–1519) can be established is the so-called "Goldene Dachl" in Innsbruck. Of the original residence of the ruler, not much more than a façade remains, its principal feature being a bay window reminiscent of a spectators' balcony—which is exactly what it was. Built by Niklas Türing from Memmingen, it commemorates the marriage in Innsbruck of Maximilian to Bianca Sforza from Milan, and was used as a balcony during public celebrations in the market square. The first upper story, designed as a rectangular bay window, is covered in heraldic motifs (reliefs of coats-of-arms and painted flag-bearers). The projecting loggia resting on top of it was also designed for festive occasions. Here portraits of the ruler and his two wives, as well as reliefs of Moorish dances, were displayed.

Most Gothic "bay windows" in the German lands were commissioned by rich citizens. The standard polygonal design undoubtedly goes back to earlier private chapels, the apses of which, with their several corners, projected from the house front. In Nuremberg, bay windows began to be built on the roofs of houses, a practice that from the 15th to the 17th century created one of Europe's most fasci-

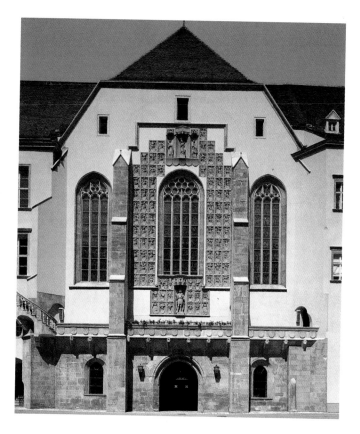

nating roofscapes. Thus a house in the Weinmarkt (see above, right), built about 1482, used the tracery and pier buttresses from the repertoire of sacred forms (though such forms can also be seen as a domestication of castle architecture).

Albrechtsburg Palace in Meissen (see opposite) has the reputation of being the most original piece of 15th-century secular architecture in Germany. Until long after the Renaissance, many of its individual motifs were copied throughout east-central and northeastern Europe. The brothers Ernst and Albrecht von Wettin gave the commission for the new building to the architect Arnold of Westphalia in 1470. The result was the first German building that deserves the name of palace rather than castle.

Albrechtsburg Palace is the expression of a unified design with a clear aesthetic perspective. It is also the expression of a highly original approach to architecture that came close to the limits of what was possible. The ground plan expresses the modernity of the complex, which has an extraordinary dynamism. Access is by a main spiral stairway that leads to the main and north wings. The latter led to another, diagonally placed, wing on the northeast corner. Five sides of a polygonal chapel project from the east side of the palace and a large spiral stairway was attached on the west. To the south, the building is connected to a Gothic cathedral, the two buildings forming an imposing complex on a hill above the Elbe. In elevation, the white castle is characterized by sharp, angular "expressionist" forms. The smooth walls are divided merely by simple cornices, but are pierced by large arched "curtain windows," a form that became known as far afield as Portugal and Mexico. The roofscape, which boasts the second-oldest dormer windows in Germany (they are prior to 1453) after Hannover town hall, is also impressive.

A highly original spiral staircase climbs in a tower-like building opened by arcades (see opposite, bottom left). The staircase, which creates a completely fluid effect, exhibits several remarkable innovations: the steps are curved, the core of the stairway is hollow, and the supports are three slim columns into which the banister is incorporated. Apart from the steps, all these features are built of brick. Added to this is the crystalline "cell vault" with few or even no ribs, a further brilliant creation by Master Arnold. In contrast to the brick of the stairway, all the walls are made of stone. Rooms such as the elector's room (see opposite, bottom right) reveal the cell vaults in their full glory. The only traditional element here is the bench running along the wall. In all other respects the room has an almost futuristic feel to it. It is hardly surprising that its highly original form was reflected in Expressionist buildings and films in the 1920s. The tall irregular vault, with its series of hollows, bears witness to a creative freedom unique in Gothic architecture.

At the turn of the 16th century, Saxony was without doubt one of the culturally most advanced regions of Germany. It was here that Master Hans Witten created a remarkable pulpit for the collegiate church in Freiberg in 1508–10 (see page 230, left), an astonishing work, half sculpture, half architecture, in which the body of the pulpit probably represents a lily. The important feature here is the stairs, the steps of which are arranged as individual stone slabs without risers, for the first time ever, as far as we know. Once again, Late Gothic architecture in Saxony anticipated the modernity of the 20th century. The pulpit can be seen in the context of the elaborate plant motif architecture of around 1500, of which the best examples are in the Colegio of San Gregorio in Valladolid (see page 283) and the former Benedictine church in Chemnitz.

Bold and innovative stairways can be seen as a distinctive feature of German Gothic architecture. A highly original double spiral staircase, commissioned by Maximilian I, was built in Graz Castle (see above, right). Here two staircases meet at a common landing on each story. But only the lower stairs are supported: the upper stairs, astonishingly, form a suspended structure. "A violent stream of movement, intensified by dramatic dark-light effects, pulsates through this powerfully sculpted structure" (Günter Brucher).

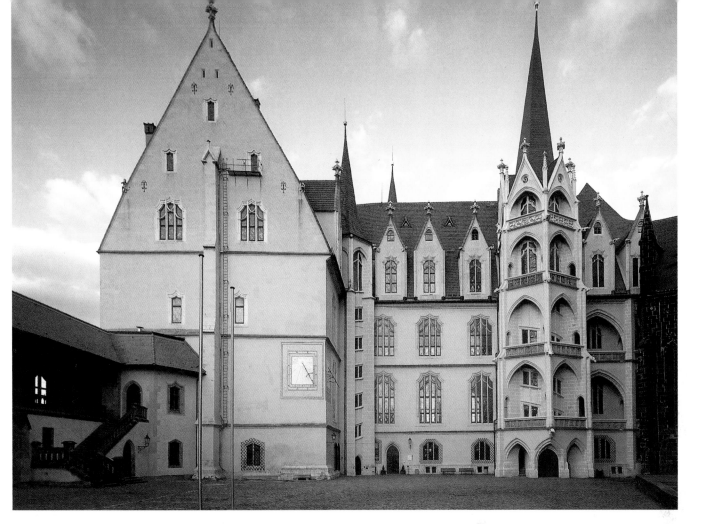

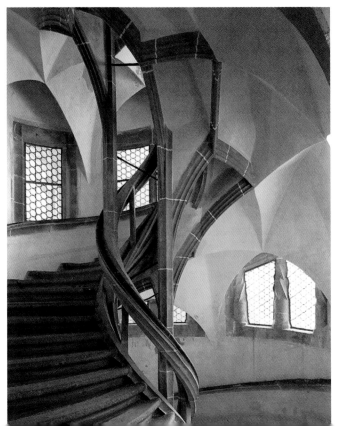

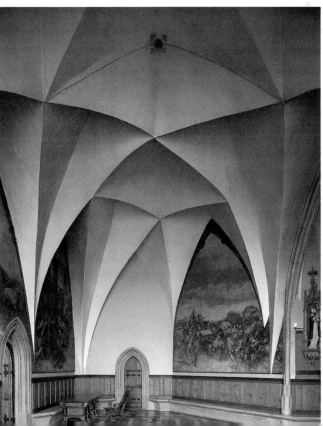

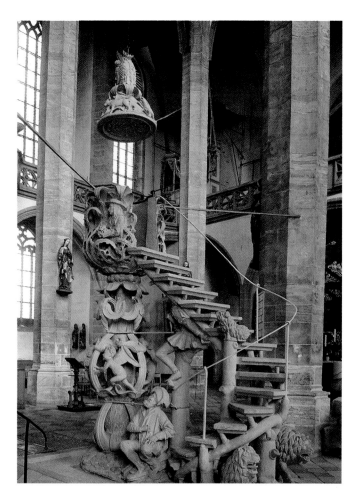

Master Hans Witten
Freiberg Minster (Saxony)
Pulpit, 1508–10

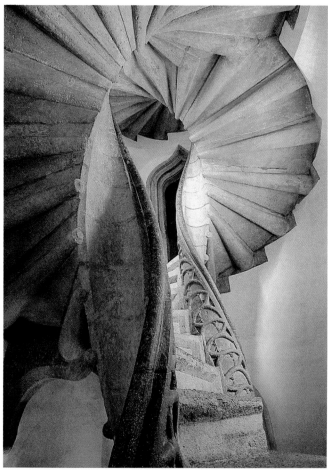

Graz Castle,
Double spiral staircase, ca. 1500

Timber-frame Buildings

Timber-frame construction in secular building was common almost everywhere in the German lands. Although known in many parts of Europe, it flourished here in particular, though there were also strong traditions in England and Normandy. If one considers that in the German lands more than 90 percent of medieval buildings were constructed using this technique, it becomes clear that the omission of these buildings in any work about the architecture of the Middle Ages would represent a serious failing. Paradoxically a number of towns on the North Sea coast still regarded as distinctively medieval, such as Bruges in Flanders, have lost all their timber-frame buildings in the course of time, which means that their appearance has changed greatly. Anyone who wants to visit towns that have preserved their original timber-frame architecture has to visit towns such as Quedlinburg, Goslar, Celle, Duderstadt, Hannoversch Münden, Schwäbisch-Hall, or Colmar.

Timber-frame construction consists of a skeleton construction of wood beams; the wall spaces are filled with clay or bricks. This means that in a timber-frame building structure and decoration are one and the same thing. The load-bearing elements, visible externally, give a clear and bold articulation to the structure so that the standard elements of classical architecture such as cornices, friezes, and pilasters are not needed. Timber-frame construction was a versatile form of architecture: timber-frame buildings include houses, warehouses, fortified buildings, hospitals, town halls, and small churches. The principal weakness of timber-frame buildings, however, is that they are susceptible to fire, though oak is resistant. Many municipalities took measures against fire, banning thatch roofs or promoting the building of thick masonry firewalls (as in Osnabrück, for example). They also encouraged replacing timber-frame fronts with stone ones, as in Nuremberg. This probably occurred earlier than

230

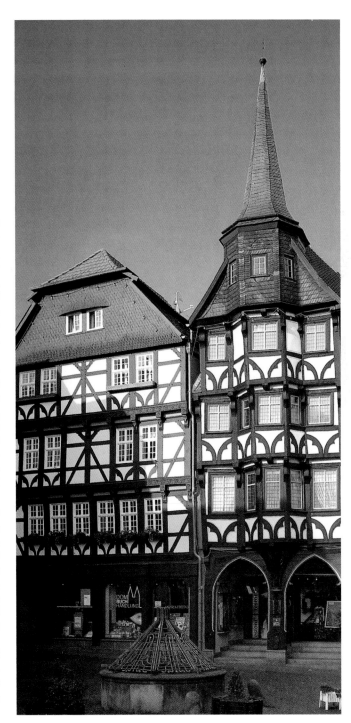

Fritzlar, guild house of the
Michael Confraternity
(right-hand building), ca. 1480

researchers have so far allowed. For example, house number 12 in
Obere Krämergasse in Nuremberg (see page 232, top right, house on
the left) possessed a stone façade as early as 1398. Only the windows
were changed in its translation into stone. Originally they were
grouped in threes with a slightly raised middle window, a design
found throughout the Upper German region, including Switzerland.
The neighboring timber-frame houses on stone plinths, 16 and 18
Untere Krämergasse (on the right of the picture), are, by contrast,
dated to 1452 and 1560.

There was a link between the wealth of a citizen and the building
materials used in building his house, though this is not always
evident. The quality of some timber-frame houses commissioned by
powerful guilds or wealthy patricians was extraordinarily high.
A typical guild house from about 1480 (see right, building on the
right) can be found on the marketplace in the timber-frame town of
Fritzlar, the guild house of the Michael Confraternity. It is clearly
distinguished from neighboring houses by a hall at ground level
which opens in two arcades with pointed arches and by a bay
window extending over three stories. On the roof this forms an
octagonal tower with a spire. All this emphasizes the narrowness of
the building, which had to conform to town-planning regulations
specifying small building plots with gables facing the street. In terms
of its construction, this building belongs to the Franconian tradition
of timber-frame building found in central and western Germany.

In Ehingen in Swabia, the Neuhaus of the Heilig-Geist Hospital
(see page 232, bottom right) has been preserved with the characteristic
Alemanic timber-framing predominant in the whole of the southwest
of the German lands. It is easily recognizable by, among other things,
the small windows, squeezed into the space between the head rail and
breast rail, and the widely spaced posts. Together with the braces, the
latter form various geometrical shapes that were given anthropomor-
phic names. The first floor served as the poor house while on the
second and third stories the so-called "scholars" and servants had
their rooms. The kitchen was originally on the third story.

A house in Knochenhauerstrasse in Brunswick (see page 228, left)
can serve as an example of timber-framing typical of Lower Saxony,
though it can also be found in the whole of northern Germany.
Although now in a fragmentary state, the house clearly displays the
characteristics of its type: a framework constructed entirely of right
angles, strongly projecting stories, a close series of posts, and, finally,
a continuous series of windows called a "lantern." The sills were
provided with carvings, a staircase frieze, inscriptions, and typical
Late Gothic ornamentation all of which anticipate the rich decorative
carving of the 16th century.

In 1480, the Junker-Hansen Tower (see page 232, left) was erected
in Neustadt near Marburg, a fortified round building of mixed con-
struction consisting of stone and timber-framing. It served to protect
the castle and the small village. Architecturally, it is midway between
the castle keep and the wall bastion.

Hans Jakob von Ettlingen
Neustadt near Marburg,
Junker-Hansen Tower, 1480

BELOW:
Nuremberg, 12 Obere Krämergasse
(building on left), no later than 1398
Timber-frame houses, Untere
Krämergasse, 1452–1560

BOTTOM:
Ehingen (Swabia),
Heilig-Geist Hospital, 1532

BELOW:
Matthäus Roritzer
Nuremberg, St. Lawrence
Parapet gallery of hall choir,
completed 1466 at latest

BOTTOM:
Annaberg, St. Anne,
1499–1525
North aisle

Hall Churches in Saxony

Religious architecture in the mid 15th century still profited from the innovations of Parleresque architecture without creativity waning in any way. In the church of St. Lawrence in Nuremberg (see right, top) the cornice dividing the stories of the choir in the Parler church in Schwäbisch-Gmünd has become a wall passage with tracery parapet, protruding like a pulpit. This wall passage, completed in 1466 at the latest, was a feature that quickly became part of the German architectural repertoire. Hall churches throughout Saxony employed it, though with slight modifications, the lower row of windows generally corresponding to the chapels under the wall passage. It appeared again in the collegiate church in Freiberg (from 1484), and later in the churches of the Virgin in Zwickau, Pirna, and Marienberg, in the Benedictine churches in Chemnitz, St. Wolfgang zu Schneeberg, and in the market church in Halle an der Saale.

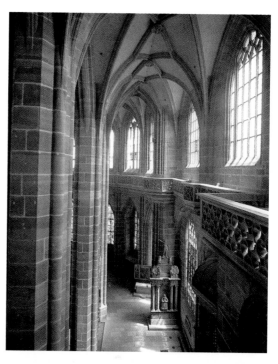

The finest example, however, is in the remarkable church of St. Anne in Annaberg (1499–1525; see right, bottom). Here the tracery of the parapet gives way to figurative reliefs. The church has many other notable features. The pier buttresses have been completely transferred to the inside, where they penetrate the vaults with an admirable lack of respect. As at Freiberg, the column edges are slightly concave, a motif that once again comes from the north, from the church of St. Nicholas in Lüneburg (1407/40). The celebrated vault of the church (see page 235) reflects the artistic freedom which German architects had acquired in the Late Gothic period. Of greater note than the beautiful "flower" designs or the form of the vault springers, which grow out of the pier like branches from a tree, are the sweeping interlacing ribs which do not merely bend but curve away in three dimensions, with a freedom found rarely, even in the most innovative buildings of the Baroque.

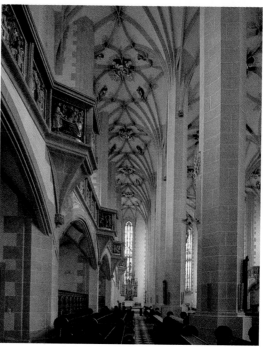

The model for the vaults in Annaberg, and for all similar designs, is a secular building by a south German master, Benedikt Ried—the Vladislav hall in the Hrad in Prague (1493–1515; see page 234). With long flexing ribs running in all directions, forming a web of cells, the space of the hall is liberated from its usual imprisonment in rectangular shapes.

Apart from the vault in the Vladislav hall—which really does seem to consist only of vault—vaults should not be studied at the expense of the remaining architecture, no matter how important their function in shaping the space. If the vault exercises a specific effect on our perception of the space, then it does so only because the whole space was designed in such a way as to make this possible. No vault can be seen separately from the building as a whole. Such over-emphasis on the vault, a commonplace of architectural history, is based on a failure to understand apparently simple building elements, the true value of which is often considerably more difficult to appreciate. A comparison between the traditional vault shapes still much in use around 1400 (see page 235, bottom left) and the compositions of the early 16th century, such as those in Annaberg

Benedikt Ried
Prague, Hrad, Vladislav Hall,
1493–1515

OPPOSITE:
Annaberg, St. Anne
Vault, completed 1525 (top)

Alsfeld, St. Walpurgis, Keystone of choir
vault, ca. 1400 (bottom left)

Schwäbisch-Hall, St. Michael, Keystone of
choir vault, after 1525 (bottom right)

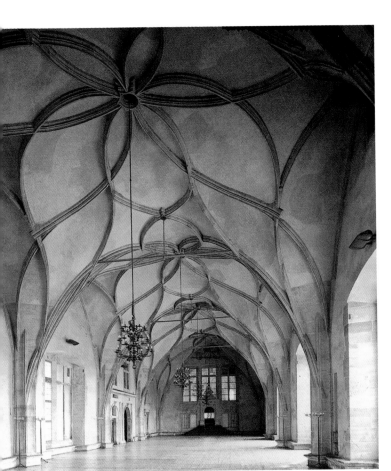

resulted in no real progress. The impact of Renaissance architecture was very different from the impact of Renaissance painting: in Germany a "Dürer of architecture" will be sought in vain. In time, the clash of the two architectural cultures would go so far as to lead to an inferiority complex on the German side, not only among masterbuilders, but also among later architectural historians.

That this was not so at the beginning, that things might have been different, becomes evident from contemporary records. This view does not, of course, accord with the image of architectural history that has been created by 500 years of over-emphasis on the Italian Renaissance. In 1517 the Italian companion of Cardinal Luigi d'Aragon noted on a trip through central Europe: "[the Germans] devote much attention to the Mass and to churches, and so many churches are being built, that when I compare this with the attitude towards the Mass in Italy, and think how many poor churches are being neglected here, I am not a little jealous of these countries..."

and Schwäbisch-Hall (see opposite, bottom right), clearly shows a shift towards more complex designs and a more sophisticated use of space.

Conclusion

It is impossible to say how architecture in the German lands (which, as we have seen, had achieved unprecedented modernity by 1500) would have developed if two historical phenomena had not intervened: the Reformation and the Renaissance. Both brought profound change. Though Late Gothic architecture in Germany was more than capable of meeting a demand for new churches, church building declined as a direct result of the Reformation. As for the Renaissance, we have to imagine the shock, confusion, and contradictory feelings that the new Italian architecture provoked in the master stonemasons of Late Gothic, quite apart from the contemporary debate about the forms and principles of classic architecture, which in the long term

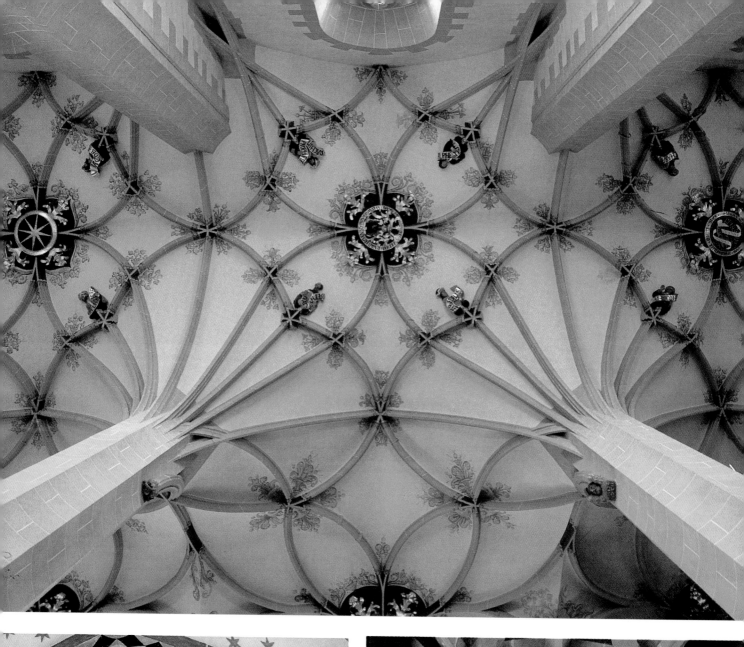

Pablo de la Riestra
**Gothic Architecture in
Scandinavia and East-Central Europe**

Medieval architecture in Scandinavia and east-central Europe is a fringe subject almost completely overlooked by art historians; they obviously find it too cold and alien on the edge of Europe! We therefore should not be surprised to find these regions have seldom been considered part of the cultural heritage of Europe. Yet the island of Gotland alone has 91 medieval churches and Riga is one of the finest and most tower-endowed of Hanseatic towns. Not even Napoleon's opinion counts: smitten by the church of St. Anne in Vilnius, he is reported to have said: "If I could, I'd put this church in my palm and take it to Paris."

In the case of Poland, there is a particular problem. Many ancient monuments are on former historical German territory and are therefore not looked at here. Thus there is no mention of Silesia, for example, Thuringia, or Bohemia outside Prague. Moreover, in Poland, as in Scandinavia in the same period, the local Gothic style was often very closely related to that of the various regions of Germany.

"Towards the end of the Middle Ages, a separate cultural area evolved as a

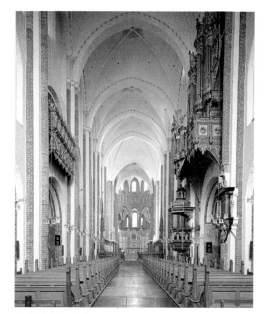

Roskilde Cathedral
View towards east

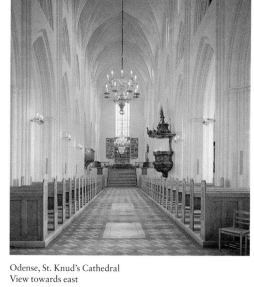

Odense, St. Knud's Cathedral
View towards east

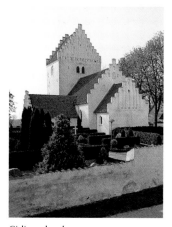

Gislinge church

result of the long interchange between peoples around the Baltic and the close symbiosis of their inhabitants… An important function as carrier of this shared identity devolved on Low German as a lingua franca. It was used from western Flanders right up to the eastern Baltic and was understood alongside native tongues, above all in northern cities" (Gerhard Eimer).

In this connection, the Hanseatic League and its center in Lübeck occupied a special position. More detailed analyses would also need to identify the roles played by the Scandinavian monarchs, the Cistercians, and the friars, while

various separate intellectual currents such as "Bridgetinism" from Sweden would also have be taken into account. Baltic Gothic is not just the style of Lübeck and the Hanseatic League, nor even the architecture of brick, as is evident from numerous stone-built examples in Estonia and Sweden.

Denmark and Sweden

Gothic architecture in Denmark and Sweden has diverse roots. The cathedral of Roskilde (see above, left) shows a receptiveness to early French Gothic shortly before Gothic first made its appearance in German architecture. Though Roskilde is different from the Gothic churches of Noyon, Arras, and Laon, it is nonetheless inconceivable without them. The historically and architecturally important cathedral of Uppsala (see opposite, bottom left) is difficult to imagine without French architecture and the work of Estienne de Bonnueil. By contrast, the cathedral of Trondheim is English. St. Peter's in Malmö, St. James in Riga, or the Riddarholm church in Stockholm could be placed in Lübeck without further ado. Even Westphalia contributed its share to the significant features of Gothic architecture in the Baltic region.

Despite this variety, practically all the main churches throughout this immense area were furnished with winged altarpieces and other works of art by celebrated Lübeck artists, a fact which clearly underlines Lübeck's role as the cultural powerhouse of the medieval Baltic. The artist Bernt Notke alone was responsible for the altar in Aarhus Cathedral, the *Danse Macabre* in the church of the Holy Ghost in Tallinn, the former

high altar in Uppsala, and the St. George group in the church of St. Nicholas in Stockholm. The altarpieces of Our Lady in the cathedrals of Aarhus and Odense, on the other hand, are by Klaus Berg.

A general description of Gothic church architecture in Denmark inevitably focuses initially on a single feature, the stepped gables of the exterior. It was a feature often applied to all the gables on the church, including the main gable, the top of the tower, and the saddleback roofs of the transepts (see left). It was clearly borrowed from Westphalia, though there they used an unstepped triangular gable. Danish stepped gables are simple, without pinnacles, and are articulated in the Lübeck fashion with blind niches, clearly a feature derived from secular architecture. This feature is not unknown on churches in Germany, as the monastery of Wienhausen near Celle bears out, but in Denmark it was applied systematically to buildings large and small. The stepped gables in church architecture found in Brandenburg or Ermland are, by way of contrast, more complex; they are clearly distinct from the Danish form. As regards the structure of the churches, the arrangement is often a pseudo-basilica blind at clerestory-level. Examples include St. Mary in Helsingör, St. Nicholas in Köge, St. Peter in Nästved, and St. Nicholas in Halmstad.

Of the four most important Gothic churches on Danish territory today, three are cathedrals: Roskilde, already mentioned, Aarhus, and Odense (see above, right). The fourth is the former collegiate church of the Virgin in Haderslev. Roskilde represents a smooth translation into brick of the northern French

galleried choir dating from the very early 13th century. Significantly, it was a style that was not developed further. Even though the nave galleries are windowless, the cathedral of St. Knud in Odense has the elevation of a basilica, though it can scarcely be linked with Roskilde. The most interesting feature of this essentially 14th- and 15th-century cathedral is the motif of the elaborately profiled arcades. In Aarhus, the chancel of the cathedral was rebuilt in the 15th century as a hall church with huge octagonal piers. Like most northern German and Danish churches in the Late Gothic style, the interior of the cathedral is whitewashed throughout. Finally, the basilica church of the Virgin in Haderslev, erected 1430–40, betrays Lübeck influences. The polygonal chancel of Haderslev, with its tall windows, is probably the finest Gothic example in Denmark.

Danish Gothic also includes a series of remarkable small churches which, as in Sweden, have completely painted interiors, fine examples being those at Fanefjord, Säby, and Tuse. It was usual to paint parts of major cathedrals like this, an exception being the Epiphany Chapel in Roskilde Cathedral.

In Sweden, three of the most important Gothic church structures have been preserved only in much altered form. The cathedrals in Uppsala and Skara were reworked in Gothic Revival style during the 19th century, though the former underwent a further courageous "de-neo-gothicking" in the 1970s, shortly before revival of interest in Gothic Revival would have prevented it—which would in this case have been a sad loss. Similarly, the Great Church (St. Nicholas) in Stock-

holm underwent an unfortunate external remodeling much earlier (1763–65) so that it would match the Baroque architecture of the Royal Palace.

However, like Roskilde in Denmark, Uppsala as a standard-bearer for French Gothic remains an exception. The typical style in Sweden was the Westphalian hall church, examples being Linköping (stone) and Sigtuna (brick). On the island of Gotland, Westphalian influence was likewise decisive, with northern German hall churches being the models for churches in Skänninge, Våsteras, and many other towns.

Vadstena monastery (see below, right) is of particular interest. It corresponds literally to the "heavenly" building instructions of its founder, St. Birgitta (Bridget). Her building specifications are unique in the 14th century for their precision. The church and separate enclosures for nuns and monks were built on the site of a one-time royal lodge, which represented for the saint a symbol of pride that had to be humbled.

The material to be used for the church (constructed 1369–1435) was stone, even if this was not originally visible through the painting. The apseless, rectangular interior is a hall made up of three aisles of five bays measuring "20 by 20 cubits" (10 meters/33 feet). The monks' choir lies on the west side while the nuns' choir consisted of a now vanished "floating" wooden structure in the nave, accessible from the *claustrum* (the nuns' area within

the monastery) via a bridge. As a religious movement, Bridgetinism was already so important in the early 15th century that it gave rise to earnest discussion at the Council of Basle in 1435.

The Baltic
Of the Baltic republics, Lithuania has the least Gothic architecture. This is bound up with the late arrival of Christianity, in 1386. Thus despite its proximity to Poland and Prussia, this Baltic country is the most remote from German architectural history. In contrast to Latvia and Estonia, there were neither Hanseatic cities nor fortresses created by the Teutonic Knights. Nevertheless, Kaunas and Vilnius were governed by Magdeburg law and were thus, in part at least, western-oriented.

Probably the most interesting architectural features in Lithuania are a few brick façades, above all that of the church of St. Anne in the Cistercian abbey in Vilnius (see right), built around 1500. Viewed from the perspective of western European architecture, this seems a completely independent, exotic creation. The lavish, powerfully profiled articulation displays a round-arch window in the middle, subdivided vertically beneath an ogee that resembles a Palladian Diocletian window long before its time. In this respect, it is reminiscent of the idiosyncratic creations of the 19th-century Gothic Revival. A much more western-oriented composition is the Late Gothic

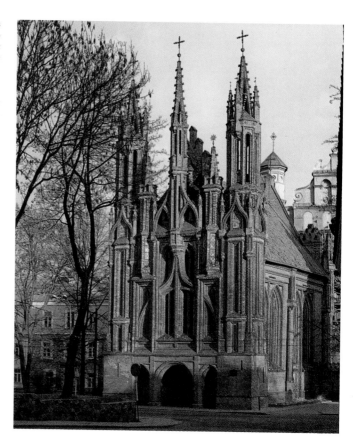

Vilnius
St. Anne, west front

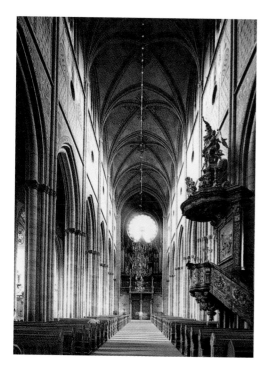

Uppsala Cathedral
Nave, looking towards west

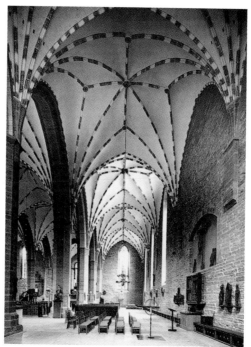

Vadstena, monastery of St. Birgitta (Bridget)

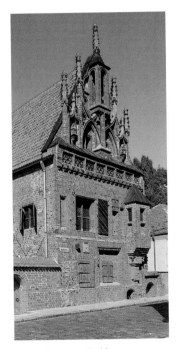

Kaunas, Perkaunas building
Street front

Perkunas building in Kaunas, probably built by Hanseatic traders, perhaps shortly after 1500, as a warehouse and head office (see above).

Riga, the capital city of Latvia, was founded as a German city in 1201 by Albert of Bremen. Stylistic sources for the medieval buildings of Riga are, in chronological order, Westphalia, Lübeck, and, finally, Gdansk (Danzig). The four oldest churches of Riga—the cathedral, St. James, St. Peter, and St. John—can be considered German Gothic only in part. The same applies to secular buildings such as the great Three Brothers guildhall, and many others. The church of

St. Peter (see below, left), probably the most important church building, is based, perhaps through the mediation of Rostock, on the church of the Virgin in Lübeck. The massive basilican choir was completed in 1407–09 by the master mason J. Rumeschottel. The late 17th-century Baroque tower on the other hand is reminiscent of St. Catharine's church in Hanseatic Hamburg.

In 13th-century churches built as stone hall churches or churches with stepped apses, the Gothic style seen in Tallinn, in Estonia, reveals the influence not of Lübeck but of Westphalia. In the 15th century, the fashion was for the loftier basilican style. The churches of St. Nicholas and St. Olai (see below, center) are fine, simple structures supported by rectangular piers. The transverse arches rest on corbels, leaving the wall surface unarticulated. The cathedral of Tartu-Dorpat, a ruin since the 16th century, displays a massive basilican elevation containing a pseudo-triforium and octagonal piers with engaged columns at the corners. In many smaller churches in the country, borrowings from early Gotland Gothic are evident.

Finland remained for a long time under the influence of German and Swedish architecture. Turku (Åbo) contains one of the finest brick-built cathedrals of the Baltic (see below, right). The basilican structure seems enormously lofty due to the dimensions of the nave, 24 meters high and 9.9 meters wide (79 by 32 feet).

Poland

In Poland, the density of Gothic work is—like the population—much greater than in Scandinavia. The larger towns in the kingdom were reformed according to German law in the 13th century (in Lesser Poland, Sandomeriez in 1244, Cracow in 1257, and Lublin only in 1317; in Greater Poland, Gniezno before 1243, Poznań in 1253, and many others). In the 14th century, numerous settlements were founded, many tracing their origins directly to Casimir the Great (1333–70).

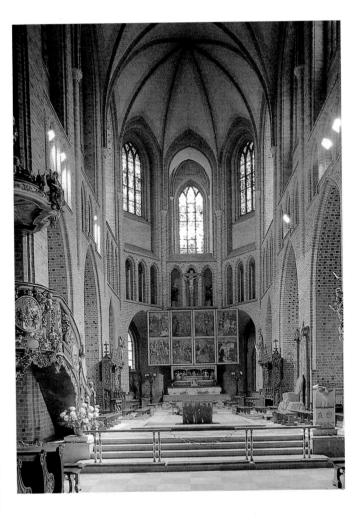

Poznań Cathedral
Choir

The proportion of Germans among the citizens of old and new towns alike was considerable.

Among the most interesting buildings is the church of Wislica, built shortly after 1350. It is an original adaptation for church use of semi-secular architectural concepts such as the refectories and chapter houses of monasteries. The star-ribbed vault of the two-aisled building is supported by polygonal piers with no capitals. The model for such a design must have been monasteries such as Bebenhausen or Maulbronn or, for the vault, buildings erected in Prussia by the Teutonic Knights.

Architectural historians constantly refer to the role of Cistercian architecture in Polish Gothic. This also applies to a building of supreme quality such as the stone- and brick-built cathedral on the Wawel in Cracow, started in 1320. Unfortunately, its original style is blurred by later remodelings and the sheer quantity of internal furnishings.

The ambulatory of Cracow Cathedral has a basilican elevation and a rectangular east end, the structure being two-part: massive openings in the arcades below and an elegant clerestory above with lancet windows, each flanked by a pair of blind niches. The east end shows a similar division, arising from the vaulting

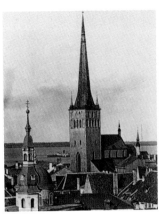

Riga, St. Peter
East end

Tallinn, St. Olai

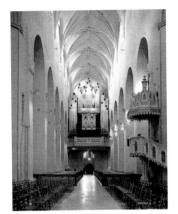

Turku (Åbo) Cathedral
Nave, looking west

Cracow, church of
the Virgin

Cracow, Collegium Maius
Inner court

of the end bay. The rectangular field of the vault is subdivided into three smaller triangular fields, their common tip lying on the central axis of the wall. This surpasses the east end of the cathedral in Wrocław (Breslau), which has a single window over two arcades at the east end.

The cathedral in Poznań, constructed as a transept-less basilica (see opposite, top right) is especially interesting for its remodeling in the 15th century. On the east, south, and north sides of the ambulatory rise three tower-like spaces up to the full height of the clerestory. The effect of these is highly original, creating a continuous triforium cut off from the chancel area. Unfortunately the church was altered in the Baroque and Neo-Classical periods and then tragically destroyed in World War II, so that what we have today is an approximate reconstruction. Nonetheless, Poznań represents a highly developed spatial concept executed entirely in brick.

The church of the Virgin in Cracow was until the 16th century the church of the city's German community. The steeply rising basilica is the result of expensive works in the 14th century carried out by the architect Niklas Werner. The west front, which has no buttresses, has two towers, the northwest one belonging to the town and not the church (see above, left).

In 1478, the carpenter M. Heringk added to this a pinnacled parapet that is among the finest in Europe; it ranks with that of the Teyn Church in Prague, and gives proof of the highest geometrical skills. It consists of eight projections (forming an eight-point star in plan) surmounted by pinnacles that encircle a tall central spire. Below the lowest encircling ledge is a decorative frieze of carved wood reminiscent of similar wooden decoration in Switzerland and eastern Europe. A gilt crown (the Virgin's?) adorns the spire (the original crown was replaced by the present one in 1666). Gold crowns of this kind are familiar from other Gothic buildings in Europe such as Toledo Cathedral and the

monastic church in Königsfelden, though their presence could also serve diverse symbolic purposes. The cathedral on the Wawel in Cracow had a similar steepled roof in the past, but it was removed during the Renaissance.

Cracow also possesses one of the few surviving medieval university buildings in Europe, the Collegium Maius (Greater College), which was built by Johann the Mason in 1492–97, an original architectural achievement. The wings are grouped around a courtyard, the main features of which are an arcade placed forward of the wall to accommodate an upper-level walkway, over which looms a roof overhang of the same width as the walkway (see above, right).

During the Renaissance in Cracow, the castle on the Wawel was constructed on the same principle. The still Gothic arcaded court is one of the oldest north of the Alps. The arcading recalls the summer palace of King Matthias Corvinus (1458–90) in Visegrad, Hungary. In many details, like the geometrical patterns carved on the

arcade piers, the Collegium is closely related to the architecture of the west galleries in Late Gothic churches in Austria.

East of Poland and south of the Baltic republics Russia begins. As this was the land of the Orthodox Church, with its own characteristic architecture, Gothic never took root there.

An imaginary world map of Gothic architecture would produce the following picture: the western border would lie in the island of Santo Domingo in the Caribbean, where the Castilians erected a cathedral of the hall church type; the southeastern border would be formed by the Holy Land, the destination of the Crusades; and within Europe the most easterly region would be Transylvania, where Gothic spread as a result of German colonization.

Gothic persisted as a style through the late 16th and the 17th centuries by pushing back the frontiers to Mexico and Ecuador, while in the 19th and 20th centuries Gothic Revival became virtually a worldwide architectural style.

Ehrenfried Kluckert
Medieval Castles, Knights, and Courtly Love

After cathedrals, the greatest buildings of the Middle Ages were undoubtedly the castles. In Germany, after the development of the dynastic fortress in the 11th century, thought turned to the practical and symbolic advantages of height—the higher the castle, the better. There was rivalry as to which ducal or princely family stood literally "higher." For the medieval mind, the height of the castle stood in direct relationship to the possessor's power and wealth.

Taking as an example southwest Germany, which is one of the areas of Europe where castles are particularly

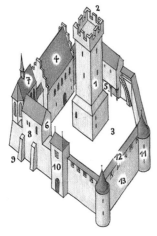

Plan of a Medieval Castle
1 Keep or donjon 2 Battlements
3 Bailey or ward 4 Palas or great hall
5 Animal pens 6 Domestic buildings
7 Chapel 8 Battered revetment
9 Buttresses 10 Gatehouse 11 Corner tower 12 Allure 13 Curtain wall

The medieval castle was the focus of court life. Documents bear witness to lavish court functions such as the extended and extravagant celebrations arranged by Count Albert II of Hohenberg during Christmas 1286 to welcome and entertain his brother-in-law, the German king Rudolf I. We also know that the castle employed numerous court officials such as butlers, seneschals, and marshals, which suggests that festivities were held frequently.

How are we to imagine a typical medieval castle? Despite great regional differences between types of castle, medieval German castles were to a great extent constructed along similar lines. Castles had to satisfy two primary requirements: they had to provide a strong defence against attack and a well-organized setting for the social life of the community in general and the court in particular (see diagram).

Castles were generally surrounded by a circuit of curtain walls supported by massive buttresses. Along the wall a covered allure or walkway was usual, while other parts of the walls were protected by battlements. Access to the castle was via the gatehouse. Towers were built at the corners and along the walls. Domestic buildings and the castle chapel were generally built near to these towers for safety. The principal building, which served as the residential and public areas for the family, was the "palas," equivalent to the great hall elsewhere. Stalls for livestock were adjacent. In the center of the bailey, sometimes nearer the palas or forming a single unit with it, loomed the keep.

Lichtenberg Castle north of Stuttgart is among the few medieval German castles to have been preserved complete (see below). Stonemasons' marks indicate a construction date of around 1220.

Returning to the Hohenbergers, they were, along with the Counts Palatine of Tübingen, one of the dominant ruling

Horb am Neckar. On the left beside the parish church is the "Rogue's Tower."

families of southwest Germany in the 12th and 13th centuries, owning considerable estates in the Upper Neckar Valley. Besides their principal seat of Hohenburg, they also acquired castles in Rottenburg, Horb, and elsewhere.

It was in Horb, a town built on a hill overlooking the Neckar, that their vision of a fitting residence full of towers reaching to the sky came closest to being fulfilled. The previous owner of Horb, Count Palatine Rudolf II of Tübingen, had planned, but not lived to complete, a huge castle project on a rocky outcrop above the marketplace. In the late 13th century, ownership of Horb passed by marriage to the Hohenbergers, who then completed construction work, uniting the castle area with the town proper to include the town church (completed 1260–80), the collegiate church of the Holy Cross, and the church now dedicated to the Virgin.

In Horb, town and castle grew together in a unique fashion (see above). This was

almost certainly the first German town to acquire a town-based seat of power (a Residenz). This involved the increasing concentration of the counts' accommodation in the town itself, a development that greatly enhanced the court's function as a social institution.

In Rottenburg am Neckar, another step forward occurred in 1291 when Count Albrecht II of Hohenberg, who once lived atop the isolated Weilerburg, established a residence above Rottenburg where castle and town formed a unified settlement. Increasingly the ruling powers preferred to locate their seat in an environment better suited to a court's social and political functions. The isolated clifftop castle cut off from social events of the town below was of course not abandoned, but largely lost its residential function. This relocation of the ruling seat soon turned Rottenburg into the Hohenberg capital, its character as a Residenz town outliving the Hohenbergs themselves.

Thus the development of the medieval Residenz town of the 13th and 14th centuries resulted largely from moving the castle into the town. Creating a new constellation in terms of urban architecture—one that had political and social repercussions—this development could be seen as the consequence of frequent changes of power and ownership. Enhanced political power led to more lavish court households and to the financing of expensive building schemes such as castle towns and castle palaces.

Often, of course, the assertion of power attracted danger. The castle and surrounding territory had to be well defended. Strongly fortified castle walls and well-equipped knights were essential for repelling predators, but conflict was usually preceded by tough diplomatic negotiations. If all possibilities of non-violent resolution proved fruitless, a declaration of feud was dispatched and the parties withdrew to their castles to make the necessary preparations for war.

widespread, we can look briefly at some of the political, social, and legal aspects of castle building.

The Hohenberg dynasty, descendants of the counts of Zollern, were typical in their construction of clifftop castles as a symbol of ruling power. In the mid 12th century, this branch of the Zollern family selected for their fortified seat a rocky peak adjacent to an upland meadow, nowadays known as Hummelsberg, near Rottweil. Some 1,000 meters (3,250 feet) high, it was nearly 150 meters (500 feet) higher than the castle of the Zollern, Hohenzollern. To underline this fact, the counts named their family line after this "high peak," or "hohen Berg." Such conical outcrops, which are precipitous on all sides, are typical of the Swabian uplands. They were ideal as geographical symbols of power and majesty.

Oberstenfeld, Lichtenberg Castle
(near Stuttgart), ca. 1220

Unknown Flemish master
The Gotha Lovers, ca. 1480–85
Oil on wood, 118 x 82 cm
Gotha, Castle Museum

Either an attack was launched from the castle or strenuous preparations were made to withstand an attack, preparations that would involve both castle and town. At the end of a feud, a peace treaty was concluded, with the sole aim of preventing a further feud. Borders were set down in the treaty, often defined in fine detail, for example in terms of specific pastures or fiefs. Later generations often contested these divisions of spoil, renewing the feud, which, if not settled, could eventually lead to the destruction of a castle or a change of ownership. In the Middle Ages, formal feuds were often regarded as a legal means of restoring ancestral rights.

Occasionally medieval castles, and subsequently the town-based Residenzes, developed into cultural centers. Art-minded princes attracted scholars and artists to their courts, founded universities, and commissioned the building or decoration of churches and palaces.

Among the many courtiers were the knights. Without going into the details of the origins of knighthood, we can identify service at court as the root of the concept in early medieval times. As feudal service was an inherited obligation, many who owed knight-service gradually acquired property, and so eventually won a great deal of independence; counts of knightly origin generally looked back on a long tradition of service. It was from this political and social foundation of knight-service that the military function of knights developed. They acted as the retinue of kings and emperors and so were enfeoffed for their military services, in other words provided with estates that later became their property.

The knight developed into a central feature of the ideal of medieval court culture, a culture whose most romantic and colorful expression was courtly love (known in the German tradition as Minne), that is, the chivalric love of a humble knight for a highborn lady. Its essence was the selfless homage the knight paid his beloved.

Courtly love found formal expression in various ways. A central token of the relationship was a slender cord the lady bestowed on her knight. In an engraving of an amorous couple standing between two coats of arms (see top left), dating from around 1480, a scarf with fringes tied together with a lover's cord can be made out round the knight's neck. The cord was clearly a symbol of the bond of love that held the couple together. A variant in the 14th and 15th centuries in

tapestries of courtly love was the double knot, demonstrating the couple's indissoluble fidelity.

The theme of the lovers' cord can also be clearly seen in the exquisite painting *The Gotha Lovers* by an unknown

Sight, ca. 1500
French tapestry of wool and silk,
300 x 330 cm
Paris, Musée de Cluny

soming plants, is a symbol of courtly love. In many cases a mirror is introduced, though with ambiguous intent: it is a symbol of vanity or a reference to the self-adoring gaze of Narcissus as he admires his own face in a pool.

Flemish artist, likewise from around 1480 (see left, center). This painting is an interesting illustration of courtly dress, in this case that of the 15th-century fashionable nobility. In the Middle Ages clothes were an unmistakable indication of social rank. Codes of dress were even backed by law, the middle class and the peasantry being banned from wearing certain garments reserved for the aristocracy. In the late Middle Ages, the urban middle classes increasingly asserted themselves and succeeded in winning a few privileges of dress comparable to those of the nobility. The peasantry of course remained excluded.

A central theme of courtly love was the Garden of Love, first presented in the 13th century in a French verse allegory of courtly love, *The Romance of the Rose*. In an engraving by the Master of the Garden of Love from around 1450 (see left, bottom), Venus has been transformed into Lady Minne, who is bestowing arrows—one of the many symbols of courtly love—on the courtiers before her. In the background a knight in armor is kneeling under a pavilion, his hands clasped in entreaty, and all around lovers engage in amorous dalliance.

In such images, the garden itself, with its many animals and luxuriantly blos-

A tapestry entitled *Sight*, from a series of French medieval tapestries whose subject is the five senses, depicts a courtly lady with a unicorn (see above). In accordance with the legend that only virgins could tame unicorns, she soothes the beast while holding up a mirror so that it can gaze at its own image. This scene takes place against a floral background, a meadow gay with flowers and populated by hares, dogs, a leopard, and a lion.

This, too, is a variant of the Garden of Love, a theme that frequently places a loving couple in a setting which, with its many animals, flowers, and trees, clearly refers to yet another garden, the Garden of Eden. This religious background to scenes of courtly love is clear in the *Garden of Paradise* at Frankfurt am Main (see page 435, top).

The art of the courts borrowed the compositions and iconography of religious works. In late medieval representations of such themes as the soul and the virtues, as well as biblical allegories, the dividing line between the Christian and the courtly was often uncertain.

Master of the Garden of Love
Lady Minne in the Garden of Love, ca. 1450, engraving

Barbara Borngässer

Gothic Architecture in Italy

"Is this Gothic really Gothic?" asked art historian Paul Frankl in 1962, gazing at the Duomo, Florence's cathedral. Even if art historians since then have replied with an emphatic yes, many still have doubts about the huge, solid building that possesses so little of the diaphanous or the ethereal, so little of that "dissolving of the wall" characteristic of Gothic churches north of the Alps. A further argument unsettles the stylistic purists: pointed arches and rib vaults, long seen as defining features of Gothic architecture, were known in Italy before Gothic itself appeared in France. The Normans in Sicily took over the pointed arch from Islamic architecture as early as the end of the 11th century, about the same time as the rib vault was introduced in Lombardy.

It is now widely agreed that Italian Gothic cannot be measured by its degree of dependence on France. Art historians established that, early on in Italy, architectural solutions were found that drew on traditions quite separate from those developing in France, in particular the spatial concepts of Roman antiquity. This happened not in ignorance of northern European models, but in a deliberate attempt to exploit Italy's own past. The churches of the Franciscan and Dominican orders showed the way, with an earthbound weight and solidity contrary to the weightlessness of French Gothic. The impression of sublimity is achieved not through soaring naves and light-flooded choirs, but through carefully balanced ratios and structural clarity. Even so, the results remain broadly faithful to the French (above all Cistercian) models, particularly in the ground plan.

Cathedrals, however, found it difficult to accommodate the simpler requirements of monastic architecture. They had to establish their place in the cityscape by means of monumentality. Cityscapes were dominated by the fortress-like town halls, whose crenellated silhouettes reared up as proud symbols of urban power. It was largely a striving for self-assertion that stamps the architectural output of all urban groups: clerical and communal clients vied to construct ever more lavish and imposing buildings. The rivalry of rich guilds, powerful bishops, and influential families marked cities, helping to create the conditions necessary for the rise of Early Renaissance culture. Considerable value seems to have been placed on the individuality and originality of a building, in itself another important factor shaping the unique nature of Gothic architecture in Italy.

There was also within Italy skepticism about—indeed a polemic against—Gothic architecture. The famous 16th-century architect, painter, and art theoretician Giorgio Vasari had hard words to say about northern-inspired buildings that seemed made of paper rather than stone or marble. This *maledizione di fabbriche* (accursed building style), he lamented, was the bane of Italian architecture. Such works, he fulminated, so clearly different in ornament and proportion from both the antique and the modern, should be called German. He believed the style came from the Goths, who, after destroying the monuments of the classical world, had set about creating their own barbaric *lavoro tedesco* (German work).

For Vasari, the friend and champion of Michelangelo, a principal aim was to separate Renaissance art from medieval art. Yet there was more to Vasari's words than that. The term "Goths" was used throughout the Middle Ages to describe barbaric tribes, especially those who crossed the Alps into Italy after the collapse of the Roman empire. Given the contemporary political situation in Florence, under the Holy Roman (German) Emperor Charles V, Vasari's polemic against Gothic acquires an explosive political force over and above the art-historical aspect. Yet whatever his purpose in making disparaging comments, he could hardly have known he was bestowing a name on a whole age. Though he cannot be said to have invented the term, he was the first to define the *maniera gotica* (Gothic style), even if negatively, as a style in contrast to the Classical.

A closely related issue is the development of Late Gothic throughout Europe. In view of the role played by the Renaissance in the study of art history, the argument about how to evaluate Late Gothic raged with particular bitterness. Is the 15th century the "waning of the Middle Ages," as the Dutch historian Johan Huizinga famously claimed, or is it instead to be seen, as "the revolt of the medievalists" makes clear, as a period that saw the emergence of the modern? Even today, it is still the differences between Late Gothic and Renaissance art that are emphasized rather than their interdependence. In terms of Italian architecture, this means that the truly gigantic building projects of the declining 14th century—the Duomo (cathedral) in Milan and the church of San Petronio in Bologna—are written off as medieval resistance to more up-to-date trends toward the Classical. Their achievement as monumental résumés or *summae* of international building traditions and fore-runners of the new aesthetic values remains largely overlooked.

Italy in the Late Middle Ages

The regions of the Italian peninsula were united neither politically nor culturally, while the conflicting interests of Holy Roman Empire and Church split them into two hostile camps. Southern Italy was ruled until 1266 by the Swabian house of Hohenstaufen, with Emperor Frederick II (emperor 1220–50) creating a state there that was cosmopolitan in outlook. Antique-style painting and con-struction projects were combined with the latest Gothic styles, while the culture of the court embraced Provençal poetry and Arabic science. After the death of Frederick II's son Manfred in 1266 and the beheading of Frederick's grandson, Conradin, two years later, the house of Anjou came to power, at the pope's invitation, a development that brought powerful French influences to southern Italy. In central Italy, Rome and the papacy were for the whole of the 14th century in almost continuous crisis. Both the "Babylonian Captivity" (the displacement of the papacy to Avignon between 1309 and 1377, and the Great Schism (1378–1417), when there were two, sometimes three popes at one time, threatened the prosperity of the Eternal City.

The communes of central and northern Italy had as varied a history, and one anything but peaceful. The death of Frederick II (1250), which led to the weakening of imperial power in the north of Italy, allowed cities there to become independent and wealthy. The population grew and trade and industry flourished, creating the conditions for the emergence of a lively urban culture. Even so, the late Middle Ages in Italy was a period of harsh crises. Plague epidemics constantly haunted the cities, beginning with the Black Death of 1347–52, which claimed vast numbers of victims, probably one-third at least of the population, while in prolonged civil wars factions loyal to the Church and those loyal to the Holy Roman Empire fought each other to exhaustion. This clash between rival Guelphs (supporters of the pope) and Ghibellines (supporters of the emperor) caused divisions not only between communes but even within them. Major cities such as Florence, Siena, and Pisa were embroiled in war time and again.

Eventually, sickened by the disastrous quarrels of the nobility, the non-aristocratic bourgeoisie began to organize themselves into guilds and executive councils. In Florence in 1293, for example, the Ordinances of Justice were enacted, excluding the nobility and great landowners from government and placing power with the heads of the guilds (though the traditional rulers could still wield influence by entering a guild). However, attempts to set up a degree of popular rule ultimately misfired, as the control of power remained unstable. During the 14th century the need for a strong hand became urgent everywhere. In the end, the bourgeoisie surrendered power to the nobility and plutocracy only too willingly. In Florence, it was the banking family of the Medici who sensed its opportunity and adopted a populist image.

Thus two forms of government confronted each other: the city republic based on the upper middle classes, as in Florence and Venice, and powerful princes, often *condottieri* (mercenary captains), as in Milan, Ferrara, and Mantua.

Churches of the Mendicant Orders

The Franciscan and Dominican orders were the first to give the Gothic architecture of Italy an individual face. In contrast to the Cistercians, who withdrew to secluded valleys to build their monasteries, the Franciscans and Dominicans sought contact with the populace. Their aim was less contemplation than pastoral care and preaching in the rapidly growing cities. The mendicant orders responded wholeheartedly to this challenge. Located near city centers, their spacious churches accommodated large crowds. To be buried in them ensured the well-to-do heavenly mediation and intercession of the order's saints. The ground plan and elevation of the churches are clear and simple, with ornamental elements reduced to the minimum. The expansive wall surfaces were used for narrative fresco cycles which, in conjunction with sermons, served as visual aids for preaching to the lay congregations.

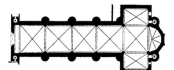

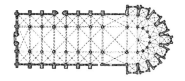

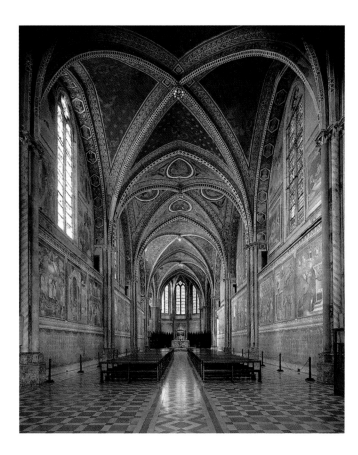

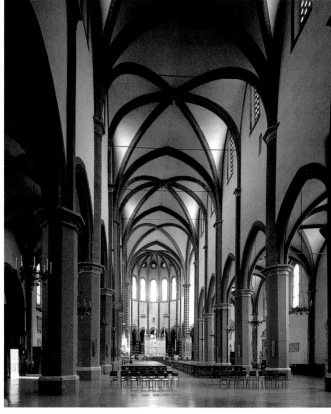

The construction of San Francesco in Assisi marked the start of a new era not only in Italian architecture but also in Italy's cultural history. The double church (one on top of the other) was founded for the interment of St. Francis of Assisi (ca. 1181–1226) in 1228, the year of his canonization; the church was consecrated in 1253. The architecture and furnishings embody a new ideal of piety which Francis had formulated in his self-imposed solitude: an industrious life lived in total poverty and humility, compassion for all creatures, and the renunciation of all worldly power. Giotto and his colleagues depicted Francis's life in the unique fresco cycle in the Upper Church (see above, left). A remarkable series, it covers the saint's life and death, including well-known incidents such as St. Francis preaching to the birds and receiving the stigmata, which took place not far away in the hills around Assisi.

Whereas the Lower Church still resembles a Romanesque crypt, the Upper Church represents a new concept of design that became a model for church architecture throughout Italy. The broad two-story space is clearly structured, and despite its solid walls is flooded with

light. Slender clusters of engaged columns support the ribs of the four rectangular bays. Although French models were followed for the ground plan and elevation (Angers Cathedral, Ste.-Chapelle in Paris), the spatial impression it creates is quite different from that of French churches. Horizontals and verticals stand in a balanced relationship, the weight of the structure is not denied, and there is no clear separation of walls and load-bearing elements. Here the aesthetic philosophy of a unified, self-contained space is reminiscent of ancient Roman architecture as well as of Romanesque buildings.

Other churches in Assisi, such as Santa Chiara—and indeed many churches in central Italy—followed the model of San Francesco. However, the Franciscan church in Bologna (see above, right), dating from about the same time, follows a quite different tradition. Behind the protruding screen-type west front (the front does not echo the cross-section of the nave) lies a nave-and-aisle structure with an ambulatory in the best Cistercian manner. The elevation reveals other influences, however. Following the tradition of the region of Emilia Romagna, the building is constructed of brick while both the six-part

Florence, Santa Maria Novella,
begun 1246

Florence, Santa Croce, 1294–95
Ground plan (right)

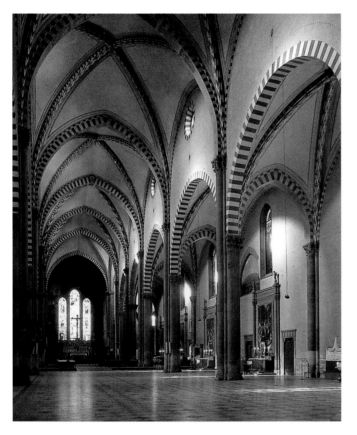

Florence, Santa Maria Novella,
begun 1246

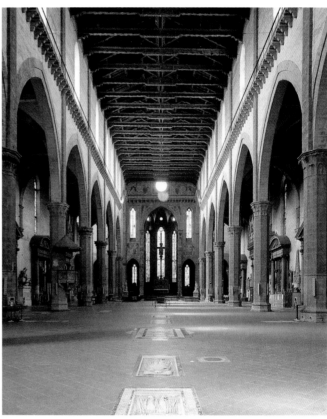

vault and the distinctive crossing piers point to Notre-Dame in Paris. Also distinctive is the difference in style between nave and choir. As Wolfgang Schenkluhn has shown, this is not, as often asserted, a break in continuity, but an intensification of the design through deliberate contrast.

The Dominican church of Santa Maria Novella in Florence (see above, left) set new standards in Italian church building. Here too the Cistercian scheme of nave and aisles with a transept is followed in principle, with square chapels and a straight east end. As in the previously mentioned examples, what is novel and distinctive is the articulation of space. The slender piers with attached half-columns and high arcades serve more to mark the longitudinal rhythm of the 100-meter (330-foot) church than to separate nave from aisles. Of particular interest here is the fact that the intervals of the arches lessen towards the apse, a trick of perspective exploited during the Renaissance to increase spatial depth. The lifting of the vertex of the vaulting has the effect of creating a sense of height hitherto rare in Italy. At the same time it reduces the horizontal thrust, allowing

external buttresses to be dispensed with. Another notable feature is the use of lozenge-striped arcades of light and gray-green sandstone, which lends the building a distinctive dynamic. The use of such polychromatic architectural features was traditional in Tuscany.

It is certainly right to suppose rivalry between the buildings of the Franciscans and Dominicans, as both orders were endeavoring to increase their influence. But whereas the Franciscans appealed to the emotions of their congregations, the Dominicans placed more emphasis on an intellectual approach to faith. An expression of this was their close involvement with universities. Both writings and pictorial cycles reflect these differences. However, in architecture it is unwise to come to hasty conclusions about how ideological differences are expressed. If, as was often the case, there was a great deal of competition—between the orders themselves, between communes and the Church, or between rival political factions within cities—it was often less a matter of using a particular architectural style as an ideological weapon than of trying simply to outshine opponents in the quality and size of the buildings commissioned.

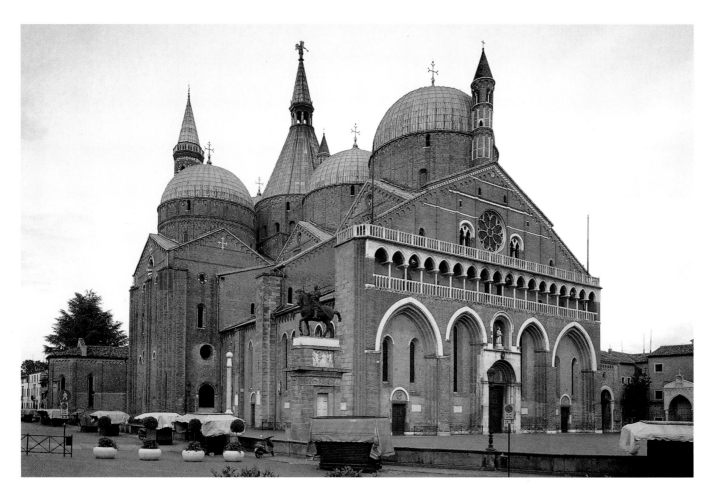

In Florence in 1294 the Franciscans, eager to outdo the main Dominican church, began a new church whose length of 115 meters (377 feet) and width across the transept of 74 meters (242 feet) not only surpassed the Dominican church by one-sixth, but whose height of 38 meters (124 feet) exceeded it by almost a quarter. With these dimensions, the church of Santa Croce (see page 245, right) put many a French cathedral in the shade. But the increased dimensions should not be attributed solely to self-advertisement. Wealthy Florentines favored building their family mortuary chapels in Franciscan churches as a means of paying their respects to the Franciscan ideal—in death if not in life. At Santa Croce the banking families of the Bardi, Peruzzi, and Alberti founded chapels and established monuments to themselves in the fresco cycles of Giotto, the Gaddi, and other artists. (Subsequently Vasari had the frescoes whitewashed, which radically altered the atmosphere of the interior. Even today, some frescoes still remain covered.)

The Franciscans were well aware of the discrepancy between their founder's spiritual legacy of poverty and pious simplicity and their increasingly worldly contacts with the wealthy and powerful. Two of the most ardent champions of poverty, Pietro Olivi and Ubertino da Casale, castigated the Florentine taste for luxury as a work of Antichrist. Despite this, Santa Croce was built with an almost early Christian monumentality, and at considerable cost. However, the grandiose ambitions of the building were expressed not in richness of decoration, but in the church's dimensions, in the clarity of its interior, and in the elegant simplicity of its decoration. The separation of nave and aisles by octagonal piers and thin clerestory walls is hardly noticeable. The only decorative elements are the flat pilasters rising from the pier capitals and the *ballatoio* (walkway) carried on consoles above the arcade, which emphasizes the horizontal axis. Instead of a vault, an open wooden truss roof spans the nave, providing an additional longitudinal accent. The spacious transept, at the very end of the nave, is amply lit by tall lancet windows. Left and right of the small polygonal apse are five straight-ended chapels on each side. The architect of the Duomo in Florence, Arnolfo di Cambio (ca. 1240–1302) most likely also supplied the design for Santa Croce.

An ongoing problem for 14th- and 15th-century Italian architects was the west front. Like Santa Maria Novella, the Duomo, and many other churches, Santa Croce was long without a west front—it still does not have one that is final. Clearly, a basilican elevation fitted with difficulty into the aesthetic principles of Italian architects.

The proposition that there was highly innovative architecture of great quality built by the mendicant orders but that there is no such thing as "mendicant order architecture" is challenged by a consideration of further key buildings throughout Italy. A particularly informative example is the Santo in Padua (see opposite), in which the bones of St. Anthony of Padua were preserved. The history of the church is unclear. The known foundation date of about 1230 may refer

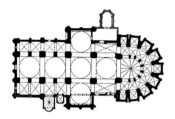

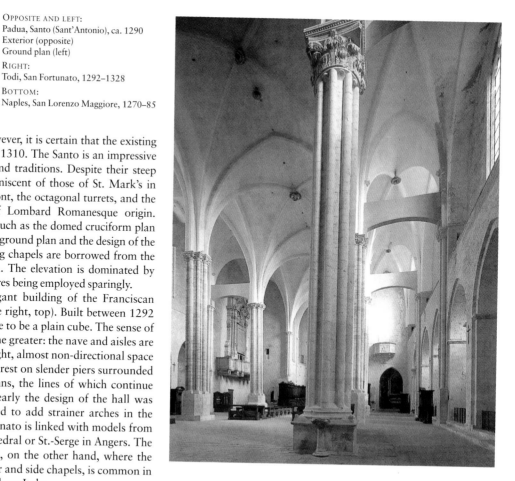

to an earlier church on the site. However, it is certain that the existing arrangement was completed around 1310. The Santo is an impressive mixture of various building types and traditions. Despite their steep drums, the massive domes are reminiscent of those of St. Mark's in Venice while the screen-type west front, the octagonal turrets, and the style of the brick masonry are of Lombard Romanesque origin. Byzantine and Aquitanian elements such as the domed cruciform plan and domed nave are combined in the ground plan and the design of the interior. An ambulatory and radiating chapels are borrowed from the church of San Francesco in Bologna. The elevation is dominated by round arches, Gothic structural features being employed sparingly.

Quite different again is the elegant building of the Franciscan church of San Fortunato in Todi (see right, top). Built between 1292 and 1328, it appears from the outside to be a plain cube. The sense of surprise on entering is therefore all the greater: the nave and aisles are arranged as a hall church, with a bright, almost non-directional space spanned by wide rib vaults. The ribs rest on slender piers surrounded by a cluster of eight engaged columns, the lines of which continue through the capitals to the ribs. Clearly the design of the hall was over-daring: the builders were forced to add strainer arches in the aisles. The arrangement of San Fortunato is linked with models from western France such as Poitiers Cathedral or St.-Serge in Angers. The ground plan of the wall-pier church, on the other hand, where the buttresses are relocated in the interior and side chapels, is common in Catalonia, southern France, and southern Italy.

An important key instance of this Mediterranean variant of the friary church is San Francesco in Messina in Sicily. Largely a reconstruction today, the building was begun as early as 1254. Likewise a wall-pier church, in its simplicity it reflects the Franciscan ideal best of all. Covered by a wooden ceiling, the aisleless nave is flanked by eight chapels. The spacious transept projects only slightly beyond the external walls and is extended by three polygonal apses of various sizes. The walls are almost plain, the only ornamentation the noble outlines of the broad pointed arches of the arcade.

The church of San Lorenzo Maggiore in Naples (see right, bottom) still counts among the most impressive buildings in that city. As at Messina, the nave is made up of a broad space with an open truss roof and side chapels. A three-centered arch links the nave to the protruding transept and aisled chancel, which terminates in an ambulatory with radiating chapels. This essentially French east end was originally added to an older building, before the nave was completely remodeled. The break between the lavish chancel layout and the monumental but plain nave gave rise to much debate among historians, some of whom attributed the discrepancy to a supposed change in the political climate under Charles II. Others argued that it was important to remember that individual building schemes were often deliberately executed in several different styles according to changes in architectural fashion during their construction (precisely what had happened at the church of San Francesco in Bologna).

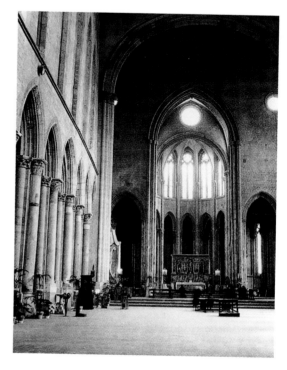

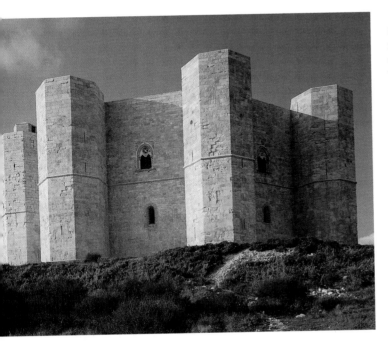

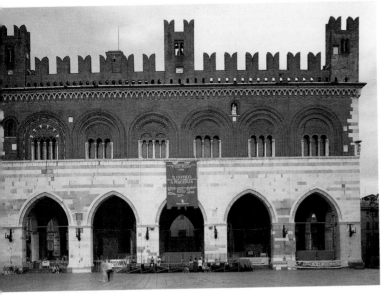

The friary churches also had a lasting influence on the architecture of Venice. Though the legacy of Byzantine and Roman architecture might be evident in the Santo in neighboring Padua, it was Lombard and Emilian Gothic that made headway in Venice, thanks largely to the mendicant orders. The lofty nave of the Dominican church of Santi Giovanni e Paolo, locally known as the Zanipolo (1246–1430), reaches the extraordinary length of 100 meters (325 feet), its unity stressed rather than restricted by massive round piers and broad arches. Stone and brick achieve a charming combination in the elevation. However, in terms of structural engineering, the builders overlooked the fact that land in the Venetian lagoon would not support loads of this kind. When the wooden uprights of the foundations threatened to give under the pressure, the builders were forced to insert wooden tie rods and braces in the vaulting. In contrast to usual practice, the almost completely windowed filigree choir was erected after the nave, around the turn of the 15th century. The Frari church (begun around 1330) took over this spatial arrangement, merely endeavoring to improve stability by reducing the width between the columns so that a stone vault could be built.

Fortresses and Early Communal Palaces

The principles for the construction of Gothic fortresses were altogether different from the principles of church building. To this day, neither the historical nor the architectural background of Castel del Monte (see left, top), begun prior to 1240 as a hunting lodge for the Hohenstaufen emperor Frederick II, has been adequately explained. It is difficult to name with any certainty the models for the octagonal design with octagonal towers at the angles. Scholars argue as to whether Ummayad palaces or Byzantine or Norman fortresses were the source, whether it was influenced by the castles of the Crusaders or the Teutonic Knights, and whether, in its abstract clarity, it looks back to the Middle Ages or forward to the Renaissance. It is not even clear whether the two-story arrangement is ultimately a defensive or a residential-cum-pleasure castle. A stylistic classification, however, is not so problematic: the architectural moldings indicate kinship with Cistercian Gothic.

The significance of the monument becomes clear only if the cosmopolitanism of Hohenstaufen culture is taken into account. Though short-lived, the culture of Frederick's court was one of the great achievements of European civilization. Unfortunately, little building evidence from the period remains. Apart from the antique-style triumphal arch of Capua, the principal relics are a number of razed or drastically altered castles such as Manfredonia, Gioia del Colle, Catania, Syracuse, and Prato in Tuscany. Frederick's death in 1250 brought the brief flowering of southern Italian secular architecture to an abrupt end. The resulting weakening of the empire did, however, encourage the dramatic rise of the communes and gave a boost to secular architecture. Communal palaces sprang up in self-assured confrontation with the cathedrals, redefining the city centers.

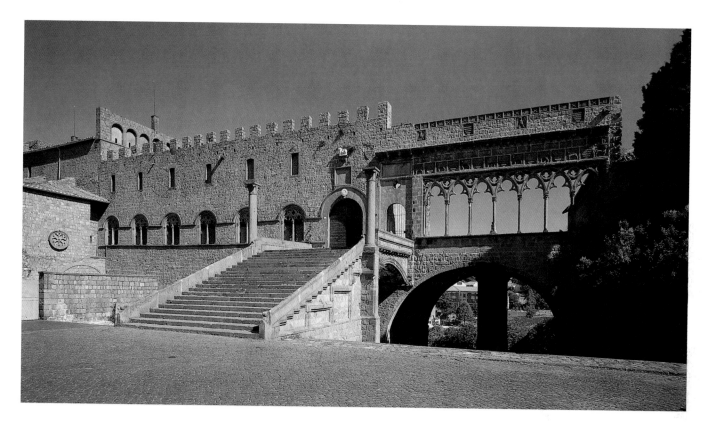

Among surviving communal palaces of the Gothic period, the oldest is the Palazzo del Capitano del Popolo in Orvieto. It was begun in 1250 as a solid building still very much in the Romanesque style. It continues a tradition established by the Broletto, the town hall of Milan. As there, the lower story in Orvieto is a spacious hall opened by arcades, while the upper story contains the broad full-length council room, opening through large windows and balconies onto the piazza. A new feature, emphasizing the opening up to the outside, is the flight of steps at the side of the building.

The Palazzo del Comune in Piacenza, begun in 1280 (see opposite, below), is among the most impressive examples of the type. The lower story, clad in off-white and pink marble, is presented at the front as a monumental loggia communicating with the city through five heavy pointed arches. The compact principal story rises above this, lavish in its ornamentation. Six triforium windows are framed by densely molded round arches while the wall surface is decorated with terracotta and brick motifs. The civic façade is not meant to contrast with the threatening battlements adorning the building; reminders of the defensive structure remained obligatory even for later buildings. The Palazzo dei Priori in Perugia, for example, begun

in 1293 and greatly remodeled in the 14th century, was, despite its urban character, also endowed with battlements, like almost all communal palaces. However, as far as the overall impression goes, one should remember that many of the now bare stone façades were once covered with frescoes. Similarly, the ample council chambers were often decorated with allegorical murals, such as survive in the Palazzo della Ragione in Padua (from 1306).

Other urban palaces, however, like the Bargello in Florence (begun 1255) or the Loggia dei Militi in Cremona (1292), retained the appearance of fortified residential keeps, reinforcing the military features for the purposes of show. Even the architecture of the Palazzo dei Papi (papal palace) in Viterbo (see above) is closely related to the style of communal palaces in central Italy, especially Orvieto. Here too the solid, wide-set building adopts a defensive appearance but communicates with its civic environment via a broad flight of steps and an open loggia with Rayonnant tracery.

In the countryside, the castles of the nobility retained their military aspect intact. Fenis in the Val d'Aosta (see page 251) and Sirmione on Lake Garda (see page 250) are strongholds that conceal comfortable residential apartments in their interiors.

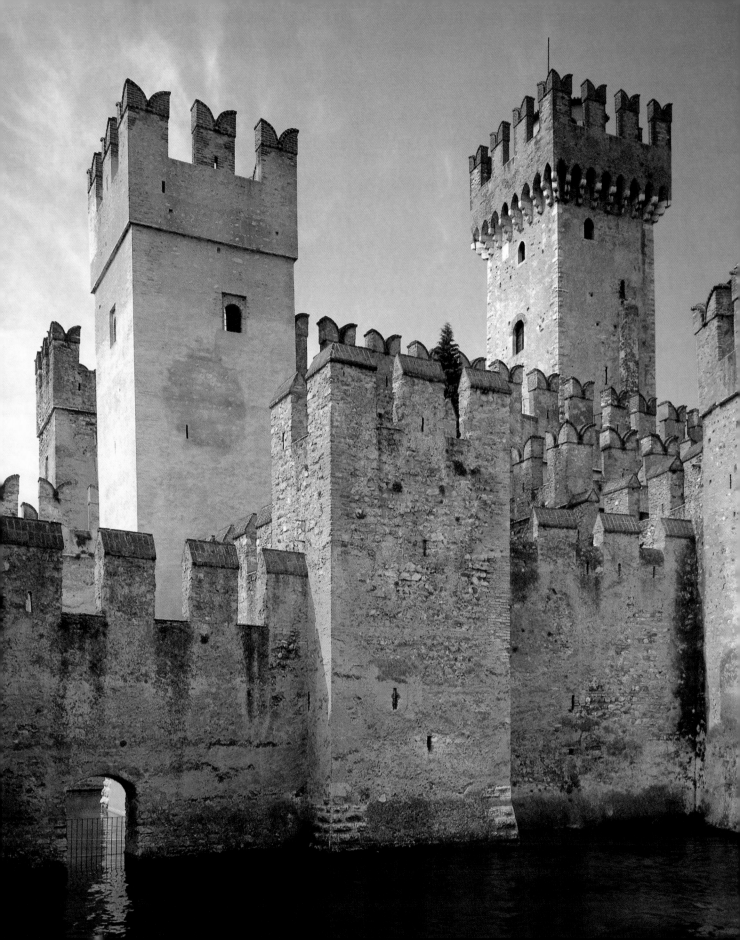

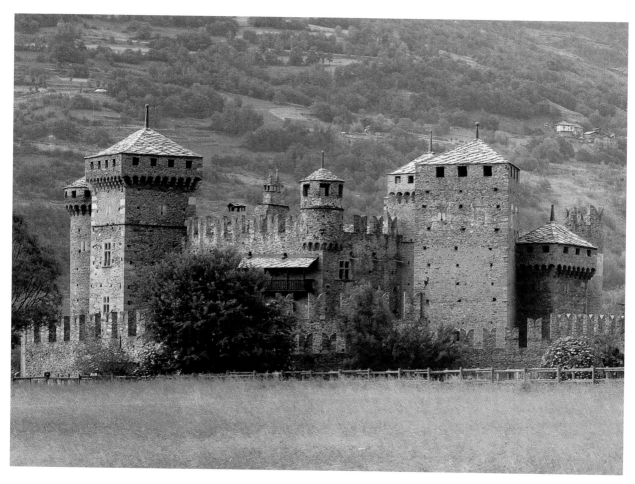

Fenis (Val d'Aosta), Fenis Castle, ca. 1340

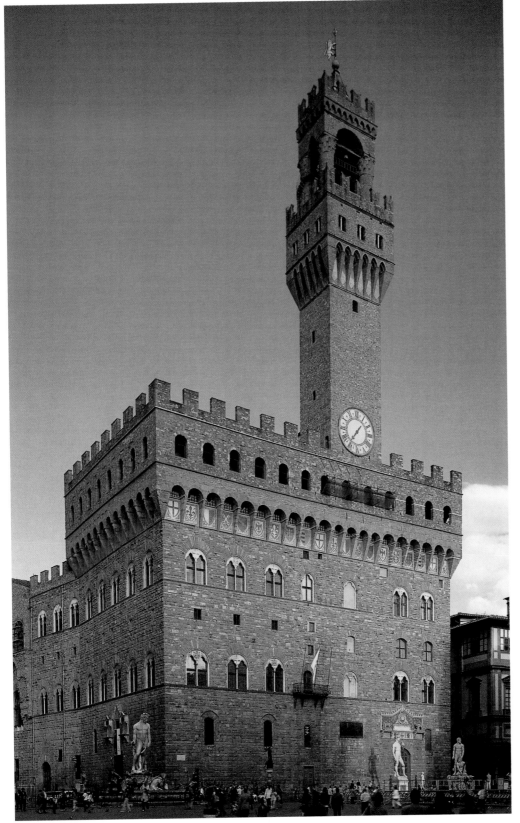

Florence, Palazzo Vecchio,
1299–1320/30
View from Piazza Signoria (left)
Ground plan (below)

Florence and Siena: Communal Rivalry

Quarrels can rarely have been as productive in terms of architectural history as those that afflicted Tuscany during the Middle Ages. From the early 13th century, tensions developed between the papal party, the Guelphs, and the imperial party, the Ghibellines, that led to almost two centuries of civil war and a succession of pacts and betrayals. The bourgeoisie strove to counter the situation by drawing up republican constitutions, but it was the conflict between the various aristocratic factions that determined the character of urban life. The central protagonists were the largely Guelph city of Florence and the largely Ghibelline city of Siena, both of which forced allied cities to toe their line.

During the frequent changes of power and incursions and counter-incursions, particularly in the 13th century, a ritual developed. The residences of the opposing party would be razed, only to be rebuilt more defensively than ever, usually as ever higher towers. These nobles' towers became a symbol of urban architecture, though the right of the nobility to build towers was soon subject to strict rules. A Florentine decree of 1251, for example, set a maximum height of 50 cubits (about 26 meters/85 feet).

As a result of the civic unrest, few cities have preserved their medieval appearance, and we have to imagine Florence and Siena bristling with impregnable towers like those of San Gimignano (see page 15, bottom left).

Out of this historical situation there grew, paradoxically, a productive rivalry that was the driving force behind many building projects in Tuscany and neighboring regions. Florence and Siena set to

Siena
Campo (after 1280), Palazzo Pubblico (begun 1297), and Torre della Mangia (1325–48)

work at about the same time on comprehensively redeveloping their city centers and constructing grandiose civic buildings. The first proposals for the Palazzo Pubblico in Siena (see right) were approved in 1282, the decrees for laying out the Campo, the shell-shaped open space in front of the Palazzo Pubblico, in 1297. The Palazzo Vecchio in Florence, the seat of government, was constructed between 1299 and 1314. Both buildings have a defensive aspect, particularly the Palazzo Vecchio, whose compact, almost inaccessible, exterior indicates that it was built in uneasy times. Around the turn of the century, renewed fighting broke out in Florence between the two factions of the Guelph party, the Bianchi (Whites), largely the increasingly influential middle classes, and the Neri (Blacks), the aristocrats—a conflict that exiled Dante.

The Palazzo Pubblico in Siena corresponds more to the 13th-century type of communal palace, with open ground-floor arcades and richly decorated triforium windows. Only the four-story center block was planned originally. The two-story extensions were added in the early years of the 14th century, the final story in 1680. The characteristic tall bell tower, the Torre della Mangia, reached through a loggia on the left side, was also added later, in the mid 1300s. It must have outreached all the nobles' towers by a wide margin. The palace itself housed all the civic and political institutions crucial to the running of the city. How these institutions saw themselves is eloquently depicted in frescoes by Simone Martini and Ambrogio Lorenzetti in the interior (see pages 448–449, top).

The townscape setting is also subtly planned. Set on the lower edge of the sloping Campo (city square), the building stands in stage-set fashion, much like the *scenae frons* of an ancient theater. From 1280, all surrounding buildings had to conform with regulations so as not to mar the unified appearance of the Campo. The most novel feature of the area was a loggia (built at the rear on top of a massive substructure), which offers a splendid view of the surrounding countryside.

In comparison, the Palazzo Vecchio in Florence is much more conservative, resembling one of the older, fortress-like palaces of the city (the Bargello, for example) but surpassing them in size and monumental balance. Here too, the tower, likewise off center, is a symbol of communal power and self-confidence.

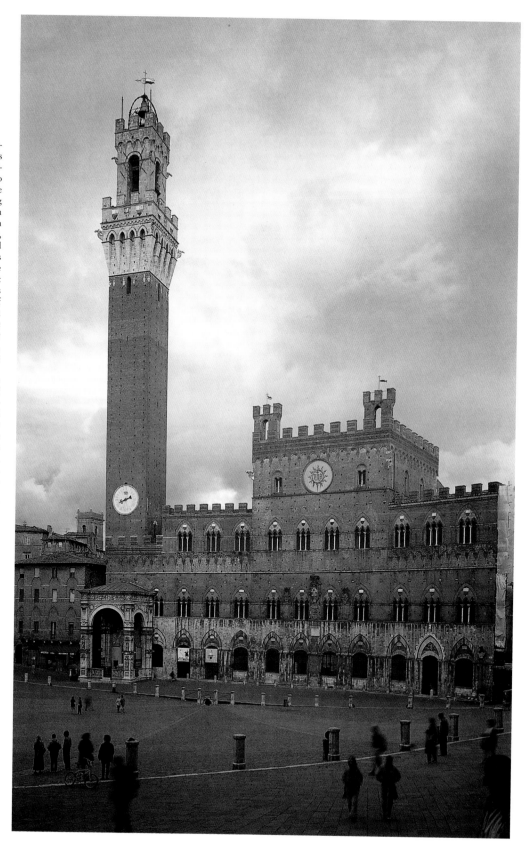

Siena Cathedral
Remodeling of the Romanesque
structure from the early 13th century
Nave (below)
Ground plan (right)

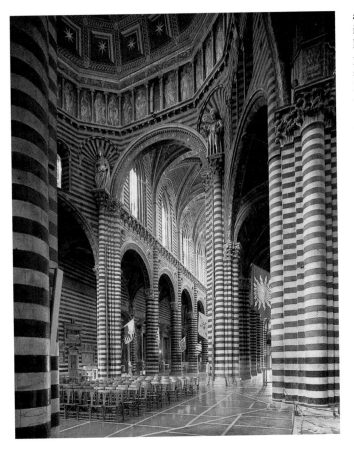

The Cathedrals of Siena and Florence

Although Italian cathedrals could not match the Gothic cathedrals of France, they too were caught up in city rivalry. It was not a question of outdoing the French at their own style, more a matter of surpassing other Italian cathedrals in monumentality and originality. Here, too, Siena took the lead (see above), an example of civic megalomania. Work on remodeling the Romanesque cathedral in the manner of the Cistercian abbey of San Galgano started in the 13th century. However, a much larger crossing was then agreed upon, to provide adequate support for a huge dome spanning almost the entire width of the nave. Because of the height of the dome, the design for the nave and west front had also to be modified. At the east end, a rectangular baptistery was built, at a lower level on account of the sloping terrain, to act as the substructure for a new choir. The next step was to be an extension of this, together with a lavish east front.

However, the idea was abandoned in favor of a still more grandoise scheme. It was decided to build a new cathedral, the Duomo Nuovo, at right angles to the existing building, integrating the old building into it—as a transept. After the walls of the nave and the right aisle had been constructed, however, experts from Florence—of all places—pointed out that mistakes had been made in calculating the strength of the piers and vaulting. These mistakes would, they said, lead to the collapse of the dome while the harmonious proportions of the old church would be ruined by the new structure. These objections, together with the devastating impact of the Black Death, which reached Siena in 1348, led to the work being abandoned. Siena Cathedral is a compromise between the Romanesque nave and the ambitious rebuilding work of the 13th century. Yet the end result is astonishingly unified, due largely to the marble cladding, which covers interior and exterior with bands of black and white.

Work on the new building in Florence had a more successful outcome. Despite several changes of design and the cessation of work on the west front, construction reached a triumphant conclusion in Brunelleschi's famous dome. Renovation of the old cathedral of Santa Reparata had been mooted back in 1294 because it no longer seemed large enough for the rapidly expanding commercial city. The financing of this *opus plurimum sumptuosum* (most sumptuous work) was taken over by the city and the wealthy guilds of cloth merchants and weavers. The foundation stone was laid in 1296. The first plans were supplied by the famous sculptor and architect Arnolfo di Cambio, a pupil of the sculptor Nicola Pisano. Arnolfo worked for both the papacy and ruling families, mainly in Rome but also in other parts of Italy. His design probably looked something like the present nave, though the cathedral was, like Santa Croce, to have a wooden ceiling. Attached to an octagonal crossing, for which a dome was planned even then, there would have been a triconch like that at Santa Maria d'Aracoeli on the Capitol in Rome, and at the church of the Holy Apostles in Cologne.

After Arnolfo's death in the early years of the 14th century, activities were suspended until Giotto was appointed architect in 1334. Giotto devoted himself entirely to building the campanile, however, so that it was not until 1357 that work on the cathedral resumed, this time on the basis of a model by Francesco Talenti. In contrast to Arnolfo, Giotto provided a rib-vaulted nave of huge size and a still more enormous crossing dome spanning nave and aisles; he also extended the east end. The nave with its four bays, each measuring 20 by 20 meters (65 by 65 feet) on the ground and rising to 40 meters (130 feet) in elevation, was completed in 1378. The foundations of the choir followed in 1386, the crossing piers in 1398. In 1413, after the completion of the drum of the dome, there arose the difficult question of the engineering and the aesthetic aspects of further work on the dome. This problem was entrusted in 1420 to Filippo Brunelleschi, who solved it by constructing a dome within a dome. This strong and elegant dome must be considered one of the great engineering achievements not just of the early years of the Renaissance but of all time.

Florence, Duomo,
Begun 1294/96–1302 under Arnolfo
di Cambio, continued from 1357 by
Francesco Talenti
East end (1380–1421), dome by Filippo
Brunelleschi (1418–36), west front by
Emilio de Fabris (1875–87)

BELOW LEFT:
Florence, Romanesque baptistery
(bottom left of picture), 19th-century
west front of the Duomo, Giotto's
campanile (right of picture), and
Brunelleschi's dome

BOTTOM LEFT:
Duomo, nave looking east

Giotto di Bondone
Florence, Campanile, begun 1334

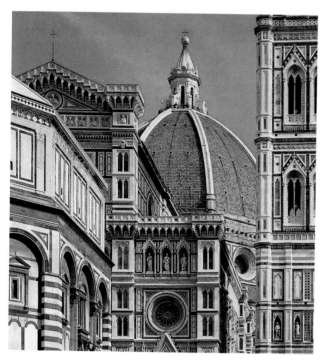

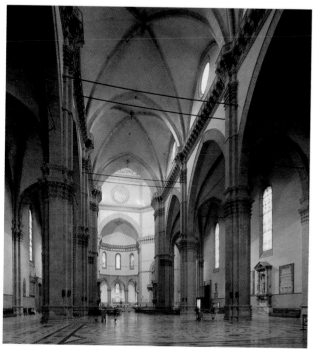

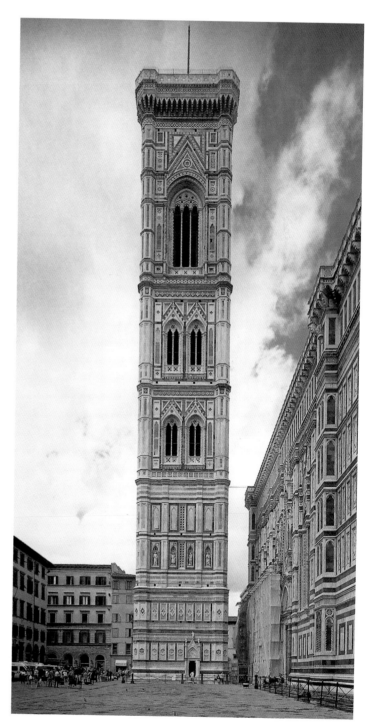

255

Lorenzo Maitani
Orvieto Cathedral, west front, 1310

Giovanni Pisano
Siena Cathedral, west front
Remodeled in Gothic style 1284–99,
completed after 1357

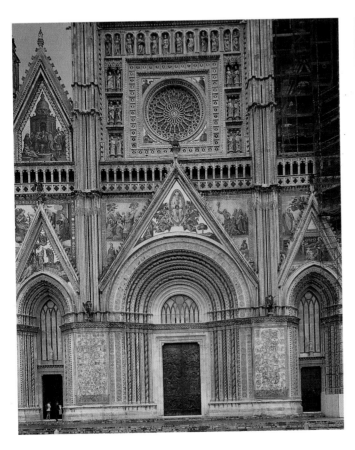

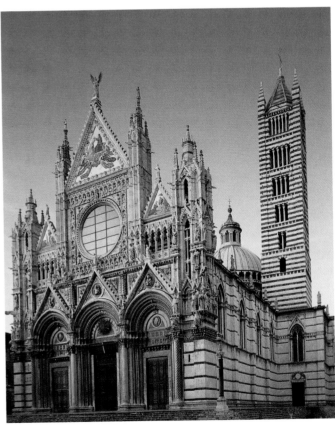

Cathedral West Fronts

Designing the west front of a cathedral was obviously a difficult enterprise aesthetically. Even with the friary churches, it had become apparent that no adequate front had yet been found for a church of the basilica type, with its characteristic arrangement of nave and aisles. In the case of cathedrals, there was also the problem of fitting in with the city fabric in general, since cathedrals were centrally placed and had important symbolic functions. Arnolfo di Cambio obviously had classical stage architecture in mind for the façade of the Duomo in Florence, with niches for statuary. This, according to his design, was to be combined with the French-style gabled doorway. However, only the lower third of his scheme was carried out (there is a drawing in the cathedral archives), and even this was demolished in 1587, to be finally replaced in 1875–87 by the Gothic Revival west front of Emilio de Fabris.

Despite, or perhaps because of, these calamities, there developed a passion for west-front designs, affecting Siena and Orvieto first, and soon spreading to Florence. It was started by Giovanni Pisano, the sculptor and architect, who began the triple-porched screen façade in Siena in 1284 (see above, right), clearly using French churches as his models. (To undertake this activity as master of works at the cathedral, Giovanni had first to be accepted as a member of the commune, as such high office was not open to foreign masons.) Giovanni created a tripartite screen front strung between two substantial corner turrets. Whereas the bottom story is dominated by three deep, heavily molded round arches capped by ornate gables, the upper story is taken up by a huge rose window whose proportions and frame largely ignore the portal level below. Flanking the central rose are arcaded and gabled galleries, the overall façade crowned by a monumental triangular gable above the rose. Tympana and remaining wall surfaces are decorated with mosaics and rich moldings, and the whole façade is covered by a complex program in sculpture (it includes Giovanni's famous *Prophets*). The architecture is used as a backdrop to this excessively ornate surface.

The Siena façade was immediately seized upon by Orvieto. At about the same time, the cathedral there (see above, left) was given a

three-portal, gabled west front whose internal articulation is both tauter and more logical than that of Siena. A further contrast with Siena's front is the vertical stress created by continuous buttresses. The architect of the Orvieto front was Lorenzo Maitani, whose design was preferred to another single-gable design. (Both designs can be seen in the cathedral archives in Orvieto.)

A further example in this series is a project (not executed) for the Siena Baptistery (about 1339?). All these façades have something oddly flat and tapestry-like about them, in marked contrast to the spacious arrangement of the interiors. One reason for this is that in Italy it was always assumed that all the wall surfaces would be covered with frescoes, thus discouraging the provision of more complicated internal structures or the decoration of small areas.

Architecture as a Shrine

During the 14th century there was a growing tendency to give cubic structures a decorative surface. Giotto's campanile for the Duomo in Florence is a truly outstanding example of this. Almost 85m (275 feet) high, it towered above all Florence's so-called "towers of nobility," though not above the tower of the Palazzo Vecchio. It was begun in 1334 to a design by Giotto (a drawing is preserved in the cathedral archive in Siena). Again, the work had to be finished by others, as the new master architect died in 1337.

Giotto's successors, Andrea Pisano and Francesco Talenti, introduced relatively few changes, sticking for the most part to Giotto's specifications for a square tower with octagonal buttresses at the corners. The structure was varied horizontally by means of two stories articulated with panels and moldings below three stories pierced by windows. The planned steeple (reminiscent of that of Freiburg Minster) was not built. The compact plainness of the architecture is combined attractively with Late Gothic tracery and colored marble inlays, a design echoed on the west front of the Duomo. In the pictorial program of the panels, the whole span of medieval life is encompassed: Creation, the world according to scholasticism, trades and occupations, the virtues, and the Christian sacraments—the narrative themes portrayed in the portals of French cathedrals.

On some buildings, the character of a precious shrine was created intentionally. The lower story of Orsanmichele in Florence (now a church) is a good example. On one of the piers of the one-time granary a miraculous image appeared which led to the transformation of the open loggia into a consecrated area. In 1366, the arcades were enclosed by Simone Talenti and windows with the finest Flamboyant tracery were inserted. The tabernacle by Andrea Orcagna (made 1249–59), a monumental but nonetheless filigree marble setting for the miracle-working Virgin, gives the impression of being entirely goldsmith's work.

Similarly, if we did not know its actual dimensions, we might also take the church of Santa Maria della Spina in Pisa (see above) for a shrine. The oratory contains what was believed to be part of Christ's

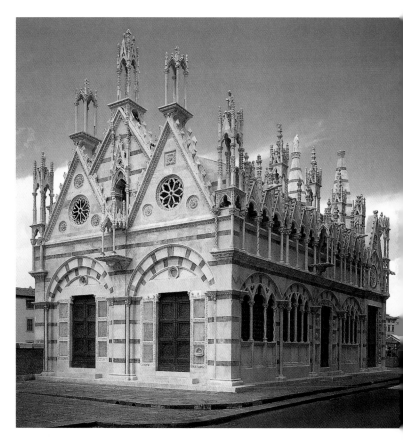

crown of thorns, which the city had acquired in 1333. The acquisition provided the impetus to extend the existing chapel. Undoubtedly the Ste.-Chapelle in Paris, where the entire crown was preserved, was the model (see pages 84–85). The side walls in particular display an array of French-inspired motifs, a forest of gables, pinnacles, and tracery. As at the Ste.-Chapelle, the sculptural moldings are an integral part of the architecture and not, as at Siena, mere surface decoration. The façade itself is a wholly three-dimensional concept, as is evident in the recessing of the center gable. It is this sculptural quality, and the emphatic gracefulness of the proportions, that make this church so remarkable.

Gigantism at the End of the Middle Ages

Two buildings endeavored, each in its own way, to present a *summa* of the architecture of the Middle Ages: the Duomo in Milan and San Petronio in Bologna. The seat of Lombard rulers, Milan had by the late 14th century become a flourishing metropolis under Gian Galeazzo Visconti, whose power at one point extended over the

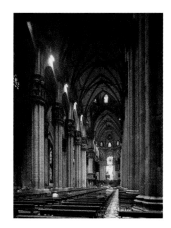

Milan Cathedral, 1387–19th century
Choir and transept (left)
Interior (below)
Ground plan (bottom)

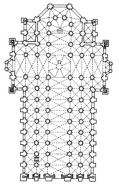

whole of northern Italy. It was thus imperative that the episcopal church of the city should be able to stand comparison with the finest cathedrals of Christendom. In 1386/87, therefore, Simone da Orsenigo began work on designing a huge double-aisle structure (see above), with a projecting aisled transept and gigantic polygonal ambulatory. Apart from the dimensions, the design was derived from north Italian models such as the Romanesque cathedral of Piacenza.

Before the building—whose planned interior space was unique in scale—could be turned into reality, difficult structural problems had to be solved. A commission of international experts was convened. The Italian representatives on this were master masons from the da Campione family and the mathematician Gabriele Stornaloco. Nicolas de Bonaventure and later the painter Jean Mignot came from France and Hans Parler, Heinrich Parler III, Johann von Freiburg, and Ulrich von Ensingen, the celebrated Swabian master tower mason, from Germany.

The main problem was the elevation, which was to be as high as it was wide, and constructed in marble. The relationship between the height of the nave and the four lateral aisles needed to be determined

exactly, not only for structural reasons. The proportions had to be mathematically exact, for the sake of the "transcendent harmony" that was a principal aim.

Thanks to designs and planning sketches, we are well informed about discussions and the technical difficulties the experts faced in creating the "ideal cathedral." Doubts were constantly expressed as to the practicability of the gigantic project, doubts which were discussed in the form of *dubia et responsiones*, doubts and responses. Heinrich Parler advocated a super-elevated nave like those of Cologne or Ulm but was outvoted by the Italians, who wanted a broad layout. Parler stormed off the site in a rage, muttering darkly about "the great damage and disadvantage that threatened because of these evil deeds."

When work was about to begin on the vaulting in 1400, Jean Mignot presented a list of 54 defects which would inevitably lead to the collapse of the building. The response of his Italian colleagues reveals a conflict that went far deeper than the technical level. Mignot's pedantic adherence to medieval structural schemes was met by the Milanese demand that they be adapted to more complex,

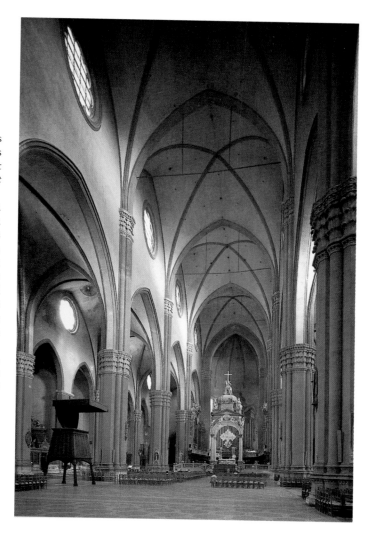

up-to-date aesthetic concepts and a pragmatic approach to what was possible, based on their own building experience. To Mignot's contention that *ars sine scientia nihil est* (art is nothing without science), the Italians countered succinctly *scientia sine arte nihil est* (science is nothing without art).

During the dispute, the Italian masons demonstrated a considerable familiarity with northern European buildings. With straight-faced self-assurance, they suggested remedying the mistakes of Notre-Dame in Paris, particularly the gloominess of the interior, and rebuilding it with classical proportions, in the Italian style! In 1401, a new 12-man commission was set up, which went into Mignot's objections at the highest theoretical level. After long and heated debate, it was finally decided to go back to the designs of the mathematician Stornaloco. His elevation scheme was based on isosceles triangles, a Pythagorean concept that was now to be adapted to the parts already built. Mignot was shut out.

The Italian master masons were not wrong in their calculations, for the massive building is still standing. Though construction was completed only in 1572, and large stretches of the exterior were not decorated until the 18th and 19th centuries, Milan Cathedral is a fascinating document of late medieval architectural history. The colossal breadth of the interior, which contains 52 closely spaced compound piers, casts a spell on every visitor, even if the masons did fail to solve the problem of interior gloom. A unique feature is the application of sculpture to the imposts above the capitals. The exterior is preponderantly 19th-century Gothic Revival, yet thanks to the rich filigree bar tracery covering the walls and windows, and the roof line made up of innumerable gables and turrets, we can get a good sense of how it looked in the imagination of its original designers.

Scarcely four years passed between the start of design work on Milan Cathedral and similar work on a rival project. This time it was a parish church founded by the citizens of Bologna, San Petronio (see right), that was to set new standards. A wooden model by Antonio di Vicenzo reveals a basilica with nave and aisles 182.4 meters (nearly 600 feet) long and 136.8 meters (445 feet) across the transept. To be built of brick, and with lateral chapels, the building was to terminate, like the Duomo in Florence, in a huge east end. A vast crossing-like domed area was planned, branching off into transepts and chancel like a crucifix. The huge interior, plainer and more logical than that of Milan, was begun in 1390. When the architect died in 1400, the first two of the six nave bays had been completed, with the high vaults spanning bays 20 meters (65.5 feet) square! The remaining bays were completed by 1525 and provided with an interim south apse and north façade. After that, work was abandoned. The transept and choir were never begun. But, although incomplete, San Petronio is an impressive development of Tuscan and Lombard church architecture. Once again, spatial breadth, elegant clarity, and a skillful use of materials indicate the tremendous creativity of Gothic architecture in Italy.

Late Gothic Secular Architecture in Venice

In the course of the Middle Ages, the maritime republic of Venice had become the main link between the eastern Mediterranean and western Europe. Its politics, trade, and culture were all characterized by its role as an intermediary between Europe and the Orient. These were links which the conquest of Constantinople by the Ottoman Turks in 1453 did not sever, although the economic center of gravity gradually moved westwards. The demand for building in Venice came from the aristocracy and wealthy citizens, who had lavish palaces and commercial buildings constructed along the Grand Canal.

The unique situation of Venice, built on islands in a lagoon, created a particular type of urban palace focused solely on the waterfront façade. The broad center section of the façade is opened up by arcades and tracery-framed loggias behind which are concealed the broad hall, the *portego*, on the ground floor and the *sala*, the main living room, on the first floor. Closed, tower-like areas of wall, *torreselle*, flank the filigree structure and lend it optical balance. The Ca' d'Oro (see page 261), built in 1421–36 for Mario Contarini, is probably the finest Late Gothic example.

BELOW:
Venice, Doge's Palace, begun ca. 1340,
expanded and remodeled 1424
Façade facing St. Mark's Basin

BOTTOM:
Bernardo Rossellino
Pienza Cathedral
Begun 1460

OPPOSITE:
Venice, Ca' d'Oro, 1421–36

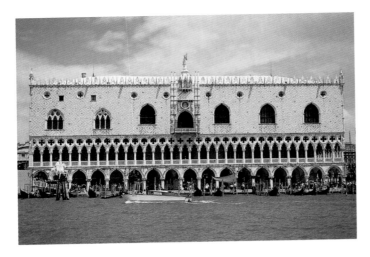

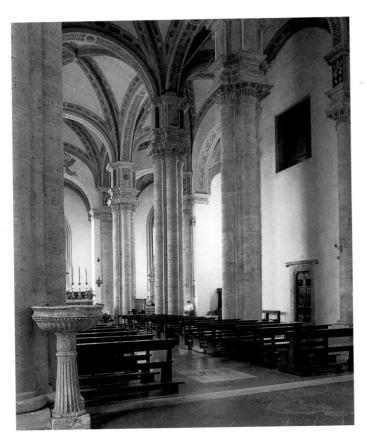

That Venice also went its own way in large-scale projects is proven by the Palazzo Ducale, or Doge's Palace (see left, top). Constructed around 1340 on top of older buildings, its familiar modern appearance is the result of extensions in 1424. As in numerous Italian communal palaces of the period, the ground floor is an open arcade. Above this rises the compact main block with council chambers. Yet what appears in Orvieto or Piacenza as a massive base is here shaped with immense lightness.

The Doge's Palace rests on two graceful rows of arches, so that it is mainly the pointed tracery ornament of the upper part that determines the overall impression. In engineering terms, everything seems upside down. The solid top story, its solidity reluctantly relieved by broad window apertures and patterns in colored marble, rests all its weight on delicate arches, which carry the heavy burden with apparent ease and elegance. There is only one source for this wholly unclassical building aesthetic—Islamic architecture. A glance at the Lion Court in the Alhambra in Granada, which was built a bare 50 years earlier, can verify this. Here too, closed, compact wall surfaces rest on match-thin columns, as if defying gravity.

Pienza

Mention must finally be made of an oddity among Gothic architectural works in Italy, the cathedral of Pienza (see left, bottom). In the mid 15th century, Pope Pius II (Aenea Silvio Piccolomini, pope 1458–64) had his home village of Corsignano south of Siena rebuilt. Bernardo Rossellino was given the task of redeveloping the center of the village into the ideal town of "Pienza" (named after Pius) in accordance with theories elaborated by the architect Leon Battista Alberti. The aim was to create a model humanist city. Cathedral, communal palace, papal palace, and bishop's palace are laid out like a stage set round a square dominated by the Renaissance-style façade of the cathedral.

However, passing through the doors of the cathedral, the visitor enters another world. At the express wish of the pope, Rossellino constructed in 1460 a Gothic hall church with polygonal choir, the form Pius II had seen "among the Germans in Austria." A chronicler described the bright interior of the cathedral thus: "As you pass through the central doorway, the whole church opens before you, marvelous for the fullness of light in it and striking in the splendor of the work. Three aisles, as they are called, make up the building, all of the same height. The chancel ending is divided into five chapels, like a crowned head. It had the same number of vaults, which, equal in height to those of the aisles, seemed, because of the gold stars and blue background, like the real sky…" Visitors to the church "imagined themselves surrounded by a building not of stone but of glass…"

Possibly no building erected in the whole Middle Ages in Italy better fits the image of Gothic than this—Renaissance architecture paying homage to the Gothic ideal.

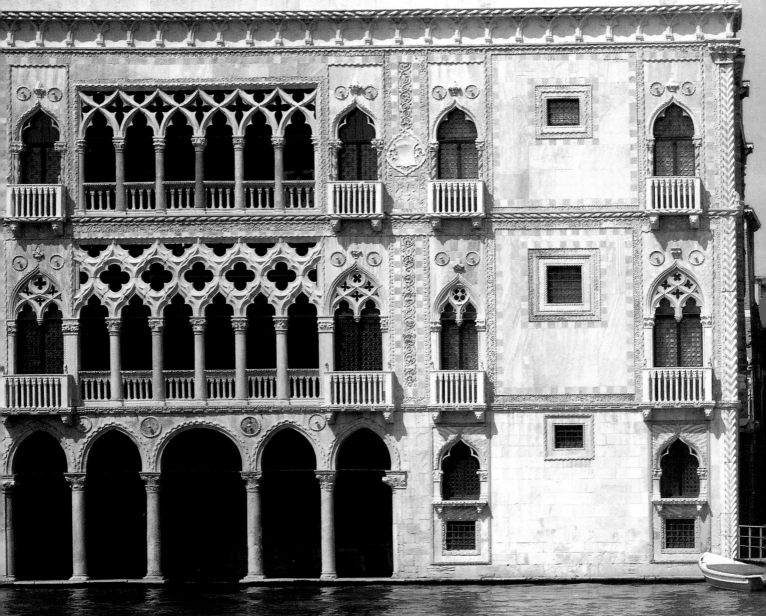

Devil and usurer
Archivolt figures from south doorway
of Chartres Cathedral, ca. 1210–15

The Gothic city represents the apogee of urban development in Europe in the centuries between the fall of Rome and the Industrial Revolution. The economic and demographic character of cities during this time explains the richness of their urban form, their architecture, their art, and their culture.

In the year 1000 the population of Europe can be estimated to have been about 42 million. By 1300 that population had reached about 73 million. Between 1300 and 1340, with a series of devastating wars, famines, and economic disasters, the rate of population growth began to decrease. With the Black Death, between 1347 and 1351, population growth ended, and indeed reversed, with the population falling to about 51 million. Italy suffered as much as a 50 percent death rate in some cities. Europe was not to regain its growth rate and the

high population of the Gothic period until the beginning of the 18th century.

These statistics speak for much more than population. The growth of the European economy between the 11th and early 14th centuries was facilitated by transformations of the agricultural economy that had already begun under Charlemagne and continued throughout the period in question. More land under cultivation provided multiple benefits. The agricultural economy moved from mere self-sufficiency to surplus. These surpluses allowed some peasants to move to cities, and furthermore fed them, their families, and their neighbors once they arrived. The flow of peasants to the city increased the authority of urban magistracies and armies, simultaneously disempowering the feudal nobility.

The clearing of woods for crops in order to feed the growing population

made the landscape much more open and safe. This land fell increasingly under the control of urban centers, the governments of which improved highways and thereby facilitated commerce between city and land, between city and city, and between city, ports, and long-distance trade routes.

Easier trade passages combined with increased work forces that were capable of labor and eager to consume meant growing markets. At the intersection of supply and demand, and of city, country, and trade routes, lay two further related phenomena.

One was money and the whole business of money—money-changing, insurance, and credit. An abstract, easily portable form of exchange now allowed for the possibilities of growth described above to accelerate geometrically.

The other was a new class of laborers who worked with this abstract means of exchange, whether this involved changing goods into money (sellers), money into goods (buyers), money into money (changers), fear into money (insurance), or even time into money (bankers, also known as usurers in contemporary parlance). This group can be characterized by our contemporary term for a social stratum that had no clear place in the structure of early medieval society: the middle class.

"A commonwealth, according to Plutarch, is a certain body which is endowed with life by the benefit of divine favor, which acts at the prompting of the highest equity, and is ruled by what may be called the moderating power of reason... The place of the head in the body of the commonwealth is filled by the prince... The place of the heart is filled by the senate, from which proceeds the initiation of good works and ill. The duties of eyes, ears, and tongue are claimed by the judges and the governors of provinces. Officials and soldiers corre-

spond to the hands. Those who always attend upon the prince are likened to the sides. Financial officers and keepers... may be compared with the stomach and intestines..." ("The Body Social," in John of Salisbury's *Polycraticus*, translated by J. Dickinson, 1927).

The linguistically questionable status of the late medieval middle class corresponded to an even greater social questionability. In the body politic as it is described by John of Salisbury (ca. 1115–80), the financial administrators are allocated the unflattering location of the intestines.

The full implication of this idea, which became pervasive with the growth of the money economy, is represented in graphic detail in the imagery of Hell in the frescoes in the Collegiata of San Gimignano (see bottom left). A devil is defecating gold into the open mouth of the prosperous usurer. Whereas monks and clerics previously had the exclusive privilege of being depicted as excessively corpulent, now their ranks were increased by another priesthood whose members lorded over something that was just as mysterious, even transubstantive, as the host: money.

The enmity which the middle class earned from the practice of changing and lending money—inevitable in what was rapidly becoming an international credit-based economy—can be best understood by their most common caricatures, Avarice and Usury. Both represent individuals who, like the hated monks and clerics of the agricultural economy, hoarded wealth that was often gained by exploitive means. Indeed, in an agricultural economy the usurer came into service only in times of dearth, when hoarded wealth could be returned to those without savings at often exorbitant interest rates.

Even though the investor or banker in the new credit economy functioned in just the opposite way, as a facilitator of ventures, the memory of earlier situations of lending remained powerful. While not every merchant in every transaction was engaged either in usury or hoarding money, the contact with money itself made them questionable.

Where previously transactions tended to be based either on barter or on faith—the direct exchange of goods in kind or the promise of such an exchange—now the faith exchange was replaced by money. Transactions were frequently between individuals who often, in the

Taddeo di Bartolo, devil and usurer, detail from *Last Judgment*, 1393
Collegiata, San Gimignano

Reconstruction of a medieval town from documentary and archaeological sources
Painting by Jörg Müller

No vice is worse and none more execrable…" And as St. Peter Damian (1007–72) wrote: "First of all, get rid of money, for Christ and money do not go well together in the same place" (translated by Little).

This distortion of the fundamentally positive—and indeed inevitable—growth of trade and traders can be attributed not so much to the excess of imagination that such ripe imagery implies, but rather to a poverty of imagination. The usurer and the miser were the only ways in which the middle class could be perceived, even by itself.

It should therefore not be surprising that the medieval bourgeoisie invested considerable amounts of money in developing alternative ways of representing themselves. Their story is inscribed in their urban architecture just as much as in their literature, portraits, and family houses. The streets, squares, and buildings of the emerging medieval middle class are not, however, just records of their success, but rather expressions of their aspirations.

The difference is critical. The middle class of Europe's cities never aspired to being middle class, as such an aspiration had been, in their experience, at best a contradiction in terms, at worst impossible due to the repugnance of associated imagery. Instead, they aspired to being either noble or holy, generally both.

It is worth arguing (though more evidence would need to be brought to bear than could fit within this brief summary) that the inappropriateness of the historical framework of aristocracy to which the middle class was attracted led them away from initiatives to define themselves for what they were. The noble aspirations of the Gothic city and of its chief inhabitants, the middle class, necessarily brought with them a rejection of the essence of the city as a place of interchange and a denial of their social function as the creators and exchangers of wealth. This paradox helps to explain why, at the moment of the greatest expressions of their economic power in grand urban and architectural projects, the medieval bourgeoisie and their cities were sliding into a decline that was to last between two to six centuries, depending on geography.

The process by which the medieval bourgeoisie lost track of themselves was gradual. They could not end their moneyed trade in populous cities, not to mention their need for international contact and travel, all of which made them perceivable as strangers even in their own towns. However, they could amplify their personal presence in a variety of ways that allowed them to fit into earlier, reputable social types. One of these was by association with the nobility, whether this was through marriage, through economic partnership, or through forms of fealty—sometimes simply by copying their behavior. Another way was by similar association, again in the form of a kind of fealty, to bishops and priests, as advisors and patrons of church finances.

The third, and most novel, way was by forming brotherhoods modeled either on knightly brotherhoods, which provided models for business partnerships and guilds, or on canon or monastic brotherhoods, which provided models for new, specifically urban, religious orders, namely the mendicant orders and their associated confraternities. Such association with noble or religious individuals, institutions, or behavior allowed the merchant class to begin to transform wealth into status.

The transformation of the middle class and of the Gothic city was therefore part of a dynamic relation with historical institutions and their imagery. These historical institutions continued to exist throughout the period in question and engaged the middle class in ways that varied according to locality and time. Where relations were most conducive to the development of trade, urban growth increased fastest. In less favorable situations, urban growth still occurred, but with greater splits between projects undertaken by the middle class and those undertaken by the noble or clerical classes.

The political status of cities also affected their growth—capitals grew faster and with more grandeur than subject or secondary cities. The moment a city changed its political status, its infrastructure, architecture, and, fundamentally, the civic identity of its populace were all affected. History, politics, and urban expression were inextricably linked. Settlements with extended histories, especially Roman foundations, in most cases retained the inheritors of Roman magistracies, bishops. Throughout Latin Christian Europe, the title of *civitas* (Latin for city), was granted only to cities with bishops.

Two primary influences on the growth not only of cities, but also of their unique residents, the bourgeoisie, can therefore be established: potential trade and Roman origins. Trade developed according to geography. Coastal cities rose early and quickly. Following close behind them were cities on major inland pilgrimage, crusader, or trade routes, such as the roads leading to the shrine of St. James at Santiago de Compostela in Spain or to Rome.

Major inland cities tended to have a greater concentration of agricultural, that is, local, trade. In these cities the landed nobility tended to dominate, whether in private architecture or in their occupation of monastic foundations. Inland cities with bishops' seats balanced agricultural trade with regional administration, both secular and religious.

In the north of Europe, such cities remained under the control of bishops generally longer than in Italy. The cathedrals and their sculpture and glass workshops, described in other sections of this

growing city, had no kin or neighborhood contact with one another. Commonly accepted currencies such as the 12th-century Lucca lira or the 13th-century Florentine florin provided at once the security necessary to trade with strangers and the seeming proof of what such a need for security implied, that strangers were not to be trusted. Scatological imagery was therefore not limited to the usurer, but extended to anyone with much contact with money, especially those who kept it to themselves—hence the corpulence of the usurer in the fresco at San Gimignano.

According to John of Salisbury, again in his *Polycraticus*, here translated by Lester K. Little (1978): "Although prodigality is clearly wrong, I think that there should be no place at all for avarice.

TOP:
Chartres, aerial view of cathedral
and city

CENTER:
Anton Woensam
View of Cologne, woodcut, 1531

BOTTOM:
Aerial view of Lübeck

book, thrived in these cities, often against
the will of the bourgeoisie, as representa-
tions by bishops of their combined divine
and secular authority.

Views of cities serve therefore as dia-
grams of power and, in some cases, its
contestation. What follows is a general
sketch of a few characteristic cities in
different regions which should provide a
basis for reading the people and histories
of these and other medieval cities accord-
ing to their urban form.

In inland Chartres in northern France
the cathedral dominates at a scale that is
incomprehensible for the size of the city.
It can be understood only as a monument
of regional power—in this case, on two
scales. One scale was that of the bishop,
who remained powerful far into the
Gothic period, concentrating the wealth
of grain from the Île de France's bread-
basket in a single structure.

Merchants thrived within this frame-
work, building themselves individual
residences with powerful representa-
tional forms, but never developing an
architecture to express their collectivity
which was comparable to that of the seat
of the bishop. The only collectivity other
than that of the bishop's chapter that
could be visualized at the cathedral was
that of the aspiring French kings, who, as
the German historian Hans Sedlmayr has
observed, represented their aspirations in
the novel Gothic form, typology, and
scale of their region's cathedrals.

Although distant geographically, and
subject to the English monarch, Salisbury
in the south of England was in a very
similar situation. Just as in the treatise by
John of Salisbury, Salisbury Cathedral
clearly defines the hierarchy of the social
order, to the point even of isolating itself
in a field of green apart from the city.

It is an extreme representation of an
idea that often attracted the urban classes
despite periodic tax revolts—the dualistic
concept of the city, a concept of the
heavenly and earthly city that predates
even St. Augustine's famous early 5th-
century treatise on the subject, the *City of
God*. At the top of this order is the alli-
ance of priest and king, empowered
directly by God to rule over the secular
world and its subjects.

The history of Cologne in Germany
offers a good example of how powerful
the social hierarchy described by John of
Salisbury remained, even in a city with a
long history of many religious founda-
tions and considerable social diversity.
Although it was one of the Rhine's most

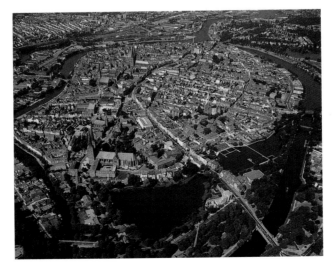

important bishoprics, Cologne's economy
depended as much on the considerable
trade that passed through its ports along
the river.

A constellation of 14 churches founded
by 1075 and restored or rebuilt between
1150 and 1250 served a diverse urban
population ranging from merchants to
bankers, clerics, and the feudal aristoc-
racy. After increasing their power
through two rebellions against the
bishop, in 1074 and 1106, the citizens of
Cologne eventually succeeded in extend-
ing the city walls, in 1180, to encompass
all the city's churches, monasteries and
convents, and marketplaces.

Two structures of the later Gothic
period began to transform this diverse
cityscape. One was the Late Gothic town
hall, whose Gothic forms reveal part of
its mission. The town hall and the square
in front of it were built on the site of the
razed ghetto, replacing an area vital to
trade and banking with a place repre-
senting the aspirations of the dominant
non-Jewish members of the merchant
class to be a holy and devout Christian
community.

The second structure is the one that
dominates the city skyline, but in a way
that distorts its original diversity and
success—the magnificent Gothic cathe-
dral of Cologne, begun in 1248. Even
though the citizens evicted their arch-
bishop in 1288, they continued to invest
in the construction of this structure up to
economic failure in the 15th century. The
builders' crane in Anton Woensam's
1531 view of the city is therefore testi-
mony to the consequences of Cologne's
bourgeoisie restricting their image of
themselves to exclude a vital component
of their merchant population and activ-
ities. The cathedral remained unfinished
up to the 19th century.

While the world of the cathedral domi-
nates the Gothic period of Europe, other
forms of urban development existed in
parallel. Examples of other trends, of an
urbanism and associated architecture that
celebrated diversity and valorized the
bourgeoisie on terms closer to their own,
can be seen in cities whose geography and
origins empowered the merchant classes
to such a degree that bishops never
existed or were easily eclipsed.

Flemish and Hansa mercantile cities
such as Amsterdam, Bruges, Ypres,
Lübeck, or Gdansk (Danzig), even impe-
rial market cities such as Nuremberg,
seldom developed cathedrals that domi-
nated the city. The largest church in

BELOW:
Venice, area around St. Mark
Detail of map by Jacopo de' Barbari,
1500
Museo Correr, Venice

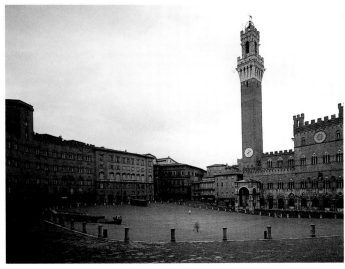

ABOVE:
Campo, Siena, after 1280

Lübeck, the church of the Virgin, was built at the highest point of the city and exceeded the scale and impact of the cathedral. Furthermore, as Wolfgang Braunfels points out, unlike bishop's foundations such as those of Cologne, Strasbourg, or Regensburg, the church of the Virgin was actually completed.

Some of the most intriguing exceptions that eventually prove the rule of the Gothic city are the Italian city-states. Out of four of the peninsula's dominant cities—Venice, Milan, Florence, and Siena—only one never built a bishop's cathedral as the dominant monument.

That exception is Venice, where the basilica of St. Mark originated as the chapel adjoining the palace of the Doge, the elected ruler sharing power with the city's patriciate council. The Piazza and Piazzetta of St. Mark form an image of the city's balance of powers. The regular rhythm of the Procuratie government offices surrounds the Piazza, terminating in the dominant form of the basilica of the patron saint. At this point the geometry bends 90 degrees, with the Doge's Palace framing, but not dominating, the primary axis, which terminates at the other patron of the city, the sea.

The two other major urban spaces in Venice support a very different notion of social and economic order: the Rialto market area and the Arsenale, providing for the local and long-distance trade and maritime connections that allowed the city to continue to thrive as a republic up to the time of Napoleon and the ending of the republic in 1797.

Siena presents something of a hybrid of the forms of urban expression observed in the cities discussed above. It was a Roman city grafted onto an Etruscan hilltop foundation. The medieval bishop's seat was located in an area appropriately entitled *civitas*, in Italian the Terzo di Città. The cathedral was situated at the oldest settled area and the highest elevation.

As the Sienese began to make their mark on the Mediterranean economy, through the development by their bankers of novel forms of insurance and credit, the city began to grow across the ridges defining its site, into two levels of precincts and neighborhoods which are known as *terzi* and *contrade* (and which still exist today). Each of the *contrade* contributed to the town its own militia, which in turn provided it with a semi-autonomous identity.

By the end of the 13th century the Sienese began a project similar to that of their counterparts at Cologne, building a central governing palace and piazza, the Palazzo Pubblico and the Campo, symbolically uniting the *terzi* and *contrade* of the city with a consistent form and fenestration which were rigorously stipulated by building ordinances.

With this very moment of defining a unified image of this expanded city, the Sienese began to project contradictory images of themselves. In the hall of the nine ruling magistrates in the Palazzo Pubblico, the Sala dei Nove, Ambrogio Lorenzetti painted for the commune the fresco the *Allegory of Good and Bad Government*. Part of a mix of urban views, landscape, and allegorical images, the fresco creates an image of diversity and complexity as the basis for the Good City's vitality. At the same time an enigmatic male figure dominates the sections depicting Good Government. Some say he represents the Commune, some that he represents its major legal institution, the statutes—the basis of good government.

In a city of diversity and republican rule, the image of the king seems out of place. It makes more sense in the light of a contemporary project in the city, the rebuilding of the cathedral.

Anxious that the Florentines might eclipse them in urban architecture, the Sienese began in the 1330s to transform the nave of their Romanesque and Gothic cathedral into the transept of a new and vast scheme. Within two decades, with the decline of the economy, the impact of the plague, and the draining resources as a result of civic and regional strife, the project had to be abandoned. It was doomed from the outset by the application of narrow Gothic piers to an over-scaled building. As at Beauvais and even Cologne Cathedrals, the aspirations of the city exceeded, and even compromised, the economic and engineering capacity of its builders.

Today the huge uncompleted nave continues at once to proclaim and to mock the attempt by the Sienese to condense their identity at a single place, representing themselves as a divine, not mercantile, city.

Barbara Borngässer

Late Gothic Architecture in Spain and Portugal

As explained earlier in this volume, Early and High Gothic architecture on the Iberian peninsula followed French models closely. The churches and monasteries built by the Cistercians, together with the classic cathedrals of Burgos, Toledo, and León, adhered to models that had been tried and tested in northern France. Nonetheless, idiosyncrasies such as the persistence of Romanesque ground plans or a taste for Islamic decorative elements led to an early evolution of local stylistic variants. As almost everywhere else in Europe, however, this development came to fruition only toward the end of the 13th century, when a differentiation of regional styles and decorative types set in on a large scale.

The development of architecture in the Iberian peninsula is closely linked to the history of the peninsula's various kingdoms, which were independent until the 15th century. The date of the Reconquista (the campaign to drive the Moors from the peninsula) in different regions thus establishes the earliest possible date for the first Gothic church buildings. This affected principally the south of Spain, which came to Gothic architecture very late. On the other hand, the economic prosperity that developed in the Mediterranean in the 14th century promoted secular building in Catalonia. Finally, cultural and dynastic connections with France, England, and Germany contributed to the development of the architecture of the Iberian kingdoms. Only in the late 15th century did a national Spanish style evolve, combining western European Late Gothic, Mudéjar ornament, and Renaissance forms. It was the style of the Catholic Kings Isabella I of Castile and Ferdinand V of Aragon (who came to power in 1474 and 1479 respectively). In Portugal, a distinct Manueline style developed as a state architecture. The resounding final chords of Late Gothic architecture were sounded by the great Spanish and Portuguese cathedrals of the 16th century. Even as the Renaissance was celebrating its triumph in Italy, these cathedrals gave proof of the astonishing adaptability of medieval engineering and the timeless beauty of its creations.

Catalonia

Religious and secular architecture in both Catalonia, part of the kingdom of Aragon, and the briefly independent kingdom of Majorca were long considered derivative of French developments. Both regions, which had become rich and powerful in the late 13th century thanks to maritime trade, evolved distinctive and high-quality architecture. The Cistercian monasteries of Santes Creus (1158), Poblet (1150/62–96), and Valbona de les Monges (1172) were pioneering buildings that, though they owed their overall design to the French mother houses, incorporated and developed regional elements of Romanesque tradition. A later stage in the style (from 1220 onwards) was displayed in another significant building, the Dominican church of Santa Catalina in Barcelona, a church built under royal patronage. The monumental hall structure with side chapels combines southern French spatial structure with High Gothic

stylistic features of the Île de France, thereby setting the scene for the impressively large hall churches constructed in Catalonia in the course of the 13th and 14th centuries.

Barcelona, capital of the Catalan-Aragonese empire, became the center of an architectural development that moved from religious architecture more and more in the direction of secular building. Initially ecclesiastical and secular power vied to erect showpiece buildings crowded inside the new walls of the *barrio gótico*, the Gothic quarter: the juxtaposition of the cathedral, royal palace, and bishop's palace all jostling for space bears eloquent witness to this. Soon afterwards the urban scene was enhanced by the palace of the parliament (*Corts*), the city hall, the chamber of commerce, the exchange, hospitals, and of course the town palaces of the aristocracy. Added to these were the indispensable Drassanes, the shipyards, the guarantee of maritime supremacy. All these buildings are preserved as a quite remarkable ensemble.

On May Day 1298, the foundation stone of the Seu (cathedral) of Barcelona was laid. The third church on the site, like its predecessors dedicated to the Holy Cross and Santa Eulália, this huge building, 79 meters long, 25 meters wide, and 26 meters high (257 by 81 by 85 feet), is one of the most impressive monuments of Catalan Gothic (see right, top). The work was directed by the master mason Jaume Fabre, who constructed a broad nave with aisles (of much the same height as the nave) which leads to an ambulatory at the east end. Massive cluster piers punctuate the nave bays, whose vault was completed only in 1448 with the addition of painted bosses. Galleries over the chapels add to the complexity of the interior, heightening the grandeur of an already imposing interior. In 1337 the crypt of the cathedral was completed, probably also under the direction of Jaume Fabre. The shallow 12-part rib vault also derives from him, and was the inspiration of works by the celebrated twentieth-century architect Antonio Gaudí. Apart from the 19th-century Gothic Revival west front, the exterior of the cathedral is plain, with large wall surfaces and few off-sets. Flying buttresses, which absorb the thrust of the vault, appear only in the window area in the upper story. Lower down, the piers belonging to them are set inside, so that the exterior appears solid and enclosed, more of a fortress than a church. As in many Spanish churches, the upper parts of the vault are open and accessible, a type of construction that saved materials and labor, but could be used only in very dry regions.

However, the cathedral was soon overshadowed by the parish church of Santa María del Mar (see right, bottom), in the Barrio de Ribera district of Barcelona. Begun in 1329 and consecrated in 1384, it was considered the church of seafarers and merchants, who sailed the seven seas and conquered foreign lands under her patronage. Personally involved in the work, sailors contributed greatly to its unusually rapid completion, as recorded on contemporary capitals and reliefs. The documentation of construction is unusually good, and allows a glimpse of the building work. The first architect was

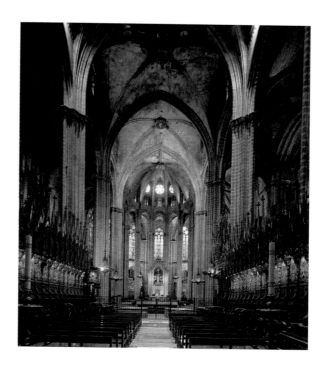

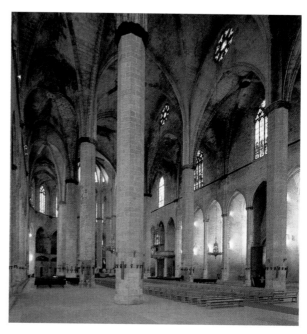

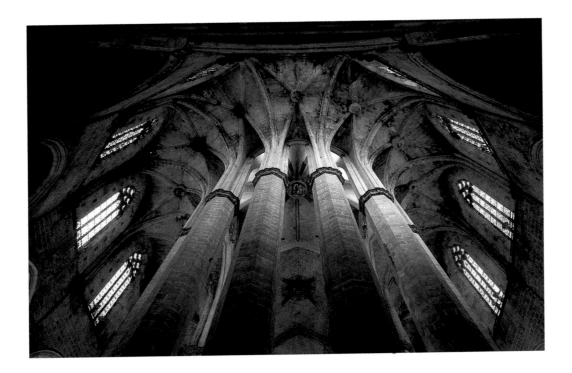

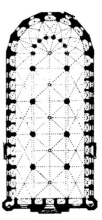

Barcelona, Santa María del Mar
Ground plan

Berenguer de Montagut, who had earlier constructed the cathedral of Manresa. He was succeeded by Ramon Despuig, then Guillem Metge, who died before the building was consecrated.

Like most churches of Catalan Gothic, the exterior of Santa María del Mar is compact and plain. The brick walls are articulated by only two off-sets and flying buttresses emerge from the heavy building only at the level of the upper story. Even the west front is sober, giving no indication that it conceals one of the grandest of Gothic interiors. This interior is overwhelming, not least because of the striking contrast with the narrow alleys of the Barrio de la Ribera district. Broad, harmonious proportions and subtle natural lighting lend the space an almost celestial sublimity. It is unadorned: plain octagonal piers support the vault, and the moldings are reduced to the minimum mass so that the architecture can speak for itself. The simple ground plan follows the tradition of Catalonia and southern France: there is a nave and aisles, with no pronounced transept, and the aisles and the chapels between their piers are carried round the choir, as in the somewhat earlier building of Manresa. The span of the four nave bays is unusually large. Fourteen meters (45 feet) was a sensation for the time, surpassed only by the vaulting of the cathedral in Gerona. The aisles reach almost the same height as the nave, and give the building the appearance of a hall church. Aesthetically, the highlight is the arrangement of piers and vaulting in the apse (see above), which allows sunlight in as if from Heaven.

Hardly less interesting are the parish church of Santa María del Pi, whose ground plan goes back to that of the Dominican church of Santa Catalina, and the aisleless church of the Poor Clares (begun in 1326 by Ferrer Peiró and Dominec Granyer), in which Queen Elisenda was buried.

Likewise constructed in the 14th century in Barcelona were two sensational secular buildings. Between 1359 and 1362, Guillem Carbonell built the Saló del Tinell, the audience chamber of the royal palace (see opposite, top). This monumental aisleless structure is impressive for its bold roof structure: a truss roof rests on six huge transverse arches that, almost reaching the ground, span the enormous distance of 33.5 meters (109 feet). The lateral thrust is absorbed by buttresses on the exterior walls. The models for the structure, found only in Catalonia, were presumably the dormitories and refectories of monasteries such as Santes Creus or Poblet. This structure was used in more modest forms in numerous council chambers.

In the Drassanes, the shipyards, Barcelona possesses a unique historic industrial monument (see opposite, bottom left). Toward the end of the 13th century, the Aragonese king Pere el Gran ordered new shipyards to be constructed because the old buildings had become

Guillem Carbonell
Barcelona, Royal Palace,
Saló del Tinell, 1359–62

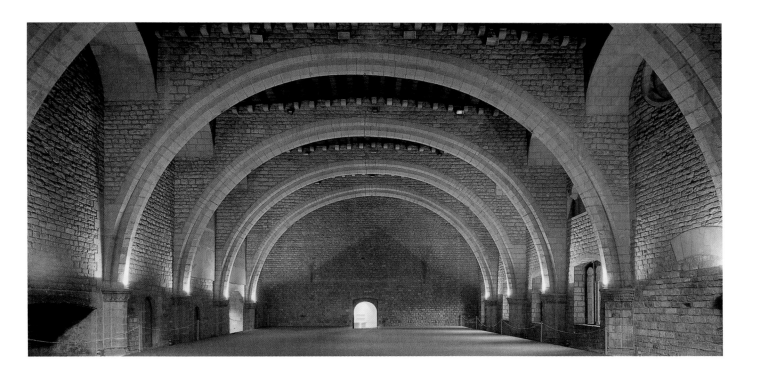

Barcelona, Drassanes (shipyards),
end 13th century–18th century

inadequate. Initially they were constructed as open yards with porticos and military defenses, but these were extended in the 14th century as eight parallel covered halls. Up to 30 galleys could be repaired in them at the same time. To provide room for the construction of still larger ships, the two central halls were combined and the roof raised in the mid 18th century.

As an example of palace architecture in Barcelona, we can mention the Pati Gòtic, the Gothic courtyard of the Parliament, the *Generalitat* or *Diputació*, dating from the 15th century (see page 270). It was flanked by the façade of the Capella de Sant Jordi (St. George; see page 271), with its rich covering of Flamboyant decoration. Such interior courtyards with flights of steps and arcaded galleries on several floors became a standard feature of the urban palaces built by the Catalan nobility.

One Gothic building outside Barcelona needs special mention: the cathedral of Gerona. Its unique choir and sensational nave vaulting make it one of the most important examples of medieval architecture in Spain (see page 272). As at Milan, building work was preceded by a long debate on technical and aesthetic matters. The cathedral chapter had decided in 1312 to add to the Romanesque building a new choir with a naturally lit ambulatory and nine polygonal chapels, a commission given initially to Henri de Fauran, then in 1321 to his

Barcelona, States Parliament,
Pati Gótic, 1425

OPPOSITE:
Marc Safont
Barcelona, States Parliament,
Capella de Sant Jordi (St. George)

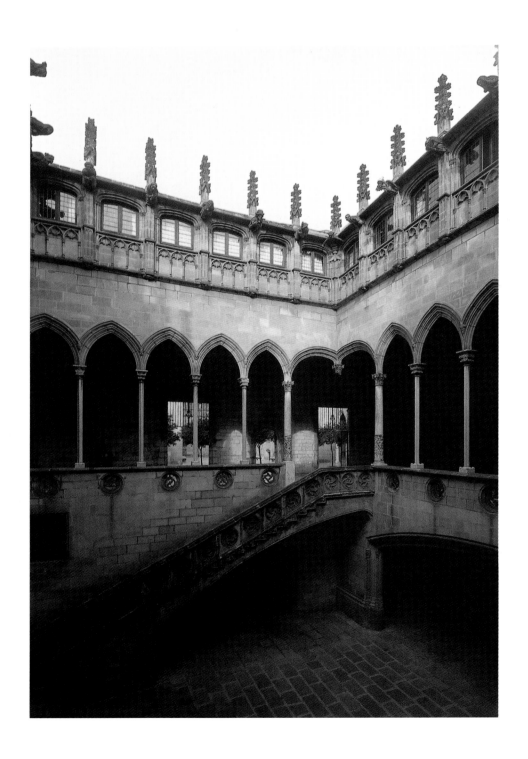

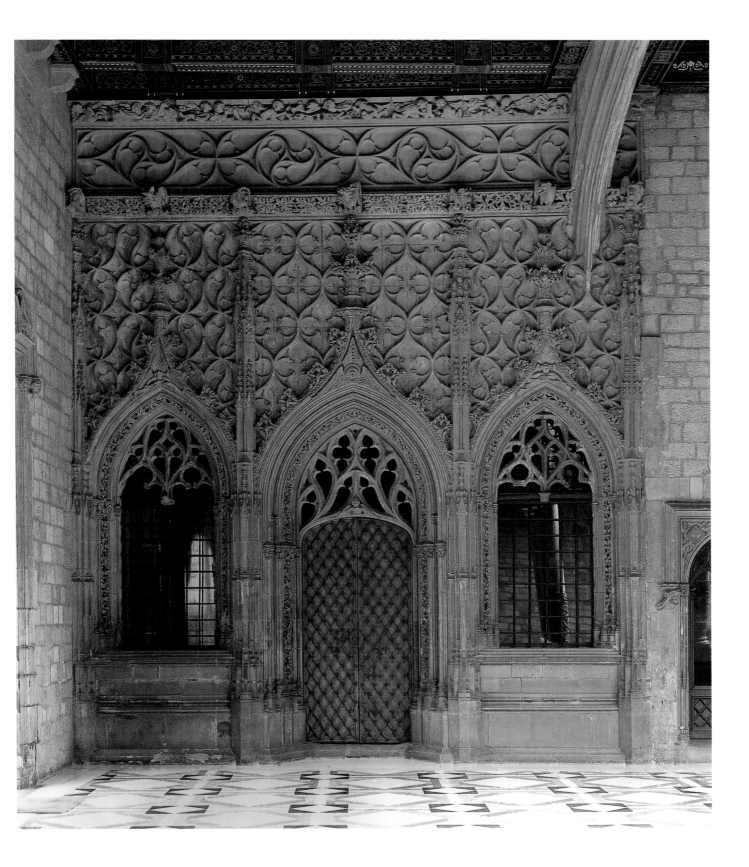

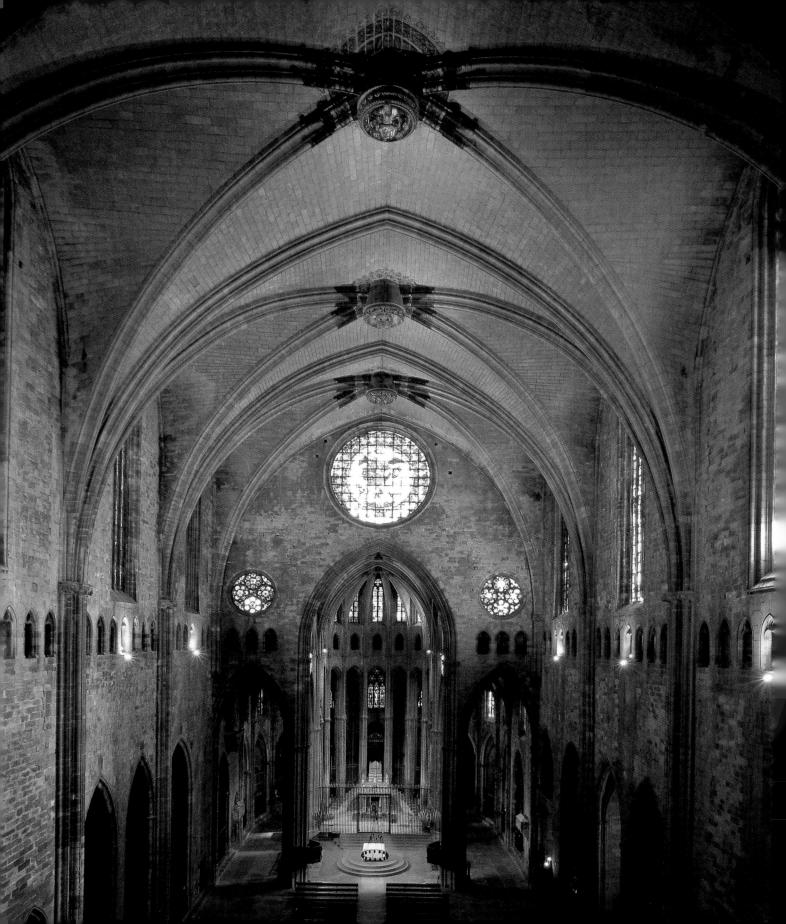

OPPOSITE:
Henri and Jacques de Fauran, Guillem Bofill
Gerona, Cathedral of Santa María, 1312–1604
Nave (begun 1417) and choir (mid 14th century)

Pedro Salvá
Palma de Mallorca, Castell Bellver,
1309–14
Courtyard

brother Jacques, master mason of Narbonne Cathedral. Though the chancel was largely completed on the basis of this plan by the middle of the century, only a few lateral chapels were constructed in the nave. In 1386 and 1416, commissions of experts were convoked to discuss whether the building should develop as a nave with aisles or as an aisleless hall. Doubts as to the practicability of a single vault were voiced, principally by masons from Barcelona. In 1417, the decision was nonetheless taken to build an aisleless church, as this would be "finer and more remarkable." The argument about the nave in Gerona reveals, incidentally, a most exciting development: during the debate aesthetic arguments were raised more and more frequently, in contrast to considerations of a purely technical nature. It was now incumbent on the architect Guillem Bofill to construct Gothic architecture's largest vault, with a height of 34 meters (110 feet) and a span of 23 meters (75 feet).

Although the building was completed only in 1604, its creation is informative, and exemplary for the history of Gothic architecture in Catalonia. In terms of structural engineering, it represents the perfection of a type familiar from Barcelona (the cathedral and the churches of Santa María del Mar and Santa María del Pi), in which the thrust of the vault is absorbed by buttresses incorporated into the interior, which leave space for chapels in between. Externally, the structural elements hardly project, so that the wall appears as an unbroken surface. The solidity of the exterior thus corresponds to the amplitude of the interior, which opens up as a transeptless, aisleless single hall—or, rather, as a hall with several aisles of approximately the same height. All forms are reduced to the minimum, wall surfaces are sparingly articulated, and even the supports are carried through into the load-bearing ribs virtually without a break. The aesthetic appeal of this architecture is expressed not in the multiplicity of forms used, nor in their hierarchical intensification. In Catalan Gothic, large spaces predominate, their unity underlined by a purist simplicity.

Majorca

The kingdom of Majorca, which was independent between 1276 and 1349, reaching far into what is now the south of France, provided sensational new buildings in the 14th and 15th centuries. The first steps taken were to transform the Moorish royal palace of Almudaina into a Christian seat, and to modernize the court in Perpignan. Following that, the foundations were laid for the main churches in the capital. Founded in the 13th century, but partially completed only in the 14th and 15th centuries, the parish church of Santa Eulalia (begun 1250), the Franciscan church of San Francisco (largely complete by 1286), and the cathedral of Santa María are the most important monuments of medieval Majorcan church architecture.

The cathedral, built over the Moorish *mezquita* (mosque), whose foundation walls were preserved until 1412, is a building that has an extraordinary effect as a feature of the townscape (see page 274, top). Anyone approaching the island from the sea is not likely to forget the

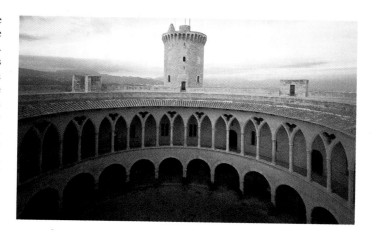

outline of this Gothic fortress of faith. For its entire length the body of the church is articulated by a system of massive, close-set supporting walls and buttresses that lend the 110-meter (358-feet) sides a graphic verticality reminiscent of iron bars. It is sublime but defiant. The external buttresses correspond to eight narrow bays in the interior, which comprises a nave, aisles, and chapels (see page 275). The fourth bay is extended like a transept, while the east end has straight-ended chapels, one of them projecting a long way forward because it was originally intended as the royal burial place. The nave and aisles were built around 1369 using slender octagonal supports for a 42-meter (136-feet) high vault; the rose window at the west end was also constructed at this time. The overwhelming space created allows this interior to be compared with those of the cathedrals of Bourges, Beauvais, or Milan. The layout, elegance, and technical brilliance of the support system suggest that the Catalan master mason Berenguer de Montagut, who had already been at work on the cathedral of Manresa and at Santa María del Mar in Barcelona, was summoned to Majorca for this major project. The markedly varying height of nave and aisles, and the typical external buttressing, however, also support the notion of north European influences.

Typologically interesting is Castell Bellver, close to Palma, which was built between 1309 and 1314 by Pedro Salvá. The summer residence of the Majorcan kings, it is a circular defensive building whose ground plan is punctuated by four massive towers. The two-story inner courtyard, framed by intersecting Gothic arcading, is charming (see above). How it fits in with the development of architectural history has not been clarified. Possible sources include the Castel del Monte in Apulia in Italy, some 60 years older, or the core building of the royal palace of Olite in Navarre.

Between 1426 and 1446, the Llotja, or Exchange, of Palma de Mallorca was built (see page 274, bottom). It is included here as being exemplary of similar buildings of this type in Valencia and

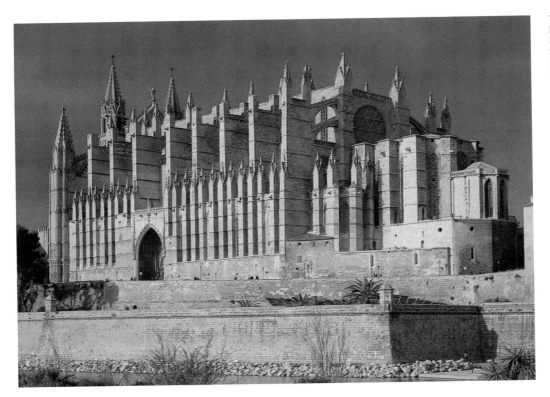

TOP LEFT AND OPPOSITE:
Berenguer de Montagut (?) and others
Palma de Mallorca, Cathedral of
Santa María, begun ca. 1300
Exterior (left)
Interior (opposite), 1369

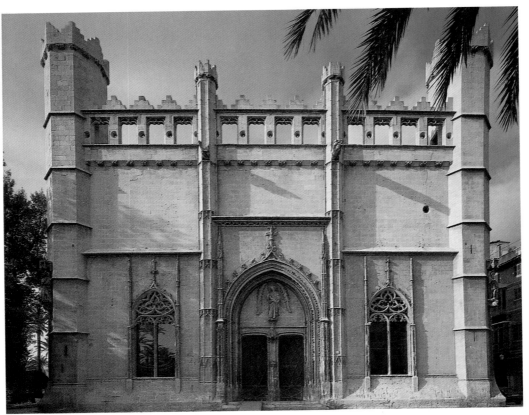

Guillem Sagrera
Palma de Mallorca, Llotja (Exchange)
1426–46

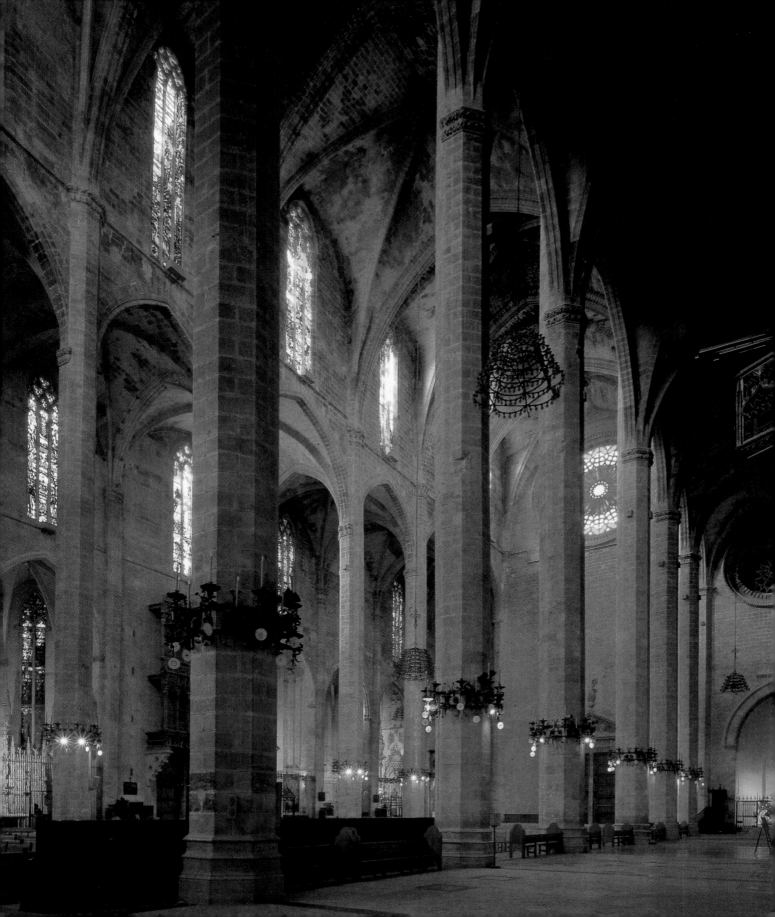

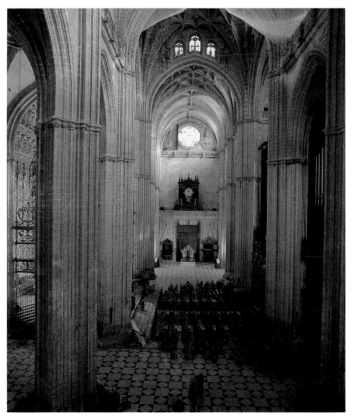

Barcelona. The exterior has a solid appearance, the four corners being marked by towers. The portals and windows are decorated with Flamboyant tracery. The hall-style interior is again impressive for its size and the extraordinary vault structure. A mere six columns carry the ceiling, which measures 40 by 28 meters (130 by 91 feet). The originator of this pioneering building was the Majorcan architect Guillem Sagrera, who after completing the work went to Italy to work on the interior of the Castel Nuovo in Naples.

Andalusia

The biggest building project in Andalusia during the 15th century was the cathedral of Seville (see left). Strong political interests were behind its construction, as Seville had until 1248 been the last and most important bulwark of Islam (with the exception of the Nazarite empire of Granada). The reconstruction of the episcopal seat was correspondingly bold. The layout was taken over the foundation walls of the old mosque, which was given a Christian consecration on the occasion of the conquest of the city in 1248. Its original Islamic courtyard, now the Patio de los Naranjos, and the Giralda or minaret, completed in 1198, were preserved and remodeled, and thus integrated into the new Christian surroundings.

As early as 1401, when the chapter resolved to build a new cathedral, a unique building was demanded that would put all others in the shade, a church "whose construction will make others think us insane." And indeed, Seville Cathedral is one of the great religious buildings of the West, a square, nave-and-four-aisle plan with lateral chapels, transepts, and an apse. The stepped construction of the exterior is accompanied by an imposing framework of flying and solid buttresses and pinnacles that bestow a welcome delicacy on an otherwise very solid complex. The original idea of building a double ambulatory, as at Toledo, was dropped, as Juan II (1406–54) gave up the notion of using it as a royal burial church. The design therefore lacks a pronounced orientation toward the east. The broadly laid out, hall-like interior also contains echoes of the cubic, and similarly non-directional, interior of a mosque. At 36.38 meters (118 feet), the nave is little higher than the aisles. Richly molded piers which support tall arches lead straight up to the vaulting; there is no triforium. The vaulting itself is decorated only in the area around the crossing, where a lavish Late Gothic stellar vault is employed. Tall four-part windows with rich tracery allow in plenty of light.

Various master masons, most of them foreign, were successively responsible for the work, including Pedro García (1421–34), followed by the Flemish builder Ysambert in 1434, the Frenchman Carlín (Charles Galtier de Rouen?) from 1439 to 1449, his fellow countryman Juan Norman from 1454 to 1572, and finally Juan de Hoces. In 1496 a Master Ximon is mentioned, possibly Simon of Cologne, to whom we shall return in connection with Burgos. He

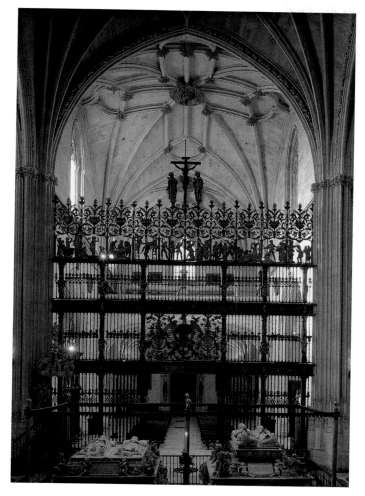 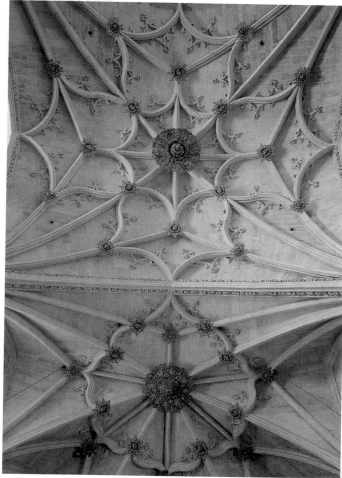

probably designed the massive crossing tower, which was completed in 1506 but collapsed in 1511. In 1515, the much sought-after Juan Gil de Hontañón took over as master mason. It was he who provided the sumptuous Flamboyant styling of the vault. The Coro and Capilla Mayor were built into the middle of the cathedral during the 16th and 17th centuries, and these were followed by numerous other additions and remodelings.

Seville Cathedral is a showpiece like no other late medieval building on the Iberian peninsula. Built over the foundations of the mosque, whose spatial structure it incorporates though it rises much higher, it signals for all the world to see the triumph of Christian architecture. At the same time, lavish stone decoration is superimposed on the Moorish brickwork of the original building. Even within Gothic architecture in Spain, Seville Cathedral stands at a crossroads. For the first time outside Castile and León, the exterior is broken up by buttressing, thereby combining an element of classic French Gothic with the closed outline of the Catalan or Aragonese form of church. The international nature of Juan Gil de Hontañón's work had its influence on central Spain, bringing Flamboyant forms to New Castile via Seville, most notably to Toledo.

The Capilla Real in Granada (see above) acquired similar symbolic value. The Catholic Kings commissioned this in 1504 from Enrique Egas as a burial church, directly beside the main mosque of the city, which had been recaptured in 1492. It was an act of historical appropriation. The richly furnished chapel accommodated the tombs of the Catholic Kings and also that of their daughter Joanna the Mad and her husband Philip the Fair. Ground plan and elevation, portal and rib vault follow Late Gothic tradition, whereas the tombs are already decorated in Renaissance style.

Apart from Andalusian church architecture, which made extensive use of Christian Gothic style, secular Spanish architecture continued with the Moorish style. This was hardly a matter of ideology, more that the greater comfort and richer decorative furnishing of Islamic palaces were appreciated. The craftsmanship and decorative skills of the Moors enjoyed a tremendous reputation among Christian clients, and Christian artists often followed Islamic models closely. In the 14th and 15th centuries, court and nobility imitated Moorish culture throughout the Iberian peninsula. Dress, food, and, particularly, architecture were orientated to the Moorish palaces of Andalusia, whose luxury was thought unsurpassable.

Barbara Borngässer
Mudéjar Architecture

The word *mudayyan*, which means subject or taxpayer, was used in Christian Spain to refer to Moors who were allowed to remain resident in the regions reconquered by the Christians. These *mudéjares* constituted a vital social factor from the 13th to the 15th centuries until they were finally persecuted and driven out by the Catholic Kings Isabella I and Ferdinand V, Spain thereby losing a significant portion of its cultural and intellectual heritage, and many of its finest craftsmen.

For centuries, many craft industries had remained in Moorish hands. Both technical and intellectual knowledge was passed on and developed by Arab scholars. Islamic forms of decoration such as the infinite repetition of geometric patterns, calligraphy, and tapestry-style decoration on façades were absorbed in Christian art almost without question. Islamic technology such as building in brick (*ladrillo*) and the artistic construction and shaping of truss roofs (*artesonado*) strongly influenced Spanish archi-tecture. Ceramic tiles (*azulejos*), woodwork (*carpintería*), and plaster-work (*yeserías*) supplied sumptuous forms of surface decoration and to this day are a distinctive aspect of Mediterranean craft work.

Toledo, El Tránsito Synagogue, 1355–57
Torah wall

Burgos, monastery of Las Huelgas, Capilla de Santiago,
ca. 1275
Wooden ceiling

Toledo, Santiago del Arrabal,
late 13th century

As a term for a style, the word *mudejarismo* was first used by the Spanish art historian Amador de los Rios in 1859. For some scholars, the style came to be seen as the essence of Spanish medieval art. Indeed complex Arab features were incorporated into Christian culture in Spain on a scale found nowhere else. In Portugal, which was brought back under the Christian banner relatively early, only a few Islamic monuments have survived, such as the *mezquita* (mosque) of

Mértola, so that no direct involvement with the art of the "infidels" resulted. In the Spanish realms, on the other hand, Mudéjar passed through various phases in the course of centuries. The subject craftsmen had to accommodate the diverse interests of their clients and changing historical conditions.

In such circumstances, it is unhelpful to talk about Mudéjar as a style. It was more a case of centuries of exposure to Islamic culture, comparable to the recurrent classicisms of Western art. Using tried and tested chronological divisions, the various historical styles are termed *mudéjar-románico*, *mudéjar-gótico*, and, after the final victory of Christendom in 1492, *morisco*. Using Islamic style and dynastic terminology, however, the style can be divided into *mudéjar-taifa* (after the *taifas* or Islamic principalities that developed in Spain from 1009 onwards), *mudéjar-almohade* (after the Almohad rulers, in power from 1147), and *mudéjar-nazarí* (after the Nasrid rulers of Granada in the 14th and 15th centuries).

Toledo became the most important center of Mudéjar culture. This Castilian city, which had been the seat of a taifa until 1085, managed to preserve its Islamic appearance after its conquest by Alfonso VI. Within its walls there resulted the coming together of not only Christianity, but also Judaism and a far more developed and refined Islamic tradition. Scholarship and the arts experienced a unique golden age. The whole of Europe benefited, as scholars edited, translated, and disseminated Greek, Latin, Hebrew, and Arabic writings. Toledo became a model of peaceful coexistence and mutual cross-fertilization .

In the realm of architecture, Islamic art remained the model into the 15th century, with only cathedrals being constructed, for symbolic reasons, in the style of French Gothic. Already in the 12th and early 13th centuries, buildings had been created which combined Islamic brick technology and ornamentation (horseshoe arches, cusped arches, and *arcos polilobulados*, arches made up of various arc segments). They include El Cristo de la Luz, built as a mosque in the 10th century and reconstructed as a church from 1187, and San Román (consecrated in 1221?).

Built in the late 13th century, the church of Santiago del Arrabal (see left), a nave-and-aisles brick-built structure with three semi-circular apses, plays with horseshoe arch and polyfoil arch motifs both internally and externally. The church of Santa María la Blanca, built as a synagogue in the 13th century and taken over by the Christians in 1405, is divided into aisles by arcades of horseshoe arches. The ground plan is almost that of a mosque, but the resemblance stops once the stepped elevation and Early Gothic capitals are reached.

A superb example of the adoption and integration of Hispano-Moresque ornamental concepts in a non-Islamic building is the synagogue of El Tránsito (1355–57). The furnishing of the interior, which measures 33 by 9.5 meters (107 by 31 feet), displays all the features characteristic of Nazarite ornamental art in Granada. The wall surfaces, covered as if with tapestries, are sumptuously decorated, especially on the Torah wall, with *yeserías* or plasterwork (see above, left). They are framed by

band moldings with texts from the psalms and the Bible praising Jewish priests. Above this, a continuous fascia with a frieze of leafy tendrils, lilies, and coats of arms of the royal house of Castile-León runs round the plinth. The blind arcading of the upper quarter is reminiscent of the triforium in Christian churches, but is nonetheless clearly articulated with Islamic features. Between the cusped arches are *celosías* (transenna windows) and above them runs a frieze of *muqqarnas* (stalactite motifs). The climax of the interior is the open truss roof, rising above tie beams. On the

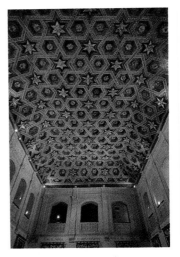

Alcalá de Henares, University
Paraninfo (auditorium), 1516

278

elaborate ceiling panel (*almizate*), star-shaped geometric motifs (*lazos*) alternate with linear ivory inlays.

The extent to which Mudéjar culture gained a foothold in the court milieu is indicated by the Cistercian monastery of Las Huelgas, near Burgos, which was under royal patronage. Islamic decoration, especially the Moorish-style chapels in the vicinity of the *claustrillas* (small cloisters) suggests that high-ranking Andalusian and Toledo artists were summoned to work on the monastery.

One of these chapels, the Capilla de Santiago, constructed around 1275, was used for the dubbing of Christian knights—in architectural surroundings that are a sumptuous expression of the culture of the infidel enemies of the one true faith! A horseshoe arch opens into an exquisitely furnished room, the high point of which is a unique star-shaped wooden ceiling (see opposite, top right).

Wooden vaults were among the principal features of Mudéjar decorative art. Celebrated under the name *carpintería de lo blanco*, they were particularly successful in secular buildings. The surface treatment was often complemented with *muqqarnas* borrowed from plasterwork, as they lent the ceiling greater depth and three-dimensionality. In the 16th century, Mudéjar carpenters began to include Italianate classical motifs in their work.

Examples of such *artesonado* ceiling work are to be found in the Paraninfo, the 1516 auditorium of the University of Alcalá de Henares (see opposite, bottom right), and in the chapter house of Toledo Cathedral (1508–11). Here the Mudéjar ornament is subsidiary to the overall scheme of the coffered ceiling. It is no accident that both buildings were built for Cardinal Francisco Jiménez de

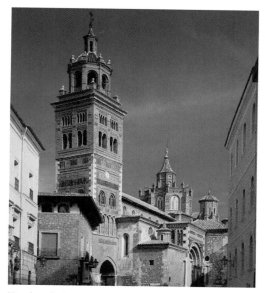

Teruel, Cathedral of Santa María
Bell tower, 1257–58

Teruel, San Martín,
Detail of bell tower, 1315

Cisneros, a man who knew the art of combining humanist erudition and the full range of Hispanic tradition.

Mudéjar ceiling structures provided many models for the stonemasons of Late Gothic. Thus Islamic decorative motifs were introduced in the filigree crossing towers of Zaragoza Cathedral (1412) and Burgos Cathedral (completed 1567; see below, left), where it was combined with Flamboyant Gothic. The result is vaulting of the highest technical skill and aesthetic sophistication.

Mudéjar culture spread far beyond the borders of Castile. A parallel architectural development can be identified in Aragon, where a number of high towers were erected. Built to square or octagonal ground plans, and richly decorated in their horizontal registers, they are the descendants of Islamic minarets. The finest examples are in Teruel, a city on which the Moors had conferred privileges. The various towers are quite different from those of other regions by virtue of their multicolored ceramic inlays, which break up wall surfaces in bold patterns.

Notable examples include the cathedral (1257–58; see above, left) and the churches of San Martín (1315; see above, right), San Pedro (early 14th century), and San Salvador. In the following period, polychrome ceramic patterning or reliefs in brick were applied to other wall surfaces, for example in apses, as in the cathedral of Zaragoza.

Even in Andalusia, where because of the long survival of Islamic rule the deepest reservations about Moorish culture might have been expected, Moorish work remained the norm, at least in secular architecture. It is signifi-

cant that the Christian king Pedro I (1350–69) had the *alcázar* (Moorish fortress) of Seville extended entirely in the Moorish style, summoning artists from Nazarite Granada and Córdoba in order to carry this out.

Even around 1500, Governor Pedro de Enriquez of Andalusia chose Mudéjar decorative features to adorn his splendid city palace. The Casa de Pilatos in Seville is a Renaissance-style villa that is lavishly decorated with Moorish tiles, plasterwork, and *artesonado* ceilings.

Its courtyard is surrounded by two stories of stilted arcading (see below),

while the sumptuous stairwell is completely covered with tiles. Above this is a screen cupola, rising from corner squinches with muqqarnas. The sculptural furnishings, on the other hand, correspond entirely to the taste of Italian princely courts, with antique busts, columns, fountains, and allegorical frescoes making up a thoroughly eclectic program.

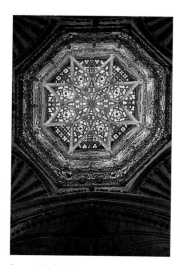

Burgos Cathedral
Cimborrio (crossing tower), 1567

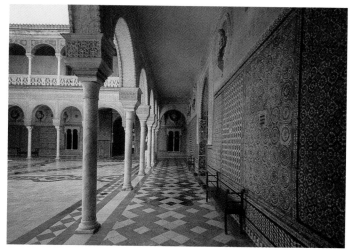

Seville, Casa de Pilatos, ca. 1500
Courtyard

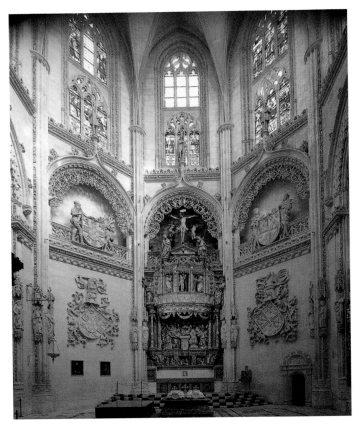

Castile and the Hispano-Flamenco Style

In Castile, building activity initially remained dormant in a country weakened by economic crises and civil war. Building work was restricted to remodeling or decorating existing cathedrals, where the Mudéjar style handed down by Arab craftsmen often overlay Gothic structures. Only towards the end of the 14th century was work resumed on major church architecture such as the cathedrals of Pamplona (begun 1394), Oviedo, and Murcia (begun 1394, later extensively damaged), and new choirs at Lugo and Palencia. All these buildings, however, largely followed familiar designs.

At the beginning of the 15th century, links with Burgundy strengthened under Juan II, and as a result of trade, connections developed between Castile and Flanders, above all in the cloth industry. Court and nobility began to look to northern European models of gracious living, with French, Flemish, and German artists being invited to Spain or their paintings and other luxury goods being bought. The styles thus introduced blended seamlessly with that of

Islamic tradition. When north European architectural traditions were added to the technical knowledge and craft skills of artists schooled in Mudéjar traditions, the results included Moorish arches finished with Flamboyant motifs. The style thus created, which was both a style of decoration and a style of architecture, is known as Hispano-Flamenco. The term does not do justice to the multiplicity of forms it covers, but is used for want of a better expression. It is also striking that, with a few exceptions, the early Renaissance style then being pioneered in Italy found hardly any echo in Castile, even though Juan II made much of his humanist studies. In Castile and León, matters continued in the way already begun at Seville Cathedral, with Flemish and German master masons summoned to work on the major projects. In the following decades, more than 20 artists of west or north European origin were active in the Spanish kingdoms; they made no small contribution to stylistic developments.

One of the first was Master Hanequin from Brussels, who was commissioned by Don Álvaro de Luna to build a burial chapel in the ambulatory of Toledo Cathedral. He later also built the Puerta de los Leones there, a well-known portal. The chapel in Toledo displays a wall elevation richly decorated with Flamboyant decorative elements and a vault spanning a polygonal ground plan. The chapel became the inspiration for a whole series of memorial buildings, of which the Capilla del Condestable in Burgos is probably the most lavish example. Burgos became an important center for the diffusion of the Hispano-Flamenco style, in which many German elements were incorporated. In the mid 15th century, the master mason Hans of Cologne (Juan de Colonia) came to Spain, probably at the behest of Archbishop Alonso de Cartagena, inaugurating a whole dynasty of artists who brought German features with them. Hans himself was the creator of the pierced steeple in Burgos, which closely follows predecessors in Ulm and Esslingen and later became a model for other Spanish steeples. His son Simon (Simón de Colonia) was the architect of the Capilla del Condestable, toward the end of the century. It is a masterpiece of decorative architecture, the Gothic structure of the spacious two-story building being covered inside and out with filigree decoration in the Flamboyant style (see left). The stellar vaulting, deeply undercut, is reminiscent of the work produced under the Moorish Almoravid dynasty.

The Architecture of the Catholic Kings

Whereas the burgeoning of the Hispano-Flamenco fashion around the middle of the century can be attributed to the preferences of certain farsighted clients, under the Catholic Kings the new style became official. It is therefore not wholly inappropriate to call the art of the late 15th and early 16th centuries the Isabelline Style or, more accurately, the Style of the Catholic Kings. (How far Queen Isabella herself influenced development is unclear.)

The first building in the style is thought to be the church of the Hieronymite monastery of El Parral in Segovia, an aisleless hall

Juan and Simón de Colonia,
García Fernández de Matienzo
Cartuja de Miraflores (near Burgos),
begun 1454
Interior looking toward the retable by
Diego de Siloé

Juan Guas
Toledo, San Juan de los Reyes, begun
1476

Juan Guas
Toledo, San Juan de los Reyes
Cloister, completed after 1500

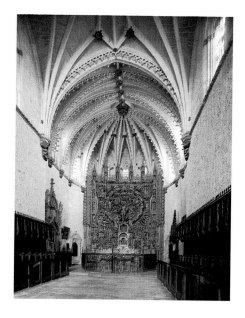

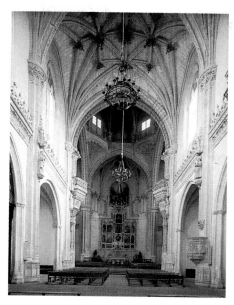

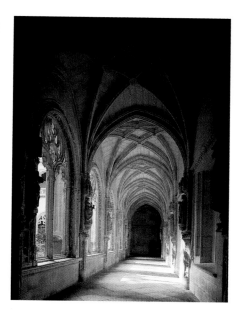

church covered by a huge stellar vault. The trefoil choir was intended as a burial chapel. Begun in 1455 by Juan Gallego, the work was undertaken from 1472 by Juan Guas (Jean Wast), presumably a Breton, who had been employed in Toledo as Hanequin's assistant and was now called in for all major commissions. The type of church he created became the standard for most foundations in the milieu of the Catholic Kings.

The Cartuja de Miraflores near Burgos is also a memorial building, a new building intended as a worthy resting place for Juan II and his wife, Isabella of Portugal (see above, left). Here too it was decided to build an aisleless, exquisitely furnished interior, which was designed by Hans of Cologne and his son Simón de Colonia, and completed by García Fernández de Matienzo. Gilles of Antwerp, known in Spain as Gil de Siloé, created the unique sculptural furnishings.

In 1476, Queen Isabella founded the Franciscan monastery of San Juan de los Reyes in Toledo to celebrate both the birth of an heir to the throne and victory at Toro (see above, center and right). Once again, Juan Guas was called in as architect, and again the architecture of the noble, aisleless church with lateral chapels was deliberately toned down in order to bring out the fine detail of the decoration and the perfection of the masonry. In the *cimborrio* (lantern) rising on squinches above the broad crossing, and in the net vaulting of the nave bays and chapels, a technical and artistic virtuosity is displayed that hardly corresponds to the ideals of poverty and simplicity the mendicant orders originally espoused. Coats of arms, insignia, and figured representations are also woven into the decora-

tion. Nonetheless, the building takes on a wholly autocratic, indeed propagandistic, character from the inscriptions exalting the conquest of Granada and the expulsion of the Jews. Prominent on the façade of the church are chains representing the shackles that once bound the "Christian prisoners" of Andalusia, and thus symbolizing the final liberation of Spanish Christendom from "the yoke of Islam." The adjacent two-story cloister, with its filigree tracery, finely worked molding, and decoration which combines plant forms and words, belongs among the masterpieces of Isabelline art, the term here being used, for once, quite appropriately. The building was originally intended as the burial place of the Catholic Kings, but after the conclusion of the Reconquista in 1492 the monastery had to relinquish that privilege to Granada.

The church of San Tomás in Ávila, a Dominican convent, was begun in 1483 at the behest of the Grand Inquisitor of the Catholic Kings. It was financed from confiscated Jewish property. Designed by Martín de Solórzano and constructed of granite, the decoration is restrained compared with that of San Juan de los Reyes. The aesthetic appeal rests on technical and material considerations, which at the same time reflect the austere faith of the patrons (see page 282, left).

In Valladolid there arose in quick succession the Colegio de San Gregorio (1487–96), which nowadays houses the Museo Nacional de Escultura (National Museum of Sculpture), and the west front of San Pablo (ca. 1505), monuments that have become famous principally for their lush façade decoration. Both buildings expressed in their lavishly decorated portals a program that structurally and

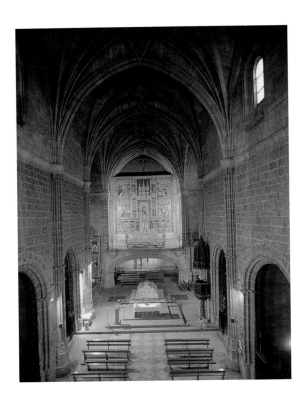

iconographically can be compared only with the monumental altar constructions peculiar to Spain, in which wall and framed pictorial surfaces are combined into colossal showpieces. On the portal of San Gregorio (see opposite, top left), the design of which is probably ascribable to Gil de Siloé and Diego de la Cruz, there appears an eminently political program. Clearly in reference to the Evangelists, a lion and an eagle hold the monumental coat of arms of Spain, united since 1479. In a parallel reinterpretation, the Tree of Jesse becomes a pomegranate, symbol of the reconquest of Granada. Angels, heralds, putti, and wild men complete the programmatic ensemble, which has still to be interpreted satisfactorily. In the portal of San Gregorio, the architecture becomes a mere backdrop. In the architectural articulation, as is evident from the oppressive central pictorial field above the filigree ogee, it has become nothing more than a canvas for the symbolic design.

On the façade of the neighboring church of San Pablo, built only a few years later, the beginnings of a structural articulation are already evident, although here too the decorative and emblematic tone remains obvious.

Not to be omitted from this list of "altarpiece façades" is the front of the celebrated University of Salamanca (early 16th century; see above, right). Although the design is already Plateresque, and has a number of Renaissance motifs, it is in spirit and content still entirely within the tradition described above. The fantastic allegorical program on the display wall, which is conceived as an iconographic standard-bearer, sets out the role of the Spanish monarchy as defender of the faith, patron of science, and champion of virtue in the constant struggle against vice.

The architecture of the Catholic Kings was not just decoration, however. Besides the memorial-type church already mentioned, a new kind of building arose in commissions for hospitals. These were public displays of beneficence by the young Spanish empire, anxious to display an awareness of its welfare responsibilities. Familiar with Italian models of centrally planned buildings, such as Santa Maria Nuova in Florence, Filarete's Ospedale Maggiore in Milan, and Santo Spirito in Sassia in Rome, the Spanish opted for a cruciform ground plan with arms of approximately equal length. Though this is a Renaissance concept, the implementation remains wholly within the Spanish tradition. Thus the hospitals in Santiago de Compostela (Enrique Egas, 1501–11) and Granada (Enrique Egas, 1511–27) are finished with a wooden Mudéjar ceiling, while the crossing carries a rich, stellar vault in the Late Gothic style.

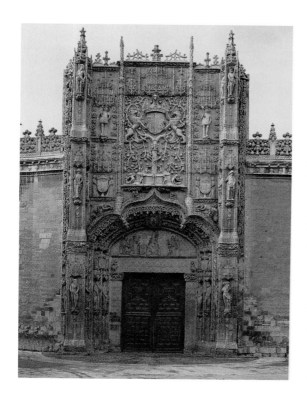

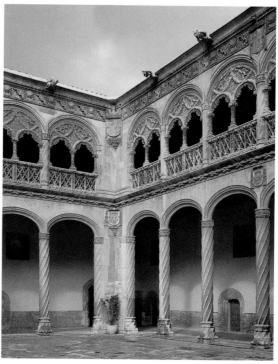

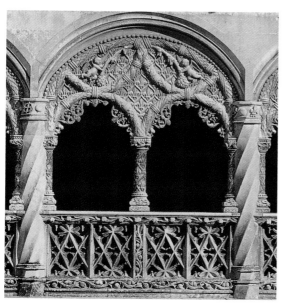

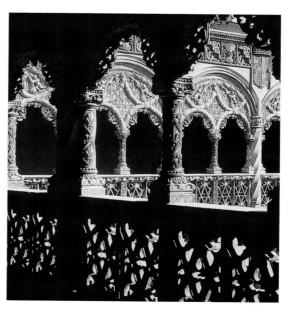

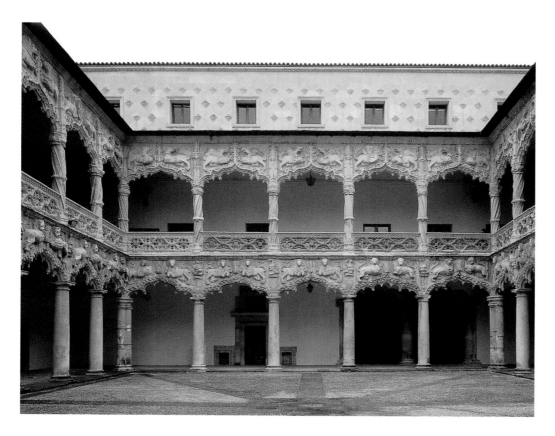

Castles

In Castile, castles were a particularly important aspect of architecture. Again, a few examples will have to serve to illustrate a complex development. As already mentioned, residential buildings, and even defensive buildings, were in great measure based on Arab models. These were not only far more comfortable and practical, but also technically tried and tested—and cheaper, largely because they were built of brick.

One of the most imposing *castillos* of the region is that at Coca, which was built for Bishop Don Alonso de Fonseca in the 15th century (see opposite, bottom). Again, it is constructed of brick in the Arab tradition, the perfect workmanship and color gradations achieving a superbly artistic effect. The square superstructure is constructed on top of a massive rounded base. Both the keep and the curtain walls are peppered with numerous semi-circular or polygonal bastions that curve out of the wall and are elegantly decorated at the top with attached half-columns and pinnacles. Despite its elegance, Coca's very real defensibility is still entirely in the medieval tradition of castle building.

The patronage of the Mendoza family introduced new ideas to Spanish castle building, even though here the attachment to the exquisite workmanship and decorative exuberance that is typical of Islamic culture remained intact. A construction that illustrates the transition from fortress to elegant castle perfectly is the Castillo el Real de Manzanares, a building begun under the first Marquis de Santillana in 1435 and rebuilt, most probably by Juan Gaus, after 1473 (see opposite, top). Although the fortress aspect remained, the

sculptural finish of the allure and towers lends a decorative character to the exterior.

In the Palacio del Infantado in Guadalajara (begun 1480) the fortification features have been wholly removed and the allure has been turned into a viewing platform. Presumably the same architect then constructed for the same client, Iñigo López de Mendoza, a palatial four-sided building with a two-story courtyard (see above). Here the urban character is unmistakable. In this respect it is like the Italian city palace of the Renaissance, though the opulent architectural ornamentation mixes Islamic, Late Gothic, and even occasional classical motifs. Moorish nail-head moldings and lozenges adorn the exterior façade, while the courtyard is articulated by renovated Tuscan columns below and twisted columns above, spanned by heavily decorated Isabelline curvilinear arches. A complex iconographic program woven into the stone and plasterwork decoration of the building proclaims the client's erudition and rank.

Around the turn of the 16th century, the economic situation in Spain improved. In parallel to this, numerous fanciful aristocratic palaces were built, including the Casa del Cordón in Burgos (1482–92), surrounded by a stone cordon, and the shell-adorned Casa de las Conchas (shells) in Salamanca (1512), to mention just two. Both are city palaces with courtyards, and possess façades designed in accordance with the personal fancies of their patrician owners. Soon, however, decades earlier than in church architecture, secular architecture went over to more modern Italianate forms, a development which is seen, for example, at the palaces of Cogolludo (ca. 1492?) and La Calahorra (1509–12).

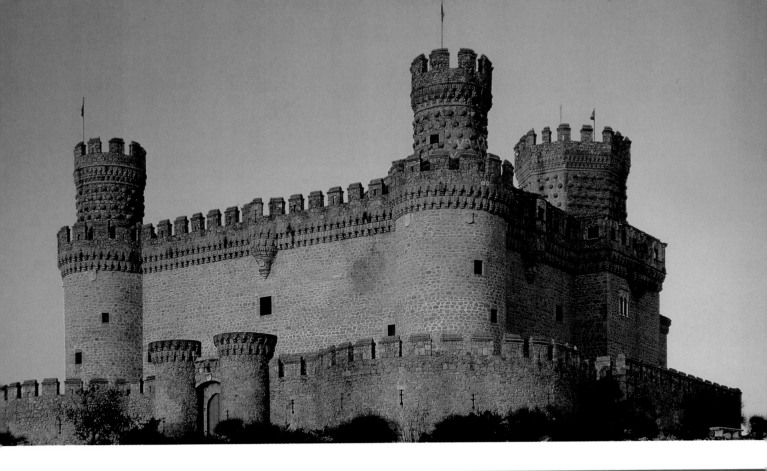
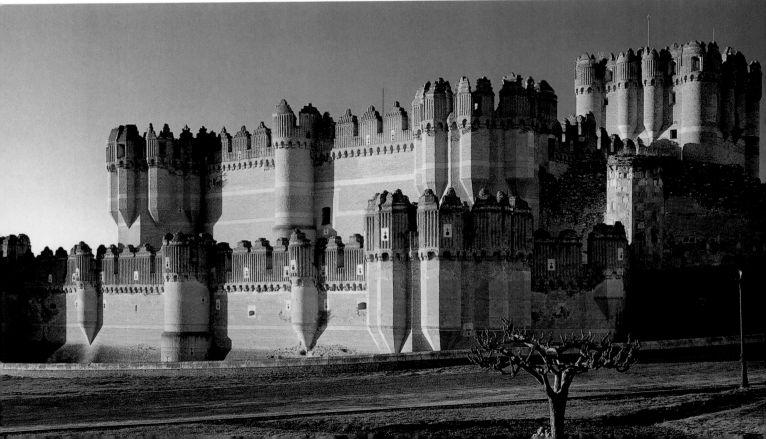

Juan and Rodrigo Gil de Hontañón
Segovia, Cathedral of Santa María,
begun 1525
East end (below)
Ground plan (right)

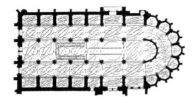

OPPOSITE:
Juan de Álava, Antonio Egas, Juan
and Rodrigo Gil de Hontañón,
Juan Gil el Mozo
Salamanca Cathedral, begun 1513
Crossing

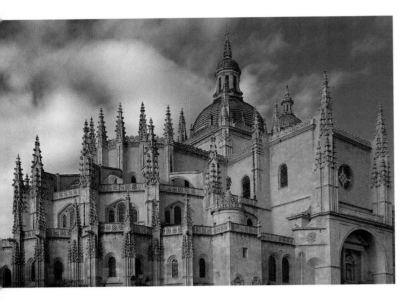

Astorga, Cathedral of
Santa María, begun 1477
Choir

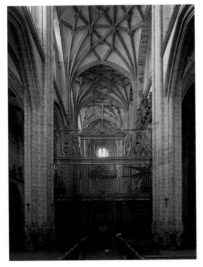

Astorga, Cathedral of Santa María

Gothic Cathedrals of the 16th Century

Church building in the 16th century represents a high point of Spanish Gothic architecture. Yet, with the exception of a pioneering study by the Spanish art historian Fernando Marías (1989), there are no comprehensive studies of the subject, nor of Spanish Late Gothic generally. At a time when St. Peter's was being rebuilt in Rome as a model of classical architecture, cities such as Salamanca, Segovia, and Plasencia were erecting breathtaking new cathedrals in the Late Gothic style, while in Palencia the building of the 14th century was continued without the slightest discontinuity of style. Until the early 18th century, numerous parish churches and chapels looked back to the late Middle Ages for their inspiration.

The fact that they clung to Gothic building engineering is in no way to be seen as backwardness. From various sources it is clear that the two architectural languages enjoyed equal status: the Gothic, which was seen as *lo moderno* (the modern), and the classical as adopted by the Renaissance, called *lo romano* (the Roman).

That the Gothic system was not felt to be obsolete can be attributed to several factors. In the first place, Gothic architecture in Spain had not been condemned by advocates of classical principles of design, nor was it seen as the epitome of a "dark" Middle Ages. Gothic was, and remained, the "show style". Until Philip II's era (1556–98), it was used to evoke the victory of Christianity over Islam and the power of the Spanish crown. In the second place, Late Gothic architecture in Spain was able to accommodate itself to new building types such as hospitals and college buildings. Conservation of the traditional system was no obstacle to its being updated and given new functions; the renovation of what had been preserved was seen as perfecting the past.

It is nonetheless quite possible that precisely the emblematic function accorded to Late Gothic architecture was not accepted in some aristocratic families. Thus the introduction of classical forms in Spain is closely connected to the powerful Mendoza family who, by exercising patronage in the Italian manner and collecting Renaissance art, set themselves apart from the royal family.

The flourishing of Late Gothic church architecture started with the Cathedral of Santa María at Astorga (see left, bottom). Begun in 1471 as a nave and aisles with no transept but with three polygonal apses, it appears to hark back structurally to German models. The vertical stress of the piers, which continue without capitals into the vault, is striking. Later additions and remodeling by Rodrigo Gil de Hontañón make the building seem more "Spanish" that it originally was. Its stellar and net vaulting structures are full of variety.

The cathedrals of Salamanca (see opposite), Palencia (see page 288), Plasencia (a new building dating from the 15th century), and Segovia (see left, top) are largely of the same type: Salamanca has a nave and aisles with side chapels and a straight end while Segovia has a round east end with radiating chapels. Neither possesses a transept extending beyond the exterior walls.

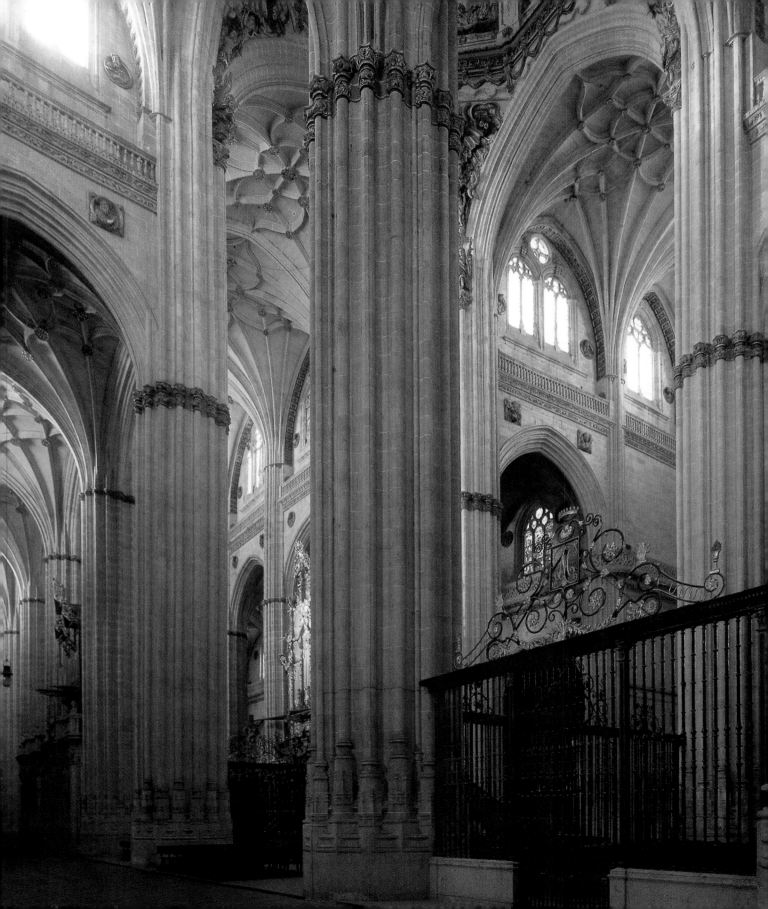

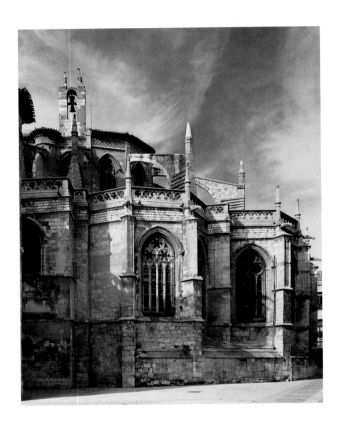

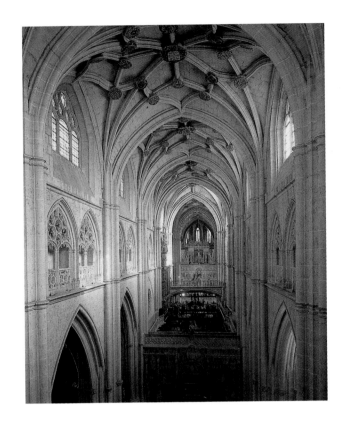

The construction of these churches was preceded by a debate by panels of experts, a process that has a thoroughly modern air. The best-known architects were summoned: Alonso Covarruvias, Antonio Egas, Juan de Badajoz, and Juan Gil de Hontañón, whose design was adopted in Salamanca in 1512 (where he worked with Antonio Egas) and in Segovia in 1525. After the death of Juan Gil in 1526, his son Rodrigo Gil de Hontañón took charge at both these sites. In plumping for Juan Gil, who had already made a name for himself in the construction of Seville Cathedral, the choice was also made for a Late Gothic style. The cathedrals of Salamanca and Segovia are similar so it is reasonable to assume that in choosing as a model the important cathedral of Segovia, the chapter of Salamanca may well have been choosing a programmatic architecture.

The Gothic skeletal structure of Salamanca lends monumentality to the exterior and striking clarity and grandeur to the ample interior. The internal elevation is that of a basilica, with tall arcades carrying a light clerestory above delicate tracery parapets. The shafts of the compound piers run straight into the richly modeled net vault, and are the sole, though superb, adornment of an architecture whose beauty is otherwise expressed through its construction. It is thus not surprising that a Salamanca source of 1522 countered an attempt to add Renaissance motifs to the decoration: "This Roman [*quel romano*] style that Juan Gil [el Mozo] applied to the transept doorway... is badly wrought and arranged [*hordenado*], and does not match the work as a whole." That this is not a criticism of poor execution but of classical features in general is only too obvious.

Charles I (Holy Roman Emperor 1519–56) set new trends with his building policy in Granada. Nevertheless, until the reforms of the Council of Trent and the construction of the Escorial, church architecture in the Spanish Empire remained Late Gothic. In other European countries, for example in England, Flanders, the German Empire, and France, a similar phenomenon was observable, though the parallels have not been closely studied. It is all the more remarkable that in Spain, following the European discovery of America and the associated missionary campaigns, it was not the incomparably more modern formal language of the Renaissance that became the symbol of the Christian world empire but the Gothic style, which had already served as a counter to the world of Islam.

BELOW:
Lisbon, Cathedral of Santa Maria (Sé)
Ambulatory
Mid 14th–first third of 15th century

BOTTOM:
Évora Cathedral
Cloister, after 1350

PORTUGAL

14th and 15th Centuries

In the Cistercian abbey of Alcobaça (begun 1178) Portugal possesses an outstanding monument of Early Gothic and one of the best preserved (see pages 98–99). However, Portugal's principal contribution to medieval architecture came later. If in the 13th and 14th centuries it was in the main the friar orders which steered development, once the cultured Diniz (Denis) I (king 1279–1325) and his wife Isabella of Aragon came to the throne, building commissions from the court and the aristocracy followed.

The two greatest buildings of that time are linked to a single master mason, Domingos Domingues, who clearly enjoyed the favor of the royal house. Between 1308 and 1311 he constructed the cloister at Alcobaça and the architecturally more important church of Santa Clara (a Velha) in Coimbra (consecrated 1330). Characteristic of the predominantly conservative attitude of Portuguese Gothic of the early 14th century is the massive exterior, still Romanesque in character. The interior, a nave-and-aisles plan with no transept, is a first for Portuguese architecture in being completely vaulted (pointed barrel vault in the nave), though the difficulties in handling the technique are still clearly visible. Oddly enough, the building, which is covered to a height of 5 meters (16 feet) by the sands of the River Mondego, later served as the trigger for the reception of romantic Gothic in Portugal.

During the reign of Alfonso IV (1325–57), the Romanesque cathedral of Lisbon, having suffered earthquake damage several times, was given a new east end. The original building provided for a tall, narrow two-story choir and ambulatory opening into radiating polygonal chapels. The plan was carried out in amended form in the 15th century (see right, top). The unity of the ambulatory vault is emphasized by a continuous longitudinal rib. On the exterior, massive buttresses project a long way from the exterior walls, obviously built in this way in the expectation of further tremors. In Alentejo, the region south of Lisbon, significant buildings were also constructed, notably the cloister of the cathedral of Évora, begun in 1350 (see right, bottom). Its four wings are all vaulted with steep rib vaults. Again, a continuous longitudinal rib links the bays.

A quantum leap for Portuguese architecture was the construction of Batalha (see pages 290–293), a monastery constructed by João I (1385–1433) in fulfillment of a vow after the victory in battle against Castile at Aljubarrota. The Dominican convent and the royal burial chapel were an advertisement for the new Aviz dynasty which would steer the fortunes of Portugal until the regency of Philip II (1598–1621). The complex was added to until well into the 16th century, so that it represents a fair part of Portuguese architectural history. Batalha was viewed as a kind of experimental laboratory, and became a model for virtually all important church building commissions throughout the country. A first phase began in 1388 with the design of the overall layout by Afonso Domingues, to which

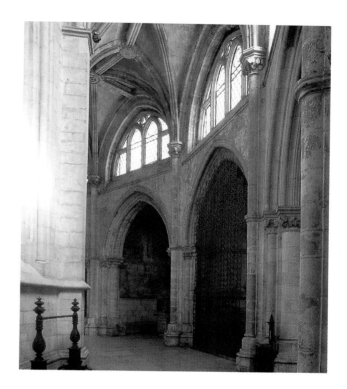

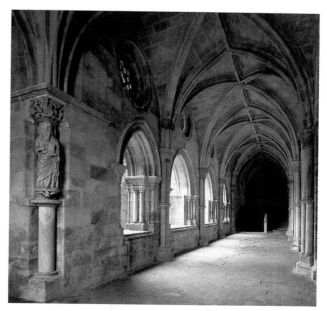

BELOW:
Batalha, monastery of Santa
Maria da Vitória, 1388–1533

BOTTOM:
Afonso Domingues
Batalha, monastery of Santa Maria da Vitória
Royal Cloisters, late 14th century
Tracery by Diogo Boitac, ca. 1500

OPPOSITE:
Afonso Domingues, Huguet
Batalha, monastery of Santa Maria
da Vitória
Nave of church, begun 1388
Vault, 15th century

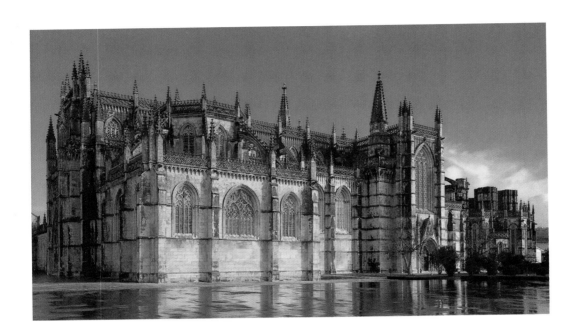

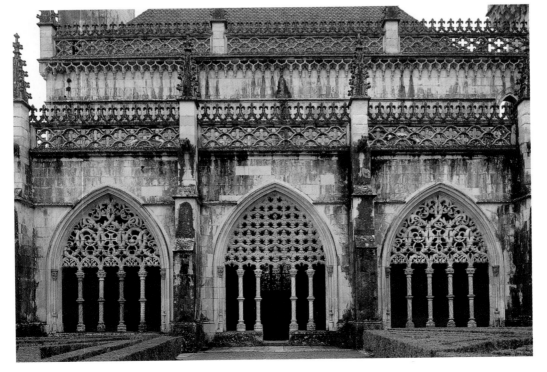

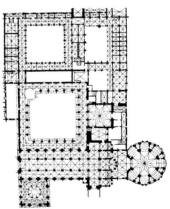

Batalha, monastery of Santa Maria
da Vitória, 1388–1533
Ground plan

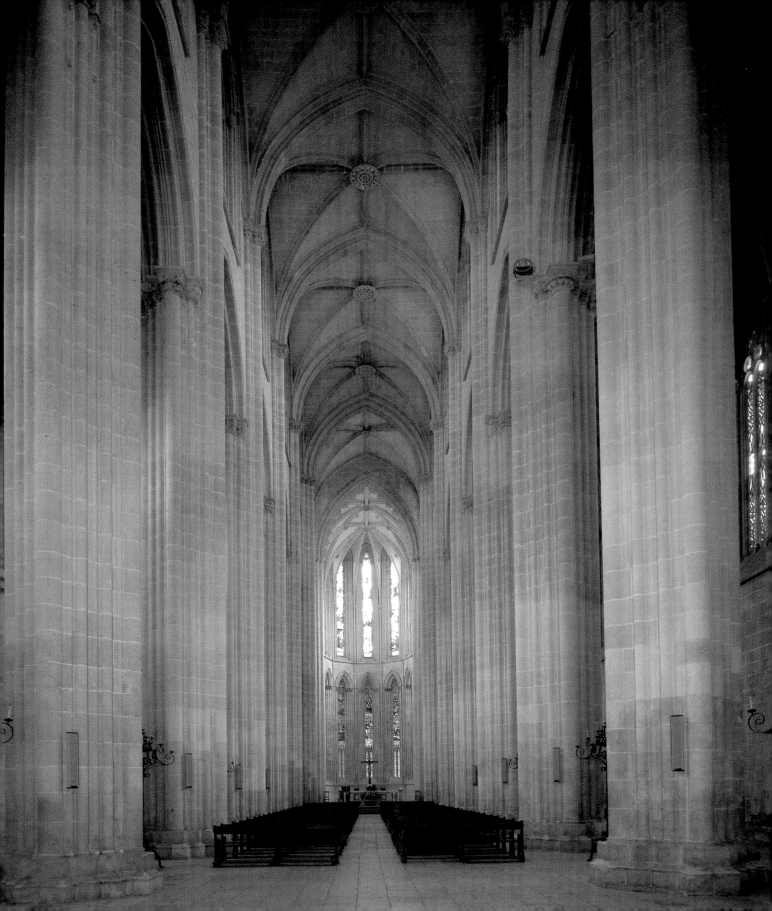

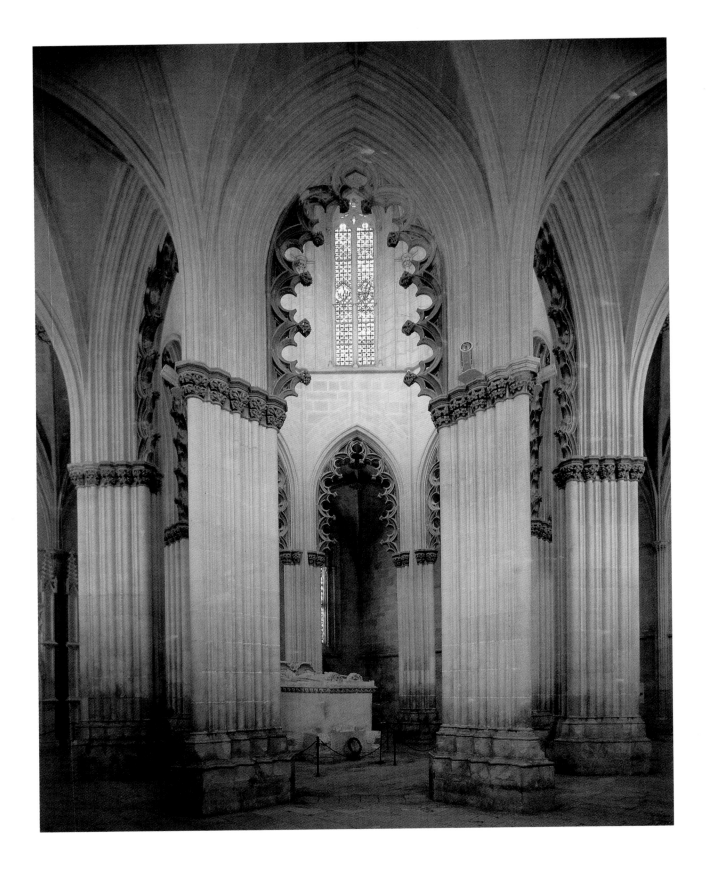

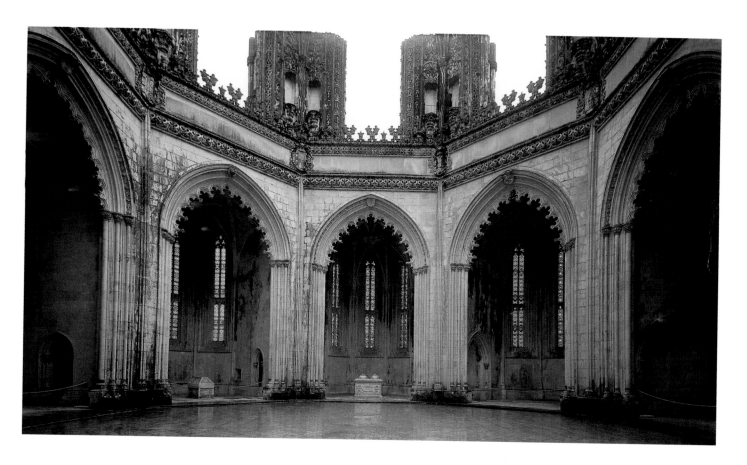

was added the construction of the church, consisting of nave and aisles, with a transept and five attached chapels.

Though based on a common type among the preaching orders, the building is unusual for its dimensions: 80 meters long, 22 meters wide, and 32.5 meters high (260 by 71 by 106 feet). In terms of scale, it clearly looks back to the monastery of Alcobaça. Details such as the basilica elevation (without a triforium) and the contrast between pier type and naturalistic capitals set a norm for subsequent buildings, in particular the Augustinian church of Santa Maria da Graça in Santarem. The Igreja do Convento do Carmo in Lisbon must also be included. Significantly, it was founded at the same time as Batalha, again as a votive church, by Nuno Alvares Pereira, João's military commander. As a result of the devastating earthquake of 1755, only the choir and arcades of the nave are still standing, today accommodating an archaeological museum.

In Batalha, Afonso Domingues completed parts of the church, and the royal cloister and the chapter house. In 1402, Master

Huguet took over the work. He was an architect possibly of English origin, or at least with close English connections. Dynastic links between Portugal and England had been established by João I's marriage to Philippa of Lancaster, daughter of John of Gaunt, and English Perpendicular influence on Batalha cannot be excluded. Huguet's task was to complete the vault on the parts begun by Domingues. He increased the height of the nave and thereby the amount of light. He also constructed the west front (see page 385, left), where the rich sculptural program of the doorway is framed by the linear decoration of the center section and crowned by Flamboyant tracery windows.

However, Huguet's most important work was in the two burial chapels attached to the church, the square Capela do Fundador on the south side, completed in 1434, containing the tombs of João I and his wife (see opposite), and the circular chapel intended as a mausoleum for Duarte I (1433–38) and his family. This remained unfinished, and is therefore called the Capelas Imperfeitas, the

Unfinished Chapel (see page 293). The Capela do Fundador, the Founder's Chapel, is a masterpiece of masonry work. The rectangular space is brightly lit, an octagonal dome with delicate stellar vaulting over the tomb of the royal couple. The loftiness of the graphically conceived architectural decoration creates an atmosphere of unique lightness and clarity. Everything—architectural members, ribs, moldings, plant and heraldic motifs—is executed with the utmost delicacy, the pale stone adding flexibility to the decoration. Probably the Capelas Imperfetias was intended to be fitted out in the same way. The central structure, which includes seven chapels, is in the tradition of Spanish models such as Don Álvaro de Luna's chapel in Toledo or the Capilla del Condestable in Burgos, all costly memorial buildings constructed behind the choir of the church.

Some instructive, if often heavily restored, military buildings have been preserved in Portugal, such as the castles of Leiria, Beja, and Guimarães, the fortresses of Almourol, Óbidos, and Chaves, and numerous fortified towers and walls. A characteristic example of these is the castle of Braganza, begun around 1390. It consists of a curtain wall fortified with towers, inside which is the monumental residential keep called the Torre de Menagem (see above). Defensive building in Portugal remained closely connected with feudal residential building until well into the 16th century, as fortified building was an obvious necessity in troubled times. Moreover, Portuguese military architects also played an essential part in the

conquest and defense of colonies in Africa, South America, and Asia, which further contributed to the continuing survival of Portuguese fortified architecture.

Manueline Architecture

The "Manueline" style of architecture is difficult to reconcile with the concept of a Gothic age. It nonetheless will be looked at here, since its source must be sought in Late Gothic. In terms of content, or more precisely its pictorial program, it belongs to the modern era: dynastic propaganda and assertion of power on the part of the rising colonial power came to the fore, pushing medieval tradition into the background. As a generally accepted term, Manueline is justifiable, for the zenith of Portuguese power, historically and architecturally, coincides with the reign of Manuel I (the Fortunate), 1495–1521. As a stylistic term, the word is less suitable. "Manueline" combines Late Gothic features of the most diverse origins with Renaissance forms and its own program of political symbolism. Unlike Spain, the Moorish legacy played no part in Portugal.

Two buildings of the late 15th century bear witness to the radical change from a Portuguese civilization still in the cast of the late Middle Ages to the cosmopolitan culture of the age of discovery. The Franciscan church in Évora, a foundation by João II (1481–95), anticipates the spatial forms of the 16th century. Its broad nave flanked by side chapels is enclosed by a continuous pointed barrel vault with intersecting groins (see opposite, bottom left). This pulling

OPPOSITE:
Braganza Castle, 12th–16th centuries

Francisco de Arruda
Belém, near Lisbon, Torre de Belém,
1515–21

together of the interior as a unified whole was a process completed by the Italian architect Vignola in the church of the Gesù in Rome, the foundation building for the Jesuits that became a model for Baroque church interiors everywhere.

Other clues indicate a search for new architectural forms: broad porticos, portal decoration with twisted columns, and emblematic programs—João II's pelican, Manuel I's armillary sphere. In the Igreja do Jesús in Setúbal, the motif of twisted columns is transferred to the interior. The church is a nave-and-aisles hall church begun in 1491. The columns (six, twisted like ship's cables) carry the rib vault, while the *capela-mor* (funeral chapel) is adorned with a complicated stellar vault. Work on the building is attributed to Diogo Boytac or Boutaca (ca. 1460–1528), a mason possibly of French origin, later to formulate the official Manueline style in the monasteries of Belém and Batalha. The columns in the Magdalene church in Olivienza (see below, right) are even more elegant and sophisticated than those in Setúbal. Another notable feature at Olivienza is the splendid curvilinear arch leading to the presbytery.

The Hieronymite monastery of Belém (Bethlehem), located not far from the mouth of the river Tejo outside the walls of Lisbon, is architecturally and ideologically the masterpiece of Manuel I's reign. It was during this time, as the Middle Ages evolved into the modern

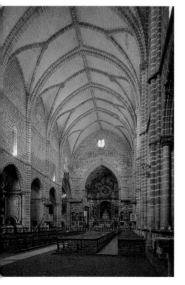

ora, San Francisco,
gun 1481

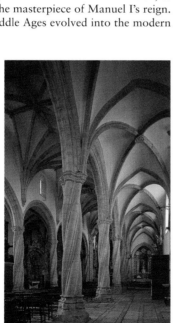

Olivienza (Estremadura), Santa Maria
de la Magdalena

era, that Portugal's discoveries transformed it into a world power both politically and commercially. Erected mainly in the first quarter of the 16th century, the monastery at Belém is an artistic achievement which, blending Gothic structures with Plateresque decoration and dynastic symbolism, has an unmistakably Portuguese character (see pages 296–297).

The monastery was a royal foundation of 1496, initially intended as a burial place for the Aviz dynasty and as a devotional center for the seafarers who set out from there. The present building was begun in 1501 and made over to the Hieronymites. It replaced a charterhouse founded by Henry the Navigator, which had been under the control of the Knights of Christ and no longer met their practical or ideological requirements. Along with the nearby Torre de Belém (see above), the Hieronymite monastery was then, as now, the official seaward entrance station to the capital of a vast colonial empire.

The first architect was Diogo Boytac, who had already made a name with the construction of the monastery of Jesús in Setúbal. He planned a much greater scheme than the previous one, with his new monastery having four cloisters. Under his direction, the ground plan was laid out for the nave and aisles of a large hall church with a clearly demarcated high choir and scarcely protruding transept. The first two (of five) bays were then erected by Boytac, but the support systems and unique vaulting enclosing the whole interior were completed after 1517 by João de Castilho (ca. 1475–1552), an architect and sculptor of Spanish origin involved in all important

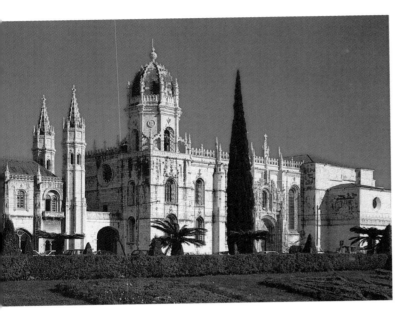

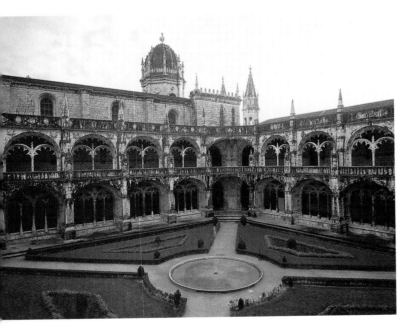

Diogo Boytac, João de Castilho
Belém, Hieronymite monastery, begun 1501
Cloister, ca. 1517

commissions for Manuel. The complicated net vaulting of the nave is carried on six octagonal piers 25 meters (81 feet) high and is completely covered with Renaissance ornamentation.

The construction of the interior is a masterpiece in both engineering and aesthetic terms, surviving even the great earthquake of 1755 intact. The exterior is notable for the richly decorated framework of the portals, which carry a complex iconographic program. The *capela-mor*, on the other hand, the pantheon of Manuel and his successors, was demolished in 1563. It was rebuilt in the Mannerist style by Diogo de Torralva (ca. 1500–66) and completed by Jean de Rouen in 1572. Evidence of familiarity with the Spanish monastic seat of the Escorial is unmistakable.

Probably also begun to plans by Boytac, but in the event substantially realized by Castilho, is the cloister of the monastery, which represents a high point of Manueline architecture on the threshold of the Renaissance (see left, bottom). The square two-story layout has six bays vaulted with net vaults in every wing, four bays having broad, deep arcades punctuated by weighty buttresses. The corner bays are linked diagonally by a broad arch, opening up the richly decorated corner pier to view. Whereas in the interior of the cloister Late Gothic forms predominate, on the sides facing the cloister Plateresque motifs, probably introduced by Castilho himself, come to the fore. Extensive surface ornamentation and slender columns bearing pairs of cusped tracery arches offset the otherwise stolid masonry with filigree decoration. The overall impression, with the regular succession of round arches and the strong emphasis of the horizontal, points already in the direction of the Renaissance. Influences from Spain can also be discerned. The cloister not only provided a place for monks to contemplate, but also an important site for the display of dynastic propaganda. As in the church itself, Late Gothic structures are combined with Renaissance ornamental motifs and figured representations with emblematic motifs such as the cross of the Knights of Christ, armillary spheres, and escutcheons. The aesthetic charm of the ensembles is readily felt, though the iconography is by no means completely deciphered.

The extension of the Hieronymite monastery in Belém was less the consequence of pastoral necessity than of the ideological needs of the burgeoning colonial power. Attempts were being renewed to bring about the unification of Spain and Portugal: Manuel planned to marry his son João to Eleanor of Austria, sister of the later emperor Charles V (Charles I of Spain). In 1517 it was decided to relocate the burial place of the Aviz dynasty from the monastery of Santa Maria da Vitória in Batalha to Belém. The plan initially failed because of vigorous objections from the monks. Only after the turn of the 16th century did Manuel and his family find their final resting places, in the choir and transept of the church at Belém.

At the time it was built (1515–21), the Torre de Belém mentioned earlier stood in the middle of the Tejo, the river having now altered course. It is the work of the military architect Francisco de Arruda.

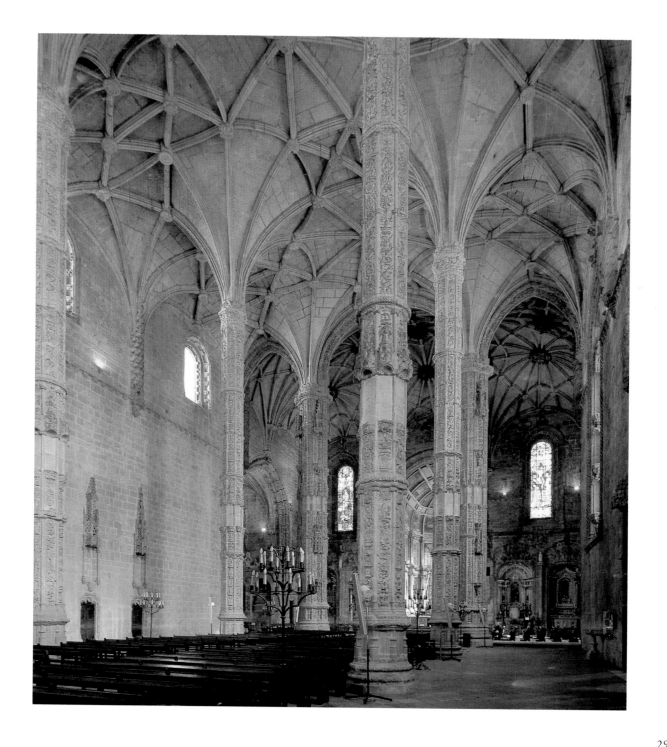

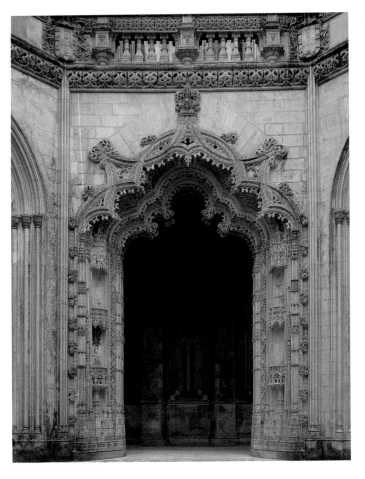

continuation of Late Gothic decorative tendencies then in fashion in Spain (the Palacio del Infantado or San Juan de los Reyes), Flanders, and Burgundy. Yet there is in the detail a new feature. On the jambs, among the animal and plant motifs, is the repeated motto of Duarte I: "I will practise loyalty as long as I live." Also present are the armillary spheres of Manuel I and the insignia of the Knights of Christ. In 1516 work on the chapel was largely abandoned. Various reasons have been cited, that Manuel was now focused on the Hieronymite monastery in Belém, which was to be remodeled as a burial place or that Mateus Fernandes had died. Other master masons, almost all of them military architects, were needed to safeguard the African coast. Even João de Castilho, who took over as master mason in 1528, added only a Renaissance loggia. Duarte's pantheon finally remained incomplete.

A further key work of Portuguese architecture is the monastery of the Knights of Christ in Tomar. The fortress-like central church of the Templars, dating from the second half of the 12th century, was given an annex at the beginning of the 16th century. The architects were João de Castilho and Diogo de Arruda. The annex was to serve as a high choir and chapter house. It is not the architecture of the two-story interior that is of interest, being vaulted with the usual net vaulting. In its subtle combination of elaborate decoration and ideological message, it is, even more than Belém or Batalha, the major achievement of the Manueline style. The opulent decoration of the exterior by João de Castilho contrasts with the spare but impressive design of the interior. The whole repertoire of Manueline decorative forms—which form a political program in themselves—is displayed on the portal, the window framing, the massive, repeatedly stepped buttresses, and the frieze (see opposite). Coats of arms and royal emblems, nautical devices, ship's cables, and marine plants and animals all feature in this decorative world, combining under the cross of the Knights of Christ to create a complex Christian symbolism. As in the south portal of the Hieronymite

Although his arrangement represented the latest advances in military techniques, the building had more symbolic than strategic value.

At the same time as Belém was being constructed as an advance post of Lisbon, work on the royal monastery of Batalha was also proceeding. Mateus Fernandes had run an efficient workshop since the turn of the 16th century, and it was he who was entrusted with the continuation of work on the Capelas Imperfeitas, the pantheon of Duarte I. By 1509 the main doorway was complete. It is probably the richest and finest masonry work of its time (see above). The Late Gothic splayed doorway is capped by several layers of intersecting arches while all the architectural features are covered with Flamboyant decoration; plant, ornamental, and heraldic motifs are blended into a decorative weave reminiscent of pillow lace. The external appearance of the portal could be interpreted as a

Batalha, monastery of Santa Maria da Vitória
Main portal of Capelas Imperfeitas, 1509
Device of Duarte I

Diogo de Arruda or João de Castilho (?)
Monastery of Knights of Christ
Chapter house window, early 16th century

João de Castilho
Monastery of Knights of Christ
Main doorway of church of Christ, 1515

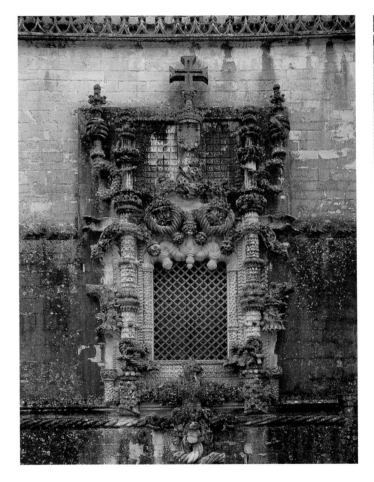

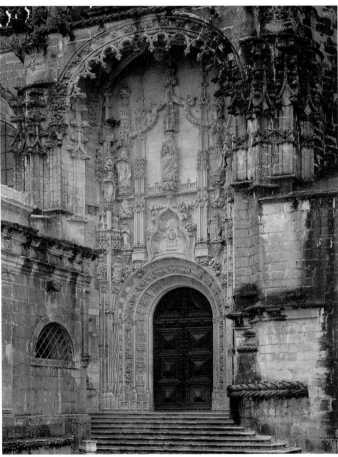

monastery of Belém, the main doorway is framed by a Late Gothic tracery arch that spans the whole height of the façade, enclosing a complex pictorial program on different registers. Prophets, saints, and the Virgin are traditional religious subjects, while the armillary spheres above the archivolt are a symbol of nautical knowledge that underlines the status accorded to seafaring in Manuel's time. Of course, this too was in the name of Christ: voyages of discovery were regarded as missions to rescue the heathen from spiritual darkness, and ideas of a new crusade to liberate the holy places were being discussed. The consequence was that in Tomar, as in other church architecture of the early 16th century, secular elements came to the fore.

The most striking example is the outer framing of the window of the chapter house, ascribed to Diogo de Arruda or João de Castilho.

In it, the imagination and creative power of the Manueline age is apparent (see above, left). Artfully created in stone, seaweed, coral, shells, and cables twine over the masonry, the whole scene supported by a half figure (the artist?), crowned and flanked by the cross of the Knights of Christ and the armillary sphere, symbols of the two mainstays of the Portuguese dynasty. The imaginative, naturalistic, and emblematic decorative motifs on the church of the Knights of Christ in Tomar characterize the art of an age spanning the transition between the dying Middle Ages and the modern era, vividly translating the age of discovery into visual terms. It is obvious that the reign of Manuel I was artistically and politically an age of radical change. In stylistic terms, Late Gothic still predominates, but the glorification of the Aviz dynasty bears the unmistakable stamp of modernity.

Uwe Geese

Gothic Sculpture in France, Italy, Germany, and England

Gothic Sculpture in France

The statues that adorn the three portals of the west front of Chartres Cathedral, the so-called Royal Portal, are widely seen as the epitome of Early Gothic sculpture. (There were originally 24 statues, but only 19 have survived.) The portals were built between 1145 and 1155 after a fire in the town in 1134 had destroyed parts of the cathedral. Thus they are not the oldest examples of Gothic sculpture—this is at St.-Denis, and is nowadays dated to before 1140. Nevertheless, it is the Chartres sculptures which art historians see as marking a clear dividing line between Romanesque and Early Gothic sculpture.

From being part of Romanesque wall reliefs, the figures stepped forward, as it were, from the columns of the portal jambs. With this step forward—the reason for which art historians are still unable to determine conclusively—these statues at Chartres signal the beginning of a new era in sculpture. Though they cannot yet be described as free-standing, the statues, carved together with their columns from single blocks of stone, are almost fully rounded. Though firmly integrated with the architectural elements of the portal, they give the impression of being independent and have a distinctive aesthetic appeal that derives above all from their elongated forms, clothed in the rich courtly dress of the period. About their bodies the exquisite silken material falls in long vertical folds like fine fluting on columns—so much so that the 19th-century French writer Joris-Karl Huysmans was reminded of sticks of celery! Though this comparison drawn from nature may have a comical ring, it contains an element of truth: these figures reveal a new way of seeing nature, indeed a new way of seeing humanity.

Gazing at these column statues on the jambs of the central portal of the west front of Chartres, one is immediately aware of the contrast between, on the one hand, the contained, columnar form of the sculpture and the almost ceremonial stylization of the poses, and, on the other, the fact that each figure has its own, almost individual, character. An example of this individuality is provided by a slender queen with youthful long braids on the left jamb of the central portal, who corresponds to another queen, on the right-hand jamb, whose rounded abdomen shows her to be a woman of mature years.

There have been many attempts to go further still and to interpret the facial expressions of the jamb figures. In the mid 19th century the French architect and influential restorer of medieval buildings Viollet-le-Duc claimed that these heads had "the character of portraits." He wrote of one of the prophets on the center portal: "This eye is inclined to become ironic, this mouth despises and mocks." He continued: "there is about this whole figure a mixture of firmness, greatness, and acuity. In the raised eyebrows there is even frivolity and vanity, but also intelligence and coolness at moments of danger." Such characterizations—which often reach very different conclusions—continue, and have produced a rich literary harvest, especially in the age of psychology. Certainly there had been nothing

Bernard de Montfaucon
Old Testament figures from the façade of St.-Denis, engraving from
Monuments of the French Monarchy (1729). The statues were
removed in 1771.

like these statues before in medieval sculpture. But to speak of partic-
ular people being portrayed in all their individuality is going too far,
though the ability to distinguish youth and age in a way so closely
imitated from nature was indeed quite new.

Writing of these Chartres sculptures in his book *The Beginnings of
the Monumental Style in the Middle Ages* (1894), Wilhelm Vöge,
then only 26, recognized that these figures, created from the mass of
the stone block, represented a new departure. He showed how the
sculptors had formed them in such a way as to achieve stylistic unity.
In other words, he detached the portal sculpture of Chartres Cathe-
dral from its Late Romanesque context and identified it as the begin-
ning of Gothic sculpture. He went further still, attempting for the
first time, and on the basis of stylistic criteria, to attribute individual
works to the different sculptors whose "intellectual property" they
were, as Wolfgang Schenkluhn has expressed it. In his study, Vöge
linked the statues at Chartres with an slightly older school of sculp-
ture which he saw as having had decisive and lasting influence on
French sculpture. This theory had important consequences for art
history for until fairly recently it formed the basis for the widely
accepted view of Early Gothic sculpture in France.

Vöge's interpretation gained such wide currency largely because so
many of the sculptures of the older portal complex at St.-Denis had
been lost, through acts of destruction and through disastrous attempts
at restoration in the 18th and 19th centuries. Thus, it was the happy
accident of the preservation of the Chartres statues that allowed them
to obscure their immediate forebears at St.-Denis. As recent research
has shown, it is also questionable whether the arrangement of the
Chartres portal is original. Certainly there is more reason to accept the
idea that it was St.-Denis that had a genuine "royal portal" in which a
claim to political legitimacy would have been supported by a powerful
merging of religious and political iconography.

The Abbey Church of St.-Denis

When Abbot Suger ordered the building of the new west end of
St.-Denis and had to decide on the sculptural program, he was prob-
ably inspired by the series of ancestral figures that had been carved on
the porch built by Charlemagne above the tomb of Pepin, figures about
which very little is known. At St.-Denis, that energetic and politically
powerful abbot, a friend of Louis VI (king 1108–37), had the opportu-
nity to make use of the centuries-old links with the monarchy in order
firmly to establish this abbey as the monarchy's principal religious
center. St.-Denis was not only a royal mausoleum, with the tombs of
Charles the Bald and Hugh Capet, founder of the ruling Capetian
dynasty, but also the place where the insignia and banners of the
kingdom were kept. Thus, next to Reims Cathedral, where coronations
were held, St.-Denis was the church most closely linked with the
French monarchy. In the jambs of the main portal at St.-Denis there
were 20 "column statues" of Old Testament kings, queens, and prophets.
These were removed in 1771 and only a few fragments survive.

A record of their appearance is preserved in Montfaucon's illustrations
in his *Monuments of the French Monarchy* of 1729 (see above).

By placing figures of Old Testament kings on the new portal of his
abbey church, Suger established a clear link between biblical and
contemporary rulers. The purpose of creating such a link was to
present the contemporary monarchy as a continuation of that of the
Old Testament, thus giving the French monarchy a sacred contempo-
rary legitimacy. This was of political significance because the French
monarchy was in conflict with the German (Holy Roman) Empire.

Chartres

The designation *porta regia* (royal portal) is known to have been
given to the west portal at Chartres (see pages 303–305) as early as
the first half of the 12th century—at a time, indeed, when the present
portal did not yet exist. The significance of the name has yet to be

satisfactorily explained. However, the cathedral was the most impor-
tant shrine to the Virgin in the whole of France and was visited by
large numbers of pilgrims. In view of this link, it has been suggested
that the designation "royal" refers to the Virgin as Queen of Heaven.

Between the massive buttresses of the towers is a façade that
shows what appears to be a elaborately worked out sculptural
program with a clear hierarchical structure. Although art historians
have come to regard this present arrangement as the norm, we should
not overlook the fact that it represents a departure from the design of
earlier portals. The subject of the tympanum of the central portal is
not new. Tympana above the entrance doors to churches, first used as
a pictorial medium in the Romanesque era, had long been dominated
by the theme of the Last Judgment. The portal at Moissac (see
below), built barely two decades earlier, was meant to trouble devout
beholders as they entered the church. Here the threatening image of
God as Judge at the end of the world was accompanied by the

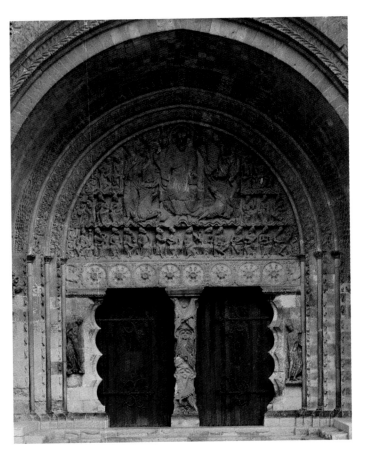

terrifying figures of the Apocalypse. At Autun a depiction of the
weighing of souls was added to these disturbing scenes, at Beaulieu-
sur-Dordogne, hellish hybrid creatures, and at Conques-en-
Rouergue, a dramatic representation of the punishments of Hell.

At Chartres too, the Judge of the World appears enthroned on the
tympanum of the central portal. But how changed! No longer is there
any sense of the ecstatic contemplation of God or of the terrors of the
end of the world. The infernal monsters, now barely visible, have
retreated to the edges of the portal, and the apocalyptic beings have
taken on a rigid heraldic immobility and expressionless beauty. The
anarchically vulgar, even erotic, elements of Romanesque portal
sculpture have been tamed.

In the figures on the jambs of the west portal at Chartres, two
things are happening that to the modern observer appear contradic-
tory. For a long time the fact that the statues had "stepped forward"
from the columns was seen as a liberation of sculpture from its close
bonds with architecture, and so interpreted as "artistic progress."
But as Horst Bredekamp pointed out in 1995 in a contribution to a
series on "My Most Hated Masterpiece," this development can also
be given a new perspective if viewed in terms of its historical context.
For what had angered St. Bernard of Clairvaux about Romanesque
art—the temptation presented by its wild proliferation of strange
creatures and demons—is subtly controlled in the west portal at
Chartres, where the sculpture is made to serve the hierarchy of the
building and the power of the monarchy. This, it could be argued,
represented a deliberate attempt to curb the imagination. For Brede-
kamp, at Chartres, "sculpture changed its nature and became archi-
tecture in order to set against the fantastical, protective magic of the
Romanesque the image of a secure world order. With the creation of
the west portal, sculpture was taken from the realm of freedom into a
domain narrowly constricted by theology."

The three entrances in the west portal are linked by their lintels,
which are all of the same height. This link is further underpinned by
the 24 capitals of the jamb columns, which together form a unified
series of scenes from the life of Christ. The composition of the
tympana of the side portals is such that they are almost mirror images
of each other; the central portal dominates the arrangement by virtue
of its size. While the theme of the south portal is the Epiphany, the
first appearance of Christ, the tympanum of the north portal shows
the Ascension. The angels witnessing these events refer iconographi-
cally to the tympanum of the central portal where the Second
Coming, the coming of Christ for the Last Judgment, is portrayed.

Whereas at Moissac the 24 Elders of the Apocalypse are divided
between the tympanum and the lintel, at Chartres the sculptors
placed them on the archivolts above the tympanum. As a result of the
stepping of the portal these architectural elements now provided new
space to carry images. The Elders are shown on the two outer archi-
volts, each seated on a small throne, pious and dignified spectators.
Here too ecstatic absorption in the presence of God has given way to

Chartres (Eure et Loire),
cathedral of Notre-Dame
Main door of Royal Portal, ca. 1145–55

FOLLOWING PAGES:
Chartres (Eure et Loire),
cathedral of Notre-Dame
Main door of Royal Portal
Figures on left-hand jamb (left)
Figures on right-hand jamb (right),
ca. 1145–55

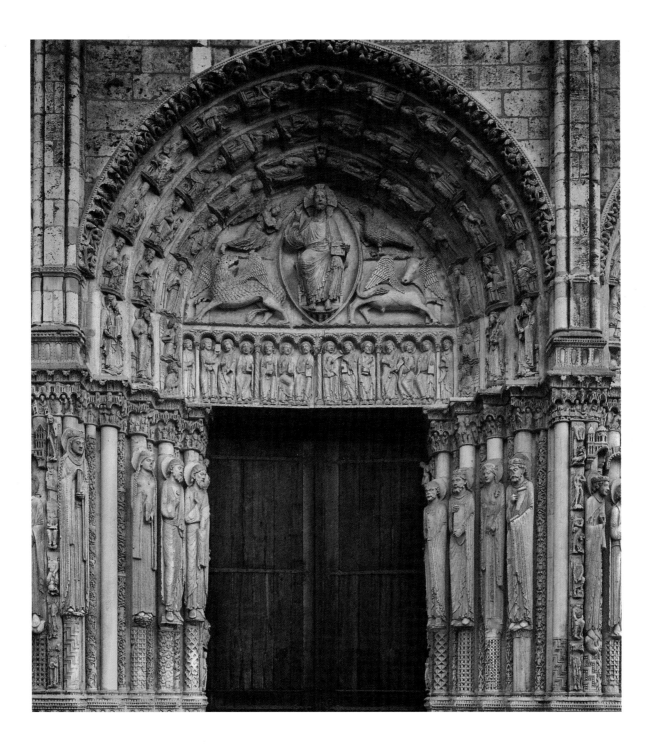

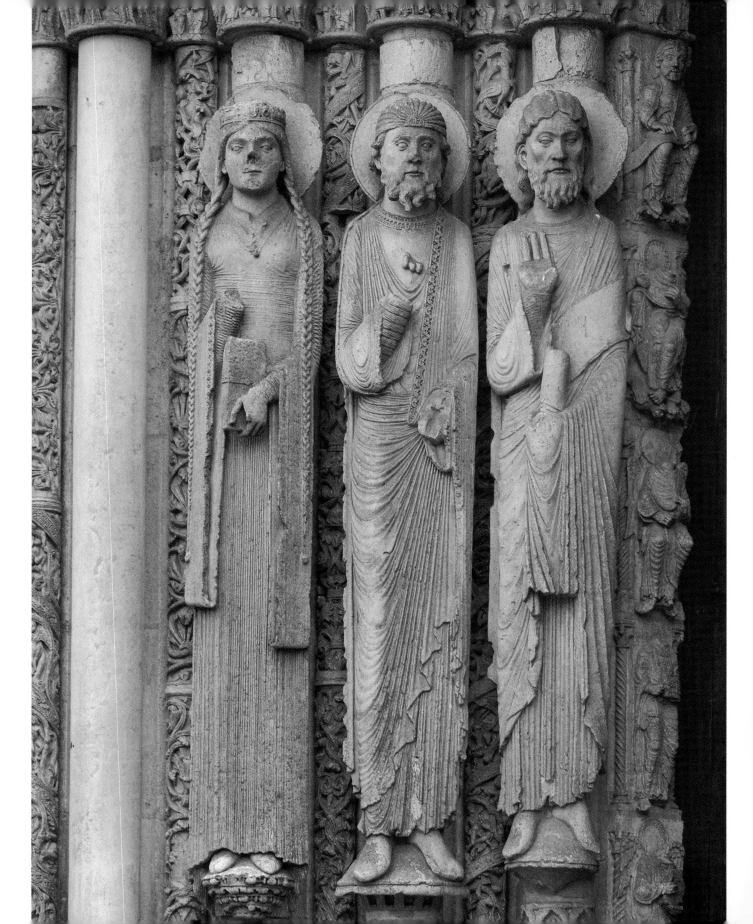

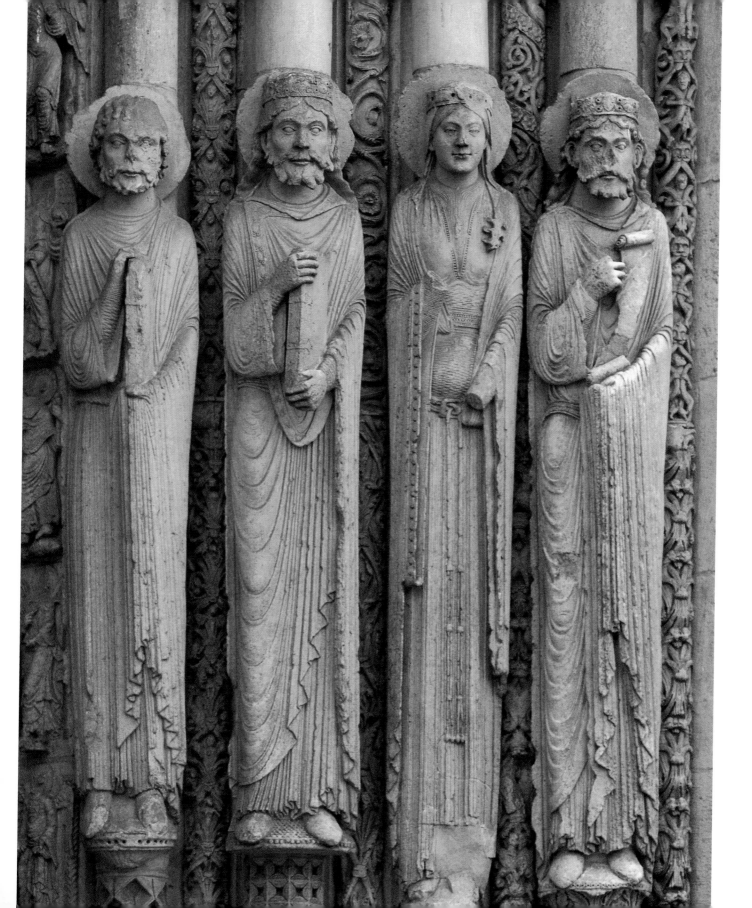

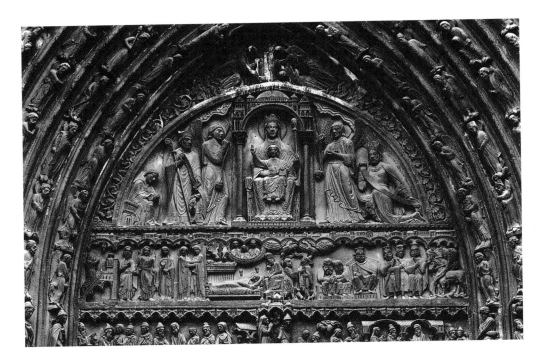

a pious veneration in which emotion is subdued. On the archivolts of the south portal the liberal arts are represented, while on the archivolts of the north portal there are the signs of the zodiac and the Labors of the Months.

The Former Mary Portal at Notre-Dame in Paris

Although the west front of Notre-Dame in Paris (see page 45, bottom right) dates only from the 13th century, older sculptures were re-used in the construction of its southern (St. Anne) portal. They can be seen in the tympanum, in the upper lintel, and on the 52 voussoirs that were transferred from the older building to the west front of the new cathedral. On the voussoirs the Prophets and the Kings can be identified, as well as the 24 Elders, who can be recognized by their musical instruments.

At the center of the tympanum (see above) the crowned Virgin sits on a throne beneath a canopy that is flanked by two angels, the Christ Child on her lap. Behind the angel on the right kneels a king, behind the angel on the left stands a bishop, and behind him sits an attendant, writing. Both dignitaries are holding scrolls whose lost inscriptions may once have given their names. They are now thought to be Germanus, the later canonized Bishop of Paris, and King Childebert, both of whom had played a vital role in the building of the cathedral.

The lintel immediately below shows, from left to right, Isaiah, the first prophet of the coming of the Messiah, then scenes of the Annunciation and the Visitation. These are sharply separated from the Nativity scene by a dividing-line at one end of the bed. At the head of the bed sits Joseph (looking rather bored) and behind his back we can see the angel announcing the birth of Christ to the shepherds. Between the shepherds and King Herod seated on his throne, a Pharisee and a scribe sit waiting anxiously on a bench. Finally we see, on the far right, the stately Magi and their horses.

It was only when the St. Anne Portal was restored in 1969 that the close stylistic affinity between these sculptures and the portal sculpture at St.-Denis and Chartres was recognized. This meant that the St. Anne Portal had to be redated, for the date usually ascribed to it was too late. The chief conservator of French museums, Alain Erlande-Brandenburg, believes that the elements from the older portal must date from before 1148, the year in which the influential archdeacon of Notre-Dame, Erlande de Garlande, died. In 1977 the discovery of a large number of sculptures provided confirmation of this revised assessment, for the finds included parts of the jamb figures and of the trumeau. As Xavier Barral i Altet has rightly observed, the outstanding sculptural quality of these works earns this portal "a place in the first rank among the early examples of Gothic sculpture."

The original portal of the church (which had been founded in the 4th century) was devoted to the Virgin. Renovation work on it was begun in the 1120s. This Mary Portal was later incorporated into the west front (started in 1210) of the new building designed in 1160 by the newly appointed bishop, Maurice de Sully (formerly headmaster at the cathedral school). When it was incorporated, the Mary Portal not only received many additions but also had its iconographic program given new significance in response to the growing veneration of St. Anne, mother of the Virgin. The most important of these additions is in the lower lintel, which features scenes relating to St. Anne. Along with the famous portals at St.-Denis and on the west front at Chartres, the former Mary Portal, which after its adaptation became the St. Anne Portal, must be counted as one of the major works marking the beginning of Gothic sculpture.

Senlis

A tall lintel sculpted in two panels forms the powerful base for the tympanum of the west portal of the Cathedral of Notre-Dame at Senlis (see page 307). In the left-hand panel are depictions of the

OPPOSITE:
Paris, Cathedral of Notre-Dame
Tympanum of St. Anne Portal
West front, in part pre-1148

Senlis (Oise), Cathedral of Notre-Dame
West portal, ca. 1170

death and entombment of the Virgin, images that have suffered damage over the years. While the Apostles place her body in the sarcophagus, two angels fly up to Heaven with her soul in the form of a child over whom they hold a crown. On the right-hand panel this is complemented by the physical raising of the Virgin: the angels lift the body from the sarcophagus in order to carry it too up to Heaven. This lintel underpins, not only architecturally but also iconographically, a program that appears for the first time on a portal: the Virgin and Christ facing one another, a scene that is depicted in the tympanum. They are shown sitting on small thrones symmetrically placed, each backed with a rectangular frame: dwellers in Heaven of equal status.

In the sculpture in the south doorway of the west portal at Chartres and in the St. Anne Portal of Notre-Dame in Paris, the Virgin is presented frontally, enthroned, with the Christ Child on her lap. This manner of depicting her corresponds to the allegorical type *sedes sapientiae* (the seat of wisdom), derived from the Old Testament description of the throne of Solomon. The tympana of the other portals generally show only Christ.

Thus at Senlis we find something completely new. Not only has the Virgin been crowned, but she has also been received into Heaven and sanctified, and in the tympanum is shown enthroned and of equal status with Christ. This reflects the growing contemporary reverence for the Virgin, in which she is regarded as more than merely the earthly mother of the divine Christ Child. At the same time she can also be interpreted as the Bride of Christ and hence as the personification of Ecclesia (the Church), with whom Christ as the Bridegroom is united. It is surely no accident that the two figures are enclosed by a double arch in a shape resembling the "M" of medieval uncial script.

The other sculptures support this central image, though the figures on the jambs stand in a clearer relationship to Christ than to the Virgin. The attributes of the figures on the right-hand side identify them as David, Isaiah, Jeremiah, and Simeon. As prophets of the Messiah they are symbols of God's incarnation in the person of His Son. On the opposite side, St. John the Baptist, Samuel, Moses, and Abraham represent Christ's role as Savior. The figures on the archivolts, on the other hand, together form the Tree of Jesse, the family tree of the two divine central figures, and as such relate directly to the Virgin as well as to Christ.

It has not so far been possible to arrive at a precise dating for this significant extension of Marian iconography. On stylistic grounds the suggested date for the portal is around 1170. Xavier Barral i Altet regards this work as "a special case" which, though not directly imitated, was frequently alluded to. This happens, for example, on the west front of the abbey church of Notre-Dame at Mantes, where the life of the Virgin and her ascension into Heaven are shown somewhat differently, but where a cross above Christ and the Virgin is, as it were, a confirmation of the iconography of Senlis.

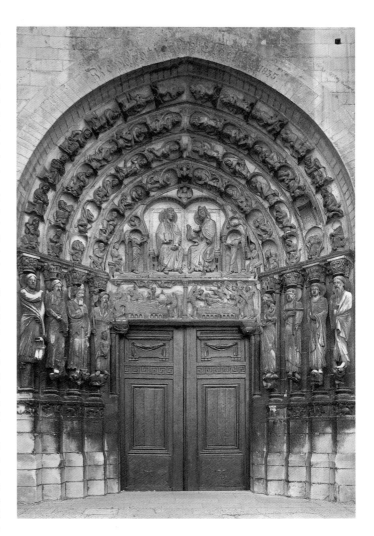

Laon and Sens

Around the turn of the 13th century the sculpture of Northern France started to show a strong classicizing tendency. The decoration of the west portal of the Cathedral of Notre-Dame at Laon (see page 308, left), dating from around 1200, seems to mark the beginning of this development. Of the three doorways, the left-hand and central ones are devoted to the Virgin while the subject of the right-hand one is the Last Judgment. In its Marian iconography, the center portal, with the addition of one archivolt, follows the same sequence as that seen on the portal at Senlis. Here, too, three archivolts depict the Tree of Jesse. All the figures in the genealogy

Laon (Aisne), Cathedral of Notre-Dame,
ca. 1200
Central portal of west front (left)
Detail of archivolts (center)

Sens (Yonne), cathedral of St.-Étienne
Central doorway of west portal
St. Stephen, on the trumeau, ca. 1200

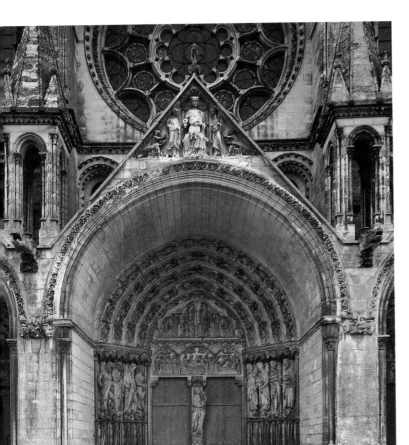

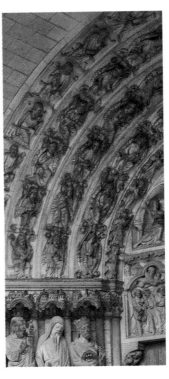

of Christ sit on small thrones, with the branches entwined around them. They wear garments of antique style, though beneath the garments their living physicality is visible. In the figures of the prophets in the outer archivolt, movement shows still more clearly beneath the folds of the ample robes, which play about their bodies in flowing curves.

If we compare these works with the early Gothic sculpture at Senlis, and more especially with that at Paris or Chartres, we can see how much they embody that new approach which since a major exhibition in New York in 1970 has been known as "the style of 1200." There is only an apparent contradiction in the fact that Gothic sacred sculpture was becoming more physically alive while Gothic architecture was at the same time moving away from the material. The spiritualization fostered by scholasticism demanded of architecture that it should overcome matter by imbuing it with higher meaning. Of sculpture, on the other hand, it required that it should breathe new life and spirit into its works. This was to be achieved by making the figures carved in stone appear animated and human. However, Gothic sculptors were not to achieve this without at the same time strongly conveying the contemporary view of God and biblical figures by giving them a monumental aspect. It is in

the context of this humanization of the divine that the steadily increasing cult of the Virgin must be seen.

In the central door of the west façade only the figures on the archivolts and the tympanum have survived. As for the others, it is as if each one had been forced to step down to the guillotine, their heads having been broken off in the iconoclasm of the French Revolution. In the 19th century and later, many restorations were made that make it difficult for us nowadays to form a clear impression of their original appearance.

Comparable to the sculpture at Laon, and of similar importance in art history, is that of the west portal of the cathedral of St.-Étienne at Sens. Although the building itself is among the earliest Gothic churches, having been begun at the time of Bishop Henri Sanglier between 1122 and 1142, the west front dates only from the years between 1185 and 1205. Here stylistic elements drawn from antiquity have been introduced in the archivolts of the central doorway. The five archivolts contain standing and seated figures that are full of movement and whose clothes show richly folded drapery. The fluid lines of the folds, which in the case of the angels on the inner archivolts actually become a gentle swaying at the hem, have an enormously enlivening effect on these statues.

Chartres (Eure et Loire), cathedral of Notre-Dame
North transept, central portal with the Triumph
of Mary
Jamb on east side with the Old Testament figures
of Melchizedek, Abraham with Isaac, Moses,
Samuel and David (below)

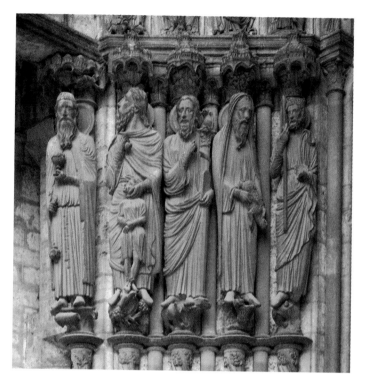

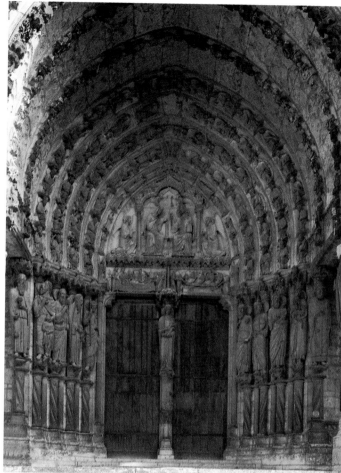

The Transept Portals at Chartres and the Transition to High Gothic: The Triumph of Mary Portal

Chartres Cathedral was rebuilt after a fire in 1194 destroyed large parts of the old cathedral. A completely new kind of building was erected, one whose transept façades have portals that were given as much importance as those on the west front. The oldest of these is the middle doorway on the north façade, the so-called Triumph of Mary Portal (see above).

In 1204 the Count of Blois had made Chartres Cathedral a gift of the head of St. Anne. In acknowledgment of this new and important relic a figure of St. Anne appeared on the trumeau of the central portal of the north transept. This portal probably therefore does not predate that gift, and a date of 1204 or 1205 is now generally regarded as safe. The other transept portals are later. In style, the portal follows Senlis. Here, too, in the tympanum Christ and his crowned Mother sit under a Gothic arcade, while the lintel illustrates two scenes, the death and the assumption of the Virgin. The tympanum is surrounded, on the innermost archivolt, by angels, followed by one archivolt of prophets and two showing the Tree of Jesse. On the outermost archivolt appear more prophets, also enthroned, and other Old Testament figures. In the jambs of the portal are, on the east side, Melchizedek, Abraham with Isaac, Moses with the brazen serpent, Samuel, and David. Facing them on the west side are Isaiah, Jeremiah, Simeon, St. John the Baptist, and St. Peter.

The imitation of the forms of classical statuary discernible at Laon and Sens can be seen here too, but changed. Compared with the swaying robes of, say, the figures on the archivolts at Laon, the sculpture at Chartres appears more static and the folds of the drapery are more tautly marked. The art historian Willibald Sauerländer has spoken of "a conception of creating figures which lacks anything emotional or expressive, but which shows, in compensation, a new nobility." Sauerländer also remarked that the composition of this portal accorded equal importance to sculpture and architecture. This aspect has led Martin Büchsel recently to make the comment that, compared with the Virgin tympana at Laon and Senlis, the tympanum at Chartres most strikingly lacks three-dimensionality. The gestures of the two figures enthroned in heaven, which convey a strong sense of movement, make the central axis the focus of the portal's composition. The reduction in physicality and the consequent loss of depth are, he argues, a consequence of the emphasis on the lines of the composition. Both elements, gesture and line, are indeed oriented towards the central axis, which is a major element in

Chartres (Eure et Loire), cathedral of Notre-Dame
Central portal of south transept with Last Judgment,
ca. 1210

OPPOSITE:
Paris, cathedral of Notre-Dame
Central doorway of west portal
Tympanum with Last Judgment,
after 1200

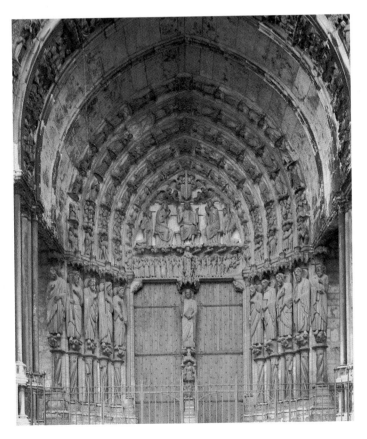

the architecture. Büchsel stresses that, isolated from the architecture, the gestures would be merely formulaic. There is thus a kind of symbiosis here between architecture and sculpture, which reaches its height in the figure of St. Anne on the trumeau. The orientation of the figure, especially of its clothing, toward the architecture is based essentially on symmetrical structures. The human presence of the figure is conveyed without any special stance, reduced simply to a slight inclination of the head, while the straight, almost column-like fall of the folds strengthens the bond between the figure and the trumeau. In this way the style itself expresses the integral relationship between the architecture and the sculpture.

The Judgment Portal

The portal of the south transept of Chartres is wholly devoted to the theme of the Last Judgment (see above). This is depicted above the center portal, but with additional iconographic material on the side portals. On the left doorway the statues of the Martyrs appear with

their attributes to represent their championing of the Christian faith, even to the point of their own violent death. On the jamb of the right-hand portal the Confessors and the Church Fathers are assembled, while in the tympanum and in the archivolts numerous religious legends are depicted.

In the center portal the dramatis personae of the Last Judgment are divided between the different areas. Whereas previously, for instance, the Apostles had been with Christ in the tympanum, they have now found their way down to the jambs, where they are shown with the instruments of their martyrdom. While in the tympanum Christ the Judge is flanked by the intercessors for humanity, the Virgin and St. John, and by angels, in the lintel the Archangel Michael performs the weighing of souls, after which the Blessed move off to the left and the Damned to the right, toward Hell. In the archivolts, the Blessed, who have risen and been saved, continue on their way while the Damned have to set out on their journey through the infernal regions.

Encircled, as it were, by the Apostles in the jambs, Christ appears again on the trumeau. Like the figure of St. Anne in the Triumph of Mary portal, so here Christ, the "Beau Dieu," lacks all physicality; his raised right forearm merely reinforces the verticality of the composition of the portal as a whole. Starting out from him, the whole ensemble is composed as a vertical composition: from Christ on the trumeau the central axis continues upward through the figure of the Archangel Michael and up to that of Christ the Judge. The Apostles also conform to this strict orientation: their clothing hangs down in vertical folds and their gestures are limited to slight turns of the head and to holding their attributes.

Notre-Dame in Paris

The center portal of the west façade of Notre-Dame also depicts the Last Judgment. This portal has been repeatedly restored, first around 1240 and then in the mid 19th century. This has resulted in various inconsistencies, mainly of technique, that pose questions unresolved to this day. The iconography—the language of the pictures—is clear and enticingly easy to understand, however.

The type of Last Judgment that was worked out in the south portal at Chartres has its successor here in the west portal of Notre-Dame, but there is a significant iconographical change. As at Chartres, Christ sits on his judgment throne at the center of the upper register of the tympanum. But the figures attending him, the Virgin and St. John, have moved outward and are no longer enthroned. Instead they kneel, praying for sinful mankind, in the bottom corners of the tympanum. Christ raises his hands to display his wounds, as at Chartres, but here the angels who have moved close to him hold the instruments of the crucifixion (the cross, the nails, and the lance) so that attention is strongly drawn to the theme of the Passion. Christ no longer appears as the fearsome Judge—which he had already ceased to be at Chartres—but as the Savior. He is enthroned above

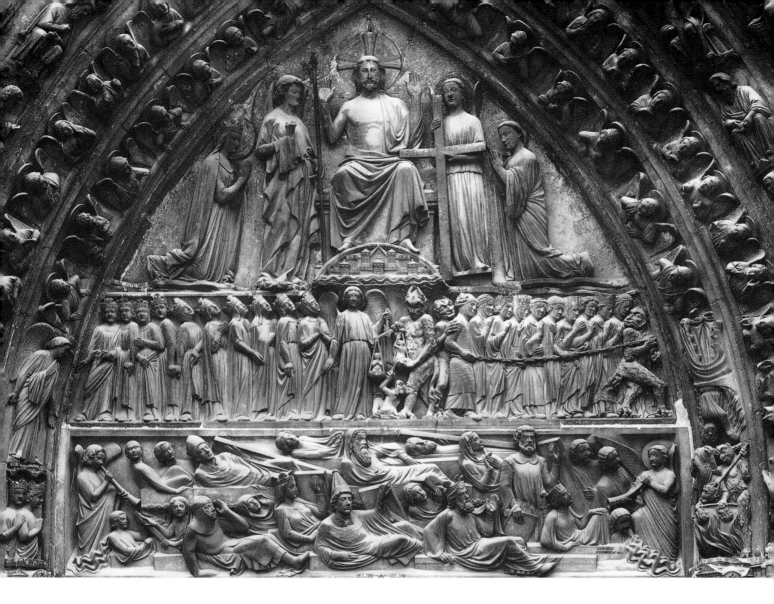

the Heavenly Jerusalem mentioned in the Revelation of St. John (21, 2), with its four towers that stand for both the four elements and the four Evangelists. Not for nothing does the arc above the city, on which Christ rests his feet, also span the scene of the weighing of souls, which appears just below. The sinner who has not done penance receives his just desserts, falling headlong into Hell with the damned, as we see happening to one such individual in the first archivolt on the right-hand side. But whoever follows the faith proclaimed by the Church has the prospect of salvation. They may take their place with the other redeemed souls in the bosom of Abraham, to whom the angel in the first archivolt on the left is pointing. In the jambs stand the Apostles, turning toward Christ, who is depicted teaching on the trumeau. Below the Apostles are two rows of reliefs showing the virtues and vices, while on the doorposts are the figures of the Wise and the Foolish Virgins.

The lintel, reconstructed in the 19th century, shows the dead being awakened by the angels sounding the trumpets of doom. People of every degree rise from their graves, each awaiting salvation. In the first two archivolts framing the tympanum, angels watch the spectacle as though from boxes in the theater. Each of them expresses wonder at what is taking place in their own way: there is no repetition in their gestures and poses. This idiosyncratic Last Judgment, of which Martin Büchsel saw some signs in the portal at Chartres, and in which there is a new emphasis on the condemnation or salvation of each human being according to their merits, is here shown even more clearly.

The hope of salvation was indeed now based on a new awareness of individual existence in this world. People's sense of being intimately bound up with the universal, implacable, unshakable totality created by God and proclaimed by the Church was not as strong as it had been in the past. Gradually people were learning to see themselves as independent individuals. With this new consciousness of self they looked anew at their social environment and began, very gradually, to make a distinction between their own personal existence and their status as members of a group or section of society.

Paris, cathedral of Notre-Dame
North portal of west façade with
Coronation of the Virgin, ca. 1210

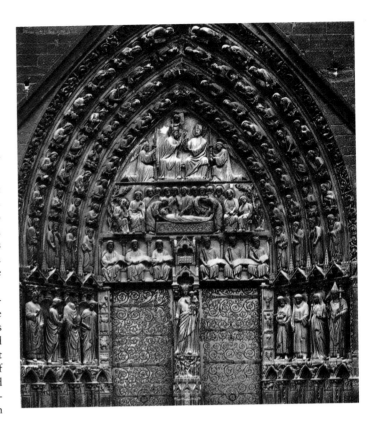

The portal of Notre-Dame and its iconographic program were executed at the beginning of the 13th century. This was the time of the great heretical movements that swept across the whole of Europe. As early as 1140 the scholar of canon law, Gratian, had declared that anyone was a heretic who "shows intellectual arrogance and prefers his own opinion to the opinion of those who alone are entitled to pronounce upon matters of faith." And precisely this—a conviction of one's own, a personal inclination or way of thinking—is what is signified by the word "heresy," derived from the Greek *hairesis* (a choice), a conviction, in short, that causes individuals to oppose the dogma of the Church and thus challenge its authority.

The most widespread heretical movement at this time was probably that of the Cathars (from the Greek *katharos*, "pure"). The persecution of heretics in the late 12th century and the early decades of the 13th, which finally reached its terrible climax in the so-called Albigensian crusade in southern France, ranks among the most extraordinary but also the most depressing chapters of the history of European dissidence. The argument that the remission of sins could be obtained by defending the true faith against heresy was successfully used to divert the crusading armies, originally formed to reclaim the Holy Land, to the fight against the Cathars. The crusade became a war against Christians in a Christian country, which then, under the insignia of cross and crown, broadened into a brutal colonial war (see pages 116–117).

Meanwhile in Paris a portal was being built with a program of sculpture that used the language of pictures in an entirely new and lucid way—they were, after all, addressed to people who were almost without exception illiterate, but who were nevertheless, with each passing day, gaining a new sense of their own individuality. People were no longer so easily disturbed by the terrifying images on the tympana of the previous century. Instead of being shaken to the depth of their souls by these apocalyptic visions of the end of the world, they were more likely to turn away and embrace heretical ideas. On the portal at Notre-Dame, a new need for an element of humanity, which was also felt by the sculptors (and indeed by those who commissioned the work), caused overwhelming force to be replaced by the power of persuasion. With great clarity, the portal portrays the separation of good and evil, and the gentle humility of the intercessors. The few scenes of Hell have been consigned to the archivolts. The fact that the program was so easy to understand was due to the clear arrangement of the images. This portal graphically reflects the historical phenomena of its age, which mark a profound change in European thought and feeling. Once this stage had been attained, there was no going back.

The portal showing the Coronation of the Virgin, to the left of the center portal (see above), has the same clarity. Likewise seriously damaged in the French Revolution, though later skillfully restored, the tympanum has to be read from the bottom upward. Above the trumeau with the standing figure of the Virgin, the Tabernacle and the Ark of the Covenant are shown, flanked by seated priests or patriarchs and kings. The Ark is seen as an Old Testament prefiguration of the bodily assumption of the Virgin into Heaven, which begins with the raising of her body (shown above the Ark) and culminates at the apex of the tympanum with her coronation. Both this sequence and the fact that angels officiate at the coronation are iconographic innovations, as is the fact that here for the first time local saints appear on the jambs.

Of the sculpture on the west portal of Notre-Dame, the most impressive artistically, but the most puzzling as to origin and iconography, are the four small reliefs, imperfectly preserved, on the buttresses at the sides of the central door. They show Abraham, a hunter, a figure who is perhaps the first earthly ruler Nimrod, and a tormented Job sitting on the dungheap. These pieces, which indicate a sculptor of the highest rank, are among the works that strongly reflect the classical stylistic influence that took hold of European sculpture around 1200. The scene with Job in particular is likely to have been influenced by late classical ivory reliefs.

Amiens

A superabundance of sculptural decoration adorns the west front of the cathedral of Notre-Dame in Amiens, widely considered one of the most important buildings of French High Gothic. Here too the central portal is devoted to the theme of the Last Judgment, but the representation of it is far more extensive here than anywhere else. There are no fewer than six stepped jambs, with six archivolts arching above the figures on them. All the jamb figures of the three

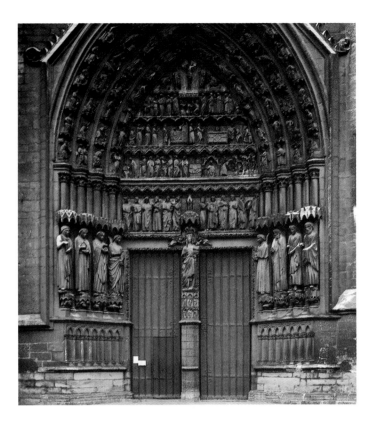

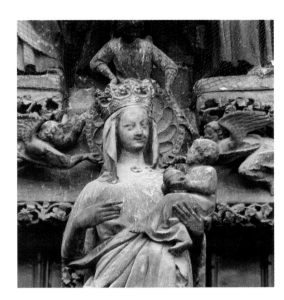

Amiens (Somme), cathedral of Notre-Dame
Portal of south transept
Detail of *Vierge Dorée* on the trumeau (below),
ca. 1240–45

portals combine to form a horizontal series going right across the façade, including the buttresses, creating a strong unity between architecture and sculpture. The tympanum is divided into four levels, of which the lowest is itself divided into two zones. Here the Weighing of the Souls of the risen dead takes place, while the separation of the Blessed from the Damned extends into the first archivolt. As at Notre Dame, here too Christ appears on the trumeau.

While the right-hand doorway, with the standing Virgin and Child on the trumeau, is reserved for the Virgin, at Amiens the left-hand doorway also shows local saints, an arrangement which since its first appearance in Paris had become quite common in large sculptural programs. The tympanum shows scenes from the life of the principal local saint, St. Firmin, the first bishop of Amiens, whose statue also adorns the trumeau.

Artistically more significant is the south transept portal (see above), the sculpture on which dates from 1235–45. Inserted between the tympanum and archivolts above and the jamb baldachins below is the lintel, flanked by columns, where two of the Apostles, dressed in traveling clothes, are turned toward each other, bidding one another farewell. The various registers of the tympanum relate the life of St. Honoratus, another former bishop of Amiens. The two upper registers together depict the legend according to which an image of Christ crucified bowed before the relics of Honoratus.

The most famous figure, however, is on the trumeau. This is the so-called *Vierge Dorée*, the Golden Virgin (see above, right), whose name derives from the fact that once—indeed right up to the 18th century—she was gilded. She is smaller than the jamb figures, her pedestal is higher, and she stands under a baldachin that bisects a register on which the Apostles stand. Her shoulders and head reach up into the architrave where three angels hold a rosette with spiraling petals as a nimbus behind her crowned head. The *Vierge Dorée* is the real center of this portal, partly because of the three-dimensionality that makes her stand forward from the plane of the tympanum. While the upper registers are almost in bas-relief, there is a noticeable increase in three-dimensionality as one moves downward, until the Virgin on the trumeau is almost a fully rounded figure even though she can be viewed only from the front. The right-hand side of the figure is made jagged by a series of folds, while on the left-hand side the bunching of the garments creates a long and smooth curve. As though supported by this gentle curve, the Christ Child sits on the Virgin's left arm, uniting with her to form an intimate group. Turning to gaze at him, the Virgin accords the Christ Child the central position to which the whole composition of the group relates. How clearly this focus upon the child has always been recognized is shown by the probably mistaken restoration of the Virgin's right hand, which almost certainly did not originally point toward the child.

However, the true significance of the *Vierge Dorée* in the history of art comes from the figure of the Virgin herself. Her smile, directed toward the child, is quite new, and conveys to us not only the intimate relationship between the two, but also its very human aspect. More important still is the tension that seems to come from within the figure, which shows itself in the position of the slightly extended right leg, and the barely perceptible inclination of the upper torso towards the right, which is countered by a slight turn of the head to

the left. Principles of classical sculpture such as contrapposto (the twisting of the figure in opposite directions) have thus been adopted for the standing figure of the Virgin, a subject that was widespread in the Île-de-France around the middle of the 13th century, and not only on cathedral façades. The art historian Robert Suckale has pointed out that by introducing movement, that is to say by changing the form, the sculptor also changed the content; merely by the way he has presented the figure the sculptor goes "one step further along the path away from the hieratic Madonna who is only a frame for the Child to the mother totally devoted to the Child." From this point of view the Amiens *Vierge Dorée* is the starting point for many sculptures of the Virgin and Child, not only in France.

Reims

As a masterpiece of French art, Reims Cathedral, together with the cathedrals of Chartres and Amiens, is considered a classic cathedral of France. Its sculpture, too, which here extends to the interior of the west portal, is among the outstanding work of French High Gothic. Reims Cathedral derived its superior status from its function as the coronation church of the French kings. As a consequence, the sculptural decoration of each of its portals reflects the political standing of the archbishop of that time.

The portal of the south transept provided direct access from the bishop's palace to the crossing with the main altar and to the presbytery. It had the character of a private entrance for the archbishop and was therefore not given special embellishment. However, the north transept, which adjoined the chapter cloister and was enclosed by it, was designed to be extremely impressive and was richly ornamented with sculpture (see below). Some sculptural work on the comparatively small western entrance—for instance the enthroned Virgin and Child—probably came from the earlier church and would have been executed around 1180.

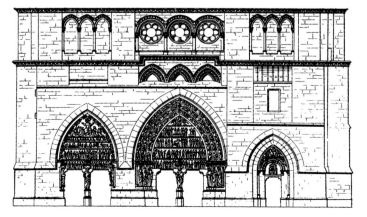

The two other portals are most unusual even in their choice of subject matter. On the left is the Last Judgment, which is normally depicted only in publicly accessible places. Moreover, it accompanies the central portal featuring the legends of the bishops of Reims, which at first appear to be of only local significance. While the actual entrances, each divided by a trumeau, are no higher than the moldings above the lower courses of the church, the tympana reach a height on the façade where they actually obscure all but the very tips of the lancet windows behind.

The purpose of the portals becomes clear if we look at them in their architectural and thematic contexts. Christ holding the orb of the world on the trumeau of the Judgment portal is accompanied by the Apostles in the jambs, while on the central portal the figure of a pope on the trumeau is flanked by the two most important bishops of Reims, St. Nicasius and St. Remigius. A visible link is thus established between the works of the Apostles and the deeds of these bishops: the Apostles continued the Lord's work, fulfilling his commands in an exemplary manner, while the Reims bishops—Remigius (Remi) as the converter and baptizer of the heathen king Clovis, and Nicasius as a martyr beheaded by pagans in the church at Reims—are placed alongside them as their successors. By analogy with the typological interpretation of the history of salvation by medieval theologians in which the Old Testament points forward to the New, the Apostles are here intended to be seen as the precursors of the bishops of Reims. In the same way, the figure of a pope on the trumeau visually affirms the closeness of the bishops to the papacy. This emphasis on the apostolic is of fundamental political significance, invoking the Rheims bishop-saints as guarantors of the right to crown the monarchs of France. This portal was the one by which kings of France entered the church for their coronation.

The divinely legitimated kingly power that was about to be bestowed on them did not permit the future monarchs to enter this most holy place where kings were consecrated through the west portal, since they would then seem to have come from among the people. Above all, however, the concern of the archbishops of Reims to assert their position would probably not have allowed it, for given that they had constantly to defend their right to crown kings, they insisted that they personally should bestow the divine legitimacy of the monarchy on the new ruler through their coronation ritual. This therefore was the equivalent of papal power; it was this power that was impressed upon the king as he passed through the center portal of the north transept.

In the west portal (see pages 59 and 316), through which the king, once crowned, stepped outside, these ideas are presented programmatically through a sequence of images. The three entrances are placed before the west wall, joined together as though to form a triumphal arch. Their tall tympana bear no sculpture, but instead rose windows and foils. The subjects that usually occur here have been placed in the gables above the doorways: the Coronation of

BELOW:
Reims (Marne), cathedral of Notre-Dame
Central doorway of west portal
Figures on the jambs around the left
buttress, 1252–75

BOTTOM:
Reims (Marne), cathedral of Notre-Dame
Central doorway of west portal
Figures on right jamb, 1252–75

the Virgin in the center, the Crucifixion on the left, and Christ's return at the Last Judgment on the right. The crowned Virgin and Child on the trumeau of the central portal is accompanied by jamb figures representing scenes of the birth and childhood of Christ: on the right the Annunciation and the Visitation and on the left the Presentation in the Temple.

These eight figures, executed at different times, are among the masterpieces of 13th-century French sculpture. The famous group representing the Visitation, the meeting in a domestic setting of the two pregnant women, Mary and Elizabeth, from a formal point of view is considered as the climax of medieval sculpture inspired by that of antiquity (see right, bottom). In contrappostal poses, the women stand before the jamb columns, hardly appearing to be supported by them. The older woman, Elizabeth, makes a gesture of greeting but seems to wait as the young Mary turns toward her. Their garments are draped about their bodies in deeply cut folds that are full of movement.

There is a marked stylistic contrast between these two figures and the Virgin of the Annunciation next to them (the pair on the left) and the figures of the Presentation in the Temple scene on the facing jamb. The mobility of these other figures is less pronounced and tends rather to emphasize the vertical. This is especially apparent in the treatment of their clothing. The style of Elizabeth and Mary is thought to be based on models at Amiens. They are assumed to be the work of a sculptor from Amiens. On the other hand, the figures on the facing jamb—the Joseph of the Presentation and the female figure in fashionable clothes beside Simeon, tentatively identified as Mary's maidservant—are attributed to another sculptor, known as the Joseph Master. So too is the angel of the Annunciation, whose famous smile seems as expressive as the face of Joseph.

On the question of the dating of these and the other figures in the west portal, which can be divided into different groups on stylistic grounds, there has been some progress since documents were discovered some years ago proving that the foundation stone for the west portal was not laid until after April 8 1252. Contrary to earlier assumptions, it now seems possible that most of the figures in the west portal date from between 1252 and 1275.

We can now consider once again the route taken by the new king. With the sacrament of kingship legitimated by God and received from the Archbishop of Reims, the king made his way from the interior of the cathedral to the west portal. With its broad steps and splendid jambs, the west portal was clearly designed as an impressive doorway to be used for ceremonial occasions. The people standing outside the cathedral waiting for the king saw the images of the childhood of Christ. Following the analogical manner of thinking common in the Middle Ages, they saw the subjects depicted in the gables and in the groups of jamb sculptures as prefigurations of the arrival of the new Lord of the World, and so related them to the future ruler of France, who was presented to them on these very steps

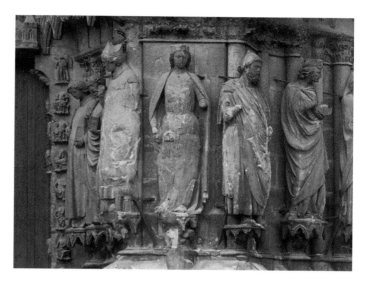

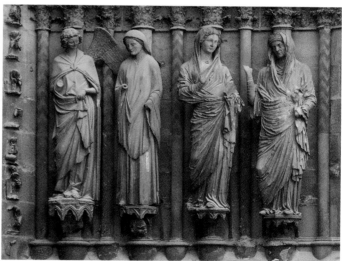

by the archbishop of the cathedral. And on his way from the altar to the exit on the west side, the newly crowned king saw the saints and martyrs: St. John the Baptist, baptizer of Christ the King and archetype of all the beheaded, and, on the inner side of the trumeau of the west wall, St. Nicasius, holding his severed head in his hands. A prefiguration of the beheading of a French king in later history? Not quite: the martyrs were intended to remind the new king that he was required to defend with his life the office for which he has just received the crown.

OPPOSITE AND BELOW:
Reims (Marne), cathedral of Notre-Dame
Central doorway of west portal, after 1252
Interior (opposite)

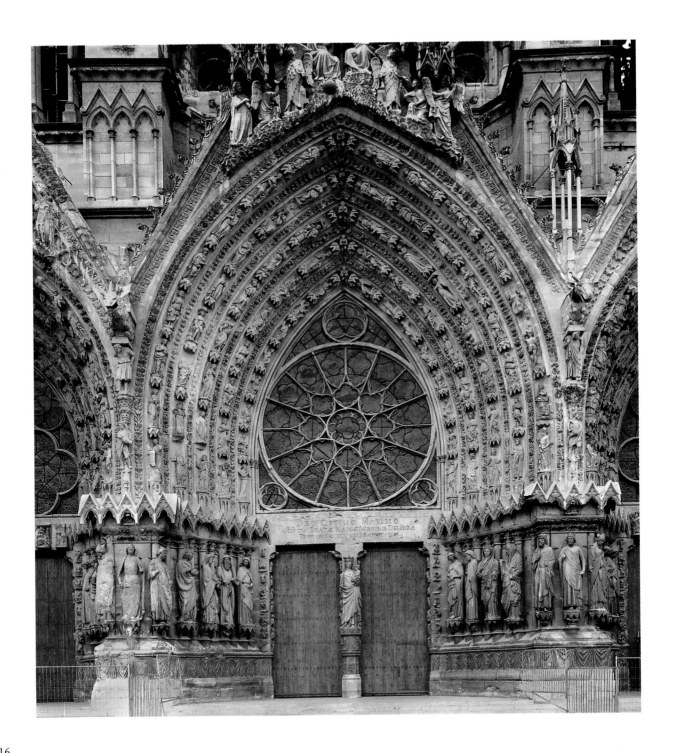

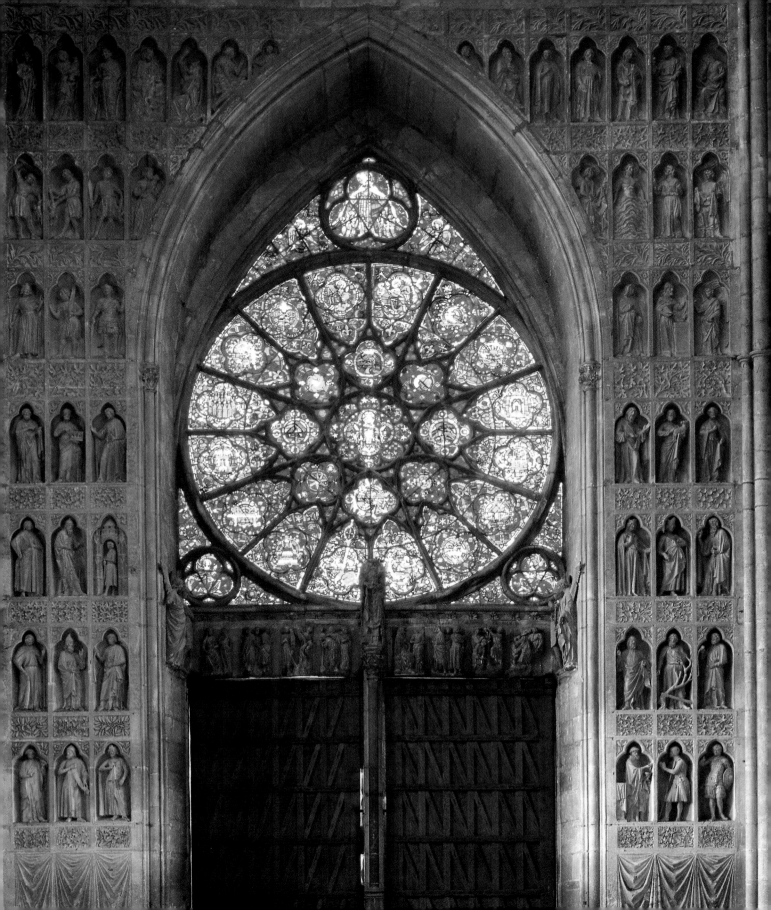

Adam, from south transept of
Notre-Dame, Paris, shortly after 1260
Paris, Musée National du Moyen Âge
(Musée de Cluny)

The sculpture of Reims Cathedral is of immense importance as examples of Gothic art, but unfortunately much has been lost. Thus the Coronation of the Virgin on the central gable of the west portal is a modern copy (though a faithful one). When Maurice Eschapasse, Inspector of French Monuments, regretfully records in his tourist guide of 1975 that "the First World War almost destroyed this unique work, the first significant historic building to fall victim to a modern war," he does little more than hint at the events of the first year of the war. When on September 19 1914 the German army bombarded Reims and its cathedral with artillery fire, it was directing its guns at the spiritual home of its arch-enemy's former monarchy.

Mingled with the roar from the artillery were the voices, at once heroically patriotic and infamous, of German art historians, led by the one under whose name the *Handbook of German Monuments of Art* still appears today, Georg Dehio: "That cult of monuments, inappropriate to the times, now seems like a strange, anachronistic sentimentality at a moment when what is at stake is not the outcome of some single combat taking place on a field marked out for the purpose, but our very survival, our existence as a nation, the victory or the destruction of all that Germany stands for in the world." While the French had made arrangements to protect national cultural treasures from the vandalism of war, Germans were talking of replacing the word "vandalism" with "Gallicism" and were pointing out, with cynical pride, that at Reims some of the German troops were under the command of a general "whose own background was that of an art historian."

The Figure of Adam from Notre-Dame in Paris

A statue of the naked Adam (see left), which once had a companion Eve figure, and is today in the Musée de Cluny, stood originally in the south transept of the cathedral of Notre-Dame in Paris. Adam and Eve stood at the feet of the Savior, beside whom were angels holding the instruments of the Passion and blowing trumpets. Although one arm and the hands and feet are restorations, this hardly detracts from the extraordinary quality of the sculpture. The details of the body of this slender, somewhat elongated, figure are worked delicately and with restraint. Unobscured by clothing, the contrapposto, with its subtle alternations of direction, is all the more clearly appreciated: the right hip, pushed out to one side, continues the line of the right leg on which Adam rests his weight. The upper torso leans over the other, slightly extended, leg, while the head once again is inclined slightly to the right. The physical movement visible in this, the only surviving life-sized nude figure in 13th-century French sculpture, had begun beneath the drapery of the *Vierge Dorée* at Amiens. The Adam figure shows notable development in the perception of the human body and its potential for movement. We may assume that it was originally placed in a niche and could thus only be viewed from a single perspective. Cleaning has also revealed that the statue was originally colored a pale pink.

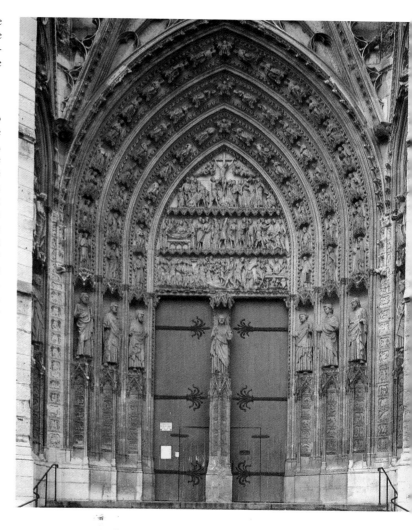

Rouen (Seine-Maritime), cathedral
of Notre-Dame, south transept
Portail de la Calende, ca. 1300

This work is closely linked with another group of figures by the same sculptor, which came from the choir screen and are today in the Louvre. One of these, the Christ in Limbo, shows even bolder movement than the Adam of the south transept. Both the Adam and the figures in the Louvre may be dated to shortly after 1260.

The Portal at Rouen

Around 1300, and during the first decade of the 14th century, the two transept portals of the cathedral of Notre-Dame at Rouen were executed. The portal thought to be the later one is on the south side, on the Place de la Calende, and has borne the name of that square since at least the 15th century (see right). The three registers of the tympanum show the Passion of Christ. On the trumeau Christ, and in the jambs the Apostles, stand on distinctive pedestals. Set between slim engaged pillars, and framed by vertical bands of quatrefoils, these pedestals bear bas-reliefs with cycles from the Old Testament: on the trumeau the story of Job, on the right jamb that of Joseph, and on the facing jamb that of Jacob. Read like picture books, they present their stories in great detail, yet both the rendering of the figures and the indication of the background remain simple. There are iconographical and typological links between these and the Passion in the tympanum, but a new element is present, described by Sauerländer as "discursiveness, the garrulous spinning out of the narration."

The Portail des Libraires on the north side owes its name to the fact that from the 15th century onward books were sold in the courtyard in front of it. Of its tympanum, devoted to the subject of the Last Judgment, only the two lower registers have survived. It is the lower of these that is the more striking in its composition. It shows the dead rising from their graves, while the register above portrays the lines of the Blessed and the Damned. Although their gestures and attitudes draw upon the standard repertoire of forms, a closer look shows the scene on the lower register to be most unusual: those rising from the grave appear in two lines, which are not, as is customary, divided between two registers, but appear together on one. This creates an impression of turmoil that contrasts strongly with the normally lucid structuring of the tympana of French cathedrals. In the upper relief too, the way that the rows of human figures overlap creates a spatial depth that is more reminiscent of the reliefs of, say, the Italian sculptor Nicola Pisano, than of other French sculpture. Nevertheless, though new stylistic elements were appearing here that were to be developed further as time went on, many of the sculptural forms on the Portail de la Calende adhered to the sculptural traditions of the previous century.

Jean de Liège

After 1360 we are able to identify a sculptor in Paris who was above all a master of funerary art. The earliest work that can definitively be attributed to Jean de Liège (who is documented between 1361 and 1381) is the head from the monument created in 1364 for Bonne de

France, the daughter of Charles VI, who died in 1361 when only one or two years old. This head, which is now in the Mayer van den Bergh Museum in Antwerp, shows a style, already mature, that is based on close anatomical observation and a marked tendency toward individualization. Such works are referred to by art historians as "pseudo-portraits."

Among Jean de Liège's most important and most representative tomb monuments is that of the queen of England, made in London in 1367. It can be seen, still in an excellent state of preservation, in the choir of Westminster Abbey. It shows the recumbent figure of Philippa of Hainaut, wife of Edward III, who died in 1369. Her

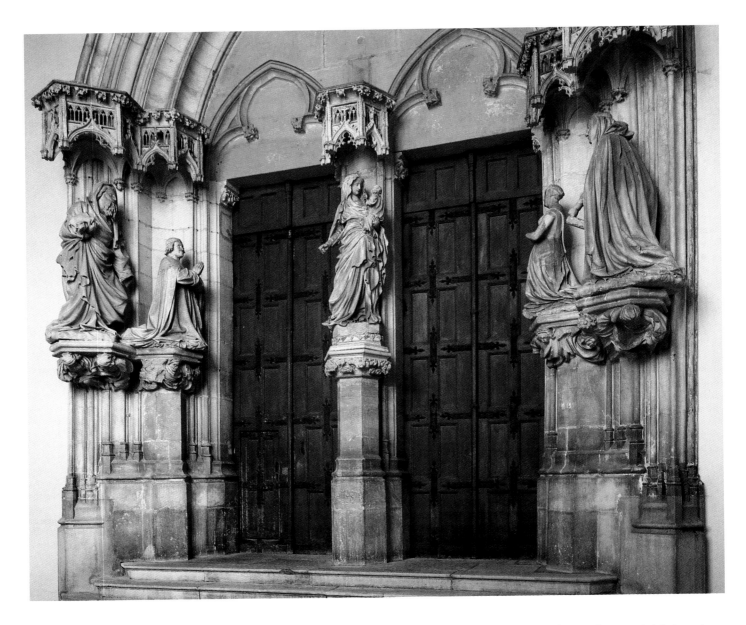

features as represented on the tomb give the impression of an individual likeness, though without actually doing so. Here as elsewhere, Jean de Liège uses the artistic device that Ulrike Heinrichs-Schreiber calls "the imitation of phenomena which can be comprehended empirically," thereby creating a stronger sense of a real presence in the tomb figure.

By comparison, the *gisants* for the tombs containing the vital organs of Charles IV and Jeanne d'Évreux, dating from 1372, are of less high quality and are thought more likely to be the product of a workshop. This may be linked with the manner of entombment chosen by Charles IV. After his death his remains were laid to rest in three different places. While his body lay at St.-Denis, the Paris Dominicans received his heart, and his other vital organs went to Maubuisson. Shortly before her death in 1371, his third wife Jeanne

began to favor this procedure. As the practice spread, it led to a large increase in commissions for sculptors. At Maubuisson the small-scale *gisants* (see opposite), now in the Louvre, lay on a slab of black marble with gilt inscriptions, columns, and canopies. The left arm of each lies across the breast, and the hand holds a bag with entrails to indicate what the tomb contains.

The well-known works of Jean de Liège enable us to identify him as an established court artist whose documented period of activity lasted from 1361 to his death in 1381. The fact that his work includes such important works as the tomb of Philippa of Hainault in Westminster Abbey gives us some idea of how highly his skill as a sculptor was prized by the later Capetian monarchs in France, and how great the demand for his work was even during the Hundred Years' War between France and England.

320

OPPOSITE:
Claus Sluter
Dijon (Côte-d'Or), Charterhouse of Champmol
Memorial to Philip the Bold
Chapel portal, 1389–1406

Jean de Liège
Gisants of Jeanne d'Évreux and Charles IV,
Maubuisson, ca. 1370–72
Paris, Louvre

Claus Sluter

Around 1400, at Dijon in Burgundy, a portal was created that was radically new in the forcefulness of its modeling. Surpassing everything that had gone before, its creator broke completely new ground in sculptural expression. In 1385 Philip the Bold had brought the sculptor Claus Sluter (ca. 1355–1406) from the Low Countries to Dijon to work on the decoration of the mortuary chapel of the Dukes of Burgundy, the Charterhouse of Champmol.

The portal (see opposite) has the Virgin and Child on the trumeau. The Virgin is harmoniously poised with her weight on her left leg, while the right foot is greatly extended. Her upper torso is turned toward the Christ Child, whom she holds on her left arm. Her full cloak is gathered in front of her hip and falls around her in voluminous cascades. In her right hand, which she holds out, there was once a scepter.

In art history this figure belongs to the period of the "beautiful style," though in fact it goes far beyond the characteristics of that style. Thus the stance, a balanced contrapposto, has nothing of the idealized posture of the "beautiful Madonna," but is based on exact observation and a mastery of the movement of a standing body. The same is true of the modeling of the face which, with its slight double chin and dimple, was evidently observed from life, as were the eyes and forehead.

The jambs, with their almost heretical iconography and unusual composition, bear figures of a kind never seen before, and perhaps possible only in a monastery chapel remote from the public eye. Depicted life-size, kneeling, and turned toward the Virgin in prayer, are, on the left jamb, Philip the Bold, the powerful Duke of Burgundy, and opposite him his wife, Margaret of Flanders, escorted by their patrons, St. John and St. Catherine. The facial features of the couple, the monastery's founders, are recognizably portraits.

Never before had living people been portrayed on the portal of a sacral building (and so realistically), in a position that was properly reserved for holy figures from the Bible and for saints and martyrs from the early and more recent history of Christianity. It was permissible to portray the local saints of, say, Paris or Amiens, because they were canonized as figures belonging to the past history of religion, but the appearance of individually portrayed, secular human beings here—occupying the same three-dimensionally sculpted plane of the Virgin, and in a religious context of the utmost sanctity, that of the salvation of mankind—was a wholly new manifestation of a ruler's wish for self-representation.

Together with the relatively naturalistic portrayal, characterized as "Flemish realism," of the standing Virgin, these portal sculptures, created between 1389 and 1406, mark an epoch-making change in the sculptural treatment of human beings. There had already been signs of such a change in the Prague portrait busts by Peter Parler, dating from about 1370. But the fact that this realism also penetrated the sacred sphere is of such far-reaching significance that Heinrich Klotz recently called this the "first great monument of early Renaissance art" north of the Alps.

Sluter's work at the Charterhouse of Champmol was not confined to this portal. He is believed to have worked from 1385 onward on the tomb of Philip the Bold, as assistant to the sculptor Jean de Marville. His greatest work is perhaps the Moses Fountain in Dijon. The Old Testament figures Sluter sculpted for this fountain also show his extraordinary observation of detail, in which he was far ahead of his time.

Gothic Sculpture in Italy

The Gothic sculpture of Italy differs from that of France in that it is not primarily tied to architecture. The figure portal of the French cathedrals, with its rich jamb and archivolt sculpture, did not gain widespread acceptance in Italy. All the same, Italian sculpture of the early 13th century clearly shows the influence of the Île-de-France, though its use tends to be linked with certain elements of church furnishing and ornamentation. The beginnings of Italian Gothic sculpture, while still perceptibly influenced by Romanesque, also reflect other influences that resulted from contacts either with the East or with the stricter style of Byzantine art.

In addition to this, the tradition of the ancient world is more clearly visible south of the Alps than elsewhere in Europe: the Hohenstaufen empire of Frederick II (emperor 1220–50), which modeled itself on the imperial power of ancient Rome, was more prepared to look toward the art of the past. It is in Italy, too, earlier than in other regions, that individual artists who expected and received recognition for their skill are known to us by name. Consequently—and with few exceptions—the history of art in the Italian 13th century is also a history of artists.

Benedetto Antelami

While the famous relief of the Deposition of Christ from the choir-screen of the cathedral of Santa Maria Assunta in Parma, which an inscription dates to the year 1178, was already influenced by Benedetto Antelami's work in the south of France, at St.-Trophime in Arles and at St.-Gilles, his later works are no less strongly influenced by French sculpture, though now by the Gothic sculpture of the Île-de-France. This is especially true of the Labors of the Months, sculpted in marble in about 1220, in the baptistery in Parma (it has been suggested that Antelami was also the architect of the baptistery). Although the question of the original placing of these pieces within the baptistery is still unresolved, there is now little doubt, because of the high quality of many of the sculptures, that they are to a large extent the work of Antelami himself. The representation of the month of November (see left) shows, beneath the zodiac sign of Sagittarius, a peasant at work in the field. The modeling of the head, delicately handled but at the same time using sharply ridged lines for the nose, hair, and beard, marks the transition of Italian sculpture from Romanesque to the Gothic that Antelami's work represents. Among the French sculpture that may have influenced him is that of the north transept of Chartres Cathedral as well as the Mary Portal of Notre-Dame in Paris.

Nicola Pisano

At the time when Nicola "de Pisis" (from Pisa; ca. 1205–80) is first documented, in a will drawn up in Lucca in April 1258, he must already have been a citizen of Pisa and a celebrated sculptor there. For it was only a year later that he signed the contract for the pulpit in the baptistery at Pisa, the first work documented as having been executed by him personally. Since he was referred to as Nicolas Pietri di Apulia (Nicolas the stonemason from Apulia) and was therefore presumably of southern Italian origin, he almost certainly had worked at the court of Frederick II at Castel del Monte, where he would not only have gained his earliest experience as a sculptor, but would also have become accustomed to studying and imitating models from classical antiquity.

The pulpit at Pisa (see opposite) is the earliest example of a new part of the church being used to bear images, and one which became more significant as a result of the tendency among the Franciscans to use visual images in their preaching. Alexander Perrig has been able to deduce from contemporary verses by priests mocking the new, and to them disconcerting, manner of giving sermons, that "the Franciscans used to make their sermons into small picture shows, taking panels with pictures or banners with them into the pulpit." It was Nicola Pisano's task to create a pulpit that would give greater emphasis, through pictures to the proclamation of the Word of God.

Six columns with foliate capitals, of which alternate ones rest on the backs of lions, support round arches with trefoils enclosed in them. While at the corners there are statuettes of the cardinal virtues

Nicola Pisano
Pisa, Baptistery
Pulpit, 1260
Marble, height 465 cm

Details:
Presentation in the Temple (top)
Crucifixion (center)
Last Judgment (bottom)
Each panel 85 x 115 cm

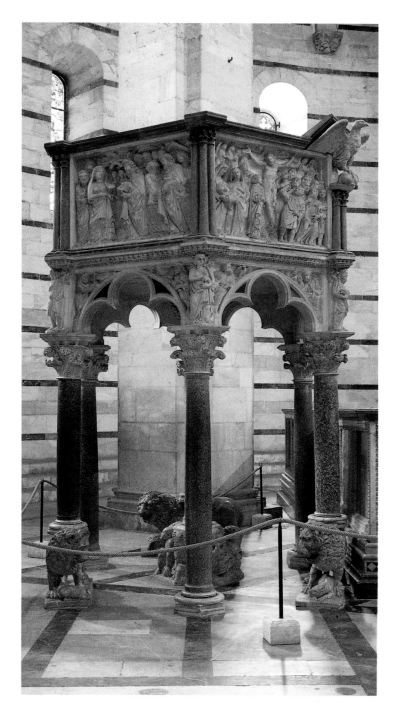

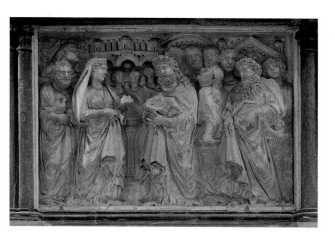

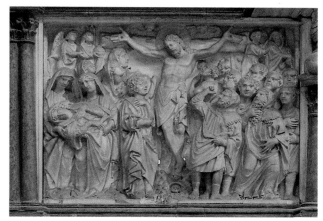

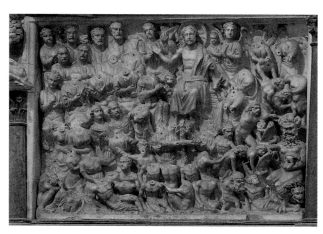

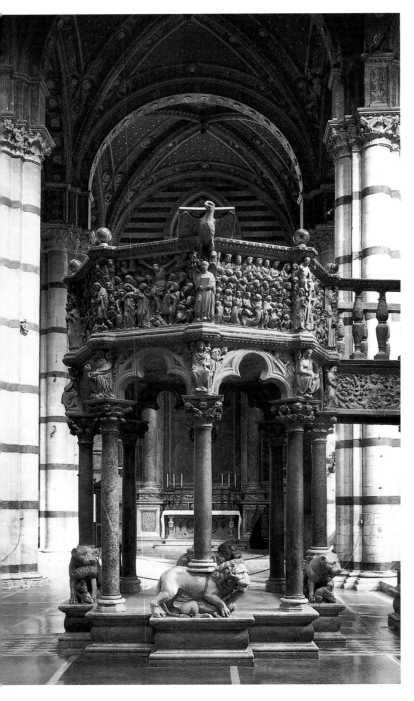

and of St. John the Baptist, the spandrels show prophets and the Evangelists. The actual pulpit above this is supported by a central column standing on a base with figures of animals and human beings. Flanked by small columns, mostly in pairs, reliefs cover five sides of the six-sided pulpit; the sixth side remains open to allow access. The lectern is supported by the spread wings of an eagle.

What is new about this pulpit is that as a free-standing object it appears more as architectural sculpture than as a piece of church furniture. The structural forms and the sculpted images point to different stylistic influences. Not only have the lions been carved *all'antica*, but the design of the reliefs themselves, with a multiplicity of figures huddled together and ranged in closely packed, receding rows, is derived from classical reliefs, whose style is here for the first time imitated in the design as a whole. The simultaneous depiction within a single pictorial frame of the Annunciation, the Nativity, the Washing of the Christ Child, and the Annunciation to the Shepherds is an outstanding example of this kind of composition.

However, the Crucifixion and the Last Judgment (see page 323, right) are treated quite differently. The wealth of images contained in the Crucifixion, with its dramatically heightened composition, cannot be explained with reference to antique models alone, for there are also Byzantine elements. More significant still are stylistic elements from French Gothic art such as the so-called "three-nail" type of the crucified Christ and, previously unknown in Tuscany, tracery with foils in the round arches. Both these features had first been widely used in the Île-de-France.

On September 29 1265 the *operarius* (superintendent of building) of Siena Cathedral, Fra Melano, made a contract with Nicola Pisano for a new pulpit for the cathedral (see left), which he was to execute with the assistance of two of his pupils, Arnolfo di Cambio and Lapo, later joined by Nicola's son Giovanni and a fourth colleague. The Siena pulpit is octagonal, and its columns—here too every alternate one stands upon a lion—bear figures of warriors between the arches, which here too contain trefoils.

The seven marble reliefs flanked by statuettes show a series of scenes similar to those on the Pisa pulpit. Yet their style is fundamentally different. Although here too figures crowd closely together in each panel, they are not related to the antique tradition. The garments of the corner figures in particular fall to the ground in curving Gothic folds, the excess material gathering around the feet. This recalls the contemporary models of the Île-de-France to which Nicola Pisano was now increasingly turning, presumably at the behest of his supervisors at Siena Cathedral. As a result, the reliefs gain in individual expressiveness and depth of feeling, elements lacking in the classically derived and often rather static scenes on the pulpit in Pisa. The development that first made its appearance in the Gothic-inspired elements of the Pisa reliefs is here continued by the creation of different depths in the relief. Against this, there is a loss in monumentality, due to the fact that the only available models were small-scale works of French

sculpture such as ivory panels or silver reliefs. Nicola Pisano acknowledged receipt of the final payment from the chief administrator of the cathedral workshop on November 6 1268.

Back in 1254 the council of the city of Perugia commissioned a design for a large fountain, to be fed by water from the Monte Pacciano three miles outside the town. For this purpose an underground pipe had been laid, though this was destroyed in 1273. Four years later an aqueduct was built, and now the building of the fountain was set in motion as quickly as possible (see right). The artistic execution was entrusted to Nicola and Giovanni Pisano. Work was finished in just over a year.

The lower basin rests on a circular base consisting of four steps. This basin has 25 sides, each of which consists of two reliefs separated by small slender columns. The reliefs in turn are flanked by clusters of three small twisted columns similar to those of the pulpit at Pisa. The reliefs, in the shape of upright rectangles, show the most diverse subjects—the Labors of the Months and fables from Aesop, heraldic beasts and Old Testament scenes, representations of the liberal arts and the Rome foundation myth of Romulus and Remus. Within this surround, and only a little taller, are short columns supporting the second basin, a polygon whose shape is marked by 24 corner figures. Iconographically their subject matter is no more homogeneous: they show not only Old Testament figures and saints, but also personifications of cities, the nymph of Lake Trasimene, and living contemporaries such as the mayor, Matteo da Correggio, and Ermanno da Sassoferrato, Capitano del Popolo in the year of the fountain's completion. While the reliefs of the months of June and July can be attributed with certainty to Nicola, those of the liberal arts suggest the style of his son. However, the speedy execution and the high quality of many of the reliefs make it necessary to assume a fairly large number of sculptors. Whether a signature by Giovanni relates to the making of the fountain as a whole, indicating that he had overall responsibility, or only to the relief on which it is carved is a subject of controversy among art historians.

At the center of the upper basin stands a column bearing a plain bronze bowl with an inscription stating that a certain RVBEVS made it in the year 1277. The Italian scholar Norberto Gramaccini has suggested that this bronze-caster, whose Italian name would have been Rosso, may be identical with the anonymous but significant German metalworker Rotgiesser (red caster) of the same period. The fountain is crowned by a bronze group of three female figures standing back to back, who together bear a small water bowl on their shoulders. The exceptionally high quality of this sculpture, often singled out as the oldest free-standing bronze statue of the Middle Ages, has led to divergent opinions about its attribution. The elder and the younger Pisano, and also Arnolfo di Cambio, have all been named in this connection.

Built on what is today Piazza del Quattro Novembre, between the town hall on one side and the Loggia di Braccio of the cathedral on

the other, the fountain is an assertion of the right of every citizen to free access to water as a basic necessity. It is also, with its remarkable program of images, which are executed with such skill, an expression of the prosperity and civic pride of the citizens of Perugia.

Giovanni Pisano

The first independent piece of work carried out by Nicola's son Giovanni (ca. 1248–after 1314), following the collaboration with his father on the fountain in Perugia, was the sculptural decoration of the façade of Siena Cathedral, thought to be the earliest example of a Gothic façade in Italy with an integrated sculptural program. The badly weathered originals of the sculptures are now in the Cathedral Museum and copies have been substituted in the original positions. Around 1297 Giovanni received the commission for the pulpit of Sant'Andrea at Pistoia (see page 326, top); an inscription states that it was completed in 1301. Like Nicola's pulpit in the Pisa Baptistery, this too is hexagonal, but its architectural form is much more strongly Gothic. There are lancet arches instead of the round arches with trefoil tracery.

Of the five reliefs, which show scenes from the life of Christ from the Annunciation to the Last Judgment, one of the most impressive depicts the Massacre of the Innocents. While this scene, with its many figures, gives the impression of a single, block-like ensemble, reminiscent of battle-scenes on the sarcophagi of late antiquity, each group of figures is nevertheless clearly separated from the others and self-contained, with its own dynamic of movement. This creates a sense

BELOW:
Giovanni Pisano
Pistoia, Sant'Andrea
Pulpit, 1301
Marble, height 455 cm
Detail of *Massacre of the Innocents*

BOTTOM:
Giovanni Pisano
Pisa Cathedral
Pulpit, 1302–11
Marble, height 461 cm
Flight into Egypt panel

and reliefs reflect more clearly than any other contemporary work of Italian sculpture how sculptors were inspired but also challenged by the disparate influences of the works of classical antiquity and the new Gothic style coming in from the Île-de-France.

The last pulpit, executed in the first decade of the 14th century in the cathedral at Pisa (see left, bottom), is once again octagonal, though its round base and the convex curve of the reliefs make this piece of church furniture appear to be round. Although the most highly developed and most elaborately designed of the four, this pulpit appears stylistically less unified than the one at Pistoia, mainly because it is the work of so many hands. Moreover, after being dismantled in 1602, it remained so until 1926. By the time the pulpit was reassembled some of the reliefs had been removed to museums in New York or Berlin and reconstructions had to be made of those reliefs.

Arnolfo di Cambio

Arnolfo di Cambio (ca.1254–1302/10), Nicola Pisano's most important pupil after his son, is thought to have begun working as an independent artist after the completion of the pulpit at Siena; he was still working there in 1268. Eight years later he was in Rome, where he executed a number of funerary monuments. He is recorded in 1277 as being in the service of King Charles of Anjou (1268–85), of whom he made a statue in the guise of a Roman senator. This was the same year in which the Council of Five Hundred at Perugia asked the king to allow Arnolfo to come to that city to assist in the work on the great fountain (see page 325).

Before Arnolfo went to Rome, where he experienced his richest creative phase, he spent some time in Orvieto, where on April 29 1282 the French cardinal Guillaume de Braye, the former Archdeacon of Reims, died while on a visit to Pope Martin IV. Arnolfo was commissioned to execute a marble tomb for him in the church of San Domenico, as is indicated by an inscription beneath the throne of the Virgin (see opposite). In its present form the tomb is a reconstruction: it has lost, above all, the more extensive architectural setting that it once had. Two angels with censers that originally belonged to it are now in the museum of Orvieto Cathedral.

The effigy of the deceased archdeacon lies, with eyes closed and hands crossed, on a splendid bed set on top of the actual sarcophagus and enclosed in a kind of tabernacle. Two acolytes, clerics in lower orders, are drawing back the curtains to reveal the recumbent figure. Alternatively—this cannot be determined with certainty—these figures, sometimes interpreted as angels, are closing the curtains on the dead cardinal. In the round arch at the top of the wall niche, in a higher register devoted to the Virgin, the deceased appears again on the left, alongside the inscription. Here he is depicted alive, kneeling before the Virgin as though in a founder's portrait, and presented to her by the figure opposite, either St. Peter or St. Dominic. Although questions remain open concerning the attribution of parts of the

of drama. Again and again elements from antiquity are brought into harmony with Gothic elements in such a way that neither dominates. This is helped by the relatively free manner of working, where for instance the hair is lightly sketched in while the figures are deeply undercut. Giovanni's work also shows the influence of contemporary French Gothic ivory reliefs.

Just half a century lay between Nicola's creation, in the baptistery at Pisa, of the first pictorial pulpit for the new Franciscan style of preaching, and his son Giovanni's completion in 1311 of the work on the last of their four pulpits. Their successive treatments of figures

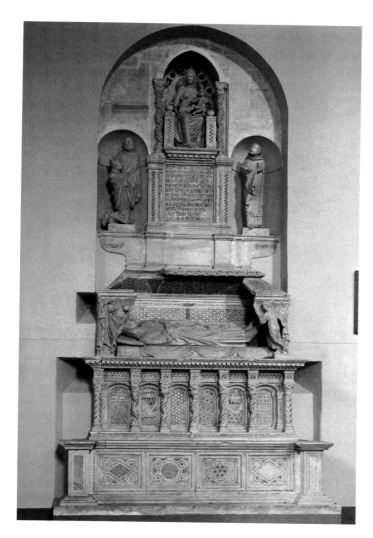

Tino di Camaino

In 1315, following the death of Emperor Henry VII (1308–13), Tino di Camaino (1280/85–probably 1337), a pupil of Giovanni Pisano, was recalled from Siena, a city where the Guelph faction was in power, to Pisa, where the Ghibellines dominated, to execute the Emperor's tomb. At the same time Tino, also an architect, was made *operarius* (master of works) of the cathedral in Siena. He was active there in this function in 1319 and 1320 before going to Florence to execute a number of important tomb monuments.

One of these is the tomb created for Bishop Antonio d'Orso, who died in 1321 having been both papal chaplain and leader of the Florentine Guelphs in opposition to Henry VII. It is beyond dispute that the idiosyncratic figure of the bishop in the cathedral in Florence, depicted in a sitting posture, with his eyes closed and his head nodding forward, belonged to this tomb. He is not asleep, however, for his crossed hands show that he is enthroned in death. To present a dead man in this way is without parallel in the history of art. The *Virgin in Majesty*, with crown, book, and Christ Child, whose plinth bears the inscription SEDES SAPIENTIAE (the Throne of Wisdom), is now also believed to have been part of the Orso tomb. The restrained, and some would say lyrical, expression of delicate sensitivity conveyed by this statue, now in the cathedral museum, makes Tino di Camaino the outstanding representative of the "court style" of the first third of the 14th century.

In about 1323 or 1324, Tino di Camaino moved to Naples, where up to his death in 1337 he executed a series of tombs at the court of Robert of Anjou, exercising through these a lasting influence on the sculpture of this period.

Lorenzo Maitani

The fame of Lorenzo Maitani (ca. 1270–1330), who was born in Siena and whose father Vitali di Lorenzo, known as Maitano, was also a sculptor, rests more on his work as an architect than on his sculpture. Lorenzo is first recorded in Siena in 1290, but he then left to work in Orvieto. There he was initially employed in the cathedral workshop before being appointed on September 16 1310 as *universalis caput magister* (chief master of works) for the building work on the cathedral.

The high esteem in which he was held as the architect directly responsible to the cathedral's supervisors of building, and thus to the bishop, not only brought him many privileges, such as a 15-year exemption from taxes, but also meant that his expert opinion as an architect was sought in connection with numerous certification documents in and around Siena. His principal architectural achievement was the façade of the cathedral at Orvieto (see page 256, left, and page 328). The fact that he was also involved in producing sculpture there, apparently by his own hand, is attested by documents that refer to his part in casting bronze figures. The British art historian John Pope-Hennessy credited him with sculpting the symbol of

tomb to Arnolfo or his pupils, the sculptural quality of this piece is of the very highest degree. In particular, the sophisticated mobility of the acolytes and the modeling of the clothing and of the left-hand curtain testify to a successful blending of classical and Gothic concepts of form.

Beyond this, Arnolfo gives the niche tomb, which derives from the French High Gothic, an Italian expressiveness by depicting the deceased in different spheres and thereby, as Panofsky observed, attempting for the first time to adapt this type of tomb to the taste and spirit of the burgeoning Renaissance.

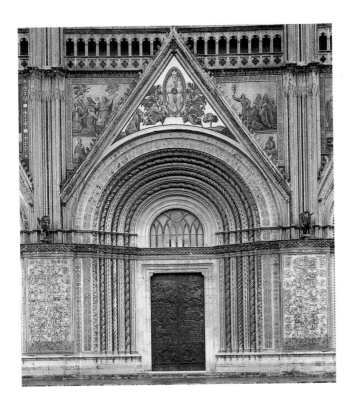

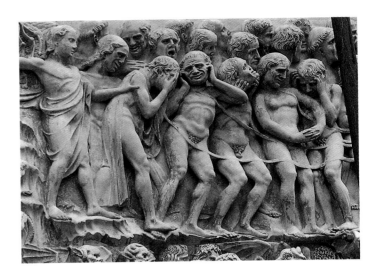

Lorenzo Maitani
Orvieto Cathedral
Center portal of west façade, 1310–30 (left)
Detail of the depiction of Hell on fourth buttress
(below)

St. John; the Italian historian Cesare Gnudi also names as Lorenzo's work the symbols of the other three Evangelists, cast in 1329, and the six angels, cast in 1325, who draw aside the curtain of the baldachin in the tympanum of the central portal to reveal the Virgin.

Marble reliefs adorn the four buttresses of the façade up to the full height of the jamb of the central portal. On the left outer buttress the story of the Creation and of the Fall and the origin of the arts are depicted, followed on the pier to the left of the central portal by the Last Judgment, entwined with tendrils of the Tree of Jesse. On the inner buttress on the right are scenes from the life and Passion of Christ. The sequence ends on the extreme right with portrayals of the Resurrection of the Dead, the Blessed and the Damned, and Hell. These are reliefs of the highest sculptural quality. French sculpture is not the only influence. The reliefs make use of various compositional motifs derived from classical antiquity. This is particularly noticeable in the composition of the scenes and in the presentation of individual figures. Thus the depiction of the chaos of hell, with its double row of figures, is reminiscent of the resurrection scene at Rouen, but also of battle scenes on classical reliefs. Above all, however, anatomical details of the naked human body are shown that until then had scarcely been seen in post-classical European sculpture (see above, right). The rib cage, for example, arches up over a belly, here presented as a fully integrated part of the body. And the ribs themselves, standing out sufficiently to be counted—and hitherto reserved, as attributes, so to speak, for the haggard devils from Hell—now form anatomically correct components of the body, albeit the bodies of the Damned. Legs are fully articulated, the knees are reproduced with anatomical precision, and sinews hold together limbs that arteries supply with blood and muscles move.

In the Creation story the anatomical portrayal of the human body is hardly less fully realized, as the naked figure of Adam shows. That it lacks the drastic naturalism of the scene depicting Hell does not necessarily indicate the work of two different sculptors. It is no accident that these naturalistic representations of the exposed human body are taken to their furthest extent in the sphere of Hell and the Damned. The body, especially the naked body, still occupied a place far below the higher level accorded in the Middle Ages to the soul; it belonged, indeed, to the realm of evil. "A greater enemy than my body I have not," St. Francis of Assisi had lamented. It was the lusts and temptations of the flesh that posed the worst dangers for the devout Christian and obstructed the path to Paradise. In view of this, the sculptural treatment of the naked human form here shows a perception that, though partly inspired by antiquity, points ahead toward future developments.

Andrea Pisano

Although there is documentary evidence that Andrea Pisano originated from Pontedera near Pisa, the year of his birth is unknown. The dates usually given are that he was born between 1290 and 1295 and probably died in 1348. He refers to himself either as "Pisano" or "Andrea... de Pisis" (from Pisa). We have no information about his training and nothing is known about his early work. It is thought likely that he completed an apprenticeship with a goldsmith in Pisa or Florence and then worked in gold, ivory, and bronze, before executing the first work documented as his, bronze doors for the baptistery in Florence (see opposite).

The sources are informative about the sequence of events concerning the making of the doors. A document that describes

Andrea Pisano
Florence Baptistery
Bronze door of south portal, completed 1336
Baptism of Christ (below)

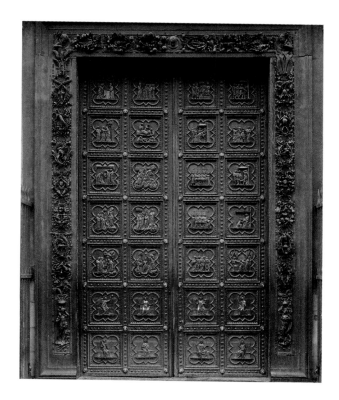

Andrea as the *maestro delle porte* (master of the doors) records that he made a start on the work on January 22 1330. The casting of the doors appears to have been carried out in April 1332. Even so, there was a delay of almost three years before they were installed. It was only on June 20 1336 that they took their place, as the first of three pairs of doors, on the south portal of the baptistery, facing the city. It is this doorway, and not the baptistery's main portal facing the west front of the cathedral, which to this day is used on a daily basis by the people of Florence, and which in consequence is almost always open.

Both the iconography and the composition of the program reflect the fact that this was a baptistery and that the doors were in constant use. In this, the first project of its kind, it was obvious that the church's titular saint, St. John the Baptist—also the patron saint and protector both of the city and of the Calimala, the cloth merchants' guild—had to be portrayed. In addition, the program had to be set out in such a way that to those entering, the two open halves of the door were like pages of a monumental open book, each having a meaningful sequence that could be read separately.

Of the 14 reliefs on each door, the ten upper ones on the left-hand door depict the life of St. John the Baptist (see above, left), while those on the opposite door illustrate the story of his death. The lower eight reliefs of the two doors show personifications of the virtues. These scenes and figures are enclosed in quatrefoils, as they appear also in the lower zone of Rouen Cathedral's west front and other French churches. Andrea Pisano exploits to perfection this system of frames, each made up of circles and a oblique square, by composing his scenes according to a simple scheme of horizontals and verticals. When, moreover, in the relief depicting Salome giving the head of John the Baptist to her mother, he exactly matches the height of the

architecture featured in the picture to the length of the sides of the square. The frame becomes a system of proportions that in this instance adds a further dimension to the playful geometric interaction between square and circle.

That the quatrefoil is more than just a decorative framing device is shown even more clearly by its symbolic significance. As a standard form in the Gothic style, foils were among the foremost vehicles for medieval symbolism, primarily because of their capacity to represent numbers. While, for instance, the trefoil symbolizes the divine sphere of Heaven, the six-lobed foil stands for the relationship between the divine and the earthly spheres, a symbol of the six days of the Creation. The quatrefoil symbolizes the four cardinal points, the four seasons, the four elements, and, through many other sets of four, earthly life as a whole. The narrative of St. John the Baptist is set within this quatrefoil shape because he, a wholly earthly human being, was chosen to baptize the Son of God.

Andrea Pisano and Giotto

In Florence, Giotto directed the preliminary work and the first phase of construction of the campanile of the cathedral, Santa Maria del Fiore, commonly known as the Duomo. He retained this function until his death in 1337. It then passed to Andrea Pisano, mentioned in 1340 as *major magister* (senior director of works) for the campanile. At that time building work had reached the third story, and it was into this that Andrea incorporated the figure niches.

The two lower stories (see page 255, right), built by Giotto, are ornamented with hexagonal and rhomboid reliefs. Among these, the ones portraying the inventors of the arts are for the most part attributed by Lorenzo Ghiberti, in his *Commentaries*, to Andrea Pisano.

Ghiberti also reports having seen several drawings by Giotto that would have made ideal patterns for the sculptor to follow. Largely on the basis of these passages, it has always been assumed that Andrea Pisano was involved with the building of the campanile from the outset, some six months, that is, after completion of the main work on the bronze doors. When the reliefs on the west side of the Campanile's first story were to be removed, it was found that they had been set into the marble cladding at the time of construction, not the case with those on the other sides. From this it was possible to deduce that Andrea Pisano and Giotto did collaborate on the tower from the start, thus confirming Ghiberti's report.

The relief with the smithy scene (see right) is regarded with a high degree of certainty as a work by Andrea Pisano from this first phase of construction. It shows a man clothed in a long garment with a leather apron covering his lap to protect him from sparks. With a pair of tongs he holds the piece he is working on over the forge, which is fanned by the bellows behind him. Although the setting is contemporary, the man does not have the appearance of a contemporary smith. His hair and beard, influenced by models from antiquity, are in effect identifying attributes that place him in the dim past of ancient Greek or biblical myths of humanity's beginnings. He is Tubal Cain, the biblical metalworker descended from Cain to whom was attributed the invention of the metalworker's craft, so that he became the ancestor and prototype of "every artificer in brass and iron."

The hexagonal frame encloses the interior of the smithy, which has clear-cut architectural subdivisions and is dominated by the figure of Tubal Cain. In the design of this scene we can recognize Giotto's concern to create an autonomous pictorial space. In this respect he leads the art of his time in a new direction. But it is the energy discharged, so to speak, in the vivid three-dimensionality of both the clearly structured architecture and the naturalistic human figure in this relief that affords a revealing insight into the collaboration of the two artists, in this instance displaying an equal level of genius.

Nino Pisano

Andrea Pisano was occupied with directing construction of the Campanile until about 1343. It is to the period which follows, between 1343 and 1347, that a sculpture is dated which has given rise to controversy among art historians, the famous *Maria lactans*, the *Madonna and Child* from the church of Santa Maria della Spina, now preserved in the Museo Nazionale di San Matteo at Pisa (see opposite). On the basis of Vasari, the figure was regarded until the 1960s as the work of Andrea's son, Nino Pisano (ca. 1315–68). This attribution was supported by the assumption that Nino Pisano and his father had jointly maintained a workshop in Pisa between 1343/44 and 1347. Nowadays this group, the first portrayal in Italian art of the motif of the Virgin suckling the Christ Child, is considered to be the father's work. Similarities to the style of the Baptistery doors, as well as links with the figure of the Virgin from the façade of Orvieto Cathedral (now in the Museo dell' Opera del Duomo), support this view.

Andrea Pisano directed building work on the cathedral in Orvieto between 1347 and 1349 and is thought to have died in 1350. Nino took over that role from his father on July 19 1349. Despite the existence of some archival evidence, it is still difficult to gain an overall impression of Nino's work as an architect, goldsmith, and sculptor. In 1357 and 1358 he was in Pisa, working as a silversmith on a screen for the cathedral altar. But no written document can be directly connected with any work by his hand. However, there do exist three signed sculptures—a Virgin in Santa Maria Novella in Florence, another Virgin from the tomb of Doge Marco Coronaro in Santi Giovanni e Paolo in Venice, and the figure of a canonized bishop in the church of San Francesco at Oristano in Sardinia—works that show that Nino's style was influenced by French sculpture. Their locations also testify to the wide distribution gained by his art during his lifetime. It is possible, however, that the sculptures were produced in Pisa and despatched to their various destinations.

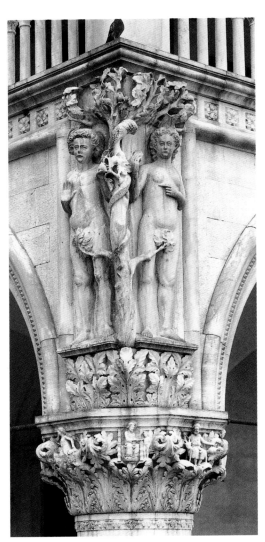

Filippo Calendario

Before the Venetian architect and sculptor Filippo Calendario was executed in 1355 (date of birth not known) as a fellow-conspirator of Doge Marin Falier, he had not merely designed and begun to construct the Doge's Palace, one of Venice's greatest buildings, but had also created outstanding sculpture for its façade. Both the *Drunkenness of Noah* on the corner nearest the Ponte della Paglia and the *Expulsion from Paradise* on the corner between the Molo and the Piazzetta show him to have been an artist of great expressiveness with a gift for observing everyday life.

The biblical first couple are placed diagonally across the corner. Between them stands a figtree, around which the serpent is coiled (see above, right). They are turned not toward each other, but toward the observer, showing their differing degrees of complicity in this key event. Eve holds a fig (rather than an apple) in her right hand and points with the index finger of her left hand toward Adam, whose behavior is contradictory: while he is himself reaching for a

fig, he is holding up his right hand in front of his breast, as though to fend off misfortune.

The inebriated Noah stands swaying next to a tree that here too forms the corner. His drinking cup is slipping from his hand (see above, left). On the other side of the tree are two of his sons, one helping his old father, the other showing his horror at his drunken state. As with Adam and Eve, the presentation of the contrasting reactions includes the facial expressions. Calendario's works, executed between the beginning of construction of the Palace in 1340 and his death, are among the finest late Gothic works in Venice.

Late Gothic splendor finally reached its culmination with the Porta della Carta, the portal of the Doge's Palace. The signature here of Bartolomeo Buon indicates the authorship of the design as a whole rather than the actual execution of the sculptures. While the figure of Justice on the apex is unanimously attributed to Buon, he left the remaining figures to be executed by other sculptors. Their sculptures too are major works of Venetian Late Gothic.

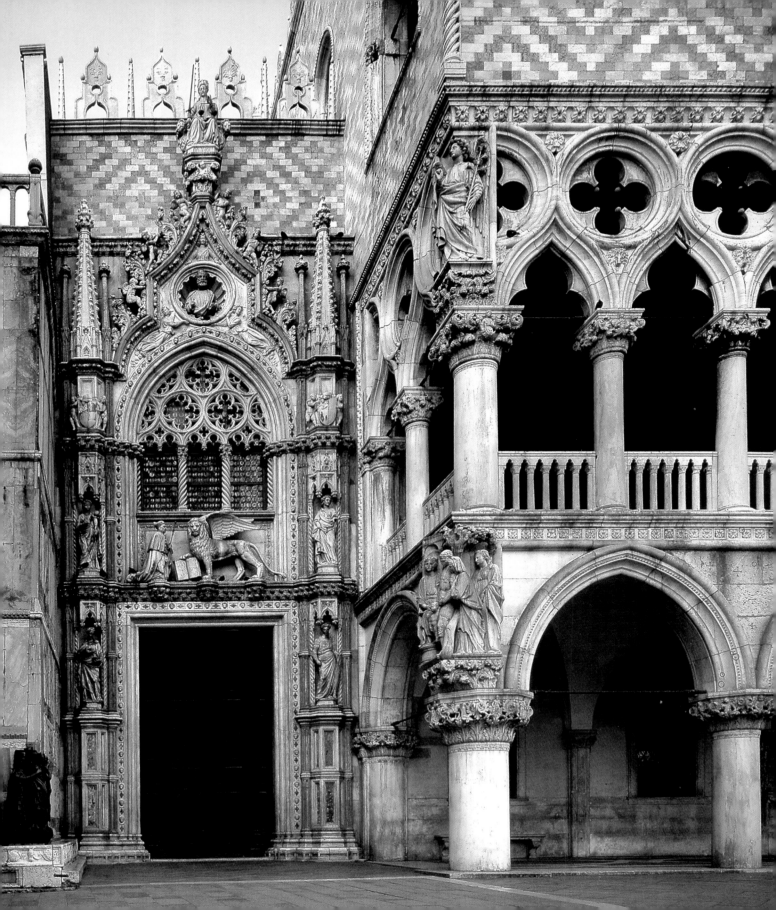

Gothic Sculpture in Germany

In Germany too, Gothic sculpture shows strong French influence. The sculpture of the Chartres transept portals and of the portals at Laon, Reims, and Paris, was always regarded by German sculptors as exemplary, though it was not used simply as a model to be slavishly copied. Copying would not have been possible in any case, for early Gothic French sculpture in particular, given its intimate relationship with architecture, was closely bound up with the building programs of the 12th and 13th centuries. In Germany, the 12th century was not a period when building flourished. This was to change in the course of the 13th century, but without leading to the creation of elaborate portals. With rare exceptions, for instance at Strasbourg, opportunities for the composition of grand figure programs hardly arose. Precisely in the area where in France the fusion of architecture and sculpture attained perfection—the three-dimensional modeling of archivolts—German churches offer nothing but ranks of bare arches. Even so, the development of Gothic monumental sculpture in Germany is in no way inferior to that of France. Through its very separateness from architecture it achieved independence. Indeed the most important sculptural work of the 13th century was created for the furnishing and decoration of interiors.

The Triumphal Cross Groups at Halberstadt and Wechselburg

Probably to mark the dedication of Halberstadt Cathedral in 1220, a monumental group known as a "Triumphal Cross" was made for the junction of nave and chancel (see opposite). At the mid-point of a rood beam, inserted between the eastern pair of crossing piers, stands a cross with quatrefoil ends. This frames the cross itself, supported by Adam, who lies under its foot in the quatrefoil that is held by two angels. He embodies the beginning of the process of salvation that is completed by Christ as the "New Adam." While the two angels in the lateral quatrefoils hold the arms of the cross, another angel appears in the apex quatrefoil with a banner. Christ stands with both feet—without nails—on the dragon that symbolizes the evil overcome by his death. Despite the similarity to the four-nail type of Crucifixion, this is not a portrayal of Christ in triumph: with his head drooping forwards, he is shown dead. The accompanying figures also stand on symbols of Christian victory: the Virgin on the serpent, to whom it is prophesied in Genesis that she "shall bruise thy head," and St. John on a crowned figure cowering on the ground who represents defeated heathendom. The group is flanked by two cherubim, each with six wings, who stand on the fiery wheels of God's throne and hold out their hands, with golden orbs. Their bodies are hollowed out. The cavities, closed by small doors at the back, probably once held relics.

Of the numerous Triumphal Cross ensembles of the German Middle Ages, only a few survive. The one in Halberstadt Cathedral is both the earliest and the best. Its extensive Christological program unites the death on the cross with the Resurrection and is infused with intimations of the Last Judgment. Art historians consider this multi-figure group to be the highest point of early Gothic sculpture in Germany. Traditional representational elements and more modern stylistic features are both present. Thus Christ's stance, in the tradition of the "four-nail" type of crucifix, and the absence of the lance-wound in his side and of the crown of thorns, belong to the iconography of Romanesque art. On the other hand, the depiction of Christ in death already alludes to the salvation motif of *Christus Salvator* while the movement and detailed modeling of the body draw upon the formal repertoire of early Gothic. The figures of the Virgin and St. John are installed at a considerable height, from where they gaze down upon the faithful. The inclination of their heads, designed to be viewed from far below, reaches back to Byzantine tradition. The fine folds of their garments, on the other hand, together with the relationship between these garments and the bodies of the figures, suggest that stylistic features of the classically inspired treatment of drapery (particularly at Laon and on the transept portals at Chartres) may be imitated here. But unlike the jamb figures at Laon and Chartres, the more than life-size figures at Halberstadt are sculpted in the round, enabling them to be viewed from the chancel as well as the nave.

A direct successor of the Halberstadt Crucifixion is the Triumphal Cross ensemble in the Schlosskirche (castle church) at Wechselburg, Saxony (see page 336). Executed around 1235, it was mounted on a choir screen that was altered in the late 17th century. The present reconstruction is disputed. As at Halberstadt, the actual cross is surrounded by a cruciform frame with trefoil terminals. Here too, the risen Adam lies beneath the upright of the cross, while two angels support the arms. At the top, instead of another angel, God the Father appears together with the dove representing the Holy Ghost. Thus that group is iconographically expanded to include the Trinity. The cherubim, guardians of the throne, are missing, and the Virgin no longer stands on the serpent, but on a crowned figure who, seeming to kneel before the crucified Christ, represents Judaism overcome. Thus it is in the first instance the content that has undergone a significant transformation. In place of Halberstadt's evocation of Golgotha and its allusions to the Last Judgment, Wechselburg has the three figures making up the Trinity as a symbolic representation of the Throne of Mercy.

However, the changes that are most striking—and are of epoch-making significance—occur in the figure of the crucified Christ, who is depicted according to the new type, that of the "three-nail crucifix." This change imparts more movement to the posture of the figure. The legs no longer stand stiffly side by side: both feet are fixed at a single point so that the leg in front can project further forward and the hip can be pushed out to the side. This in effect humanizes the crucified Christ, the emphasis now being on his suffering and death. It is in keeping with this human interpretation that Christ is

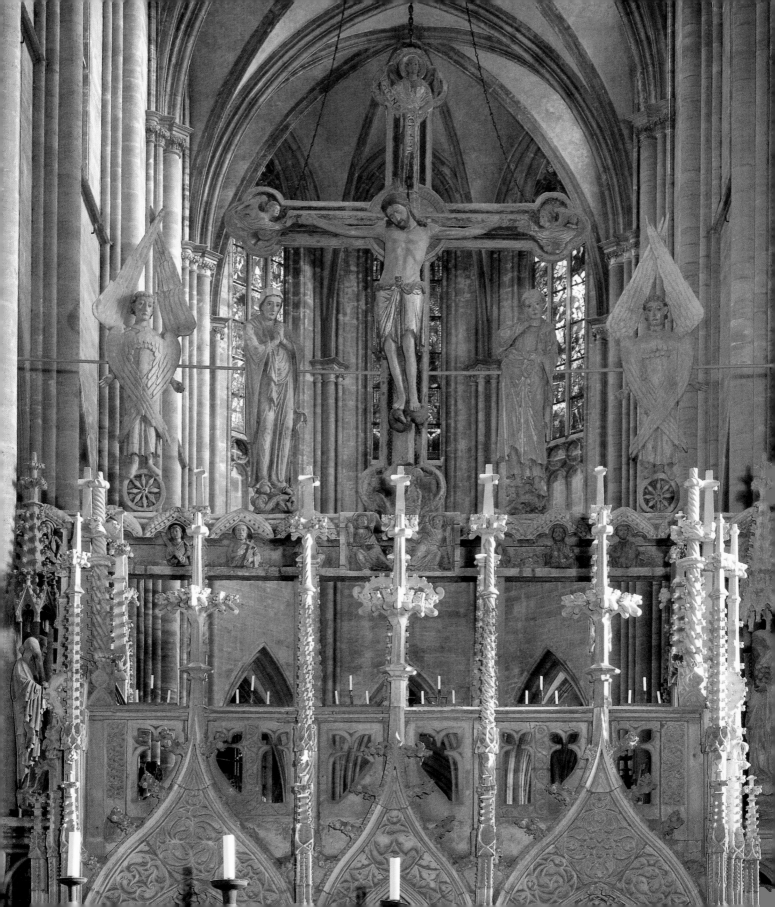

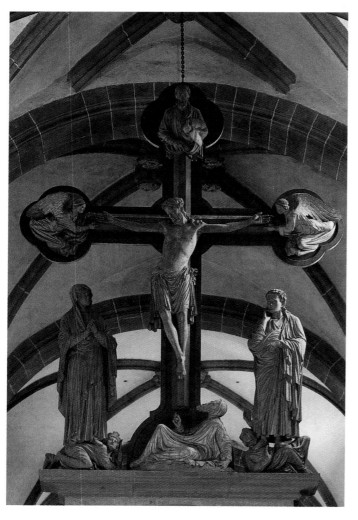

Wechselburg, church of the former
Augustinian monastery (Castle Church)
Triumphal Cross ensemble, ca. 1235

here portrayed still alive and with his eyes open. Shown now with the crown of thorns and the wound in his side, he turns to the Virgin at the moment of death. The accompanying figures are freer in their movements than they are at Halberstadt. Their garments are draped in folds forming narrow parallel ridges, as is Christ's loincloth, and laid in flowing, ample curves around the shoulders and arms. This manner of modeling drapery—with folds of a type that can be traced back even more clearly than at Halberstadt to the French architectural sculpture that was executed at Laon around 1200 and on the Chartres transept portals soon after that—is first found in Saxony in the Triumphal Cross ensemble produced a few years earlier than

Wechselburg's for the cathedral in Freiberg. Here most probably were the models that decisively influenced the Wechselburg sculptor.

Strasbourg

Next to Bamberg Cathedral, Strasbourg Cathedral is the most significant work of church construction in Germany in this period. In the early 1220s, sculptors from Chartres were commissioned to furnish the double portal of the south transept with sculpture in the most modern style (see opposite). The appearance of the richly ornamented portal they created is known to us only from an engraving dating from 1617 as most of it was destroyed during the French Revolution. The left tympanum (see opposite, right, and top left) shows the death of the Virgin. On the lintel below, the bearing of her body to the grave was depicted, while on the lintel of the right-hand portal the Assumption and the passing on of her girdle to St. Thomas preceded her Coronation in the tympanum above. Only the tympana have survived. The 12 Apostles were depicted on the jambs, and between the portals King Solomon was enthroned as judge below the half-length figure of Christ. Both portals were flanked by the allegorical figures of Ecclesia (the Church) on the right and Synagoga on the left (see opposite, bottom far left and left). These figures, whose originals are preserved in the Musée de l'Œuvre de Notre-Dame, have been replaced by copies. The jamb figures, the lintels, and the figure of Solomon, on the other hand, are 19th-century reconstructions.

As at Bamberg, the iconography of Ecclesia and Synagoga is based on the medieval interpretation of the Song of Solomon. Most unusually, however, the two female figures turn toward each other and toward the central figure of the double portal, Solomon. The women, who allegorically represent Christianity and Judaism, were generally shown as engaged in a dispute in which Synagoga, the personification of Judaism, was the inferior and was shown vanquished, but at Strasbourg the conflict is reinterpreted and given, as it were, a conciliatory outcome.

The figure of Ecclesia, standing almost stiffly upright, wears a crown. The cross and chalice are replacements, but these attributes seem insignificant compared with the figure's majestic appearance. She turns to speak her final word to Synagoga, while the latter, already turning toward her opponent, will maintain her attitude of rejection only for a few moments more. She still holds the broken staff and the Tablets of the Law, and turns away, blindfolded, because she has not yet recognized the revelation of Jesus Christ. This dramatic moment contains within it the following one, in which the whole contemporary interpretation of the Song of Songs will be illustrated. When Synagoga finally turns her face toward Ecclesia, she will at the same time be turning toward the portal's central figure, Solomon, who appears here as a typological precursor of Christ—not only in his function as a wise judge but simultaneously as a prefiguration of the heavenly Bridegroom. His legendary wisdom as a judge,

Strasbourg Cathedral

BELOW:
Death of the Virgin tympanum
Double portal, south transept,
ca. 1235

BOTTOM:
Ecclesia (left)
Synagoga (right)
Double portal, south transept,
ca. 1235

Death of the Virgin tympanum (detail)
Double portal, south transept

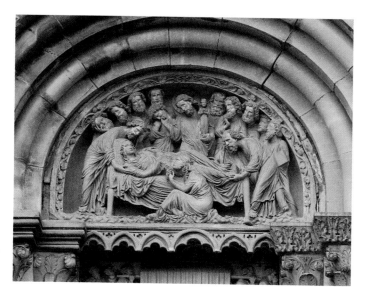

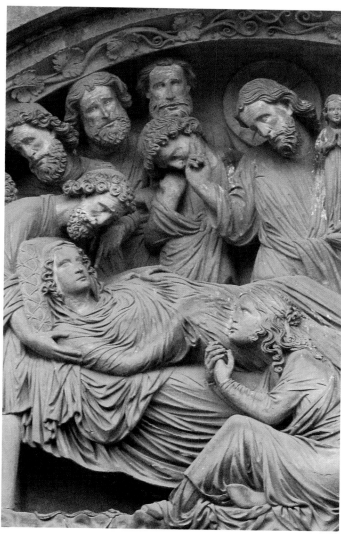

demonstrated in the dispute between the two mothers, will enable him to unite Ecclesia and Synagoga, at the end of time, "in shared love of their divine Bridegroom."

The iconography of this portal, which refers to use of the church as a court of law, is complemented by the Angels' Pillar in the interior of the south transept (see page 338). An octagonal pillar with attached columns bears figures comprising a Judgment program. In the lower zone stand the four Evangelists, holding scrolls, on plinths shaped like capitals in the form of buds, with baldachins above their

heads. In the middle zone four angels sound their trumpets for the Last Judgment. In the uppermost zone, Christ presides, accompanied by angels holding the instruments of the Passion. Showing the wound in his side, Christ raises his left hand, although this does not here signify the gesture of benediction. Below his capital, small figures of the Resurrected turn directly to him, for the Virgin and St. John are not present as intercessors. Also absent are the Blessed and the Damned. In the tradition of ancient legal symbols, the Angels' Pillar was also recognized as a place where the bishop held an ecclesiastical

Strasbourg Cathedral
Angels' Pillar, ca. 1225–30
Lower zone: Evangelists

Angels' Pillar, ca. 1225–30
Top zone: Christ (below)
Middle zone: angels with
trumpets (bottom)

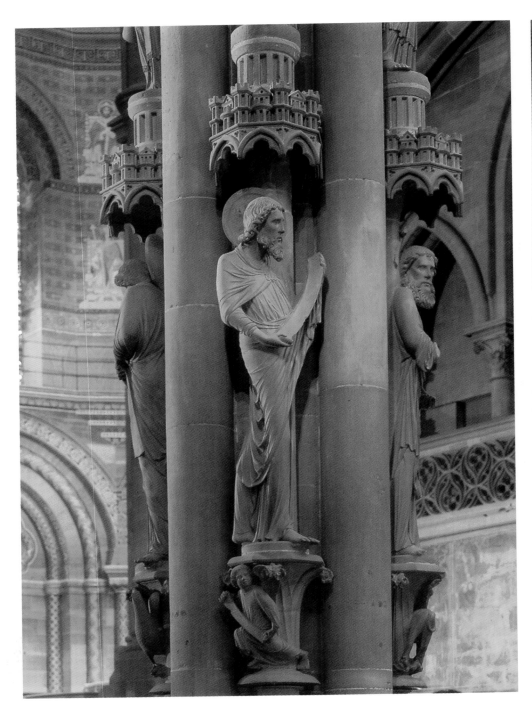

Bamberg, cathedral of St. Peter
Last Judgment
Tympanum of Princes' Portal
(portal on north side of the nave),
between 1225 and 1237

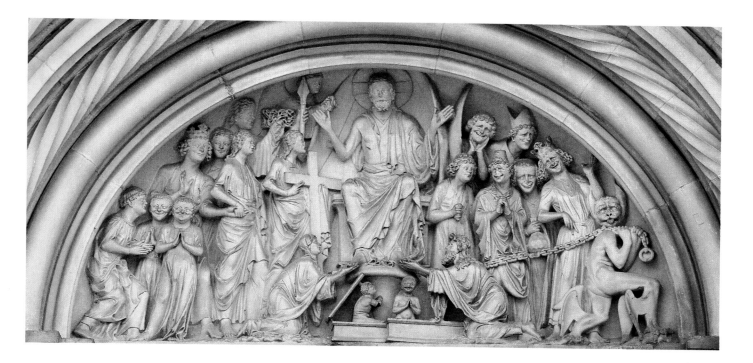

court. This being so, there is an iconographic link between the double portal of the south transept and the Judgment pillar. While on the portal the latter-day reconciliation of Ecclesia and Synagoga is imminent, in the interior, with the portrayal of the Last Judgment, the moment of judgment and salvation has arrived.

Stylistically the two ensembles also belong together. The figures, both inside and outside, stand tall and slender on their plinths. The garments with their wealth of fine folds appear, even in the tympanum relief of the Death of the Virgin, light and of almost veil-like transparency, allowing one to sense the bodies and their movement. This is especially the case with the two allegorical female figures who wear long gowns, clinging like silk, based on the style of the French court and represented here even earlier than in Bamberg, probably for the first time in Germany.

Bamberg

Bamberg Cathedral was one of the most important cathedral building projects to be undertaken in Germany in the early 13th century. Its extensive figural ornamentation was probably begun in the 1220s and it must have been virtually complete by the time of the re-dedication of the cathedral in 1237.

Whereas the tympanum of the Portal of Mercy is still composed largely in the idiom of the late Romanesque, with a political program,

the tympanum of the Princes' Portal (see above) is of a wholly different character. Unlike the Judgment tympanum at Reims, where the narrative is distributed among several registers, here all the events of the Last Judgment take place on a single level immediately above the lintel, which rises so far into the tympanum that it is like a stage. In the centre, Christ is depicted sitting on a column and showing his wounds, accompanied on his right by angels with the instruments of the Passion. The Virgin and St. John, as intercessors, touch his feet. Between them two of the Blessed emerge laughing and naked from their graves. At the sides, the groups of the Blessed and the Damned are portrayed in an extraordinarily lively manner. A smiling king, followed by his wife, is led forward by an angel, while on the opposite side a devil with ass's ears and with wings on his calves leads away the Damned by a chain, their features contorted with misery. The first in line is a king, followed by a pope, a bishop, a miser with a bulging money bag, and a youth. These figures are so precisely characterized that one cannot help wondering whether the artist had particular individuals in mind. This highly expressive manner of conveying feelings through facial expression had not appeared previously in German sculpture.

To complement the Judgment, two figures were installed outside the portal: the statue of Ecclesia on the side of the Just, and that of Synogoga on the side representing the Damned. Nowadays these figures are inside the cathedral. Their sculptural form is designed to

accord with their symbolic significance as the New and the Old Testament, the personification of victorious Christianity and defeated Judaism. In a frontal, almost motionless stance, with crowned head, Ecclesia presents herself to the faithful as coolly stern and commanding. Synagoga is depicted quite differently, extremely sensuously (see above, left), her spiritual blindness indicated by her blindfolded eyes. While she holds the broken lance in her right hand, Moses' Tablets of the Law slip from her left. She wears nothing but a dress of almost transparent material which, girdled at the hip, is as revealing as wet silk. Her lower body is thrust forward, so that this allegorical female figure fits the role ascribed to her by contemporary theology, that of being "God's first bride" who, having been "unfaithful to him and sunk to the level of a harlot, will return to him at the end of time," as the art historian Helga Sciurie puts it. There is further confirmation of this when the figure is seen from behind, for the sculpture is executed in the round as a free-standing statue,

possibly the first such statue of post-classical times. It is here that the sculptor shows off her lascivious figure to the full. Her dress gives the impression of being sleeveless and of clinging even more closely than when viewed from the front. And yet, with her head held high, Synagoga preserves the dignity that enables her to sustain her position as a worthy, if antithetical, counterpart to Ecclesia.

A further group of female figures, the Mary and Elizabeth pair (see left) in the eastern choir dedicated to St. George, is stylistically closely related to the Visitation group in Reims, itself a high point of medieval allusion to classical forms in monumental sculpture. The Bamberg figures are derived largely from the formal repertoire of antiquity. The shift of body weight to one leg is answered in each case by the counter-movement of the upper torso and by the slight movement of the head. The women's mantles are draped in cascades of folds, some deeply cut, over the free leg, and are gathered up into the left hand, from where the material, bunched in voluminous spiraling folds, falls downward in front of the weight-bearing leg. As earlier in Reims, so here in Bamberg one is struck by the degree to which, almost in the manner of actual quotation, the modeling of these two statues is influenced by classical antiquity.

Facing each other during the meeting at Mary's house, the Visitation, the two women are shown pregnant, Mary with Jesus and Elizabeth with John, who will baptize Jesus. They lived at the time of the Roman Emperor Augustus. This historical context leads Helga Sciurie to suggest a convincing explanation: the classical guise in which the women appear is intended to identify them as figures from the period of the origin of Christianity. This suggestion, which justifies a new view of the iconography at Reims too, seems plausible in relation to Bamberg because the imperial prince and bishop Ekbert von Andechs-Meranien, who initiated the building of the new cathedral, was one of the closest associates of Emperor Frederick II (emperor 1220–50). The emperor himself had in 1225, through the purchase of a fief in Bamberg, provided the extraordinarily large sum of 4,000 silver marks toward the new building. Knowing that the Apulian court fostered an interest in antiquity for reasons of its own political ambitions, and that it had adopted as a goal the recreation of the *Pax Romana* of the Roman Emperor Augustus, Bishop Ekbert had the link between the two New Testament figures and the ancient world sculpturally emphasized. Together with various stylistic "quotations" in the architecture of Bamberg Cathedral, they are a device intended to evoke a glorious past in order to enhance the prestige of the Hohenstaufen empire.

Magdeburg

In the 1240s Magdeburg had a workshop whose sculptors, extremely innovative in what they produced, adopted markedly contrasting approaches to style. This is evident if one compares two sculptural groups that both have only a limited relationship to any architectural context. One is the *Magdeburg Rider* from the Alter Markt (Old

Magdeburg Rider (Emperor Otto I?),
from the Old Market, Magdeburg
Magdeburg Kulturhistorisches Museum,
ca. 1245–50

Market; see left), while the other is the group of the *Wise and Foolish Virgins* at the cathedral (see page 342). Today a modern bronze copy of the *Magdeburg Rider* stands in the Alter Markt in a Baroque surround while the original, repeatedly restored after suffering extensive damage, is now displayed, together with the attendant figures, in the city museum. The rider sits astride his horse, his feet firmly in the stirrups. His left hand grasps the (now lost) reins firmly, his right hand is extended, and his lips are slightly parted as if he is about to speak. He has long wavy hair on which rests a large crown, and his beardless face shows him to be a young man. He wears a cloak with a clasp, fastened at the neck, as a traveling garment. Originally the *Magdeburg Rider* stood on a slender pillar under a tabernacle-like baldachin that spanned both him and the flanking figures, two young women bearing a shield and lance (or banner).

This column was originally set up opposite the town hall with its court, the place where the burgrave carried out the archiepiscopal and imperial juridical function conferred on him by royal decree. Unusually for equestrian statues, the crowned rider was not symbolically placed with this "architecture of authority" behind him, but was turned toward it, an alignment emphasized by his mouth, open for speech, and the gesture of his right hand. From this, and from his traveling clothes, it has been inferred that what is portrayed here is the arrival and reception of the ruler. When the king or emperor approached a city in the 14th century, he was met with a baldachin, under which he made his entry into the city and ceremonially rode through it. Such receptions of the monarch were important occasions for the confirmation of the rights and privileges of cities and clergy, and also of particular groups within the population. It is this reception of authority that the Magdeburg sculptor has given visible form.

As a symbol of justice and law, this fully three-dimensional statue, which is to some extent influenced by the *Bamberg Rider*, is designed to be viewed from below and from a distance. In his treatment of this subject, the Magdeburg sculptor reveals an artistic conception which expresses itself effectively in the tension between, on the one hand, the large, heavy, rounded folds of the cloak and the bulky appearance of the horse, and, on the other, the finely worked waves of the rider's elegant hair. In other words, the portrayal of human features here has been achieved without needing the example of the figures of the specific benefactors, as was the case in the cathedral at Naumburg (which we will discuss below). In the Magdeburg workshop itself there was evidently a sculptor able to develop this stylistic approach into a radically new way of depicting the human form. Art historians suppose him to have been the master in charge of the sculptural work of the cathedral workshop.

The *Wise and Foolish Virgins* (see page 342) are depicted as an ensemble of ten figures, five of each kind. Today they stand in the north porch of the cathedral. Their animated bearing, especially the swirling movement of their garments, left art historians baffled as to their original positioning. They would not fit into a portal jamb, or any setting where they were constrained by the architecture. Only

Magdeburg Cathedral
Foolish Virgins
Paradise Portal, ca.1245

Magdeburg Cathedral
Wise Virgins
Paradise Portal, ca. 1245

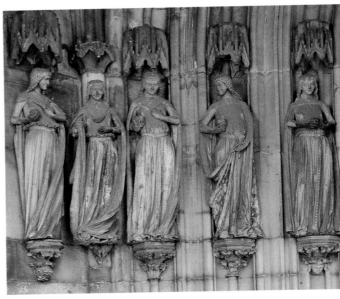

when an attempt was made at a reconstruction of the cathedral's lost choir screen was it suggested that the ten figures might have occupied small blind arcades in an upper zone of the screen, which fitted in with their character of free-standing figures that nevertheless seemed to have been close to a wall. The figures would have stood in front of the plain screen, on each side of the figures of Christ and the Virgin enthroned in the center, with the Wise Virgins on Christ's right, the Foolish on his left. Two of the figures still stand on their original foliate supports (the supports of the others have been replaced), with one leg slightly advanced, like all the other figures. Dressed in the manner of their day, they are presented as unidealized young girls of the 13th century. Their dresses, girdled at the waist, fall in long, deeply hollowed, folds to the floor, where the hems pile up a little. With their full cloaks around their shoulders, the Wise Virgins hold up their oil lamps, overjoyed at being received into Paradise, while the foolish ones, overcome with horror, let their hands with the empty lamps hang down. The statues were originally colored, which, in conjunction with their gestures and facial expressions, must have made a more life-like impression than anything achieved before.

Iconographically these Virgins are linked with the theme of the Last Judgment. The sculptural achievement of the master who created them lies above all in his skill in vividly portraying elemental human emotions through the modeling of the facial features. The women express their feelings so powerfully that medieval observers must have felt that they were being confronted with their own fears of eternal damnation at the Last Judgment. The Magdeburg Virgins are still more significant in art-historical terms for another reason: with their widely spreading garments and sweeping gestures they are liberated from the block-like quality of architectural sculpture and its rigid vertical axis. As a consequence, a simple frontal view has given way to a more three-dimensional concept of the figure, the eye being drawn around to the sides.

Naumburg

The celebrated figures of the Benefactors in the west choir of the cathedral of St. Peter and St. Paul at Naumburg (see opposite) are among the outstanding works of 13th-century Europe. Their history, much discussed by art historians, has been the subject of differing views and sometimes real controversy—the literature on this topic reveals the ideological fashions that have too often governed the thinking of art experts. If at one time the discussion focused upon historical and stylistic criteria, there have been other times when it was informed by Romantic notions of genius, and yet other periods when it was dominated by a chauvinistic ideological emphasis on their essential "German-ness." It was only in the second half of the 1960s that the adoption of an international and interdisciplinary approach to sculpture introduced some objectivity into the debate. Disagreements continue, but on the whole a clearer picture is beginning to emerge. Among the questions that remain are those of when the sculptures were executed, what the historical motive for their creation and installation may have been, and how they should be interpreted in terms of art history or cultural history.

Naumburg, cathedral of St. Peter
and St. Paul
Ekkehard and *Uta*, from the Benefactors
West choir, ca. 1250

The 12 life-sized figures stand on the side walls of the west choir at Naumburg, in front of the attached columns supporting the vaulting. They are placed at window level just above a passage that runs round the west end of the cathedral, in a position and at a height where one would normally expect to see saints or apostles. These figures, however, are almost without exception lay people, some of whom are identified by inscriptions. Apart from the two figures placed directly against the walls, the sculptures are inseparably linked to the architecture, for their bodies are, as in French portal sculpture, carved from the same blocks of stone as the sections of the attached columns in front of which they stand. These columns in turn are load-bearing elements forming an integral part of the construction of the vaulting. From this it is clear that the sculptures were executed at the time when the choir was built. What is more, the perfect unity between architecture and sculpture has led many to the conclusion that the sculptor must also have been the architect.

In a famous letter of 1249, regularly cited in connection with the figures of the Naumburg Benefactors, Bishop Dietrich von Wettin appeals for donations toward the cost of the construction, probably already well under way by that year. It must be around this time that the sculptures were carried out: the proposed dating is the 1240s or 1250s. But that document contains more than just an appeal for funds. It also refers to the *fundatores*, the 11th-century benefactors, ten of whom are named. They are held up to contemporaries as models to be emulated. By being commemorated in sculpture in the west choir they are, in death, being remembered in the prayers of the living. If the fund-raising for the rebuilding of Naumburg Cathedral is seen as the reason for the execution of the sculptures, then the interpretation of the statues of these benefactors follows directly from this. By their donations they atoned for their earthly sins, and are close to attaining the anticipated salvation of their souls on Judgment Day. Placed at window level, though along the passage rather than over it, they are to be seen as being in an intermediate realm, on the way to the heavenly Jerusalem.

The Naumburg Master (as we have to call him, since his identity is unknown) endowed his figures with individual characteristics in a way unmatched by any earlier sculptor. The people he was required to portray had been dead for well over a hundred years, and even though in the context of the veneration of relics it was already customary to reflect the individuality of the person in their sculptural representation, it was still not possible for the Naumburg Master to create true portraits. The benefactor figures are all 13th-century sculptures portraying historical individuals of the 11th century. Just as the architecture and the sculpture relate to each other here in a perfect overall design, so too a relationship is established among the individual figures. In 13th-century dress, the Margrave Ekkehard and his wife Uta represent the high nobility (see right), forceful, self-assured, and aristocratically aloof. Ekkehard clasps the sword he wears as a sign of his judicial authority. His features are those of a

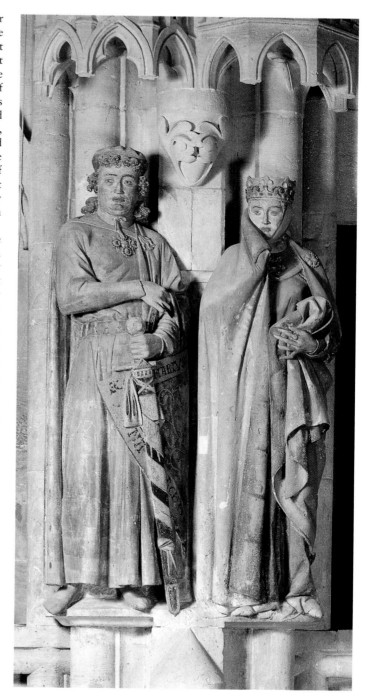

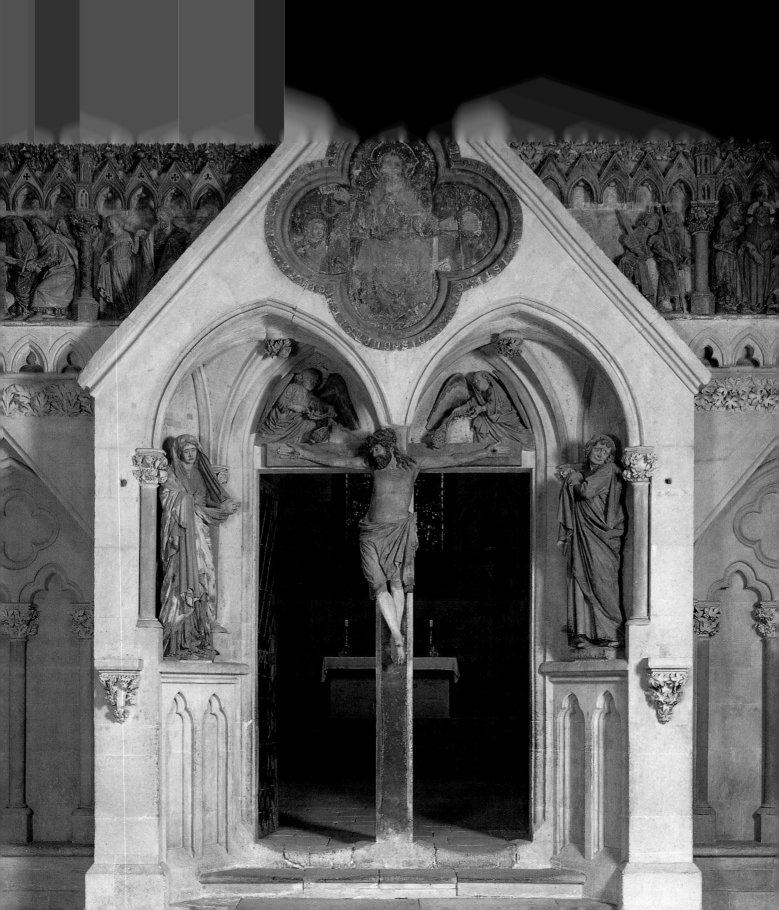

OPPOSITE:
Naumburg, cathedral of St. Peter
and St. Paul
Portal of west choirscreen, ca. 1250

Meissen Cathedral
Emperor Otto I and his Wife Adelheid
North wall of choir, ca. 1255–60

ruler in his prime, a little stout maybe, but full of vigor. His wife stands beside him, beautiful and charming, but equally unapproachable, a *grande dame*. By turning up the collar of her cloak she seems to underline her independence, even from her husband.

At its eastern end, the Benefactors' Choir is closed off by a screen that denied the laity access. The sections of the screen on either side of the entrance to the choir are decorated with blind arcades, two on each side. Above these runs a frieze, divided by architectural structures, with reliefs showing scenes from the Passion. The screen is dominated, however, by its entrance porch (see opposite). A simple arcade of two pointed arches, set forward from the screen, is contained within a gable that also encloses a quatrefoil in which there is the painted image of Christ in Judgment, accompanied by angels with the instruments of the Passion. This image and the inscription surrounding the quatrefoil refer to the Last Judgment. The porch thus acquires something of the status of a church portal. But here the lintel and its trumeau, the structural cross of the portal, bear the cross of Golgotha, to which Christ is nailed. While the tympana of the two arches have reliefs of angels swinging censers, the mourning escorting figures of the Virgin and St. John stand in the "jambs" of this portal. But going through this doorway is not like going through a main church portal. As the clerics step under the outstretched arms of the crucified Christ and enter the Benefactors' Choir between Christ and the two mourners, they themselves, in their own person and at that moment, pass through the climax of the Passion depicted above them, Christ's agony on the Cross. Art can hardly be more presumptuous than this: it is conferring upon the mortal intercessors for the salvation of the benefactors' souls, even as they enter the space devoted to remembrance of these very benefactors, the symbolic authority of being witnesses of Christ's sacrifice.

Meissen

The superb sculptural achievement, often described as revolutionary, of the Naumburg Master was continued in the sculpture of Meissen Cathedral. It is uncertain whether the Naumburg Master carried out any of this work himself, or whether it is only his workshop of assistants and pupils who should be regarded as the creators of the sculpture in the cathedral at Meissen. Art historians have recognized clearly that the Meissen statuary is a direct continuation of the Naumburg Master's influence and have made every effort to gain information about this unknown sculptor's background and career. He is thought likely to have been trained in France, and his work is first identified in the surviving parts of the west choirscreen from Mainz Cathedral. He was probably working as an independent sculptor by the time he executed this screen, which was removed in the 17th century. A work from the surroundings of Mainz now attributed to him with certainty is the relief of the *Bassenheim Rider*.

His Meissen works comprise seven 13th-century statues, the oldest ornaments of the cathedral, located in two different areas.

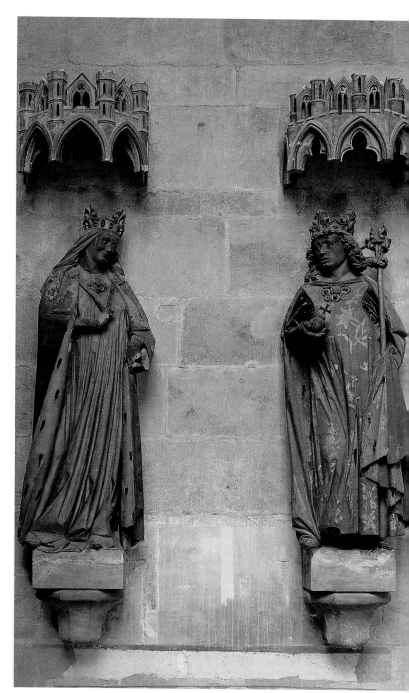

345

BELOW:
Braunschweig, cathedral of St. Blaise
Tomb of Henry the Lion and his wife
Matilda, ca. 1230–40

BOTTOM:
Fontevrault (Maine-et-Loire)
Abbey church
Recumbent effigies of Richard the
Lionheart and his wife, first quarter
of 13th century

Three of the figures—the Virgin and Child, St. John the Baptist, and a deacon swinging a censer—are placed in the octagonal porch. The remaining four statues stand in an extension of the upper choir, which was probably built especially for them. On the north side of the front bay of the choir stand Emperor Otto I and his second wife Adelheid (see page 345), opposite them St. John the Evangelist and Bishop Donatus. Thus on the one side the cathedral's founders are revered, on the other its patron saints.

Clothed in splendid robes, the imperial couple at Meissen stand in front of a plain wall that allows them more freedom of movement than the benefactor figures at Naumburg, who are closely tied into the architecture. Thus the empress stands on her left foot, extending the right to the side, while her upper torso is turned toward the emperor. Framed by the deliberately emphasized symbols of imperial power, she reveals to the beholder an almost melancholy expression. Even the insignia of nobility, her crown and brooch, seem rather to stress her royal rank than establish a real harmony between her own personality and the attributes of her status. Yet in neither figure does the face seem of less importance than the symbols of rank: in each case it holds its own in relation to the obtrusive insignia. What is more, in the forcefulness of their personal appearance these two figures create an expressive contrast to the insignia, a contrast reinforced by the fact that for all the lordliness of the outward impression they create, their self-awareness seems focused on their essential being, on their humanity. In this respect there is a strong affinity between the Meissen emperor and empress and the character portraits created by the Naumburg Master.

On the south side of this short extra section of the choir, the cathedral's patron saints, by contrast, manifest true power. By establishing his association with the opening of St. John's Gospel, shown in the open book held by the Evangelist, the bishop-saint legitimizes his power by reference to God himself. As Ernst Schubert points out, the age of the real might of imperial power had passed, and the Church had taken its place.

Tomb Sculpture

The Tomb of Henry the Lion and his Wife Matilda

Around the middle of the 12th century in northern France the *gisant*, an effigy of the deceased lying on his or her tomb, became widespread. This form of funereal monument was increasingly used, particularly in the burial-places of secular rulers. The Plantagenet tombs in the abbey church at Fontevrault, executed between 1200 and 1256, probably represent the first attempts at direct portrayal of the dead actually lying in state (see right, bottom). The four figures (out of an original six; a fifth, but disputed, figure has been discovered in recent times) do not lie, as earlier figures had done, on bare stone slabs, but are depicted as they would have appeared when ceremoniously laid out just after death, placed on finely draped beds and dressed in their finest clothes.

The earliest example of a tomb of this kind in Germany, executed about 1230–40 in the form of a double tomb, is in the cathedral at Braunschweig. Its presence there is probably directly linked with the tombs at Fontevrault because it depicts the Saxon Duke Henry the Lion and his second wife Matilda (see opposite, top), who was both a Plantagenet princess and the sister of Richard the Lionheart, one of the four whose tomb effigies lie at Fontevrault.

Henry the Lion is depicted slightly larger than life-size on the sculpted tomb, which is placed above the sarcophagus buried below it under the floor. He holds a model of a church to identify him as the founder of the cathedral of St. Blaise, which he had rebuilt and richly endowed after his return in 1173 from Jerusalem and Constantinople. The sword with a band wound round it, which Henry holds up against his shoulder with his left hand, shows that he also has power of jurisdiction. He is portrayed as generous and just, and his wife, with her diadem, as pious and virtuous. Matilda lies, a slightly shorter figure, beside her husband; with her hands folded in prayer she draws her cloak over her body.

However, there is in these superb creations of Gothic sculpture an inherent contradiction that cannot be overlooked. While the heads of both the figures rest on pillows, their feet are placed on plinths in the shape of carved foliate bases that are quite clearly surfaces for standing on. The subjects are thus simultaneously depicted in two different ways. They are clearly shown, by the pillows and by the way that parts of the clothes spread out on the bed, to be lying down, and thus mere human beings subject to the transitoriness of earthly life. At the same time, however, they are depicted in the prime of life, with their eyes open and—much more significantly—accoutred with the symbols of their birth and their power: Matilda's diadem identifies her as the daughter of an English king, while, as mentioned above, Henry the Lion's sword represents his office as sovereign dispenser of justice and the model of the church shows him in his role as generous benefactor.

The Tomb of Archbishop Siegfried III von Epstein in Mainz
In contrast to the French *gisants*, the Archbishop of Mainz, Siegfried III von Epstein, is shown on the slab of his tomb as not merely alive, but active (see page 348). In a self-contradictory composition, his head rests on a pillow but his feet stand on the backs of two animal figures, a dragon and a lion, pressed down by his weight. He is not alone, but accompanied by two smaller figures and his hands are placing a crown on the head of each. Both these smaller figures wear the sword encircled by a band, the symbol of temporal jurisdiction, and carry the staff topped by a lily to show that they are princes whose right to bear a crown has the sanction of the Church. They have been identified as Landgrave Heinrich Raspe of Thüringen and Count William of Holland.

The imagery on this tomb slab amounts to a forceful assertion of the political claim of the Archbishop of Mainz to the right to crown German kings. At the same time, it documents one of the most dramatic phases in the struggle between the two universal powers, pope and emperor, around the middle of the 13th century. At an assembly convened in Vienna early in 1237, Emperor Frederick II had his son Conrad, then aged only nine, elected king of Germany and future emperor, and appointed the Archbishop of Mainz as regent. In August 1241 Frederick's implacable opponent, Pope Gregory IX, who had excommunicated him for a second time in 1239, died. Although Archbishop Siegfried von Epstein had at first refused to proclaim the ban of excommunication in Germany, he changed his policy after the pope's death and, in association with the power-hungry Archbishop of Cologne, Konrad von Hochstaden, brought the excommunication into force. Frederick was unable to reach an accommodation with Pope Innocent IV, elected in 1243 following a lengthy interregnum. The forces opposed to the emperor in the college of cardinals repeatedly gained the upper hand, so that on July 12 1245, at a general council in Lyons, where the Pope had fled to escape Frederick, events reached a decisive conclusion, the deposing of the emperor. At the same time, all Frederick's subjects were released from their oaths of fealty.

Heinrich Raspe, who had been made regent after the defection of the two ecclesiastical princes, began to waver after the election of Innocent IV as pope and as early as the beginning of 1244 he decided to transfer his allegiance to the papal party. In May 1246 Raspe was elected German king, the so-called anti-king, and for accepting the throne received the sum of 25,000 silver marks from the Pope. He was mocked as *rex clericorum* (the clerics' king) and no coronation was able to take place, since he died very soon afterwards, on February 12 1247. His successor as anti-king, Count William of Holland, was not able to extend his sway much beyond part of the Rhineland territories.

Thus the funeral slab, originally no more than a cover for a tomb chest, is here principally a declaration of the political claim asserted by the archbishop in the context of the rivalry among the German bishops for the right to crown monarchs.

The Tomb of Archbishop Uriel von Gemmingen
The Upper and Middle Rhine continued, long after the end of the 13th century, to be regions where outstanding sculptors in stone were active. In the field of funeral sculpture another notable tomb monument, also in Mainz Cathedral, marks the end of the Late Gothic period. This is the tomb of Archbishop Uriel von Gemmingen (see page 349), who died in 1514. It is attributed to Hans Backoffen (ca. 1460/70–1519), and must therefore have been created between 1514 and 1519. Beneath the crucifix, which is attended by angels, stand, in bishop's vestments, the two principal saints of the bishopric, St. Boniface and St. Martin. At the foot of the cross, under which can be seen a skull from Mount Calvary, kneels the portrait-figure, gazing at the crucified Christ. The tomb monument is no longer in its original location.

OPPOSITE:
Mainz, cathedral of St. Martin and
St. Stephen
Tomb of Archbishop Uriel
von Gemmingen, between 1514
and 1519

LEFT:
Mainz, cathedral of St. Martin and
St. Stephen
Tomb slab of Archbishop
Siegfried III von Epstein, after 1249

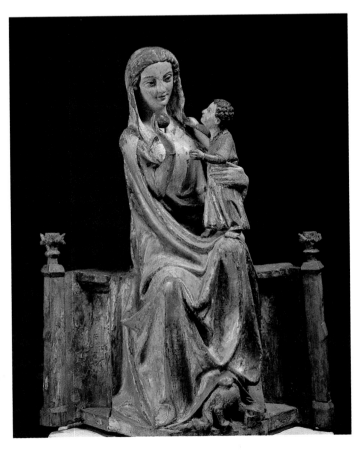

*Virgin and Child Seated on a
Broad Throne*
Cologne, ca. 1270
Oak, painted. Height 61.5 cm,
width 46 cm, depth 20 cm
Cologne, Schnütgen Museum

Moreover the flanking escorting figures are missing, Gemmingen's head has been much restored, and the boy peeking out from behind his back is an erroneous piece of restoration.

The coats-of-arms at the sides show the armorial bearings of Mainz and the Gemmingen family. An inscription records that it was the dead Archbishop's successor, Albrecht von Brandenburg, who had this monument erected. It was also Albrecht who had brought the sculptor Hans Backoffen to Mainz. Hans Backoffen, who is first recorded in Mainz only ten years before his death, is one of those sculptors to whom, in the absence of information about other artists, many works of high quality have been attributed. The earliest mention of Backoffen, in 1509, is made in connection with a wooden crucifix, now lost, which he carved for the church of St. Stephen in Mainz. Besides the tomb of Uriel von Gemmingen, the monument in the same cathedral for Archbishop Jakob von Liebenstein (died 1509) is regarded as his most important work.

Devotional Statues

Architectural sculpture and tomb sculpture were the main kinds of work carried out by sculptors attached to a cathedral workshop. In the second half of the 13th century, sculptor-craftsmen organized in guilds began increasingly to carve wooden sculptures that were then colored by specialized painters. These sculptures, commissioned by monasteries and other foundations and by parishes, had liberated themselves from architecture to become free-standing, movable statues. This meant that the form of the statues could respond to changing religious needs. It also meant the statues themselves, through their changing appearance, could in turn influence the religious practice of the faithful.

The power of religious images is indicated by the fact that they have sparked wars and violent acts of iconoclasm. From time immemorial the veneration of images had fallen under the biblical prohibition of idolatry, of the worship of "graven images." The synod of Hiereia in 754 confirmed this prohibition on the grounds that earthly representations of Christ divided his being, which is one and indivisible, into a divine and a mortal nature. This was disputed by clergy in the later Middle Ages, who argued that the commandment against making an image of God belonged to the Mosaic Law of the Old Covenant, and hence to an age when God had not yet taken human form. Under the New Covenant, however, after God had become flesh, the making of likenesses was no longer forbidden. It was even claimed by its advocates to be desirable, since the image was held to possess the same educational value for the illiterate as scripture had for the literate. Thus at the beginning of the 14th century numerous new kinds of images and new iconographic subjects emerged, for the most part concerned with Christ's Passion and designed to arouse empathy and religious devotion in the beholder.

However, the nature of such devotion continually provoked vehement criticism because of the danger that the image might not be distinguished from the saint it portrayed. Relics were therefore of particular significance for images of saints. Already in Ottonian art the emergence of movable sculpture had been associated with the safekeeping of relics. To a great extent this enabled the sculptures to avoid the accusation of idolatry, for in the relic of a saint the whole person of the saint was held to be present. From the early reliquaries representing the relevant part of the body, known as "speaking reliquaries," there eventually developed busts and complete figures of saints in which the relics were incorporated and were at first visible, as proofs of authenticity, but were later generally concealed.

The Virgin in Majesty

The Schnütgen Museum in Cologne has in its collection a Virgin in Majesty that is famous under the name of the *Virgin and Child Seated on a Broad Throne* (see left). Owing to its exceptional quality, it was often thought to be a French work, but recent research has revealed it to be the product of a Cologne workshop, not least because of the

Michel Erhart
Ravensburg Madonna of Mercy,
ca. 1480–90
Limewood, painted. Height 135 cm
Berlin, Staatliche Museen: Preussischer
Kulturbesitz, Sculpture Gallery

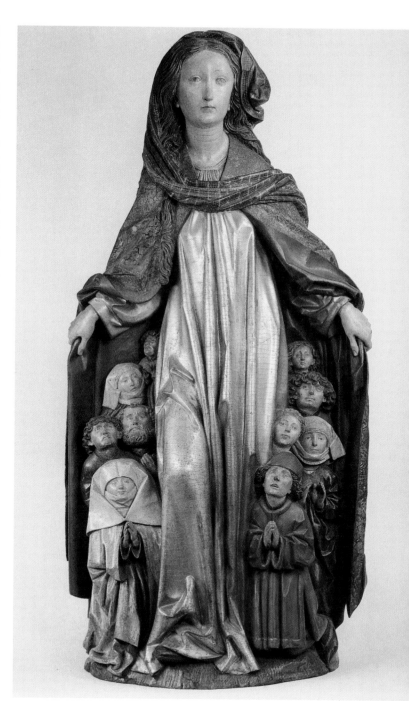

Rhine oak from which it is carved. It is not in its original state. At the time of a restoration, which can be dated to 1317, the sides of the throne were removed so that it could be widened and the back was flattened so that the statue could be placed in an altar ensemble. New colors were applied and, in conformity with that period's taste in Madonnas, extensive gilding. Under her left foot the Virgin tramples a small dragon while on her left thigh, which is raised, the infant Christ stands, supported by her left hand.

With her right hand she is offering him an apple, to which, however, he pays no attention, for his gaze is directed upward, a motif that creates different impressions when viewed from different angles. From a directly frontal view Jesus might seem to be looking into Mary's eyes, but the three-quarter profile reveals that he is gazing up to Heaven. The mother, too, is looking not at her child, but downward, past the beholder, into an indefinite distance. Though at first sight appearing to interact, the two figures are in fact not attentive to each other. By his gaze, the no longer childlike Christ standing on his mother's lap refers to both his origin and his destiny. The gaze of his earthly mother indicates to the viewer a premonition of her son's Passion. The apple she holds identifies her as the new Eve and so symbolizes the final triumph over evil and salvation from sin. The dating of the statue to around 1270, which derives from comparisons with contemporary French sculpture, has been confirmed by investigation of the original coloring, which has survived to the present day on the Kendenich Madonna of almost the same date, which is also in the Schnütgen Museum.

The Madonna of Mercy

The image of the Virgin, generally standing, who shelters under her outspread mantle a group of the faithful in need of protection is probably derived from one of the provisions of medieval law. This conferred on women of high rank the privilege of granting to persecuted people who called upon their aid the so-called "protection of the mantle"—safe refuge and freedom from persecution. This motif is found in theological literature from the early 13th century onward, and it soon appeared in the plastic arts, emerging as a devotional image in the late 13th century and becoming widespread during the two following centuries. The religious aspect of this legally based symbol was applied not to the Virgin alone, as the most powerful of the intercessors before God's throne, but also to other female saints such as St. Ursula or St. Odilia. The Cistercians and Dominicans in particular contributed, notably by accounts of visions, to the wide distribution of this image.

The famous Madonna of Mercy in the Berlin sculpture collection (see right), originally attributed by art historians to the Ravensburg sculptor Friedrich Schramm, is now unanimously considered to be the work of Michel Erhart of Ulm. The Virgin stands, tall and slender, on a grassy plinth. Showing movement only to the extent of a slight curving of the body, she protectively holds up her garment in the

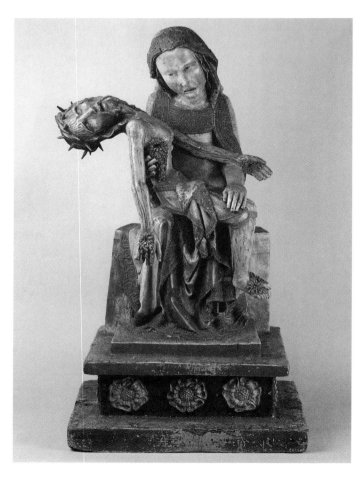

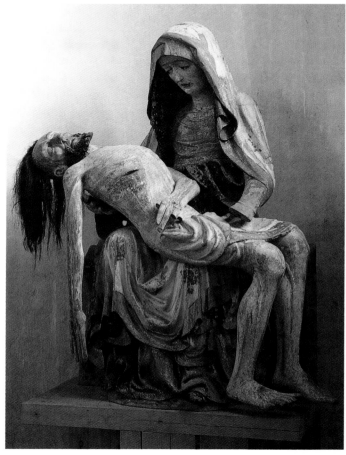

gesture of the "protection of the mantle". Beneath it a large number of the faithful find refuge. Her elegant reserve and the nobility of her posture match the refined facial expression, emphasized by her strikingly slender throat. These features, together with the artistic framing of her face by the wavy hair falling to her shoulders and the shawl covering her hair, reflect Erhart's endeavor to achieve in sculpture an idealized image of beauty, an effect further enhanced by the largely original polychrome coloring.

The Pietà

One of the most intensely moving kinds of representation in Christian art is the Pietà. It emerged as a separate devotional image in the late 13th century and owes its German name of *Vesperbild* to the Good Friday custom of remembering at vespers—between Christ's

death on the Cross and his burial in the tomb—the scene where his mother contemplates his broken body. Its Italian designation, *Pietà*, meaning "compassion" or "sharing in suffering," gives a clearer indication of the nature of the worship associated with it. In the depiction of the mother's anguished grief and the broken body of her crucified son, individual human suffering cries out for sympathy from the beholder. Through this *compassio*, this sharing in universal spiritual and physical pain, the medieval believer achieved a state of intense mystical excitement not infrequently associated with self-scourging, ritualized by groups known as Flagellants, as well as—starting with St. Francis of Assisi—the appearance of stigmata.

A Pietà among the best known, because it is particularly expressive, is the one from the former Röttgen collection now in the Rheinisches Landesmuseum in Bonn (see above, left). With anguished

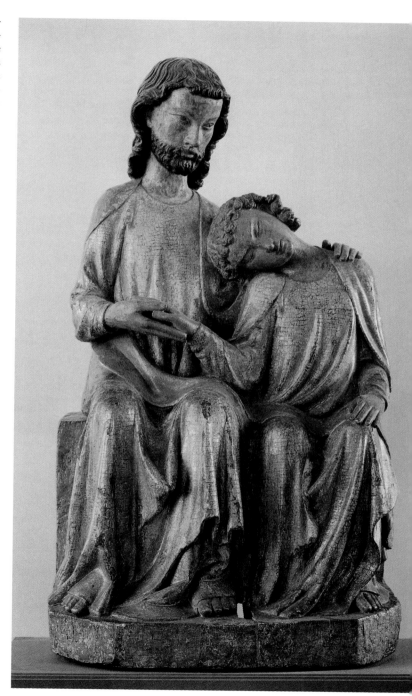

Christ and St. John the Evangelist
Sigmaringen, ca. 1330
Oak, painted and gilded
Berlin, Staatliche Museen,
Preussischer Kulturbesitz

face, the Virgin holds the wasted body of her son, horribly and mercilessly ravaged, on her lap. His head with its crown of thorns sags lifelessly backwards. Thick, grape-like drops of blood well from the wounds, an allusion to Christ as the "mystical vineyard." This Röttgen Pietà, executed around 1300 and one of the early sculptures of this type, is distinguished by its direct and forceful style of representing suffering. Like the apocalyptic prophesies of the period, these graphic portrayals of suffering expressed the mysticism and intense religious emotion that followed the wars and epidemics of plague that ravaged Europe from the mid 14th century onward. Such images soon spread from Germany to other parts of Europe.

A Pietà in St. Martin's Cathedral in Freiberg (see opposite, right) belongs to a type of Pietà that, starting in about 1400, emerged in parallel to the *Schönen Madonnen* (Beautiful Madonnas) and were likewise distinguished by a more refined spirituality. The Virgin's richly folded gown and youthfully beautiful face, with its gentle expression of suffering, reflect courtly taste. The appearance of Christ's dead body is also depicted far less brutally; he is laid almost horizontally across the Virgin's lap, in the style of the period. The incongruous backward loll of his head and the extreme naturalism of the hair are the result of a remodeling of the statue carried out at a later period.

Christ and St. John

Two passages in St. John's Gospel are the source for a type of image that first became a subject for sculpture in the early 14th century in southwest Germany. At the Last Supper, at the moment when the betrayal is foretold, "there was leaning on Jesus' bosom one of his disciples, whom Jesus loved" (John 13, 23). It was John who laid his head against Jesus' breast to ask who it was who would betray him (John 21, 20). From an early date, the motif of the close personal relationship between Christ and St. John was taken up both theologically and iconographically, and was linked with the bridal symbolism of the Song of Songs. The emergence of the Gothic sculptures of Christ with St. John corresponded particularly closely to visionary images conceived by some German women mystics of the 13th century and given vivid expression in their writings. In the convents, the friendship between Christ and St. John, intensified by the bridal symbolism, was a subject for profound mystical contemplation which could lead to the *unio mystica*, in which the nuns experienced the union of their souls with God.

The youthful Christ sits on a small bench. On his right sits John, the beloved disciple, handsome and boyish in appearance, his head sunk on the older man's breast. His eyes are closed and his right hand rests on Christ's; with his left hand, Christ gently embraces John's shoulder. The two figures are as though fused into one, and the softly flowing, gilded garments illuminate the flesh tones with a heavenly radiance. A feeling of deep peace and intimate tenderness emanates from this statue in its portrayal of the mystical union of the disciple with God (see right).

The art historian Helga Sciurie points out that the two forms of spirituality expressed by the Pietàs and by the images of Christ and St. John belong to the same convent sphere, "the pent-up emotions of the women enclosed there finding release both in the *unio mystica* and in *compassio*." These early convent sculptures are imbued with a powerful emotionalism, the expression of a conflict between the expectation of the largely aristocratic members of the orders of fully satisfying both the intellect and the senses, and the monastic life of asceticism and abstinence. "The early devotional images in the monastic houses assisted in dealing with this conflict," Sciurie concludes, noting that in the sculptures of Christ and St. John emotional and physical closeness between two people was shown for the first time.

The Parler Style

Around the middle of the 14th century emerged a family of artists who were to have a decisive influence on architecture and sculpture in the second half of the century. The special feature that distinguished these sculptors was their close imitation of nature. This applies to the development of portraiture no less than to the perception of the human body, the representation of clothing, and the depiction of plants in sculptural ornamentation. That this new sculptural representation was able to gain acceptance and exert so profound an influence is all the more remarkable given that innovative changes to medieval forms had to compete with established devotional images that had proved their miraculous powers time and again.

Art historians speak of the "Parler style," for many problems concerning the attribution of works to individual members of the Parler family have still not been solved. Documentary evidence relating to the Parler dynasty is fragmentary, but Peter Parler, probably its most important member (1330/33–99), a native of Cologne, entered the service of Charles IV some time in the early 1350s, at the age, it is thought, of 23. He became the most prominent artist in Prague, the city that Charles was intent on making into the intellectual and artistic capital of Central Europe, a counterpart to Paris.

The so-called *Parler Bust* (see right), actually a foliate corbel, shows the head and shoulders of a young woman with curly golden hair who wears a dress with a wide neckline. Her softly rounded face is half-smiling. The coat of arms on her breast bears the L-square, the Parlers' signature. Like the head of Christ wearing the crown of thorns, her head is crowned with the wreathed stems of a plant from whose leaves the corbel itself emerges as though to form a Gothic crown for the Virgin. Though the coloring is of later date, documents show that it was painted originally. This corbel-bust, probably made for the Gothic convent of St. Mariengraden in Cologne (demolished in 1817), and discovered there (it is now preserved in the Schnütgen Museum), is thought to be the work of Heinrich IV Parler.

The uncommon charm that the face of this bust possesses seems to stem from the fact that it is presented as a type in the manner of the so-called "Soft Style," and yet at the same time looks extraordinarily

like a portrait, though a mysterious one—possibly that of a female member of the Parler family. In its function as a corbel, however, Anton Legner has assumed that it was complemented by an unknown statue of the Virgin in the Soft Style. The Virgin supported by the corbel would have defined the woman beneath her as Eve. The plant forming the crown worn by the woman has been identified as artemisia, which in the Middle Ages had Marian associations and thus creates a link between the two women at the heart of the Christian religion. In this way we arrive at an image representing the typology of Eve and Mary, according to which Mary's obedience vanquishes what Eve's disobedience introduced into the world: sin and death. If this hypothesis is correct, the incorporation of what is perhaps the portrait of a Parler relative may be testimony to the artist's self-assurance and the pride he took in this important commission.

The Beautiful Madonnas

Shortly before the transition from the 14th to the 15th century, the style of art almost everywhere in Europe showed almost unprecedented uniformity. As a result of the multifarious contacts and continual exchanges of artists between the courts of Europe, a style representing a particular aesthetic, both in sculpture and in other art forms, was able to spread so rapidly toward the end of the 14th century that looking back it is difficult to trace its origin. But there

Friesentor Virgin
Cologne, ca. 1370
Walnut, painted and gilded. Height 132 cm,
width 41 cm, depth 32 cm
Cologne, Schnütgen-Museum

are many indications that this style, also known as the International Style, came into being, or was "invented," in Bohemia and quickly became widespread, partly through the work of the Parlers, active in many countries. The most significant works, and the ones most representative of this development in sculpture around 1400, are what art historians appropriately call the *Schöne Madonnen*, the Beautiful Madonnas. Although the basic type of the standing Virgin with the Child on her left arm derives from French cathedral sculpture of the 13th century, these works produced in the late 14th century set new standards both as sculptures and as religious images.

Unlike the carved images of the 14th century, these Madonnas no longer contained relics in order to prove their validity as devotional images. With their extreme aesthetic refinement, the statues of this new style were able, by their form alone, to express the religious significance that had once been conveyed by the relic, now of secondary importance. As a result, the religious significance of the work of art was so immeasurably heightened that the old charge of idolatry was, as it were, turned into its opposite: it was a precondition for the veneration accorded to these sculptures that the subject of the image be equated with the image itself. Art had become an indispensable aid to a believer's religious devotion.

The Friesentor Madonna

One of the most outstanding examples of this new style is preserved in the Schnütgen Museum in Cologne (see right). According to tradition, it came originally from one of the city gates, the Friesentor, demolished in 1882. This statue in walnut wood, which still largely preserves its original coloring, depicts a standing Virgin, her body gently curved, holding the Christ Child. Each figure has lost the lower part of the right arm. In his left hand Christ holds a bird. Mary's mantle, gathered up on her left hip, falls in close, tubular folds and ends above the knees, revealing the gown below. There is a subtle relationship between the vertically curving folds of the gown and the gentle horizontal curves of the folds of the mantle above it. The fabric remains close to the body, so that the presence of the body beneath the material is clearly discernible. The folds themselves are shallow rather than voluminous. Stylistically, this Cologne Virgin is related to the Apostles from the jamb of the St. Peter portal at the southern entrance to the cathedral. The originals of these figures, products of the Parler circle of sculptors, are now in the diocesan museum. Although the treatment of the folds is less fine and sharp-edged, the whole execution more block-like, and the flesh coloring flatter in appearance, the Friesentor Madonna may well have been carved at the same time as the cathedral Apostles, but probably not in the same workshop. Nevertheless, this figure, datable to around 1370, is regarded as the earliest known example of the large *Schönen Madonnen* category, which had a particularly wide distribution in Germany. A Virgin from Altenberg abbey, now in Braunfels castle, is thought to be the first successor to this one.

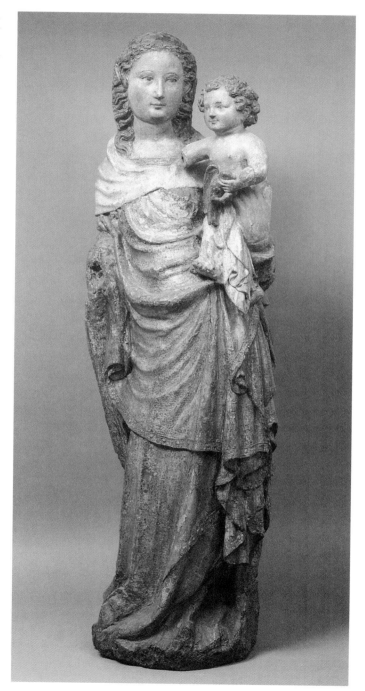

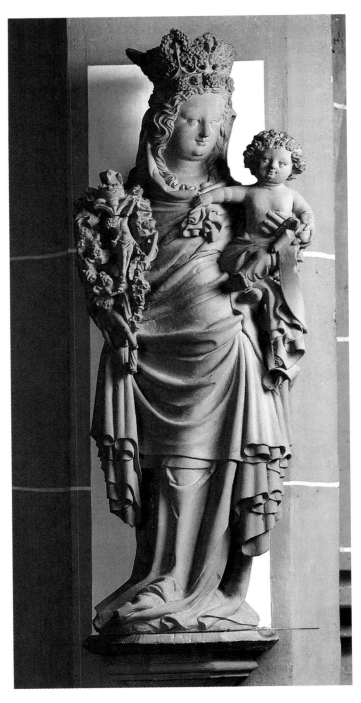

Virgin
Middle Rhine, ca. 1390
Red sandstone, restored with plaster
Height 151 cm
Mainz, Carmelite church

The Mainz "Grapevine" Madonnas

A variant of the type represented by the Friesentor Madonna can be found in the figures of the Virgin created by sculptors of the Middle Rhine around 1400. They are known as "Grapevine Madonnas" or, sometimes, "Cross-sceptre Madonnas." Instead of a sceptre topped by a lily, these Madonnas hold in their right hand a crucifix in the form of a tree, which in the case of the Virgin from Korbgasse in Mainz now in the Mittelrheinisches Landesmuseum becomes a vine hung with grapes, in allusion to the medieval view of Mary as the "vine which bore Christ, who was the grape that was pressed on the Cross."

On one such figure, from the Carmelite church in Mainz (see left), angels hover around the tree-cross catching the blood from the wounds of the crucified Christ. Above this is a pelican tearing open its breast with its beak in order to feed its young with its own blood, a symbol of Christ sacrificing himself for humanity. With her magnificent crown, the Virgin is presented as the Queen of Heaven. The Christ Child grasps his mother's shawl with his right hand, while his left holds a bird with a scroll in its beak—a reference to the Madonna sculpture from Korbgasse, in which the infant Christ is shown writing.

The Mainz Madonnas share with the Friesentor Madonna the relationship between the gentle S-shaped curve of the figure and the resulting form of the clothes, typified by the long diagonal curve from the Madonna's left hip to her right foot and the knee-length mantle draped in horizontal curves falling in tube-like folds at the sides. A further shared feature is the broad face framed by wavy hair. The wide distribution of this type and their strong stylistic similarities suggest that the figures may all be derived from a now unknown but then important cult statue whose value as a devotional image is demonstrated by the extreme faithfulness with which its form was copied. Both a silver statuette in the treasury of Aachen Cathedral, which seems to have adopted the typical motifs as early as 1330, and the figures dating from the end of the century lend support to this theory.

The Frankfurt Trinity by Hans Multscher

The turning point between these *Schönen Stils*, "beautiful styles," with their gentle, almost abstract idealization, and Late Gothic realism is marked by a small high relief in the Liebieghaus in Frankfurt (see opposite). An angel holds the dead or dying Christ, preventing him from falling to the ground. Christ's head with the crown of thorns falls sideways, his mouth and eyes slightly open, and his arms hang limply down at his sides. On the angel's right stands God the Father, his hand raised in blessing. Between his head and that of Christ is the dove representing the Holy Ghost. The relief has lost its original surround which, possibly adorned with tracery, would have emphasized the sculptural content of the image by giving it a spatial setting.

It is above all in the execution of the body of Christ that the sculptor's close observation of nature is most apparent. A dense network of veins spreads over arms and legs, the collarbone and ribs

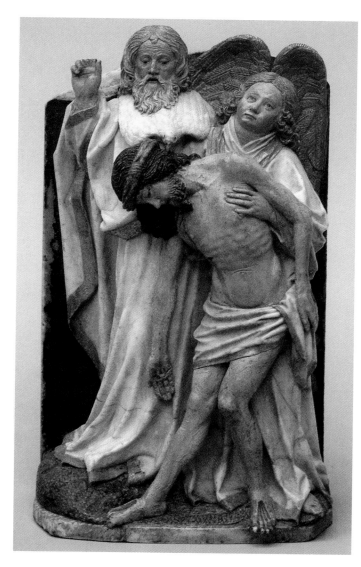

Hans Multscher
Holy Trinity
Schloss Sandizell, ca. 1430
Alabaster relief, partly painted
Height 28.5 cm, width 16.3 cm
Frankfurt am Main, Liebieghaus

reflect light with a crystalline hardness. Penetrating the translucent stone, light becomes a milky glow that seems to come from within the material itself. This makes the garments, which flow together as though to form a foil for the figure of Christ, seem to hold some secret, to suggest an otherworldly realm that gives the presentation of the racked body a background imbued with a sacred mystery.

In this work, neither a Trinity nor a Throne of Grace, different components are brought together to carry an unusual density of theological meaning. The most striking feature of this work is the portrayal of the tormented Christ as a man dying. The sculpture seems to capture the very moment of death, and so gives greater emotional emphasis to his sacrifice. The way in which he is held by the angel, as in a Man of Sorrows, forms a link with the image known as an Angel Pietà. In the Throne of Grace type, God the Father, seated on a throne, holds the cross on which his son is crucified. Between them hovers the dove representing the Holy Ghost. Theologically, this shows the acceptance of the sacrifice through which the divine plan of salvation can be fulfilled.

This relief, created around 1430 by Hans Multscher (ca. 1400–67), is stylistically indebted to Late Gothic Netherlandish realism. Little is known of Multscher's training, but he was certainly familiar with the iconography and formal idiom of the *Schönen Stils*. It is also likely that he spent several years in Burgundian-Netherlandish regions, where he would have been introduced to the ground-breaking naturalism of the early 15th century. In 1427 he was granted citizenship in Ulm and exempted from taxes and from the obligation of belonging to a guild. That he is also recorded as having the status of a "sworn master" shows him to have been an artist of eminence.

Late Gothic Altarpieces

Up to the end of the 13th century the design of Gothic altars underwent significant changes that had to do with reforms of the liturgy. In the Romanesque period it was usual to have a table-like altar. The priest celebrating the mass would stand behind this *mensa* (table). An early form of pictorial altar decoration was the antependium, either a cloth hanging down in front of the altar or a painted panel placed before it. When it became customary to place reliquaries on the altar, it was necessary for the priest to come to the front of the altar and to perform the mass with his back to the congregation. The reliquaries eventually developed into altarpieces, at first simple picture panels set up along the back edge of the altar. As the altarpiece, which both the priest and the congregation faced, became a widespread feature of altars, it provided a new medium for imagery, and up to the beginning of the 16th century its architectural composition became more and more elaborate.

Rimini Crucifixion Altarpiece

The Liebieghaus in Frankfurt possesses a group of alabaster sculptures from an altar executed around 1430 for the church of Santa Maria delle Grazie in Rimini. The figures have survived, but the framework

are anatomically correctly formed, and a fine double fold above the navel underlines the naturalistic approach to the human body. This is further enhanced by the coloring, with the skin rendered in various tones—bluish shadows, veins clearly picked out, and the bleeding wounds painted red. Similarly, the faces and hands of God and the angel have a strongly three-dimensional presence and naturalistic coloring. There is a contrast between the flesh colors and the alabaster, uncolored except for the gilded hems of the robes of God and the angel. It is the special quality of this stone that it does not

Rimini Crucifixion altarpiece
Southern Netherlands or northern
France, ca. 1430
Alabaster, not painted. Height of cross
225.5 cm, width 91.2 cm
Frankfurt am Main, Liebieghaus

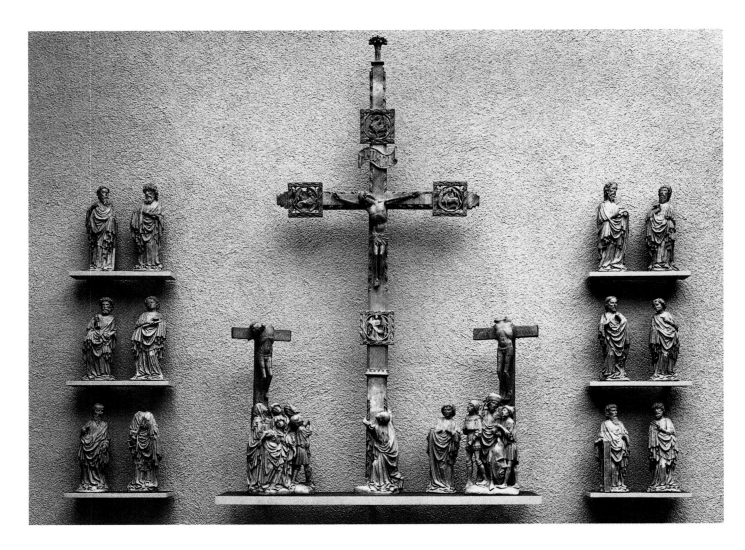

within which they stood has not (see above and opposite). The arrangement in the museum is no more than an attempt at a reconstruction. In the center stands an unusually tall cross. St. Mary Magdalene embraces its foot, gazing up at the dead Christ. The crosses of the thieves on either side of Christ are considerably smaller. In front of the cross on Christ's right stand the three grieving Marys together with the Roman centurion Longinus and a servant, complemented on the other side by the group with Stephaton, the soldier who offered Christ a drink on a sponge, and a barefoot youth. Between them and the cross stands the mourning figure of St. John. To the Calvary scene are added 12 statuettes of the Apostles.

Although they are stylistically related, the execution of the figures seems to suggest different sculptural approaches. The Apostles are generally regarded as the older and more traditional works, the Calvary figures as later and more modern. Such apparent differences of style, however, are more likely to reflect a difference in content. The Apostles are portrayed in clothing that hardly differs from one figure to another. Around their long garments are wrapped pieces of cloth serving as cloaks. Great quantities of material cover the curved bodies and the arrangement of the drapery is similar in every case. The heads represent different types, but there is no individuality. The beautiful lines with which the clothing is rendered are matched by the

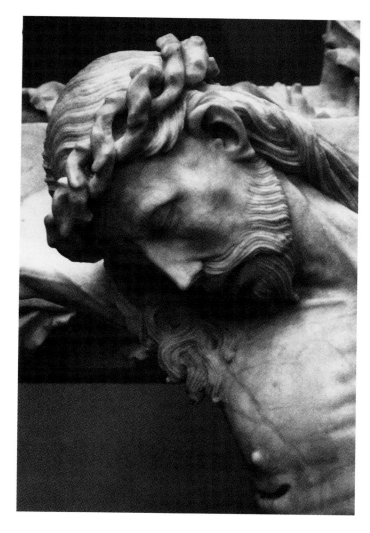

stylization of the hair and beards. Abstract and timeless, they form an appropriate framework for the events on Calvary. Thus the Rimini Apostles may be seen as late examples of the Soft Style.

The representation of the Crucifixion scene is quite different. In the groups standing at each side of the Cross, the faces are executed in so naturalistic a manner that each figure has its own character. The blindness of Longinus and the stupidity of his servant are heightened to the point of ugliness. These witnesses of the Crucifixion, who wear contemporary, and in some cases even fashionable, dress, make this depiction of the event intensely true to life and give it an extraordinarily powerful sense of immediacy.

The Blaubeuren Altarpiece

In the chancel of the church of the former Benedictine abbey of Blaubeuren stands an altarpiece almost 12 meters (36 feet) high, created by the Ulm sculptors Michel and Gregor Erhart (see pages 360–361). Michel is attested as a sculptor in Ulm between 1469 and 1522. His son Gregor (1460/79–1540) is recorded for the first time in 1494 in Augsburg. However, it is probable that before 1497 he worked in his father's workshop at Ulm and received his training there.

Supported by a predella of the same width as the altar table, the Blaubeuren altarpiece takes the form of a polyptych with two side wings that can be opened. Both the outer and inner sides of these wings and the predella are decorated with paintings. Only when both the wings were opened, that is to say on the highest feast-days of the Virgin and at Christmas, was the sculptural decoration fully revealed.

On the predella are half-length figures of Christ and the Apostles, while in the central section the Virgin stands with the Child on the sickle moon. She is accompanied, on her right hand by St. John the Baptist, the saint to whom the church was dedicated, and St. Benedict, the founder of the order, and on her left by St. John the Evangelist and St. Scholastica, the founder of the order's female branch. The left-hand wing has a relief showing the birth of Christ while the right-hand one depicts the Adoration of the Magi. In the central section of the filigree superstructure that towers over the altarpiece Christ is depicted as the Man of Sorrows. He was originally flanked by two angels holding the instruments of the Passion but one angel is now missing. At the sides of the superstructure stand the Virgin and St. John. Below each of them are three busts of saints and Church Fathers.

The two sculpted portraits that can be pulled out so as to be visible above the opened sides of the inner wings are a most unusual feature—and are, on an altar, a manifestation of overweening pride and vanity. The right-hand one depicts Bishop Heinrich III Fabri who, while still abbot, played a decisive part in the reform of the abbey and the renewal of its buildings and library, as well as in the founding of Tübingen University in 1477. A year after the start of building on the new abbey church in 1491, he was appointed bishop, and the year 1493, which saw the triumphal climax of the abbey's renewal, is the first date recorded by an inscription on the high altar. Corresponding in position to the portrait bust of Count Eberhard im Barte of Württemberg on the opposite wing, the bishop's portrait reveals a desire for self-representation comparable only to that of the wealthy aristocrats of the Burgundian court or to that of the most powerful members of the burgher class, such as the international bankers the Fuggers.

Executed in the years 1493 and 1494, the Blaubeuren altarpiece is regarded as a work in the distinctive style of the Erhart workshop. Yet it is Michel Erhart himself—the most significant sculptor, after Hans Multscher, active in Ulm in the last third of the 15th century—who is now regarded by most experts as the master

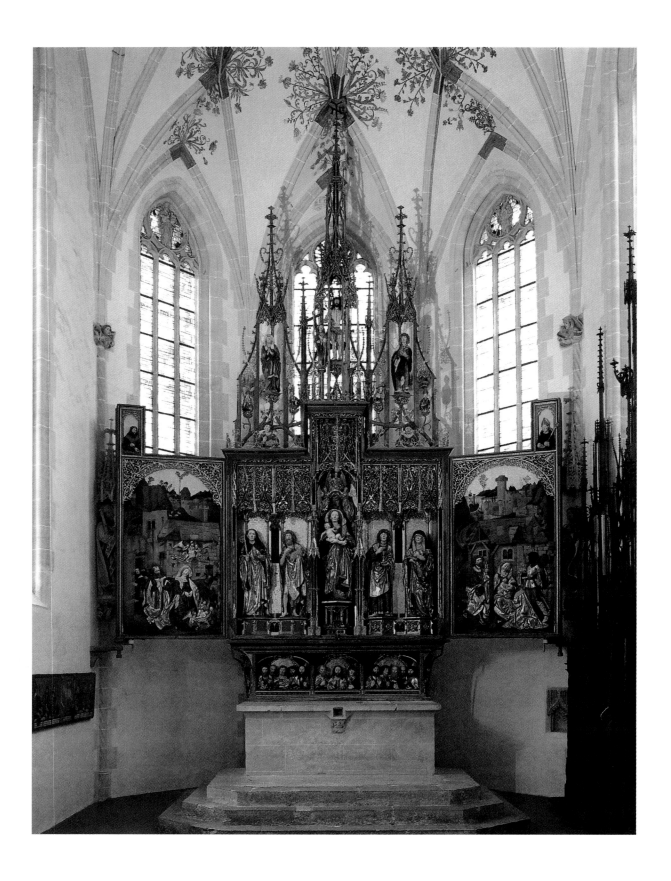

OPPOSITE AND BELOW:
Michel and Gregor Erhart
Blaubeuren Altarpiece, former Benedictine
abbey church of Blaubeuren, 1493–94
Center section (below)

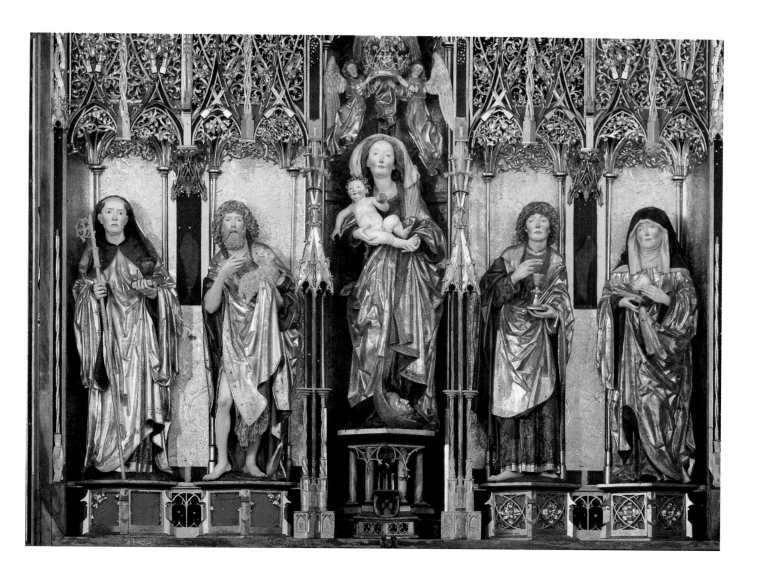

Veit Stoss
St. Mary's Altarpiece, 1477–89
Detail of central section
Wood, painted. Height 1395 cm, figures
up to 280 cm, width 1068 cm
Cracow, St. Mary

OPPOSITE:
Veit Stoss
St. Mary's Altarpiece, 1477–89
Central section

chiefly responsible for this altarpiece. This work at Blaubeuren marks the culmination of the mature Ulm style of Michel Erhart, beyond which his later sculptural works show no further advance.

The St. Mary's Altarpiece in Cracow

The earliest documentary record of Veit Stoss (ca. 1447/48–1533) dates from early in 1477, when he surrendered his Nuremberg citizenship in order to execute a monumental carved altarpiece for St. Mary's church in Cracow, the parish church of the German community. With its huge dimensions—almost 14 meters (46 feet) tall and about 11 meters (36 feet) wide—it is larger than any other surviving Late Gothic winged altarpiece. It is probable that this, the earliest known major work by Stoss, was preceded by other large-scale works that led to his being commissioned for this one. It was only in 1489, 12 years after the start of the work, which was interrupted by various journeys and other commissions, that the altar was ready to be erected.

The central section dominates the altarpiece. Its figures, far larger than life-size and arranged as if on stage, witness the death of the Virgin and her Assumption into heaven. Never before in a Late Gothic carved altarpiece had this subject been treated in so monumental a manner. Moreover, the treatment of the subject is unusual. Instead of being assembled at the deathbed, the Apostles stand, deeply moved, around the youthful Virgin as she kneels in prayer. Above them the gate of Heaven stands open with light pouring forth and the Virgin is led through by Christ. Above is the Coronation of the Virgin, where she is attended by two angels and the Polish national saints, Adalbert and Stanislaus. On the predella is a depiction of the Tree of Jesse. The outer wings, which are not movable, are decorated only on the inner sides. When the inner wings are closed a series of 12 reliefs depicting scenes from the life of the Virgin and the life of Christ are visible. When the wings are open, the left-hand one shows the Annunciation with, below it, the Birth of Christ and the Adoration of the Magi while on the right, the reliefs show the Resurrection, the Ascension, and the Descent of the Holy Ghost.

The sculptural forms used show three main gradations. From the bas-reliefs on the outer sides of the wings it moves to high relief on the inner sides and culminates in the almost fully rounded figures of the death scene. This increase in three-dimensionality is accompanied by a corresponding heightening of the coloring: the colorfulness of the outer edges is steadily reduced toward the center in favor of an increase in gilding. In the allegorical interpretation of colors in the Middle Ages, gold was accorded the highest place, "the most noble color because light is represented by it," as the Italian humanist Lorenzo Valla wrote in 1430. As the most valuable and most incorruptible metal, gold symbolized the light of heaven, in whose rays the figures of the death scene are bathed. At the same time it represented eternity, the idea of which is present in the Virgin's entry into Heaven. The blue of the background also had symbolic significance: it is the color of the sky and therefore of Heaven, and so symbolizes divine truth. The Virgin enters this blue and gold sphere at the center of the middle section of the altarpiece, accompanied by her son. Meanings in medieval allegory develop step by step by means of analogy, now in one direction, now in another. Thus the significance of the color blue—divine truth—is extended, via the idea of holding fast to the truth, to encompass steadfastness in faith, symbolized by the blue of the clothing of the Apostles. The sculptural treatment of the faces, on the other hand (see opposite), reveals the carver's outstanding ability to observe nature and his skill in translating what he has observed into an image. Each figure is given the character of an expressive individual portrait, an expressiveness heightened by the coloring.

After 19 years in Cracow, Veit Stoss returned in 1496 to Nuremberg, where alongside his work as a carver he was involved in various trading and speculative business ventures. Convicted and branded for forging a document, he fled to Münnerstadt. He was rehabilitated only after repeated attempts at mediation by Emperor Maximilian,

362

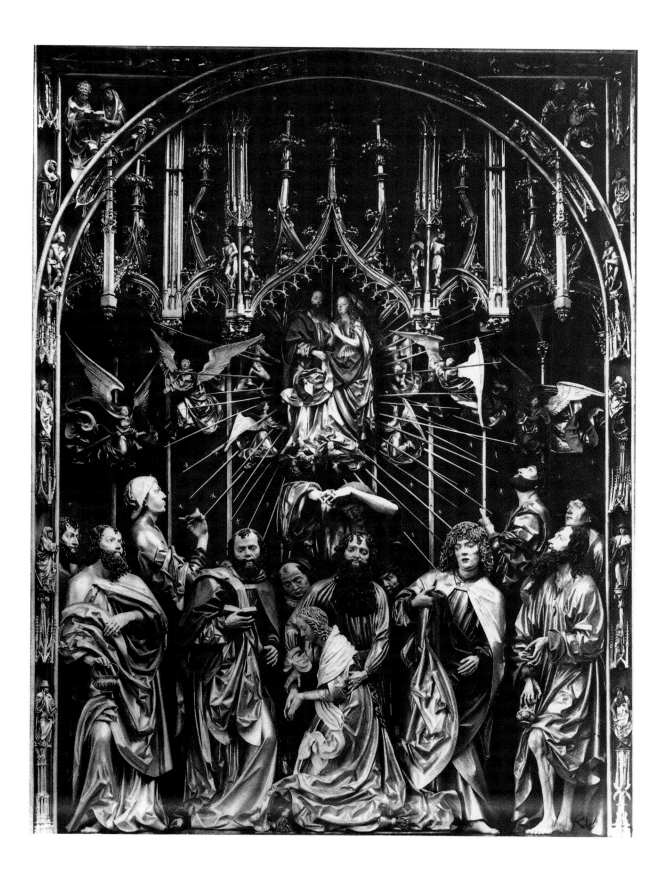

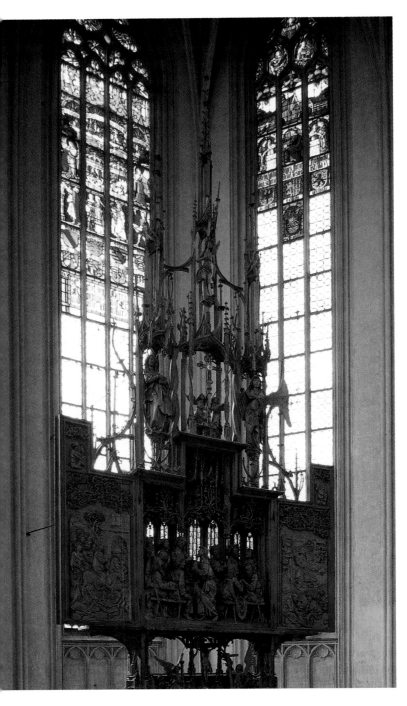

Tilman Riemenschneider
Holy Blood Altarpiece, 1499–1504
Limewood, unpainted. Height 900 cm,
figures up to 100 cm
Rothenburg ob der Tauber, St. Jacob

and a rich creative phase followed until about 1525. Although an exceptional number of contemporary references to him are preserved in archives, his origins remain unclear, as does his development as a sculptor up to the Cracow altarpiece in St. Mary's.

The Holy Blood Altarpiece at Rothenburg ob der Tauber

A small crystal, placed at the center of a cross in the crowning of an altarpiece in the church of St. Jacob at Rothenburg ob der Tauber, contained a relic of the very first rank: a drop of Christ's blood. This relic brought large numbers of pilgrims and many believers experienced miracles. The granting of indulgences increased the attraction of the relic still further. Toward the end of the 15th entury, Rothenburg town council resolved to build an altar to house this relic, and engaged Tilman Riemenschneider to carry out the sculpture for it.

Riemenschneider (died 1531), who came from Heiligenstadt im Eichsfeld in Thuringia, had a flourishing sculpture workshop in Würzburg that supplied large parts of Franconia with statuary in a wide range of materials. As well as numerous apprentices, he evidently also employed specialized craftsmen, which has led the British art historian Michael Baxandall to speak of Riemenschneider's "sculpture factory." In its heyday this workshop certainly had a large output. Riemenschneider's main period of creativity lasted from 1485, when he gained citizenship and the status of a master in Würzburg, to 1525, when, as a champion of the peasants in conflict with the bishop, he suffered imprisonment, torture, and the loss of his civic office. Besides unique works for altars, Riemenschneider's workshop also made religious objects such as crucifixes or angels holding candelabra that followed a precise pattern and were produced almost in series. This manner of working necessarily entailed a simplification of stylistic forms, which can be seen in the Rothenburg altarpiece.

The narrow altarpiece with its tall slender crowning rises up rather like an oversized monstrance. While elsewhere the predella appears as a massive, supporting base, the altarpiece at Rothenburg rests on a tripartite filigree-like arcade. Flanked by two angels in the outer arches, the crucifix stands today in the central arch where originally there was a reliquary for other relics. Equally unusual is the placing of the blood relic in the crowning, not at the centerpiece.

The *Last Supper* (see above) has a direct connection with the blood relic. It was on that occasion that Christ initiated the Eucharist with the words "This is my blood." One of the seated Apostles points to the altar table, referring to the presence of the blood of Christ in the daily sacrament of Holy Communion. However, what is unusual about this scene is the design of the center, where Judas has taken the place of Christ. He is Riemenschneider's "leading actor." This reflects the idea, hinted at in St. John's Gospel (13, 18), that Judas is the one chosen by Christ, whose betrayal is necessary for the work of salvation to be achieved. In this way the sculptor chose a narrative form of representation to encourage viewers to ponder the events closely.

Tilman Riemenschneider
Holy Blood Altarpiece, detail
of *Last Supper*

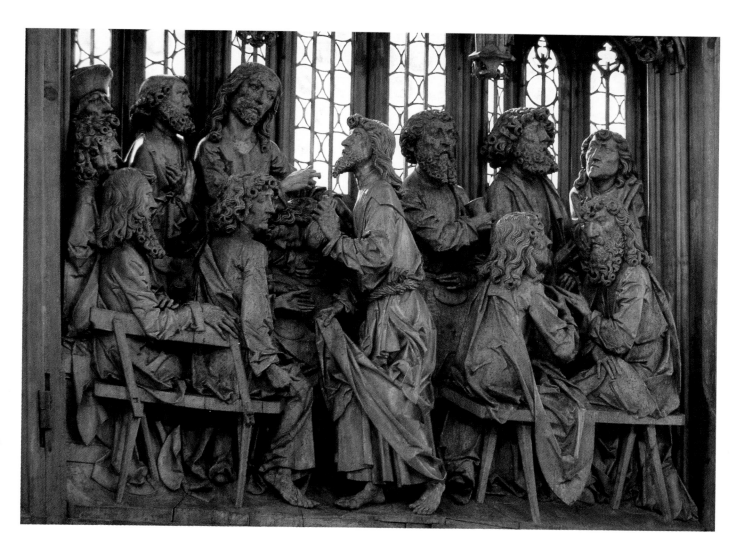

That such reflection might take many different directions according to an individual's own ideas is underlined by the design of the back of this section. Riemenschneider put in windows through which the daylight entering by the chancel windows would light the scene of the Last Supper differently from one hour to the next.

For his work Riemenschneider received only 60 guilders, a tiny sum in view of the importance of the relic and the place for which the altarpiece was destined. This may be partly due to his workshop's methods. It may also be linked with the lack of color. No expensive materials were necessary nor was there a figure-painter to be paid. These formal aspects fitted in well with the circumstances of those who commissioned the work. The Tauber valley, including Rothenburg, had since the mid 15th century been a center of the popular uprisings that, during the Peasants' War of 1525, brought the town onto the side of the people. The lack of color on the carved images not only renounced extravagant splendor; it also distanced the content of the image from observers—making the images un-lifelike, the lack of color discouraged a facile identification of what was portrayed with what was revered. In this way the altar was less exposed to accusations of idolatry, which may explain why this altarpiece survived the Peasants' War unscathed. It seems as though the *Holy Blood Altarpiece* was already in accord with new attitudes to religion and images.

St. John, from St. Mary's Abbey, York,
ca. 1200–10
Sandstone
York, Yorkshire Museum

OPPOSITE:
Wells Cathedral
West front, ca. 1230

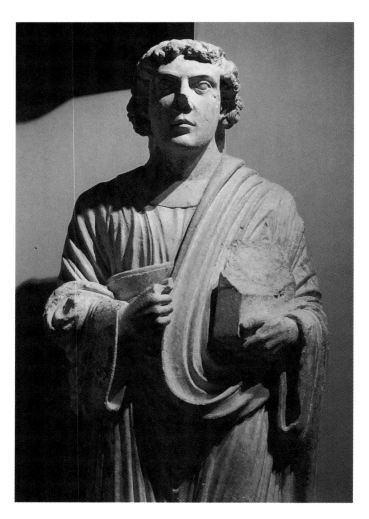

Gothic Sculpture in England

York

The sculptural adornment of English cathedrals and abbey churches was only rarely on the portals, which were generally too small and too shallow for large programs of figures on the French model. Nevertheless, 19th-century excavations in the southern aisle of St. Mary's Abbey in York revealed altogether 12 life-size statues. Since column shafts had been attached to their backs they are thought to have been portal figures, though their original positioning when they were first erected, around 1200, cannot be reconstructed on the basis of the ruins of the abbey.

Eight of the statues are of Apostles, among them a St. John who, rigid and in a fully frontal pose, is clothed in a garment that lies fairly flat against his body (see left). The treatment of the folds, which shows a strong sense of movement, indicates a Late Romanesque influence. The head of this apostle, however, appears to be of far higher quality; his youthful face is delicately formed. The curly hair encircling his head is stylized and derives from antique prototypes. Both this and the other figures must have been invested by their original coloring and gilding with a dignity that made them appear monumental.

Attempts to establish links with possible models by means of stylistic comparison have not gone beyond isolated formal aspects since the figure seems stylistically heterogeneous. In a general way it is assumed that the sculpture of the Île-de-France of around 1200 acted as prototypes, and so the style of the St. Mary's Abbey statues is seen as representing a transitional stage between English Romanesque and Gothic.

Wells

The fact that the towers of the west front of Wells Cathedral were built next to the side aisles and were twice as wide resulted in an extremely broad frontage in which the portals almost disappear. While the tympanum of the center portal extends to the full height of the lower gallery of figures, and just reaches into the arcade above it, the side portals are totally contained within the lowest zone (see page 135). The main access to the cathedral was through a vestibule on the northern side of the nave.

Within the extraordinary breadth of this "wall of images," executed in about 1230, 176 niche figures were set up and 134 reliefs placed in quatrefoils and spandrels (see opposite). Cut from a block incorporated into the wall, the reliefs of the Virgin in Majesty in the tympanum of the center portal and the Coronation of the Virgin in the center of the arcade zone above it are directly tied into the architecture. The other figures were worked separately and positioned in the many canopied niches.

As their attributes, originally of wood or metal, are now lost, it is not possible to determine their precise meaning or to form a clear image of the iconographic program that reaches up to the Last Judgment in the central gable. Apostles, saints, and figures from the Old and the New Testament are accompanied by secular rulers as well as by ecclesiastical and monastic figures. Given the number of statues, it is not surprising that they vary greatly in sculptural quality.

This extensive program has suffered considerable losses. As can be seen from the empty niches of the lower gallery, which probably contained the best of the sculpture, many of these Christian images were destroyed in the numerous iconoclastic episodes in English history. Only what was beyond the reach of the religious zealots survived—if it did not fall victim to the elements. It was very different with the tomb monuments of the English aristocracy, which were rarely the targets of acts of violence.

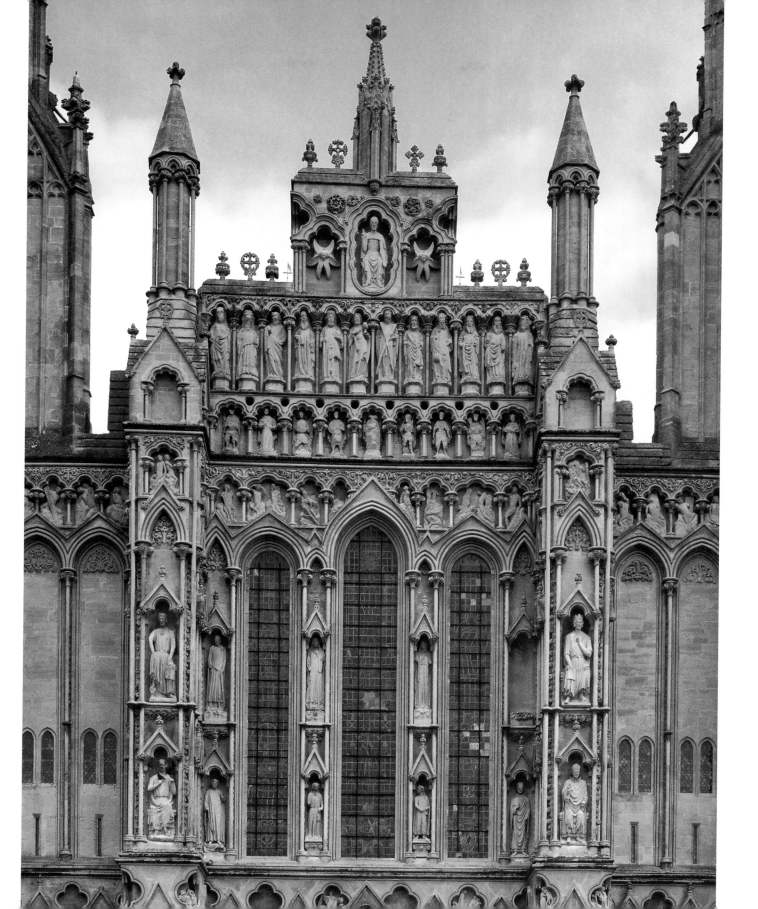

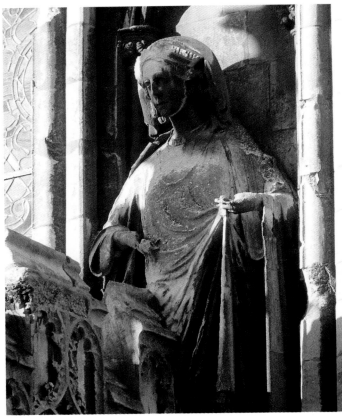

Lincoln

One statue that was not within the iconoclasts' reach was a sandstone figure on the buttress of the Angel Choir of Lincoln Cathedral (see above, right). After two damaged sculptures close by had been restored in the 19th century with replacement heads—as portrait statues of Edward I (1239–1307) and Eleanor of Castile—this statue became one of the most controversial pieces of English Gothic sculpture. It was suggested—without any justification whatever—that it represented Edward I's second wife, Margaret of France.

More serious, however, was the question of whether this figure too had been remodeled in the course of the 19th-century restorations. There is written evidence that at least at the time of the restoration of the other figures this one was undamaged, and several investigations of the figure itself established that at least the head was original, dating from the time when the statue was made.

This head, the so-called "Queen Margaret," is one of the few English Gothic sculptures of high artistic quality to have survived.

The fine-featured, cleanly contoured face with the ridged eyelids and the life-like modeling around the mouth, conveys without stylization all the refinement of an aristocratic lady. It gives a clear impression of the high level of sculptural skill that existed around 1260, which must once also have been reflected at least in the two other statues.

The Tomb of King John

Tomb sculpture provides much greater opportunities for assessing the quality of Gothic sculptural art in England than architectural sculpture, much of which has been destroyed. The Purbeck marble tomb monument of King John (1199–1216) was built shortly after his death and was placed, in accordance with his wishes, in Worcester Cathedral, close to the shrine of St. Wulfstan (see opposite, top and centre).

With his feet resting on the back of a lion, he is represented, presumably after the life, as a small man. His clothing has folds of a kind based on traditional patterns. While he holds in his hands his scepter and his naked sword, the small figures of St. Oswald and

TOP AND CENTER:
Worcester Cathedral
Tomb of King John
Purbeck marble, ca. 1225

BOTTOM:
Gloucester Cathedral
Tomb of Sir Robert Curthose
Oak, last quarter of 13th century
Detail with Sir Robert's head

St. Dunstan are depicted, in an unusual iconographic motif, beside his shoulders, sprinkling his head with incense.

This motif, like much else in funerary art of the time, seems to derive from prototypes in book illustration. Here, however, the purpose of the tomb sculpture was to rehabilitate a monarch who during his reign had had to suffer almost every possible humiliation. Most notably, following his devastating defeat at the hands of the French at the Battle of Bouvines on July 27 1214, the English barons had finally forced him, in 1215, to sign the famous Magna Carta.

The empty hollows in the crown, gloves, and borders of the king's robes, which indicate that the tomb was once lavishly adorned with sparkling jewels (presumably imitation gems made of a kind of glass paste), suggest that no effort or expense was spared to preserve the memory of the dead king in the full splendor of his regal dignity. This was taken to extreme lengths in the 19th century: in 1873, above the existing coloring, which was of uncertain origin, the whole effigy was gilded.

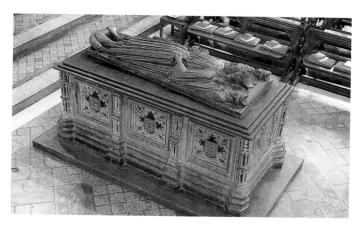

The Tomb of Sir Robert Curthose

Robert Curthose (ca. 1050–1134), eldest son of William the Conqueror (1066–87), was buried in front of the high altar of Gloucester Cathedral. There is no documentary evidence concerning his tomb monument, which is thought to date from the last quarter of the 13th century (see bottom right).

The effigy of the knight is of oak, a material that was frequently used for tomb figures in England between 1280 and 1360. Although about 80 examples have survived, most are damaged. The figure of Robert Curthose itself was broken into several pieces during the Civil War in the 17th century, and joined together again toward the end of that century. It was probably then that the tomb chest was made on which the figure of the knight now rests in the chancel of the cathedral.

Despite considerable alterations, the figure of the knight is shown in an unusual pose that first appeared in the west of England in the 13th century and soon became widespread, probably because of the use of wood, which was easier to work than stone. While the head rests on a pillow, the right hand reaches for the sword on the left hip. The left leg, which is slightly bent, is on its side, while the right foot rests on some object no longer present. This kind of pose, into which the woodcarvers put all their skill, made the effigies of knights infinitely more lively, an effect that was further enhanced by highly realistic coloring, now often lost. This type of tomb monument for a knight thus contrasted strongly with those that portrayed the dead man devoutly praying.

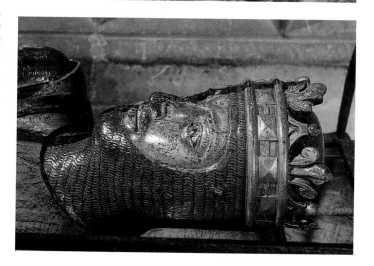

The Tomb of Edward II

Gloucester Cathedral also contains the tomb monument of King Edward II (1307–27), who was deposed and brutally murdered at Berkeley Castle on September 21 1327 (see page 370 and page 371, left). As early as 1314, at the battle of Bannockburn near Stirling in

369

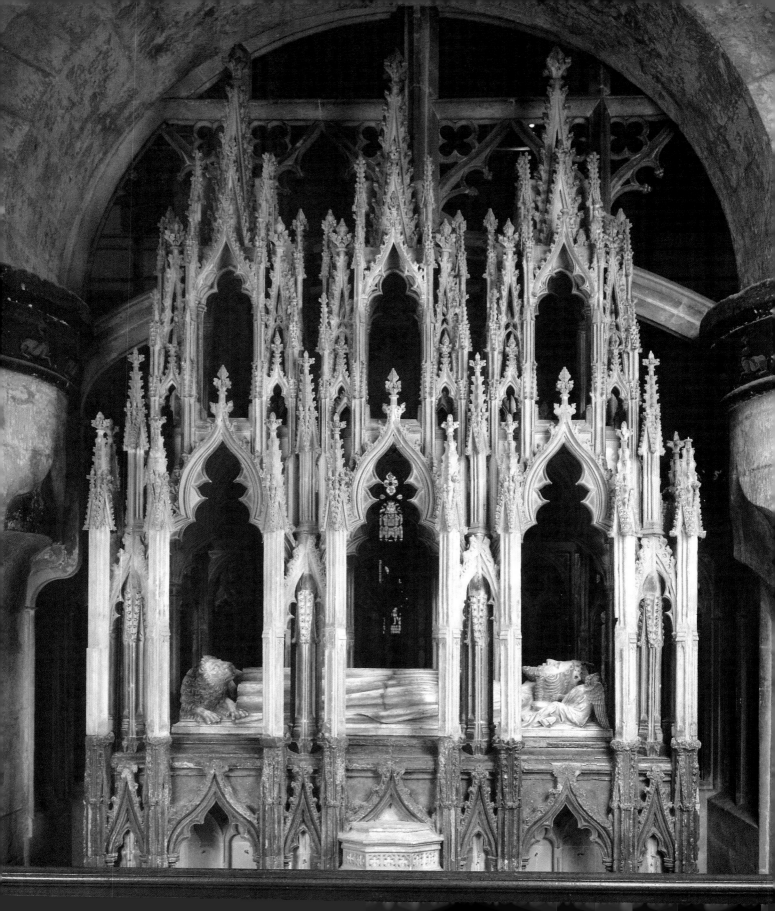

Scotland, Scottish foot-soldiers had defeated an army of English knights, and Edward's reign had continued to be a period of ignominious decline for England. He was finally forced to resign by his wife, Isabella of France and her lover, Roger Mortimer.

Edward's tomb monument shows no trace of his having been removed from power in this abrupt and brutal way. Made from the translucent material of alabaster, it shows an idealized portrait of the monarch. With its stylized representation of the king's hair and beard and the sophisticated handling of the freshly quarried, still soft alabaster, this is more than a masterpiece of English courtly art. Edward's facial expression, harmoniously combining majestic dignity with personal suffering, as well as the angels who touch his hair with respectful tenderness, lend his image an aura of sainthood.

Clearly this tomb, made only a few years after the king's violent death, represents his rehabilitation—or transfiguration—in the form of the sculpted image. In order to enhance the picturesque, softly gleaming effect of the white alabaster, and so reinforce the overall impression to be conveyed, the plinth and the canopy are partly made of contrasting Purbeck marble.

The Tomb of the Black Knight

The terrors that Edward, Prince of Wales (1330–76), eldest son of Edward III (1327–77), inflicted in the course of his many military campaigns earned him a reputation for cruelty. It was no doubt this, and not a legendary black suit of armor, that was the origin of his nickname of the Black Prince, which is first documented in

1379, the second year of the reign of his son, Richard II (1377–1400). Shakespeare probably draws upon this source when, in *Richard II*, he refers to Edward as "that young Mars of men." The duchy of Cornwall, the first to be established in England, was bestowed upon the Black Prince in 1337. He played a decisive role at the battle of Crécy in 1346, a battle that was of epoch-making significance in military history. At Poitiers in 1356 he succeeded in capturing the French king, John II. He was made duke of Aquitaine in 1362, but his tenure of that position ended with his being driven out, a sick man, in 1371.

Edward's tomb monument in Canterbury Cathedral, dating from between 1377 and 1380 (see above), was probably carried out by the same artist who was responsible for the monument of Edward III in Westminster Abbey. Both of these effigies were worked in brass, a medium that not only permitted the inclusion of a wealth of detail, but also afforded many opportunities for modeling through the use of line, satisfying a taste for elegant draftsmanship that derived from book illustration. It is this that gives, for instance, the face of Edward III an uncommonly naturalistic appearance, while the clothing is handled with relative simplicity. The armour of the Black Knight, on the other hand, is worked with the utmost care and with great attention to heraldic detail. Above the effigy is a canopy with a painting of the Trinity, upon which the dead man gazes.

Regine Abegg

Gothic Sculpture in Spain and Portugal

Castile and León (13th–14th centuries)

Burgos Cathedral

The earliest Gothic sculpture in Castile resulted from direct contact with contemporary French sculpture and modeled itself closely on it, as can be seen from the south transept portal of Burgos Cathedral from about 1235–40 (see opposite). The style of the tympanum and archivolts derives directly from the sculpture of the west portal at Amiens. The Christ in Majesty has so strong an affinity with the "Beau-Dieu" there that its author must have been a leading sculptor from that workshop. The success of this first Gothic figure portal in Castile is vouched for by its successors. Despite its old-fashioned iconography, based on Romanesque models, the tympanum was imitated on the main portal of the collegiate church at nearby Sasamón (ca. 1300) and on the center portal of the south transept of León Cathedral (second half of the 13th century).

An important factor leading to the building of the new Gothic cathedral at Burgos was the status of Bishop Mauricio at the court of the Castilian king Ferdinand III (king 1217–52). Mauricio had been entrusted by the king with the task of bringing his bride, Beatrice of Hohenstaufen, to Castile, and it was he who married the royal couple in the Romanesque cathedral in 1219. A gift from the king in gratitude for services rendered led to the laying of the foundation stone for the new building in 1221. Important court ceremonies were held at the cathedral, giving it the status of a court church, until, following the reconquest of Seville in 1248, political interests shifted to the dioceses in the re-Christianized south, and Burgos, the old *caput Castellae* (capital of Castile), began to be overshadowed.

This loss of status stands in marked contrast to the iconography of the extensive sculptural program on the extensions to the cathedral between 1260 and 1270, in which the monarchy is a prominent theme. There are series of kings in the gallery stories of the north and west façades and fashionably dressed secular figures on the west towers. Access from the south transept to the upper level of the two-story cloister built at the same time is by a magnificent figure portal adorned with the heraldic emblems of Castile-León, whose complex iconography serves to glorify the Castilian monarchy (see opposite, top right). Placed in wall niches in the cloister are life-size statues of bishops and kings, remarkably lifelike in appearance (see opposite, bottom right). Next to the entrance, a royal bridal couple, who may be identified as Ferdinand and Beatrice, commemorate the founding of the new cathedral (see page 374, top center). The laying of the foundation stone is depicted on one of the corner pillars. As at Naumburg and Meissen, and under similar historical circumstances, monumental statues of founders or benefactors retrospectively document a position of power or influence that in reality was under threat.

Although created by a workshop that had French experience to draw on, the sculpture of this second building campaign shows greater stylistic independence This applies also to the positioning of

Burgos Cathedral, south transept portal
Tympanum, ca. 1235–40

BELOW:
Burgos Cathedral
Cloister portal (south transept,
east wall), 1265–70

BOTTOM:
Burgos Cathedral, cloister
West wing, statues of kings and bishops,
1265–70

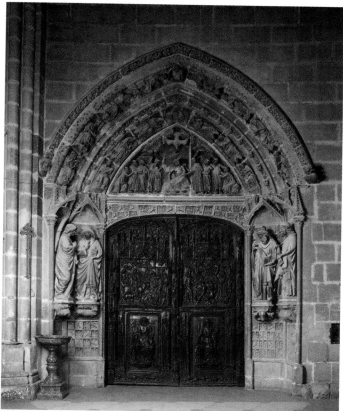

the sculpture: the backs of the statues on the towers and in the
cloister fit exactly into the regular mortaring of the stone blocks and
must have been fixed there as the walls were being built. This tech-
nique, which demands a team of builders and sculptors highly
specialized and accustomed to working together, is found nowhere
else in medieval building.

Castilian Sculpture Workshops

Apart from a series of portals added to the church of the Cistercian
convent of Las Huelgas Reales near Burgos (final dedication 1279),
only two buildings show direct links with the workshops active at the
cathedral after 1260. One is the collegiate church of Santa María de
Castrojeriz, 45 kilometres (28 miles) to the west of Burgos, founded
in the early 13th century. In the second half of the century its façade
was furnished with sculpture closely related to the figures on the
towers of the cathedral—so closely, indeed, that the baldachins were
made from the same molds. This link between the workshops no
doubt derives from the status of the convent, whose provost was a
member of the cathedral chapter and one of the nine dignitaries
charged by the bishop with the administration of the diocese.

There is a direct connection between Burgos Cathedral and later
sections of the cathedral at Cuenca, which date from the third quarter
of the 13th century. Besides the practically identical west portal
ensembles (neither of which survives), there are a number of similari-
ties between the transept galleries at Burgos and the design of the
clerestory in the nave at Cuenca, with the statues of angels set in freely
designed tracery subdivisions. Here too the interchange of architec-
tural ideas and craftsmen came through personal contacts, possibly
the move of Bishop Mateo II Rinal from Cuenca to Burgos in 1257.

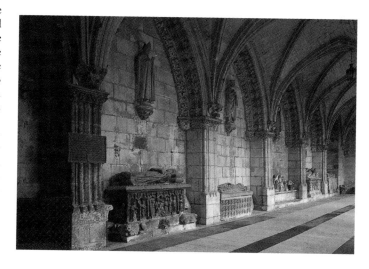

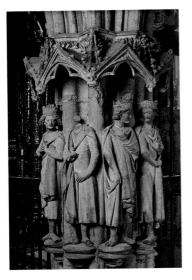

León Cathedral

The second wholly Gothic cathedral to be built in what from 1230 onward was the united kingdom of Castile-León also resulted from the initiative of a bishop who, as chancellor to Alfonso X (king 1252–84), was intimately linked with the court. León Cathedral, begun around 1255 under Bishop Martín Fernández with a subsidy from the king, was in all essentials complete by about 1300. Although this project was directed by the same master of works, Enricus (died 1277), as the second phase of building at Burgos, the two cathedrals show no similarities in building technique or form, with the exception of the portal ensembles. There was also no exchange of sculptors between the two, perhaps because the Burgos workshops were so closely tied to the cathedral workshop. The only direct link is a master who worked at Burgos on the tympanum of the north transept portal (around 1245–50) and moved to the newly opened workshop at León, where the Virgin on the trumeau of the center doorway of the west portal (the Virgen Blanca) is attributed to him (see right).

Outstanding among the sculptors engaged to execute the west portal sculptures is the so-called Master of the Last Judgment, who created, on the lintel of the center doorway, one of the most original representations of that subject. It is distinguished by a style whose exaggerated elegance far exceeds that of possible French models, and whose exquisite detail is reminiscent of small sculptures in ivory.

On the level of the motifs used, this master is inspired less by icon-ographic convention than by everyday life. A delightful example is his depiction of the organ being played before the gates of Heaven. Less original in design are the statues on the pillars of the vestibule

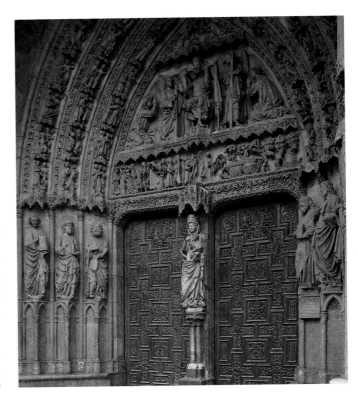

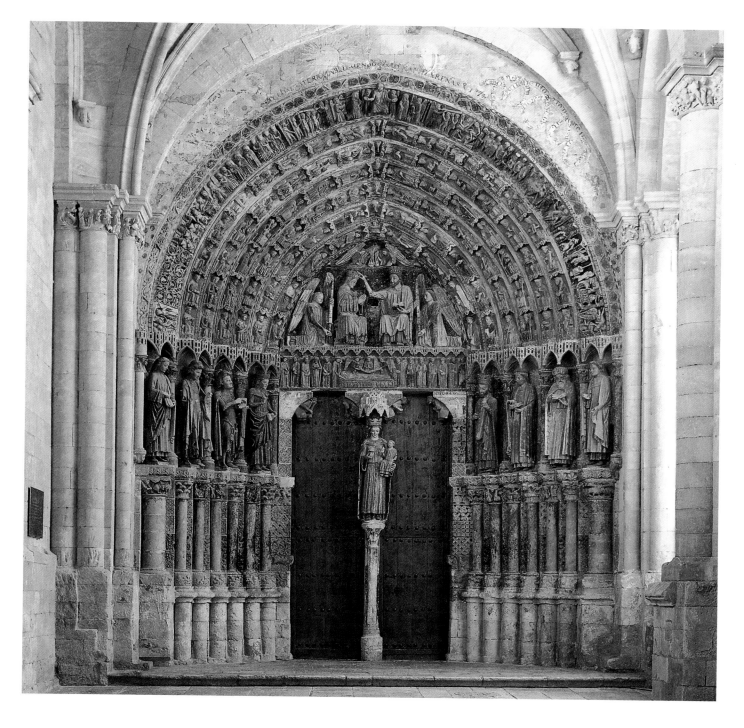

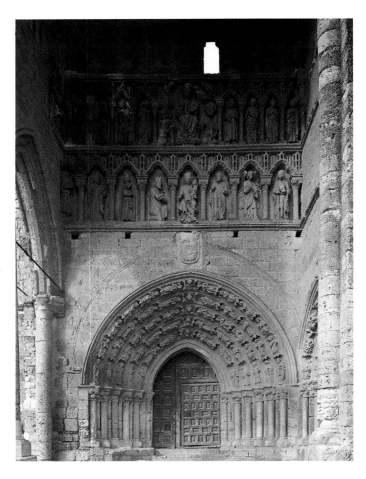

late 13th century, is an example of how local sculptors clearly not trained in the workshop of a Gothic cathedral adopted the artistic innovations (see page 375). The jamb, which consists of two zones, is a combination of the Romanesque columned portal (with strikingly old-fashioned capitals and relief decoration!) and the modern concept of the portal, inspired by Burgos and León, with free-standing figures placed between slender columns beneath a series of baldachins. Iconographically and compositionally, the Coronation of the Virgin and the Death of the Virgin on the tympanum and lintel follow the Coronation of the Virgin Portal at León, with some motifs borrowed from the lintel at El Burgo de Osma. Some individual stylistic borrowings indicate familiarity with cathedral sculpture, but they are subordinated to a rigid, severely schematized style.

The radial arrangement of the figures in the Last Judgment on the outermost archivolt follows local Romanesque tradition of the late 12th century (as on the north portal at Toro or the west portal at Santo Domingo at Soria). Similarly, the composition of the south portal of the church of Santa María la Blanca at Villalcázar de Sirga (Palencia), executed at about the same time, goes back to Romanesque architectural practice (see left). Lacking a tympanum, and with a double row of blind arches with figures above the archivolts of the portal, it is modeled on the church of Santiago (St. James) at nearby Carrión de los Condes. The archaic iconography of the upper frieze, with Christ in Majesty surrounded by the symbols of the Evangelists and flanked by the Apostles, also has a forerunner at Carrión. On the other hand, the Gothic bud capitals of the jamb columns and the finely worked figure sculpture in the archivolts and blind friezes indicate the existence of a workshop of experienced craftsmen with links to the cathedral workshop at León.

Tomb Sculpture: Innovation and Tradition

Among the innovations periodically arriving from the north was the introduction in Castile-León—at first adopted consistently only in the cathedrals—of the *enfeu* tomb monument. Early examples of such tombs, set in a wall niche, are those of Bishops Rodrigo II Álvarez (died 1232) and Martín II Rodríguez (died 1242) in León Cathedral (see opposite, left). In the French manner, the tomb chest on which the recumbent effigy lies is set into the wall and has above it a portal-like, arch-shaped architectural structure with reliefs showing angels and the soul borne upward. The program of images, however, is without precedent. The rear wall of the recess shows the performance of the office of the dead with expressively grieving mourners, while on the front of the tomb chest the virtue of charity is depicted, with equal realism, in the form of an alms-giving scene. Repeatedly copied, right into the 14th century (for instance in the bishops' tombs in Ávila Cathedral), this "modern" type of monument became the preferred form of tomb for cathedral clergy.

Local Romanesque tradition, on the other hand, provides the pattern for the free-standing sarcophagus supported by lions, as in

and on the jambs of the south transept portal (see page 374, top right). The slender figures, lacking animation and with almond-shaped eyes narrowed to slits, show almost slavish borrowing from French models of two decades earlier (the Mary Portal at Amiens and the center portal at Reims). However, as some prophets and apostles on the west doorways indicate, the sculptors at León were also conversant with the current style of drapery in France. Both the building style and the sculptural ornamentation of the cathedral suggest an ambition to create a synthesis of the best achieved in France, to produce a work epitomizing the ideal of Gothic art. León Cathedral is to this day regarded as one of the greatest products of French-inspired Gothic outside France.

León's Successors and the Regional Tradition

A direct successor to Burgos and León was the new Gothic cathedral of Burgo de Osma (Soria), begun in 1232 by Bishop Juan de Domínguez, the king's chancellor and later bishop of Burgos. The architecture of the south transept portal is taken over directly from Burgos, while the style and the level of quality of the jamb figures seem to indicate sculptors who had gained experience in the portal workshops at León.

At the collegiate church of Santa María la Mayor at Toro (Zamora), begun in 1160, the west portal, probably executed in the

León Cathedral, north transept
Tomb of Bishop Martín II Rodríguez
(died 1242)

Villalcázar de Sirga, Santa María
Sarcophagus of the Infante Felipe

Sarcophagus from Santa María de
Palazuelos, ca. 1300
Valladolid, Cathedral Museum

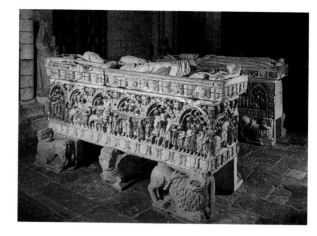

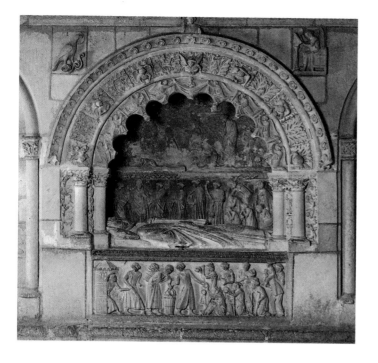

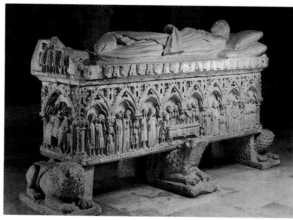

the tomb monument for the Infante Felipe (died 1274), younger brother of Alfonso X, in the Templar Church at Villalcázar de Sirga (Palencia) (see above, top right). Around the sides of the monumental colored sarcophagus, on which the tomb effigy, dressed in richly ornamented clothing, lies with his sword raised, runs a relief, between borders of coats of arms, depicting the office for the dead. The funeral procession, portrayed as a splendid ceremony led by bishops and representatives of the monastic orders, nobles on horseback, and mourning figures wildly tearing their hair, bears witness to the high status of the deceased. Designed for a prominent representative of the Castilian *nobleza vieja* (old nobility), which had shortly before Felipe's death successfully defended its feudal privileges against the centralist policies of the court, this sarcophagus became the prototype for the tombs of the higher nobility.

The abbey churches of San Zoilo at Carrión de los Condes, Benevívere, Vega, Benavides, Aguilar de Campóo, Matallana, and Palazuelos (see above, lower right), contain a large number of monuments influenced by that of Felipe, some of which are now in the museums of Valladolid, Palencia, and Madrid. Of varying quality, and stylistically far removed from the elegance of the Gothic formal canon practised in the cathedral workshops, they are clearly products of local sculpture workshops. This is confirmed by surviving artists' signatures: a sarcophagus in Aguilar de Campóo is signed in 1293 by

"Antón Pérez de Carrión," a monument at Benavides by "Roy Martínez de Bureba," another tomb chest at Carrión de los Condes by "Pedro pintor." That such traditional features, coupled with support for local sculptors, should become increasingly common just when the influence on sculpture from beyond the Pyrenees was so strong is an interesting phenomenon, especially as these works were commissioned by a class of society familiar with the new currents. Evidently an "anti-modern" stylistic idiom was deliberately chosen as an expression of the nobility's insistence on its traditional rights based on old feudal law.

14th-century Sculpture: Toledo

In the final years of the reign of Alfonso X (1252–84), economic crisis, conflict over the succession to the throne amounting to civil war, and the struggle between the crown and the nobility, in which the clergy were also involved, created a climate hardly favorable to ambitious building projects. In architectural sculpture there was little artistic innovation. Thus the sculptural decoration of the cathedral cloister at Oviedo, built mainly in the early 14th century on the model of Burgos, is of poor quality. Among the few examples that stand out are the figure portals of the city churches of San Pedro, San Miguel, and Santa María in Vitoria, the north portal of Ávila Cathedral, and the portals of Toledo Cathedral. Toledo was begun at the

377

Toledo Cathedral
Central doorway of west portal, first half
of 14th century

Tarragona Cathedral
West portal, ca. 1277 and after 1375

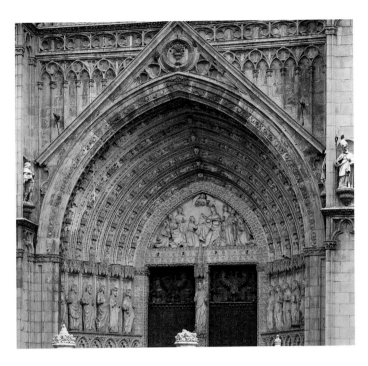

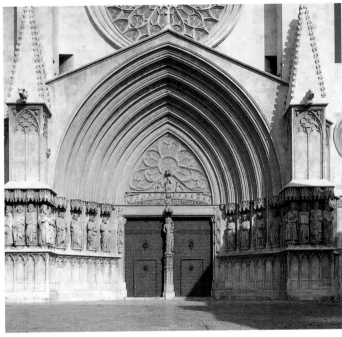

same time as Burgos, but made slow progress; sculptors' workshops became active only in the late 13th century. Around 1280–1300 the Portada del Reloj on the north side was furnished with an iconographically complex program influenced by the Old Spanish liturgy. The scenes, densely packed with figures and a wealth of detail, mark an end in the development of Gothic sculptured portals.

A desire to foster tradition can also be observed in the iconographic program of west portals, which date from the first half of the 14th century. Framed by archivolts decorated with the coat of arms of Castile-León, the tympanum of the center doorway (see above, left)—executed by a particularly able workshop—is devoted to the local saint, Ildefonso, shown receiving the chasuble from the Virgin, so that the Last Judgment is relegated to the right-hand side portal.

This new artistic impetus, coupled with the reference to the local traditions of the old archiepiscopal and royal city of Toledo, seems to have been prompted by increased royal patronage under Sancho IV (1284–95) who stipulated in his will that he should be buried in the cathedral and in 1289 had been responsible for the founding of a royal funerary chapel for those of his predecessors buried here, restoring to the cathedral its status as a place of royal burial. In the course of the 14th century influential prelates extended, furnished, and ornamented the cathedral, the seat of an archbishopric that had grown strong once more. Around 1360–75 the inner choir, with an

extensive cycle of reliefs, was erected in the nave. Pedro de Tenorio (1367–99), a prolific builder, ordered the construction of the chapel of San Ildefonso to contain the tomb monument for his predecessor in office, Cardinal Gil de Albornoz (1338–50), as well as the upper parts of the main façade, the lower cloister, and his own burial chapel, the chapel of San Blas (St. Blaise).

Gothic Sculpture in Catalonia and Aragon

It was not until the 1270s that, as a consequence of the increase in Mediterranean trade and the strengthened monarchy, Gothic sculpture based on northern French models was introduced into Catalonia and Aragon. In Tarragona, Master Barthomeu, in the service of the archbishop and the cathedral chapter from 1277, created the west portal of the cathedral, with eight figures of Apostles in the jambs and a figure of the Virgin on the trumeau (see above, right), directly inspired by a French Virgin of the same type as that in the former abbey church of St.-Corneille in Compiègne (ca. 1270). In the 14th century there was an upsurge in commissions for sculptural ensembles, especially for works for liturgical purposes and tomb monuments. Surviving documents allow us to reconstruct the activity and contractual position of artists, many of whom are known by name. Master Barthomeu, for example, not only worked for the Church but also received the royal commission to create, in 1291–1300, the

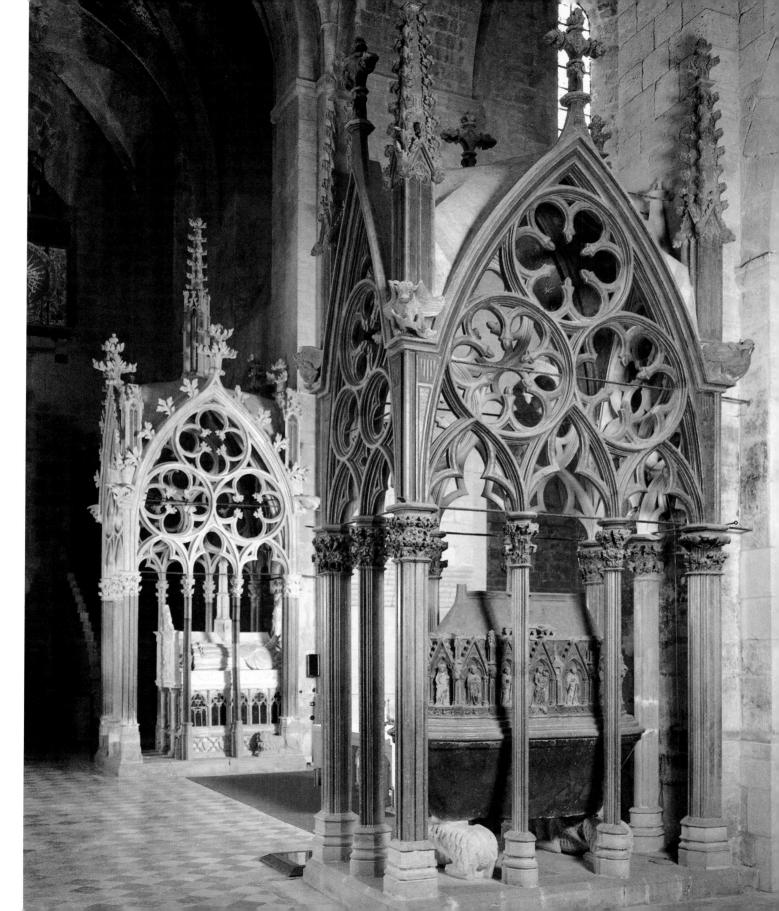

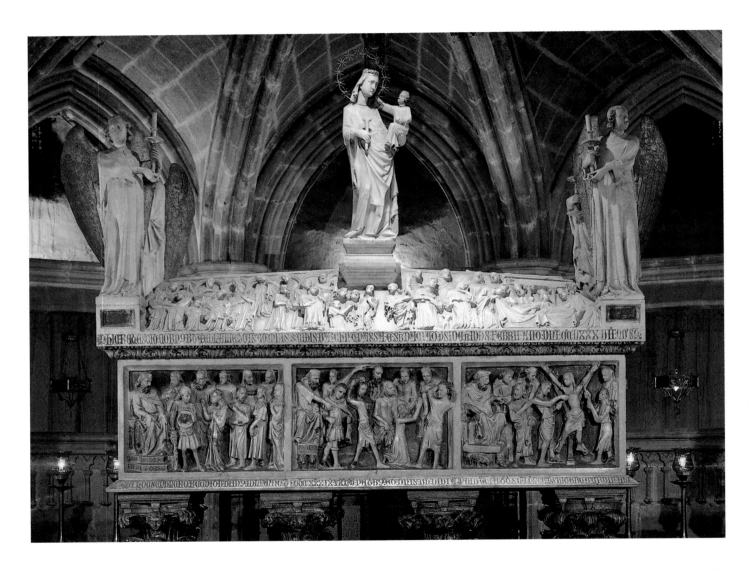

splendid tomb for Pere III (1276–85) and his wife in the Cistercian abbey of Santes Creus (see page 379). The marble sarcophagus, bearing figures in relief and colored, rests on a classical porphyry bath. Above is a baldachin ornamented with tracery. This tomb monument similar to the Hohenstaufen tombs in Palermo, is thus also a monument to Pere's claim to Sicily (conquered in 1282), a claim based on his marriage to the Hohenstaufen heiress, Constance.

Political and economic links with other countries are reflected in the multinational origin of sculptors—French, Netherlandish, Italian, English, and German—engaged in growing numbers. In 1327–39,

masters from Pisa and Siena executed the marble sarcophagus for the relics of St. Eulália in the crypt of Barcelona Cathedral (see above). The sarcophagus, bearing reliefs showing the life, torture, and martyrdom of this local saint, stands behind the altar, raised up on columns with classical capitals. The Italian connections of this workshop are indicated by the angels on the corner ledges holding candlesticks and the figure of the Virgin, with elegantly curved lines, at the centre. The marble tomb of Archbishop Juan de Aragon in Tarragona Cathedral (ca. 1337) is reminiscent of work by the Italian sculptor Tino di Camaino (ca. 1285–1337).

For the royal tombs in the Cistercian abbey of Poblet—developed into a dynastic mausoleum by Pere IV (1336–87)—Aloi de Montbrai from Flanders was engaged between 1337 and 1368. The local sculptor Jaume Cascalls was appointed to assist him from 1347. In a unique arrangement, two abnormally long sarcophagi lie, parallel to the nave, on wide, flat arches spanning the distance between the pillars of the crossing. On their sloping lids lie, one behind the other, effigies of the monarchs and their wives (much repaired and restored). Aloi or Cascalls was also responsible for the statues, now vanished, of monarchs made for the royal palace at Barcelona, of which one perhaps survives in the alabaster figure supposed to be of Charlemagne in Gerona. Jaume Cascalls, recorded at Tarragona, Barcelona, Poblet, Lleida, and elsewhere, is an example not only of the mobility of these artists but also of their versatility: in 1352 he painted the palace chapel in Barcelona and in 1361–64 he is recorded as the master of the cathedral works in Lleida, where he founded an important school of sculpture. In 1375 he was entrusted with completion of the west portal of Tarragona Cathedral (see page 378, right). However, the rather crude figures of three apostles and nine prophets are probably by other members of his workshop.

Many local and foreign sculptors are recorded in Catalonia and Aragon in the 15th century. Alongside Antoni Canet and Pere Oller, who executed the alabaster altar in Vic Cathedral, 1420–26, Pere Joan is an important representative of the kind of Late Gothic style that reflects Burgundian-Flemish influence. His earliest known work is the medallion of St. George on the façade of the Palau de la Generalitat in Barcelona (1418). In 1426 he received from Archbishop Dalmau de Mur the commission for the alabaster altarpiece of the high altar of Tarragona Cathedral (1426–36). After De Mur was transferred to Zaragoza, Pere Joan began in 1434 to work on the main altar there, but completed only the predella before being summoned to the court at Naples. The completion of the altarpiece, one of the greatest Gothic altar works in alabaster, was placed in the hands of a Swabian, Hans von Gmünd, recorded between 1467 and 1477.

Late Gothic Sculpture in Castile

From the second half of the 15th century, Castile once again took the leading role with regard to sculpture. Prestigious commissions could be obtained, owing to increasing demand for impressive display by the court and aristocratic families and prelates who commemorated themselves by elaborate and costly tombs and church adornment. This final flowering of the Gothic style occurs in the reigns of Juan II (1406–54), Enrique IV (1454–74), and the Catholic Kings Isabella of Castile (1474–1504) and Ferdinand of Aragon (1479–1512). Besides Valladolid, the royal seats and the archiepiscopal cities, especially Toledo and Burgos, became important centers. Over several generations, masters from northern Europe settled and introduced Flamboyant forms, sometimes supplementing these with elements from local Mudéjar art (see pages 278–279).

Archival sources enable us to reconstruct the production of a group of architects and sculptors from the north who were active in Toledo after the middle of the century. The most prominent was Anequín from Brussels, who as supervisor of building at the cathedral between 1452 and 1465 directed the elaborate Puerta de los Leones on the south transept, on which his brother Egas Cueman worked as a sculptor. Egas, whose activity in Castile had begun in 1454 with the carving of the choir stalls for the cathedral at Cuenca (today in the collegiate church of Belmonte), became one of the leading sculptors in Toledo. Together with the architect Juan Guas from Lyons he created a number of important works. Commissioned by the cardinal and archbishop Pedro González de Mendoza, he worked in the 1480s with Guas on the altarscreen for the cathedral, whose luxuriant Flamboyant architecture is complemented by a wealth of figures and reliefs in alabaster. Presumably on the recommendation of the Archbishop of Toledo, the same team was retained to carry out the building and ornamentation of the Mendoza palace (Palacio del Infantado) at Guadalajara, one of the chief works of secular architecture of Castilian Late Gothic (see page 284).

It was also Juan Guas who produced the design for the building and ornamentation of the monastery church of San Juan de los Reyes in Toledo. Although documentary evidence is lacking, it is probable that the ornamental and heraldic decoration, particularly the cycles of figures in the interior, of extremely high quality, are largely the work of Egas, especially as his son, the architect Enrique Egas, also worked on the building from 1494.

Challenging commissions were offered for tombs of aristocratic families at the abbey of Guadalupe, where Egas was repeatedly engaged, for instance in 1467 to execute the tomb monument for Alonso de Velasco and his wife, completed, after several changes of design, in 1476. With this wall-niche tomb, which represents the deceased in statues in the round, kneeling in prayer, a new type of tomb monument was introduced that was to be widely imitated in Castile, especially in court circles.

In Burgos the situation with regard to commissions was comparable to that in Toledo. Whereas the building trade was virtually monopolized in the second half of the 15th century by Juan de Colonia, originally from Cologne, and his son Simón, prestigious contracts for sculpture went to Gil de Siloé, a native of the Lower Rhine or Flanders. A respected citizen, he was in charge of a large workshop at Burgos but also active in Valladolid. His earliest documented work is the carved wooden altarpiece in the St. Anne Chapel in the cathedral (1486–88), one of the earliest monumental sculpted altarpieces in Castile. Two of Siloé's main works were created between 1489 and 1499, under a contract from Isabella, for the church of the Carthusian monastery of Miraflores near Burgos, built by Juan and Simón de Colonia: the marble tomb monument of Juan II and his wife, which belongs typologically and stylistically to the tradition of Burgundian rulers' tombs but is unique in having the form of an eight-pointed star

Burgos, Cartuja de Miraflores
Tomb of the Infante Alfonso, 1489–93

Opposite:
Burgos, Cartuja de Miraflores
Altar, 1496–99
In foreground, the tomb of Juan II and
Isabella of Portugal, 1489–93

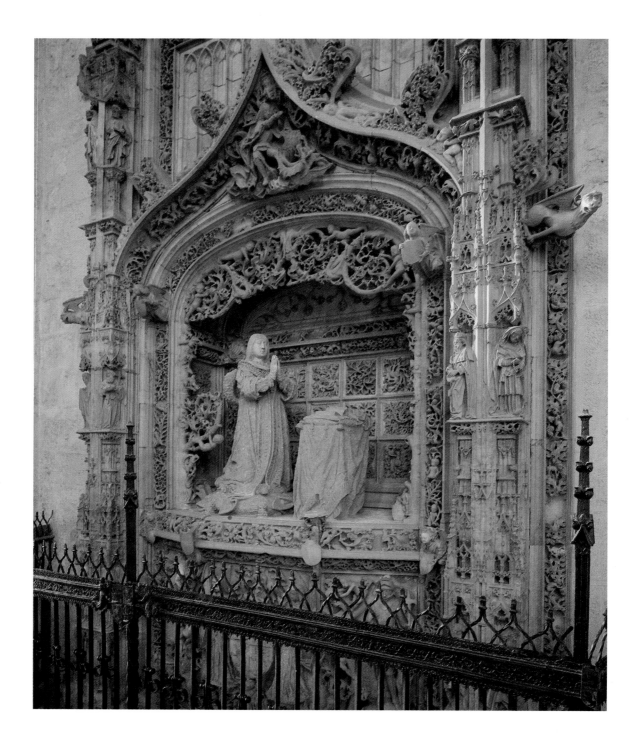

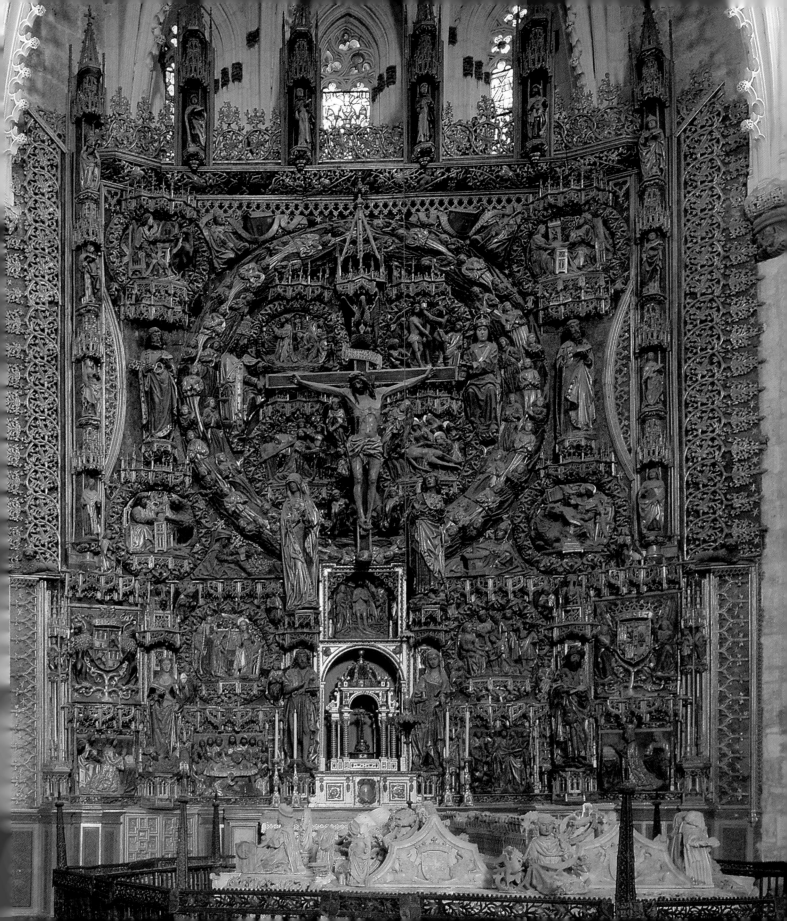

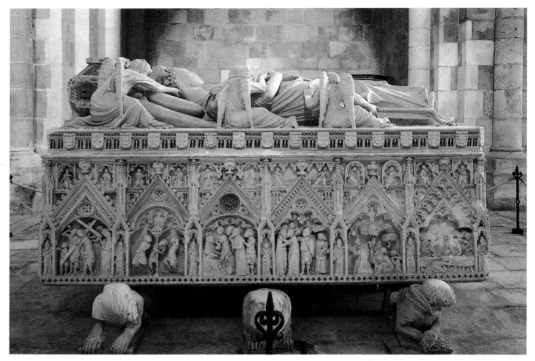

(see page 383), and the richly ornamented wall-niche monument of Isabella's brother, the Infante Alfonso (died 1468), with the figure of the deceased kneeling before a prie-dieu (see page 382). Siloé also designed the tomb monument (now in Burgos museum) of the Queen's favorite page, Juan de Padilla, killed at the siege of Granada in 1491 and buried in the church of Fresdelval. These works, with their filigree-like decoration, exquisite as goldsmith's work, and the realism with which the magnificent clothing and portraits of the deceased are rendered, are among the finest works of Spanish Late Gothic sculpture and a clear manifestation of the artistic luxury with which the Castilian court surrounded itself. A monumental altarpiece with its many figures—the Passion of Christ with the Crucifixion at the center of an idiosyncratic circular composition and the royal benefactors on the edges of the lowest register—completed Gil de Siloé's ornate decoration of Miraflores (see page 383).

Gothic Sculpture in Portugal

It was not until the late 13th century that the Gothic style became widespread in Portugal. Coimbra, seat of the Portuguese monarchs from 1139 to 1383, became a leading center of Gothic sculpture, alongside Lisbon and Évora. The most significant field for commissions was that of funerary sculpture. Some of the most important works in that field were produced by Master Pere from Aragon, active in the 1330s. These include the tombs of Archbishop Gonçalo Pereira (died 1336) in Braga Cathedral, the Infanta Vataça in the old cathedral of Coimbra, and Queen Isabella of Aragon (now in Santa Clara-a-Nova in Coimbra). Besides having a repertoire of forms strongly influenced by Catalan-Aragonese sculpture, Master Pere introduced a type of funerary monument that was to prove

influential: the sarcophagus, supported by lions, with a recumbent effigy and a Gothic blind arcade with figures of saints around its sides. The most splendid examples are two sarcophagi in the abbey church of Santa Maria at Alcobaça, dating from between 1360 and 1367, which bear witness to the love affair between the future king Pedro I (1357–67) and Inês de Castro, his wife's lady-in-waiting (see above). After succeeding to the throne Pedro ordered the making of the two sarcophagi, of white limestone and over 3 meters (9 feet) long, for himself and Inês, murdered by his father in 1355. The sarcophagi, with their dainty architectural subdivisions and the iconographically remarkable reliefs, densely packed with figures, are like exquisite carvings in ivory. The tragic love story is evoked by the scenes at the head of Pedro's sarcophagus, fitted into a rosette-like wheel of fortune.

As a memorial to the victory of Aljubarrota in 1385 against the Castilians, and as a burial-place for the Aviz dynasty, João I founded the Dominican abbey of Santa Maria da Vitória (da Batalha). The building and ornamentation of this jewel of Lusitanian Late Gothic, not completed until the 16th century, kept the best builders and sculptors occupied for decades. In 1434 the founders, João and Philippa of Lancaster, were laid to rest in a magnificent double tomb in the Capela do Fundador (see page 292). The recumbent figures, crowned by baldachins, hold hands—a motif from English funerary sculpture probably introduced through Philippa. The central part of the west façade is given emphasis by blind tracery in the Flamboyant style (see opposite, left). Its portal has 78 statues dating from before 1434 (some replaced by copies), showing Burgundian features associated with Claus Sluter. The fine reticulated and bar tracery (see opposite, top right) in the arches of the cloister by Diogo Boytac, architect to Manuel I (1495–1521), is from the last phase of the building work.

Santa Maria da Vitória (da Batalha)
West portal, ca. 1426–34

BELOW:
Santa Maria da Vitória (da Batalha)
Cloister, between 1495 and 1521

BOTTOM:
Belém, Hieronymite monastery
West portal, after 1517

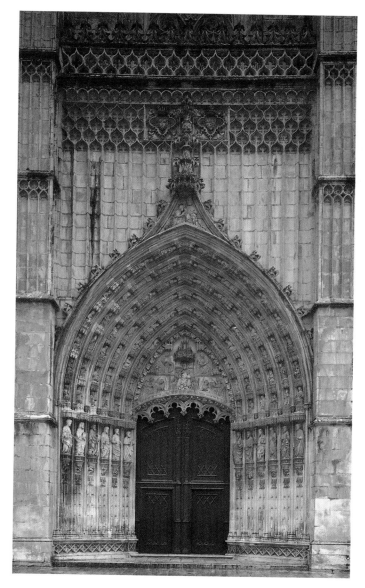

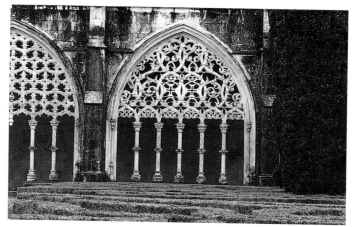

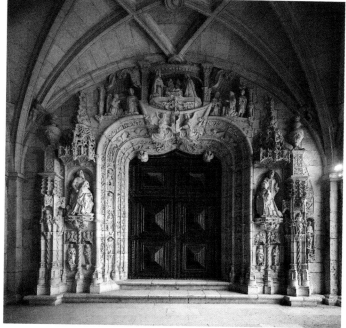

A further monument intended to celebrate Portugal's greatness is the Hieronymite monastery at Belém, founded by Manuel I after he received Vasco da Gama here in 1499 following his return from India. The south portal, executed in 1517–22 under Boytac's successor, Master João de Castilho, has on the trumeau a statue of Henry the Navigator (1394–1460), the promoter of Portuguese expansion, who had founded a chapel dedicated to the Virgin. The west portal (from 1517), by Chantarène, has kneeling figures of the founders, Manuel and his second wife Maria of Castile (above, bottom right). While the rich ornamentation still shows the characteristics of Late Gothic, the founders' portraits point forward to the Renaissance.

Ehrenfried Kluckert
Gothic Painting

Introduction

A clear definition of Gothic painting is difficult for two reasons: we need to establish a clear difference between Gothic art and Renaissance art and we also need to clarify the relationship between the art of Italy and the art of northern Europe, particularly with respect to early Netherlandish painting. As the differences between Gothic and the earlier, Romanesque period are much easier to establish, we can focus first on the main issue—how Gothic art relates to the art of the Renaissance. This should allow us to smooth out some of the inconsistencies which always arise when juxtaposing the two periods. It should also enable us to adopt a clear view of the art of the Italian 14th century, the trecento, and so determine its relationship to the art of north European painters from Jan van Eyck to Hieronymus Bosch.

Natural Space, Pictorial Space, and Everyday Life

A central problem in the issues mentioned above is the resemblance of both form and motif to nature. The following quotation provides a good starting point: "The high and the low, priests and people gather to mock God become Man. Even worthless thieves join in taunting Him. Many stand impudently before Him, raising their faces towards Him, grinning and shouting. These cruelties are committed not merely by ten or twenty, but by hundreds."

These words, taken from a sermon of the early 15th century, are typical of the medieval literature on Christ's Passion. They are also typical of the public perception of paintings, for they reappear time and again in commissions concerning altarpieces and panel paintings. The devout laity wanted to know more about the suffering and the death of Christ than they could read in the Gospels. This desire "to see as much as possible"—or, more accurately, this desire to see things in the clearest possible detail—touched both on the reality of the religious experience and on the closeness people felt it had to their everyday lives. This integration into art of events from the present demanded new ways of seeing, ways expressed in the development of different forms and new motifs.

By examining the central period of Gothic painting, between 1250 and 1450, we can clearly illustrate the aesthetic and thematic reorientation of early Netherlandish art, in particular the art of Jan van Eyck. This new art fused in an utterly captivating way traditional pictorial modes and the new demands of what a picture should represent. This development was encapsulated in the title of Hans Belting's book *The Invention of the Picture*, in which he described the continuity of the old functions of religious pictures as "a shell for a new aesthetic." Belting's belief that a new formula for painting had been found which completely determined the "European way of seeing" is a useful tool for analyzing Netherlandish painting.

It should be borne in mind that early Franco-Flemish illuminations, as well as the work of Robert Campin (the Master of Flémalle), played a decisive part in this "invention." Furthermore, Passion literature and stage design in the 14th century developed new forms of

group composition and pictorial narrative, so that Jan van Eyck or Rogier van der Weyden could refer to ready-made models of spatial composition and ways of seeing. It was the art historian Erwin Panofsky who methodically analyzed these connections, and thus placed the early Netherlandish painters firmly at the center of the art of the Middle Ages.

An analysis of the works of Jan van Eyck and Rogier van der Weyden is particularly interesting in this respect because it can help determine whether the works spanning the period from Jan van Eyck to Hieronymus Bosch belong to the Gothic or the Renaissance. The formal language of Rogier van der Weyden—which borrowed from van Eyck's realistic aesthetic in order to develop a religious narrative picture closely related to that of medieval Passion literature—contributed most to the belief that early Netherlandish painting belongs to the "Gothic camp" (even if scholars were not united in their opinions). The "van der Weyden model" was even taken as the aesthetic foundation for developments in late medieval painting in northern Europe—in other words, for the entire 15th century. So how are we to characterize Netherlandish painting in this era? The answer to this question may be found by taking a closer look at the development of Italian painting.

Hans Belting argues that the "invention of painting" occurred in the Netherlands and Italy simultaneously but independently. But there are a number of objections to this view. Certainly Netherlandish naturalism is not compatible with Florentine experiments in perspective, yet there are parallels between Giotto's construction of realistic space for his figures and the sense of space developed by other painters of the trecento. The illusory opening on a painted surface of a space in which dynamic figures could be placed and seemingly three-dimensional objects created were preconditions for Alberti's view of nature based on the science of optics.

In his celebrated treatise on painting (1436), Alberti described a technique for painting with centralized perspective, a key feature of Renaissance art. But the mathematical calculations required for constructing this perspective, which made the "new way of seeing" possible, were due in large part to Giotto's empirical research. Giotto may well have posed the crucial question: how can one create the illusion of three dimensions on a two-dimensional surface? Empirical studies also played a prominent role for Jan van Eyck one hundred years later. His solution for creating a three-dimensional depiction on a flat surface was quite different, however. As Panofsky aptly put it, he used light as though he were looking through both microscope and telescope.

That same statement applies to Italian painters from Giotto to Fra Angelico, and to Netherlands artists from Jan van Eyck to Hieronymus Bosch: just as the Italians learned to paint in a medieval style with a "modern" touch, so the north European artists of late medieval paintings moved towards the modern—that is, towards Renaissance painting.

Italy and Northern Europe

When we look at art in the years around 1300, we should be aware of the significant differences that existed between Italy and northern Europe. Only then can we appreciate the two broadly different approaches to painting and so understand more clearly the various developments that constitute "Gothic" art. The spatially accurate depiction of objects, a major concern of painting between the 13th and the 15th centuries, was not a matter that occupied only the Italians from Giotto. The French struggled with it too. Dagobert Frey argued half a century ago that in view of their imposing cathedrals, the French must have developed similar ideas about three-dimensional space in order to represent objects or space realistically. The popular sharp distinction between linear or "flat" Gothic painting in the north of Europe, and three-dimensional space in Italian painting from Giotto to the Early Renaissance is not therefore sound.

Both Giotto and the painters of the Parisian school of the 13th and early 14th centuries took a three-dimensional representation of the subject as their starting point; it was merely their concepts of space that were different. The painters of the trecento and, later, those of the Early Renaissance tried to achieve a unified pictorial representation, that is, they fused together the different parts of a painting. French artists, however, whose aesthetic model influenced the rest of northern Europe, tried rather to link all the different parts of the picture together, as if space was assembled from discrete images that could be set beside each other to form a scene (see page 388). This characterization also applies, strictly speaking, to the work of Jan van Eyck.

By describing these differing approaches to space as "simultaneous and successive," Frey introduced an illuminating insight into our understanding of this period. Frey's idea that the French had been made aware of spatial representation though the construction of their cathedrals could also be true for Italian artists. The view that artistic developments migrated in a direct line from south to north should therefore be corrected. The figures concentrated around the center (most often the keystone) of Gothic fan vaulting form a pictorial unity which relies on an abstract linear system whose individual motifs are combined in an almost Italianate manner. If certain sections of Gothic fan vaulting could be described as pictures in the widest sense, then we might be able to argue that the integration of figures into pictorial space had already begun in northern Europe when Giotto was at work in Italy.

Of course it cannot be denied that Italians provided other Europeans with important models for painting their Gothic churches. Italian painters of the trecento were at first concerned with an adequate presentation of a subject within the context of the building's architecture. They wanted to draw the pious viewer into the holy subject in order to establish a relationship between picture and believer. The church provided a frame for the religious painting in a literal and not just a symbolic sense.

BELOW:
Giotto
St. Francis in Dialogue with the Crucifix,
ca. 1295
Fresco
Assisi, San Francesco, Upper Church

BOTTOM:
St. Dionysus Enters Paris, from
Vie de St. Denis, ca. 1317
Illumination, 24 x 16 cm
Paris, Bibliothèque Nationale,
Ms. fr. 2813, fol. 474v

This was probably the reason for Giotto's invention of the wall as the foremost plane of the pictorial space. The faithful could now step, as it were, into the picture; saints became approachable. So in the Upper Church of San Francesco in Assisi, it proved possible, towards the end of the 13th century, to incorporate an external reality into the painting. This step meant a radical departure from the then dominant Byzantine style, which, though it had suggested an intimacy in the sacred, had nevertheless emphasized the inaccessibility of the saints and biblical figures.

Alexander Perrig has convincingly demonstrated that during the Middle Ages the Byzantine iconographical style was believed to be the aesthetic of early Christian painting; by order of pope and curia, it was, in both form and content, to be considered the only valid medium for religious art. In Siena, according to Perrig, the Byzantine style was the official style patronized by the state. It was precisely because of this official patronage, he argues, that Duccio's *Madonna Enthroned* was preferred to Giotto's *Ognissanti Madonna* (see page 442). In other words, for the Sienese, Giotto's naturalistic style was "false" and depicted an "unbelievable" Madonna, whereas Duccio's Byzantine style, believed to be closest to early Christian painting, guaranteed that the image was most likely to resemble the true face of the Mother of God.

Giotto and his pupils, even the followers of Duccio, moved beyond the Byzantine style in a number of ways. On the whole, a naturalistic style prevailed in Italy which consequently led to the development of new ways of seeing that were able to develop with the help of mathematical models and optical experiments based on the use of central perspective.

This critical debate between the Byzantine tradition and the naturalistic style was a major theme in Italian Gothic painting. The expression "painters of the trecento" should therefore not be used in a limited sense, but should be extended to include, for example, some of the painters of the 15th century, such as Fra Angelico or Pisanello. This would still enable us to exclude their contemporaries such as Masaccio and Uccello, and establish a sufficiently clear division between Gothic and Renaissance painting. It can therefore be argued that the foundations of Renaissance painting are to be found around 1300—even if the development of central perspective was to take another hundred years.

Cultural and intellectual changes are often accompanied by other turbulent events. The era from the end of the 13th century to the end of the 14th century was a time of great upheaval. The foundation in 1296 of the Hanseatic League in Lübeck, quickly followed by the establishment of other Hanseatic towns in Germany and the Baltic region, led to a flourishing economy which strengthened the merchant class in the many cities of northern Europe. The feudal order which dominated the social structure of the early and high Middle Ages was slowly supplanted by a social order which was based on class. The so-called Hundred Years' War between England and France

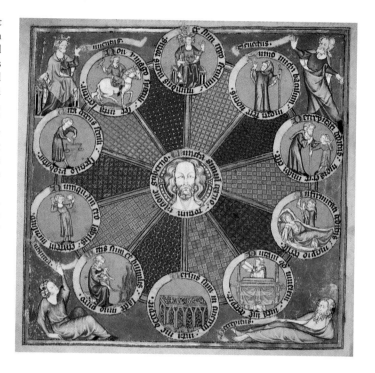

Wheel of the Ten Ages of Man, from
Psalter of Robert de Lisle, before 1339
Illumination, 34 x 22.5 cm
London, British Library,
Ms. Arundel 83, fol. 126v

(1339–1453) ravaged both countries and resulted in significant economic decline for them both. Furthermore, the Black Death (1347–51), the scourge of the 14th century, almost certainly wiped out at least a third of Europe's population. Finally, Christendom was shaken by political and religious struggles that led to the so-called Babylonian Captivity, when the papacy was based not in Rome but in Avignon in the south of France (1309–77), and then the Great Schism.

This period, then, could be characterized as a "threshold era." The beginnings of humanism and the development of non-courtly literature indicated the emergence of society into the modern age. But the proscriptions of the Church against progressive Nominalistic teachings (see page 394) and sects such as the flagellants also indicate the persistence of a somber conservatism.

The persistence of the old Byzantine style and its north European variants, a style that seems stiff and artificial compared with the flowing elegance of Gothic styles, as well as a growing sensitivity towards the natural world and its depiction in art, can be seen as responses to the complex cultural, social, political, and religious developments of the age.

The Transformation of Art in the 13th Century

Like the 14th century, the 13th century was a time of disruptive change and instability. With the decline of the Hohenstaufen empire, small independent states developed and, with them, the middle classes. The age's religious tensions can be seen in the opposing political beliefs and ambitions of two brothers: Louis IX (1226–70), later canonized as *rex exemplaris* (a model king), and Charles of Anjou (1266–85), who embroiled the papacy in his policies of aggrandizement.

Within the Church itself there were profound changes. The Cathars and other suspect groups were termed "heretics" and crushed in bloody wars (see pages 116–117), while on the other hand—and in some ways just as challenging to the Church—the Franciscan and Dominican preaching orders integrated their lay brotherhoods into the life of fraternal love and poverty. Even pagan schools of philosophy from classical antiquity were becoming incorporated into the teachings of teachers and theologians, despite the attempts of the Church to control them.

This, then, was the background for changing views on painting. Themes and motifs became richer. The changes in the depiction of Christ crucified, for example, are emblematic of the beginning of the Gothic period. The elegance of the women mourning at the Cross stands in stark contrast to the tortured body of Christ; the swooning Virgin, her reaction all too human, is supported by her companions; a servant helps the blind spearbearer. The Crucifixion was being transformed into a story, into a form known as the Crucifixion with figures type. The realism with which the pain and suffering of an execution, a scene completely comprehensible to a medieval viewer, were depicted indicates the first awakenings of a naturalistic style. This growing naturalism took many forms in Gothic art, and would

eventually lead to the brilliant achievements of the early Netherlandish painters.

Another indication of the way in which everyday life was being incorporated into early Gothic painting is the popularity of books of hours. These were used not only as prayer books, but also as a source of aesthetic pleasure, for they were illustrated with exquisite illuminations. At the end of the 13th century they had become so richly embellished and decorated that they were traded as luxury articles, particularly at the French court of Louis IX (St. Louis). The most famous workshops were in Paris, and they contributed greatly to the spread of new images and forms in European art.

Formal Aspects of Early Gothic Painting

Gothic painting did not develop seamlessly from Romanesque painting—quite the opposite. The diaphanous structure of Gothic architecture, with the walls of the cathedral broken up by delicate tracery and vast windows, denied artists the surface on which to paint. The onset of Gothic cathedral building had coincided with the high point of Romanesque painting, especially mural painting. Soon afterward, however, other artistic techniques became dominant and painting was forced into a secondary role. This subordinate status of painting at the time of the construction of the first Gothic cathedrals

St. John Shown Heaven, from
English Apocalypse, ca. 1250
Illumination, 27 x 19.5 cm
New York, Piermont Morgan Library,
Ms. 524, fol. 21r.

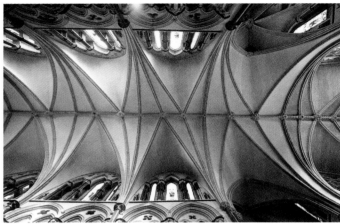

Lincoln Cathedral, St. Hugh's Choir
"Crazy Vault," 1192, rebuilt 1239

can also be seen in the techniques adopted by painters, who often tried to imitate the predominant, and costly, techniques of mosaic and stained glass.

This transitional period was followed by a highly productive relationship between painting and architecture that gave rise to interesting themes and variations. Often painting was given a higher aesthetic value by using motifs and structures borrowed from architecture. An illustration in the *Psalter of Robert de Lisle* from before 1339 (see page 389) shows the *Wheel of the Ten Ages of Man* featuring an all-knowing God in the center. The inspiration for this picture was without doubt the rose window of the Gothic cathedral. The spaces between the rays emanating from the countenance of God are ornamented with star and tile shapes that imitate the ribbed vaults of a Gothic cathedral.

Another example of painting's use of architectural motifs can be seen in the *Psalter of St. Louis*, where there is an image of a church very similar to the Ste.-Chapelle in Paris, which Louis commissioned at around the same time. Lancet windows, trefoils, quatrefoils, and rosettes became part of the standard decorative program.

But the design of an English illustration from around 1250 is remarkable in this respect (see above, left). This scene from the Apocalypse, in which an angel is depicted indicating the Holy City of Jerusalem to a kneeling St. John, recalls formal concepts derived from Romanesque art. It is characterized by the stark diagonal of the composition: the line of St. John's back, the movements of his arms, the gesture of the angel, and the positioning of its wings result in an almost eccentric distortion of the figures as they attempt to conform to a dominant diagonal. A similar asymmetrical rhythm can be found in the so-called "crazy vault" of Lincoln Cathedral choir (see above, right). Here a symmetrical order is disturbed by a rib that rises steeply from the triforium to join a boss on the ridge rib at an unex-

pected angle. In this way the organic structure of the vault becomes animated and the diaphanous walls seem to soar as a result. The same intention to animate a scene presumably underlies the English Apocalypse miniature. There are many such examples of artists of this period drawing ideas from other art forms.

New Genres

We have already seen that there were more than just changes to styles during the development of Gothic painting. The exploration of new forms also meant the exploration of new themes for painters and patrons alike. Until now, the spectrum of Gothic painting had been dominated by devotional pictures, altarpieces, and fresco cycles illustrating the lives of the saints. This situation did not change, but now new themes and different motifs were explored through the artistic back door, so to speak.

The tension between religion and everyday life produced new genres that in the 14th century were still inseparable from the religious subject. The first tender shoots of identifiable flowers appear between the feet of saints and angels (see page 435, top). The Virgin's chamber, where she is surprised by the angel of the Annunciation, is usually decorated with an elegantly fashioned candelabra and a proudly standing lily. These depictions of nature, of real life, which formerly functioned merely as artistic attributes, as "pseudo still lifes," began to assume their own separate existence. Giotto, for example, painted a *trompe l'oeil* chapel niche with a candelabra in the Arena Chapel in Padua (see opposite, left). And Taddeo Gaddi, a pupil of Giotto, placed an arrangement of pyx, paten, and flasks in a painted, trefoiled niche (see opposite, right).

These are among the first still lifes, a genre which Netherlandish painters went on to develop superbly in the 15th century. A candlestick and candle, a book and stitched coverlet on a table next

to the Virgin in an Annunciation still had symbolic meaning, but increasingly they also formed a separate ensemble with their own aesthetic value.

Similarly, early landscape painting took its form and composition from religious themes such as the Holy Family fleeing to Egypt. Gradually the figures depicted grew proportionately smaller so that already by the 15th century we can speak of a "landscape with saints," and not vice versa. Yet it was not only religious subjects which led to new forms and genres.

The renewal of European landscape painting occurred in Siena around the middle of the 14th century, when Ambrogio Lorenzetti painted a huge panoramic landscape in the town hall of Siena, using it as a backdrop for the *Allegory of Good Government* (see pages 448–449). An ascent of Mont Ventoux in southern France by the Italian poet Petrarch played a major role in the genesis of such works, as we shall see later (see pages 394–395).

In many Gothic paintings there is also clear evidence of another factor that sparked the development of a new genre: the patron. Patrons increasingly wanted to participate in sacred events in a believable, highly realistic manner and, through their presence, lend verisimilitude to the divine vision. They therefore had to be portrayed as recognizable individuals devoutly practising their religious duties (see page 392). Formally, the scenes of a diptych, the dominant form of domestic altarpiece, for private devotion, were divided equally between the patron and the saint on one panel and the Virgin on the other. This new artistic concept of devotion and worship was the starting point for the development of European portraiture (see pages 454–455).

The Patron and Artistic Content

It is almost impossible to reconstruct the relationship between the medieval patron, the artist, and the person who determined the content of a painting. Records are few and far between, but some have been found which throw light on the genesis of a picture and its themes and motifs.

During the High Middle Ages it was largely theologians who were responsible for determining the composition of motifs in a large picture (the iconographic program), but in the late Middle Ages religious and secular clients came in turn to assume this role. These clients did not necessarily design the iconographic program of the image themselves, but they often influenced it and frequently prescribed certain key motifs.

RIGHT:
Giotto
"Still life" on triumphal arch wall
Fresco, 1305
Padua, Arena (Scrovegni) Chapel

FAR RIGHT:
Taddeo Gaddi
Niche with Paten, Pyx, and Flasks
Fresco, 1337–38
Florence, Santa Croce

Jan van Eyck
Canon Georg van der Paele Kneeling,
detail of *Virgin of Canon Paele*, 1434–36
Oil on wood, 141 x 176.5 cm
Bruges, Stedelijk Museum voor
Schone Kunsten

The decoration of the Arena, or Scrovegni, Chapel in Padua is a case in point. The donor of the chapel, Enrico Scrovegni, was granted the right to call himself the sole possessor of the chapel by the pope. Scrovegni then engaged a so-called "deviser," a theologian from the nearby Franciscan house, both to ensure the accuracy of the biblical scenes depicted in the frescoes, and to make sure that his wishes were satisfied. Alexander Perrig has pointed out that the large number of figures in the *Flight to Egypt* scene in the Arena chapel is not justified by reference to the Gospels or the Apocrypha. Scrovegni may well have been giving his vanity free reign by having the Holy Family accompanied by merchants, thereby drawing attention to his own profession.

The altarpiece which was commissioned for the high altar in St. Peter's Church in Hamburg, painted by Master Bertram, presents us with an entirely different case (see page 433). We know that its deviser was Wilhelm Horborch, son of an established patrician family. Horborch was also papal nuncio and deacon of the cathedral. We know too that it was Horborch who commissioned Master Bertram to execute the design.

The altarpiece's program is relatively simple and one wonders why such a busy and highly educated person would set himself a task which could have easily been dealt with by a theologian. The reason may have been secular vanity. Wilhelm's brother, Bertram Horborch, was at the time the mayor of Hamburg and had been granted the right to call himself "patron of St. Peter's." One can assume that the brothers, in an effort to enhance the prestige of the family, wanted to be clearly seen as the altar's donors.

For many donors it seemed that only art could portray the reality of religious meditation, make tangible the vision of the pious, and ultimately prove the living presence of God. At the beginning of a prolonged illness, to which he was eventually to succumb, the Flemish canon Georg van der Paele commissioned from Jan van Eyck a *sacra conversazione*, that is, the portrayal of a meeting between himself, two saints, who intercede for him, and the Virgin in his parish church, the collegiate church of St. Denis in Bruges (see right, and page 411).

As Hans Belting has perceptively pointed out, the painted scene imitates the real church and thus elevates the picture into the realm of everyday reality. By means of this picture, Canon van der Paele establishes not only the reality of his vision but also the fact that he has been especially blessed by being permitted to pray at the throne of the Mother of God herself.

These examples from areas as diverse as Italy, Germany, and the Low Countries demonstrate not only the intentions of the donors and patrons, but also, through their composition and motifs, the social and intellectual concerns which preoccupied the age. It was the aesthetic model that the artist had already developed which appealed to the client and so led to a commission being offered in the first place.

The Characteristics of Gothic Painting

The variety of styles and motifs in Gothic painting, which also differed in style from one region to the next, does not allow us to state clearly what the "Gothic formula" is. This has not, however, stopped many people trying to establish such a formula, a formula that would provide clear principles for interpreting Gothic painting and determining its essential characteristics. For such a formula to be established, clear distinctions have to be made. In this case, the most important distinction is between Gothic art and the art of the Renaissance.

In his classic study of this period in northern Europe, *The Waning of the Middle Ages* (1919), the Dutch historian Johan Huizinga claimed that we need to trace the term "Renaissance" (which does

BELOW:
Emperor Charles IV and Charles V of France Watch a Play on the Crusades, from *Grandes Chroniques de France*, ca. 1380
Illumination, 35 x 24 cm
Paris, Bibliothèque Nationale,
Ms. fr. 2813, fol. 474v

BOTTOM:
Albrecht Dürer
Whore of Babylon, from *Apocalypse*, 1498
Woodcut

not in itself, like medieval, imply a limited period) back to its original meaning. Sluter and van Eyck most definitely did not belong to the Renaissance: they smack of the Middle Ages, both in form and in style. For Huizinga, the work of van Eyck and his followers is the mature fruit of a truly medieval spirit in its effort to render everything in paint as physically as possible.

We have already observed that the use of light as a means of conveying physicality was one way of renewing the power to see. Nevertheless, the traditional origins of this new way of perceiving physical form could also be examined in terms of how objects in the picture are constructed. The figures and groups in the *Ghent Altarpiece* by the van Eyck brothers (see pages 408–409), for example, occupy certain clearly defined segments of the picture, but their relationship to each other is more decorative than natural.

This characteristic was a set feature of 13th- and 14th-century painting in northern Europe as well as in Italy, still under Byzantine influence (for example, the work of Cimabue or Duccio). Gothic painting in the north of Europe still clung to the notion of isolating the figure, as was the case in the Romanesque tradition, where each figure or object was to be read as a sign.

The ornamental structure separated the parts rather than connected them and so forced the viewer to read the elements of a picture in succession. Pictorial representation seemed to orient itself to the metaphors of language, so that the theme of a text could be translated directly into a pictorial narrative (see right, top). This technique was also employed in many trecento fresco cycles, the difference being the aspects of spatial composition we have already touched upon in relation to trecento painting.

The uniquely "Gothic" aspects of Gothic painting may perhaps be explained by its emergence from Romanesque or Byzantine traditions. Familiar terms like "naturalism," "conservatism," or "elegance" refer only to the expressive aspects of Gothic art and should not be taken as its defining characteristics. If we develop Huizinga's ideas on the development of painting from the late 13th to the 15th century, we are led to the conclusion that Gothic art reached its zenith in the work of the early Netherlandish artists.

Despite this, the term "early northern Renaissance," which Heinrich Klotz has recently applied to Jan van Eyck and his followers, cannot be dismissed. Many paintings evince both old and new traits, and precise points of transition are hard to define. Moreover, the language of art history is often too inflexible for cultural crossing points, whether they relate to time or place.

Albrecht Dürer's *Apocalypse* woodcut cycle from 1498—he started the cycle after his first journey to Italy in 1494–95—appears almost medieval, in other words Gothic, in the conception of its narrative. Dürer nevertheless composed the successive scenes in a unified space that precisely determines the perspective of the observer. Dagobert Frey is correct in remarking that the Middle Ages and the Renaissance meet in Dürer's *Apocalypse*.

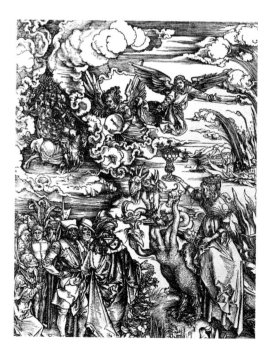

Master of the Wilton Diptych
Wilton Diptych
Richard II of England (left panel,
kneeling) is presented to the Virgin (right
panel) by his patron saints, between 1377
and 1413
Tempera on wood, each panel
46 x 29 cm
London, National Gallery

Subjectivity, Beauty, and Nature: Medieval Theories of Art

Three things characterized medieval thinking on art, and therefore the changes in its forms and structures: how the subject was defined, reflections on beauty, and the discovery of nature as a legitimate source of aesthetic and emotional experience.

The commonly held view that the medieval artist saw himself as a divine instrument because he had placed his talents in the service of God is not entirely accurate. Medieval painting was not merely a reflection of the supernatural but, in some respects, also a representation of a sometimes secular world in which everyday objects and events featured (see pages 448–449, top).

The title of Umberto Eco's novel *The Name of the Rose* is an allusion to these observations on discrete objects and reflections on their reality. One of the central philosophical issues of the Middle Ages, the problem of universals, figures prominently in his novel. For the Realists, such as Anselm of Canterbury (1033–

1109), individual things depended for their reality on the general terms (universals) they exemplify; universals were, as it were, "more real" than individuals.

The Nominalists, on the other hand, like Roscelin of Compiège (ca. 1050–1123/25) and Peter Abelard (1079–1142), maintained that general terms were nothing more than words or *nomina* (names), that is, abstractions of the mind. For the Nominalists, only individual things really exist. The "name" of the rose was not reality, but simply a generic term. Only as an "individual thing" does the rose become real.

This early discussion on the essence of reality is evidence of the tendency to elevate the significance of nature and common experience. It was related to the medieval treatment of classical philosophy, particularly the work of Aristotle. St. Thomas Aquinas (1221–74) is the most important figure in this context, for his system of thought borrowed heavily from the logical and systematic character of the recently rediscovered Aristotelian philosophy.

According to Aquinas, the work of art was only a mirror image of the physical world, which was in itself a metaphor for the divine cosmos. In the first volume of his *Summa Theologica*, his most important philosophical work, and arguably the greatest of the Middle Ages, Aquinas argues that the senses are drawn to order and harmony and seek them in beauty; we receive pleasure from beauty because the senses perceive its inner harmony. He concludes that perfection, balance, and clarity are the preconditions for beauty.

The artist should give the work "its best physical form" according to its function. "The artist makes a saw from iron so that it can be used for sawing. He does not think to make it from glass, which certainly is the more beautiful material, because such beauty would prevent the use of the saw."

On the one hand, Aquinas relates the term "beauty" to the subjective judgment of the maker (artists and craftsmen were not yet considered separate professions) and, presumably, of the viewer of the work. In modern terms, he searched for

the characteristics of beauty in the subjectivity of the observer. But, on the other hand, Aquinas also limits the significance of subjectivity: a strictly personal approach to the beauty of an object should not be allowed to contradict its fitness for use. In other words—and here we must formulate the problem in modern terms once again—the creation of an object, and our subjective reaction to it, should always be tested against its potential practicality.

Aquinas was a liberal on the issue of universals. Like the Nominalists, he emphasized the reality of individual things, but only to the extent that they could be deduced from universals. God's universe is real, as are the individual things which are the reference points for His creation.

The recognition of the reality of individual things was the result of an empirical shift triggered by increasing familiarity with Aristotelian thought. In this respect it is interesting to note that the formal arrangement of figures in Gothic painting usually remains traditional. What changes is the growing desire to individualize the figures.

Whether placed in angelic groups surrounding the Virgin or in mass scenes of the Last Judgment, the single figure becomes more particularized and receives a unique profile. Physiognomies become identifiable and body movements stand out from the overall group pattern, which thereby becomes increasingly complex (see left).

For St. Thomas Aquinas, beauty was a means of gaining a knowledge of goodness and truth; the ordering inherent in the senses created the preconditions necessary for this to happen. The *delectatur in rebus* (pleasure in things) was therefore attributable to the realm of knowledge rather than the realm of feeling. Aquinas never discussed pure feeling in this context.

The Italian poet and scholar Francesco Petrarca, better known as Petrarch (1304–74), on the other hand, reflected upon the pleasurable effects of beauty in terms of feeling and sensibility. He was arguably the first person to celebrate a real landscape as an aesthetic and emotional event.

Knowing full well that he was undertaking "a spiritual border crossing," he made the decision to climb Mont Ventoux during his stay in southern France. In a letter from 1336 he described his feelings upon viewing the

Robert Campin (Master of Flémalle)
Virgin and Child Before a Firescreen, ca. 1425
Paint on wood, 63.5 x 49 cm
London, National Gallery

magnificent panorama which opened up before him at the summit. "The snow-covered and frozen Alps seemed almost within reach, and yet were so far away. I felt I was able to breathe the air of Italy better than I was able to see it, and I felt an irresistible desire to see my friends and motherland again."

Petrarch helped to transform the landscape in painting. From being mainly a backdrop for biblical events, it became something able to touch our souls. Gradually, standard Christian subjects such as the Crucifixion, the Lamentation over the Dead Christ, or the Rest on the Flight to Egypt were integrated into a landscape which, in all its multiplicity, incorporated worldly features such as rivers, mountains, forests, and fields.

Closed rooms in depictions of the birth of the Virgin or the Annunciation now had open windows that gave a view out on to a wide landscape, as if the holy events were happening in a building on the summit of a hill. The view through the window became a landscape painting (see right).

Even when the relationship between pictorial space and pictorial motif was derived from the Christian message of salvation—a message that embraced "the whole world"—it now also had an emotional aspect. Scenes from life, together with common animals and plants, form familiar, everyday scenes to which the viewer can relate directly.

Even the intimate depiction of the Mother of God breastfeeding the Christ Child, a type of painting known as the Madonna Lactans, probably served to strengthen the emotional bond between the believer and the subject depicted.

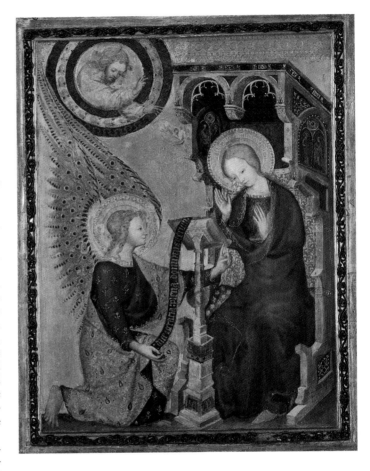

French Master (?)
Annunciation, ca. 1375
Paint on wood, 35 x 26 cm
Cleveland, Museum of Art

France and International Gothic

The "Soft Style" (Pinder), "International Gothic" (Courajod), and "Courtly Art around 1400" (Bialostocki) are all descriptions of a European style in sculpture and painting which is distinguished by softly flowing drapery, elegant or even stylized movement, and highly realistic, opulent ornamentation. The French art historian Louis Courajod used the term "International Gothic" in the 19th century to describe French painting during the reign of Charles VI (1380–1422), and by doing so placed it in a thoroughly European context. The complex network of family relationships and political ties within the ruling classes in the 14th century led to the development of a lively exchange of artistic ideas. International Gothic was a courtly and international style, influenced mainly by the painting of Siena, France, Cologne, and Bohemia.

The residence of the popes in Avignon (see pages 188–189) brought Italian artistic ideas to France and profoundly influenced the style of the Parisian school. Through political contacts these ideas were relayed to the court in Prague and thus quickly reached Bohemian workshops.

Compared with illuminations, little has come down to us of French Gothic panel and mural painting. The few examples that have survived, however, give a rough approximation of the style. The Italian factor certainly played a significant role. The influence on French art of Simone Martini, who worked in Avignon from 1339, can be seen in the *Annunciation* in the Cleveland Museum of Art (see right). The attribution of this panel to a French master is still debated by scholars, but certain characteristics, such as the color scheme and ornamentation, clearly point to a Parisian workshop. The architecture of the Virgin's throne as well as the gold background and ornamentation may have been influenced by Sienese painting. We can even trace Byzantine forms in some of the details of the jewelry.

The *Wilton Diptych* (see page 394), a painting probably commissioned by Richard II of England in 1395 and almost certainly executed in a French workshop, also illustrates the International Gothic style well. The faces of the saints on the left, and the elegant, almost stylized movements and gestures of the Virgin and the angels on the right, all point towards stylistic affiliations with workshops in Bohemia and Cologne. The identity of the master who painted it is still unresolved, as is its precise theme.

Equally unclear is its date. Did the king commission the work on the occasion of his coronation in 1377? Or did he seek divine protection before his crusade in 1395? Erwin Panofsky maintains that the work was not painted until after the death of Richard, to accompany the ceremonial passage of his body from Kings Langley to Westminster Abbey in 1413. This would mean that the picture is not a votive picture, as is commonly believed, but is instead a posthumous glorification of the king.

The lack of similar work in England is often given as a reason for attributing its provenance to a French School, and it is generally assumed that a French artist was called to the English court. Panofsky, however, associates the diptych with Melchior Broederlam from Ypres, an artist who worked for the court in Burgundy, and so relates it to a corpus of work belonging to the School of Ypres. These questions of style and attribution are never easy to resolve, but they do shed light on the intense contact between neighboring countries and the artistic exchanges which took place across their borders.

Melchior Broederlam from Ypres, Jean Malouel from Gelderland, Jean Beaumetz from Artois, and Henri Bellechose from Brabant were the most important painters at the splendid Burgundian court in Dijon. Together with the Flemish sculptor Jacques de Baerze, Broederlam created the altarpiece of the Carthusian monastery of Champmol in Dijon between 1392 and 1397 (see opposite). A comparison of Broederlam's figures and their movements, gestures, and features in this altarpiece with those of the *Wilton Diptych* goes

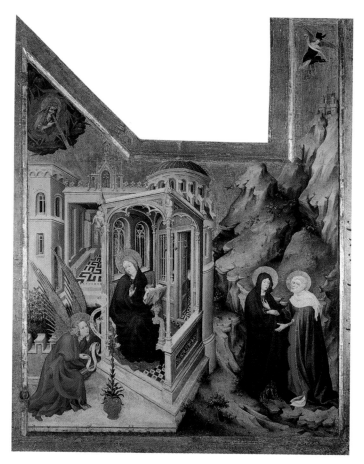

some way to support Panofsky's attribution of the *Wilton Diptych*. Furthermore, Broederlam clearly divided the scenes from the life of the Virgin between landscape and architecture. The interior scenes of the Annunciation and the Presentation at the Temple take place in the cross-section of a lavish architectural setting, which allows the events to appear as if they were happening on a medieval stage. The buildings are set hard up against mountains and trees that rise steeply to the upper part of the picture. In this part of the picture, two other events, the Visitation and the Flight into Egypt, are portrayed on the same level as the architectural scenes. There is much here which recalls the painting of the Italian trecento, for example the clear division between architecture and landscape, an architecture scaled to match the human body, and mountains that look like oversized boulders. It may be that Avignon once again played a mediating role.

A panel painting by Jean Malouel and Henri Bellechose in the Louvre in Paris shows a fascinating interplay of architecture, gold background, and landscape. The painting, which was completed shortly after 1400, shows Christ on the Cross and the martyrdom of St. Dionysus. Malouel, a native of Gelderland, was commissioned to do further work by the court in Dijon, for he settled in the Burgundian capital. It is likely that he painted only the upper part of the picture and was then unable to finish the rest; it was eventually completed by Henri Bellechose, who arrived in Dijon sometime before Malouel's death in 1419.

The masters we have just discussed, especially Broederlam, were practitioners of Gothic naturalism, which is considered a specific branch of the Burgundian School. With the work of the Master of the Annunciation from Aix-en-Provence and Enguerrand Quarton (Charonton), French painting had almost reached the limits of medieval painting.

The Aix *Annunciation* (see page 398, top), commissioned by the cloth merchant Pietro Corpivi around 1445, shows the influence of the van Eyck brothers, particularly in the realistic details, but also reveals Provençal or Italian features, such as the intense use of light. The oversized figures of the Virgin and the angel, which look as if they have been carved from stone, are depicted inside a Gothic church, the perspective making them appear as if they are an actual vision in this house of God. Quarton sought to portray his figures three-dimensionally, but he placed them in groups in a space in which the figures could move and express themselves through gesture (see pages 398, bottom, and 17).

That these innovations should be so striking in Provençal painting may once again indicate the influence of Avignon, though Flemish influences were strong too. Even the birthplace of modern painting, Italy, was influenced by the great Flemish painters such as Jan van Eyck and Hugo van der Goes.

The painter Jean Fouquet is considered to be the most important figure in 15th-century French painting. Born around 1420 in Tours, where he died 60 years later, he eagerly studied the painters of the early Italian Renaissance. Masolino, Uccello, and, particularly, Fra Angelico all influenced his figurative style. Fouquet was, according to the later accounts of the Italian writers Filarete and Vasari, a highly regarded painter who painted a portrait of Pope Eugenius IV (1431–37) for the church of Santa Maria sopra Minerva in Rome (now unfortunately lost). A handwritten note which was made shortly after Fouquet's death in 1480 by François Robertet, secretary to Peter II of Bourbon, mentions miniatures which Fouquet apparently made on the commission of Louis XI (1461–83; see page 464, bottom).

Fouquet's Italian influences can be seen in his double portrait *Étienne Chevalier with St. Stephen* from around 1450 (see page 400, left). The almost three-dimensional figures are pictured against a rich architectural backdrop with marbled walls and delicately

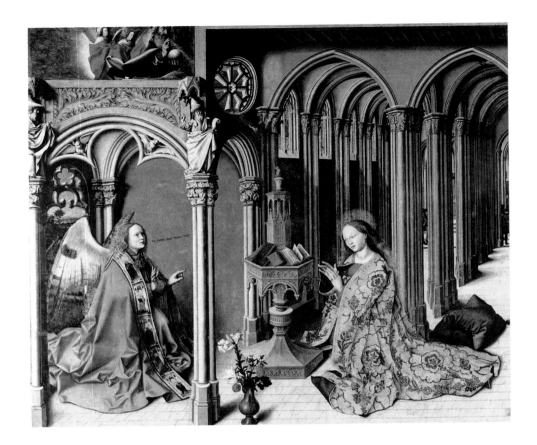

Master of the Annunciation of Aix
Annunciation, ca. 1440
Middle section of a triptych
Paint on wood, height 155 cm
Aix-en-Provence, Ste.-Madeleine

Enguerrand Quarton
Avignon Pietà, ca. 1470
Paint on wood, 163 x 218 cm
Paris, Louvre

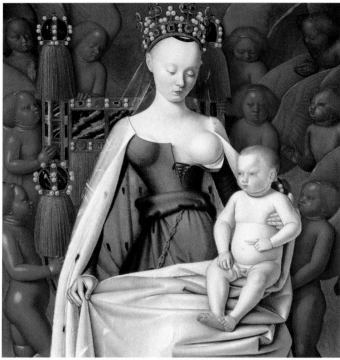

ornamented pilasters and *lisières*. This picture is possibly connected with the "Dame de Beauté," the *Virgin and Child* in Antwerp (see above, right). The panels form a diptych and were, according to Denis Godefroy, a 17th-century antiquarian, in the church of Notre-Dame in Melun until 1775.

Godefroy even claimed that the Virgin bore the features of Agnès Sorel, mistress of the king. The patron in this case, Étienne Chevalier, was the royal treasurer, executor of Sorel's will, and presumably also her lover. Whom was Chevalier worshipping in this "fashion model" (as Johan Huizinga has described this Virgin)—the Mother of God or his own mistress? The increasing overlap between the secular and the sacred which, according to Huizinga, was a widespread phenomenon in the late Middle Ages, here goes well beyond the bounds prescribed by a liberal humanist mind and indeed lends the picture more than a touch of decadence.

Nicolas Froment (ca. 1435–ca. 1485) is, along with Enguerrand Quarton, the most prominent representative of the Avignon School. In his painting *The Burning Bush*, the central panel of a triptych painted about 1476 for the church of St.-Sauveur in Aix-en-Provence (see page 399), a wide landscape, whose perspective is rendered largely by subtle modulations of color, spreads out on both sides of a hill. The strongly foreshortened river winds through slender trees in the middle of the picture then, lined by saplings, disappears in the distant blue haze. The hill with the burning bush, above which sits the Virgin holding the Christ Child, rises like a monolith from the landscape and forms an arc (a technique which is peculiar to Froment) linking the upper half of the picture to the foreground, which is dominated by the figures of Moses and the angel.

In contrast to this panel, which acknowledges the influence of Italian quattrocento painting, the so-called *Lazarus Triptych* from 1461 now in the Uffizi in Florence (see opposite, top) was strongly influenced by Flemish painting. The foreground in the left panel is wholly occupied by a group of tall figures who obstruct the view to the middle ground. In the background, and therefore confined to the upper third of the picture, a panoramic landscape of hills and trees opens out which is bounded by a walled town with bastions and towers.

The spectrum of the Provençal School in the middle of the 14th century was broad, as the diverse work of Froment, Quarton, and other southern French masters shows. Flemish and Italian styles and concepts were familiar to them, but were adapted and modified in various ways.

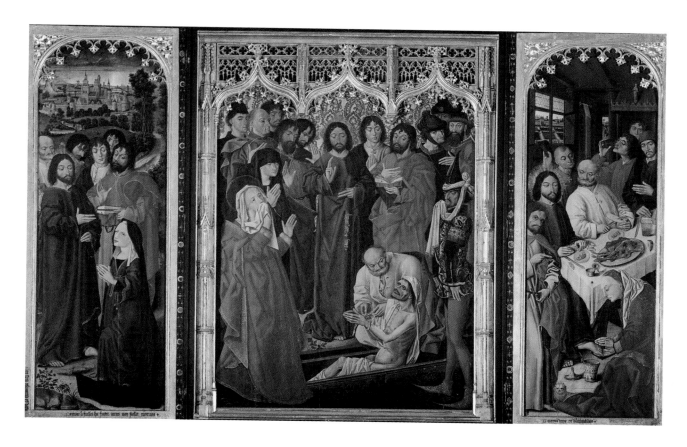

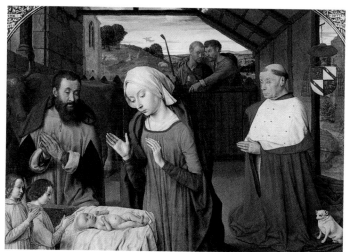

The figures of the Master of Moulins, in turn, are much softer, daintier, and less intense than those of the Provençal masters. The coloration and shapes of Jean Fouquet, who clearly influenced the Master of Moulins, are moderated. The *Nativity with Cardinal Rolin* (see left) uses Flemish compositional patterns, with the figures loosely arranged around the Christ Child. More precisely, the ox and ass, the dilapidated roof, and the marble column—which symbolize the fabric of Christ's Church—all point to the circle of Rogier van der Weyden. The faces of the figures, the treatment of the drapery, and the calm movements of the figures, on the other hand, indicate the influence of contemporary Italian artists like Perugino, Ghirlandaio, or Giovanni Bellini.

This work is probably the clearest indicator of the intersecting Flemish and Italian influences which played such an important role in French painting in the 15th century. These two characteristics—the keen study of the Italian early Renaissance styles, and the simultaneous adaptation of Flemish models—neatly define the painting of this period in France.

Fourteenth-century painting witnessed a significant change in the depiction of architecture. Whereas architecture had formerly served as a means of structuring or decorating the painting, it now attained the status of a motif in its own right. Pictorial architecture did not lose its structural function, but it was now more fully integrated into the composition of the painting, and buildings and interiors gained in importance as a subject in their own right.

Giotto's use of architectural motifs in the Upper Church of San Francesco in Assisi illustrates this development well (see page 388, top). Although the building

OPPOSITE:
Rogier van der Weyden
Pierre Bladelin Triptych, detail,
ca. 1445–50
Painting on wood, height 91 cm
Berlin, Staatliche Museen–Preussischer Kulturbestitz, Gemäldegalerie

LEFT:
Boucicaut and the Bedford Master
Palace of the Great Khan, from *Book of the Wonders of the World,* ca. 1410
Illumination, Paris, Bibliothèque Nationale, Ms. fr. 2810, fol. 37

BELOW:
Master Francke
Miracle of the Wall, detail from
St. Barbara Altarpiece, 1410–15
Paint on wood, 91.5 x 54 cm
Helsinki, Kansallismuseo

Courtesan at Table, from *Ducal Terence,* ca. 1405
Illumination, Paris, Bibliothèque Nationale, Ms. 664, fol. 209v

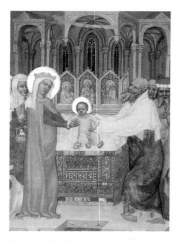

Konrad of Hainburg
Presentation at the Temple, from *Laus Mariae,* ca. 1364
Illumination, Prague, University Library, National Museum

is not constructed according to the system of central perspective, it is nevertheless painted as if it could be entered directly. Certain aspects of the architecture such as the missing tiles on the roof, the broken clerestory, and the missing sections of west wall have been consciously depicted to represent the building as if it had been actually built and then partly dismantled. This technique enhances the reality of the motif and therefore of the holy event that is being depicted depicted. Furthermore, Giotto avoided overlapping the building with the frame of the picture in order to present the church as occupying its own complete and tangible space.

Giotto was a major force in the development of European painting, particularly because of his ability to create the illusion of three dimensions on a two-dimensional surface. Gothic painters north of the Alps, on the other hand, found it harder to break out of the traditional style than the painters of the Italian trecento did. The compositional relationship between architecture and figure demonstrates this difference particularly well. In illuminated books of the 14th and early 15th century, illustrators often copied Giotto's concept of allocating each figure a specific space in which they can act.

In an illustration from the so-called *Ducal Terence* from the early 15th century (see left, top), the artist depicted a palace whose foremost plane was that of the pictorial plane, much as an Italian might had done, but he changed the proportions of the building in order to show the table scene. Is this a loggia? A view through an oversized window? Or has the wall been removed to allow a clear view of the scene? These "unrealistic" depictions of buildings are typical of French illuminated art of the 14th century, especially where they are used in genre scenes.

Bohemian painting from the 14th century provides yet another variation on the theme of the relationship of figure and architecture. An illustration from

Laus Mariae (*Hymn to the Virgin*), which belonged to Konrad of Hainburg, shows the Presentation at the Temple (see left, bottom). The presentation itself takes place in the foremost plane where the infant Christ is lifted on to the altar. The figures on the left and right stand or act at a respectful distance from the Redeemer. Above them, on the uppermost plane, the choir towers up. The rows of columns and filigree lancet windows and the vaults which open up at the back of the picture all suggest pictorial depth, as if the event is taking place in a church. But this is not the case: the architectural ornamentation behind the figures, familiar from Romanesque illuminations, serves as a kind of partition. There is no integration of the figures into this architecture. The artist was undoubtedly acquainted with Giotto's new concept of space, creating an architectural scene very similar to those of the Italian artist. Without the skillful integration of the figures, however, the architecture is only a backdrop for the scene.

Not until the beginning of the 15th century did the French start to adopt Giotto's concept of space, for example in the Aix *Annunciation* (see page 398, top). The critical factor in this painting is the coincidence of the foremost pictorial plane with the foremost plane of the church interior. This plane opens out into the background and incorporates the figures into the bottom half of the picture space.

The enhanced status of architecture as a motif in its own right—it becomes a "silent actor"—is symptomatic of the desire, using artistic means, to approach reality more closely and to affirm it more confidently.

The relationship of architecture and figure may even be reversed completely so that the figure becomes an attribute of the architecture. This disproportionate element in the relationship between figure and architecture can be seen in the work of the Boucicaut Master. In one of his illustrations from the *Book of the Wonders of the World* he depicts the palace of the Great Khan as a homoge-

neous structure with bastions and a windowed gallery (see top of page). The only figures in this picture are the three guards; the architecture, filling almost the entire picture, is the main theme.

It is interesting to note that Master Francke, who was active in Hamburg at the beginning of the 15th century, almost copies the Boucicaut Master in one of the panels of his *St. Barbara Altarpiece:* the left part of the palace wall with the guard appears in his *Miracle of the Wall* (see above). These quotations from French illuminated art are typical for the choice of subject matter and motif in this north German painters's work. Master Francke's interest in the palace motif can be seen in the dominating position of the wall in his altarpiece.

Master Francke's admiration of French art is well known and is typical of the International Gothic style around 1400, a style whose most important characteristic was the elevation of pictorial architecture to a higher artistic status.

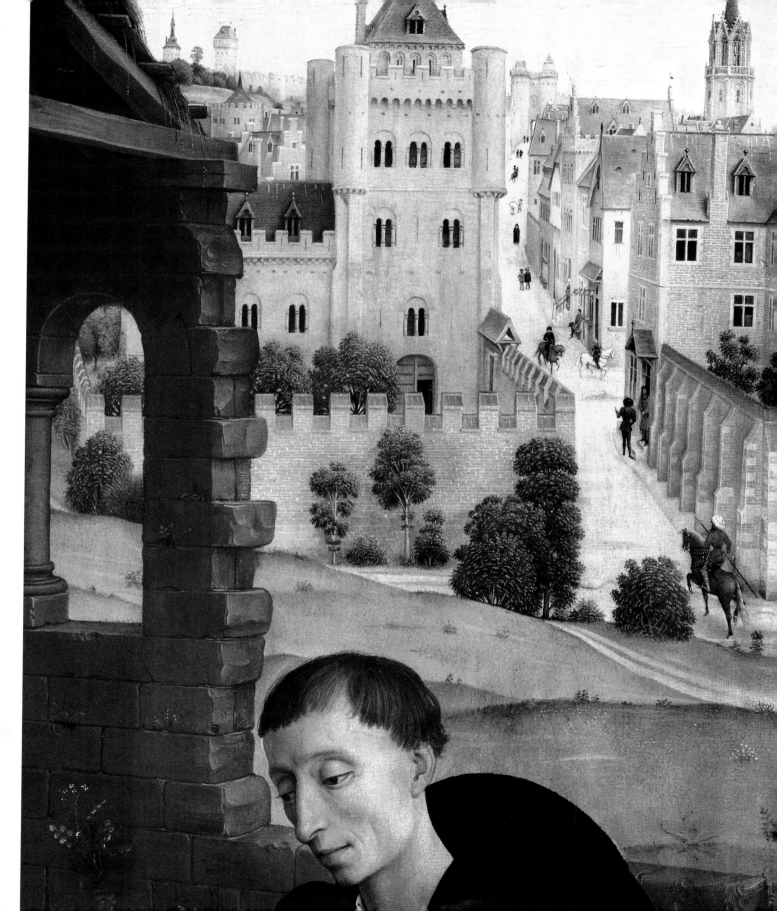

The English School

The development of Gothic painting in England is not well documented. What little work has survived does not allow us to identify either schools or even distinctive elements of a style. It is known that Henry III (1216–72) employed Italian and French artists at his court in Westminster. The only significant work from this time, the fresco cycle created between 1263 and 1267 in the King's Hall at Westminster Abbey, has been largely destroyed. Only a few fragments from an altarpiece in the abbey provide an indication of how English painting developed in the 13th century. St. Peter (see above) is portrayed as a slim figure before a gold background, his hips elegantly turned to his left,

and his robe falling in soft, wide folds. The figure is framed by molded columns and trefoil. The voluminous folds, elegant features, unnaturally splayed fingers, and fashionable curls are typical of a Continental style which was popular in England from the late 13th century.

A comparison of this work with the *Birth of Christ* panel of an altarpiece now housed in the Musée de Cluny in Paris reveals similar stylistic traits (see below, first scene). The broad modeled folds of the drapery and dainty features and delicate limbs of the infant Jesus, as well as the elegant pose of the Virgin, all show a parallel with the Westminster altarpiece fragment. The date, however, is thought to be much later, around 1350. This artistic old-fashionedness might seem surprising compared with stylistic developments on the Continent, but English stylistic trends were largely independent of the impulses at work in France or Germany.

Conclusions based on comparisons of this kind must be treated with caution because of the lack of further examples. Furthermore, this panel, which forms a single altarpiece with three other scenes, the *Death of the Virgin*, the *Adoration of the Magi*, and the *Annunciation*, is richly ornamented and decorated with a Gothic framework which suggests that it was influenced by English Psalters (see page 405, bottom). The development of English panel and mural painting should therefore be viewed in the context of illuminated art, in particular of older examples of this art form.

In the light of this evidence, a French origin for the controversial *Wilton Diptych* (see page 394) seems even more likely. We have already seen that the features and gestures of the figures and the folds of the drapery suggest the influence of Bohemian artists, possibly even those of Cologne. These are characteristics typical of International Gothic, which reached its apogee in the courtly elegance of French painting; it is precisely these characteristics which describe the *Wilton Diptych*. But it is also worth considering whether this painting might be the work of Bohemian or German artists who may have arrived in England in 1382 with Anne of Bohemia, the daughter of Charles IV and the future wife of Richard II.

The degree of influence of Italian styles on English painting was slight. A fresco from the middle of the 14th century, now in the British Museum in London, shows the death of Job's children, killed when a palace collapsed on them during a banquet (see above). The figures show features which are typical of Italian trecento painting, in particular straight aristocratic noses and tightly compressed mouths turned down at the corners.

It is debatable whether Gothic painting in England really followed a truly independent course, as it did in architecture, but a lack of evidence means the issue can never be fully resolved. We can be certain, however, that the International Gothic style was familiar to the English, and that many English artists were influenced by Continental painters, particularly the French and Italians.

Hubert and Jan van Eyck
Ghent Altarpiece, 1432
View when closed
Oil on wood, height 375 cm
Ghent, St. Bavo

The World Seen from Near and Far: Netherlandish Schools

In order to trace the origins of Flemish painting it is helpful to take a look south of the Alps and gauge the opinions of those who recognized the brilliance of Netherlandish art right from the beginning—the Italians. In a verse chronicle from around 1485, the painter Giovanni Santi wrote:

A Brugia fu tra gli altri piu lodati
El gran Iannes: el discepul Rugiero
Cum altri di excellentia chiar dotati.

"In Bruges was highly praised among other artists the great Jan [van Eyck] and his pupil Rogier [van der Weyden], as well as other artists of great mastery." Hugo van der Goes was certainly among these artists: his depiction of the Adoration of the Shepherds, known as the *Portinari Altarpiece* (see page 419, top), was commissioned by the Italian Tommaso Portinari shortly before Santi penned these lines. This view is of course a distant one from Italy. We now know, for example, that Jan van Eyck had an older brother, Hubert van Eyck, and also that Rogier van der Weyden, although undoubtedly influenced by Jan van Eyck, should be seen as part of a different tradition within northern European painting.

This enthusiasm of the Italians is understandable in light of the unusual innovations of the van Eycks' *Ghent Altarpiece* from 1432 (see right, and pages 408–409). Several years after Jan van Eyck's death the Italian humanist Bartolommeo Fazio praised him as "the prince of painters in our century." In Jan van Eyck's treatment of landscape, figures, and architecture, the Italians recognized the same artistic battle that their own masters had fought to represent three-dimensional space. There was one decisive difference, however. Whereas Masaccio constructed a grid system for perspective in order to combine pictorial events and pictorial architecture in one unified space, van Eyck represented reality apparently without recourse to any mathematical aids.

Nor would his Italian admirers have failed to appreciate the distinctive quality of van Eyck's atmospheric landscapes, which are lit by delicate rays of light and modeled by means of superb nuances of color. Only a few decades before, artists north and south had still used schematic scenery—whether a landscape or an architectural setting—merely to provide a backdrop for a religious subject, as if it were an event taking place on stage. The panel by Melchior Broederlam featuring both the Annunciation and the Visitation which he painted for the Carthusian monastery of Champmol is a good example (see page 397).

One of the difficulties in establishing the artistic precursors of Jan van Eyck—and therefore of all early Flemish painting—has to do with the abrupt conceptual change which we can see reflected in his work. After all, both artists, Broederlam and van Eyck, worked at the Burgundian court and they are separated chronologically by just a

few years. It is precisely the innovative nature of Jan van Eyck's painting that prompts some art historians to consider him to be the first painter of the early Renaissance in northern Europe.

Other comparisons, which we can mention here only in passing, shed light on van Eyck's entirely new approach to painting, and the change in attitude towards the visible world that it reflects. Briefly, Broederlam's landscapes were the backdrop, and his architecture the setting, in which biblical events occurred. In van Eyck's work, by contrast, everyday reality and the actual appearance of people and things have their own intrinsic value; he does not treat them as props nor does he idealize them. When the *Ghent Altarpiece* is closed, the outer panels illustrate almost all the subtle variations of this new visual authenticity and clearly indicate the direction in which Flemish painting was to develop (see above). The angel of the Annunciation

Jan van Eyck
Annunciation, ca. 1435
Oil on canvas, 93 x 37 cm
Washington, National Gallery of Art

and the Virgin are depicted in a room which could almost be entered by the viewer. Indeed, one is virtually invited to do so, for in the background the round arches look out onto the city and provide a view into the far distance. The donors, Jodocus Vijd and his wife, are portrayed as specific individuals on either side of figures of St. John the Baptist and St. John the Evangelist, who are depicted as painted sculptures to stress that they occupy a different level of reality.

It is characteristic of van Eyck's outlook on reality that he depicts the Annunciation in a domestic interior whose only quasi-religious features are the church windows. Jodocus Vijd was undoubtedly responsible for van Eyck's choice of interior. Although the iconographic program was probably determined by a theologian, he would not have ignored the wishes of the client. In his choice of interior, however, van Eyck was possibly influenced by the *Annunciation* in the middle panel of the Mérode altarpiece by Robert Campin (the Master of Flémalle), which was finished several years before the *Ghent Altarpiece*, between 1425 and 1428 (see page 413, top). It was common in the late Middle Ages to place sacred events in the sphere of everyday experience, but there was another side to van Eyck's sacred iconography that owes much to mysticism. The aim was obvious: the everyday realm was not only to be bound together with the sacred realm, but it was also to be made sacred through a divine presence.

This is true of the central panel of the *Ghent Altarpiece*, the *Adoration of the Lamb* (see page 409, bottom left), and also of themes associated with the life of the Virgin in other works by van Eyck, for example his *Annunciation* from around 1435, now in the National Gallery in Washington (see right). The setting for this Annunciation is a Gothic cathedral, the place where believers worship in order to gather the strength and courage to fight evil and strengthen their hopes for salvation. Details of the scene refer to the spiritual concerns of the believer. On the floor can be seen elements from the stories of Samson and David which represent the overcoming of evil, while in the stained-glass window above, Christ is shown seated on the globe, a reference to everlasting divine grace. The sacred space provided by the cathedral is symbolically intensified and is used to highlight both the commonplace practice of attending church and the believer's spiritual longings.

Returning briefly to the *Ghent Altarpiece*, we can see that the representation of everyday life in close proximity sacred elements can be interpreted both as a new aesthetic and as evidence of a more populist approach to Christianity. When the altarpiece is open, we can see Adam and Eve (see pages 408–409), the first couple, whose posture and subtly rendered nakedness make them seem more actual than the main subject, which takes up several panels (the Adoration of the Lamb, the saints, the concert of the angels, and God the Father with the Virgin and St. John the Baptist).

One might even describe these as scenes in the story of Adam and Eve because (from the standpoint of the observer) they are shown slightly elevated and walking towards the holy events. The

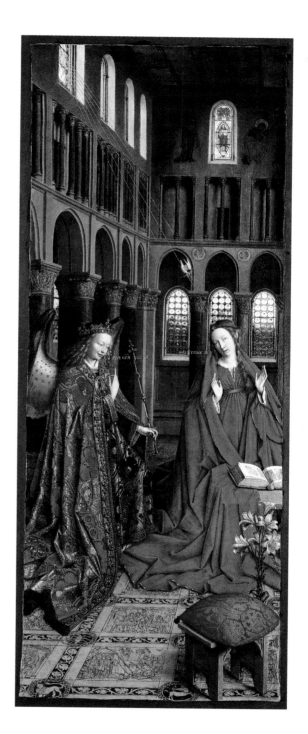

Hubert and Jan van Eyck
Ghent Altarpiece, 1432
Adam and Eve, detail of left and
right wings
Oil on wood
Ghent, St. Bavo

Hubert and Jan van Eyck
Ghent Altarpiece, 1432
View when open
Height 375 cm

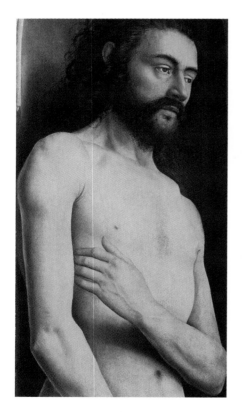

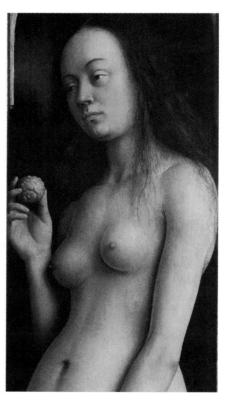

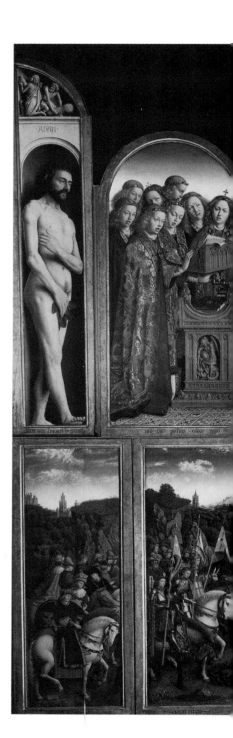

408

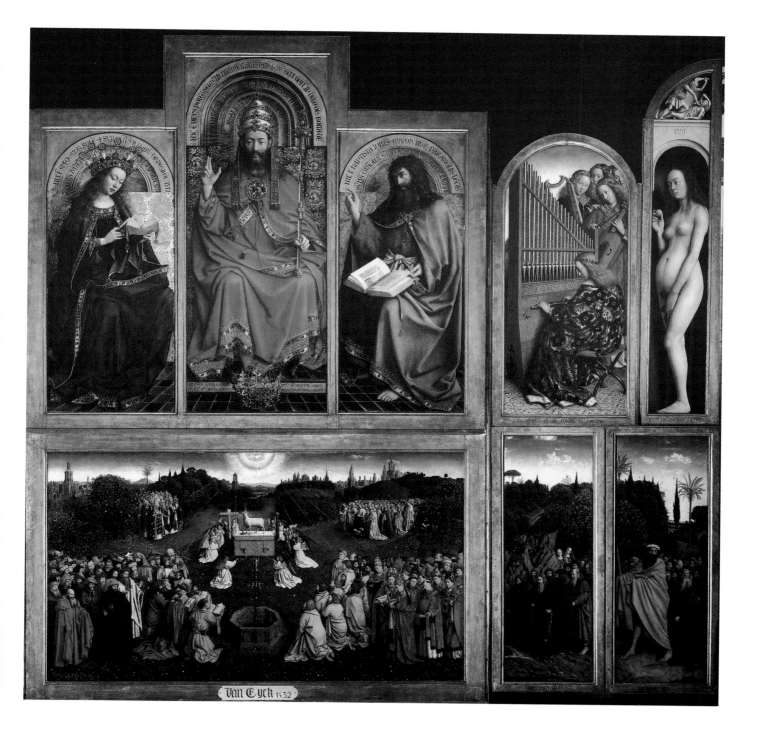

Jan van Eyck
Chancellor Rolin Madonna,
ca. 1435
Oil on wood, 66 x 62 cm
Paris, Louvre

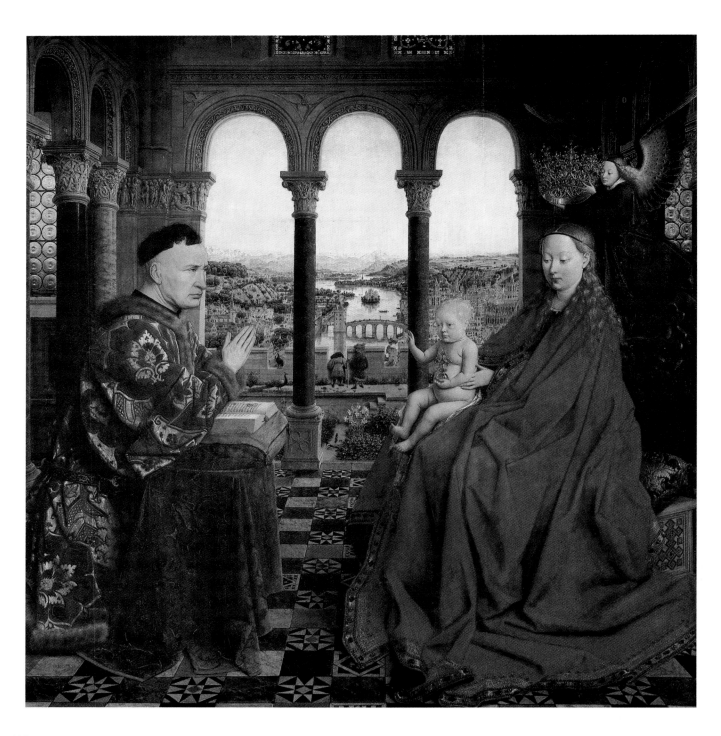

Jan van Eyck
Canon Paele Madonna, 1434–36
Oil on wood, 141 x 176.5 cm
Bruges, Stedelijk Museum voor Schone
Kunsten

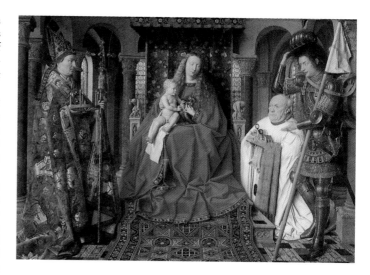

undisguised pregnancy of Eve and Cain's murder of Abel shown above her open the route to humanity's suffering—but also to God's grace and his willingness to sacrifice his own son, the "Lamb of God," in order to fulfill his promise of redemption. This interpretation takes into account the way in which the artist's aim to paint realistically accorded perfectly with the profound piety of his age.

This entry of the divine into a secular setting is illustrated both by the naturalistic style and the fusion of different levels of reality. The heavenly and the mundane, the contemplative inner life and the brash outer world, gestures of prayer and of divine grace—all these are found in one of Jan van Eyck's almost mystical compositions, the *Chancellor Rolin Madonna*, dating from 1435 (see left).

The donor, Nicolas Rolin, appointed Chancellor of Brabant in 1422, is pictured praying inside a magnificent palace. The Virgin appears before him, and is being crowned Queen of Heaven by an angel. On her lap sits the infant Jesus, his right hand raised in a gesture of blessing. In silent meditation, the Chancellor looks up and becomes aware of the divine presence. At the same time the world itself is presented as a witness to this appearance of the divine. God is shown to be both in the world and for the world. On the terrace in the middle of the picture are lilies, symbols of the Immaculate Conception of the Virgin; peacocks and magpies can be seen, giving the work an otherworldly quality. Two men stand at a balustrade, secondary figures who invite the viewer to look into the distance. The view that opens out is intended to represent the world. The town with its busy squares and streets, the river crossed by a bridge, the wide landscape with villages and fields, and the snowcapped mountains in the distant haze, all these belong to the repertoire of 15th-century props signifying "the world."

The message of the picture is legible, though it is subtly presented. Christ has appeared on earth to redeem humanity from sin. The evident piety of Chancellor Rolin, who is shown filled with the word of God, clearly conveys this message. Similarly, the link between the divine and the human is to be found as a metaphor in the capitals of the left-hand corner of the palace. These show how humanity first came to be in need of redemption: they represent the expulsion from Paradise, Cain's murder of Abel, Noah's drunkenness, and the Flood. The two secondary figures, peering over the balustrade, stand amazed before a world made peaceful and beautiful by a God hidden from their eyes—but whose presence in the world is witnessed by the observer of the picture.

Van Eyck married the sacred with the secular as a guarantee both of this world's reality and of the salvation immanent in that reality. And he did so by documenting the visible world with great accuracy and precision. As Panofsky put it, he "viewed the world through both a microscope and a telescope."

At much the same time, between 1434 and 1436, van Eyck completed the *Canon Paele Madonna* (see above). Here the visual and thematic elements are similar to those of the *Chancellor Rolin*

Madonna. Van Eyck is concerned with showing the presence of a vision and therefore of illustrating the reality of God in our world. Just as Nicolas Rolin is shown in his palace, in the midst of an identifiable environment that seems to make his vision of the Virgin all the more real, so Canon van der Paele is shown in the choir of the collegiate church of St. Donatian in Bruges, where he is being presented to the Virgin by St. George and St. Donatian. Hans Belting is of the opinion that this picture once hung in the choir of the now-destroyed church. This would mean that the depicted location mirrored the real location. Van der Paele would therefore have been able to see himself in the very place of his depicted vision and so "prove" to the world at large the reality of his divine experience.

The exquisite brocades, furs, and silks are shown in an extraordinarily lifelike and brilliant way, a way that confirms their reality, their tangibility. On the other hand, the reliefs and sculptures on the capitals in the background and on the Virgin's throne all allude to Christ's salvation of humanity. The depictions on the throne of Adam and Eve, Cain killing Abel, and Samson fighting the lion, together with the depiction on the capitals of Abraham sacrificing Isaac, create an Old Testament framework which allows the observer to reflect on the mercy of God, who sent his son, Christ the Redeemer, into the world. Redemption from sin (Cain killing his brother) is possible only through the power of faith (Samson overpowering the lion). The goodness and grace of God "at the moment of truth" (Abraham sacrificing Isaac) serves as proof of the redeeming power and presence of servants of God both celestial (St. George) and mortal (Canon van der Paele).

This is how van der Paele might have expressed the message of the painting—that paradise was at hand—a message confirmed by its

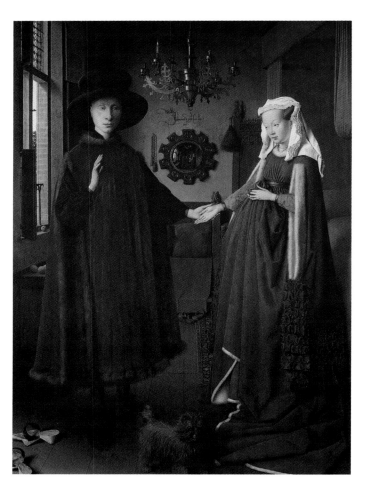

being set in a very real but also sacred context. The Virgin is pictured holding a nosegay and her son a parrot—unmistakable echoes of the Garden of Eden—and both figures have turned to face the meditating canon.

In the *Arnolfini Marriage* of 1434 (see above), van Eyck experimented with different levels of interpretation in a most unusual way. The bridegroom stares out of the picture past the viewer, as if he is focusing on a particular individual. The same could be said of the dog in the foreground, which also looks out attentively. It is not the viewer who is the object of their gaze. Who then? The only possible answer is the artist himself, Jan van Eyck, who stands before the couple and witnesses their union—as indeed a tiny reflection in the mirror in the background makes clear. The caption over the mirror spells it out: "Joannes de Eyck fuit hic, 1434" ("Jan van Eyck was

here, 1434"). The mirror is therefore proof of the wedding, but it is in addition, as Hans Belting has pointed out, a kind of visual tool. That is, it provides evidence both of the laws of physics and of the objectivity of nature.

In other words, a viewer's visual impressions of the world should not be understood merely as subjective perceptions, but as discrete images of reality itself. Viewers become aware of these subjective optical impressions when the depicted world is combined with the act of seeing themselves in a mirror—something that can happen only in a painting. Only when the process of seeing is itself transformed into a conscious, empirical act can artists begin to depict reality credibly. Mirrors can be found in many early Netherlandish paintings and their use as motifs, or as illustrations of a theme, is open to the same type of interpretation outlined here.

As we have already seen, the unusually rapid and permanent change in style over just a few decades, between Broederlam in 1399 and van Eyck in 1432, complicates the issue of the origin of Flemish painting. Panofsky claimed that its roots should be sought in Franco-Flemish illuminated books, for example in the work of Jean Pucelle. Even Broederlam is cited as a possible starting point: he portrayed, even if somewhat hesitantly, the heavens as a part of nature which was not merely the realm of angels but also the domain of native birds. Such features are the clearest indications of van Eyck's artistry: his astonishing ability to separate the world out into a patchwork of realistic details and then piece them together again in one unified pictorial space.

The superbly realistic depictions of nature, a hallmark of quality in Flemish painting, can also be seen in *Les Très Riches Heures*, a work of the Limbourg brothers completed for the Burgundian court around 1415. At the beginning of the 15th century, illuminated books occupied a key position in the development and understanding of Flemish painting.

The political map of France underwent major changes during this period. After the disastrous defeat of the French by the English at Agincourt in 1415, Henry V of England became king of much of France. Philip the Good of Burgundy allied himself with the English and governed together with the English king. This alliance (1420) gave the Duke of Burgundy freedom of action in his own lands so that he was able to pursue the unification of his territories in the Netherlands. He inherited Brabant and Limbourg, purchased the principality of Naumur and Luxembourg, and was sold the Maconnais and Auxerrois by France. An intense artistic life gradually developed within the boundaries of these territories which was encouraged not only by the Burgundian dukes in their capital of Dijon, but also by merchants, bishops, and well-to-do tradesman. The benefactors we see portrayed in attitudes of humility in large altars are eloquent testimony to this patronage.

Innovative aesthetic and thematic programs soon arose out of this new political and social situation. The *Ghent Altarpiece* is not their

BELOW:
Robert Campin (Master of Flémalle)
Mérode Triptych, 1425–28
Oil on wood, height 64 cm (middle panel
63 cm wide, side panels 27 cm wide)
New York, Metropolitan Museum of Art

BOTTOM:
Jacques Daret
Adoration of the Magi, 1435
Paint on wood, 57 x 52 cm
Berlin, Staatliche Museen–Preussischer
Kulturbesitz, Gemäldegalerie

first manifestation. They appeared even earlier with the so-called Master of Flémalle, whom Panofsky has identified as Robert Campin from Tournai. Born around 1375, this master is first mentioned in archival records in 1410 as "peintre ordinaire de la ville," that is, the town painter of Tournai.

Campin's most important work is the so-called *Mérode Triptych*, painted between 1425 and 1428 (see above). X-rays of the left-hand panel indicate that the identity of the artist of this part is more likely to be Rogier van der Weyden, Campin's most gifted pupil. In this scene the patrons of the altar, Peter Engelbrecht and his wife, are depicted, kneeling devoutly, along with a man standing by a gate in the background. The discovery of additional layers of paint has led to the conclusion that the donor's wife and the man at the gate were added at a later stage.

Furthermore, the brushstrokes, the detail, and the spatial composition of the panel indicate a different artist from that of the *Annunciation* (center panel) and the contemplative *Joseph in his Workshop* (right-hand panel). It is likely that Rogier van der Weyden painted this left-hand panel and then perhaps added the man and woman at a later date. The woman is probably Heylwich Bille, Engelbrecht's second wife, and it may be that her portrait, dated to 1456, replaced that of Engelbrecht's first wife.

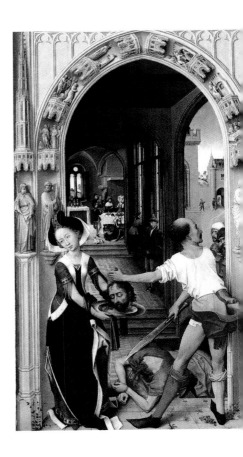

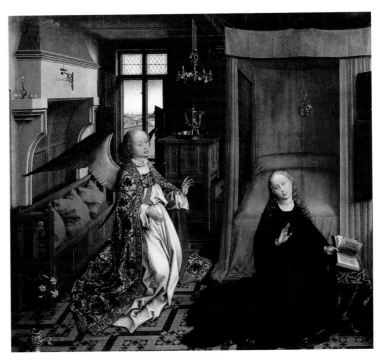

If we compare van der Weyden's earlier work with this panel of this triptych, certain similarities become obvious. The treatment of facial characteristics and the detailing of the masonry and the vegetation, which looks like inlay, all point to Campin's workshop as the place of origin. Rogier van der Weyden's *Annunciation Triptych* from 1440 unites all of these characteristics (see opposite, bottom). This work shows that van der Weyden adopted a new iconographic concept as the focus of the central panel, the Annunciation, a thematic concept which Campin had probably been the first to use.

It could therefore be said that Flemish painting was born in the Burgundian Netherlands, in Tournai. Another of Campin's pupils, Jacques Daret, was also active there. The *Adoration of the Magi* altarpiece (page 413, bottom), from 1435, has been positively attributed to him. Campin, court painter to Philip the Good, met van Eyck, who visited Tournai twice before commencing work on the *Ghent Altarpiece*. We can assume that he inspected the work of the young van der Weyden closely on these occasions.

A number of connections can be made between van der Weyden, Daret, and their master, Campin—a fact which is hardly surprising considering the long years they spent together in the same workshop. But van der Weyden soon began producing work which is markedly different from that of his teacher. While Campin concentrated on the appearance of objects, and the atmospheric effects of light and color, van der Weyden devoted himself to creating pictorial spaces suited to the somber depiction of religious themes.

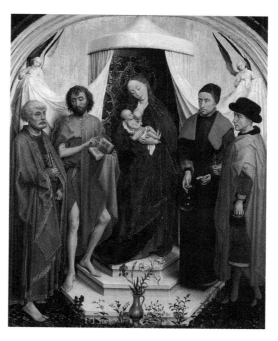

For the *St. John Altarpiece* in the church of St. James in Bruges (see opposite, top), painted about 1454, van der Weyden constructed the portal to look like that of a real church. The grisaille paintings portray archivolt figures as well as saints in scenes which parallel the main motifs. The main scene in the central panel, the Baptism of Christ, is accompanied by tiny figures in the arch molding showing the Temptation of Christ and St. John the Baptist preaching.

The church façade is therefore not only a holy place, but also a pictorial element that sets the event firmly in a biblical context. At the same time, the spiritual world becomes accessible to the secular world: scenes appear from everyday life and the view gives on to a vista that includes a landscape and a town in the distance. It is here that van der Weyden's concept of art meets van Eyck's. The sacred fuses with the everyday and it is towards the latter that the holy events are oriented. The differences between the two artists cannot of course be ignored: while van Eyck's treatment of the contact between the sacred and the secular was free and light, van der Weyden insisted on a strict separation.

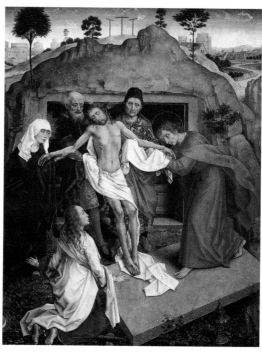

Van der Weyden's journey to Italy in 1450 taught him about new and more rigorous methods of composition, about spatial construction in a two-dimensional plane. The panel painting in the Städelsches Kunstinstitut in Frankfurt showing a thoroughly unnorthern *sacra conversazione* (the Virgin and Child surrounded by saints) may be attributable to Italian influences (see above).

Dirk Bouts
The Visitation, ca. 1445
Panel of the *Infacy Altarpiece*
Paint on wood, 80 x 52 cm
Madrid, Prado

was of German origin and was born in Seligenstadt on the River Main. Memlinc's date of birth is uncertain, though it seems reasonable to suggest that he was born some time between 1435 and 1440. According to another source, he grew up in Moemlingen, a few kilometers south of Seligenstadt. Whatever the case may be, he is first officially mentioned as being in Bruges in 1466, probably after completing his apprenticeship in the Brussels workshop of Rogier van der Weyden. Many of his Virgins, particularly their facial expressions and the shape of their heads, show the influence of van der Weyden. For example, the features of the Virgin in van der Weyden's *Adoration of the Magi* (see opposite, top), with her slightly tilted head and soft facial features almost frozen in gentle humility, can also be seen in the Virgin in the diptych Memlinc painted for the Bruges nobleman Maarten van Nieuwenhove in 1487 (see opposite, bottom). In Memlinc's picture the Virgin and Child seem more animated, their gestures more natural. Christ, depicted in a pose similar to the same figure in van der Weyden's work, reaches eagerly for the apple held by his mother. This gesture expresses the acceptance of his later Passion, which was necessary to redeem humanity from original sin (symbolized by the apple).

This panel shows Memlinc's mastery of a rich vocabulary of allusions in the Flemish tradition of a van Eyck. As in the *Arnolfini Marriage*, a convex mirror hangs on the wall behind the Virgin and captures the entire scene. We can see the nobleman at prayer and the Virgin at his side. His holy vision has become a reality through the painter's art, which, in a metaphorical sense, is a witness to the event. The form of the diptych separates the levels of meaning: the sacred images of the Virgin and Child are on one side and a secular portrait of the donor on the other. However, these levels of meaning are embedded in a unified and domestic space which envelops both panels—a real room in the house of a prosperous nobleman. The divine sphere has been shown to enter the sphere of this Bruges nobleman's everyday world.

The influence of van der Weyden's Virgins is even more conspicuous in the figure of the maid helping her mistress Bathsheba from the bath and wrapping a robe around her naked body (see page 418). The similarity to van der Weyden's type of Madonna is so striking that scholars were previously inclined to attribute this large painting to him. Not only is this picture unusual for featuring a nude outside a religious context (they usually appeared only in depictions of the Fall or the Last Judgment), but it is significant for revealing a number of features which have helped to define Memlinc's significance for 15th-century painting.

Memlinc constructed a narrative space in this work which is exemplary for northern European painting. On the back wall of the bathroom a window is open, revealing a roof terrace: "And it came to pass in an eveningtide, that David arose from off his bed, and walked upon the roof of the king's house: and from the roof he saw a woman washing herself; and the woman was very beautiful to look

Even the *Entombment*, with its centrally positioned and monumental tomb, cannot be entirely equated with the Netherlandish tradition (see page 415, bottom). It was only after his visit to Italy that van der Weyden developed a characteristic style. We can agree with Max Friedlaender, however, that the composition seems somewhat stiff and its figures bloodless. Van der Weyden never discovered the narrative richness of a van Eyck or the magnificent repertoire of gestures of a Hugo van der Goes. In spite of this, his compositions and the earnest piety of his figures lived on in numerous pictures by his Flemish successors.

It has been assumed that Dirk Bouts spent some time in the Brussels workshop of van der Weyden. The four panels in the Prado in Madrid (see above), probably painted around 1445, seem to support this assertion. However, the archivolts have an ornamental role as an inner frame for the scene with the Virgin and are not realistically modeled as church architecture.

Among those artists who studied Rogier van der Weyden's work and applied his techniques, one deserves special mention: Hans Memlinc, or "Jan van Mimmelinghe ghebooren Zaleghenstadt," as he is called in the Bruges register. This entry indicates that Memlinc

Rogier van der Weyden
Adoration of the Magi, ca. 1455
Centre panel of *St. Columba Altarpiece*
Paint on wood, 138 x 153 cm
Munich, Bayerische
Staatsgemäldesammlungen,
Alte Pinakothek

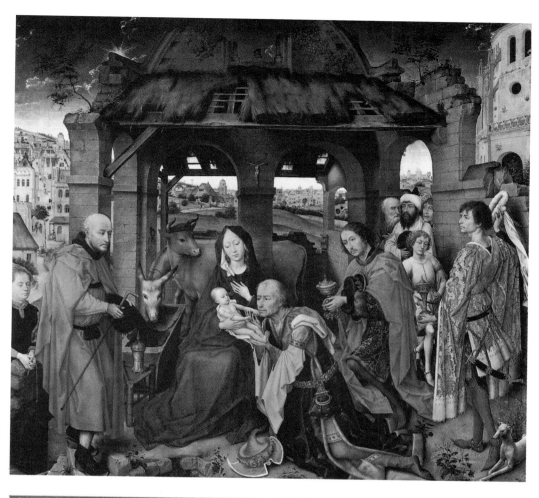

Hans Memlinc
Nieuwenhove Diptych, 1487
Oil on wood, each panel 52 x 41.5 cm
Bruges, Museum van het Sint
Jans-Hospitaal (Memlingsmuseum)

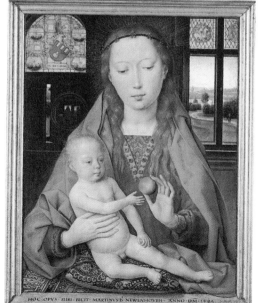

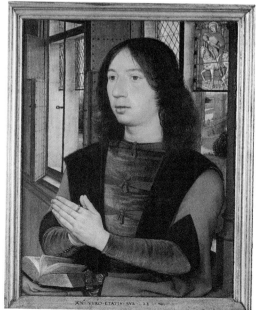

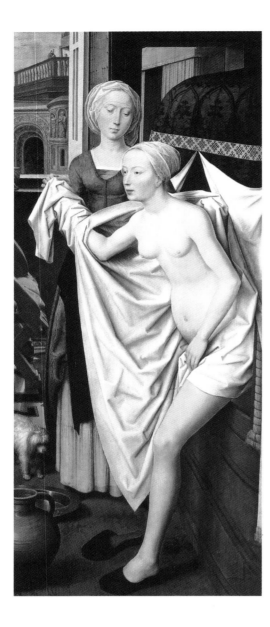

Hans Memlinc
Bathsheba, 1485
Oil on wood, 191 x 84 cm
Stuttgart, Staatsgalerie

hand corner has been added at a later date, probably in the 17th century. The original corner piece, now in the Chicago Art Institute, shows David giving a messenger a ring for Bathsheba.

Hugo van der Goes was born at around the same time as Memlinc, probably in the town of Ter Goes in Zeeland, or perhaps in Ghent. It is in Ghent that his name was first officially recorded in 1465. Archival sources relating to the award of his mastership date from 1467.

A year later the artist was called to Bruges where, together with other artists, he worked on the decorations for the marriage of Charles the Bold and Margaret of York. At this time, or perhaps later, he must have been in contact with Tommaso Portinari, who was living in Bruges with his family as a representative of the Medici bank. The commission for the so-called *Portinari Altarpiece* dates from this time (see opposite, top).

The central panel features the Adoration of the Shepherds, and the side panels depict, on the left, St. Anthony, St. Thomas, Tommaso Portinari and his two sons, on the right, St. Mary Magdalen, St. Margaret, Maria Portinari, and her daughter. The panels are united by one continuously modeled background landscape. The humble stable, a mix of ruined beams and walls, dominates the foreground and the middle of the central panel. The massive column represents the new church to be built on Christ, who is its foundation stone. The landscape is depicted as a narrative. Rock formations, hills, and hollows, as well as distant buildings and fences, frame a scene which tells the story of Christ's birth and what preceded it. At the left, descending a hill and supported by Joseph, we see a heavily pregnant Mary. On a hill in the central panel, the shepherds receive the joyful news of Jesus' birth from a hovering angel, and on the right the Magi are approaching with their train.

Compared with figures in contemporary Italian painting, the characters seem rough, though dignified. Their wrinkled unshaven faces, even the gap in the teeth of the middle shepherd, are evidence of an attention to detail unknown until that time. The painters of the early Italian Renaissance must have been greatly taken with this work, although in many respects it could hardly have fitted with their own conception of art.

This would explain why the inspiration for the composition of Domenico Ghirlandaio's 1485 altarpiece, the *Adoration of the Shepherds*, for the Sassetti Chapel in the church of Santa Trinita in Florence (see opposite, bottom), was the *Portinari Altarpiece*.

upon." This is the description of events in the Second Book of Samuel (chapter 11), prior to the king committing adultery and murder. Below the palace is a portal leading into a church on which a wall relief can be seen depicting the death of Bathsheba's husband, the Hittite Uriah, whom David sent to certain death in battle. Beside the portal projects an apse on whose wall can be seen painted sculptures of Moses and Abraham as representatives of the law.

The painting is divided into a dominant scene in the foreground and a secondary scene, subordinate to this, in the background. This background narrative is of the traditional pattern, that of painted church sculpture. Memlinc was not so much concerned with the biblical story—which may have served as justification for the depiction of a nude figure—as with the translation of a biblical motif into a domestic setting in 15th-century Flanders. Moreover, the upper left-

Hugo van der Goes
Portinari Altarpiece, 1475–79
Oil on wood, height 249 cm (middle panel
300 cm wide, side panels 137 cm wide)
Florence, Uffizi

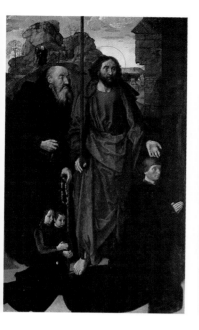

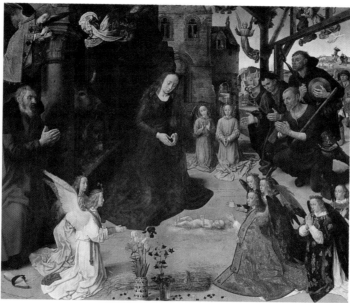

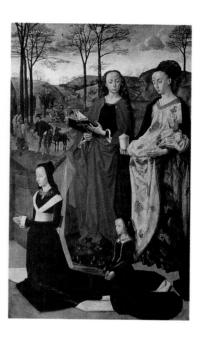

Domenico Ghirlandaio
Adoration, 1485
Paint on wood, 285 x 240 cm
Florence, Santa Trinita, Sassetti Chapel

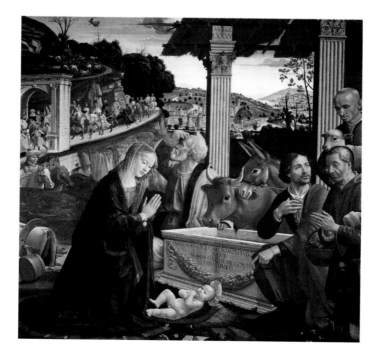

Narrative Motifs in the Work of Hans Memlinc

Flemish painting developed a unique form of story-telling in pictures. We have already seen how in the work of Rogier van der Weyden and Jan van Eyck certain areas of the picture such as a painted church portal could be used to present a subsidiary narrative sequence (see page 414, top). These areas were painted in grisaille, and in this way could form distinct and independent narrative zones within the picture.

setting. The individual scenes gradually came together into a sequence of events divided up by buildings, hills, or clumps of trees. This meant that the viewer could quickly identify the various scenes of a narrative. The entire story was depicted in one unified pictorial space, and the temporal sequence was deliberately presented as an illusion, a form of presentation known as "continuous narrative".

It was this form of narrative painting that Hans Memlinc developed with particular success. One of his best-known examples is *The Seven Joys of Mary*,

mental stage on which his characters act out their parts.

The vast landscape appears as a miraculous panorama of the world in which can be seen the arrival and departure of the Magi, Herod's Jerusalem, the stable of Christ's birth, and the palaces of the miracle of Pentecost, as well as the hill of the Ascension.

To divide up this diverse and complex story, Memlinc employs several techniques. He does not hesitate, for example, to depict the stable twice in order to maintain both the direction in which the

takes place just to the right of this. Buildings are shown cut away to expose the scenes inside. Space has also been found for genre scenes, such as the horses being watered in the middle foreground, just right of center.

Even minor events such as the miracle of the cornfield mentioned in the Apocrypha (left, above the roofs of Bethlehem) are included in this sacred narrative. The miracle of the cornfield occurs during the flight of the Holy Family from Bethlehem, pursued by Herod's henchmen. The Holy Family leave the stable and

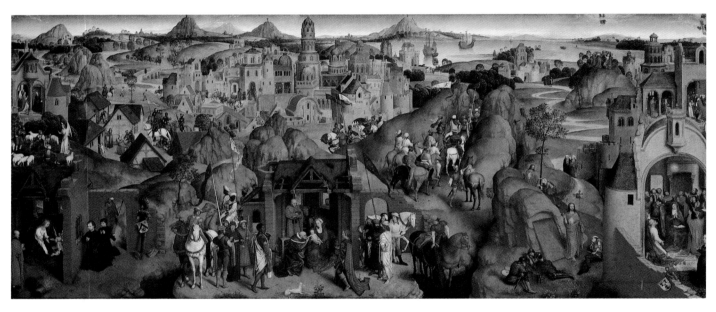

Hans Memlinc
The Seven Joys of Mary, 1480
Oil on wood, 81 x 189 cm
Munich, Bayerische
Staatsgemäldesammlungen,
Alte Pinakothek

Hans Memlinc, *The Seven Joys of Mary*
K1 The Magi See the Star, K2 Journey to Jerusalem,
K3/K4 Welcome and Conversation with Herod,
K5 Adoration, K6 Departure, K7 Embarkation.
M1 Annunciation, M2 Annunciation to the Shepherds,
M3 Nativity, M4 Adoration of the Christ Child,
M5 Slaughter of the Innocents, Miracle of the Cornfield,
M6 Flight into Egypt, M7 Pentecost, M8 Death of the Virgin,
M9 Assumption of the Virgin. C1 Resurrection, C2 Noli me
tangere (St. Mary Magdalene), C3 Christ Meets His Mother,
C4 Road to Emmaus, C5 Sea of Galilee, C6 Ascension.

Iconographically, the choice of scenes depicted in grisaille drew on the usual imagery of Gothic portals and thus represented a narrative which accompanied the main events of the painting. The middle section of the picture, however, with its views of castles, palace courtyards, marketplaces, or landscapes, was sometimes defined as a kind of stage on which everyday events took place. These events, added as supplementary features and not in any way connected to the main theme, were gradually arranged into a close sequence of stories which took place within a unified urban or rural

painted in 1480 for Bruges Cathedral (see above), which is housed today in the Alte Pinakothek in Munich.

At first sight the scene seems hopelessly confused. However, Memlinc presents an overview of the various narrative stages that enables every one of the scenes, even those only hinted at in the distance, to be identified. He dispenses with a proportional relationship between figures and landscape, moving the middle and the background of the picture closer together and then bringing both closer to the foreground. He also tilts the landscape forward slightly so that it forms a monu-

painting should be read, and the spatial sequence of the Adoration and Nativity.

The Adoration of the Christ Child is presented as the main scene and is accentuated by two deep ditches that separate the center from the right and left of the picture. Above the dilapidated roof of this central stable rises a rock formation which leads off to the right as a gorge into which the departing Magi ride. Earth ramparts, roofs, and bushes separate events which are close in space but distant in time, for example the Annunciation to the Shepherds (far left) and the Slaughter of the Innocents, which

hurry over a stubble field but the soldiers are unable to find any trace of their footsteps because the corn has miraculously sprung up to cover the tracks.

In another continuous narrative, the *Turin Passion*, Memlinc integrates scenes of Christ's Passion into the buildings of a late medieval city (see opposite). This panel was painted at approximately the same time as *The Seven Joys of Mary*, but on a somewhat smaller scale. It concentrates the Passion scenes in a dense gathering of people and divides the scenes using buildings pierced by wide openings. Only at the outer edges of the

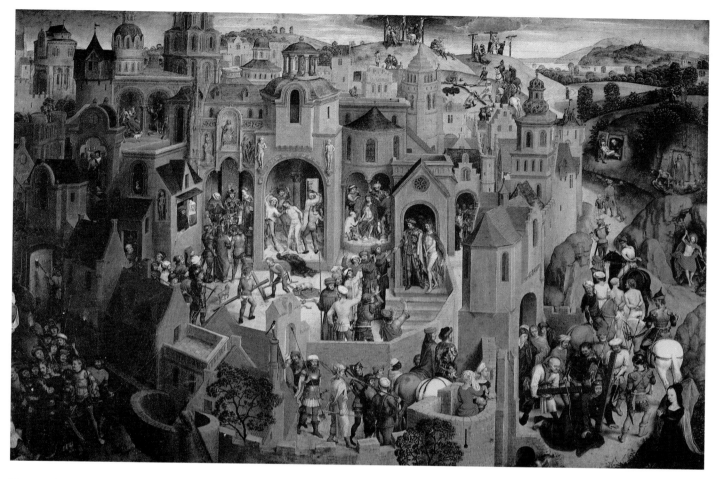

Hans Memlinc
Turin Passion, ca. 1480
Oil on wood, 56 x 92 cm
Turin, Galleria Sabauda

Hans Memlinc, *Turin Passion*
1 Christ's Entry into Jerusalem, 2 Money-Changers Driven from the Temple, 3 Judas before the High Priests, 4 Last Supper, 5 Mount of Olives, 6 Arrest of Christ, 7 Christ before Caiaphas and Pilate, 8 Flagellation, 9 Christ Crowned with Thorns, 10 Ecce Homo, 11 Barabbas, 12 Christ Carrying the Cross, 13 Christ Nailed to the Cross, 14 Crucifixion, 15 Deposition, 16 Entombment, 17 Resurrection, 18 Descent into Hell, 19 "Noli me tangere," 20 Road to Emmaus, 21 Sea of Galilee.

picture do we see ramparts, hills, bushes, and cliffs, which provide reference points for scenes such as the Entry of Christ into Jerusalem (not shown here), the scene on the Mount of Olives (bottom left), the Via Dolorosa (bottom right), the Crucifixion (top), the Entombment and Resurrection (top right), and the Descent into Hell (right).

Just as in *The Seven Joys of Mary*, Memlinc compresses pictorial space and tips the landscape forwards slightly so that he can depict other scenes in the far distance, for example the miracle on the Sea of Galilee (top right). The tiny figures

here can barely be identified but should be understood in the general context of Christ's miracles.

Continuous narratives had precursors in 15th-century Flemish painting, though they were not as specific and coherent as those created by Memlinc. Memlinc himself painted such subsidiary narratives in his *Shrine of St. Ursula* (1489) and Lübeck *Triptych* (1491) in order to support and animate the principal scenes. This type of continuous narrative was known to Rogier van der Weyden, Dirk Bouts, and Hugo van der Goes but the unity of the narrative and

the balanced distribution of the individual scenes that Memlinc brought to the form were new and remained almost unique to him.

Memlinc was first and foremost concerned with narrative, his inspiration coming less from illuminations or Romanesque murals than from medieval theater and Passion plays.

The latter in particular told the Easter story through the use of a series of different locations. Platforms and stages would be set up in a marketplace, the buildings acting as scenery and backdrop. The Passion procession would

make its way into and through the town, accompanied along the route by crowds of pious believers and curious onlookers. At various places on the route it would stop and the players would act out scenes of the Passion such as the Flagellation or the Ecce Homo.

Scholars have pointed out that Memlinc's major narrative works owe a debt to such late medieval mystery plays and the so-called Madonna plays. Medieval theater was not only a source of religious education for the masses, it was also an important source of inspiration for artists.

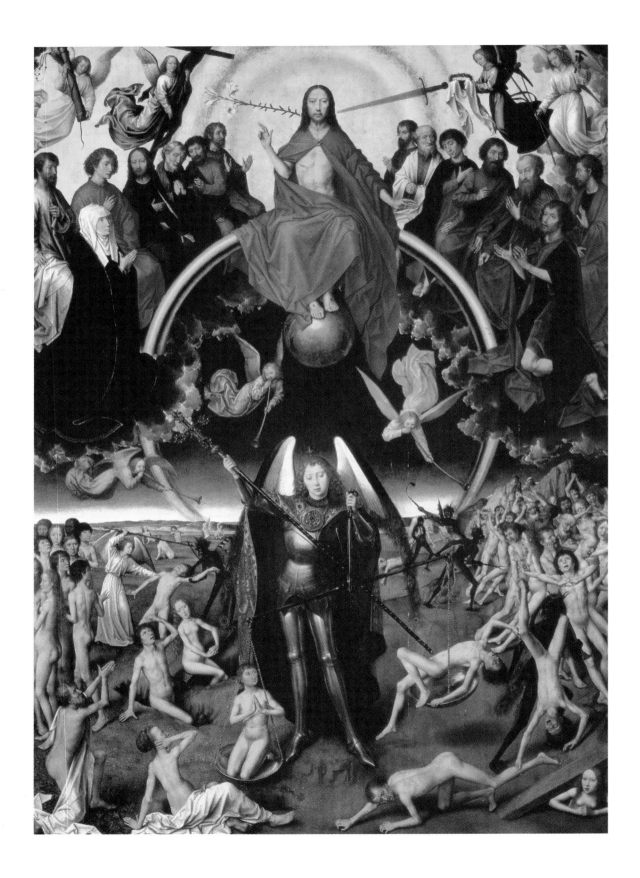

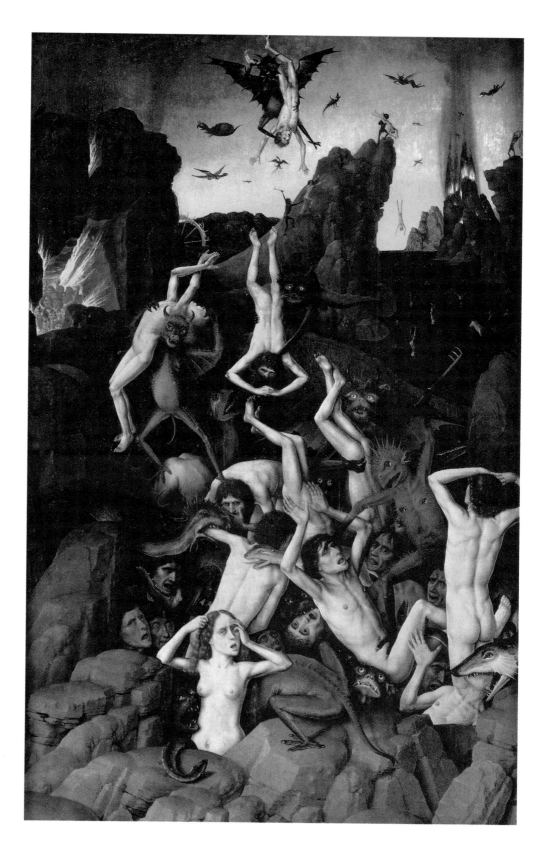

Visions of Heaven and Hell in the Work of Hieronymus Bosch

"Ghostly fantasies," "dreamlike visions," "demonic horrors"—these are some the expressions scholars have used in attempting to define the world of Hieronymus Bosch. According to some theories, Bosch, who was born around 1450 in s'Hertogenbosch and died in 1516, belonged to secret societies or esoteric sects and created his demons and macabre visions for them. Such hypotheses are popular but cannot be proven. Using what little we know in order to explain what we do not know, if it is otherwise impossible to throw any light at all on an artist's life, is a tried and trusted technique.

The compiler of an inventory for Philip II of Spain described Bosch's *Garden of Delights*—a painting often claimed to be the cult image of a secret sect—as *"una pintura de la variedad del mundo,"* a painting showing the world's diversity. Bland though it is, this description could well serve as a starting point, albeit an undramatic one, for our approach to Bosch's art. Bosch painted pictures of the world: his theme was our attempt to understand the world in which we find ourselves, a world which is often strange and mysterious, and in which we seem destined to suffer.

Hans Hollaender, in an early but still relevant analysis of Bosch, characterized the broad themes of the artist's work by means of its relationship to the *conditio humana*, the human condition. This applies just as much to the scenes of Christ's Passion as it does to the pictures of Hell or the moralizing scenes, for Hollaender's definition goes some way to encapsulating Bosch's thematic range.

The moralizing aspect of Bosch's art is evident in a panel painting with the programmatic title *The Seven Deadly Sins and the Four Last Things* (see above). The painting takes the form of a table which counsels moderation for those eating or gambling. The sins of humanity are depicted in a series of graphic scenes from everyday life.

Contemporary viewers must have been shocked to recognize themselves in one or other of the images—shocked, because the consequences of these sins are depicted in the small round picture at bottom left (see right). A toad has leapt into the lap of a naked young woman who is marked with the word *superbia* (arrogance or vanity). A demonic, ape-like creature hurries by and holds a

Hieronymus Bosch
Seven Deadly Sins and the Four Last Things, ca. 1485
Oil on wood, 120 x 150 cm
Madrid, Prado

OPPOSITE:
Hieronymus Bosch
Haywain Triptych, ca. 1500
Oil on wood, 135 x 190 cm
Madrid, Prado

Hieronymus Bosch
Hell, detail from *Seven Deadly Sins and the Four Last Things*

OPPOSITE, BOTTOM:
Hieronymus Bosch
The Conjurer (detail), 1480
Oil on wood, 48 x 35 cm
St.-German-en-Laye,
Musée Municipale

424

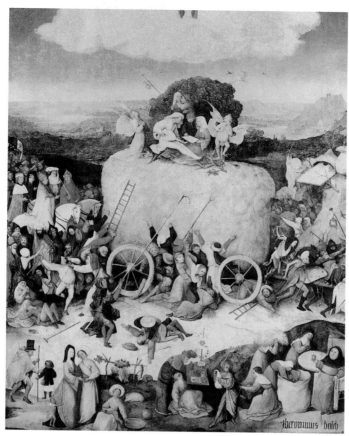

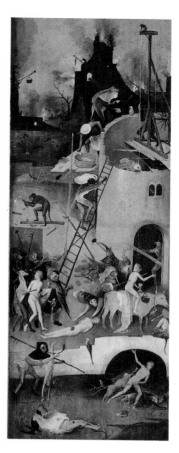

mirror up to the terrified woman. In a bed the color of flames a lustful couple are dragged away from each other by demons in the shape of bats and spiky insects. A lizard-like creature crouches snorting at the bottom of the bed, waiting to ravage them.

Bosch's theme here is the link between everyday sinfulness and the demonic punishment which follows as the invariable consequence. For Bosch, it is often people's stupidity which drives them to evil or to suffering. In the market scene in *The Conjurer* (see right), a credulous cleric leans over a table on which lies a magician's paraphernalia. Behind him stands a figure in the vestments of a monk who looks piously upwards while he skillfully relieves the cleric of his purse. A child, presumably working with the monk, stands beside the cleric in order to distract him at the critical moment. The victim is a cleric whom even God does not help, as he seems incapable of helping himself. The culprit, on the other hand, is a monk who is exploiting his office with the help of God. The world, it seems, is full of paradoxes.

Another, infinitely more complex, message of Bosch's paintings might be formulated as a question, namely: What

do people do with their lives? To say that they "seek heaven" would hardly be an adequate answer, for clearly people seek success and meaning in everyday life. Bosch formulated a multitude of answers to this question, exploring them in his depictions of the religious as well as the secular world.

His *Haywain Triptych* in the Prado (above) is one of the best examples. The left-hand panel depicts Paradise, the right-hand panel Hell; the central panel is a secular allegory. In the middle of the center panel is the eponymous haywain, around and on which people are engaged in various activities—a microcosm of the world. People brawl under the wheels while the Emperor and the Pope, powerless and therefore uninvolved, ride by at the head of a procession of clerics and believers. A couple embrace in a bush at the top of the wagon.

Christ hovers over the whole scene on a cloud, his arms outstretched. Whether he is displaying his wounds to indicate the remission of sins or expressing his sadness at the spectacle below him, cannot be known for certain. Whichever the case, events on earth take their course without anyone being aware of the Redeemer's presence, and the viewer is

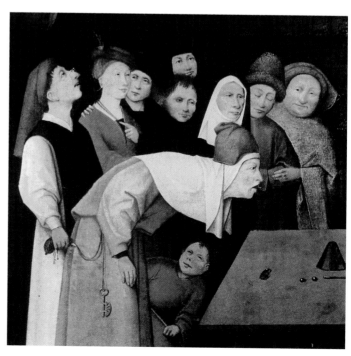

Hieronymus Bosch
The Garden of Earthly Delights, ca. 1515
Oil on wood, height 220 cm (central panel
195 cm wide, side panels 97 cm wide)
Madrid, Prado

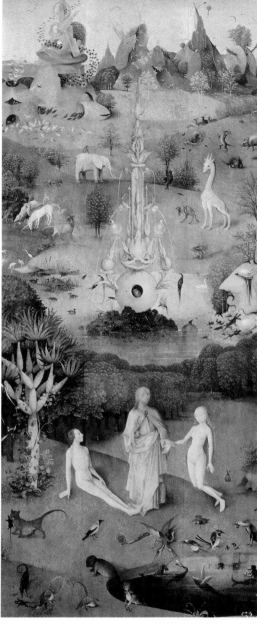

drawn to the conclusion that his suffering
has been in vain. The haywain, an alle-
gory of the world, is drawn by monsters
and its direction is clear—it is trundling
toward Hell, whose gates are open in the
right-hand panel.

It is unlikely that this work was com-
missioned by the Church; it was a prob-
ably a private or even royal commission.
The *Haywain Triptych* was in the posses-
sion of Philip II, who had two versions,
one in Madrid and the other in his
palace-monastery, the Escorial. It is not
known which is the original.

We do Bosch a disservice, however, if
we associate him purely with visions of
Hell. These images are indeed spectac-
ular, but they should be seen firmly in the
context of the human condition. Our
existence is in constant peril, largely
through our own doing. But the Church
also presents threats, for the idea of sins
not being forgiven is associated with
dreadful visions in the afterlife.

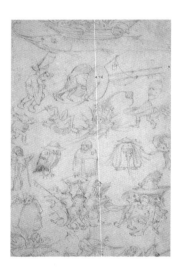

Hieronymus Bosch
Studies of Monsters, ca. 1490
Pen and ink
Oxford, Ashmolean Museum

For this purpose, Bosch developed an
architecture of Hell that has no equal in
Western art. In the panel depicting Hell
in the *Haywain Triptych*, we see crea-
tures covered in scales, half-man and
half-lizard, at work in the tower of Hell.
Bizarre ruins stand before a background

of blood-red flames. Gallows are being
erected: the tortured must endure
hanging but are unable to die.

The panel depicting Hell in the triptych
The Garden of Earthly Delights (above),
Bosch's most famous and most puzzling
work, has a similar scene: icebergs in
burning seas, dark ruins from which
flames shoot out, armies of the damned
who are being fed into monstrous torture
machines. Hellish creatures, aptly des-
cribed by Hans Hollaender as "assembly-
line devils," assist the demonic torturers

and constantly drag in new sinners. Much
of the symbolism is inexplicable and
presumably can be accounted for only in
terms of the fertility of the artist's imagina-
tion. The types of materials depicted are
overwhelming: the monsters appear with
elaborate armor, steel sheets, garlands of
horn, suits of bone armor, or leather
uniforms. Collections of curiosities must
have been one of Bosch's sources of
inspiration.

Distorted images of normal, everyday
life are represented by monstrous musical

instruments, such as organs or stringed
instruments, in whose workings the
damned are trapped in order to suffer
from the very things which provided
them with earthly pleasure. It is remark-
able that the central panel depicts the
joys of an afterlife in intoxicated and
sensual terms that seem to make the
Garden of Eden pale into insignificance.
Plant life composed of fantastic and
unfamiliar forms is present in the left-
hand panel, but seems sparse at times,
and the scene showing God the Father

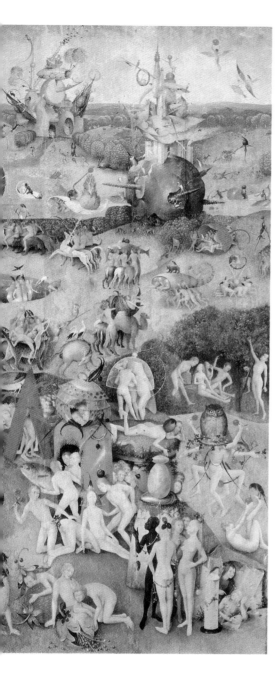
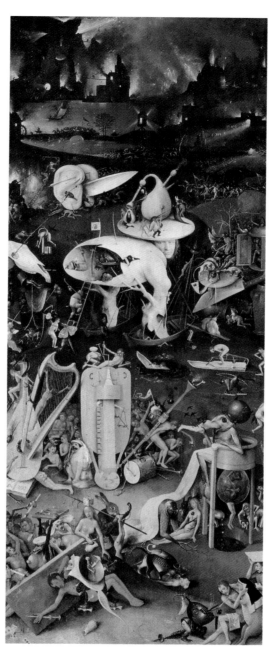

and the newly created pair of Adam and Eve appears somewhat joyless. Animals, some of which have already aggressively rounded on one another, writhe at the feet of Adam and Eve as well as in the lake in the center of the picture. Because of this, the central panel gains in significance. Does it represent one of the dreams of humanity, the utopia of paradise in which animals and people live side by side in harmony and without sin? Or is it a warning of the consequences of the desires of the flesh?

These questions have never been satisfactorily answered. Perhaps we ought to be content with the description from Philip II's inventory: the painting is "una pintura de la variedad del mundo."

Naturalism and Delight in Narrative: Painting in Germany, Austria, and Bohemia

It is relatively easy to draw a line between Romanesque and Gothic painting in Germany. The so-called Angular, or Jagged Style, variations of which developed in the mid 13th century, can be considered the forerunner of Gothic painting. This singular style was confined to Germany. Its most typical example is the retable for the Wiesenkirche in Soest which dates from around 1250 (see above). The spiky, pointed folds of the drapery lend the figures a certain energy and expressiveness, and form a stark contrast to the drapery depicted in the Romanesque style widespread at the time.

It is likely that the adoption of a new approach to art, characterized by a break with the stiff formalism of the late Romanesque period, was triggered by the development of the Gothic

style in French cathedrals and also by the fall of the Hohenstaufen dynasty, with its classical monumental style. Byzantine influences were undoubtedly also important, as perhaps was late Romanesque English painting, as examples from the Chapel of the Holy Sepulchre in Winchester Cathedral show.

The Angular Style exercised a small but significant influence on early Gothic painting in Germany. It is worth noting that frescoes on the vaulted ceilings of the St. Maria Lyskirchen in Cologne also show evidence of the Angular Style. The style persisted, if more modestly and in a reduced form, most notably in the works of those early Cologne masters who created altarpieces, winged altarpieces, and diptychs after 1300.

The double panels of an altarpiece now in Cologne which depicts the legend of St. Achatius (see left, bottom) show tapered and serrated drapery folds, though curved and elegant forms clearly still dominate. Moreover, it can be seen that the spiky patterns are not uniform. The Angular Style was therefore pressed into the service of depicting movement. In other words, the dynamic form unique to the Angular Style was transferred to the figures, even if this required some modification of the original style.

However, it would be a mistake to attribute the origins of early Cologne painting to the Angular Style. There were simply too many influences at work for it to be possible to claim that any one single style held such sway. Moreover, it would be wrong to assert that there was such a thing as a unified style in the city in the 14th and 15th centuries. Cologne lay at the crossroads of important European transport routes and its citizens were adept at forcing their archbishop to grant them liberties. Petrarch, who visited the city in 1333, called Cologne a "royal city," and artists came from far afield to work there, though with few exceptions their names are unknown to us. The influence of French illuminated books in the 13th century can also be shown. The main conduit for this influence was the Dominican and Franciscan friars and lay brethren, who cultivated close contacts with Paris, at the time a hothouse of political and theological ideas.

The six scenes of the *Klaren Altarpiece* in Cologne Cathedral, painted around 1360, express a new formal language (see opposite, bottom right). The pose of the Virgin, her weight resting on one leg, is elegant, her gestures and expressions soft and graceful. The style is comparable with that of a painter active in Cologne between 1395 and 1425, the Master of St. Veronica, responsible for the painting *St. Veronica* (see opposite, bottom left). This painter was one of the central figures of the Cologne School in the early 15th century, his work representing the coming together of various strands of European styles to form International Gothic, which is characterized by flowing forms, soft and smooth transitions, and restrained gestures. The highly sensitive nuances of color and the restraint shown in rendering contrasts are features that could also be claimed for other Cologne masters.

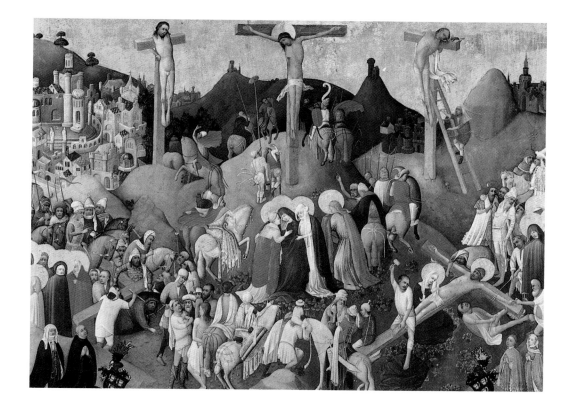

The *Wasservass Calvary* (see above), painted around 1430 in Cologne, bears a resemblance to the work of the Master of St. Veronica, especially as this master had already created a similar composition of the Crucifixion with figures type. But we must also search for more significant clues elsewhere. The way in which nature is realistically depicted, the delight which is taken by the artist in telling a story, and the composition of the groups all point to Burgundy, and specifically to the van Eyck brothers. This Calvary seems to confirm the views of Panofsky, who described a Brussels manuscript of Jacquemart de Hesdin dated 1402 as "the birth certificate of the landscape painting of northern Europe," and claimed these pages as models for later painting. It is entirely possible, then, that this is the very first Flemish or Burgundian "narrative landscape" painted in Germany, even anticipating the continuous narratives of Hans Memlinc.

The work of Stefan Lochner forms a high point in the Gothic painting of Cologne. Lochner, who came from the Lake Constance area, is mentioned in official records for the first time in 1422. He died in Cologne of plague in 1451. The drama and gritty realism of his *Passion Altarpiece* betray Flemish influences.

Lochner's masterpiece is the *Adoration of the Magi* (see page 430), which he painted at the beginning of the 1440s for the Chapel of the Virgin; it was not until 1810 that it was finally transferred to the still unfinished cathedral of Cologne. When it is closed, its outer panels show the Annunciation to the Virgin (see page 430, bottom). The scene can be compared with Jan van Eyck's depiction in the *Ghent Altarpiece* of a few years earlier, and so throws light on the close connection between the workshops of Cologne and the Lower Rhine and those of Flanders.

As an expression of the new way of seeing and depicting reality, at which the Flemish painters were so accomplished, Lochner's *Madonna of the Rose Bower* (see page 431) is without a doubt more enlightening than his *Adoration of the Magi*. The gold of the

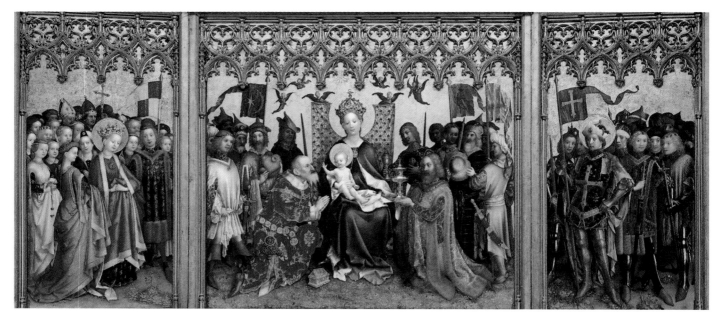

Stefan Lochner
Adoration of the Magi, ca. 1440–45
Paint on wood partly covered with linen,
central panel 260 x 285 cm, side panels
261 x 142 cm
Cologne Cathedral

BELOW:
Stefan Lochner
Annunciation, from *Adoration of the Magi*
(closed)

OPPOSITE:
Stefan Lochner
Madonna of the Rose Bower, ca. 1448
Mixed media on wood, 51 x 40 cm
Cologne, Wallraf-Richartz Museum

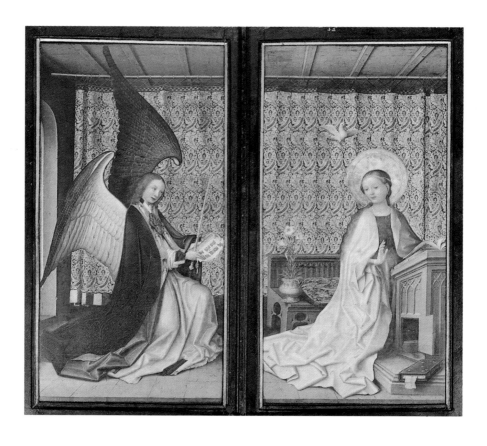

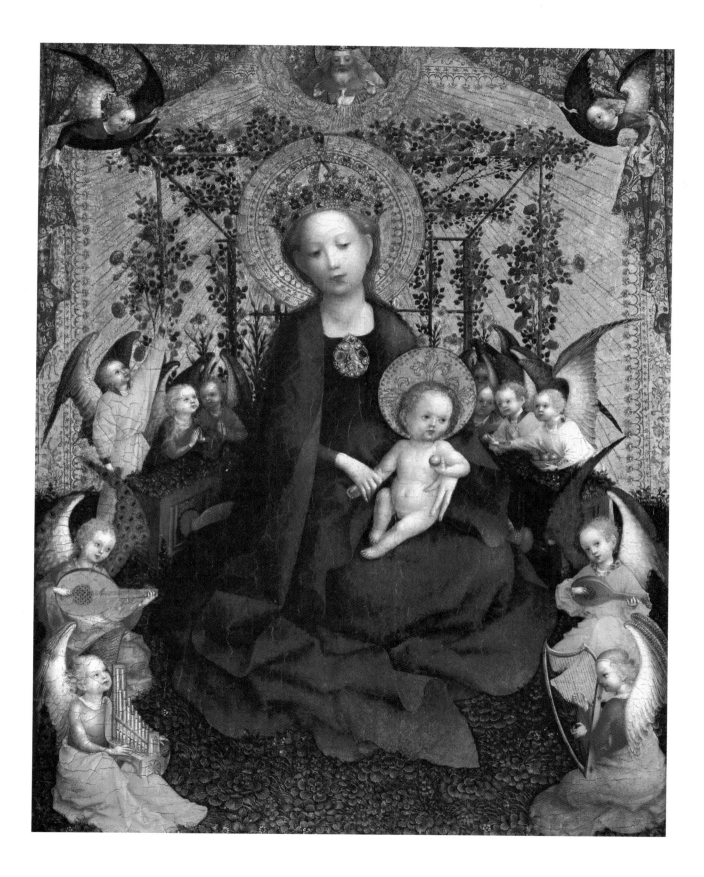

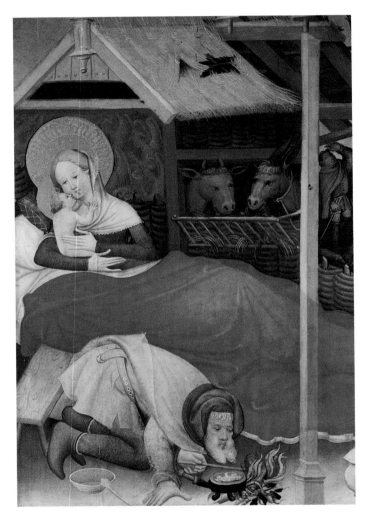

The work of the Dortmund painter Konrad von Soest should also be seen in the context of early Cologne painting. Scenes from his *Wildung Altarpiece*, which is dated 1403 and signed on the reverse side with *"per conradem pictorem de suato"* ("by Konrad of Soest, painter"), owe their effects to their detail and gently flowing style. The color contrasts are surprising, with bright gold and yellows as well as deep blues and reds enlivening the scenes. Konrad's *Nativity* (see left) is a successful genre scene, showing Joseph on his knees, his cheeks puffed out as he blows on the fire. As we can see from his face, the world portrayed here is that of the earthy and blunt peasant—people and objects from everyday life provided religious painting with a range of pictorial effects and subjects.

"The panel of the high altar of St. Peter in Hamburg was made in 1383. The artist was named Bertram of Mynden." So states an entry in the Hamburg Chronicles. Master Bertram from Minden, the creator of this work (see opposite), used the same pictorial means as Konrad von Soest. His stable in the *Nativity* (see opposite, bottom left) is even more spartan and ramshackle in appearance than that of Soest. Joseph bends to present the Christ Child to Mary. At her side lie a miniature ox and ass.

Master Bertram knew exactly how to employ the relatively limited space of the individual altar panels in order to populate the biblical story with a maximum of incident. He was less concerned with a realistic portrayal of the objects than with the manner of their presentation. In the *Creation of the Animals* (see opposite, center), fish rise from the waters and float upwards. Above them, a swan, a rooster, a peacock, and a goldfinch are arranged in ascending order.

This attention to realistic detail, as well as the thematic scope of the altarpiece, which embraces the whole of the biblical spectrum, from good to evil and obedience to violence, points to a private patron, identified as Wilhelm Horborch, a member of an old patrician family in Hamburg. It was presumably he who was responsible for the iconographic program. His brother, Bertram Horborch, was mayor of the city from 1366 to 1396 and maintained close relations with Emperor Charles IV in Prague and the pope in Avignon. The work may have been commissioned by both brothers.

The connection with Bohemia is significant. Master Bertram, born in 1340 in Minden, and first recorded as a resident of Hamburg in 1367, may have spent his apprenticeship with a Bohemian master in Prague. This would certainly explain the Bohemian coloring of his work. The commission for the Hamburg altarpiece may well have reached him when he was still working in Prague.

During the reign of Charles IV (1346–78) Bohemia experienced a political and cultural revival. The Prague workshops were dominated by two exceptional figures, the Master of Hohenfurth and Master Theoderic. The *Nativity* by the Master of Hohenfurth (see page 433, bottom right) is a panel painting from the abbey church of Hohenfurth. It has a number of stylistic similarities with Master

background dissolves into the finest detail and is structured by a superb network of tendrils and flowers. A thick carpet of leaves, grasses, and flowers is spread out under the dark blue robe of the Mother of God. The angels seated at her feet playing music provide a complement both in composition and in color.

After his death, the style perfected by Lochner declined. Increasingly, wealthy Cologne burghers commissioned their work from outside artists. Godder von dem Wasservass, for example, had an altarpiece for his family chapel (the *St. Columba Altarpiece*, see page 417, top) painted by Rogier van der Weyden. From that time on, the Flemish style influenced successive masters in Cologne.

Master Bertram
Grabow Altarpiece, 1383 (open)
Paint on wood, 266 x 726 cm
Hamburg, Kunsthalle

Master Bertram
Nativity
Panel from *Grabow Altarpiece*

Master Bertram
Creation of the Animals
Panel from *Grabow Altarpiece*

Master of Hohenfurth
Nativity, ca. 1350
Paint on wood, 99 x 92 cm
Prague, Narodní Galerie

Bertram's panels, in particular the stylized hills, miniature trees, and the plants set individually on mounds of earth.

The hill formations, with their zigzag pattern of trenches, derive from Giotto and Duccio. It is clear that the Master of Hohenfurth reworked themes from Giotto's *Nativity* in the Arena (Scrovegni) Chapel in Padua, an indication of the cultural network which linked the court in Prague with other European countries. The influence on Bohemian art of developments in neighboring Austria should also not be underestimated.

Around the year 1365, Master Theoderic of Prague was named head of the Prague guild of painters. A highly original artist, he broke free of the styles that were dominated by Italian, Austrian, and French art and tried to develop his own distinctive style. Painted between 1360 and 1365, the 30 icon-like portraits of the saints which decorate the Chapel of the Cross at Karlstein Castle are one of the most impressive results of these efforts. The robust features of the individual saints are impressively depicted. Three-dimensional objects have been added, such as carved coats of arms, mounted in the manner of collages on the surface of the paintings. Ornamented with discs of gilded Venetian glass and strips of marble encrusted with semiprecious stones, the chapel seems like a Byzantine treasure chamber. It is possible that this room and the adjacent *privatorium* were intended by the Emperor to create a vision of his future Eastern empire.

The golden age of Bohemian painting faded with the death of Charles IV. His successor, Wenceslas IV (1378–1419), known as Wenceslas the Drinker and Wenceslas the Lazy, did not play an important role as a patron of the arts. The zenith of Bohemian painting passed with the Master of Wittingau who worked under Wenceslas and of whom we shall see more later (page 438).

Austrian painting was intimately connected with its Bohemian neighbor and was also influenced by developments in France and Italy. After the unique silver altar by Nicholas of Verdun in Klosterneuburg was damaged by fire in 1322, the decision was taken to reconstruct it, working largely in silvered enamel. The rear side has four panels which include the *Three Marys at the Tomb* and *"Noli me tangere"* (see opposite, bottom left). The panels were painted in 1324, before Bohemian painting began to flourish. This fact is important in that the obvious Italian imports in the composition such as the reversed perspective of the tomb and the typical Giottoesque landscape of hills with jagged gullies may have had an influence on the Master of Hohenfurth. At the least, this panel may have led in Austria to an awakening of interest in the painting of the Italian trecento.

It appears that in the second half of the 14th century and at the beginning of the 15th century artists in various central European countries showed no great differences in style. The Master of St. Veronica in Cologne, Konrad von Soest, and Master Bertram, as well as the Bohemian and Austrian painters already cited, subscribed

Master of the Upper Rhine
Garden of Paradise, ca. 1410
Mixed media on wood, 26 x 33 cm
Frankfurt am Main, Städelsches
Kunstinstitut

Bottom:
Three Marys at the Tomb and *"Noli me*
tangere," 1324
Panel from *Klosterneuburg Altar*
Paint on wood, 108 x 120 cm
Stift Klosterneuburg

to the same stylistic principles that were employed throughout Europe, which were to a greater or lesser degree dependent on developments in France and Italy. The intermarriage of European ruling families and the constant exchanges between their courts contributed to an unusually lively cultural life, and ultimately led to the development of International Gothic.

In the period after 1400, however, a change in stylistic direction can be seen, which we have already examined in the case of the Netherlands. The dominance of Flemish painting, which extended as far as Italy, also influenced German painting. The influence of French illuminated books remained strong. We have already seen how the work of Stefan Lochner can be considered part of this new, late Gothic movement, while Master Francke has been discussed in connection with French illuminated art.

The transition from a hard to a soft style in the 1420s presaged new concepts of form and composition. While the pictorial space of Master Bertram required that elements in his paintings be presented in series—more or less as if they were to be read—Master Francke, working around 1410, was one of the first north European artists to strive to integrate all the various elements into one coherent pictorial space. Thus in late Gothic altar painting the mere adding of elements was transformed into the coalescence of pictorial elements. Each is related to the others and together they form a unified scene. This is true whether the picture is an individual scene or a sequence of scenes in a simultaneous narrative.

This concept applies to the Frankfurt *Garden of Paradise,* which was painted about 1410 in a workshop on the Lower Rhine (see above). The scenes occurring simultaneously capture a single moment in time for the saints, the Virgin, and the Christ Child, the setting ornamented by the meticulous depiction of the emerald green lawn, the delicate spring flowers, the Tree of the Knowledge of Good

Lucas Moser (Master of the
Tiefenbronn Magdalene Altar)
Magdalene Altarpiece, 1432
Mixed media on wood, 300 x 240 cm
Tiefenbronn, St. Mary Magdalene

and Evil, with its elegantly twisted trunk, and the birds that perch in the trees and on the walls of the garden. The picture depicts a *hortus conclusus* (enclosed garden), a symbol of the purity of the Virgin. Here the accurate details illustrate a growing interest in the study of nature, an interest that is generally associated with a new age in painting, the Renaissance.

In Germany, the dividing line between late Gothic and the artistic ideal generally considered "Renaissance" is difficult to draw. Stefan Lochner's works, painted in the early years of the 15th century, appear to lie in the shadowy area between the Middle Ages and the modern. On the other hand, the woodcuts of the *Apocalypse* by Albrecht Dürer mentioned at the beginning of this chapter appeared in the last years of the 15th century and yet still display medieval features, even though they coexist with a "modern" conception of painting (see page 393, bottom).

Transitions between artistic styles are usually seamless, and the art produced in the era under consideration was very diverse. Styles were adapted in a multitude of ways, and the influence of specific

regional art forms led to unique achievements, some of which we have already discussed.

Others are also worthy of mention. The so-called *Tiefenbronn Magdalene Altarpiece* by Lucas Moser ranks among those exceptional works produced in Germany in the first half of the 15th century (see left). We have singled this piece out not simply because its artistic quality is representative of developments during this era, but also because of the controversy surrounding the painter himself.

According to Gerhard Piccard, the graphologist and paper expert, "Lucas Moser" never existed. The name and date of 1432 on the back of the altarpiece are inventions, he claims, which date only from the 19th century. Piccard further says that the panels were put together at a later date, as shown by the fact that they have been cut to size. Moreover, he claims, the style suggests an origin in Burgundy rather than southwest Germany, even more specifically, the area around Lake Constance. Perhaps, he speculates, the painting was executed in 1380 by pupils of the Sienese master Simone Martini, who worked in Avignon during the period of papal exile.

Indeed, there is no documentary evidence for the name Lucas Moser—except for this dubious signature on the altarpiece. Technical analyses, however, challenge much of Piccard's theory. The fact that the figurative style, the depiction of the landscapes, and the painted architecture have little in common with the art produced in southwest Germany does not imply that it is a Sienese or Burgundian import. After all, the faces of the figures certainly bear comparison with Swabian examples of the period. It is necessary to see the work in the context of close European ties, as is the case with Stefan Lochner and Master Bertram. The *Tiefenbronn Magdalene Altarpiece* may contain a reference to Melchior Broederlam's diptych (see page 397), for scenes from the life of St. Mary Magdalene are placed in front of and within the pictorial architecture. In just the same way, Lochner's *Judgment Day* shows the influence of the works of the Flemish artist Rogier van der Weyden.

In addition, many other paintings produced in Germany during this period clearly demonstrate close links with Burgundian and Flemish art. Examples of this are the works produced by the Ulm workshops around 1470, such as the *Eucharist Mill Altarpiece* and the altarpiece by Hans Leonhard Schäufelin.

Gold, Light, and Color: Konrad Witz

The Bohemian masters' use of color is characterized by a unique richness of contrast. The Master of Wittingau, for example, contrasted dark areas with bright, luminous areas of color (see right). The landscape and clothing of the figures are muted, while the haloes and the red background set with stars glow brightly. The color scheme was necessary for the depiction of light, which here is created through the contrast between light colors and dark colors. This contrast creates an illusion of space. It also, by giving the figures greater three-dimensionality, makes them appear more dynamic.

However, the Master of Wittingau's technique was still unable to differentiate between the effect of light itself and the color of the objects he was depicting. He produced an impression of light through the contrast of colors rather than through a systematic modulation of color within a single object. For this reason he painted the background red, on which he then painted a broad weave of stars. The gold of the haloes increases in intensity as a result and is perceived as a dazzling, dematerialized light.

The discovery of light in painting may have resulted from similar experiments in the late 14th century. The painters of the Bohemian School were pioneers in this development. One of them, Konrad Witz, who was probably born around 1400 in the town of Rottweil in Württemberg, adapted Lochner's idea of depicting light through contrasting light and dark areas of color. In the *Miraculous Draft of Fishes*, a panel from the *Altarpiece of St. Peter* of 1444, Christ in his red robes appears almost three-dimensional against the smooth surface of the lake (see below). The dark and subdued tones of the foreground and middle ground lend the red a luminous quality which seems to radiate from the figure itself. Similarly, the landscape is also divided up into light, clear zones, with trees, buildings, and fields appearing to grow out of the painting from below the dark ridges of the mountains in the distance.

Witz's primary concern was to convey the reality of the subject matter, not to create an illusion of a real world or to articulate three-dimensional forms; light is a function of the landscape as experienced by the viewer. The *Miraculous Draft of Fishes* is one of the very first

monumental landscapes whose individual components—Lake Geneva with the harbor wall and the Petit Salève mountain in the distance—can still be seen today.

Using color to depict light did not just mean dividing colors between somber backgrounds and glowing figures or objects. The traditional gold background, symbolic of the sacred realm, was given the additional function of intensifying the three-dimensionality of the figures.

In his *King Solomon and the Queen of Sheba* panel from the *Heilspiegel Altarpiece* of 1435, Witz painted a gold background with filigree ornamentation and placed both his figures before it (see page 437). The blue, red, green, and white of the clothing and the restrained ochre of the hands and faces may be the only colors, but they radiate light when set against the intense gold of the background, whose effect is increased still further by the elaborate inlay pattern. Witz recognized that an abstract gold background sharpened the contours of a form and made it almost tangible.

Here two distinct artistic techniques combine in Witz's work: the traditional

Master of Wittingau
Christ on the Mount of Olives,
ca. 1380–90
From the altarpiece of the parish church of St. Aegidius

use of gold for a background and the new technique of defining light by color. If we compare the King Solomon painting with the traditional application of gold by the artists of the so-called Soft Style such as Master Bertram (see page 433), the differences and similarities become immediately apparent. Master Bertram was also aware of the capacity of gold to make figures and objects palpable. In contrast, Witz did not employ gold simply to signify a sacred, non-specific place, but rather to decorate the vertical background and in this way to establish a counterpoint with the horizontal bench, covered with a cloth of rich red. The seated Solomon and the Queen of Sheba, who leans toward him, perform their actions in a space whose light is defined by this gold background.

The use of gold surfaces to highlight contours can also be seen in the figures of the Virgin and St. John the Evangelist in the *Ghent Altarpiece* by the van Eyck brothers (see pages 408–409). The luminosity of the colors should be seen in this context: dark shadowy zones and glowing golden colors bring out the intensity of light within the forms.

The exploration of ways to depict light is without doubt a feature common to Jan van Eyck and Witz. Where they differ is in how the reality of that light is evoked through color. Van Eyck employed a richly populated and detailed cosmos in which light could be dispersed. Witz, on the other hand, constructed monumental figures which, though like substantial, two-dimensional sculpture, seem illuminated from within.

Konrad Witz
Miraculous Draft of Fishes, from *Altarpiece of St. Peter*
Paint on wood, 85 x 79 cm
Geneva, Musée d'Art et d'Histoire

The Depiction of Visions and Visual Perception

Master Bertram's *Annunciation* (below) from the altar of St. Peter's in Hamburg is structured according to the standard iconography of the day. God the Father appears in the upper left-hand corner and sends forth beams on which the Holy Ghost, in the form of a dove, and Christ are transported into the Virgin's chamber. The angel, pointing upwards, acts as a guide to the miraculous event.

The remarkable qualities of this picture become all the more apparent when it is placed alongside another which has nothing to do with religion, an illustration of a human eye from a medieval manuscript on the problems of perspective (bottom). The manuscript was published under the title *Perspectiva communis* in 1320 by John Peckham .

Master Bertram
Annunciation, 1383
From *Grabow Altarpiece*
Paint on wood
Hamburg, Kunsthalle

John Peckham
Diagram of the human eye, from *Perspectiva Communis*, ca. 1320
Illumination on parchment, 18 x 11 cm
Oxford, Bodleian Library
Ms. Ashmole 1522, fol. 153v

According to one school of medieval thought, light rays emanate from objects and fall on the semicircular surface of the eye and ultimately on the pupil. The object then forms an image on the retina. According to this system, however, it is equally feasible that the very act of looking can have a material effect. St. Thomas Aquinas and his teacher, Albertus Magnus, believed that light rays originating in the eye itself were capable of influencing nature. Looks can indeed kill or curse, though they can also heal and bless. God's gaze in a depiction of the Annunciation therefore symbolizes the salvation of humanity and our redemption from original sin.

This theory of the rays of vision, supported by the scientific exploration of optics, was nothing less than an interpretation of divine miracles in terms of cognition. The depiction of these rays of vision was primarily confined to supernatural, mostly divine events that could be seen only by the chosen few.

The often dramatic staging of the transubstantiation of the Eucharistic bread and wine into the body and blood of Christ reaches its high point when the priest raises the host. Through this act, the believer was able to feel the presence of God, but without being able to see the divine rays of God's gaze necessary for this metamorphosis to take place. This is something witnessed only by the Elect, of whom St. Brigitte of Sweden was one.

In an illustration of one of her visions, we can see how the transformation of the host occurred (see right). The saint is seated at her writing desk. In front of her the Eucharist is being celebrated. Her head is lit by a divine ray which descends from an open heaven in which the angels and saints have gathered. The Virgin and Christ, seated in a mandorla, impart the rays which reveal the miracle: only Brigitte is able to see the body of Christ rising from the wafer.

These examples from religion and science reveal aspects of visual perception which relate to two theories discussed in the newly founded universities of the day: the theories of "intromission" and "extromission." The supporters of extromission claimed that the human eye was a source of light that made objects visible by illuminating them. In the late 12th century Richard of St.-Victor believed in the power of the human eye to perceive divine reality in a vision. The supporters of the theory of intromission objected to this, however, claiming that the human eye had first to be made capable of seeing, in other words it had to be blessed by divinely created light.

This concept, which originated with Aristotle, came to dominate the debate in the 13th century. The object itself sent out images which either assumed real shapes on the retina or formed themselves into visions in the soul. The latter could be more accurately defined as divine inspiration.

Mystical Vision of St. Brigitte of Sweden
Illumination on parchment, last quarter of 14th century, 26 x 19 cm

New York, Pierpont Morgan Library, Ms. 498, fol. 4v

In an Italian altarpiece by Francesco Traini in Pisa, St. Thomas Aquinas receives not only divine wisdom but also the wisdom of the Evangelists and the philosophers of the Classical world (see left). He then conveys this to the Christian community, and also, in order to convert them, to the enemies of the Church. The intertwining structure of these rays of vision or wisdom (difficult to see in a small reproduction) determines the composition of the picture and creates a pictorial order which reflects the divine order of the cosmos.

Francesco Traini
Triumph of St. Thomas Aquinas, ca. 1340
Tempera on wood, 375 x 258 cm
Pisa, Santa Caterina

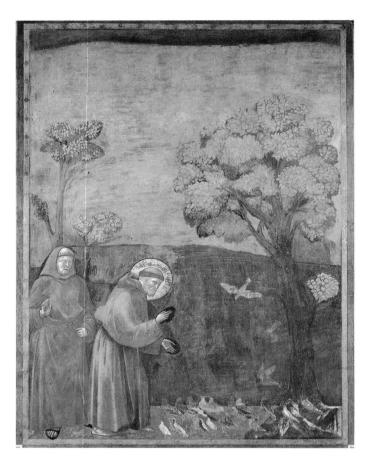

Giotto
St. Francis Preaching to the Birds,
ca. 1295
Fresco
Assisi, San Francesco, Upper Church

BOTTOM:
Assisi, San Francesco
Apse and north transept
with paintings by Cimabue and his
school, ca. 1280

architectural elements were opening themselves up. In the middle picture, the *Farewell*, the architecture is divided evenly between left and right; the undefined space in the middle through which the central axis runs acts as a dividing line that emphasizes the separation of father and son. The building in the left-hand scene is clearly a continuation of the church being supported by St. Francis in the right-hand panel. Here the architecture of the picture is composed in such a way that the columns and tower of the collapsing Lateran basilica are supported by the double columns of the neighboring bedchamber.

This three-part sequence is accommodated in a single bay of the church in Assisi, below the windows. In order to indicate that this sequence of images forms an artistic whole within the church, Giotto employed a further technique: the perspective of the painted console frieze below the image sequence is aligned with the central axis of the fresco's middle panel. This system of three-part images in sequence can be applied to the entire decorative scheme of the church. Giotto attempted to draw up a system of painting whose pictorial space was compatible with the inner space of the church and its internal divisions (see page 244, left).

By defining a space in which his figures could be seen to act, Giotto diverged sharply from the Byzantine tradition, a development that can be clearly seen elsewhere in the church of San Francesco. Around 1279, two decades before Giotto's work, Cimabue (born in

Spatial Composition in Italian Art

We have already seen that Giotto's concept of "simultaneous space" contrasts with the "successive space" of northern European painting. This contrast can be seen mostly clearly in a comparison of Giotto's *St. Francis Preaching to the Birds* (see above) and Master Bertram's *Creation of the Animals* (see page 433, middle of bottom row). While the north German artist arranged birds, fish, and mammals alongside and on top of one another, the Italian artist combined man, animals, and landscape in one unified space. The method of integration that Giotto practised requires the elements of his image to be seen simultaneously; Bertram's style requires the individual motifs be read in sequence.

Such a comparison is not intended as an endorsement of advanced compositions like those of Giotto, but as a way of illustrating very different ways of handling space. The St. Francis fresco is part of a cycle, the whole of which Giotto intended for the church of San Francesco in Assisi. The paintings were intended to be read in succession in order to follow the deeds of the saint, but the individual pictures themselves are held together by both the painted and the real architectural environment. The scenes *St. Francis Praying in San Damiano*, *St. Francis Saying Farewell to His Father*, and *St. Francis Supporting the Church* (see opposite, top) are united by the relationship between the figures and the buildings. On the left, the church of San Damiano is pushed slightly backwards, as if the

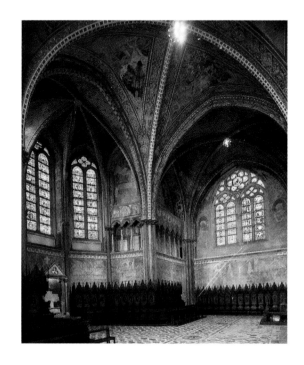

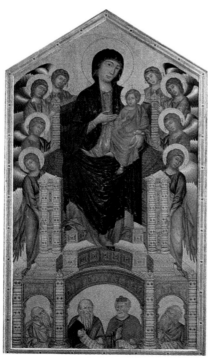

1240 in Florence) painted the choir, the crossing, and parts of the transept in the traditional "Greek manner" (see opposite, bottom right). In the crossing vault, the Evangelists are seated, monumental and rigid, just as the Byzantine school prescribed. The central positioning of the figures and their exact placement on the diagonals of the vault's ribs could be considered typically northern. In Gothic churches such figures were usually placed between the ribs of the vaults so that the ribs form the diagonals and establish a composition whose central point is the keystone. The unity of the picture was therefore based on an abstract linear system which drew together all the pictorial elements.

This break with tradition can be seen even more clearly if we compare Cimabue's *Madonna Enthroned* (see left) and Giotto's *Ognissanti Madonna* (see page 442, right). A mere 20 years separates Cimabue's work from Giotto's, but the differences are astonishing: the flat composition of Cimabue is transformed by Giotto into a spatial one. The throne architecture constructed from the towers of a heavenly Jerusalem becomes, in Giotto's hands, a filigreed and realistic throne with steps and cushions. The faces of the angels in Cimabue's painting correspond to the same formal style as those of the Virgin and Child. Giotto, by contrast, differentiates between the refined features of Mary, the childlike appearance of the Christ Child, the faces of the surrounding angels, and the biblical figures, who are clearly characterized by their various hairstyles and beards.

Duccio
Madonna Enthroned (Rucellai Madonna), ca. 1285
Tempera on wood, 450 x 290 cm
Florence, Uffizi

Giotto
Ognissanti Madonna (Madonna Enthroned), ca. 1305
Tempera on wood, 325 x 204 cm
Florence, Uffizi

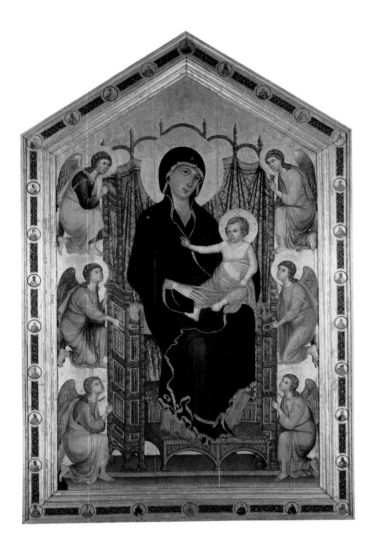

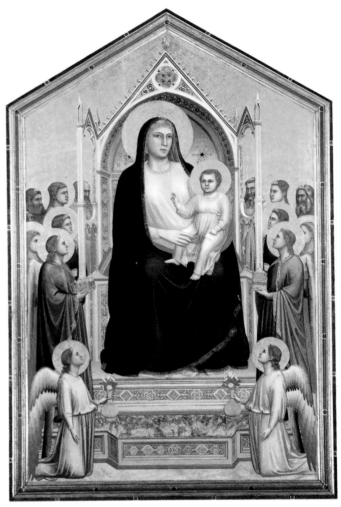

Giotto
Raising of Lazarus, ca. 1305
Fresco, 185 x 200 cm
Padua, Arena (Scrovegni) Chapel

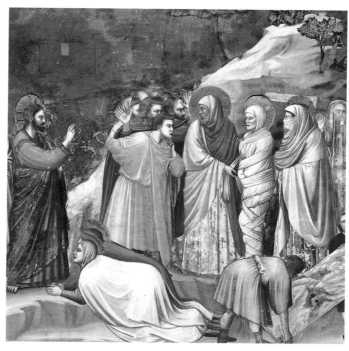

Moreover, the rigid Byzantine approach is loosened in Giotto's work and his use of space gives the figures the appearance of movement. His realistic and dignified Madonna seems to rise from the throne and move towards the viewer. The angels placed around the throne, as if in a gallery, serve to open the space for the divine presence.

Giotto's use of drapery is defined by the dynamic interplay of human form and clothing. Both unite to define the structure of the figure. Clearly Giotto recognized that the form of the drapery had to reflect the movement of the body beneath it. In the *Raising of Lazarus* in the Arena Chapel in Padua (see right) the individual movements of the figures can be perceived in the folds of their drapery. In addition, the actions played out between the characters highlight their movements and provide a compositional structure which is derived from observations of real scenes and is not determined by a traditional, prescriptive aesthetic.

These aspects highlight the difference between Cimabue's and Giotto's approach to figures and reveal the evolutionary step necessary for a spatial definition of the human form—and therefore of human individuality (see pages 454–455). The writer Boccaccio, a near-contemporary of Giotto, may have had precisely this in mind when he praised Giotto as the greatest of artists, a man who painted the "essence of things" rather than merely their appearance.

The relationship between Cimabue's vault frescoes and comparable works in Gothic cathedrals north of the Alps has already been hinted at. Similarly, Giotto's draped figures are likely to have had their Gothic precursors as well. An examination of Gothic cathedral art is interesting in this respect, particularly the draped figures of the west portal of Reims cathedral (see page 315). Although the typically Gothic style of broad folds predominates, the movement of the figures creates a contrasting smoothing out of the garments in places. The saints and biblical figures appear heavier and more substantial, especially the smaller seated figures on the outer jamb of the portal.

Giotto's links with northern styles can also be detected in the decorative system of the Arena Chapel in Padua, especially in the grisaille figures of the niches in the lower part of the wall where the Virtues and Vices are depicted. Justice is seated on a Gothic throne whose back takes the form of a trefoiled window (see right). The interior of the west wall of the cathedral of Reims is decorated with similar figures, miniature sculptures which are also in trefoiled niches (see far right). It seems plausible that Giotto knew of developments in French cathedrals, probably from sketches brought back by merchants or bankers, and adapted these motifs to his own purposes.

Taddeo Gaddi, one of Giotto's pupils, worked in Florence between 1300 and 1366. He painted the Baroncelli chapel in the church of Santa Croce in Florence around 1328, brilliantly employing the technical achievements of his teacher. His scenes for the *Life of the Virgin* (see page 444, bottom) were painted with two goals in mind. First, to compose the painting so that it corresponded

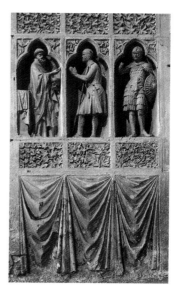

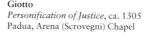

Giotto
Personification of Justice, ca. 1305
Padua, Arena (Scrovegni) Chapel

Reims Cathedral, inner west wall
Niche figures
1225–55

BELOW:
Maso di Banco
Pope Sylvester Tames the Dragon,
ca. 1340
Fresco
Florence, Santa Croce, Bardi di
Vernio Chapel

BOTTOM:
Taddeo Gaddi
Life of the Virgin,
ca. 1328–30
Fresco
Florence, Santa Croce, Baroncelli Chapel

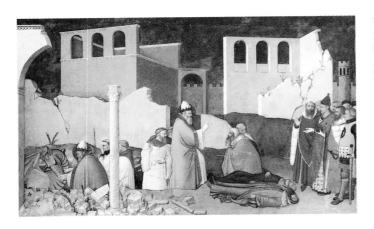

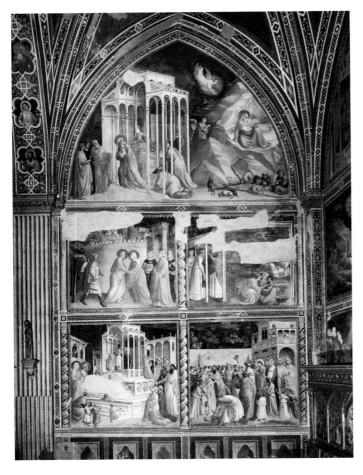

to the form of the chapel bay, which was arched. Second, by means of the architecture of the painting itself, to create a sufficiently deep stage for the sequence of events to be played out. Gaddi came up with an ingenious solution for the upper section directly under the arch. He placed the architecture of the temple directly beside a cliff which looms up on the right so that in the upper section a quatrefoil shape is created, an open space out of which he let an angel descend. This served to link the scenes *Joachim Driven from the Temple* and the *Annunciation to Joachim*. The sections below, with their alternating interiors and exteriors, appear as sets in front of which, and in which, the events take place. From the *Meeting at the Golden Gate* (top left) we move on to the *Birth of St. John the Baptist*, the *Virgin on Her Way to the Temple*, and finally the *Betrothal to Joseph*. As in San Francesco in Assisi, the architecture of the painting is closely linked to the architecture of the church, the continuous narrative to the way a viewer reads.

The possibilities of Giotto's art were further developed by his pupils Maso di Banco and Bernardo Daddi. The composition of the paintings relaxed and the movements of the figures became more dynamic and expressive. The decorative system also became more sophisticated. The details of the scene were formulated more for the atmosphere generated by groups of figures than as a consistent narrative sequence.

Maso di Banco was perhaps the most original of Giotto's pupils. The events of his paintings took place in the same architectural space as Giotto's but he re-interpreted the figures in order to emphasize the actions and unique physiognomies of individuals. The ruins of the Roman landscape in the depiction of the legend of St. Sylvester, painted for the church of Santa Croce in Florence (left), convey an eerie atmosphere appropriate to a scene in which a grave is being opened. The play between ruined walls and fully developed figures is a virtuoso achievement. Here, however, the drama of the scene has less to do with the events as a whole than with the depiction of the individuals' actions.

Painting in Siena developed alongside that of Giotto and his followers, but the founder of Sienese painting, Duccio di Buoninsegna, had his own, very different, aesthetic ideas. The basis of Duccio's work was still the Byzantine style, but he attempted to transform this, as Giotto had, his concern being to emphasize meditation on the divine and, connected with that, the spiritual as an essential part of everyday life. Duccio's main task was to produce devotional pictures for the home and, less often, comprehensive series of frescoes. He was not as concerned with the subtleties of placing figures in space and depicting objects realistically as he was with the aesthetic requirements of his employers, who preferred conservative or courtly styles. Byzantine models were preferred for solemn themes like the Transfiguration of Christ or the Madonna Enthroned. Duccio's *Madonna Enthroned* of 1285 (see page 442, left) still owes much to the Byzantine style but shows signs of new

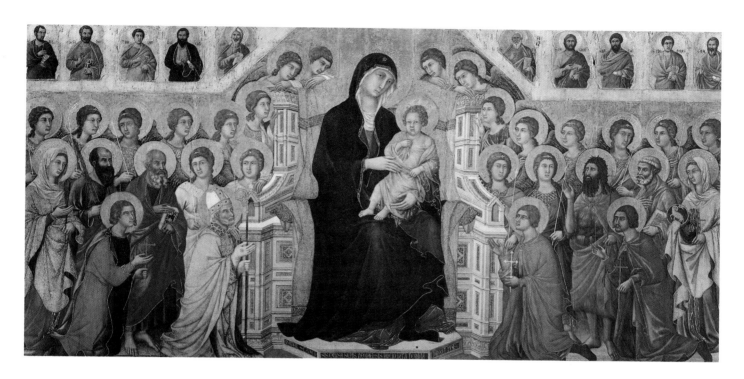

developments. The architecture of the throne conveys a sense of space and allows the angels, whose gestures are largely uniform, to appear more realistic. The elegant curtain seems to correspond to contemporary French taste, perhaps that of the painting's patron.

A quarter of a century later, Duccio painted the *Maestà* for Siena Cathedral (see above). *Maestà*, "Her Majesty," was the name given to tabernacle and devotional pictures of the Virgin that decorated public spaces. For the Sienese they had a special significance: as a result of a battle fought in 1260 between Siena and Florence, the Queen of Heaven was also the Queen of Siena. Besieged, the Sienese had placed themselves under the protection of the Mother of God, and then proceeded to defeat the numerically superior Florentines. From that time on she had been considered the patron of the city. Thus the *Maestà* was a type of state portrait. Duccio's painting was treated accordingly, carried from his workshop to the cathedral in a stately procession. It must have appeared as if the Virgin herself had descended from Heaven to take her place on an earthly throne. Seated on a marble throne, whose pilasters reflect the architecture of the cathedral, the Virgin is both an object of devotion and a queen holding an audience with her subjects. This sort of "iconographic positioning" was surely the political intention of the clients, who were eager that the Virgin should continue to exercise her steward-ship of the city.

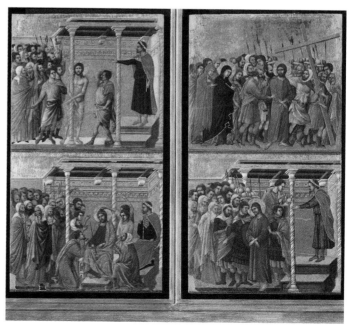

Simone Martini
Maestà, 1315–16
Fresco, 1060 x 980 cm
Siena, Palazzo Pubblico

OPPOSITE:
Simone Martini
Knighting of St. Martin, ca. 1320–25
Fresco, 265 x 200 cm
Assisi, San Francesco, Lower Church

Duccio understood perfectly how to balance realism with sacred symbolism. The gold background and the uniform ranks of people and angels, as well as the inlaid ornamentation, still belong to traditional, Byzantine concepts of form, and so stress the glory of the Queen of Heaven and the divine order. The architecture of the throne, however, has all the appearance of one of Giotto's figurative spaces and gives depth and movement to the Virgin and the Christ Child. On the reverse of the panel are 26 scenes of the Passion (see page 445), whose style repeats the balancing act between realism and symbolism, albeit on a different plane. Here it is the elements of nature which appear schematic and Byzantine, whereas space is structured according to Giotto's model. This also holds true for the gestures and postures of the figures, who are individualized and animated. If Giotto was crucial for the development of the early Renaissance, then it is also true that Duccio evolved an aesthetic that ranged even wider in its dialogue with the Byzantine tradition. This explains the fact that in the mid 14th century the fame of Siena's art was more widespread in Europe than were the formal ideas of Giotto and his school.

It was Duccio's pupil, Simone Martini, who first brought international renown to Sienese painting. He was praised in Petrarch's sonnets. Several years after the triumphal procession which carried Duccio's *Maestà* into Siena Cathedral, Simone Martini received a commission to paint another image of the city's heavenly ruler, in this case for the Palazzo Pubblico. The fresco in the Sala del Mappamondo (see above) was completed in 1316. This *Maestà* still shows the influence of Martini's teacher, Duccio, but details such as the billowing canopy, the three-dimensionality of the Virgin, and the spatial grouping of the angels and saints are evidence that a gulf was opening up between modern art and the Byzantine tradition.

The perspective effect of the canopy, seen from below, is a sure sign of an intense study of Giotto's depiction of space. Simone Martini also worked in the church of San Francesco in Assisi where he painted his most important work, the frescoes of the chapel of St. Martin, between 1322 and 1326 (see opposite). The pictorial architecture, the composition of the figures, and the decorative system were developed in an extraordinary harmony with the actual structure of the chapel. Like Giotto, Martini arranged his images according to the point of view of a visitor to the chapel.

Simone Martini can also be considered the first true court painter. He worked mainly for the French royal house of Anjou and was knighted for his services in 1317. Given his standing and his achievements, it is not surprising that in 1340, toward the end of his life, he was called to Avignon to work for the papal court. Sadly his frescoes in the portico of Avignon Cathedral have been lost. However, the frescoes in the papal palace, which date from around 1340 (Pope Clement IV resided there at this time), painted by his pupils or by masters belonging to his circle, can still be seen. These paintings, derived from classical Roman paintings of gardens, are unique depictions of medieval rural scenes (see page 189, bottom). The range of important aesthetic concepts developed by Simone Martini and his pupils was influential, not only in France but in many other parts of Europe as well.

It is important to remember that the development of Sienese painting after Duccio was largely based on his *Maestà*. This applies especially to the reverse of the panel, where scenes from the Passion are depicted. Pietro Lorenzetti was obviously fascinated by the groups of figures Duccio so skillfully integrated into their architectural setting in his *Christ's Entry into Jerusalem* (see page 448, bottom left). They appear in a similar composition in a fresco of the same subject by Lorenzetti in San Francesco in Assisi (see page 448, bottom right).

Pietro's brother, Ambrogio Lorenzetti, was also inspired by Duccio's depiction of architecture. He seems to have been especially interested in the placement of figures in Duccio's *Denial of St. Peter* (see page 449, bottom left). The church of San Francesco in Assisi contained another architectural study by Giotto, in his *Expulsion of the Demons from Arezzo* (see page 449, bottom right). Both must have helped in the conception of Ambrogio's unique city portrait in the Palazzo Pubblico (see pages 448–449, top). The placement of the groups and the arrangement of the individual figures show that Ambrogio had solved the problem of the relationship between figure and architecture more successfully than Giotto had. Furthermore, the proportions are far more accurate, so that a lifelike depiction of urban life replaces Giotto's architectural fantasy.

This imaginative handling of space and figurative groups developed into a clear composition and thus into a new relationship between the objects in the painting, the space depicted in the painting, and the surface of the wall. Agnolo Gaddi, Giovanni da Milano, and Altichiero da Zevio competed in the development of Giotto's

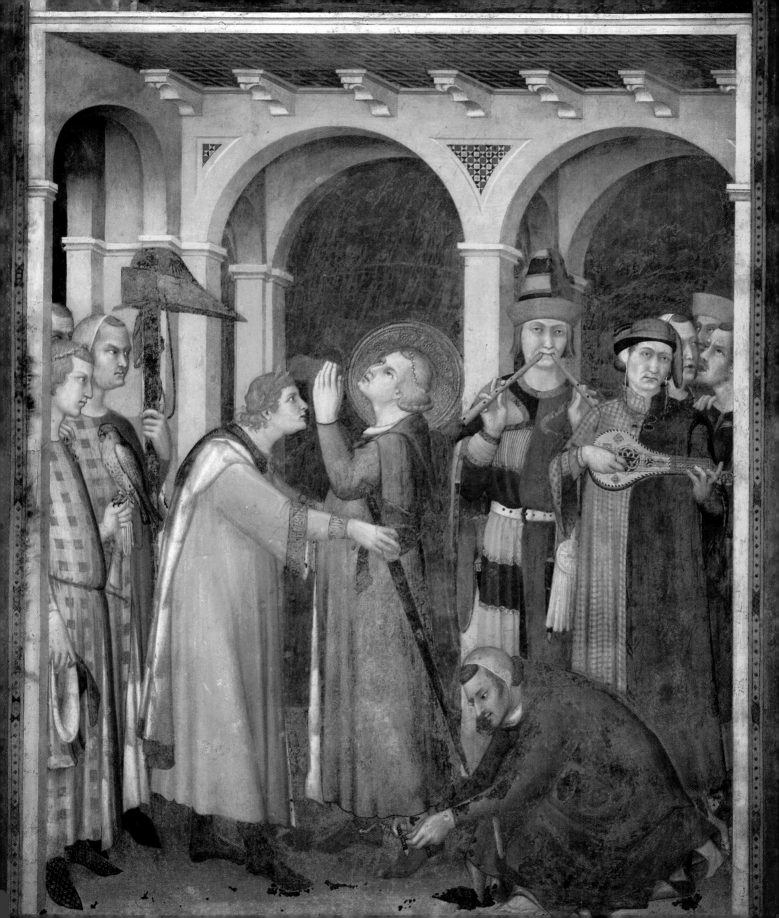

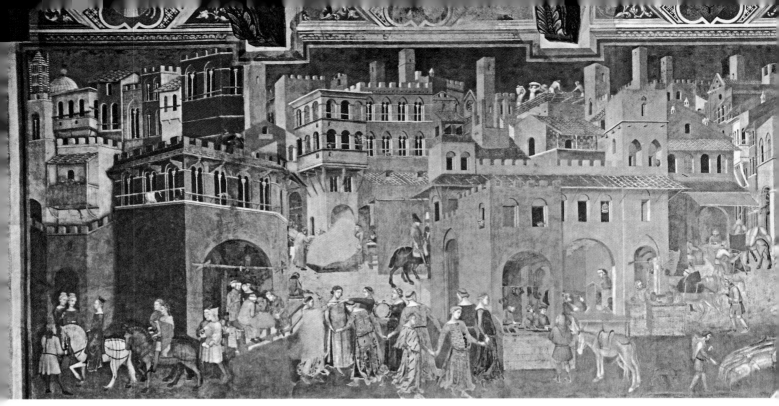

Ambrogio Lorenzetti
Allegory of Good Government,
ca. 1337–40
Fresco
Siena, Palazzo Pubblico, Sala della Pace

Duccio di Buoninsegna
Christ's Entry into Jerusalem, 1311
Passion scene from reverse of *Maestà*
Tempera on wood
Siena, Museo dell'Opera del Duomo

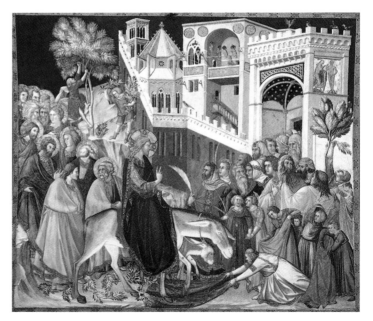

Pietro Lorenzetti
Christ's Entry into Jerusalem, ca. 1330
Fresco
Assisi, San Francesco, Lower Church

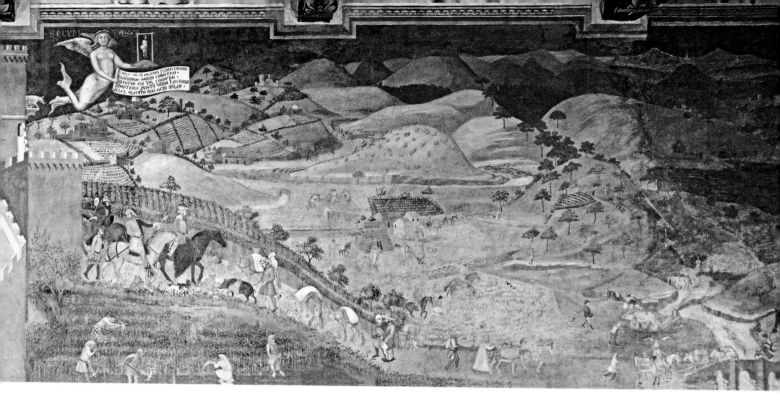

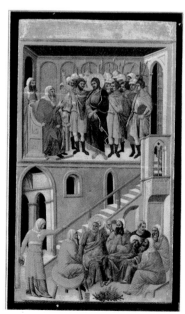

Duccio
Christ Before the High Council and
Denial of St. Peter, 1311
Passion scenes from reverse of *Maestà*
Siena, Museo dell'Opera del Duomo

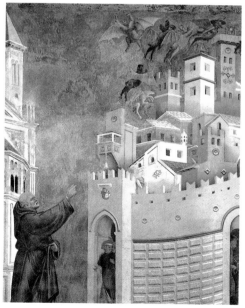

Giotto
Expulsion of the Demons from Arezzo,
ca. 1295
From *Cycle of St. Francis*
Fresco

BELOW:
Giovanni da Milano
Birth of the Virgin, ca. 1365
Fresco
Florence, Santa Croce, Rinuccini Chapel

BOTTOM:
Altichiero da Zevio (and others)
Crucifixion, 1376–79
Fresco, 840 x 280 cm
Padua, Sant'Antonio, Chapel of
San Giacomo

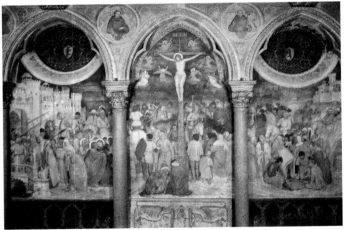

architecture. Around 1380, he and Jacopo Avanzo painted a cycle of frescoes in the Chapel of San Giacomo in the Santo (the church of Sant'Antonio) in Padua. The group compositions of his *Crucifixion* (see left, bottom) are clearly those of Giotto's figures, but the architecture is structured so that it seems to recede ever deeper into the background of the picture. Only a stone's throw from the chapel, the young Titian was to work in the Scuola del Santo in 1511, where he was deeply impressed by Altichiero's color scheme and composition.

Giotto and his pupils and successors in the 14th century were doubtless the first to bring this new way of apprehending space into the public consciousness. Their perceptual model encouraged artists and theoreticians of the early Renaissance such as Masaccio, Filippo Brunelleschi, and Leon Battista Alberti to carry out their own experiments in order to prove that space could be depicted in its correct proportions on a two-dimensional surface.

But we would be doing the painting of the Italian trecento a disservice if we were to see in it merely the development of new ways of visualizing space and constructing its pictorial equivalent. Gothic painting extended the possibilities and conditions of aesthetic perception. Surfaces become three-dimensional and in this way the picture could be redefined as a stage suited to the depiction of actions and nature. In addition, compositions developed which were to fuse different spatial perspectives and pictorial motifs.

The paintings in the Chapter House of Santa Maria Novella in Florence, which has been called the Spanish Chapel since the 16th century, are typical. Working on a commission from the Dominican order, Andrea da Firenze (Andrea Bonaiuti) painted a multi-layered allegory of the teaching and work of the order, relating it to the story of salvation (see opposite). In this fresco, entitled the *Path to Salvation*, the pictorial concepts of the trecento appear to have been combined and to have developed a new dimension. The architecture, landscapes, and figures all vary in scale according to the interpretative perspective. A small group of young girls, lost in dance, is placed alongside a mighty St. Dominic, who is showing the Blessed through the gates of Heaven. The rolling Tuscan hills with their castles, seen in the background, contrast with the monumental, idealized view of the Florentine cathedral that dominates the foreground. Above all this sits God, enthroned in Heaven and surrounded by the angelic choir. All the differing elements—landscape, discrete depictions of architecture, and figure scenes—are drawn together into a vast unified scene.

The attempt to categorize certain Italian painters active at the beginning of the 15th century means entering uncertain territory. Do they belong to Gothic or early Renaissance art? Some of them at least, like the Veronese painter Antonio Pisano, known as Pisanello, and the Florentine Fra Angelico, can only be considered "Renaissance" artists with some qualification.

Perhaps the problem is best described in the following way. Pisanello used medieval patterns much as Altichiero used late

figurative space. The plane of the wall as the foremost level of fictive space, combined with perspective in depth, remains. But the painting of the Rinuccini Chapel in Santa Croce in Florence in 1365 by Giovanni da Milano points up the further possibilities of pictorial architecture in its ornamental framing (see above). The compressed space loses its importance as architectural space and gains in decorative elegance, though even here the figures in the story of the Virgin act within an architectural stageset. The poetry of their movements reflects the refined patterns painted on the frame.

The Veronese painter Altichiero studied Giotto's frescoes in Padua and borrowing from them developed new forms of pictorial

Andrea Bonaiuti (Andrea da Firenze)
Path to Salvation, ca. 1365–67
Fresco
Florence, Santa Maria Novella,
Chapter House (Spanish Chapel)

medieval techniques, but in a "modern" way, through the composition, the "pictorial architecture," of Masolino or Masaccio, though without being familiar with their mathematical model of perspective. As a consequence, Pisanello sometimes fell back on medieval techniques. His *Vision of St. Eustace* (see above) employs the techniques of proportion (recognizable from the horse and rider) keenly debated in the Renaissance workshops of Uccello and Donatello, but he also makes use of the vocabulary of International Gothic. The placing of hills, trees, and animals on top of one another is familiar from Franco-Flemish illuminated books; it has been established that Pisanello borrowed motifs from the books of hours by the Limbourg brothers. Similarly, his portrait of a young woman, probably Ginevra d'Este (see page 455, right), is flat, and its flowers and butterflies, though drawn from nature, seem like ornamental patterns from French or Flemish tapestries.

A similar special case is that of Fra Angelico, whose work rests squarely on the dividing line between Gothic and early Renaissance. Fra Angelico was able to combine a feeling for the divine order and the sensibility of a heart yearning for salvation with the mathematical construction of pictorial space. His sublime images of angels and saints are devotional pictures which serve purely meditative needs. Around the middle of the 15th century Fra Angelico painted the cells of 45 monks in the monastery of San Marco in Florence. His harmonious spatial compositions, and the figures depicted in contemplative retreat from the world, were appropriate for the purpose of the cells as refuges for meditation. One of these cells is represented in his *Annunciation* (see above, right). St. Sylvester observes the events

taking place against a background of bare walls and an elegant cross vault. Every monk, the painting seems to say, is capable of perceiving the divine when in the depths of prayer, even in his bare, undecorated cell.

By contrast, the *Annunciation* in Cortona (see opposite) is dominated by decorative forms and ornamental patterns which strongly recall Byzantine models. The golden rays surrounding the angel, the golden halos, the gold patterning of the throne of the Mother of God, and the designs on the robes could all be by Duccio or another Sienese painter. The holy story is told in traditional form. The setting, a loggia, is pictured according to the architectural convention of the day (the model was Brunelleschi's hospital for foundlings built several years before). While the Virgin and the angel are only set slightly back into the architecture of the picture, the architecture is dramatically foreshortened. A view of a landscape with flowers and a palm tree, as well as a distant hill showing the expulsion from Paradise of Adam and Eve, forms a border to the loggia.

Fra Angelico is one of the most interesting artists of the early Renaissance. In many respects he is still a practitioner of Gothic painting. The use of medieval forms of expression with modern ways of seeing, expressed through the use of centralized perspective, is one side of the rich and varied painting styles of the first half of the 15th century. Fra Angelico's work makes us aware that perspective was not necessarily an achievement of the modern age, but an aspect of the delight late medieval painters took in experimenting with depictions of reality. The mathematical conception of space—perspective—could be thought of as an aesthetic model for illustrating the order of the divine cosmos.

Fra Angelico
Annunciation, ca. 1432–33
Tempera on wood, 175 x 180 cm
Cortona, Museo Diocesano

Nicolas Spiering
Christ Nailed to the Cross, from
Book of Hours of Mary of Burgundy,
ca. 1480
Illumination on parchment, 22 x 16 cm
Vienna, Austrian National Library,
Ms. 1857, fol. 43v

The Path to Individualism

One of the key phrases of the philosophy of the Middle Ages was *individuum est ineffabile,* "the individual is inexpressible." This thought conveys a fundamental which was not fully discussed in all its ramifications until the transition period from the Middle Ages to humanism—that people have an intrinsic and lasting value which is independent of God and the heavenly powers.

Any definition of individuality is colored by humanistic thought. The humanists saw people as independent creatures blessed with reason, capable of taking responsibility for their own actions and of seeing themselves as the bearers of ethical and moral values. This understanding of individuality developed only slowly, and not always through intellectual means. We should not ignore the fact that the medieval term "ineffabile" in fact stimulated philosophers and artists to attempt to describe or illustrate "the inexpressible." The long path towards the concept of individualism can be traced from the Middle Ages to the beginning of the modern age; we have already pointed out some of the stations along this route.

Duccio, who felt an inclination to paint devotional pictures for the home, had to distance himself from the strictures of the Byzantine style in order to fulfill the individual wishes of his clients. Sacred themes are enriched with the objects of this world—carpets, flowers, vases—creating intimate ensembles of objects which later artists developed into autonomous still lifes, as in the work of Giotto and Taddeo Gaddi (see page 391). The early Flemish painters in particular cultivated this "image within an image" and ultimately developed a style which enabled sacred events to be placed in a believable domestic setting.

An illustration from a book of hours belonging to Mary of Burgundy, painted around 1480 (see right), shows a framed view of a landscape in which Christ is being nailed to the Cross. The biblical event seems almost incidental in view of the unusually sumptuous architecture which surrounds it. The private chapel of the patron is depicted, with cushions, jewelry boxes, bottles, pearls, and an open Bible arranged as a still life. In addition, Mary, heir to Charles the Bold and first wife of Emperor Maximilian I, turns her head to look at the viewer in order to emphasize the connection with the private realm.

This growing emphasis on the private sphere can be taken as an indication of an increasing sense of individualism. This was especially so for the art collectors who purchased precious objects for their own personal pleasure.

The archetype of the medieval collector was Duke Jean de Berry. The illuminated book *Les Très Riches Heures* (see pages 462–463) was commissioned by him from the Limbourg brothers and contains an

accurately. As we have already seen, Giotto achieved this through his definition of pictorial space and his successful integration into that space of the human form. This evolution of a naturalistic space in which movement could be suggested helped to lead in turn to the realistic depiction of people themselves.

The decisive steps towards this—the origins of modern portrait painting—can be traced to another type of three-dimen-

illustration showing his castle. The depiction of a lion looking up at an ape in a tree is also intriguing: it is a reference to the duke's passion for collecting. According to contemporary documents, in 1388 the Duke possessed 1,500 dogs, bears, lions, swans, and other exotic animals.

By placing art at the service of the personal whims of kings and princes, religious themes began to lose their importance and, to a certain extent, eventually became simply a pretext for the depiction of secular motifs.

In the Middle Ages, the path to individualism was encouraged by the discovery of nature and the invention of artistic means to depict the world

sional approach to the figure, the sculpture of the 13th century. Examples are the sculptures of Rudolf of Habsburg in Speyer Cathedral (ca. 1280) and Philip the Bold in St.-Denis (1298–1307). Thus the isolation of the human figure and the creation of a natural space in which to set the figure were the preconditions for the development of the portrait. Giotto seems to have created these conditions in his paintings, an illusory space in which his figures, increasingly individual in form, seem to act.

But only in the course of the 14th century did painting discover the figure as personal portrait, for example the *Portrait of John the Good* (ca. 1360) in

the Louvre (see above, left), or the images of Emperor Charles IV and Anne of Schweidnitz from the same period in Karlstein Castle, near Prague.

These considerations suggest that "the discovery of the individual" was not the achievement merely of the humanists, but also of artists—that seeing and understanding, as so often, had a mutually stimulating effect on each other. This claim—that the exploration of pictorial space is closely related to the discovery of how to portray people in their full individual subjectivity is significant. A dynamic concept, individualism has to be able to develop spatially, to have, as it were, room in which to grow.

These ideas had already been established by the philosopher Nicolas of Cusa, and were related to the belief that God has bestowed on us the gift of free will. Because individualism had to be "legible," it had to be translatable into pictorial terms. The realistic, and therefore spatially conceived, depiction of the human face comes very close to Cusa's philosophical concept of individualism.

BELOW:
Spanish School
Women Lamenting, ca. 1300
Ceiling detail from tomb of Sancho
Saiz Carrillo, 54 x 86 cm
Barcelona, Museu Nacional d'Art
de Catalunya

BOTTOM:
Pere Serra
Virgin with Christ Child and Angels,
ca. 1350
Central section of Madonna Altarpiece,
196 x 130 cm
Barcelona, Museu Nacional d'Art
de Catalunya

Italian, French, and Flemish Influences in Spanish Painting

Spanish Gothic painting can be divided into clear epochs. Between 1290 and 1490 there are four different periods, of which the first was still clearly influenced by the late Romanesque style and the last already bore traces of early Renaissance painting.

The first style, the so-called Linear Style, developed principally in the north of Spain, its straight lines and rigid figurative scheme recalling contemporary Romanesque Apocalypse manuscripts. The row of lamenting women on the ceiling of the tomb, now in Barcelona, of Sancho Saiz Carrillo, a nobleman from Burgos, is Gothic only in that the figures are positioned in rows and overlap (see left). The posture and gestures, even the physiognomies, are borrowed from a largely traditional style that still clearly bears signs of the Romanesque. The work's firm lines make it a particularly bold example of the Linear Style, which dominated Spanish painting in the years between 1290 and 1350.

The picture of Islamic dignitaries in the dome of the middle alcove in the royal hall of the Alhambra in Granada (see page 458, left) is intriguing in terms of developments in Spanish painting. It does not fall into any of the usual categories of Christian iconography, though it was in fact painted by Christian artists with their customary techniques. The paintings are executed on leather and show the rulers of the Nasrid dynasty depicted against a gold background. Here, too, the contours dominate. The finely modeled faces recall the work of Avignon artists, who probably completed this work around 1380.

Italian influences were particularly marked in Catalonia as this region was open to French and Italian culture through its close ties with Provence and northern Italy. These connections led to the obvious second phase of Spanish painting, the Italian Style. The central panel of an altar from the mid 14th century showing the Virgin and Child as well as angels playing musical instruments follows the Siena school in its composition and in its ornamental treatment of figures (see left).

Stimulated by French painting, especially that of Avignon, International Gothic gradually gained ground in northern Spain from around 1400. Ramón de Mur is considered the greatest representative of this third phase, which is characterized by a shift away from Italian forms. On an altarpiece now in the episcopal museum of Vic, Mur depicted the Fall in a Paradise which is surrounded by castle-like architecture (see opposite, top).

Other representatives of this style are the painters Lorenzo Zaragoza with his *Jérica Altarpiece* (1395) and the German Marçal de Sax with his *St. George Altarpiece* (London, Victoria and Albert Museum). The first influences of Franco-Flemish illumination can be discerned in their work. Later it was Flemish art that came to dominate Spanish workshops, especially those of Castile and León. This was the final phase of Spanish Gothic painting, which was known as the Flemish Style.

BELOW:
Ramón de Mur
The Fall, 1412
Vic, Museu Episcopal

BOTTOM:
Luis Dalmau
Virgin of the Councilors
Paint on wood, 1445
270 x 275 cm
Barcelona, Museu Nacional d'Art
de Catalunya

Luis Dalmau worked in Flanders from 1431 to 1436 and studied the works of the van Eyck brothers. Strongly influenced by them, in 1445 he created an altarpiece for the chapel of the Barcelona town hall (see right, bottom). The Virgin and Child appear in the central panel, surrounded by saints and councilors. The Virgin is seated on a richly ornamented Gothic throne in the middle of painted ecclesiastical architecture. Windows with tracery and quatrefoil patterns lead the eye over the heads of the saints and into a delicately composed landscape. The figure of the Virgin, especially her gestures, shows great similarities with van Eyck's Madonnas. Another influence apparent in this painting is Flemish architecture, which was enormously popular at the time.

Jaime Huguet chose a different route. He attempted to distance himself from Flemish painting, which he had studied closely, in order to develop his own style. His *Vinzenz Altarpiece* in Sarriá, painted around 1458, shows that he was largely successful in this (see page 458, right). Many of the pictorial attributes and details of the architecture recall Flemish models, but the individualistic faces of his figures and the spatial composition of his groups indicate that he was the first Spanish painter to find his own formal concepts—and therefore a "Spanish way" to the Renaissance.

Italian masters were also probably studied at this time. King Alfonso V (king 1416–58), who ruled in Valencia, maintained a close political relationship with Naples. Spanish painters such as Alonso de Sadena worked for periods in Naples and passed on these new influences to their Spanish colleagues on their return. It would therefore be one-sided to see developments in the second half of the 15th century as resulting from specifically Flemish influences. Spain, in contrast to France and Germany, was open to influences from both northern Europe and Italy.

Pedro Berruguete worked together with the Fleming Justus van Ghent on the decoration of Federico da Montefeltro's palace in Urbino in Italy. The Spaniard painted the allegories of the liberal arts and most of the portraits in the duke's *studiuolo*, including a portrait of Federico and his son which today still hangs in the ducal palace (see page 459, right).

Given these strong international influences, Spanish painting in the late 15th century was relatively slow to develop its own stylistic characteristics. In the decades of political and artistic turmoil in Europe, princes and kings understandably wanted modern, popular styles and they chose to employ the artists who practised them. Thus, for larger commissions, Flemish or Italian painters were brought to the Spanish court. Juan de Flandes for example, obviously a painter of Flemish origin, was Isabella of Castile's court painter from 1496 to 1504.

From 1567, Philip II employed numerous Italian artists to decorate the Escorial palace. Not until the end of the 16th century did the great age of Spanish painting begin with the work of Domenikos Theotocopoulos, known as El Greco.

Avignon School
Ten Islamic Dignitaries, ca. 1380
Paint on leather
Granada, ceiling painting in
Royal Hall of the Alhambra

Jaime Huguet
Vinzenz Altarpiece, ca. 1458
From Sarriá parish church
Paint on wood
Barcelona, Museu Nacional d'Art
de Catalunya

Fernando Gallego
Flagellation, ca. 1506
Paint on wood, 104 x 76 cm
Salamanca, Museo Diocesano

Pedro Berruguete
Federico da Montefeltro and
His Son Guidobaldo, ca. 1477
Paint on wood, 138 x 80 cm
Urbino, Palazzo Ducale

Illuminated Books

France

Teaching requirements at the University of Paris, together with the generous patronage of kings and the nobility, meant that in France toward the end of the 13th century the art of illuminated manuscripts flourished as never before. Paris became the center of European miniature painting, the workshops being located in the rue Erembourg (rue Boutebrie), close to the copyists and paper merchants who conducted their business in the rue de la Parcheminerie.

The most famous miniaturist of the age was Master Honoré, who ran an important workshop between 1288 and 1291. This workshop was responsible for the production of the *Breviary of Philip the Fair*. The illustration depicting the two David scenes (see above, left) combines typically French decorative motifs with aspects of Byzantine narrative, notably the appearance of the same person several times: as David gets ready to use his sling, Goliath is already clutching his forehead, while in the background David lifts his sword to cut off Goliath's head. A noteworthy feature of the work is the languid elegance of the figures, which seem almost to take on the curves and long, willowy bodies of 16th-century Mannerism.

Jean Pucelle, who also worked in the rue Erembourg, is generally thought to have had still greater influence than Master Honoré. While Master Honoré had a tendency to concentrate on the pictorial motif rather than decorative elements, Jean Pucelle sought out and transformed decorative features. He joined ornaments to framework borders and small capital letters, and combined these with architectural motifs and figures to form almost abstract patterns.

His *December* from the *Breviary of Belleville*, painted around 1325, is especially interesting (see above, right). The woodcutter and his roaring winter fire, which is consuming the felled trees, illustrate the month's activities. The Virgin, the Queen of Heaven, has a banner featuring the Christ Child in the crib. On the lower border, a prophet appears with the message "I have come to awaken your children," a reference to the Church, the Resurrection, and eternal life; the synagogue in the picture has already fallen into ruins. There are grotesque little figures in the margins (so-called drolleries) who, caught up in the vines and leaves, play music or perform various tricks. The gracefulness of these miniature figures and the integration of ornament, architecture, and script constitute the special attraction of the work of Jean Pucelle. He had a lasting influence on illuminated art, a fact that can be seen in particular in the products of the workshops of Burgundy and Berry.

The passion for art of the dukes of Burgundy, especially Duke Jean de Berry, was fueled by their increasing influence on French politics. English intervention in France had weakened the French monarchy but strengthened the power of Burgundy and other dukedoms and allowed the economy and arts in these areas to flourish. Jean de Berry, younger brother of Charles V of France, was one of the first princes to establish his own extensive library.

The Turin *Les Très Belles Heures du Duc de Berry*, whose illustrations scholars once attributed to Jan van Eyck, combines superb landscapes, accurate, spatially correct interiors, and ornamental borders familiar from the work of Jean Pucelle (see right, top). The Flemish temperament evident here is even clearer in the work of Jacquemart des Hesdin, who arrived at the court of Duke Jean de

Berry from Artois in Flanders in 1384. His workshop produced all the duke's books of hours including the famous *Les Très Belles Heures de Notre Dame* in the Bibliothèque Nationale in Paris and the so-called *Brussels Book of Hours* (*Les Très Belles Heures*) in the Royal Library in Brussels. Besides the obligatory decorative patterns and the Flemish-inspired architecture, Bohemian influences can also be detected in the execution of the faces and the treatment of the drapery.

Jacquemart des Hesdin remained at the court of the duke until 1409. A year later the Limbourg brothers were called to the court of Duke Jean de Berry at Mehun-sur-Yevre, near Bourges. There they painted a unique masterpiece, *Les Très Riches Heures*, which today still draws countless admirers to the Musée Condé in Chantilly, north of Paris. Now only ruins remain of the duke's favorite castle, the Mehun-sur-Yevre, but in his chronology of 1400, the French poet Jean Frioissart praised this castle as the most beautiful in the world. One of the illustrations from *Les Très Riches Heures* depicting the temptation of Christ does justice to Froissart's hymn of praise (see right, bottom). With its white towers decorated with Gothic tracery, the castle depicted looks like a monumental crown. It symbolizes the wealth of the world which Christ, seen on top of a minaret-like mountain, has refused in order to overcome the temptations offered by the Devil. The duke possibly wanted to relate this scene to the change in his own life, the quality of which is hinted at in the depiction of the castle, a metaphor for the temptations of the world of the senses. But it is doubtful whether de Berry was always as upright as the model he set himself.

The depictions of the months relate the activities of people to specific historical places. Hay-making, for example, takes place outside the city walls of Paris in the month of June (see page 463). The medieval architecture of the Palais de la Cité and the Ste.-Chapelle are depicted in exact detail. The relationship of the figures and the landscape recalls similar Italian compositions, for example those of Ambrogio Lorenzetti (see pages 448–449). The Limbourg brothers may also have been inspired by Lorenzetti's urban architecture and the way in which he combined houses to form architectural complexes.

Before Paul and Jean Limbourg arrived at Duke Jean de Berry's court, they worked for his brother, Philip the Bold, Duke of Burgundy. Philip employed other artists as well and commissioned work from Paris. The Dijon court also received books from Paris workshops, illustrated by Boucicault and the Bedford Master.

Flemish influence became more and more pronounced around the middle of the 15th century. Jean de Wauquelin's workshop produced illustrations for the *Alexander Romance* and the *Hennegau Chronicles* during the reign of Philip the Good. In the dedication leaf to Philip (see page 464, top), the decorative elements inspired by the Flemish masters are particularly conspicuous. Not confined to the borders of the picture, they extend to the interior and also the figures' clothes.

461

Limbourg brothers
June, from
Les Très Riches Heures, ca. 1415
Chantilly, Musée Condé

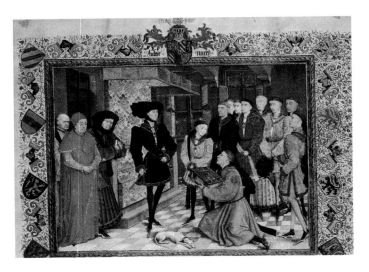

During the Hundred Years' War against the English and beyond, French kings from Charles VII (1422–61) to François I (1515–47) had their court in the Loire valley. It was there that they built many of their finest residences. Jean Fouquet worked there, presumably after having done his apprenticeship as a miniaturist in Paris. A journey he undertook to Rome provided him with further inspiration, which he incorporated into his illustrations with great ingenuity. With its detailed depictions of cities, villages, and people, the *Great Chronology of the French Kings* gives a vivid picture of medieval French life. Even more significant are the miniatures for the book of hours for Étienne Chevalier, secretary and treasurer to Charles VII. Here we see landscapes typical of the early Italian Renaissance, along with depictions of palaces and castles typical of the Limbourg brothers or the Parisian School (see left, bottom).

With Fouquet, who worked for the French ruling house together with other artists from Tourain, the great age of French illumination came to an end. The appearance of Robert Campin, Jan van Eyck, and Rogier van der Weyden meant that the center of gravity of European art shifted to Flanders and the Netherlands.

Italy

The main centers of Italian illuminated art were Milan and Pavia, cities which were the official residences of the Visconti dukes of Milan. Even in Bologna, despite the demand provided by the university, miniature painting developed only in fits and starts and certainly never reached the heights it did in the French principalities. Both northern Italian centers, Bologna and Milan, were greatly influenced by French sources. The first independent artist was Niccolò di Giacomo da Bologna. His typical motifs are golden acanthus vines in the background, well-formed realistic figures, and glowing colors (see opposite, top left).

The magnificence of the Visconti court, together with its political connections with Burgundy, left its mark on the art of Lombard workshops. The main subjects were chivalrous romances such as *Tristan* and *Lancelot of the Lake*. Giovanni de' Grassi painted the miniatures of the *Ambrosian Breviary*, borrowing from Burgundian models. The ornamental border, decorated with leaves incorporating tiny figures, as well as the delicate Gothic finials, reflects the refined tastes of the court (see opposite, top center).

Although the work of Lombard miniaturists was also popular in central Italy, Florentine masters attempted to distance themselves from their north Italian colleagues and to develop their own style. At first they turned to Giotto and attempted to make their work more populist by employing more realistic motifs. An illustration by Domenico Lenzi with the title *City Scene* (from the *Il Biadaiolo* codex) illustrates this (see opposite, top right). It was painted around 1340 and is reminiscent of the urban pictures of Giotto or Ambrogio Lorenzetti.

The illustrations created half a century later for Dante's *Divine Comedy* (see opposite, bottom right) also evince a plain, unadorned

style. The miniaturist has avoided decorative devices and ornamented the scene only with those architectural or landscape features which are required by the text. In contrast to the Lombard masters, the Florentine miniaturists developed their miniatures in accordance with their own artistic traditions.

Germany, Switzerland, Austria, and Bohemia

In German workshops, the influence of Romanesque illumination could still be felt until late in the 13th century, though these artistic ideas were neither unified nor bound to any national body of formal concepts. On the whole, the aesthetic ideas of the German miniaturists were determined by Byzantine influences and, above all, by French taste.

The famous *Minnesänger* manuscript of the Swiss Manesse family is the most compelling of all the books which were produced in the region during this period. It was made between 1315 and 1340 in Zürich, and its illustrations combine Ottonian ornamentation with French figurative style. In spite of this, it captures something unique, almost certainly because of the unusual subject matter. The manuscript, which is also called the *Royal Manuscript,* contains the songs and verse of 140 poets. The work of each poet is illustrated with a picture and generally also with a small scene connected with the text. The most famous image is the depiction of Walther von der Vogelweide, who is pictured seated in the very posture he describes in his poem (page 466, left).

Florentine School
Dante in Hell, from
Divine Comedy, ca. 1405
Milan, Bibiloteca Trivulziana,
Ms. 2263, fol. 31r

The depiction of an orchestra being conducted by Heinrich Frauenlob (see above, right) is intriguing as a piece of cultural history. Violas, flutes, and bells can be seen, and the conductor is signaling to the soloist standing in the middle. The other musicians are resting from playing and look attentively at the conductor.

While the artist who created these pages was still strongly influenced by traditional illuminated art, Austrian miniaturists looked to Italy for their models. Documents show that Giovanni di Gaibana was employed in the workshops of the monasteries of Admont, Seitenstetten, and Klosterneuburg. The *Admont Missal* from the late 13th century and the *Klosterneuburg Bible* from the early 14th century are works worthy of mention.

The court in Vienna also employed Bohemian artists. Paralleling developments in painting, Bohemian miniature painting reached a brilliant peak in the 14th century. The *Passional of Abbess Kunigunde* was painted around 1320 (see opposite, left). The highly original illustrations, which reflect French as well as Italian influences, demonstrate most effectively the flamboyant Gothic style of the region. Even the scene of the story of Lot (see opposite, right) from the *Bible of Velislav* shows, in its clear lines, the influences of French models. These works once again go to prove the stylistic intertwinings of International Gothic. But this is not to detract from the unique character of these works. Bohemian illuminated art was famous throughout Europe, a fact shown by the presence of Bohemian miniaturists at European courts such as Paris and Buda. It should be emphasized, however, that the centers of Gothic illuminated art were in France. The richness and quality of books produced there was unrivaled.

Bohemian School
Church Militant, from
Passional of Abbess Kunigunde, ca. 1320
Prague, University Library
Ms. XIV A 17, fol. 22v

Bohemian School
Story of Lot, from
Velislav Bible, ca. 1340
Prague, University Library
Ms. XXIII C 124, fol. 18v

Gothic Stained Glass

Brigitte Kurmann-Schwarz

Though stained-glass windows are among the most beautiful and fascinating products of medieval art, for a long time they were not accorded anything like the same value as frescoes or panel paintings. Creating monumental pictures from colored glass was not of course an invention of the Gothic age. The origins of the technique go back to late antiquity. The unique effect of stained glass is the result of the translucency of its ground, the colored glass, while the actual paint used for outlines, the black pigment, is opaque. Panel and fresco painters of the Middle Ages, by contrast, laid paint on an opaque ground and had to reproduce light through the use of gold or tones lightened with white.

Like every artist, the glass painter began his work with the sketch, which he worked out in accordance with the instructions of the client and then submitted for approval. If the composition met the patron's wishes, work could begin on the painting proper. As the monk Theophilus Presbyter reports in a treatise dating from the early 12th century, glass painters first prepared wood panels onto which they transferred the sketch at the actual size of the finished product. On that they drew in the lines of the leading and fixed the colors of the glass, which would be cut to measure according to this design, and finally painted. Depending on the custom at the workshop, the glass painters first painted either the contours or the liquid color for glazing. The fall of drapery folds, faces, limbs, and objects were then shaded to give form and depth.

Until around 1300, glass painters had only black or brown grisaille available as paint. Then around that date, silver stain was rediscovered by stained-glass painters in the milieu of the French court (though it had long been known to Islamic artists). The use of this new paint soon spread from France to neighboring areas such as England and southwest Germany.

Once the pieces of glass making up a pane had been painted, they were stacked in an oven and fired. This fixed the grisaille, which was made of crushed glass and metal coloring additives (mostly forge scale), onto the smooth surface of the glass. If the firing was successful, the painting would be capable of resisting weathering for centuries. Silver stain was an alloy of crushed silver and antimony to which yellow ochre and water were added. It fused with the glass during firing (it was always fixed to the back of the glass), staining it yellow. This new shade of paint permitted two colors to be placed side by side without the complication of cutting glass.

As soon as the pieces of glass were fired, they were laid out on the workbench and leaded together on the wooden panel with the original cartoon. This was done with cames, grooved strips of lead about 60 centimeters (2 feet) long with a profile of a sideways H. They were produced by casting. In the 15th century improvements in their manufacture allowed much longer cames to be produced, so that larger shapes were possible. The cames, which were soft and easy to adapt to the irregular shapes of the glass, were soldered together to make a connecting web holding all the pieces of glass together.

Bourges Cathedral
Departure of the Prodigal Son,
detail of the Parable of the Prodigal Son
window, ambulatory
ca. 1210

Finally the finished pattern was reinforced with thin metal armatures and mounted into the framework of the window.

The earliest evidence of medieval stained glass, discovered in the churches of the monasteries of Jarrow and Monkwearmouth in northeast England, dates from the 7th century. Already featuring there were ornamental and figured panes, though the glass was not yet painted. A head from the monastery of Lorsch, now in the Hessisches Landesmuseum in Darmstadt, is perhaps the oldest extant pane fragment with fully developed painting. The piece is variously dated, but could have been made in the second half of the 9th century. Evidence of glass painting remains scant from before 1100, although written sources report that churches were already adorned with scenes from the Bible, the legends of saints, and individual monumental figures. Shortly after 1100, Theophilus composed a treatise on the arts that includes a description of the making of stained glass. The description attests to a considerable maturity of technique, and so suggests that in the period around 1100 glass painting was already flourishing rather than—as the paucity of surviving work might indicate—just beginning.

Until almost the mid 12th century, churches still possessed relatively small windows, so that they had room only for stained glass depicting just a few scenes or a single figure. After about 1150, however, there was a sustained trend toward opening up the walls with ever larger windows. Smooth wall surfaces were finally so much reduced that the architecture came to consist virtually of a framework for windows. The cathedrals where glazing began at the end of the 12th century—Soissons, Bourges, and Chartres in France and Canterbury in England—constitute the first high point in this development. Their great and influential windows were furnished with colored panes showing narrative cycles in which numerous scenes were fitted in an overall geometric framework. The glass in the clerestory, on the other hand, was decorated only with individual figures or a few small scenes.

The medieval mind regarded light as a manifestation of the divine, and so the glowing pictures of colored glass seemed overwhelming and utterly compelling illustrations of the word of God. Theologians consequently ascribed to the stained glass the power to enlighten humanity and keep them from evil. The parable of the Prodigal Son was a particular favorite in stained glass around 1200. The story was one from which several lessons could be drawn. It warned the faithful against arrogance, extravagance, drunkenness, gambling, and visits to women of easy virtue, for clearly vices led ultimately to misfortune. The story also taught, through the example of the Prodigal Son's father, that those who left the straight and narrow way and yet repented could be welcomed back into the fold.

A pane from Bourges Cathedral (see above) shows the Prodigal Son at the beginning of the story. A typical noble of the 13th century, he rides out on his gray horse, his falcon on his hand. He wears a purple gown whose fine folds play round his body, and a splendid

cloak with fur lining. The story is told in scenes that are fitted alternately into large quatrefoils and smaller medallions. An ornamental tapestry fills the surfaces between the pictures, and a border with palmette ornamentation frames the whole. The pictorial subject reflects the views of those who belonged to the upper classes. To them, the sharp fall of the prodigal son to the lowly status of a swineherd would have seemed appalling.

The color range of the window includes red and blue, with white, various shades of purple, yellow, and green predominating in the figurative areas. The protagonists move either on the frame of the picture, on a slightly wavy strip of terrain, or on a kind of bridge, depending on whether the scene takes place inside a building or in the open air. In the departure scene, the multi-colored strips of terrain indicate that the journey is on land. The figures in the Bourges window have delicate, slender bodies that are surmounted by large heads with protruding skulls.

OPPOSITE:
Chartres Cathedral
St. Eustace (detail)
North aisle, ca. 1200–10

Canterbury Cathedral
West window depicting the Tree of Jesse,
ca. 1200
Overall view (right)
Detail with Aminadab in the center
(below)

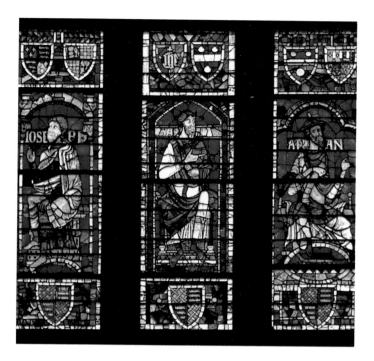

The world of the nobility also figures in a scene from the St. Eustace window in the north aisle of Chartres Cathedral (see opposite). The window is made up of large and small circles arranged around central squares. The first picture in a square shows the saint riding out to hunt. As at Bourges, red and blue dualism dominates the palette of the decorative areas, whereas green, purple, white, and yellow feature in the figurative areas. The picture frame serves as a terrain for the deer as it plunges away from the riders, who storm into the frame from the left. In his ability to suggest powerfully built bodies under the drapery, the artist reveals a mastery of line and color.

The cathedral buildings in Bourges and Chartres were both begun in the 1190s. The authorities must have planned the glazing even then and set up workshops for it. Both the examples discussed so far date from around 1200–10. The sources are silent as to the name and origin of their creators. The master of the St. Eustace legend may have come to Chartres from northern France, perhaps from St.-Quentin. At Bourges, however, all traces of the painter's identity have been lost. A mastery of finely folded drapery links the stained glass of Bourges and Chartres with other works in northern France and the Maas area dating from the second half of the 12th century. Drapery folds of this kind distinguish the artistic output of early Gothic glass until about 1230 and characterize a style known to scholars as the "hollow fold" or "classicizing" style.

This artistic idiom spread quickly and established itself in England as well as in the German-speaking areas bordering France. Local variants developed. After the disastrous fire at Canterbury Cathedral in 1174, the cathedral authorities decided to rebuild. The monastic choir was rebuilt first, then the chapel behind the high altar, the Trinity Chapel. The windows at ground level were given narrative cycles and the clerestory windows enthroned figures of the ancestors of Christ. This impressive program is no longer in its original position, but in the course of time the glass finished up in the southwest transept and the great west window, where the figure of Aminadab was also relocated (see above, left). Again, fluid drapery envelops a powerful human frame.

A later variant of the Early Gothic style is displayed by fragments of stained glass from the Late Romanesque minster in Freiburg im Breisgau, which in 1509 were transferred to the Late Gothic choir and afterwards into the windows of the façade of the south transept. The patriarch Jacob, who in his left hand holds a tablet bearing his name and in his right hand the ladder of Heaven (see page 472), came from a genealogy of Christ, in other words the Tree of Jesse. This goes back to a prophecy by Isaiah (11,1): "And there shall come forth a rod out of the stem of Jesse, and a branch shall grow out of his roots." From this text there developed the image of the sleeping Jesse, from whose chest a tree grows. In its branches the ancestors of the

BELOW:
Freiburg Minster
Jacob with the Tree of Jesse, south
transept, ca. 1218

BOTTOM:
Lausanne Cathedral
Rose window in south transept,
ca. 1200–10

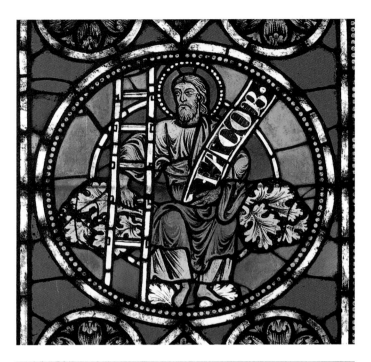

Virgin and Christ are enumerated, flanked on both sides by prophets and patriarchs. Probably completed before 1218, the stained glass in Freiburg Minster shows no connection with extant work from the Upper Rhine. New research suggests that the Jesse window in Freiburg was possibly the work of a workshop in the Maas area, where the classicizing style in sculpture had its roots. The Freiburg patriarch has a similar monumentality to the Aminadab figure, though the proportions are more balanced, his expression more restrained.

The rose window in the south transept of Lausanne Cathedral in Switzerland retains a large proportion of its magnificent glass, which depicts a cosmology of the world as people imagined it in the 13th century (see left, bottom). The Sun, Moon, Earth, signs of the zodiac, and the four elements represent the entire world. Depictions of themes such as the seasons and the labors of the months symbolize the passing of time. An elegantly clad woman represents the zodiac sign of the Virgin, her dainty body and large head very like the figures in the Prodigal Son window in Bourges, whereas the coloring is closer to the St. Eustace window in Chartres. The comparisons with Bourges and Chartres indicate that the stained glass of the rose window in Lausanne is probably earlier than previously assumed, from around 1200–10.

The Early Gothic style, with its fluid drapery folds, its jewel coloring, and its richness of decoration, lasted in France until the 1230s. The stained-glass windows by the Caraunus Master (Maître de Saint-Chéron) and those in the transept windows at Chartres herald a change of idiom in French stained glass. Yet Chartres was not directly involved in the new developments in Paris, which was then a powerhouse of artistic innovation. Probably sculptors coming from Paris to Chartres prompted the change in stained glass. At any rate, by the 1240s the High Gothic style of figure, with its elegant proportions and large-scale, sharply delineated drapery folds, prevailed throughout the heartland of French Gothic.

As the stained glass in the Ste.-Chapelle in Paris shows, this did not happen all at once, since a large project would have employed older painters alongside younger ones. The cycle depicting the deeds of the Old Testament queen Esther was among the works that wholeheartedly adopted the High Gothic idiom (see opposite, top). The figures are notable for their balanced proportions and elegant bearing. The Ste.-Chapelle, which was begun in 1239, constitutes one of the most accomplished buildings of the High Gothic *style rayonnant*. Since it was constructed with tracery windows throughout, it became possible to expand each window aperture to the entire area between the load-bearing elements of the architecture, thus creating what is effectively a wall of glass.

In contrast to the stained-glass painters at Chartres and Bourges, painters here faced the new task of providing scenes for very tall, very narrow lancet windows. So, in the Ste.-Chapelle, the initial approach was to divide the window panel into geometric pictorial fields on a tapestry background. However, because of the narrowness of each

BELOW:
Paris, Ste.-Chapelle
Esther and Ahasuerus, from the
Esther Window, Upper Church, 1240–50

BOTTOM:
Naumburg Cathedral, west choir
St. Sebastian (left), ca. 1250–60

panel, the pictorial fields had to be reduced in size and increased in number, which lessened their overall legibility. The iconographic program of the cycles covers the history of the world in hundreds of scenes, from Creation up to the arrival in Paris of the relics of the Passion that Louis IX (1236–70) acquired for his chapel. The pictures are full of allusions to the French monarchy, associating it with the kings of the Old Testament and with Christ. The life and deeds of Queen Esther are held up as a mirror to queens as they attend mass in the palace chapel.

During the first half of the 13th century, and drawing much of its inspiration from Byzantine art, a distinctive pictorial style developed in German-speaking areas, alongside variants of the Early Gothic idiom of France. Characterized by a profusion of sharp angles, this pictorial style is known as the Jagged Style and can be regarded as the typical style of painting in these German-speaking areas. After the middle of the 13th century, it came to take on more of the character of French High Gothic painting.

The change can be traced in the glass of the west choir of Naumburg Cathedral, executed after 1250. At work in the cathedral at the same time as the glass painters was the Naumburg Master, probably the greatest German sculptor of the Gothic age. Here he created his outstanding works of sculpture, the tomb of Bishop Dietrich in the east choir and the famous sculptures of the church benefactors on the entrance wall to the west choir (see page 343). His idiom was based on the style of early High Gothic works of art in the eastern provinces of France, such as in Reims. From him the glass painters took over the treatment of figures, but integrated them into their own, distinctive Jagged Style.

The figure of St. Sebastian is framed by an extended foil, which consists of two quatrefoils run into each other, backed by a rich tapestry pattern (see lefthand figure below). This type of composition, which was very popular in 13th-century German and Austrian stained glass, enabled the artist to place several standing individual figures above each other within a single frame. The figure type and gestures of St. Sebastian refer unmistakably to the statues of the benefactors in the west choir, while the modeling and crossed legs remain firmly in the tradition of the Jagged Style and its Romanesque origins. Red and blue play an important part in the color scheme, but they are combined with green and yellow to make up the typical palette of Gothic stained glass of German-speaking areas.

Only a short time before the west choir at Naumburg was glazed, work commenced on the stained glass for the nave clerestory at Strasbourg Cathedral (see page 474). The panels, which were created between 1250 and 1275, monitor step by step the change from the Jagged Style to the High Gothic idiom of French origin. It is only in the easternmost window on the south side that the figures are framed by extended foils. The figures now fill almost the entire area, so that the ornamental tapestry is omitted, leaving just enough room for a border. In contrast, the window on the north side opposite displays

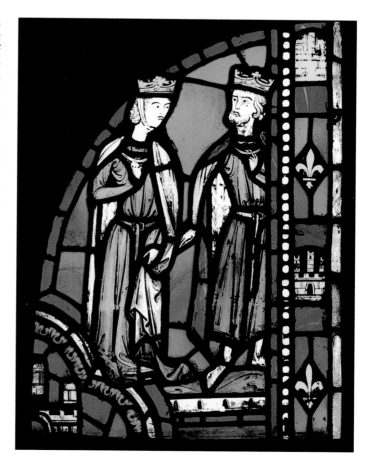

473

Strasbourg Cathedral
Detail of St. Arbogast
window, ca. 1265 (left)
North clerestory (bottom)

an entirely new kind of composition containing not more complicated foil motifs but a frame of arcading with architectural canopies. The design of these forms was no longer drawn from the artists' imagination but copied from Strasbourg's architectural drawings of Gothic buildings. The figure of St. Arbogast in the third window of the north clerestory is a fine example of the lively modeling of the saints, who are set out in multiple rows (see left, top). A prominent St. Arbogast, turning to one side, stands on a pedestal. A double border adorned with naturalistic motifs separates the figures from the stone window frame. The richly decorated clothes of the saint are multi-layered: the chasuble hangs in heavy, sculpturally modeled, bowl-shaped folds over the vertical strips of the tunic and the delicately fluid lines of the alb. Although this figure is realized in terms of the High Gothic concept of stained glass, the expressive face of the saint gives the work a character of its own: head, hair and beard, eyes and lips stand out in contrast to the flesh tones of the face and neck.

The great cathedral buildings of Strasbourg (work began on the nave in the 1240s) and Cologne (work began on the choir in 1248) played an important part in popularizing the French Gothic idiom in German-speaking areas. However, the Dominicans and Franciscans also constituted a close link with France.

The St. Gertrude window now in the Westfälisches Landesmuseum in Münster, on loan from Count von Kanitz, is from a demolished Dominican nunnery church in Cologne (see opposite, top right). This, and the Bible window from the Dominican monastery in Cologne now in the cathedral, mark the final victory of French High Gothic in the lands along the Rhine. Thanks to its close ties with the modern architecture of Cologne and Strasbourg, stained glass adopted the High Gothic idiom sooner than other painting arts, thereby showing the way for future developments in painting styles after the end of the 13th century. In the St. Gertrude window the Virgin stands beneath a tabernacle, the canopy of which is very similar to that in the St. Arbogast window in Strasbourg. The architectural frame is closed off in the background by a blue tapestry of diaper work and is surrounded by a mainly red patterned ground.

At the foot of the elegant Virgin, whose gestures and stance are derived wholly from French models, kneels the Dominican monk Igbrandus. He may have been the donor of the stained glass, perhaps given to the monastery as part of a donation connected with an endowment that involved an annual liturgical celebration on the anniversary of the donor's death. Over and above the written agreement usual in such cases between the donor and the convent, the image itself is a constant reminder to the nuns to recall the benefactor of their monastery in their prayers and to intercede on his behalf. In the Middle Ages, even stained glass was endowed not because it had great artistic value but because it opened the door to Heaven.

The French High Gothic style of stained glass soon spread to England, though the elegant proportions of the figures and the large sharp-edged drapery folds gained widespread acceptance only

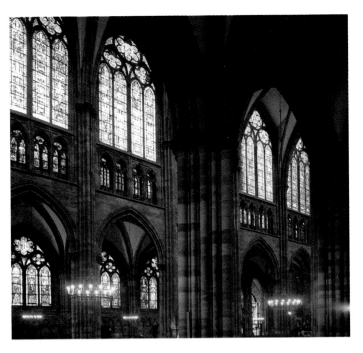

BELOW:
Exeter Cathedral
Stained glass from east window with
Isaiah (right) and an unidentified figure,
1301–04

RIGHT:
Virgin and Child with Brother Igbrandus
(right) and St. Gertrude (far right)
Former Dominican convent of
St. Gertrude, Cologne, 1280–90
Westfälisches Landesmuseum
(on loan from Count von Kanitz)

around 1270–80. The great cathedrals (Salisbury, York, Lincoln) and Westminster Abbey, all of which were glazed in the first two-thirds of the century, were largely furnished with grisaille glass, in other words colorless ornamental panes of the kind Cistercian churches, for ideological reasons, used exclusively. These provided excellent natural lighting to show up the richly detailed architecture of the Early English and later Decorated styles. Two further innovations from France, the tracery window and the figure set beneath a canopy, the forms of which were determined by real built architecture, had major consequences for the development of High Gothic stained glass in England. Tracery allowed the east ends and the west fronts of the great cathedrals of York, Exeter, and Gloucester, for example, to be turned into walls of glass. In the choir, this had the effect of turning the east wall into what in effect had now become a giant altarpiece behind the altar.

The splendid figure of Isaiah (see below, figure on the right) from the east window of Exeter Cathedral stands in an elegantly curved pose, pointing with his right hand at the scroll in his left hand, which bears the text from Isaiah mentioned earlier referring to the Tree of Jesse. Drapery and cloak are arranged in large, loose folds around the slender body of the prophet, and his face is framed by his elegantly curled hair and beard. A blue pattern of diamonds provides the backdrop, as in the slightly earlier Virgin panels from St. Gertrude in Cologne, setting off the architectural framework. A border with

naturalistic foliage surrounds both figure and architecture. Archival sources indicate that the oldest stained glass in the east window of Exeter Cathedral dates from 1301–04. (The figure itself is original, but the architecture and frame were heavily restored in 1884–96.)

A further high point of French High Gothic stained glass is the series of windows in the choir of St.-Ouen Abbey in Rouen, dating from 1325–38 (see page 476, top). It has already been indicated that tracery windows posed glass painters with a wholly new set of problems, since it was now a matter of providing glass for tall, narrow tracts of window. At the same time, the detail and ornamentation of the *style rayonnant* required good natural lighting for the interior so that moldings and other architectural features were visible to the onlooker. The painters' answer was to produce thinner glass of greater translucency and brighter colors. Ultimately, the painters abandoned the idea of filling the entire pane with color, opting instead for brightly colored, figured designs set on grisaille.

The problem of how to divide up the narrow panels was initially solved in a variety of ways. The full-color glazing of the choir of Troyes Cathedral (see page 476, bottom) shows each frame divided horizontally into three areas filled with scenes or figures, framed by painted architecture or a kind of extended foil. The choir of Tours Cathedral, which was glazed in the third quarter of the 13th century, was still furnished with mainly full-color panels. It was the glass

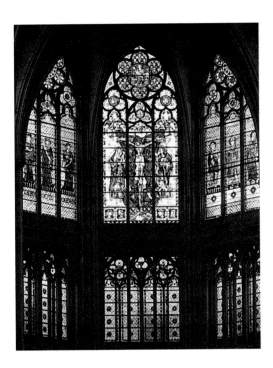

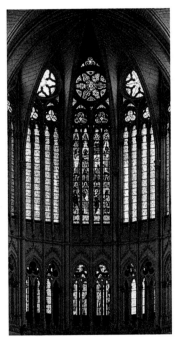

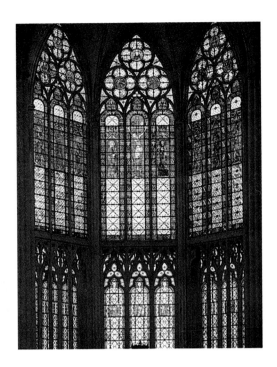

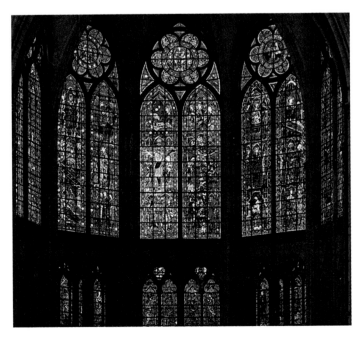

painters of the Canons of Loches window around 1260 who first discovered how to provide tall narrow lancets with stained glass in an aesthetically satisfactory way without having to elongate the figures, as is the case in the central window of the choir at Amiens Cathedral (see above, center). Their solution also met the requirement for more light in interiors. The windows were given a large area of grisaille glass in which the figures are set as a horizontal band of color. The system was further elaborated in the collegiate church of St.-Urbain in Troyes (see top right) and around 1280 in Sées Cathedral, and became predominant in the stained glass of French buildings until the mid 14th century.

In the choir of St.-Ouen in Rouen, this combination of grisaille and color glazing was developed into the standard technique. The chapels of the ambulatory were given grisaille windows with colored borders and a central colored element (heads, foliage). Lozenges structure the grisaille, forming a trellis around which delicate naturalistic foliage winds. Placed centrally, the full-color figure panels occupy about half of the windows, forming a broad band of color that stretches around the whole outer shell of the ground floor of the choir.

The Annunciation is located in the northeast window of the axial chapel, the Lady Chapel. The Virgin stands under a rich canopy, behind which extends a red foliate background. Her pose forms an elegant S-curve, and the drapery plays around her solid, rounded

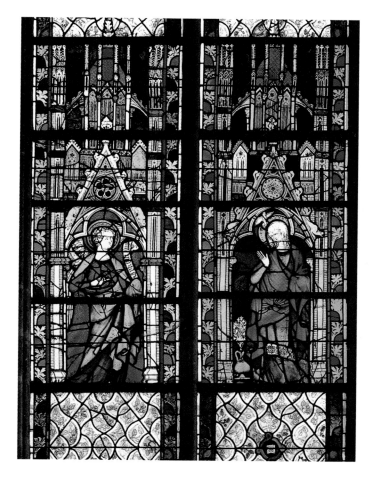

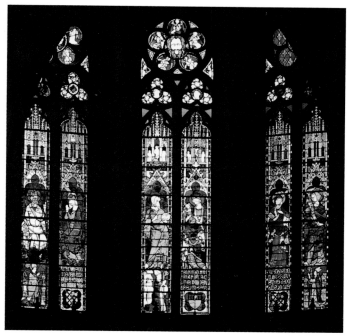

body in loose, hanging folds. A mastery of finely differentiated shadows gives depth to the drapery folds, head, and limbs, projecting the figure forward from the background like a relief. Sundry yellow and blue tones plus a deep red lend the coloring a glow of warmth, setting it off from the silvery grisaille panels above and below. The figured style of the Rouen windows is linked with the latest advances in Parisian painting, notably those developed in the circle of the illuminator Jean Pucelle. The stylistic closeness to contemporary Parisian art—the stained glass in the central chapel of St.-Ouen must date from around 1325—suggests that the abbot of St.-Ouen called in artists from the capital to glaze his church.

Further work of outstanding quality survives in the choir of Évreux Cathedral, southwest of Rouen (see above, right). The stained glass in the newly erected choir clerestory there was the initiative of Bishop Geoffroy Le Faë, among others. Whereas the windows in the choir of St.-Ouen were endowed with monumental color figures on a grisaille background, the three windows at the end of the sanctuary at Évreux are glazed in full color. The center window features the Virgin and Child (the cathedral is dedicated to the Virgin), accompanied by St. John the Baptist, the patron saint of the previous bishop, Jean du Prat. In the window on the left there is a monumental Coronation of the Virgin, and in the window on the right an Annunciation. In each case, the donors of the stained glass are shown

kneeling, alongside their coats of arms, in the bottom panel. The elegance of the ambulatory glazing here reaches a level of grandeur that is no mere pale imitation of the Rouen style but something new, a distinctive achievement in its own right.

A series of windows whose quality is comparable with the stained glass of St.-Ouen and Évreux was made for the choir of the former abbey church of Königsfelden in Switzerland (1325/30–40). The monastery was founded by two women from the Habsburg dynasty, Queen Elizabeth and Queen Agnes, on the spot where King Albrecht I was murdered by his nephew in 1308. As befitted their exalted rank, the two women provided their foundation, a double monastery of Franciscans and Poor Clares, with lavish premises. In the center of the glazing of the choir are scenes from the life of Christ, including an Adoration of the Magi (see opposite, left). Architectural surrounds enclose the scenes of this narrative, which are distributed over all three panels of the window. The Christ Child in Mary's lap turns vigorously toward the new arrivals bringing their gifts. The Virgin's three-dimensional throne and the overlap of the figures in the center panel are a hesitant foreshadowing of the pictorial use of the third dimension. Originating in Italy, this device was first systematically incorporated in painting north of the Alps in Paris in the 1320s. Where these sumptuous windows may have been made is no longer evident (perhaps in Basle?).

477

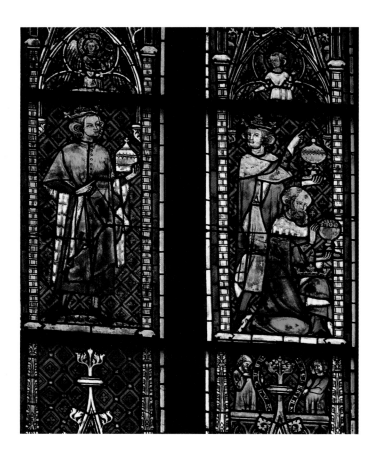

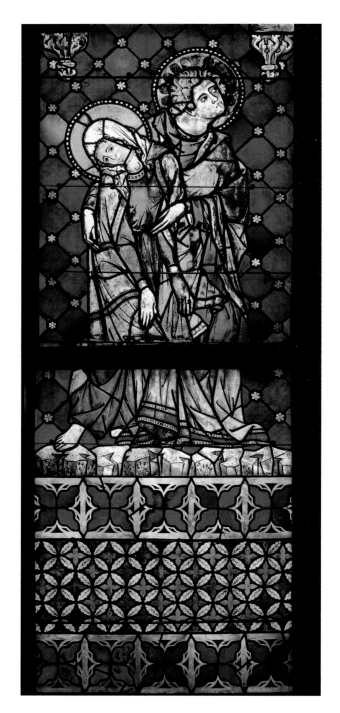

Three-dimensionality also appears in three series of stained-glass panes in southwest Germany at about the same time: the axial window of the demolished Dominican church in Strasbourg (now in the St. Lorenz chapel in the cathedral), the axial window of the Franciscan church in Esslingen, and the windows at Königsfelden. All three cycles can be dated to 1325–30.

The panels of the Virgin and St. John from the monumental Crucifixion in the choir of St. Stephen's Cathedral in Vienna (see right) were also made for a building sponsored by the Habsburgs. Under Duke Albrecht II of Austria, the High Gothic layout of the choir was eventually completed and consecrated in 1340. The great Crucifixion must have been made shortly before the consecration. The emotional intensity emanating from the figures of the Virgin and St. John is intensified by the deep red background, an eloquent expression of the deep religious feeling of the time.

The second half of the 14th century was a golden age for stained glass in German-speaking areas. It is presumed that Prague, where the

Hussites destroyed all evidence of this kind of art in the 15th century, was also an outstanding artistic center, its influence extending to Austria (Vienna), eastern Germany (Erfurt), Franconia (Nuremberg), Swabia (Ulm), the Upper Rhineland (Schlettstadt), and even England. In France, too, substantial amounts of stained glass fell victim to the vicissitudes of war (the Hundred Years' War of 1337–1453, the Religious Wars of the 16th century). Towards the end of the 14th century, the artistic styles of the two great centers, Paris and Prague, increasingly fell into step, so that, as had happened around 1200, by 1400 or so an international artistic style had developed, which art historians term the Soft, or International, Style.

The Royal Window in the choir of Évreux Cathedral (1390–1400) and the great window of the court lobby in Lüneberg town hall (ca. 1410) are outstanding representatives of this style. The donation by Charles VI in Évreux was probably commissioned from a Paris workshop (see right). The king occupies the center of the four-panel window. Shown kneeling in a small vaulted space, he turns, with St. Denis near by, toward the Virgin. The artistic virtuosity and lavishness of these panels exceed everything that is known elsewhere in France from this period. Lüneburg town hall meanwhile conserves one of the very few examples of monumental stained glass with secular subject matter (see below). The "Nine Worthies," who include Charlemagne and King Arthur, were considered in the late Middle Ages as models of good government and were therefore often depicted in town halls.

Toward the middle of the century, the influence of Flemish panel painting, the leading school of the time, became increasingly noticeable in stained glass. In 1451, the rich and ennobled French merchant Jacques Coeur provided a liberal endowment for expensive stained glass to go in his chapel in Bourges Cathedral. The glass bears the

Lüneburg Town Hall, court lobby
Charlemagne and King Arthur,
ca. 1410

stamp of Jan van Eyck's style (see page 481). As at Évreux, the central scene is divided into two panels. One contains the Archangel Gabriel, who is announcing the good news, the other contains the Virgin. As at Évreux, two further panels show the patron saints of the donor and his wife (not shown here). Angels float among the tracery, holding the coats of arms of the royal family in whose service Jacques Coeur worked. The glass was produced by a workshop in the artistic tradition of the Paris school of stained glass, working to drawings by a Flemish painter. As was normal in monumental stained glass, the figures are placed in the foreground of the composition without filling all the space available.

With the exception of the windows in Lüneburg town hall, our attention has focused on glass in cathedrals and lavish buildings associated with court circles. However, after the mid 14th century, stained glass was increasingly found in urban parish churches. Enticed by commissions from leading citizens, glass painters came to towns where there had hitherto been no tradition of stained glass, for

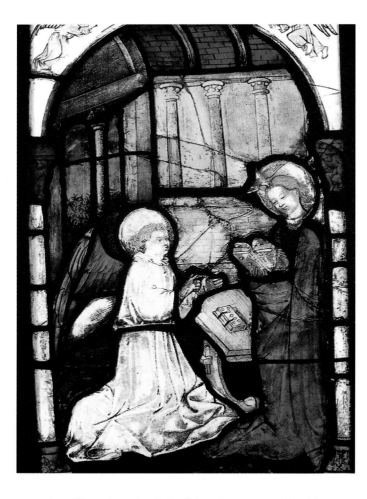

LEFT:
Ulm Cathedral, Besserer Chapel
Annunciation, ca. 1430–31

OPPOSITE:
Bourges Cathedral
Jacques Coeur Window, 1451

BELOW:
Moulins Cathedral, Crucifixion window
of Cardinal-Archbishop Charles de
Bourbon, 1480–90

example to Ulm, where the choir of the minster was reglazed between 1390 and 1420. Around 1430–31, stained glass was provided for the chapel of the Besserer family on the south side of the choir (see above, left). Someone who was familiar with the output of the Flemish painter Robert Campin (the Master of Flémalle) from Tournai must have worked on the Besserer commission. His use of the latest styles made the Ulm workshop one of the foremost in southern Germany and gained it much outside business (for example in Constance, Blaubeuren, and Berne).

It was this Ulm workshop that provided the Gothic choir of Berne Cathedral with its first window, in 1441. In 1447, the cathedral authorities decided to bring in local artists for subsequent work in the choir. One such commission was for an Adoration of the Magi window on the north side of the choir (see page 482), paid for by the Ringoltingen family. The design was by a painter or painters working in the tradition of the Master of the Upper Rhine (see the Frankfurt *Garden of Paradise*, page 435). The panels depict the story of the Magi, a story not often seen in stained glass, which here concludes with a grand adoration scene.

From the mid 15th century, it was Flemish influence that determined the artistic development of French stained glass. In 1474, Duke Jean de Bourbon II put in hand work on a new collegiate church (now the cathedral) beside his chateau at Moulins. (Work was abandoned in 1527, and the church was not completed until the 19th century.) The completed part of the church was glazed about 1480. One window of this important stained glass is the Crucifixion window of the Cardinal-Archbishop of Lyons, Charles de Bourbon (see above). The work is in the style of the Flemish painter Hugo van der Goes, but it is divided, in the best tradition of stained glass, into three self-contained scenes.

From about the same time, German stained glass also fell increasingly under the influence of Flemish panel painting. Peter Hemmel of Andlau, who directed a workshop in Strasbourg, was the leading representative of the new style in Alsace. His work met the tastes of his contemporaries so precisely that for four years he ran a joint venture with four other workshops in order to be able to handle the numerous commissions coming to him.

In 1481 Hemmel supplied a superb series of windows for the Volckamer family chapel in the choir of St. Lorenz, Nuremberg, among the finest windows produced by his joint venture. The centerpiece of the generously designed composition is a depiction of the Mystic Marriage of St. Catherine (see page 483). The scene combines an elegant figurative style with an extraordinarily brilliant technique of glass painting. Unfortunately, this forms the last, radiant masterpiece of the joint workshop, a fitting finale to the history of Late Gothic stained glass.

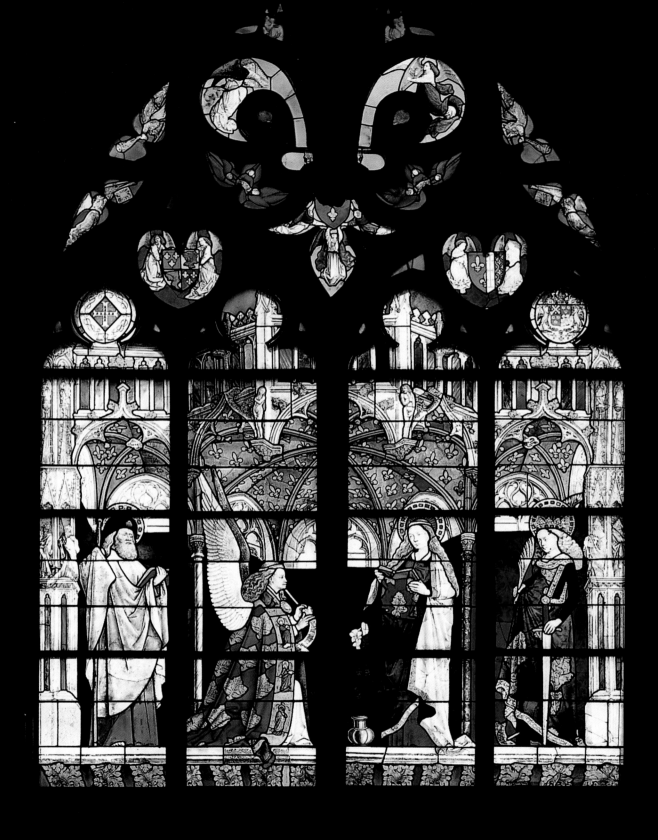

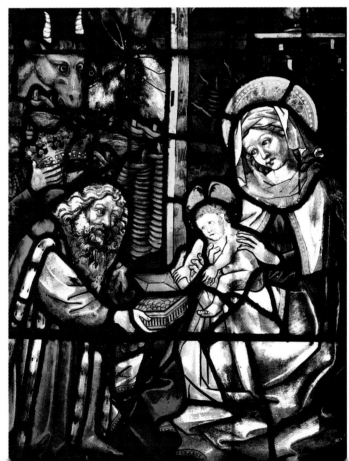

OPPOSITE:
Berne Cathedral
Panels from Adoration of the Magi
window, ca. 1453

Nuremberg, St. Lorenz
Volckamer window, with Mystic
Marriage of St. Catherine, ca. 1481

Ehrenfried Kluckert
Medieval Learning and the Arts

Beside the Duomo (cathedral) in Florence is the campanile designed by Giotto, completed in 1359 (see below and page 255, right). On the base of this campanile is a unique pictorial program in hexagonal bas-reliefs (see opposite, bottom), the scheme for which was worked out by Giotto before his death in 1337. Giotto was not only a painter, but also a highly respected architect. The reliefs depicted the history of the world—and so the doctrine of God's saving grace in history—through representations of the Christian virtues, the sacraments, astrology, the seven liberal arts, and biblical subjects. Giotto followed scholastic philosophy, according to which all knowledge comes from God and must be directed to fulfilling the divine purpose; knowledge was an aid to faith.

This encyclopedic view of the world is closely linked to the educational institutions of the Middle Ages. A precondition for the emergence of the universities was the blossoming of an urban way of life. This was the situation that in Italy first gave rise to humanist thought in the Middle Ages.

In northern Italy, cities had gained independence as early as the 11th century and had set up their own governments. In the 13th century, a number of cities threw off feudalism and freed the peasantry from vassalage—Bologna in 1256, Florence in 1289. Henceforth it was either rich guild masters or mercantile patricians who ruled the cities, not the landed aristocracy. The peasantry could sell their goods in their own shops or dispose of them to dealers. Artisans worked in their own workshops and were bound not to the nobility but instead to their guilds.

Florence, Campanile,
1359

Dialectic (left), Rhetoric (center), and Geometry (right), 1270–90
Freiburg Minster, west front

It is interesting, and characteristic of the period, that the first humanists of the 14th century came from different social circles. The poet and scholar Petrarch (1304–74) began his career as an elegant cleric at the papal court in Avignon; the writer Boccaccio (1313–75) was born into the mercantile class.

The development of individualism in urban centers went hand in hand with a new rationalism, which began to reject an approach to the world based on the metaphysics of religion. One of the first signs of this rationalism was the philosophy of Nominalism, according to which only individual objects "really exist" and abstract concepts are merely words (see page 394). It was nominalism that introduced into scholasticism the first expression of the intellectual life of the urban middle classes.

This can be seen in the philosophy of the scholastic theologian Thomas Aquinas (1224/25–75). For Aquinas, knowledge is based not only on intellect, but also on perception. Since the intellect is initially passive, it needs to be furnished with sense perceptions (our immediate awareness of the world around us) in order to have something on which to work. It is only when it has a store of sense perceptions that the intellect can proceed to true knowledge. Though Aquinas never challenged the primacy of revelation, he insisted that the human mind was able to apprehend the existence and nature of God unaided.

Developing these ideas in the uncertain area between medieval theology and philosophy, Aquinas was attempting to illuminate faith by developing a complementary theory of human understanding, a theory that drew on the earth-bound concepts of the Greek philosopher Aristotle. It was with this attitude toward

faith and knowledge that around 1245, at the age of 20, Aquinas entered the university of Paris as a student and it was there that he was later to expound his ideas as a teacher.

Founded around 1210, the University of Paris, like all medieval universities, aspired to provide *universitas litterarum*, "universal learning," which in medieval terms comprised theology, philosophy, law, and medicine. At the time, the University of Paris was considered one of the leading educational institutions because it was based explicitly on the faculties considered inherently universal, theology and philosophy. In neither Bologna, where law was the core of the curriculum (see bottom right), nor Salerno, where medicine was foremost, could the character of a *universitas litterarum* be fully realized.

The faculty of philosophy taught the seven *artes liberales*, liberal arts. In this complex learning system of the Middle Ages, there was an obvious synthesis of medieval piety and intellectual doctrine. The Roman statesman and writer Cassiodorus (ca. 490–ca. 583), creator of the early medieval educational canon, drew up guidelines for secular studies in the second book of his *Institutes*. This contains a reference to a saying of Solomon (Proverbs 9,1) according to which knowledge rested on the "seven pillars" hewn out by wisdom. These seven pillars were defined by the Neo-Platonic grammarian Martianus Capella (5th century AD) as the *artes liberales*, though the concept of the intellectual *artes* goes back at least to the Roman philosopher Seneca (4 BC–65 AD).

The seven liberal arts were subdivided into the *trivium* and the *quadrivium*: the former included grammar (that is, study of the Latin language), rhetoric, and dialectic; the latter, arithmetic, geom-

etry, astronomy, and music. In accordance with the universal nature of Paris's core subjects of theology and philosophy, an illustration from *The Garden of Delights* by Abbess Herrad von Landsberg, dating from the 13th century personifies the *artes* (see below). In the center of this allegory of knowledge is enthroned Philosophy, holding a scroll with the inscription "All knowledge comes from God." Socrates and Plato sit at her feet. The seven liberal arts radiate from her breast, and are seen in the outer circle, surrounded by attributes and epigrams. Grammar is depicted with a book and rod, Rhetoric with a pencil and writing tablet, and Geometry with compasses and measuring rod.

In Germany, the only surviving pictorial series illustrating the seven liberal arts is on the south side of the porch of Freiburg Minster (see left). The *artes* are depicted as female personifications holding their attributes. Most of the figures follow the standard iconography:

Allegory of Learning, from *The Garden of Delights* by Abbess Herrad von Landsberg, 13th century

Rolandino Passageri (died 1300)
Jurist Mausoleum, Bologna University

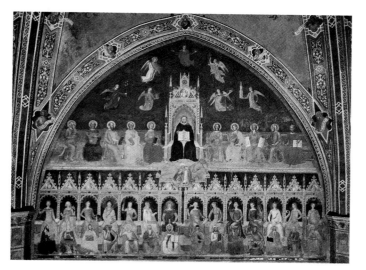

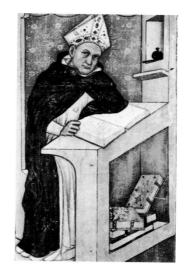

Andrea da Firenze (Andrea Bonaiuti)
Apotheosis of St. Thomas Aquinas,
ca. 1360–68
Florence, Santa Maria Novella, Spanish
Chapel

Tommaso da Modena
Albertus Magnus, detail from the fresco
series *Forty Learned Dominicans,*
ca. 1352
Treviso, Chapter house of San Niccolò
(former Dominican convent)

Grammar, for example, is shown holding a rod and attended by pupils. However, two of the personifications of the *trivium*, Dialectic and Rhetoric, deviate from the traditional iconography. The remarkable gesture of Dialectic (the figure on the far left) presumably derives from a gesture used in debating. That Rhetoric is shown dispensing gold coins with both hands (middle figure) is likewise unusual. It probably refers to the "treasure" that rhetoric bestows on those striving for knowledge.

These depictions are still closely tied to the theological canon of knowledge. The same applies to the St. Thomas Aquinas fresco in the Spanish Chapel in Santa Maria Novella in Florence (see above, left). This monumental fresco is usually known as the *Apotheosis of St. Thomas Aquinas* but is also referred to occasionally as *Christian Wisdom in the Spirit of St. Thomas Aquinas,* a title that emphasizes both its philosophical and its

theological aspects. Painted by Andrea da Firenze between 1366 and 1368, the fresco presents the seven liberal arts seated on thrones that are linked to form choir stalls. Each allegorical figure is allocated a leading figure from that discipline, whether from the sacred, the secular, or the classical sphere.

Whereas in this representation knowledge is presented as a divine blessing, in the reliefs on Giotto's campanile there is a distinct shift toward everyday life. These representations owe more to the urban environment and the active daily life of the community. The series of reliefs was begun by Andrea Pisano and his workshop in the mid 14th century and completed by Luca della Robbia in 1437. Della Robbia was responsible for the lower row of hexagonal reliefs which includes the *Grammar School* (bottom left) and the *Dispute between Logic and Dialectic.* In the medieval system of learning, grammar referred to the study

of the Latin language and literature, dialectic (logic) was meant to teach conceptual thought and logical inferences, and rhetoric was concerned with eloquence and the art of persuasion.

The depictions of the *quadrivium,* likewise attributed to Luca della Robbia, are still more interesting. Music is represented by Jubal (see below, second from left)—an earlier representation of music by Tubal Cain, the biblical first "artificer in brass and iron," was made by Andrea Pisano and Giotto (see page 331). In both cases it was the melodic and rhythmic striking of a metalworker's hammer that was seen as a metaphor for making music. For the medieval mind, mathematical principles were the basis of music, for harmony could be expressed by numerical relationships.

Gionitus features as the first astronomer, representing the art of calculating the positions and movements of the celestial bodies (see below, second from right),

while the Greeks Euclid and Pythagoras, likewise appearing as reliefs, represent the arts of geometry and arithmetic (see below, far right).

What is particularly significant in these examples is that the figures are not abstractions but historical personalities, and their attributes are familiar implements which had been in use for a long time. During the Middle Ages there was considerable progress in technology, with the mechanical clock, magnifying glass, and measuring instruments such as the astrolabe or quadrant being invented or greatly improved.

In the depiction of scientific activity as an everyday event which could be observed in workshops and schools, we can see an unmistakable sign of the growing self-awareness that would help to create the Renaissance. It is this late medieval view of the world, now superceded, that is captured so eloquently on the reliefs on the Campanile in Florence.

Luca della Robbia
Grammar School, 1437
Campanile relief
Florence, Museo dell'Opera del Duomo

Luca della Robbia
Jubal, or *Music,* 1437
Campanile relief
Florence, Museo dell'Opera del Duomo

Luca della Robbia
Astronomy, 1437
Campanile relief
Florence, Museo dell'Opera del Duomo

Luca della Robbia
Geometry and Arithmetic, 1437
Campanile relief
Florence, Museo dell'Opera del Duomo

Harald Wolter-von dem Knesebeck

Gothic Goldwork

In 1237, the French king Louis IX (1236–70) acquired from the Latin Emperor of Constantinople, Baldwin II (1228–61), who had fallen on hard times, one of the most important of Christian relics—Christ's crown of thorns. This and other relics were intended to demonstrate to the world the exalted status of the French king among Christian monarchs and the primacy of his people. What was effectively a huge monumental shrine to house this treasure—the Ste.-Chapelle—was erected near the royal palace on the Île de la Cité. Thanks to the latest building technology, this remarkable building was constructed in the record time of three to five years and consecrated in 1248 (see pages 84–85). The cost, 40,000 pounds, was also something of a record—but modest compared with the 100,000 pounds that the real shrine inside cost. Made of gold and studded with precious stones, it was placed on a raised platform of its own, beneath a canopy behind the altar in the upper chapel. Here the still more precious relics were housed.

As the actual shrine has vanished, we can get an impression of its splendor only from contemporary shrines (even if they are less lavish) such as the shrine of St. Elizabeth of Hungary in Marburg (see opposite, top). It was with the lost shrine and its precious contents, as well as further shrines nearby for the other relics, that the description by the theologian Jean de Jandun in 1323 reached its climax in a lyrical description of the upper chapel of the Ste.-Chapelle: "The choice colors of the painting, the costly gilding of the carving, the delicate translucency of the red glowing windows, the splendid altar coverings, the miracle-working power of the sacred relics, and the decoration of the shrines sparkling with their precious stones lend this house of prayer such an intensity of adornment that on entering one would think one had been transported to Heaven, setting foot in one of the finest rooms of Paradise."

The magnificence of the expensive, imperishable materials of the shrines, the gold and silver and the precious stones to which were attributed the same kind of *virtus* or healing power as the relics, is embedded here in the setting of the heavenly Jerusalem as a location in Paradise. In the Revelation of St. John (Chapter 21) this city is described as being "like unto a stone most precious, even a jasper clear as crystal," while "the wall of it was of jasper. And the city was pure gold like unto clear glass, and the foundation of the wall... was garnished with all manner of precious stones... The twelve gates were twelve pearls..."

This picture makes clear that shrines decked out at such great expense were meant to be reflections of the heavenly city. Characteristically, beneath one gable end the saint herself is shown passing through the gates of Heaven. Gold and precious stones had always been considered an especially suitable medium to represent the imperishable, eternal body of the saints, already received in Paradise.

This is particularly evident in the large and commanding bust reliquary of Charlemagne in Aachen (see opposite, bottom right). Wearing the imperial crown, he is shown as the ideal courtly knight,

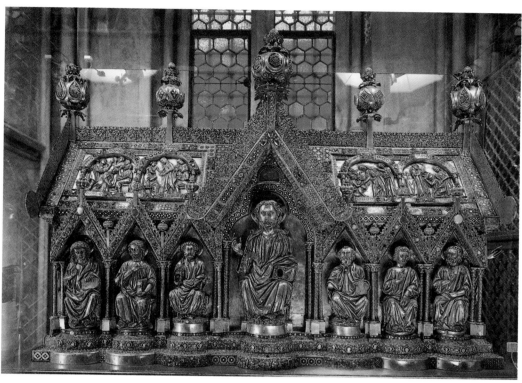

ABOVE:
Shrine of St. Elizabeth of Hungary,
after 1235/36–49
Copper and gilt. Length 187 cm, width
63 cm, height 135 cm
Marburg, Elisabethkirche

Built to house the relics of St. Elizabeth
of Hungary, Countess of Thuringia,
canonized in 1235, the shrine is designed
as a hall-like building with a transept.
The four gables show, beneath trefoil
arches and pointed gables, Christ and the
Crucifixion (transepts), the enthroned
Virgin, and St. Elizabeth entering the
heavenly city (nave). The gable ends are
linked by arcading enclosing the apostles.
Unusually, the roof slopes are devoted to
scenes from the life of St. Elizabeth,
noted for her piety, self-abasement, and
devotion. Possibly Thuringian or Saxon
drawings were used as models. Overall,
the shrine of St. Elizabeth continues a

tradition set by the great Rhineland
shrines of the Romanesque period. It is
closely related to a slightly older shrine of
the Virgin in Aachen.

RIGHT:
Bust reliquary of Charlemagne, ca. 1350
Silver, part gilt. Height 86.3 cm
Aachen, Cathedral Treasury

This large bust-shaped reliquary was
made to house the head of Charlemagne.
The black eagles and golden *fleurs-de-lys*
refer to the imperial eagle and
Charlemagne's coat-of-arms (which in
fact dated only from the 13th century). In
other respects, Charlemagne is dressed as
an aristocrat of around 1350.

BELOW:
Reliquary of Charlemagne,
ca. 1350
Silver, part gilt. Height 125 cm
Aachen, Cathedral Treasury

In the unusually lavish architecture of this reliquary, which is extraordinary both in its size and in the quality of its work, the

relics are distributed over various levels depending on their sacred ranking. Angels and four figures of importance in the life of Charlemagne, including Archbishop Turpin and Pope Leo III, stand in front holding the coffin-shaped, open-sided shrine containing the arm relic of the Emperor. The lid of the coffin serves as a pedestal for the Virgin and Child (center),

St. Catherine (right), with the relic of her tooth in a miniature reliquary, and Charlemagne (left), who holds a model of Aachen Cathedral, which thereby itself acquires the status of a reliquary. In the three turrets on the roof are displayed the most important relics, those of the Passion of Christ. The central turret contains Christ himself, who holds a nail,

while the two side turrets contain angels. As with the other two Aachen reliquaries from this period, the bust reliquary of Charlemagne, ca. 1350 (see page 487, bottom right), and a three-turret reliquary from 1370–80, we have no indication of the donor. The question of the origin of the work, probably Liége or Cologne, is also unresolved.

his wavy hair in the style fashionable at the date the reliquary was made, the years around 1350.

From the Gothic period on, it became much more common for relics to be made visible, by being encased in glass, for instance. An example of this is the presentation of various relics in the reliquary of Charlemagne (see left), also preserved in Aachen. Reminiscent of a Gothic tomb, this is 1.25 meters (over 4 feet) high, the biggest and broadest example of its type and time to have survived. It contains, among other things, an armbone of Charlemagne. But even a tiny object measuring only 5 by 4 cm (roughly 2 by 1.5 inches) like the butterfly-shaped crucifixion reliquary found in 1991 in the hollow head of a wooden crucifix (see below) makes specific use of the contrast between mortality and eternity, even if its precious relic is not visible. Reproduced in the medium of goldwork, the short-lived beauty of a butterfly is given the permanence of gold. Though the Crucifixion represented on the butterfly, in a virtuoso display of translucent enamel, refers to the redemption of humanity through Christ's death and resurrection, the reliquary also suggests the stages of a butterfly's development from the larva through the pupa, when it is rolled up like a corpse, to its final "resurrection" from the cocoon as a butterfly. Worn as a pectoral by a cleric, both the jewelry and the relic in it would also have served for protection from evil.

The goldwork that medieval folk encountered during the Mass was seen as playing a decisive role in ensuring salvation. First and foremost were communion cups, which represent 40 percent of the medieval goldwork to survive in western Europe, far and away the most important type. Even very simple pieces, of which thousands survive, are made of imperishable metal, at least silver, since after the transformation of the wine during Mass the blood of Christ was drunk from them. Especially precious examples were worked from pure gold, like the St. Bernward Chalice in Hildesheim (see opposite, top right), for which the paten for the host has also been preserved. The principal reference to its function in the Mass is the communion

RIGHT:
Butterfly reliquary from crucifix from Donaustauf
French, first half of 14th century
Silver, gilt, and enamel. Height 4 cm, breadth 5 cm, depth 0.5 cm
Regensburg, Cathedral Museum

Found as recently as 1991 in the reliquary deposit of a wooden crucifix, this reliquary is shaped as a butterfly, with

the Crucifixion painted on it. The tiny object, just 4 cm high and 5 cm wide, is a piece of exquisite French gilt silver work, made using the technique of translucent *bassetaille* enamel. In this technique, transparent layers of enamel are laid on top of each other and then polished back to the level of the metal surface. As the reliquary is particularly well preserved, it was probably placed in the crucifix at a very early date.

Pope Gregory the Great Leading a Procession,
from *Les Très Riches Heures*, ca. 1415
Musée Conde, Chantilly
Fols. 71v–72r

BELOW:
Monstrance, Cologne (?), 1394
Silver and gilt. Height 89 cm
Ratingen, St. Peter and St. Paul

According to the inscription, this monstrance was a gift from the parish priest of Ratingen, Bruno Meens, to his parish church. Arranged as a four-buttress monstrance, it is richly decorated with figures. Angels carrying instruments of the Passion are grouped round the rock crystal cylinder for the host, thus drawing attention to the origin of the redeeming power of the Eucharist. The turret above the cylinder displays the twelve Apostles below and four saints above. The piece probably derives from one of the leading goldsmith workshops in Cologne, whose influence was long-lasting.

ABOVE:
St. Bernward Chalice
Hildesheim (?), late 14th century
Gold. Height 22.5 cm, diameter of cup 15.2 cm
Hildesheim, Cathedral Treasury

This piece of altar furnishing was associated already with Bishop Bernward of Hildesheim in the 15th century. It was donated to the cathedral by the Bishop of Hildesheim Gerhard von Berge (incumbent 1365–98), in honor of victory at the Battle of Dinklar in 1367. It consists of an unusually large chalice of pure gold and a paten. It was financed from the bishop's booty, the bishop having apparently taken part in the battle himself. Especially precious are the citrines on the knob and the high-quality antique cut stones on the base. Whereas the New Testament scenes engraved on the base are linked with the great Church festivals, and at the same time to the Virgin as patron saint of Hildesheim Cathedral, the Last Supper scenes on the cup refer to its functions at the altar during Mass. The engravings are in the north German variant of the International Style around 1400. For this reason, the piece almost certainly dates from towards the end of Bishop Gerhard's term of office.

scene depicted on the outside of the cup. The same scene appears also on the lid of the small pyx from Lichtental Monastery (see page 492, bottom right).

The consecrated host, the salvation-bearing body of Christ, was often placed on display in monstrances. These were a type of display case that developed in the 13th and 14th centuries in parallel with the change of doctrine concerning the Eucharist, in particular the institution of the feast of Corpus Christi in 1264. The monstrance took account of the belief that even contemplating the host was now considered redemptive. An especially fine example, and one of considerable art-historical importance, is the monstrance from Ratingen (see right). A monstrance was suitable not only for placing on an altar but also for carrying during processions.

The monstrance was not the only piece of church furnishing used at the altar that was carried in processions. Other objects included liturgical manuscripts bound in display bindings (see page 496), censers (see page 498, right), and vessels for holy water. A procession of this kind, led by Pope Gregory the Great during a plague epidemic in Rome, is shown in an illumination in the celebrated *Les Très Riches Heures* of Duke Jean de Berry (see above). The picture shows Gregory walking behind a reliquary shrine, which is borne by two clerics on a litter. Carried in front of them are, among other things, valuable liturgical codices in splendid bindings, a censer, and a holy water vessel. The effectiveness of the procession is demonstrated by the vision of the Archangel Michael standing on the Mausoleum of the Emperor Hadrian (later the Castel Sant'Angelo). St. Michael is sheathing his sword, which Gregory takes as foretelling the end of the devastating epidemic, which has claimed a victim even during the course of the procession.

Other furnishings usually found at the altar could also be used in processions—a crucifix, for example. And besides regular church processions there were also the great "salvation displays," which

could present a whole range of goldwork articles to a wide-eyed
public. These were displays organized at regular intervals or as one-
off exhibitions for particularly important visitors, displaying reli-
quaries and other treasures from major churches which would be set
out on a main altar or specially constructed balcony or carried in
procession. Even the appearance of the clergy was enlivened by
goldwork: the rich liturgical vestments often contained decorative
braid trimmings set with precious stones, and they were occasionally
fastened with large valuable fastenings. Bishops carried sumptuously
finished crosiers around with them (see opposite, top left).

Though a rich array of goldwork would most commonly be
encountered when coming into contact with God and the saints, in
other words on entering a church, goldwork also played an
important part in more secular settings, for example in a court of law
or at town council meetings, though even here it often had a religious
significance. In the case of the Lüneburg Civic Oath Glass, dated
1443 (see opposite, right), someone taking an oath would place their
hand on the glass cylinder on top of the small shrine-like object,
thereby affirming their truthfulness. This oath glass is appropriately
decorated with a picture of Christ Pantocrator at the Last Judgment,
to remind potential perjurers of the consequence of dishonesty,
namely punishment in Hell.

With the Lüneburg Civic Oath Glass, we come to the subject of
non-ecclesiastical objects that bear Christian subject matter and
served private devotion. Among these are some outstanding pieces
from court circles, such as the New Year present given by Elizabeth
of Bavaria in 1405 to her husband, the French king Charles VI
(1380–1422), the famous *Golden Horse* in Altötting (see page 493).
Probably the most notable piece of surviving medieval vitreous
enameling, this masterpiece was created with a technique often used
for presents and comparable courtly *objets d'art*, that is, *ronde-bosse*
or encrusted enameling on a roughened gold ground. This ousted the
translucent enamel technique favored in the 14th century and used
for important objects like the reliquary for the corporal-cloth of
Bolsena (see page 492, top left). The *Golden Horse* shows Charles VI
kneeling on the left, in prayer to the Virgin and Child. As the king
had a serious illness at the time, the gift was also a form of votive
offering, a plea for a cure expressed in visual terms (he was suffering
increasingly severe bouts of mental illness).

Another article in the *ronde-bosse* technique with a similar votive
intention is the St. Lambert Reliquary from 1467, in Liège Cathedral
(see page 494, right). This shows St. George presenting the
Burgundian duke Charles the Bold, who kneels in front of him
holding a finger relic of St. Lambert. In both this and the *Golden
Horse*, the men appear as Christian knights in armor, an ideal that
was seeing a revival in the 15th century.

The Virgin, whose cult was increasing at this time, often appeared
in works in precious metals, and not only in small works for private
devotion such as the *Golden Horse*. In 1339, for example, the

Cologne Crosier, Cologne (?), ca. 1322
Silver, part gilt. Length 146 cm,
height of crook 57.5 cm
Cologne, Cathedral Treasury

The crosier follows a widespread type.
The bishop is shown within the curve of
the crook, kneeling to the Virgin and
Child, while an angel provides support
from below. Though the translucent
enamel suggests a French or German
origin, Cologne, the center of German gold-
work, is the most likely source, with
parallels there around 1320–30 for the
design of the figures and the form of
enamel, which features birds. This show-
piece crosier may have been made for the
Archbishop of Cologne, Heinrich von
Virneburg, for the consecration of the High
Gothic choir of the cathedral in 1322.

Hans von Lafferde
Lüneberg Civic Oath Glass, Lüneberg,
1443. Silver, partly gilt. Height 24.5 cm
Berlin, Staatliche Museen Preussischer
Kulturbesitz

Executed by the Lüneberg goldsmith
Hans von Lafferde in 1443 for the city
council, this has a Last Judgment on
one side, the occasion when perjurers
would have to face punishment for their
dishonesty. In intercession for humanity,
the Virgin and St. John flank Christ in
judgment. The angels on the top are in a
style by then almost 50 years old—simi-
lar angels can be seen on the Ratingen
Monstrance produced by a Cologne
workshop (see page 489, bottom). Von
Lafferde, who had perhaps worked in
Cologne, also used older models (from
around 1400) for the other figures, a
common practice.

Left:
Fastening for a choral cloak
Cologne or Aachen (?), ca. 1425–50
Silver and gilt. Height 20 cm
Aachen, Cathedral Treasury

The scene in the center of this magnificent
quatrefoil fastener studded with pearls
and decorated with blue translucent
enamel is the Annunciation. The youthful
Mary is startled from reading her missal
by the angel kneeling beside her. The lilies
between the two figures are a symbol of
virginity. In the scene below are St.
Christopher and St. Cornelius and the
canon as donor. According to the coat-
of-arms (a later addition), he was a
member of the Schanternell family.

LEFT:
Ugolino di Vieri
Reliquary for the corporal-cloth of
Bolsena (detail)
Siena, 1337–38
Silver and gilt. Height 139 cm
Orvieto, Cathedral Treasury

A corporal-cloth is a cloth placed under the host at Mass. In 1263, in Bolsena, a corporal-cloth was miraculously stained with blood by the host in order to convince a priest who doubted the transformation of bread and wine into the body and blood of Christ during the Mass. This miracle legend, which played a major part in the establishment of the feast of Corpus Christi, is depicted along with New Testament scenes on the reliquary, which resembles an altarpiece. With its wealth of pictures, it is the most important and extensive example of a pictorial cycle in translucent enamel, indeed of the technique generally. That the style is closely dependent on Sienese painting of the early 14th century is explained by the fact that Ugolino di Vieri, the goldsmith commissioned by the Bishop of Orvieto and his cathedral chapter, came from Siena. No doubt, given the timescale (1337–38), assistants helped with the work.

OPPOSITE:
Golden Horse
France (Paris), before 1405
Enamel
Altötting, Treasury

The *Golden Horse* (the popular name, derived from the iconographically less significant feature of the horse held by a page) was a New Year's present from the French queen Elizabeth of Bavaria to her husband Charles VI, who is shown kneeling on a raised platform reached by a twin staircase. The king adores the Christ Child in the Virgin's lap, while opposite him a knight holds his helmet. The Virgin is seated in front of an arbor in a meadow, as in a garden in Paradise, being crowned by two angels. Figures of St. Catherine, St. John the Baptist, and St. John the Evangelist are probably there to intercede for the king, who suffered increasing spells of mental illness. The figures are finished in the *ronde-bosse* or encrusted enamel technique, which was particularly favored for such precious objects. However, a multi-figure composition on this scale is exceptional.

RIGHT:
Pyx from Lichtental monastery
Strasbourg (?), ca. 1330
Silver, partly gilt. Length 16.6 cm,
width 11.6 cm, height 15 cm
New York, Pierpoint Morgan Library

According to the inscription on the lid, this pyx was a gift from the Cistercian nun Margarete Pfrumbom to her nunnery in Lichtental, near Baden-Baden. She is therefore shown on the front in the company of the Magi, adoring the Virgin and Child. On the right is St. Bernard of Clairvaux, founder of the Cistercian order. He appears again with the donor on the lid, where both adore Christ at the Last Supper. This central scene, referring to the Eucharistic function of the pyx, is accompanied on the other surfaces of the lid by appropriate Old Testament scenes prefiguring the Eucharist—Passover, Elijah fed by the angel, Mechizedek offering Abraham bread and wine.

A typology of this sort could have been drawn from the book *Speculum humanae salvationis* (Mirror of Human Salvation), completed in Strasbourg in 1324. This contains systematic cross-references between the two books of the Bible in pictorial form. Strasbourg as an origin for the pyx is also suggested by the style of the fine miniature enamel representations and by the fact that Lichtental had close connections with Strasbourg.

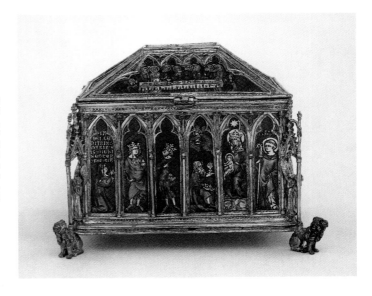

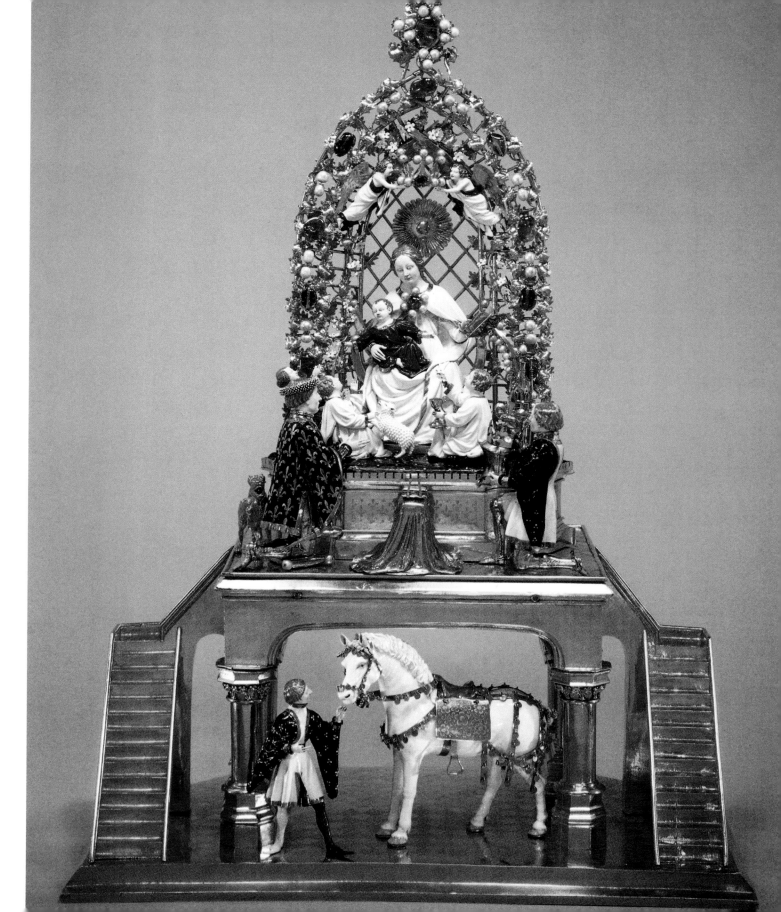

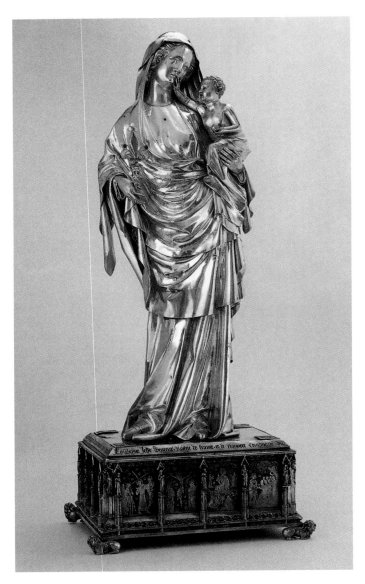

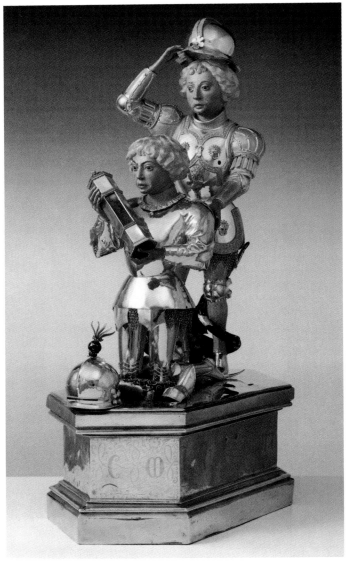

Virgin and Child
Made in Paris for Jeanne d'Évreux, queen of France, ca. 1339
Silver and gilt. Height (including base) 69 cm
Paris, Louvre

The Virgin, holding the Christ Child on her arm, stands on a casket decorated with scenes of the Passion in enamel. An inscription refers to the royal donor. The Virgin is richly dressed and stands in the elegant S-shaped pose typical of Madonnas of the period.

Gérard Loyet
St. Lambert Reliquary
Made for Charles the Bold, duke of Burgundy, 1467–71
Gold and silver gilt. Height 53 cm
Liège, Cathedral of St. Paul

Commissioned by Charles the Bold from Gérard Loyet and executed in *ronde-bosse* enamel, the reliquary shows the duke holding a finger relic of St. Lambert and presented by St. George, whose posture resembles the same saint depicted 35 years earlier in Jan van Eyck's painting of Canon van der Paele (see page 411).

Miniature (1511–13) illustrating Swiss booty
from the Battle of Grandson in Lucerne
(the Burgundian Booty)
From Diebold Schilllings,
Chronicle of Lucerne
Lucerne, Zentralbibliothek, fol. 100v

BELOW CENTER:
Goslar Mining Cup, after 1477
Silver, part gilt. Height 73 cm
Goslar Town Hall

Inscribed with the date 1477, the year
when mining was resumed in the ore-
rich Rammelsberg near Goslar, the

goblet appears to celebrate this
particularly significant event. The tiny
figures on the lid are miners going
about various tasks. The meaning of the
rider inside the canopy is unclear—
he may be St. George or the legendary
hunter Ram, associated with mining on
the Rammelsberg.

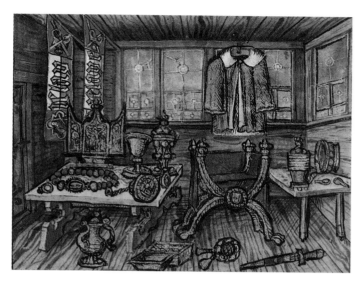

right), which is probably from the early 15th century, served not only
as practical drinking vessels but also as tableware for show. Another
fine example is the huge Goslar Mining Cup (see below, left), which,
a typical Gothic goblet, ranks among the largest pieces of secular
goldwork to survive from the Gothic era. A similar piece is the
Nuremberg Ship (see page 499), made for the von Schüsselfeld family
in Nuremberg. Like the Goslar Mining Cup, it displays an unusually
high number of figures. It may have originated from Albrecht Dürer
the Elder, father of the famous Nuremberg painter.

Thus in the late Middle Ages people would encounter goldwork
again and again, not just in church and during religious and civic
processions. Goldwork could also be seen in secular life, public and
private, even if only in the form of the dress and jewelry of fellow citi-
zens—rings and chains, belt buckles and brooches, pendants and
buttons. This was a form of goldwork that not only the moderately
well off could afford. Even a so-called "poor knight" like Oswald
von Wolkenstein, celebrated as a poet and adventurer, was able to
call "two silver bowls" his own as he sat in his bare remote residence
in the Tyrolean Alps.

French queen, Jeanne d'Évreux, donated a silver Virgin and Child
(see opposite, left) to the royal abbey of St.-Denis. At 69 cm (27 inches)
high, it is of considerable size. Artistically, it is one of the most
important of the few Gothic silver statues to survive.

Only a small proportion of the precious metalwork commissioned
by the court was religious pieces. Numerically, the overwhelming
majority of pieces were intended for courtly show. Along with the
insignia of power—crowns, scepters, seals, and so on—secular
treasuries were full of tableware of precious metals and decorative
objects for court dress.

A glimpse of the wealth of such a treasury is provided by the so-
called "Burgundy Booty." This refers to objects that the Swiss
plundered from Charles the Bold and his army at the Battle of
Grandson in 1476 and on other occasions—the duke was in the habit
of taking the treasure on campaign with him. It was displayed as war
booty in Lucerne, as a miniature from 1511–13 shows (see above).
Beside the splendid chair and numerous drinking and eating imple-
ments on the two tables, the Swiss also acquired a folding altar and,
on the table in front of it, an ornamental belt and the duke's private
seal (which has survived), on the right beside the belt. The altar is,
characteristically, the only clearly religious object in the miniature;
the various drinking implements such as tankards, goblets, and
glasses, plus various-sized plates used at court banquets, formed the
bulk of the duke's treasure and carried high status.

Such showpieces were generally not for everyday use. Their prin-
cipal purpose was to stand in great display cabinets flaunting to
guests the wealth and refined tastes of the lord of the house. Similarly,
the great wine tankards such as the Katzenelnbogen Cup (see far

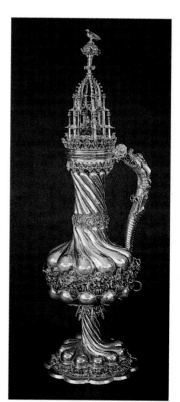

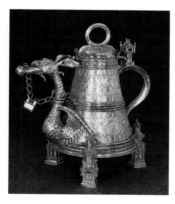

ABOVE:
Katzenelnbogen Cup,
early 15th century
Silver gilt. Height 40 cm
Kassel, Hessisches Landesmuseum

For this showpiece cup, a cooper's wooden
wine barrel was imitated in precious
metal. Between the "staves" held by
metal hoops are strips of florid acanthus
foliage. Small turreted buildings form the
feet of the cup and the attachment for the
lid, while a scaly, feathered griffin makes
a spout. The arms of the counts of Katz-
enelnbogen are embossed on its wings.
The tankard is similar to pieces made in
Cologne from around 1400.

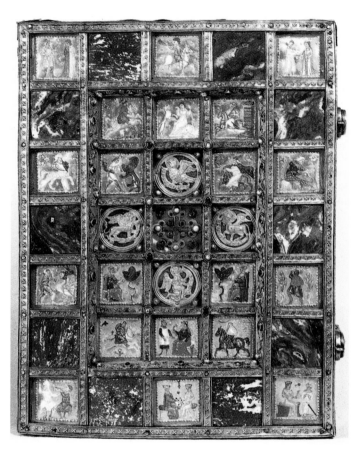

Bookcover made for Duke Otto the Gentle
Brunswick (?), 1339
Height 35.4 cm, width 26 cm
Berlin, Staatliche Museen Preussischer Kulturbesitz, Kunstgewerbemuseum

A written entry firmly dates this cover, which also has a large engraved portrait of the donor, Duke Otto the Gentle of Brunswick-Göttingen, and his wife Agnes on the back. The front of the cover is most unusual in reusing a Venetian chessboard made a little earlier. The board contains secular miniatures set under rock crystal panes interspersed with squares of red jasper. The squares have been re-arranged so that they are no longer in the original pattern of alternating light and dark but grouped round a central crucifix reliquary. The central fields around the cross have embossed depictions of the symbols of the Evangelists.

Ironically, despite the familiar use of gold, silver, and precious stones as symbols of eternity, art works made from them were anything but enduring. Because of their high material value, they were constantly in danger of being broken up or melted down. Almost every new piece of goldwork represented the loss of older, damaged, or no longer fashionable pieces, which provided the raw material for the new work. Moreover, in times of hardship such as war and economic decline, such works were an all too ready source of funds. As a consequence, very few Gothic pieces survive, particularly secular works.

Though church treasures were somewhat better protected, the Reformation and secularizing changes also led to great losses. In France, it was the Revolution that devastated the nation's patrimony of works in precious metals. In cases of financial hardship, even church plate and the insignia of power were pawned or, in extreme cases, simply melted down. A remarkable example of these desperate measures is provided by Rupert III of the Palatinate (1400–10), who in his will ordered that his crown be used to settle his debts to pharmacists, tailors, and cobblers.

Searching through surviving late medieval documents—the ever more numerous inventories of great estates and the wills of well-to-do citizens—we find clear evidence that goldsmiths tended to get church commissions for goldwork rather rarely. This may seem surprising as it is these, by virtue of being better preserved in church treasuries, that have formed our modern view of medieval work in precious metals. In fact the bulk of a goldsmith's output consisted of everyday articles such as dress pieces, goblets, plates, cups, and so on—yet these constitute perhaps only 10 percent of the surviving articles in Europe, compared with ecclesiastical plate. During the late Middle Ages the ratio was probably the reverse. Many of the secular pieces that have survived have done so because they became part of a church collection.

A particularly striking example of this is the cover of the plenary of Duke Otto the Gentle (see left), from the Guelph Treasure, the rich possessions of the church of St. Blasius in Brunswick, founded by an ancestor of Otto, Duke Henry the Lion, as a dynastic burial site. Dating from 1339, this bookcover reuses a chessboard of Venetian origin made only a little earlier. The light squares of the board consist of miniatures set beneath a thin veneer of transparent rock crystal while the dark squares are panels of red jasper. Despite their worldly subject matter—depictions of court life and scenes of hunting and combat—the miniatures were retained and arranged around the crucifix reliquary in the center.

There were, however, some heavy losses among church treasures as well. If St. Blasius in Brunswick was lucky enough to retain most of the rich inventory of a prince's donation and burial furnishings in the Brunswick Guelph Treasure, a second such treasure, which had been donated by the Guelphs to the church of St. Michaelis near Lüneburg, was melted down in the 18th century. Many major

cathedrals and monasteries likewise preserve very few or no pieces of Gothic goldwork.

This is true even of such an important center of goldwork as Cologne and of a city as rich as Lübeck, possibly the origin of a particularly lovely paten in translucent enamel (see above, left). Exquisite though it is, the paten provides small compensation for the huge amount of goldwork that has been lost.

This great loss of work is in marked contrast to the variety of surviving documentary sources relating to Gothic goldwork. Among other things, these stress the high social status of goldsmiths, who in this respect represented the top rank of craftsmen and artists. In practice, of course, the trade encompassed both the modest small-town goldsmith and the city businessman who, thanks to his knowledge of precious metals and coins, functioned as an important banker and international wholesaler of precious metals, goldwork, and jewelry. Overall, the high value which was accorded to the trade was based not on the high degree of skill required, nor even on the value of the materials used, but, above all, on the economic importance of the trade for the cities in which it flourished. It comes as no surprise, therefore, that goldsmiths might often attain the high rank of city father or even mayor.

Having completed their years as apprentices and journeymen, master goldsmiths settled in a city of their choice, setting up shop with one or two associates and apprentices in close proximity to other goldsmiths. Often they lived and worked in a well-placed street dedicated to the trade (as in Cologne and Strasbourg), around the market (as in Lübeck), or even on a bridge over a river (as in Paris). They practised their trade in workshops that also served as salerooms, the windows being symbolically left open so that the goldsmith's honesty in handling these costly materials could always be checked.

One such workshop is depicted in an engraving by the Bileam Master showing Bishop Eligius, patron saint of goldsmiths, at work

(see above, right). The saint is seen sitting in the middle of his workshop, hammering the cup of a chalice on an anvil. This is one of the basic work techniques of goldsmiths, who were especially adept at beating metal, as the virtuoso work on a typical piece like the Goslar Mining Cup shows. Two apprentices are seated on the right at a workbench, one stamping metal, the other working on the buckle of a belt. The apprentice on the left in front of the richly adorned furnace is pulling wire through a perforated board.

As well as the city goldsmiths who were organized into guilds, there were also craftsmen in the proximity of major courts who could go about their business free of any guild ties. In France and the duchy of Burgundy the most prominent of them, who created such expensive enamelwork as the *Golden Horse* (see page 493) and the St. Lambert Reliquary (see page 494), were granted the rank of *valet de chambre*. This certainly was the case with Gérard Loyet, creator of the St. Lambert Reliquary. In France, a female goldsmith, Marie la Contesse, is also documented.

Precise dating and stylistic classification are very difficult in the case of goldwork. One reason for this is that by tradition goldsmiths trained in one city, traveled widely during their journeyman years, and then settled in a second city. Another reason is the fact that work in precious metals was often strongly influenced by the other arts, and in particular by architecture, the art that determined the artistic character of the whole age, so that there is often very little stylistic continuity.

For the same reasons, the development of individual styles in goldwork can be traced, if at all, only in the evolution of particular forms and widespread types of product. Even so, it is precisely the outstanding, and nowadays isolated, masterpieces that can be linked with these. In many instances, unfortunately, all we can note is the development of parallel features in architecture, sculpture, and

Enamel casket, early 15th century
Silver and gilt. Height 34 cm, width
30 cm, depth 18.5 cm
Regensburg, Cathedral Treasury

This house-shaped ornamental casket is
finished with a rich enamel overlay inside
and outside. Besides the enamel paintings

of animals done with a brush, there are
hundreds of gold stars and crescent
shapes. These were applied to the
enameling prior to fusing to create the
impression of a star-studded night sky.
Whether the workshop that made the
casket was in Venice or the Franco-
Flemish area is a matter of debate.

Censer, ca. 1500
Silver. Diameter 12 cm
Haarlem, chapel of Bishop's Palace

Made in Edam from an design by the
German engraver Martin Schongauer, the
censer is sumptuously adorned with Late
Gothic ornamental motifs.

painting or the graphic arts, though even such parallels give few clues as to where a piece was made. On the whole, however, it is likely that numerous works that are now preserved in church treasuries were made in the place where they are preserved, or at least in the vicinity. All the same, many important church treasuries, and key outstanding works central to our understanding of artistic development, have been completely lost.

Moreover, goldsmiths were always able to add to their repertoire of skills and designs during their journeyman years and later travels. They often used older models or stamps of other regions, especially for figurative decoration and ornamentation. The practice of cooperation of different, in part specialized, workshops for the more ornate pieces of goldwork might also lead to a mixed stylistic idiom. Finally, there were sundry conditions, often laid down by clients, as to the models to be followed in making a work, conditions that often played the key role on determining the form of a work. Thus the proportions of the St. Bernward Chalice (see page 489, top right), which probably dates from before 1400, follow a late Romanesque model, which may be connected with the revived cult of the saint in Hildesheim at the time—from the 11th century the saintly Bishop of Hildesheim had been seen as a goldsmith.

Moreover, such works as the Nuremberg Ship (see opposite) and the censer in Haarlem (see above, right) were copied from engraved models. Likewise, in the case of more lavish architectural pieces, it is probable that drawings were used as models. This is almost certainly the case with such works as the small church façade on the bookcover originally from the church of St. Blasius (see page 500) in the Black Forest—a piece of outstanding quality and no doubt a major influence on the development of early Rhineland Gothic—as well as a three-turret reliquary, dated 1370–80, in the treasury of Aachen Cathedral.

Since architecture was an important influence on goldwork, it is no surprise that some of the most important architects of the Early Renaissance in Florence, such as Filippo Brunelleschi and Michelozzo, began their careers as goldsmiths. Gothic goldwork combines painting and drawing, sculpture and architecture, and the use of both form and ornament.

It was this many-sidedness that contributed to the high status goldsmiths enjoyed, and it was the same versatility that induced Johann Michael Fritz, in his standard work on Gothic goldwork, to describe its finest artistic achievements as a microcosm in precious metal of all other artistic forms.

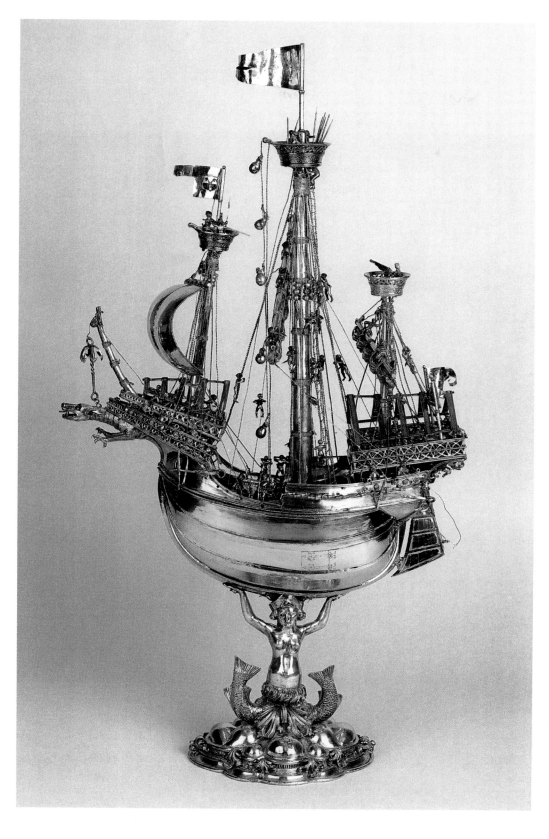

Nuremberg Ship (table centerpiece)
Nuremberg, before 1503
Silver, part gilt. Height 79 cm
Nuremberg, Germanisches
Nationalmuseum

The ship in this centerpiece is supported by a mermaid and carries a large crew. The piece, an astonishingly faithful depiction of a type of merchant ship known as a carrack, may be the work of Albrecht Dürer the Elder, father of the better-known German painter. It is probably based on an engraving.

Cover of the plenary of Duke Otto
Strasbourg (?), 1260–70
Silver and gilt. Height 38.7 cm, width
27.3 cm, depth 4.5 cm
St. Paul in Lavanttal (Carinthia)

The main field is surrounded by a broad
frame filled with a dense pattern of vine
leaves plus trefoils in the corners
containing the Evangelists. The center
field is taken up by a small Gothic church
façade representing the gate of Heaven.
Below are the Virgin and Child, on the
left the Blessed Reginbert, founder of the
monastery of St. Blaise in the Black
Forest, and on the other side Abbot
Arnold II (incumbent 1247–76). Above is
the Coronation of the Virgin, between
St. Nicholas and St. Blaise. Internal and
external evidence confirms the intended
recipient church, date of production, and
probable origin. Stylistic parallels with
works of early Strasbourg Gothic tally
with the dates and regional location of
Reginbert and Abbot Arnold II. The
quality of the bookcover makes this one
of the masterpieces of European High
Gothic goldwork. It is imbued with the
influence of the French Rayonnant style,
especially the Parisian and Reims form.
This could have been transmitted by
individual architectural sketches, or even
by small sketchbooks like that of the
French artist Villard de Honnecourt,
which were used by goldsmiths and
architects alike.

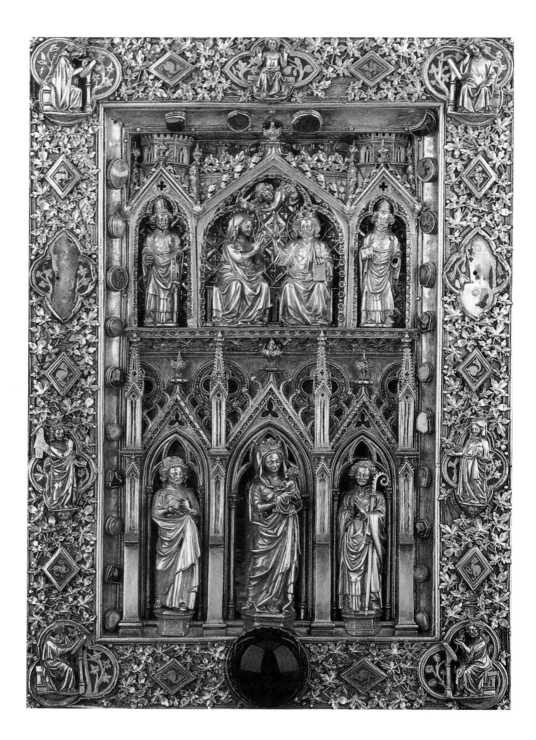

Photographic Credits

The majority of illustrations (approximately 500) that are not individually listed here are new photographs by the Cologne architectural photographer **Achim Bednorz**.

The publishing house and the publisher wish to thank the museums, archives, and photographers for making further photographs available and for allowing them to be reproduced. As well as the institutions already named in the picture captions, the following are listed here individually:

Abegg, Regine: 373 left
AKG Photo, Berlin: 241 left centre
 AKG Berlin/Erich Lessing 422
Alinari: 311, 459 right
Anders, Jörg P.: 351, 353, 400 left, 403, 413 bottom, 414 top, 428 top, 437
Archivio Fotografico Oronoz: 416, 424, 425 top, 426–27, 456 top, 457 top, 457 bottom, 459 left
Archivio Fotografico/Sacro Convento, Assisi: 388 top
Artothek–Blauel/Gnamm: 415 top, 420, 435 top
Artothek–Joachim Blauel: 417 top, 429 bottom left
Ateliér Paul, Prague: 434 bottom
Bartsch: 491 top right
Bayerisches Nationalmuseum, Foto Walter Haberland: 493
Bibliothèque Nationale, Paris: 160 top (for all other photos see picture captions)
Bildarchiv Foto Marburg: 45 right, 110 left, 213 top, 237 bottom left, 237 bottom right, 238 bottom left, 238 bottom centre, 247 bottom, 276 top, 301, 306, 312, 314, 363, 393 bottom, 432, 484 right centre, 487 top
The Bridgeman Art Library, London: 461 right
Brüdern, Jutta: 346 top
Bunz, Achim: 488 bottom
© The Cleveland Museum of Art, 1998, Mr. and Mrs. William H. Marlatt Fund, 1954.393: 396
C.N.M.H.S.: 55 top left, 55 right centre
C.N.M.H.S., Patrick Cadet: 76 left and right top
Collection Viollet, Paris: 264 top
de la Riestra, Pablo: 18–27, 193 bottom, 195 left, 196 right, 205 right centre, 208 right, 219 left top, 219 left bottom, 220 top, 221 top right, 221 bottom left, 221 bottom right, 235 bottom left, 235 bottom right, 240 left
© Dean and Chapter of Westminster, London: 404 top

Diebold-Schillings-Chronik 1513 ZB Lucerne: 495 left top
Domingie, Serge; Rabatti, Marco: 444 bottom
Domschatzmuseum Regensburg, Foto Walter Haberland: 498 left
Edelmann, Ursula: 357, 358, 359
Fotoatelier Gerhard Howald: 482
Fotoatelier (Helicopter-Foto) Federau, Hamburg: 264 bottom
Giraudon: 17, 425 bottom, 461 bottom, 462, 463, 464 bottom, 489 left top
Hilbich, Markus: 63, 154 top, 199 left, 203 top right, 204 right, 209, 210 top, 210 bottom left, 210 bottom right, 211 left, 211 right, 220 bottom, 227 right, 228 left, 230 right, 234, 238 top right, 239 left, 239 right, 362
Huber, Gernot: 205 right top
Jacot-Descombes, Bettina: 438 bottom
Kalmar, Stefan: 478 right
Karge, H.: 97 right
Lauros-Giraudon: 398 top, 399
Lensini, Fabio: 448–49 top
Lilienthal, H.: 352 left
© Matz, R; Schenk, A./Dombauarchiv Cologne: 430 top
Messagero di S. Antonio Editrice, Padua: 450 bottom
© 1998 by The Metropolitan Museum of Art, The Cloisters Collection, 1956. (56.70): 413 top
Monheim, Florian: 193 top, 194, 195 right
Monheim/von Götz: 218 left, 218 right, 219 right, 225, 226 right
Museum für kunst und Kulturgeschichte der Hansestadt Lübeck: 497 left
Museum Nacional d'Art de Catalunya, Photographic Service (Calveras, Mérida, Sagristà): 456 bottom, 458 left
National Museum of Finland: 402 right
Orsi Battaglini, Nicolò: 452 right, 453
R. Paknys Publishing House, A. Ballénas, Vilnius: 237 top, 238 top left
The Pierpont Morgan Library/Art Resource, New York: 390 left, 439 right top, 492 right bottom
Posselt, Milan: 434 top
Prost, Stephane: 401 bottom
Rheinisches Bildarchiv: 202, 350, 354, 355, 428 bottom, 429 top, 429 bottom right, 430 bottom, 431, 491 top left
R.M.N.: 241 right, 318, 321, 494 left
R.M.N.–J.G. Berizi: 423, 455 left
R.M.N.–Gérard Blot: 404 bottom
R.M.N.–Jean: 410, 455 right
R.M.N.–R.G. Ojeda: 398 bottom
Scala: 14, 15 top, 244 left, 245 right, 322, 325, 327, 391 left, 391 right, 401

top, 406, 408–09, 414 bottom, 415 bottom, 419 top, 419 bottom, 421, 439 bottom right, 440 top, 440 bottom, 441 top, 441 bottom, 442 left, 442 right, 443 top, 443 bottom left, 444 top, 445 top, 445 bottom, 446, 447, 448 bottom left, 448 bottom right, 449 bottom left, 449 bottom right, 450 top, 451, 465 top right, 485 top left, 492 top left
Staatliche Museen zu Berlin-Preußischer Kulturbesitz, Kunstgewerbemuseum (Foto: Funke): 496 (all colour photos of the Staatliche Museen in Berlin see picture captions)
Staatliche Museen Kassel: 495 bottom right
Sila, Cestmir: 433 bottom right, 438 right
© Trésor de la Cathédrale de Liège (Lüttich): 494 right
Verlag Sauerländer Aarau, Frankfurt am Main, Salzburg: 263
© Walford, Elke, Hamburg: 433 top, 433 bottom left, 433 bottom centre, 439 left top
Wiss Fa & Skandinavia Foto, Fotoagenturen Dirk Steinhäuser, Wilster: 236 top left, 236 top right, 236 left centre
Zapke, M., Seville: 276 bottom

We are grateful for permission to use photographs from:

England/Cathedral of Lincoln: by kind permission of the Dean and Chapter of Lincoln
England/York Minister: by kind permission of the Dean and Chapter of York
England/King's College, Cambridge: © King's College, Cambridge
Spain/Fundaciòn Casa Ducal de Medinaceli, Seville: by kind permission of the Fundaciòn Casa Ducal de Medinaceli, Seville
Spain/Real Monasterio San Juan de Los Reyes, Toledo: © Monasterio San Juan de Los Reyes. Toledo. 1997
Spain/Museo de Escultura Valladolid: © Museo Nacional de Escultura (Valladolid). Ministerio de Educacíon y Cultura

Glossary

abacus (pl. abaci) a flat slab that forms the top of a column's capital

acanthus stylized leaf ornament based on a type of thistle; used notably on the capital of a Corinthian column

aedicule an architectural surround, usually consisting of two columns supporting a pediment, or framing a niche or opening

aisle in a church, a passage running alongside the nave and separated from it by a row of columns or piers

alcázar (Sp.) a fortified castle, mostly in the form of a closed four-winged structure

alfarje (Arabic) in Spanish and Islamic architecture, an open, mostly trough-shaped, wooden ceiling with flat ornamentation

allure a walkway, especially one around the parapet of a castle or the roof of a church

ambo a raised lectern or pulpit that stands in the nave of a church, usually next to the choirscreen

ambulatory a passage that runs around the apse of a church; in French Gothic, the ambulatories are round or polygonal, in English Gothic, they are often rectangular (they are seldom a feature of German Gothic)

antependium a covering for the front of an altar

apse semicircular or polygonal extension to a church building, usually at the east end of the choir

aquamanile small pitcher for the water used to wash the priest's hands during Mass

arcade a series of arches supported by columns or piers; a *blind arcade* is set into the surface of a wall

arch a structural device, usually of masonry, that forms the curved or pointed top of an opening (such as a door or window) or support (such as a bridge). Arches carry the thrust of the construction above them to columns of piers that form their support. See page 26 (bottom left)

architrave in classical architecture, the horizontal stone lintel extending from one column to another, carrying the frieze and cornice of an entablature; generally, a molded frame around a door, window, arch, etc

archivolt the continuous molding curving around the inner surface of an arch

armillary sphere a celestial globe made up of metal bands representing the paths of the planets

artesonado (Sp.) in Islamic-inspired Spanish architecture, a decorative wooden ceiling, sometimes painted as well as carved. See pages 278–279

attic in classical architecture, the story above the main cornice of a building; it sometimes hides the base of the roof and can take the form of a low story

azulejo (Sp.) painted and glazed wall and floor tiles. See pages 278–279

Babylonian Captivity the period (1309–77) when the papacy, then under French domination, was in Avignon in France. The end of the Babylonian Captivity marked the beginning of the Great Schism.

baldachin a free-standing fabric canopy supported by columns; often placed over a religious object such as a tabernacle shrine or carried in church processions

baluster one of the small posts or pillars, usually with a molded shaft, that support a rail

banderole a long narrow banner or streamer, usually one on which a brief text is written

baptistery part of a church (often detached) in which baptisms are performed; they are mostly round or octagonal in plan

barrel vault a vault with semicircular cross-section

base molded foot of a pillar or column providing the transition from the plinth to the shaft

basilica originally a Roman hall for markets or a court; in Christian architecture, a church with side aisles (separated from the nave by columns) and a high row of windows (the clerestory) above the aisles

basket arch a shallow arch shaped like the handle of a basket with the two side curves flattening out to form the segment of a much larger circle. See page 26 (bottom left)

bas-relief a sculptured relief in which the design stands out only a little from the background; low relief

basse-taille a form of enameling in which a design cut into the metal base is visible through the translucent enamel

bastion a rampart or bulwark projecting from the corner of a fortified building

bay one of the major regular divisions of a building defined by such features as windows, arches, columns, etc

bead moulding molding resembling a string of beads, used, for example, on cornices or the base of columns

bevel a sloping surface, usually on an edge

Black Death an outbreak of bubonic plague that ravaged Europe 1347–1351. Originating in China, it was spread by trade routes, reaching the Black Sea in 1347 and then spreading rapidly to Italy, France, and other parts of Europe. It is thought that at least a quarter of Europe's population died, though in some regions the death rate may have reached three-quarters of the population. The Black Death had a profound effect on the social, religious, and economic life of the period.

boss a projecting keystone, usually painted or carved, that forms the meeting point of the ribs of a vault

buttress a vertical structure of stone or brick that supports a wall, counteracting the lateral thrust of an arch, roof, or vault

calotte a dome or vault with a semicircular cross-section and no drum

cameo a precious or semi-precious stone engraved with a design cut in relief, usually in a stone which has different colored layers

campanile a bell tower, usually standing separate from the main building (usually a church)

capital the molded or carved top of a column or pier that acts as the mediator between the column and the load it supports; usually decorated

cavetto a concave molding profile, approximately a quarter-circle in section

centrally planned building a building that is round, polygonal, or built over the arms of a cross of equal length

chalice a cup, usually made of precious metals and finely decorated, used for the consecrated wine during the eucharistic service

champlevé form of enameling in which the enamel fills cuts in a metal surface

chantry chapel in English churches, a chapel for celebrating Masses for the dead

chapel a small separate place for worship, either part of a large church or a separate building

chapter house in English cathedrals and monasteries, a room or hall for meetings of the chapter (governing body); usually polygonal or round in plan

chevet largely in French architecture, the east end of a church formed by the apse, ambulatory, and chapels

choirscreen in a church, the partition, made of wood or stone and often decorated with carving, that separates the space of the clergy (chancel) from that of the laity (nave)

choir the part of a church where services are sung; the eastern arm of a church, especially the area between the crossing and the apse

church types basilica (see above and page 18); hall and stepped hall (see page 19); two-celled or aisleless (see page 19, bottom left); centrally planned (see page 20, left)

ciborium an ornamental receptacle, usually of precious metals, for holding the Eucharist; a canopied shrine where the Eucharist is kept

clerestory the topmost story of a nave wall, pierced by windows

cloisonné form of enameling in which the enamel fills cells whose walls are thin strips of metal

cloister in a monastery, a quadrangular space surrounded by roofed or vaulted passages that link the church with the domestic areas; the inner walls of the passages open onto the quadrangle through colonnades

close the precinct or grounds of an English cathedral

coffering form of wall, ceiling, or vault decoration consisting of sunken ornamental panels, usually square or polygonal

colonnade sequence of columns supporting arches or entablature

colossal order (or monumental order) an architectural order in which columns or pilasters rise through several stories

column a vertical structural member having a circular cross-section and usually consisting of a base, a long shaft (often slightly tapered at the top and bottom), and a capital

compound pier a pier formed by a bundle of shafts or by a solid core surrounded by attached or detached columns

conch a semicircular apse, usually surmounted by a half-dome

contrapposto in art, a pose in which the upper part of the body turns in a direction opposite to that of the lower half

coping course of stone capping along a wall or other feature

corbel a projecting block of masonry (often carved with plant motifs or a head) on which a beam, arch, or statue rests

cornice a molded horizontal ledge along the top of a building or wall; a decorative molding between wall and roof

course continuous layer of stone or brick in a wall

crocket carved Gothic ornament resembling various leaf shapes, usually found on pinnacles, gables, etc. See page 24

crossing in a church, the central space at the intersection of the nave and transepts; the crossing is usually surmounted by a tower or dome

crypt a chamber or vault under a church, usually at the east end and often containing graves or relics

cusp a projecting point at the intersection of arcs in the tracery of Gothic windows and arches; the cusps define the foils (see below)

Decorated style the second major style of Gothic architecture in England, ca. 1240–1330, coming after Early Gothic. It is noted in particular for the development of ornate tracery and the use of ogee arches. It was followed by Perpendicular (see below).

diaper work surface decoration consisting of repeated lozenges or squares

Diocletian window (or thermal window) a semicircular window divided into three sections by vertical mullions

dissolution of the monasteries the appropriation of the property and possessions of the English and Welsh monasteries 1536–1540 by Henry VIII. It was meant both to weaken the power of the Church and to replenish the treasury; much of the property went to the aristocracy and gentry.

dome a convex roof, usually hemispherical, spanning round, square, or polygonal spaces

donjon the central fortified tower of a castle where the lord and his family lived; a keep

dormer window a vertical window projecting from a sloping roof

drum the cylindrical or polygonal base of a dome

dwarf gallery a small arcaded passage on the outside of a church, (especially in Romanesque architecture)

Early English the first major style of Gothic architecture in England, ca. 1170–1240

eclecticism the mixing of various historical architectural styles

Elector one of the German princes who elected the emperor of the Holy Roman Empire. From the middle of the 14th century there were seven Electors: the king of Bohemia, the duke of Saxony, the count Palatine of the Rhine, the margrave of Brandenburg, and the archbishops of Mainz, Trier, and Cologne.

en-délit column a column whose "grain" runs vertically rather than horizontally; in early Gothic architecture columns constructed *en délit* were usually responds not bonded into the wall

enfeu (Fr.) set in a niche; used especially of a tomb set in a niche in a church wall

engaged column a column attached to the pier or wall behind it

entablature in classical architecture, the three horizontal members (architrave, frieze, and cornice) supported by columns

exvoto (of a gift) done in fulfilment of a vow, usually because a prayer has been answered; a votive image

façade the front or principal face of a building, especially one elaborately constructed; a *blind façade* is a façade that is purely decorative and does not relate to the structure of the building

fan vault an English form of vault in which ribs spread out from their corbels to form a fan-like design. The ribs are decorative rather than structural, each fan being a solid semi-cone with concave sides.

fief in medieval law, the lands granted by a lord to a vassal in return for the homage the vassal paid to the lord

finial a carved decoration that crowns pinnacles, gables, bench-ends, etc; in Gothic architecture, these were usually in the form of stylized leaves

flagellants religious brotherhoods of men and women who whipped themselves, usually in public processions, as a spiritual discipline or as penance for their own sins or the sins of the world

Flamboyant or *style flamboyant* (Fr.) the last major style of French Gothic architecture, so called because of its highly elaborate "flame-like" tracery. It followed Rayonnant (see below).

fluting narrow vertical grooves in the shaft of a column or pilaster

flying buttress an arched buttress that carries the thrust of a wall to a vertical buttress (usually it carries the thrust of the nave vault across the aisle roof to the outer buttress)

foil in tracery, a lobe or leaf-shape formed by cusps; a trefoil is composed of three foils, a quatrefoil of four foils

fresco wall painting technique in which pigments are applied to wet plaster; the pigments bind with the drying plaster to form a highly durable image

frieze a horizontal band of architectural decoration; in a classical entablature, the horizontal member band between the architrave and the cornice

gable the end wall of a pitched roof or similar architectural form, usually triangular but sometimes stepped or arched. A gable may be used purely decoratively, as, for example, over the portal of a Gothic cathedral, where it often contains sculptural decoration. See page 26 (bottom right)

gallery originally a covered passage open at the side; in a castle, a long ceremonial hall; in a church, a balcony for separating specific groups (the court, women) during a service

gild to cover with a thin layer of gold

gisant (Fr.) a tomb effigy depicting the deceased person as a corpse

Gothic Revival (or Neo-Gothic) a 19th-century revival of the Gothic style in architecture and design

Great Schism a split in the Church, 1378–1417, when there were two lines of papal succession, one in Rome and one (of the so-called antipopes) in Avignon in France. The Great Schism was preceded by the so-called Babylonian Captivity, when the papacy resided in Avignon.

Greek cross cross with arms of equal length

grisaille monochrome painting, often intended to look like sculpture

groin vault a vault formed by the intersection at right angles of two barrel vaults

Guelfs and **Ghibellines**, in medieval Germany and Italy, the two rival factions in the struggle for power in the Holy

Roman Empire. The conflict began in Germany in the 12th century with disputes between two ruling families: the Welfs (known in Italian as Guelfs) and the Hohenstaufen (known in Italian as the Ghibellines). The conflict spread to Italy, where the Guelfs supported the pope's claim to power and the Ghibellines supported the Holy Roman Emperor's claim to sovereignty.

hall church a church in which the nave and aisles are of the same (or nearly the same) height; particularly common in German Gothic. See page 19

header in a wall, a stone or brick laid so that only its end is visible (in contrast to a stretcher)

helm roof a spire having four or more inclined faces rising above gables. See page 25

hipped roof a roof with sloping rather than vertical ends; a false hipped roof has a half sloping, half vertical end. See page 26 (bottom right)

Holy Roman (German) Empire political body embracing most of central Europe which played a major role in medieval and Renaissance politics. Founded by Charlemagne, and modeled on the Roman empire, it effectively came into existence with the crowing of Otto I in 962. The emperor was usually the dominant German prince, elected by other German princes, the Electors (see above). By the middle of the 13th century the empire embraced all the German states, Austria, Switzerland, eastern areas of France, north and central Italy, the Netherlands, and Bohemia (now the Czech Republic and Slovakia).

horseshoe arch an arch that forms a bulbous horseshoe shape, found mostly in Islamic architecture

iconography the set of symbols on which a given art work is based

imitatio (Lat.) in classical rhetoric, the imitation of worthy models

impost a stone slab at the top of a column or pillar or imbedded in a wall, on which an arch rests

Inquisition a tribunal set up by the Church to suppress heresy. It was formally inaugurated in 1231, when Pope Gregory established a commission to investigate heresy among the Cathars of southern France. The Spanish Inquisition was founded by Ferdinand and Isabella of Spain in 1478. Effectively a branch of government, and largely independent of the papacy, it played a leading role in the persecution of converted Jews and Moors about whose Christianity there was no doublt.

intarsia a form of furniture decoration in which images are created using thin veneers of different colored woods and sometimes ivory and mother of pearl. It was used on wall paneling, cabinet doors, etc.

Isabelline style late Gothic architectural and decorative style in Spain during the second half of the 15th century (named after the Spanish Queen Isabella I)

key stone central stone in an arch or vault, sometimes sculpted

Lady chapel in English churches, a chapel dedicated to the Virgin

lancet window slender window ending in a pointed arch

lantern a windowed turret set on a dome or roof; used to provide light to the area below

Latin cross a cross whose main longitudinal arm is longer than the transverse arms

liberal arts the seven main subjects in medieval education, in contrast to the manual crafts: Latin (grammar), logic (dialectic), and rhetoric (trivium), together with geometry, arithmetic, music, and astronomy (quadrivium)

lierne in a vault, a short rib linking other ribs and not linked to any of the springing points or the central boss

light in a large window, the areas between the mullions

loggia a colonnaded gallery or porch open on one or more sides; a loggia can be part of the ground floor or upper story of a building, or stand as an independent structure

longitudinal ridge rib supporting rib running the length of a vaulted ceiling

lucarne a small window or opening in a roof or spire

lunette a flat semicircular area, usually built above doors or windows; any semicircular or crescent-shaped area

Maestà (It.) a picture showing the Virgin enthroned

mandorla in religious images, an almond-shaped area of light surrounding a holy figure, especially Christ or the Virgin

Manueline a late Gothic and early Renaissance decorative style in Portugal in the early 16th century (named after Manuel I)

martyrium the tomb of a martyr; a church built on the site of a martyr's death

mensa (Lat.) altar table

mezzanine a low story between two higher ones

mihrab (Arabic) a prayer niche in a mosque indicating the direction of Mecca

mimbar or *minbar* (Arabic) the high pulpit in a mosque

minaret in a mosque, a tall slender tower from which the call to prayer is given

monastery the complex of buildings used by a community of monks. Among the main elements of the complex are the church, cloister, chapter house (used by the governing body), refectory (dinning room), and dormitory (sleeping quarters).

monks' choir a separate space in a monastery church reserved for the monks, usually equipped with choirstalls (carved seats)

monolith a column, pillar, etc cut from a single block of stone

monstrance a vessel, usually ornate and made of precious metals, for exhibiting the Eucharist during Mass

mozarabic Spanish style of art and architecture influenced by Islamic styles

mudéjar (Arabic) Spanish style of decorative art based on the imitation of Islamic forms. See pages 278–279

mullion an upright support separating the main panels of a large window

multifoil a form of tracery consisting of multiple foils

mur épais (Fr.) a thick wall, a characteristic feature of Romanesque architecture; **mur épais évidé** a thick wall hollowed out with passages

narthex the large porch or vestibule across the main (west) entrance to a medieval churches

nave the central space of a church that extends from the west portal to the choir or chancel usually flanked by aisles

nimbus in the visual arts, a disc or halo, usually depicted as golden, placed behind the head of a holy person

nodding ogee an ogee arch that projects outwards from a surface, forming a shallow canopy

obelisk a four-sided column tapering to a pyramid or cone

octagon an eight-sided building or ground plan

oculus (pl. oculi) a round window opening

off-set on the outside of a church, a sloping area of wall that helps to deflect rainwater from the walls below

ogee a molding with an S-shaped, convex-concave profile

ogee arch (or keel arch) an arch formed by four curves, the two convex curves below becoming concave curves that meet in a sharp point

openwork a pierced surface or wall made up of finely carved tracery (for example, openwork spire of German Gothic churches)

oratory a small private chapel; a church of the Oration Order

palace the official residence of a ruler or bishop; especially in Italy, a stately civic building or private residence

Palas (Ger.) one of the main building of a medieval castle, usually containing the ceremonial hall

Palladian the style of the Italian architect Andrea Palladio (1508–80), who developed an austere form of classicism derived from classical Roman architecture

palmette a decorative motif consisting of a stylized palm leaf

pantile a roofing tile with the profile of a flattened S (so that the tiles interlock)

parvise an enclosed courtyard or space in front of a church

paraments ecclesiastical hangings or vestments

paten a small plate of precious metal used to hold the eucharistic host during Mass

patio in Spanish architecture, an inner courtyard

pendentive a curving and concave triangular section of vaulting linking a dome to the square base on which it rests

pergola a passageway covered by trellis on which climbing plants are grown

Perpendicular the last of the three major styles of Gothic architecture in England, ca. 1330–1530. It is characterized by comparatively simple decoration and soaring vertical lines, hence its name. It was preceded by the Decorated style (see above).

perron an external platform reached by steps and leading to the main entrance to a building

perspective the method of representing three-dimensional space on a flat surface. There are several ways of achieving such a sense of depth. Among the most elementary are the use of *overlapping* (one object being placed behind another), and *scale* (near objects depicted larger than distant ones). In *aerial perspective* distant scenes are painted in lighter tones and less intense colors, and with less clarity.

In Western art since the Renaissance, the most important form of perspective has been *linear perspective*, in which the real or suggested lines of objects converge on a vanishing point (or points) on the horizon. This method was developed into a formal system in Italy during the early years of the 15th century, though an empirical sense of linear perspective had developed in Italy and northern Europe during the late Middle Ages.

piano nobile (Ital.) the main first floor in a large house, specifically an Italian palace

pier a large, solid, and free-standing support, usually square or round in section. See compound pier (above)

pier church an aisleless church in which the piers are built into the nave walls; chapels were sometimes built between the piers

pilaster a rectangular column set into a wall, usually a decorative rather than structural feature

pilier cantonné (Fr.) a pier consisting of a cylindrical core with four engaged columns

pillar a vertical load-bearing member; unlike a column, a pillar does not have to have a base and capital and can be square, rectangular, or polygonal in section as well as round

pinnacle a small turret-like architectural feature, often richly ornamented, that crowns parapets, pediments above windows or doors, flying buttresses, spires, etc

pitched roof a roof with gables at both end. See page 26 (bottom right)

Plateresque a highly ornate style of architectural decoration that flourished in Spain during the late 15th and early 16 centuries

plinth the square or molded slab under the base of a pillar or column; any solid base

ploughshare twist a twisted vault surface created by having the diagonal and the wall rib spring from differing heights

portico a porch or walkway supported by columns; the covered entrance to a building

predella the platform on which an altar or shrine stands; a painting or carving placed beneath the main scenes or panels of an altarpiece. Long and narrow, painted predellas usually depicted several scenes from a narrative.

presbytery an area of a church to the east of the choir reserved for the clergy

pyx a vessel in which the eucharistic host is kept

quatrefoil a form of tracery made up of four foils (see foil, above)

quattrocento the 15th century in Italian art. The term is often used of the new style of art that was characteristic of the Early Renaissance, in particular works by Masaccio, Brunelleschi, Donatello, Botticelli, Fra Angelico, and others. It was preceded by the Trecento.

radiating chapels chapels situated on the ambulatory of a semicircular or polygonal choir

Rayonnant or **style rayonnant** (Fr.) style of Gothic architecture flourishing in France from the mid 13th century to the mid 14th century, characterized by greater use of stained glass and by the "radiating" tracery of its rose windows (hence the name). The Ste.-Chapelle in Paris is the leading example of the style. It was the second major form of French Gothic, and was followed by Flamboyant (see above).

Reconquista (Sp.) the gradual reconquest by Christian forces of the Spanish and Portuguese kingdoms held by the Moors, who had conquered much of the Iberian peninsula in the early 8th century. The Reconquista finally came to an end in 1492, when the Moors lost Granada.

refectory a dining hall

Reformation 16th-century movement that began as a search for reform within the Roman Catholic Church and led to the establishment of Protestantism. This split in Western Christendom had profound political consequences, with the whole of Europe dividing into opposed and often hostile camps. Among the Reformation's leading figures were Jan Hus, Martin Luther, and John Calvin.

reliquary a container (often richly decorated) for sacred relics, usually parts of a saint's body

respond a half-pillar or column attached to a wall which supports one end of an arch or the ribs of a vault

retable a painting or sculpted panel behind an altar

reticulated vault late Gothic form of vault in which the ribs form a lattice. See page 22 (bottom left)

retrochoir in a large church, the area of choir that stands behind the high altar

rib the slender stone or brick arches that form the structural skeleton of a vault. Though structural, ribs became an increasingly important element of the decorative scheme of a church, with highly complex patterns developing. See pages 22 and 23 (top).

ribbed vault a vault in which the thrust is carried entirely by a framework of diagonal ribs. See page 22

ridge turret small tower on the ridge of a roof

riser (in a staircase) the upright face of a step

ronde-bosse (or encrusted enamel) form of enameling in which opaque enamel is applied to a three-dimensional object

roodscreen in a church, a screen dividing the chancel (for the clergy) and the nave (for the laity); surmounted by a cross (rood), it was often richly decorated with carvings and paintings and sometimes used as a singers' gallery

rose window a circular window, usually large, filled with tracery

rubble work masonry consisting of rough-hewn or undressed stone

rubble-filled wall wall consisting of rubble and mortar between regularly built external layers of wall

rustication stonework in which large square blocks are used, usually with their outer surfaces deliberately left rough-hewn; the intended effect is of massiveness and strength

sacristy a side room of a church where a priest puts on his vestments and where the sacred vessels and vestments are kept

saddleback roof a pitched roof when used over a tower

sanctuary the area around the main altar of a church

scholastisicm the method and doctrine of medieval teachers. As a method, scholasticism refers to the detailed analysis of texts by a strictly logical process of question and answer. As a body of doctrine, scholasticism refers to the theology, law, philosophy, and medicine taught in medieval institutions. Much of this was a reinterpretation of the Greek philosopher Aristotle in Christian terms, with intellect made subordinate to faith

seneschal in a large medieval household, the official in charge of domestic arrangements, in particular the work of the servants

shaft ring ring-shaped reinforcement on a column shaft; in Gothic architecture often used on responds

soffit the underside of an arch, cornice, or other architectural element

spandrel the approximately triangular area between the outer edge of an arch and its rectangular framework or molding

spire a tall conical or pyramidal roof on a church tower or turret. See pages 24 and 25

springing the point from which an arch or vault rib springs from its support

squinch a corner arch that forms the transition from a square base to a round dome or polygonal spire

stellar vault late Gothic vault shape in which the ribs (specifically the liernes) form a star shape. See pages 22 and 23

stepped gable (or crow-stepped gable) a gable with stepped sides. See page 26 (bottom right)

stepped hall a hall church in which the aisles are not quite as high as the nave. See church types, page 19

stiff leaf a carved decoration consisting of stiff curling leaves, used on capitals, bosses, corbels, etc, especially in English Gothic

stonemasons' lodge an organisation of craftsmen and architects formed to organize the construction of a medieval church

stretcher in a wall, a stone or brick laid so that its long side is visible and parallel to the wall line (in contrast to a header)

stringcourse a horizontal stone molding along a wall that separates one register from another

stucco a protective coat of coarse plaster applied to external walls; molded plaster decorations, usually interior

style rayonnant See Rayonnant

syncopated arcading double layers of blind arcading set so that the columns of the front arcade stand in the middle of the arches behind

tabernacle a small canopied recess or container in which the Eucharist or a holy relic is kept

tas-de-charge (Fr.) the stones forming the lowest course of Gothic vaulting ribs; the system of interlocking stones between the springing of the vault ribs and the point where the individual ribs separate. See page 155 (top left)

tension rod metal or wood rod used to give a structure greater strength

tierceron in a Gothic vault, the decorative ribs springing from the corners of a bay

timber framing method of construction in which a building's framework is made entirely of wooden posts, beams, and braces, etc., the spaces between being filled with clay, lath and plaster, bricks, etc. See pages 27 and 231

torus (pl. tori) a large convex molding at the base of a column

tower façade a façade with one or more towers

tracery in architecture, decorative work consisting of interlaced or branching lines, usually found in the upper parts of windows (in stone) but also (in wood) on screens, panels, and doors. Elaborate tracery was a characteristic feature of Gothic architecture and the forms of tracery are sometimes used to identify a style. See page 23 (bottom)

transenna window a window opening filled with an openwork screen or lattice

transept the part of a cross-shaped church at right angles to the nave, the intersection of nave and transept forming the crossing

transubstantiation the transformation of bread and wine into the body and blood of Christ during the Mass

trecento the 14th century in Italian art. This period is often considered the "proto-Renaissance," when writers and artists laid the foundation for the development of the early Renaissance in the next century (the Quattrocento). Outstanding figures of the Trecento include Giotto, Duccio, Simone Martini, the Lorenzetti brothers, and the Pisano family of sculptors.

trefoil a form of tracery consisting of three foils. See foil (above)

triforium an arcaded wall-passage or blind arcade that forms the middle story of the elevation of a Gothic church, between the arcade (and gallery) and the clerestory. See page 18

triumphal arch in classical architecture a monumental arch honoring an emperor or battle, usually consisting of a main arch framed by two smaller arches

trompe-l'oeil (Fr.) an illusionistic painting which through various naturalistic devices creates the illusion that the objects depicted are actually there

trumeau the post or mullion forming the middle support of a portal's tympanum

Tudor arch a shallow arch in which the corners are formed by quarter-circles and the central section by straight lines that meet in a low point (typical of 16th-century English architecture)

tympanum in medieval architecture, the semicircular area over a door's lintel, enclosed by an arch, and often decorated with sculpture or mosaic

typology the drawing of parallels between the Old Testament and the New, based on the assumption that Old Testament figures and events prefigure those in the New (for example the story of Jonah and the whale prefigures Christ's death and resurrection)

vanitas a painting that acts as a reminder of the inevitability of death or the futility of earthly ambitions and achievements

vault any stone roof based on the principle of the arch. The development of the vault, which became increasingly complex in structure, played a key role in the development of Gothic architecture. See pages 22–23

vault cells (or vault webs) the non-load-bearing areas between the ribs of a vault

veduta, (pl. *vedute*) (It.) a topographically correct view of a city or landscape

vesica tracery motif in the form of an oval with pointed head and foot

vestibule entrance hall

villa a residence in the country (in Italy); villas acquired palace-like characteristics from the Renaissance onwards

voussoirs the wedge-shaped stones forming an arch or rib

wall arch an arch on the wall or window side of a vault

waterspout a waterpipe, often decorated figuratively, for draining rainwater from a roof. See page 24 (bottom left)

web the stone infill between the ribs of a vault

westwork the west end of a Carolingian or Romanesque church, consisting typically of an entrance hall and, above, a room that opens onto the nave and a small chapel; the façade was often flanked by towers

wheel window a circular window whose radial tracery creates a wheel-like appearance

winged altarpiece an altarpiece, usually consisting of sculpture and painting, in which the middle section has been given wings that open and close. A winged altarpiece may have several pairs of wings which can be opened and closed in various combinations

yesería Moorish plasterwork decoration. See pages 278–279

Bibliography

The bibliography is organized according to the sections of the book. As well as works referred to by the individual authors, it includes other secondary material. On some topics, only a limited amount of work is available.

ROLF TOMAN
Introduction

Assunto, R., *La critica d'arte nel pensiero medievale*, Milan 1961
Bandmann, G., *Mittelalterliche Architektur als Bedeutungsträger*, Berlin 1994 (orig. pub. 1951)
Binding, G., *Beiträge zum Gotik-Verständnis*, Cologne 1995
Camille, M., *Gothic Art. Glorious Visions*, New York 1996
Châtelet, A., Recht, R., *Ausklang des Mittelalters: 1380–1500*, Munich 1989
Dinzelbacher, P., Hogg J. Lester (ed.), *Kulturgeschichte der christlichen Orden*, Stuttgart 1997
Dinzelbacher, P. (ed.), *Europäische Mentalitätsgeschichte*, Stuttgart 1993
Duby, G., *The Age of the Cathedrals. Art and Society 980–1420*, London 1981
——, *The Three Orders. Feudal Society Imagined*, Chicago/London 1980
Eberlein, J. K., Jakobi-Mirwald, C., *Grundlagen der mittelalterlichen Kunst. Eine Quellenkunde*, Berlin 1996
Eco, U., *Art and Beauty in the Middle Ages*, New Haven/London 1986
Erlande-Brandenburg, A., *L'Art Gothique*, Paris 1983
——, *The Cathedral. The Social and Architectural Dynamics of Construction*, Cambridge 1994
Grodecki, L., Prache, A., Recht, R., *Gothic Architecture*, New York 1977
Huizinga, J., *The Problem of the Renaissance*, 1920
——, *The Autumn of the Middle Ages*, Chicago 1996 (orig. pub. 1924)
Jantzen, H., *Die Gotik des Abendlandes*, Cologne 1997 (orig. pub. 1962)
——, *High Gothic. The Classic Cathedrals of Chartres, Reims, Amiens*, Princeton 1984 (orig. pub. 1962)
Kimpel, D., Suckale, R., *Die gotische Architektur in Frankreich 1130–1270*, Munich 1995
Le Goff, J., *Intellectuals in the Middle Ages*, Cambridge, Mass./Oxford 1993
List, C., W. Blum, *Sach-Wörterbuch zur Kunst des Mittelalters*, Stuttgart and Zürich 1996
Mâle, É., *The Gothic Image. Religious Art in France of the Thirteenth Century*, New York 1983 (orig. pub. 1913)
Mirgeler, A., *Revision der europäischen Geschichte*, Freiburg 1971
Nussbaum, N., *Deutsche Kirchenbaukunst der Gotik*, Darmstadt 1994
Panofsky, E., *Abbot Suger on the Abbey Church of St. Denis and its Art Treasures*, Princeton 1979 (orig. pub. 1946)
——, *Gothic Architecture and Scholasticism*, New York 1957
Pieper, J., *Scholasticism. Personalities and Problems of Medieval Philosophy*, London 1960

Sauerländer, W., *Le siècle des cathédrales, 1140–1260*, Paris 1989
Schwaiger, G. (ed.), *Mönchtum, Orden, Klöster*, Munich 1993
Sedlmayr, H., *Die Entstehung der Kathedrale*, Freiburg 1993 (orig. pub. Zürich 1950)
Simson, O. von, *Das Mittelalter II, Das Hohe Mittelalter* (Propyläen-Kunstgeschichte, vol. VI), Berlin 1972
Simson, O. von, *The Gothic Cathedral. Origins of Gothic Architecture and the Medieval Concept of Order*, New York 1965
Warnke, M., *Bau und Überbau. Soziologie der mittelalterlichen Architektur nach den Schriftquellen*, Frankfurt 1976

BRUNO KLEIN
The Beginnings of Gothic Architecture in France and its Neighbors

General

Binding, G., Speer, A. (ed.), *Abt Suger von Saint-Denis, De Consecratione, kommentierte Studienausgabe*, Cologne 1996
Bruyne, E. de, *Études d'estéthique médiévale*, 3 vols., Bruges 1946
Dehio, G., Bezold, G. von, *Die kirchliche Baukunst des Abendlandes, historisch und systematisch dargestellt*, Stuttgart 1884–1901 (repr. Hildesheim 1969)
Duby, G., *The Age of the Cathedrals. Art and Society 980–1420*, London 1981
Erlande-Brandenburg, A., Frankl, P., *Gothic Architecture*, Harmondsworth, 1962
Frankl, P., *The Gothic. Literary Sources and Interpretations through Eight Centuries*, Princeton 1960
Götz, W., *Zentralbau- und Zentralbautendenz in der gotischen Architektur*, Berlin 1968
Grodecki, L., *et al.*, *Gotik und Spätgotik*, Frankfurt 1969
Jantzen, H., *Die Gotik des Abendlandes. Idee und Wandel*, Cologne 1962
Panofsky, E., *Gothic Architecture and Scholasticism*, New York 1967
Sauerländer, W., *Das Jahrhundert der grossen Kathedralen*, Munich 1989
——, 'Die Ste-Chapelle du Palais Ludwigs des Heiligen', *Jahrbuch der bayrischen Akademie der Wissenschaften*, 1977, 1–24
Sedlmayr, H., *Die Entstehung der Kathedrale*, Freiburg 1993 (orig. pub. 1950)
Simson, O. von, *The Gothic Cathedral. Origins of Gothic Architecture and the Medieval Concept of Order*, 3rd. ed., Princeton 1988
——, *Das Mittelalter*, vol. II, *Das hohe Mittelalter*, Berlin 1976

Architects, Construction, and Organization

Binding, G., *Baubetrieb im Mittelalter*, Darmstadt 1993
Binding, G. *et al.* (ed.), *Der*

mittelalterliche Baubetrieb Westeuropas, exhib. cat., (Cologne 1987), 1992
Castelfranchi Vegas, L. (ed.), *Die Baukunst im Mittelalter*, Solothurn and Düsseldorf 1994
Claussen, P. C., 'Kathedralgotik und Anonymität 1130–1250', *Wiener Jahrbuch für Kunstgeschichte*, 46–47, 1993–94, 142–160
Colombier, P. du, *Les Chantiers des cathédrales*, Paris 1973
Hahnloser, H. R., (ed.), *Villard de Honnecourt. Kritische Gesamtausgabe des Bauhüttenbuchs ms. fr. 19093 der Pariser Nationalbibliothek*, Graz 1972
Kimpel, D., 'Le développement de la taille en série dans l'architecture médiévale et son rôle dans l'histoire économique', *Bulletin Monumental*, 139, 1977, 195–222
——, 'Ökonomie, Technik und Form in der hochgotischen Architektur', in Clausberg, K. *et al.* (ed.), *Bauwerk und Bildwerk im Mittelalter*, Giessen 1981
Kraus, H., *Gold was the Mortar. The Economics of Cathedral Building*, London and Boston 1979
Recht, R. (ed.), *Les Bâtisseurs des cathédrales gothiques*, Strasbourg 1989
Schöller, W., *Die rechtliche Organisation des Kirchenbaus im Mittelalter vornehmlich des Kathedralbaus. Baulast – Bauherrschaft – Baufinanzierung*, Cologne and Vienna 1989
Ungewitter, G. G., *Lehrbuch der gotischen Konstruktionen*, 2 vols., Leipzig 1890–92
Warnke, M., *Bau und Überbau. Soziologie der mittelalterlichen Architektur nach den Schriftquellen*, Frankfurt 1976

France

General

Aubert, M., Maillé, G. de, *Cistercian Architecture in France*, Paris 1947
Bony, J., *French Gothic Architecture of the 12th and 13th Centuries*, Berkeley and London 1983
Branner, R., *St. Louis and the Court Style in Gothic Architecture*, London 1965
Erlande-Brandenburg, A. and Mérel-Brandenburg, A.-B., *Histoire de l'architecture française du Moyen Âge à la Renaissance (IVe siècle–début XVIe siècle)*, Paris 1995
Kimpel, D., Suckale, R., *Die gotische Architektur in Frankreich 1130–1270*, Munich 1995
Lasteyrie, R. de, *L'Architecture religieuse en France à l'époque gothique*, 2 vols., Paris 1926–27
Schlink, W., *Die Kathedralen Frankreichs*, Munich 1978
Viollet-le-Duc, E., *Dictionnaire raisonné de l'architecture française du XIe au XVIe siècle*, 10 vols., Paris 1858–68

Regional Studies

L'Architecture normande au Moyen Age. Actes du colloque de Cerisy-la-Salle (28 septembre–2 octobre 1994), ed. Maylis

Baylé, 2 vols., Caen, Condé-sur-Noireau 1997
Bideault, M., Lautier, C., *Île-de-France gothique*, 1, *Les églises de la vallée de l'Oise et du Beauvaisis*, Paris 1987
Blomme, Y., *Poitou gothique*, Paris 1993
Branner, R., *Burgundian Gothic Architecture*, London 1960
Burnand, M.-C., *La Lorraine gothique*, Paris 1989
Freigang, C., *Imitare ecclesias nobiles. Die Kathedralen von Narbonne, Toulouse und Rodez und die nordfranzösische Rayonnantgotik im Languedoc*, Worms 1992
Mussat, A., *Le Style gothique dans L'ouest de la France (XIIe–XIIIe siècles)*, Paris 1963
Thiébaut, J., *Les Cathédrales gothiques en Picardie*, Amiens 1987

Individual Buildings

Amiens:
Murray, S., *Notre-Dame, Cathedral of Amiens. The Power of Change in Gothic*, Cambridge 1996

Auxerre:
Titus, H. B., 'The Auxerre Cathedral Chevet and Burgundian Gothic Architecture', *Journal of the Society of Architectural Historians*, 47, 1988, 45–56

Beauvais:
Murray, S., *Beauvais Cathedral. Architecture of Transcendence*, Princeton 1989

Bourges:
Branner, R., *The Cathedral of Bourges and Its Place in Gothic Architecture*, Cambridge, Mass. 1989
Michler, J., 'Zur Stellung von Bourges in der gotischen Baukunst', *Wallraf-Richartz-Jahrbuch*, 41, 1979, 27–86
Ribault, J.-Y., *Un Chef-d'oeuvre gothique, la cathédrale de Bourges*, Arcueil 1995

Braine:
Caviness, M. Harrisson, *Sumptous Arts at the Royal Abbeys in Reims and Braine. Ornatus elegantiae, varietate stupendes*, Princeton 1990
Klein, B., *Saint Yved in Braine, und die Anfänge der hochgotischen Architektur in Frankreich*, Cologne 1984

Caen:
Lambert, E., *Caen roman et gothique. Ses abbayes et son château*, Caen 1935

Châlons-sur-Marne:
Corsepius, K., *Notre-Dame-en-Vaux. Studien zur Baugeschichte des 12. Jahrhunderts in Châlons-sur-Marne*, Stuttgart 1997

Chartres:
Aubert, M., *La Cathédrale de Chartres*, Paris 1952
Branner, R., *Chartres Cathedral*, London 1996 (orig. pub. 1969)

Erlande-Brandenburg, A., *Chartres dans la lumière de la foi*, Paris 1986
Klein, B., 'Chartres und Soissons, Überlegungen zur gotischen Architektur um 1200', *Zeitschrift für Kunstgeschichte*, 49, 1986, 437–466
Prache, A., *Lumières de Chartres*, Paris 1989
——, 'Observations sur la construction de la cathédrale de Chartres au XIIIe siècle', *Bulleton de la Société Nationale des Antiquaires de France*, 1990, 327–350

Clermont-Ferrand:
Davis, M., 'The Choir of the Cathedral of Clermont-Ferrand, the Beginning of Construction and the Work of Jean Deschamps', *Journal of the Society of Architectural Historians*, 40, 1981, 181–202

Le Mans:
Herschmann, J., 'The Norman Ambulatory of Le Mans Cathedral and the Chevet of the Cathedral of Coutances', *Gesta*, 20, 1981, 323–332

Laon:
Clark, W. W., *Laon Cathedral. Architecture, The Aesthetics of Space, Plan and Structure*, London 1987

Noyon:
Seymour, C., *Notre-Dame of Noyon in the Twelfth Century*, Yale 1939
Polk, T., *St-Denis, Noyon and the Early Gothic Choir*, Frankfurt and Berne 1982

Paris (Notre-Dame):
Erlande-Brandenburg, A., *Notre-Dame de Paris*, Paris 1991
Kimpel, D., *Die Querhausarme von Notre-Dame in Paris und ihre Skulpturen*, Bonn 1971

Paris (Sainte-Chapelle):
Hacker-Sück, I., 'La Ste-Chapelle de Paris et les chapelles palatines du Moyen-Age en France', *Cahiers archéologiques* 13, 1962, 217–257
Leniaud, J.-M., Perrot, F., *La Sainte-Chapelle*, Paris 1991
Sauerländer, W., 'Die Ste-Chapelle du Palais Ludwig des Heiligen', *Jahrbuch der bayrischen Akademie der Wissenschaften*, 1977, 1–24

Paris (Saint-Germain-des-Prés):
Clark, W. W., 'Spatial Innovations in the Chevet of Saint-Germain-des-Prés', *Journal of the Society of Architectural Historians*, 38, 1979, 348–365

Provins:
Maillé, Marquise E. de, *Provins, les monuments religieux*, 2 vols., Paris 1939

Reims (Cathedral):
Hamann-MacLean, R., Schüssler, I., *Die Kathedrale von Reims. Die Architektur*, 3 vols., Stuttgart 1993
Kunst, H. J., Schenkluhn, W., *Die Kathedrale in Reims. Architektur als Schauplatz politischer Bedeutungen*, Frankfurt 1988
Kurmann, P., *La façade de la cathédrale de Reims*, 2 vols., Paris 1987

Ravaux, J.-P., 'Les Campagnes de construction de la cathédrale de Reims au XIIIe siècle', *Bulletin Monumental*, 137, 1982, 7–66
Reinhardt, H., *La Cathédrale de Reims*, Paris 1963

Reims (Saint-Remi):
Lanfry, G., *La Cathédrale après la conquête de la Normandie jusqu'à l'occupation anglaise*, Rouen 1960
Prache, A., *Saint-Remi de Reims. L'oeuvre de Pierre de Celle et sa place dans l'architecture gothique*, Geneva 1975

Saint-Denis:
Abbot Suger and Saint-Denis. A Symposium, ed. Paula Lieber Gerson, New York 1986
Bruzelius, C. A., *The 13th-century Church at Saint-Denis*, New Haven and London 1985
Crosby, S. McKnight, *The Royal Abbey of Saint Denis from Its Beginnings to the Death of Suger, 475–1151*, New Haven 1987
Formigé, J., *The Royal Abbey of Saint-Denis*, Paris 1960
Winterfeld, D. von, 'Gedanken zu Sugers Bau in St-Denis', *Festschrift für Martin Gosebruch*, Munich 1984

Saint-Germer-de-Hy:
Henriet, J., 'Un Édifice de la première génération gothique. L'abbatiale de Saint-Germer-de-Fly', *Bulletin Monumental*, 143, 1985, 93–142

Saint-Quentin:
Héliot, P., *La Basilique de Saint-Quentin*, Paris 1967

Senlis:
Vermand, D., *La Cathédrale Notre-Dame de Senlis au XIIe siècle*, Senlis 1987

Sens:
Henriet, J., 'La Cathédrale Saint-Étienne de Sens. Le parti du premier maître et les campagnes du XIIe siècle', *Bulletin Monumental*, 140, 1982, 81–174

Soissons:
Sandron, D., *La Cathédrale de Soissons, architecture du pouvoir*, Paris 1998

Tournai:
Héliot, P., 'Le Choeur de la cathédrale de Tournai et l'architecture du XIIIe siècle', *Bulletin de l'Académie royale de Belgique (Classe des Beaux-Arts)*, 1963, 31–54

Troyes (Cathedral):
Bongartz, N., *Die frühen Bauteile der Kathedrale in Troyes*, Stuttgart 1979

Troyes (Saint-Urbain):
Davis, M., 'On the Threshold of the Flamboyant. The Second Campaign of Construction of Saint-Urbain, Troyes', *Speculum*, 59, 1984, 847–884
Bruzelius, C. A., 'The Second Campaign at Saint-Urbain at Troyes', *Speculum*, 62, 1987, 635–640
Salet, F., 'St-Urbain de Troyes', *Congrès*

Archéologique de France, Troyes, 113, 1955, 96–122

Vézelay:
Salet, F., *La Madeleine de Vézelay*, Paris 1948

Castles

Mesqui, J., *Châteaux et enceintes de la France médiévale. De la défense à la résidence*, 2 vols., Paris 1991–93

Holy Roman Empire

Krautheimer, R., *Die Kirchen der Bettelorden in Deutschland*, Cologne 1925
Nicolai, B., *Libido Aedificandi. Walkenried und die monumentale Kirchenbaukunst der Zisterzienser um 1200*, Braunschweig 1990
Nussbaum, N., *Deutsche Kirchenbaukunst der Gotik*, Darmstadt 1994

Italy

Enlart, C., *Origines françaises de l'architecture gothique en Italie*, Paris 1894
Wagner-Rieger, R., *Die italienische Baukunst zu Beginn der Gotik*, 2 vols., Graz 1956–57

Spain and Portugal

Azcárate, J. M., *Arte gótico en España*, Madrid 1996
Chicó, M. Tavares, *A Arquitecture gótica em Portugal*, Lisbon 1981
Diaz, P., *A arquitectura gótica portuguesa*, Lisbon 1994
Karge, H., 'Gotische Architektur in Kastilien und León (12.–14. Jahrhundert)', in *Spanische Kunstgeschichte, Eine Einführung*, ed. S. Hänsel and H. Karge, vol. 1, Berlin 1991
——, *Die Kathedrale von Burgos und die spanische Architektur des 13. Jahrhunderts. Französische Hochgotik in Kastilien und León*, Berlin 1989
Lambert, É., *Gothic Architecture in Spain. Twelfth and Thirteenth Centuries*, Paris 1931
Nobre de Gusmão, A., *A Real Abadia de Alcobaça. Estudo Histórico-arqueológico*, Lisbon 1992
Yarza, J., *Arte y arquitectura en España 500–1250*, Madrid 1987

Switzerland

Biaudet, J.-C. et al., *La Cathédrale de Lausanne*, Berne 1975
Gantner, J., *Kunstgeschichte der Schweiz*, vol. III, *Die gotische Kunst*, Frauenfeld 1947
Reinhardt, H., *Die kirchliche Baukunst der Schweiz*, Basle 1947

Individual Buildings

Cologne:
Clemen, P., *Der Dom zu Köln (Die*

Kunstdenkmäler der Rheinprovinz, vol. 6,3, *Die Kunstdenkmäler der Stadt Köln* 1,3), Düsseldorf 1937
Wolff, A., 'Chronologie der ersten Bauzeit des Kölner Domes', *Kölner Domblatt* 28–29, 1968, 7–229
——— (ed.), *Der gotische Dom in Köln*, Cologne 1986

Marburg:
Hamann, R., Wilhelm-Kästner, K., *Die Elisabethkirche zu Marburg und ihre künstlerische Nachfolge*, 2 vols., Marburg 1924–29
Kunst, H. J. (ed.), *Die Elisabeth-Kirche – Architektur in der Geschichte*, Marburg 1983

Maulbronn:
Frank, G., *Das Zisterzienserkloster Maulbronn. Die Baugeschichte der Klausur von den Anfängen bis zur Säkularisation*, Hildesheim, Zürich, New York 1993

Magdeburg:
Ernst U. (ed.), *Der Magdeburger Dom. Ottonische Gründung und staufischer Neubau* (Symposium vom 7. – 11. Oktober in Magdeburg), Leipzig 1989

BARBARA BORNGÄSSER
The Cathar Heresy in Southern France

Aué, M., *Das Land der Katharer*, Vic-en-Bigorre 1992
Baier, L., *Die grosse Ketzerei. Verfolgung und Ausrottung der Katharer durch Kirche und Wissenschaft*, Berlin 1984
Borst, A., *Les Cathares*, Paris 1988
Brenon, A., *Les Cathares. Vie et mort d'une église chrétienne*, Paris 1996
Domke, H., *Frankreichs Süden. Im Bannkreis der Pyrenäen*, Munich 1982
Lambert, M., *Medieval Heresy. Popular Movements from Bogomil to Hus*, London 1977
Nelli, R., *Les Cathares*, Paris 1995
Quéhen, R., Dieltiens, D., *Les Châteaux cathares et les autres. Les cinquante châteaux des Hautes-Corbières*, La Barbère 1983
Roquebert, M., *L' Épopée cathare*, 4 vols., Toulouse 1970–89
Zerner-Chardavoine, M., *La Croisade albigeoise. Choix des textes et documents*, Paris 1979

UTE ENGEL
Gothic Architecture in England

General

Age of Chivalry. Art in Plantagenet England 1200–1400, ed. J. Alexander, P. Binski, exhib. cat., London 1987
Age of Chivalry. Art and Society in Late Medieval England, ed. N. Saul, London 1992
The Archaeology of Cathedrals, ed. T. Tatton-Brown and J. Munby, Oxford 1996
Artistic Integration in Gothic Buildings, ed. von K. Brush, P. Draper, V. Raguin, Buffalo and Toronto 1995

Bock, H., *Der Decorated Style*, Heidelberg 1962
Böker, H. J., *Englische Sakralarchitektur des Mittelalters*, Darmstadt 1984
Bony, J., *The English Decorated Style. Gothic Architecture Transformed, 1250–1350*, Oxford 1979
Cook, G. H., *Mediaeval Chantries and Chantry Chapels*, rev. ed., London 1963
Fergusson, P., *Architecture of Solitude. Cistercian Abbeys in Twelfth-Century England*, Princeton 1984
Harvey, J., *English Medieval Architects. A Biographical Dictionary Down to 1550*, rev. ed., London 1984
———, *The Perpendicular Style, 1330–1485*, London 1978
The History of the King's Works. The Middle Ages, ed. H. M. Colvin, 2 vols., London 1963
Kowa, G., *Architektur der Englischen Gotik*, Cologne 1990
Leedy, W. C., *Fan Vaulting. A Study of Form, Technology and Meaning*, London 1980
Metcalf, P., Pevsner, N., *The Cathedrals of England*, 2 vols., New York 1985
Pevsner, N., *The Buildings of England* (in county volumes), Harmondsworth 1950–
———, *The Englishness of English Art*, Harmondsworth 1978 (orig. pub. 1956)
Platt, C., *The Architecture of Medieval Britain. A Social History*, London and New Haven 1990
Tatton-Brown, T., *Great Cathedrals of Britain*, London 1989
Webb, G. F., *Architecture in Britain. The Middle Ages*, London 1956
Willis, R., *Architectural History of Some English Cathedrals*, 2 vols., Chicheley 1972–73
Wilson, C., *The Gothic Cathedral. The Architecture of the Great Church, 1130–1530*, London 1990

Individual Buildings

Canterbury:
Druffner, F., *Der Chor der Kathedrale von Canterbury. Architektur und Geschichte bis 1220*, Egelsbach, Frankfurt, Washington 1994
Woodman, F., *The Architectural History of Canterbury Cathedral*, London 1982

Gloucester:
Welander, D., *The History, Art and Architecture of Gloucester Cathedral*, Stroud 1991

Ripon:
Hearn, M. F., *Ripon Minster. The Beginning of the Gothic Style in Northern England*, Philadelphia 1983

Salisbury:
Cocke, T., Kidson, P., *Salisbury Cathedral. Perspectives on the Architectural History*, London 1993

Wells:
Wells Cathedral. A History, ed. L. S. Colchester, Shepton Mallett 1982

Westminster (London):
Binski, P., *Westminster Abbey and the Plantagenets. Kingship and the Representation of Power, 1200–1400*, London and New Haven 1995

Winchester:
Winchester Cathedral. Nine Hundred Years, 1093–1993, ed. J. Crook, Chichester 1993

Worcester:
Engel, U., *Die Kathedrale von Worcester*, in course of publication

York:
A History of York Minster, ed. G. E. Aylmer and R. Cant, Oxford 1977

British Archaeological Association Conference Transactions (BAACT), Bristol (vol. XVIII), Canterbury (vol. V), Durham (vol. III), East Riding of Yorkshire (vol. IX), Ely (vol. II), Exeter (vol. XI), Gloucester and Tewkesbury (vol. VII), Hereford (vol. XVI), Lichfield (vol. XIII), Lincoln (vol. VIII), London (vol. X), Salisbury (vol. XVII), Wells and Glastonbury (vol. IV), Winchester (vol. VI), Worcester (vol. I), Yorkshire Monasticism (vol. XV)

CHRISTIAN FREIGANG
Medieval Building Practice

Binding, G., *Baubetrieb im Mittelalter*, Darmstadt 1993
Binding, G., *Der mittelalterliche Baubetrieb Westeuropas*, exhib. cat., Cologne 1987–92
Castelfranchi Vegas, L. (ed.), *Die Baukunst im Mittelalter*, Solothurn and Düsseldorf 1994
Claussen, P. C., 'Kathedralgotik und Anonymität 1130–1250', *Wiener Jahrbuch für Kunstgeschichte*, 46–47, 1993–94, 142–160
Colombier, P. du, *Les Chantiers des cathédrales*, Paris 1973
Der Dom zu Regensburg. Ausgrabung – Restaurierung – Forschung. Regensburg, Domkreuzgang und Kapitelhaus, exhib. cat., Diözesanmuseum Regensburg, (Kataloge und Schriften vol. 8), Munich and Zürich 1989
Freigang, C., 'Ausstellungen und neue Literatur zum gotischen Baubetrieb', *Kunstchronik*, 43, 1990, 606–627
———, 'Die Expertisen zum Kathedralbau in Girona (1386 und 1416/17). Anmerkungen zur mittelalterlichen Debatte um Architektur', in idem (ed.), *Gotische Architektur in Spanien* (Akten des Kolloquiums Göttingen 1994), Frankfurt 1998
Hahnloser, H. R., *Villard de Honnecourt. Kritische Gesamtausgabe des Bauhüttenbuchs ms. fr. 19093 der Pariser Nationalbibliothek*, Graz 1972
Kimpel, D., 'Le développement de la taille en série dans l'architecture médiévale et son rôle dans l'histoire économique', *Bulletin Monumental*, 139, 1977, 195–222

———, 'Ökonomie, Technik und Form in der hochgotischen Architektur', in Clausberg, K. et al. (ed.), *Bauwerk und Bildwerk im Mittelalter*, Giessen 1981
Mojon, L., *St.-Johannsen, Saint-Jean de Cerlier. Beiträge zum Bauwesen der Benediktinerabteikirche 1961–1984*, Berne 1986
Recht, R. (ed.), *Les Bâtisseurs des cathédrales gothiques*, Strasbourg 1989
Schöller, W., *Die rechtliche Organisation des Kirchenbaus im Mittelalter vornehmlich des Kathedralbaus. Baulast – Bauherrschaft – Baufinanzierung*, Cologne and Vienna 1989
Vroom, W. H., *De financiering van de kathedraalbouw in de middeleeuwen in het bijzonder von de dom van Utrecht*, Marssen 1981

PETER KURMANN
Late Gothic Architecture in France and the Netherlands

Albrecht, U., *Von der Burg zum Schloss. Französische Schlossbaukunst im Spätmittelalter*, Worms 1986
Buyle, M. et al., *Architecture gothique en Belgique*, Brussels 1997
Christ, Y., *Pierres flamandes*, Paris 1953
Erlande-Brandenburg, A., 'La priorale St-Louis de Poissy', *Bulletin monumental* 129, 1971, 85–112
Freigang, C., *Imitare ecclesias nobiles. Die Kathedralen von Narbonne, Toulouse und Rodez und die nordfranzösische Rayonnantgotik im Languedoc*, Worms 1992
Gosse-Kischinewski, A., Gatouillat, F., *La cathédrale d'Évreux*, Évreux 1997
Hacker-Sück, I., 'La Sainte-Chapelle de Paris et les chapelles palatines du moyen-âge', *Cahiers archéologiques*, 13, 1962, 217–257
Haslinghuis, E. J., Peeters, C. J. A. C., *De Dom van Utrecht* (De Nederlands Monumenten van Geschiedenis en Kunst), 's-Gravenhage 1965
Héliot, P., *Les églises du moyen-âge dans le Pas-de-Calais*, Memoires de la Commission départementale des monuments historiques du Pas-de-Calais (Arras), vol. 7, 1951–53
Klijn, K., Smit, J., Thunnissen, C., *Nederlandse Bouwkunst. Een Geschiedenis van tien eeuwen Architectuur*, Alphen 1995
Krohm, H., 'Die Skulptur der Querhausfassaden an der Kathedrale von Rouen', *Aachener Kunstblätter*, 40, 1971, 5, 40 ff.
Kurmann, P., 'Köln und Orléans', *Kölner Domblatt*, 44/45, 1979/80, 255–272
Kurmann, P., Freigang, C., 'L' église de l'ancien prieuré de St-Thibault-en-Auxois. Sa chronologie, ses restaurations, sa place dans l'architecture gothique', *Congrès archéologique de France*, 144, 1986 (1989), 271–290
Mesqui, J., *Châteaux et enceintes de la France, médiévale. De la defense à la résidence*, vol. 2, *La résidence et ses éléments d'architecture*, Paris 1993

——, 'La naissance et l'essor du gothique méridional au XIIIe siècle', in *Cahiers de Fanjeaux*, 9, 1974
Nantes. La cathédrale St-Pierre. Inventaire général des monuments et des richesses artistiques de la France, 2 vols., Paris 1992
Ozinga, M.D., Meischke, R., *De gotische kerkelijke bouwkunst (De Schoonheid van ons land)*, Amsterdam 1953
Peeters, C., *De Sint Janskathedraal te 's-Hertogenbosch (De Nederlandse Monumenten van Geschiedenis en Kunst)*, 's-Gravenhage 1985
Sanfaçon, R., *L'architecture flamboyante en France*, Quebec 1971
Schürenberg, L., *Die kirchliche Baukunst in Frankreich zwischen 1270 und 1380*, Berlin 1934
van de Walle, A. L. J., *Belgique gothique. Architecture, art monumental*, Brussels 1971
Villes, A., *La cathédrale de Toul. Histoire et architecture*, Toul 1983

CHRISTIAN FREIGANG
The Papal Palace in Avignon

Castelnuovo, E., *Un pittore italiano alla corte di Avignone. Matteo Giovanetti e la pittura in Provenza nel secolo XIV*, Milan 1963
Kerrscher, G., 'Herrschaftsform und Raumordnung. Zur Rezeption der mallorquinischen und spanisch-islamischen Kunst im Mittelmeergebiet', in Freigang, C. (ed.), *Gotische Architektur in Spanien* (Akten des Kolloquiums Göttingen 1994), Frankfurt 1998
Labande, L. H., *Le palais des papes et les monuments d'Avignon au XIVe siècle*, 2 vols., Marseilles 1925

PABLO DE LA RIESTRA
Gothic Architecture of the "German Lands"

Antoni, M., *West- und Ostpreussen* (Dehio), Munich and Berlin 1993
Binding, G., Mainzer, U., Wiedenau, A., *Kleine Kunstgeschichte des deutschen Fachwerkbaus*, Darmstadt 1977
Böker, H.-J., *Die mittelalterliche Backsteinarchitektur Norddeutschlands*, Darmstadt 1988
Bräutigam, G., *Gmünd – Prag – Nürnberg, die Nürnberger Frauenkirche und der Prager Stil vor 1360*, Berlin 1961
Brucher, G., *Gotische Baukunst in Österreich*, Salzburg and Vienna 1990
Busch, H., *Deutsche Gotik*, Vienna and Munich 1969
De la Riestra, P., *El claustro de Comendadoras de Santiago en Valladolid y el Patio Welser de Nuremberg*, Valladolid 1994
——., 'Varia sobre el »juego« entre lo sacro y lo profano en arquitecturas del gótico alemán', in *Estudios de Arte*, Valladolid 1995
Fehr, G., *Prag, Geschichte/Kunst/Kultur*, Munich 1979
Griep, H.-G., *Kleine Kunstgeschichte des deutschen Bürgerhauses*, Darmstadt 1992

Gruber, K., *Die Gestalt der deutschen Stadt*, Munich 1952
Kier, H., Ernsting, Krings, U., *Köln, der Rathausturm*, Cologne 1996
Klotz, H., *Der Stil des Neuen*, Stuttgart 1997
Kunst, H.-J., *Aspekte zu einer Geschichte der mittelalterlichen Kirchenarchitektur in den niedersächsischen Städten*, Braunschweig 1985
——, 'Der Domchor zu Köln und die hochgotische Architektur in Norddeutschland', *Niederdeutsche Beiträge zur Kunstgeschichte* 8, 1969, 9–40
——, *Die Marienkirche in Lübeck*, Worms 1986
Legner, A. (ed.), *Die Parler und der Schöne Stil 1350–1400*, Cologne 1978
Lützeler, H., *Der Turm des Freiburger Münsters*, Freiburg 1955
Meischke, R., *De gotische bouwtraditie*, The Hague 1988
Meuthen, E., *Das 15. Jahrhundert*, Munich 1984
Möbius, F. (ed.), *Geschichte der deutschen Kunst 1200–1350*, Leipzig 1989
Mulzer, E., *Die Nürnberger Altstadt*, Nuremburg 1976
Nussbaum, N., *Deutsche Kirchenbaukunst der Gotik*, Darmstadt 1994
Philipp, K. J., *Pfarrkirche, Funktion, Motivation, Architektur*, Marburg 1987
Phleps, H., *Deutsche Fachwerkbauten*, Königstein im Taunus 1962
Schubert, E., *Einführung in die Grundprobleme der deutschen Geschichte im Spätmittelalter*, Darmstadt 1992
Seibt, F., *Karl IV., ein Kaiser in Europa 1346 bis 1378*, Munich 1978
Wagner-Rieger, R., *Mittelalterliche Architektur in Österreich*, Darmstadt 1991
Windoffer, B., *Backsteinbauten zwischen Lübeck und Stralsund*, Berlin 1990
Wolff, A., *Der Kölner Dom*, Cologne 1995
Worringer, W., *Formprobleme der Gotik*, Munich 1927
Zorn, E., *Landshut, Entwicklungsstufen mittelalterlicher Stadtbaukunst*

See also **Dehio, G.**, individual *Handbücher der deutschen Kunstdenkmäler*, Deutschen Kunstverlages Munich; *Schweizerische Kunstführer*, GSK, Berne, *Kleine und Grosse Kunstführer*, Schnell &. Steiner Verlages, Regensburg

PABLO DE LA RIESTRA
Gothic Architecture in Scandinavia and East-Central Europe

Andersson, A., *Medeltida konst*, Stockholm 1966
Benzon, G., *Vore Gamle Kirker og Klostre*, Copenhagen 1973
Crossley, P., *Gothic Architecture in the reign of Kasimir the Great*, Cracow 1985
Eimer, G., *Bernt Notke*, Bonn 1985
Essenwein, E., *Die Mittelalthterlichen

Kunstdenkmale der Stadt Krakau, Leipzig 1869
Estreicher, K., *Collegium Maius dzieje gmachu*, Cracow 1968
Frey, D., *Krakau*, Berlin 1941
Hootz, R. (ed.), *Kunstdenkmäler. Baltische Staaten Estland, Lettland, Litauen*, Darmstadt 1992
Kamphausen, A., *Backsteingotik*, Munich 1978
Knox, B., *The architecture of Poland*, London 1971
Lagerlöf, E., Svahnström, G., *Die Kirchen Gotlands*, Kiel 1991
Lorenzen, V., *De gamle Danske Domkirker*, Copenhagen 1948
Murray, R., *A Brief History of the Church of Sweden*, Stockholm 1961
Skibinski, S., *Polskie Katedry Gotyckie*, Poznan 1996

See also individual volumes of **Danmarks Kirker** and **Sverige Kyrkor**, Copenhagen and Stockholm

EHRENFRIED KLUCKERT
Medieval Castles, Knights, and Courtly Love

Bumke, J., *Höfische Kultur im Mittelalter. Literatur und Gesellschaft im hohen Mittelalter*, 2 vols. Munich 1986
Hess, D., *Das Gothaer Liebespaar*, Frankfurt 1996
Kluckert, E., 'Das Kunstwerk im mittelalterlichen Bildungsplan', *Zeitschrift für Kunstpädagogik*, 5/6, 1978, 263–280
——, *Rembrandt neben der Honigpumpe. Von der Themenvielfalt der Kunst*, Pliezhausen 1982
Le Goff, J., *La civilisation de l'occident médiéval*, Paris 1964

BARBARA BORNGÄSSER
Gothic Architecture in Italy

Ackerman, J., 'Ars sine scientia nihil est. Gothic Theory of Architecture and the Cathedral of Milan', *Art Bulletin*, 31, 1949, 84–111
Arslan, E., *Gothic Architecture in Venice*, London 1972
——, *Venezia gotica. L'architettura civile gotica veneziana*, Venice 1970
Bialostocki, J., *Spätmittelalter und beginnende Neuzeit* (Propyläen Kunstgeschichte vol. 7), Berlin 1972
Biebrach, K., *Die holzgedeckten Franziskaner- und Dominikanerkirchen in Umbrien und Toskana*, Berlin 1908
Braunfels, W., *Mittelalterliche Stadtbaukunst in der Toskana*, Berlin 1979
Bruzelius, C. A., 'Ad modum Franciae. Charles of Anjou and Gothic Architecture in the Kingdom of Sicily', *Journal of the Society of Architectural Historians*, 48. 1989, 158–71
Decker, H., *Gotik in Italien*, Vienna 1964
Dellwing, H., *Studien zur Baukunst der Bettelorden im Veneto* (Kunstwissenschaftliche Studien 43), 1970

Dellwing, H., *Die Kirchenbaukunst des späten Mittelalters in Venetien*, Worms 1990
Enlart, C., *Origines françaises de l'architecture gothique en Italie*, Paris 1894
Franklin, J. W., *The Cathedrals of Italy*, London 1958
Grodecki, L., *Gothic Architecture*, New York 1977
Gross, W., *Die abendländische Architektur um 1300*, Stuttgart 1948
Krüger, J., *S. Lorenzo Maggiore in Neapel. Eine Franziskanerkirche zwischen Ordensideal und Herrschaftsarchitektur*, Werl 1986
Middeldorf, A., *Die Fassade der Kathedrale von Orvieto. Studien zu Architektur und Skulptur 1290–1330*, Munich 1996
Paatz, W., *Werden und Wesen der Trecento-Architektur in Toskana*, Burg bei Magdeburg 1937
Paatz, W. und E., *Die Kirchen von Florenz*, Frankfurt 1952–55
Pace, V., Bagnoli, M. (ed.), *Il Gotico europeo in Italia*, Naples 1994
——, *Il Palazzo Ducale di Venezia*, Turin 1971
Porter, A. Kingsley, *Lombard Architecture*, New Haven 1917
Rodolico, F., Marchini, G., *I Palazzi del Popolo nei comuni toscani del medio evo*, Florence 1962
Romanini, A. M., *L'architettura gotica in Lombardia*, 2 vols., Milan 1964
Schenkluhn, W., *Ordines Studentes. Aspekte zur Kirchenarchitektur der Dominikaner und Franziskaner im 13. Jahrhundert*, Berlin 1985
Simson, O. von, *Das Mittelalter, II. Das Hohe Mittelalter* (Propyläen Kunstgeschichte Bd. 6), Berlin 1972
Sthamer, E., *Dokumente zur Geschichte der Kastellbauten Kaiser Friedrichs II. und Karls I. von Anjou*, 2 vols., repr. Tübingen 1997
Toesca, P., *Storia dell'arte italiana*, vol. II, *Il Trecento*, Turin 1951
Trachtenberg, M., 'Gothic / Italian 'Gothic'. Towards a Redefinition', *Journal of the Society of Architectural Historians*, 50. 1991, 22–37
Wagner-Rieger, R., *Die italienische Baukunst zu Beginn der Gotik*, 2 vols., Graz and Cologne 1956–57
White, J., *Art and Architecture in Italy, 1250–1400*, New Haven and London 1993 (orig. pub. 1965)

ALICK MCLEAN
Medieval Cities

Barber, M., *The Two Cities. Medieval Europe, 1050–1320*, London 1992
Barone, G., 'L'ordine dei predicatori e le città. Teologia e politica nel pensiero e nell'azione dei predicatori', in *Les Ordres nendicants et la ville en Italie centrale (v. 1220–1350), Mélanges d'Archéologie et d'Histoire, Moyen Âge–Temps Modernes*, 89, 2 (Rome, École Francaise de Rome, 1977), 609–618

Benevolo, L., *La città italiana nel Rinascimento*, Milan 1969

Benvenuti Papi, A., *Pastori di popolo. Storie e leggende di vescovi e di città nell'Italia medievale*, Florence 1988

Bering, K., *Kunst und Staatsmetaphysik des Hochmittelalters in Italien. Zentren der Bau- und Bildpropaganda in der Zeit Friedrich II*, Essen 1986

Braunfels, W., 'La storia urbanistica tedesca nel sacro Romano Impero di Nazione Germanico 1300–1800,' in *La storiografia urbanistica. Atti del I convegno internazionale di storia urbanistica*, Lucca 1976, 45–56

——, *Mittelalterliche Stadtbaukunst in der Toskana*, Berlin 1988

——, *Urban Design in Western Europe*, Chicago 1988

Burckhardt, J., *The Civilization of the Renaissance in Italy*, New York 1954

Buttafava, C., *Visione di Città nelle opere d'arte del Medioevo e del Rinascimento*, Milan 1963

Cecchelli, C., 'Continuità storica di Roma antica nell'alto medioevo,' in *La città nell'alto medioevo. Settimane di studi del centro italiano di studi sull'alto medioevo*, VI, Spoleto 1959, 89–150

Cipolla, C., *Before the Industrial Revolution. European Society and Economy, 1000–1700*, 3rd. ed., London and New York 1993

Cultura e Società nell'Italia Medievale, 2 vols. Rome, 1988

Deckers, J., 'Tradition und Adaption, Bemerkungen zur Darstellung der christlichen Stadt', *Mitteilungen des Deutschen Archeologischen Instituts Roemische Abt.*, 95, 1988, 303–82

Fasoli, G., Bocchi, F. *La città medievale italiana*, Florence 1975)

Frugoni, C., *A Distant City. Images of Urban Experience in the Medieval World*, Princeton 1991

Girouard, M., *Cities and People. A Social and Architectural History*, New Haven and London 1985

Guarducci, A. (ed.), 'Investimenti e civiltà urbana, secoli XIII–XVIII', in *Atti della Settimana di Studi*, 9, Florence (22–28 April 1977), 1989

Jones, P., 'La città-stato nell'Italia del tardo Medioevo', in *La crisi degli ordinamenti comunali e le origini dello stato del Rinascimento*, ed. G. Chittolini, Bologna, 1979

——, 'Communes and despots. The city state in late-medieval Italy', *Transactions of the Royal Historical Society*, 15, 1965

Larner, J., *Culture and Society in Italy 1240–1420*, London 1971

Le Goff, J., 'Ordres mendicants et urbanization dans la France medievale', *Annales E.S.C.*, 25 (1970), 924–946

——, 'Apostolat mendiant et fait urbain dans la France médiévale. État de l'enquête', *Annales E.S.C.*, 25 (1970), 924–46

Little, L.K., *Religious Poverty and the Profit Economy in Medieval Europe*, Ithaca 1978

——, 'Pride Goes before Avarice. Social Change and the Vices in Latin Christendom,' *American Historical Review*, 76 (1971), 16–49

Martinelli, R., Nuti, L., ed., *La storiografia urbanistica*, Atti del I convegno internazionale di storia urbanistica, Lucca 1976

Martines, L., *Power and Imagination. City-States in Renaissance Italy*, Baltimore 1988

Mumford, L., *The City in History*, New York 1989 (orig. pub. 1961)

Pevsner, N., 'Term of Architectural Planning in the Middle Ages', *Journal of the Warburg and Courtauld Institutes*, 1942, 233–237

Peyer, H.C., Stadt und Stadtpatron im Mittelalterlichen Italien, *Zürcher Studien zur allgemeinen Geschichte*, 1955, 13, 99–123

Pirenne, H., *Medieval Cities*, Princeton 1974

Topografia urbana e vita cittadina nell'alto medioevo en occidente, Settimane di studio del Centro italiano di studi sull'alto medioevo, XXI (26 aprile – 1 maggio, 1973), Spoleto, 1974

Vauchez, A., ed., 'Les Ordres mendicants et la ville in Italie centrale (v. 1220–1350)', *Mélanges d'Archéologie et d'Histoire, Moyen Âge – Temps Modernes*, l'École Francaise de Rome, Rome 1977

——, *Les Laïcs en Moyen Age. Pratiques et expériences religieuses*, Paris 1987

Waley, D., *The Italian City-Republics*, 3rd. ed., London 1988

Wolff, P., 'Les constructions civiles d'interêt public dans les villes d'Europe au Moyen Age sous l'Ancien Régime et leur financement', in *Actes du Colloque international de Spa*, 1971

——, 'Finances et comptabilité urbaines du XIIIe au XVIe siècle', in *Actes du Colloque international de Blackenberge*, Brussels, 1964

——, "'Pouvoir et investissements urbains en Europe occidentale et centrale du XIIIe au XVIIe siècle,' in *Investimenti e civiltà urbana, secoli XIIIe au XVIe siècle*," Atti della Settimana di Studi 9, ed. A. Guarducci, Florence 1989

BARBARA BORNGÄSSER
Late Gothic Architecture in Spain and Portugal

Actas del I Simposio Internacional de Mudejarismo (1975), Teruel and Madrid 1981

Actas del II Simposio Internacional de Mudejarismo. Arte, Teruel 1982

Azcárate, J. M., *Arte gótico en España*, Madrid 1996

Bayon, D., *L'architecture en Castille au XVIe siècle*, Paris 1967

Bialostocki, J., *Spätmittelalter und beginnende Neuzeit* (Propyläen Kunstgeschichte, vol. 7), Berlin 1972

Blanch, M., *L'art gothique en Espagne*, Barcelona 1972

Borrás Gualis, G. M., *Arte mudéjar aragonés*, Zaragoza 1985

Buesa Conde, D., *Las catedrales de Aragón*, Zaragoza 1987

Cantera Burgos, F., *Sinagogas españolas*, Madrid 1955

Chueca Goitia, F., *Breve historia del urbanismo*, Madrid 1968

——, *Casas Reales en Monasterios y Conventos españoles*, 1982

——, *Historia de la arquitectura española. Edad antigua y Edad media*, Madrid 1965

Cirici, A., *Arquitectura gótica catalana*, Barcelona 1968

Cómez Ramos, R., *Arquitectura Alfonsí*, Seville 1974

Cooper, E., *Castillos señoriales de Castilla de los siglos XV y XVI*, Madrid 1980

Dimier, A., *L'Art cistercien. Hors de France*, 1971

Durliat, M., *L'architecture espagnole*, Toulouse 1966

——, *Art catalan*, Paris / Grenoble 1963

——, *L'art dans le Royaume de Majorque*, Toulouse 1962

——, *Les débuts de l'art gothique en Roussillon, en Cerdagne et aux Baléares*, Toulouse 1962

Grodecki, L., *Gothic Architecture*, London 1986

Hänsel, S., Karge, H., *Spanische Kunstgeschichte. Eine Einführung*, vol. 1, Berlin 1992.

Harvey, J. H., *The Cathedrals of Spain*, London 1957

Hillgarth, J. N., *The Spanish Kingdoms 1250–1516*, 2 vols., Oxford 1976–78

Karge, H., *Die Kathedrale von Burgos und die spanische Architektur des 13. Jahrhunderts*, Berlin 1989

Lambert, É., *L'Art gothique en Espagne aux XIIe et XIIIe siècle*, Paris 1931

——, *Art Musulman et Art Chrétien dans la Péninsule Ibérique*, Paris 1958

Lampérez y Romea, V., *Historia de la arquitectura cristiana española en la Edad Media*, 2 vols., Madrid 1930

——, *Historia de la arquitectura civil española*, Madrid 1922

Lavedan, Paul, *L'architecture gothique réligieuse en Catalogne, Valence et Baléares*, Paris 1935

Lomax, D. W., *The Reconquest of Spain*, London, New York 1978

Marías, F., *El largo siglo XVI*, Madrid 1989

Mayer, A. L., *Gotik in Spanien* (Handbuch der Kunstgeschichte, vol. 5), Leipzig 1928

Merino, W., *Arquitectura hispanoflamenca en León*, León 1974

Miralles, F. (ed.), *Història de l'art català*, vols. 2 and 3, ed. N. Dalmases and A. José i Pitarch, Barcelona 1984–85

Navascués, P., *Monasterios de España*, Madrid 1985

Navascués, P., Sarthou Carreres, C., *Catedrales de España*, Madrid 1983

Nieto, V., Morales, A. J., Checa, F., *Arquitectura del Renacimiento en España, 1488–1599*, Madrid 1989

Nuere, E., *La carpintería de lo blanco*, Madrid 1985

Pavón, B., *Arte mudéjar en Castilla la Vieja y León*, Madrid 1975

Pijoan, J., *A Arquitectura Gótica na Península Ibérica* (História da Arte, vol. 4), 1972

Piquero, M. de los A., *El gótico mediterráneo*, Madrid 1984

Ponz, A., *Viajes de España, 1772–1794*, Madrid 1947

Prieto y Vives, A., *El arte de la lacería*, Madrid 1977

Puig i Cadafalch, J., *Historia General del Arte. Arquitectura (gótica)*, vol. 2, Barcelona 1901

Ráfols, J. F., *Techumbres y artesonados españoles*, Barcelona 1945

Simson, O. von, *Das Mittelalter*, II, *Das hohe Mittelalter* (Propyläen Kunstgeschichte, vol. 6), Berlin 1972

Street, G. E., *Some Account of Gothic Architecture in Spain*, 2 vols., New York 1969 (orig. pub. 1865)

Torres Balbás, L, *Arquitectura gótica* (*Ars Hispaniae* vol. 7), Madrid 1952

——, *Arte Almohade, Arte Nazarí, Arte Mudéjar* (*Ars Hispaniae* vol. 4), Madrid 1949

——, *Ciudades hispanomusulmanas*, 2 vols., Madrid n.d.

Valdés Fernández, M., *Arquitectura mudéjar en León y Castilla*, León 1981

Weise, G., *Studien zur spanischen Architektur der Spätgotik*, Reutlingen 1933

——, *Die spanischen Hallenkirchen der Spätgotik und Renaissance*, Tübingen 1953

Yarza Luaces, J., *Arte y Arquitectura en España. 500/1250*, Madrid 1979

——, *La Edad media* (*Historia del Arte Hispánico*, II.) Madrid 1980

——, *Baja Edad Media. Los siglos del Gótico*, Madrid 1992

——, *Fuentes y documentos para la Historia del Arte*, II, *Arte Medieval*, Barcelona 1982

On individual buildings, see the volumes of the **Catálogo monumental...** and **Inventario Artístico...**

Gothic and Manneline Architecture in Portugal

Atanázio, M. C. Mendes, *A arte do manuelino*, Lisbon 1984

Bialostocki, J., *Spätmittelalter und beginnende Neuzeit* (Propyläen Kunstgeschichte, vol. 7), Berlin 1972

Chicó, M. Tavares, *A arquitectura gótica em Portugal*, 3rd. ed., Lisbon 1981

Cocheril, Dom M., *Notes sur l'architecture et le décor dans les Abbayes Cisterciennes du Portugal*, Paris 1972

——, *Routier de Abbayes Cisterciennes du Portugal*, Paris 1978

Dias, P., *A Arquitectura gótica portuguesa*, Lisbon 1994

——, *A Arquitectura manuelina*, Porto 1988

——, *O Gótico* (*História da Arte em Portugal*, vol. IV.), Lisbon 1986

Évin, P.-A., 'Faut-il voir un symbolisme maritime dans la décoration manueline?' in *XVIe Congrès International d'Histoire de l'art*, vol. 2, Lisbon and Porto 1949

França, J.-A., Morales y Marín, J. L., Rincón García, W., *Arte português* (*Summa Artis*, vol. 30), Madrid 1989

Grodecki, L., *Gothic Architecture*, New York 1977

Gusmão, A. Nobre de, *A Expansão da Arquitectura Borgonhesa e os Mosteiros de Cister em Portugal*, Lisbon 1956

511

Haupt, A., *Die Baukunst der Renaissance in Portugal*, 2 vols., Frankfurt 1890–95
Lambert, É., *L'Art Portugais*, Paris 1948
Raczynski, *Les Arts au Portugal*, Paris 1846
Santos, R. dos, *O estilo manuelino*, Lisbon 1952
Silva, J. C. Vieira da, *O Tardo-Gótico em Portugal. A Arquitectura no Alentejo*, Lisbon 1989
——, *Paços Medievais Portugueses. Caracterização e Evolução da Habitação Nobre. Séculos XII a XIV*, Lisbon 1993
Simson, O. von, *Das Mittelalter*, II, *Das hohe Mittelalter* (Propyläen Kunstgeschichte vol. 6), Berlin 1972
Watson Crum, C., *Portuguese Architecture*, London 1908

On individual buildings, see also the volumes of: **Inventário Artístico de Portugal...** and **Boletim dos Monumentos...**

UWE GEESE
Gothic Sculpture in France, Italy, Germany and England

Baier, L., *Die grosse Ketzerei. Verfolgung uns Ausrottung der Katharer durch Kirche und Wissenschaft*, Berlin 1984
Baxandall, M., *The Limewood Sculptors of Renaissance Germany*, New Haven/London 1980
——, *Painting and Experience in Fifteenth-century Italy. A Primer in the Social History of Pictorial Style*, Oxford 1988
Beck, H., Bückling, M., *Hans Multscher. Das Frankfurter Trinitätsrelief. Ein Zeugnis spekulativer Künstlerindividualität*, Frankfurt 1988
Beck, H., *Liebieghaus – Museum alter Plastik. Führer durch die Sammlungen. Bildwerke des Mittelalters* I, Frankfurt 1980
Bergmann, U., *Schnütgen-Museum. Die Holzskulpturen des Mittelalters (1000–1400)*. ed. Anton Legner, Cologne 1989
Bier, J., *Tilman Riemenschneider. His Life and Work*, Lexington, Kentucky, 1982
Bredekamp, H., 'Harmonisiert, Westportal von Chartres. Mein meistgehasstes Meisterwerk (14)', in *Frankfurter Allgemeine Zeitung*, 13 September 1995, 35
Büchsel, M., *Die Skulptur des Querhauses der Kathedrale von Chartres*, Berlin 1995
Duby, G. *et al.*, *Sculpture. The Great Art of the Middle Ages from the Fifth to the Fifteenth Century*, New York 1990
Erlande-Brandenburg, A., *Notre-Dame in Paris. Geschichte, Architektur, Skulptur*, Freiburg 1992
——, *Triumph der Gotik. 1260–1380*, Munich 1988
Gardner, A., *English Medieval Sculpture*, Cambridge 1951
Geese, U., 'Die heilige Elisabeth im Kräftefeld zweier konkurrierender Mächte', in *700 Jahre Elisabethkirche in Marburg 1283–1983*, vol. 1, *Die Elisabethkirche – Architektur in der*

Geschichte. Ein Handbuch zur Ausstellung des Kunsthistorischen Institutes der Philipps-Universität Marburg, Marburg 1983
Gramaccini, N., 'Zur Ikonologie der Bronze im Mittelalter', *Städel-Jahrbuch*, Neue Folge, vol. 11, München 1987
Harbison, C. *The Art of the Northern Renaissance*, London 1995
Hawel, P., *Die Pietà. Eine Blüte der Kunst*, Würzburg 1985
——, *Schöne Madonnen. Meisterwerke gotischer Kunst*, Würzburg 1998
Heinrichs-Schreiber, U., *Vincennes und die höfische Skulptur. Die Bildhauerkunst in Paris 1360–1420*, Berlin 1997
Hermann, H., Baur, W., *Kloster Blaubeuren*, Tübingen n. d
Hinz, B., *Das Grabdenkmal Rudolfs von Schwaben. Monument der Propaganda und Paradigma der Gattung*, Frankfurt 1996
Hoffmann, K., 'Zur Entstehung des Königsportals in Saint-Denis', *Zeitschrift für Kunstgeschichte*, 48, 1985
Houvet, É., *Die Kathedrale von Chartres. Kleine Monographie*, Chartres 1973
Jung, W., *Der Dom zu Mainz (975–1975)*, Munich and Zürich 1955
Keller, H., 'Die Entstehung des Bildnisses am Ende des Hochmittelalters', *Römisches Jahrbuch für Kunstgeschichte*, 3, 1939, 267 ff.
Kimpel, D., Suckale, R., 'Die Skulpturenwerkstatt der Vierge Dorée am Honoratusportal der Kathedrale von Amiens', *Zeitschrift für Kunstgeschichte*, 36, 1973
Klotz, H., *Der Stil des Neuen. Die europäische Renaissance*, Stuttgart 1997
Kunst, H.-J., Schenkluhn, W., *Die Kathedrale in Reims. Architektur als Schauplatz politischer Bedeutungen*, Frankfurt 1988
Kunst um 1400 am Mittelrhein. Ein Teil der Wirklichkeit, exhib. cat., Liebieghaus – Museum alter Plastik – Frankfurt am Main, ed. H. Beck, Frankfurt am Main 1975
Kurmann, P., Nachwirkungen der Amienser Skulptur in den Bildhauerwerkstätten der Kathedrale zu Reims', *Skulptur des Mittelalters. Funktion und Gestalt*, ed. Friedrich Möbius and Ernst Schubert, Weimar 1987
Liebieghaus – Museum alter Plastik – Frankfurt am Main, Museumsblätter, *Kreuzigungsaltar aus Rimini. Südliche Niederlande / Nordfrankreich, um 1430*
Lorenzoni, G., 'Byzantinisches Erbe, Klassizismus und abendländischer Beitrag zwischen dem 13. und 14. Jahrhundert', in Giandomenico Romanelli (ed.), *Venedig. Kunst und Architektur*, Udine and Cologne 1997
Machat. C., *Veit Stoss. Ein deutscher Künstler zwischen Nürnberg und Krakau. Kulturstiftung der deutschen Vertriebenen*, Bonn 1984
Maek-Gérard, M., *Nachantike grossplastische Bildwerke. Italien, Frankreich und Niederlande 1380–1530/40*, Liebieghaus, Museum alter Plastik, Frankfurt am Main,

Wissenschaftliche Kataloge vol. II, Melsungen 1981
Nette, H., *Friedrich II. von Hohenstaufen in Selbstzeugnissen und Bilddokumenten*, Reinbek bei Hamburg 1975
Olson, R. J. M., *Italian Renaissance Sculpture*, London 1992
Panofsky, E., *Renaissance and Renaissances in European Art*, London 1970
——, *Tomb Sculpture. Four Lectures on its Changing Aspects from Ancient Egypt to Bernini*, London 1992 (orig. pub. 1964)
Die Parler und der Schöne Stil 1350–1400. Europäische Kunst unter den Luxemburgern. exhib. cat., Kunsthalle Köln, ed. Anton Legner, Cologne 1980
Perrig, A., *Lorenzo Ghiberti. Die Paradiesestür. Warum ein Künstler den Rahmen sprengt*, Frankfurt 1987
——, 'Malerei und Skulptur des Spätmittelalters im 13. und 14. Jahrhundert', in Rolf Toman (ed.), *Die Kunst der italienischen Renaissance. Architektur, Skulptur, Malerei, Zeichnung*, Cologne 1994
Pope-Hennessy, J., *Italian Gothic Sculpture*, 4th. ed., London 1996
Sauerländer, W., *Gotische Skulptur in Frankreich 1140–1270*, Munich 1970
——, *Das Königsportal in Chartres. Heilsgeschichte und Lebenswirklichkeit*, Frankfurt am Main 1984
——, *Das Jahrhundert der grossen Kathedralen. 1140–1260*, Munich 1990
Schenkluhn, W., 'Die Westportale von Chartres und Saint-Denis. Über Lehrbeispiele in der Kunstgeschichte', in Herbert Beck and Kerstin Hengevoss-Dürkop (ed.), *Studien zur Geschichte der Europäischen Skulptur im 12. / 13. Jahrhundert*, Frankfurt 1994
Schubert, D., *Von Halberstadt nach Meissen. Bildwerke des 13. Jahrhunderts in Thüringen, Sachsen und Anhalt*, Cologne 1974
Sciurie, H., 'Plastik', in Friedrich Möbius and Helga Sciurie (ed.), *Geschichte der deutschen Kunst. 1200–1350*, Leipzig 1989
Simson, O. v. (ed.), *Das Mittelalter*, II. *Das Hohe Mittelalter*, Propyläen Kunstgeschichte. Sonderausgabe, Frankfurt and Berlin 1990
Suckale, R., *Studien zu Stilbildung und Stilwandel der Madonnenstatuen der Île-de-France zwischen 1230 und 1300*, Ph.D. thesis 1971
——, 'Die Bamberger Domskulpturen. Technik, Blockbehandlung, Ansichtigkeit und die Einbeziehung des Betrachters', *Münchner Jahrbuch der bildenden Kunst*, dritte Folge, vol. 38, 1987
Warnke, M., *The Court Artist. On the Ancestry of the Modern Artist*, Cambridge 1993

REGINE ABEGG
Gothic Sculpture in Spain and Portugal

General

Azcárate, J. M., *Arte gótico en España*, Madrid 1990

Durán Sanpere, A., Ainaud de Lasarte, J., *Escultura gótica (Ars Hispaniae 8)*, Madrid 1956
Mayer, A. L., *Gotik in Spanien*, Leipzig 1928
Williamson, P., *Gothic Sculpture 1140–1300*, New Haven and London 1995

Castile and León

Abegg, R., 'Romanische Kontinuität als Gegenentwurf? Zum Grabmal des kastilischen Hochadels im späten 13. Jahrhundert', in *Mitteilungen der Carl Justi-Vereinigung*, 5, 1993, 58–78
——, 'Die Memorialbilder von Königen und Bischöfen im Kreuzgang der Kathedrale von Burgos', in *Georges-Bloch-Jahrbuch des Kunstgeschichtlichen Seminars der Universität Zürich*, 1, 1994
——, *Die gotischen Skulpturen des 13. Jahrhunderts im Kreuzgang der Kathedrale von Burgos. Unter besonderer Berücksichtigung der Memorialstatuen von Königen und Bischöfen*, forthcoming
Ara Gil, J. C., *La escultura gótica en Velladolid y su provincia*, Valladolid 1977
——, 'Escultura', in *Historia del arte de Castilla y León* (ed. Junta de Castilla y León), vol. 3, *Arte gótico*, Valladolid 1995
Deknatel, F. B., 'The Thirteenth-Century Gothic Sculpture of the Cathedrals of Burgos and León', *Art Bulletin*, 17, 1935
Franco Mata, A., *Escultura gótica en León*, León 1976
——, 'Gotische Skulptur in Kastilien und León (13.–14. Jahrhundert)', in *Spanische Kunstgeschichte. Eine Einführung* (ed. S. Hänsel / H. Karge), vol. 1, Berlin 1992
——, 'Influence française dans la sculpture gothique des cathédrales de Burgos, Léon et Tolède', in *Studien zur Geschichte der europäischen Skulptur im 12./13. Jahrhundert*, ed. H. Beck, K. Hengevoss-Dürkop, Frankfurt 1994
Gilman Proske, B., *Castilian Sculpture. Gothic to Renaissance*, New York 1951
Gómez Barcena, M. J., *Escultura gótica funeraria en Burgos*, Burgos 1988
Martinez Frias, J.-M., *El gótico en Soria. Arquitectura y escultura monumental*, Salamanca 1980
Moralejo, S., *Escultura gótica en Galicia 1200–1350*, Santiago de Compostela 1975
Yarza, J., *Gil de Siloe*, Madrid 1992

Catalonia:

Freigang, C., Gotische Architektur und Skulptur in Katalonien und Aragón (13. – 14. Jahrhundert)', in *Spanische Kunstgeschichte. Eine Einführung* (ed. S. Hänsel and H.Karge), 1, Berlin 1992
Miralles, F. (ed.), *Història de l'Art Català*, vols. 2 and 3, Barcelona 1984–85

Portugal,

Cardoso Rosas, L. M., Escultura e Ourivesaria', in *Nos confins da Idade-Média. Arte portuguesa seculos XII – XV*,

exhib. cat., Museu Nacional dos Reis, Porto 1992

Dias P., *O Gótico (História da Arte em Portugal*, vol. 4), Lisbon 1988

Dos Santos, R., *L' art portugais*, Paris 1953

França, J.-A., Morales y Marín, J. L., Rincón Garda, W., *Arte portugués (Summa artis*, vol. 30), Madrid 1986

EHRENFRIED KLUCKERT
The Path to Indivudualism

Alexander, J. J. G., *Medieval Illuminators and their Methods of Work*, London 1992

Antal, F. *Florentine Painting and its Social Background*, London 1986 (orig. pub. 1948)

Assunto, R., *Die Theorie des Schönen im Mittelalter*, Cologne 1963

Baxandall, M., *Giotto and the Orators. Humanist Observers of Painting in Italy and the Discovery of Pictorial composition, 1350–1450*, Oxford 1991

Belting, H., Blume, D. (ed.), *Malerei und Stadtkultur in der Dantezeit. Die Argumentation der Bilder*, Munich 1989

——, *Bild und Kult. Eine Geschichte des Bildes vor dem Zeitalter der Kunst*, Munich 1991

Belting, H., Kruse, C., *Die Erfindung des Gemäldes. Das erste Jahrhundert der niederländischen Malerei*, Munich 1994

Beutler, C., *Meister Bertram. Der Hochaltar von Sankt Petri*, Frankfurt 1984

Blume, D., *Wandmalerei als Ordenspropaganda. Bildprogramme im Chorbereich franziskanischer Konvente Italiens bis zur Mitte des 14. Jahrhunderts*, Worms 1983

Boskovits, M., *The Origins of Florentine Painting (1100–1270)*, Florence 1992

Budde, R., *Köln und seine Maler. 1300–1500*, Cologne 1986

Camille, M., *The Gothic Idol. Ideology and Image-Making in Medieval Art*, Cambridge 1991

Châtelet, A., Thuillier, J., *Französische Malerei*, vol. 1, *Von Fouquet bis zu Poussin*, Geneva 1963

De Hamel, C., *A History of Illuminated Manuscripts*, Oxford 1986

De Vos, D., *Hans Memling. Das Gesamtwerk*, Stuttgart 1994

Dittmann, L., *Farbgestaltung und Farbtheorie in der abendländischen Malerei. Eine Einführung*, Darmstadt 1987

Erlande-Brandenburg, A., *Triumph der Gotik. 1260–1380*, Munich 1988

Erösi, A., *Die Malerei der internationalen Gotik*, Budapest 1984

Evans, J., *Life in Medieval France*, Bath 1969

Fraenger, W., *Hieronymus Bosch. Das tausendjährige Reich*, Amsterdam 1969

Frey, D., *Gotik und Renaissance*, Augsburg 1929

Friedländer, M. J., *From Van Eyck to Brueghel*, New York 1981 (orig. pub. 1969)

Gallwitz, K., Sander, J. (ed.), *Städelsches Kunstinstitut*, Frankfurt 1993

Festschrift für Joseph Gantner. Konrad Witz, Zürich 1987

Gosebruch, M., *Giotto und die Entwicklung des neuzeitlichen Kunstbewusstseins*, Cologne 1962

Hetzer, T., *Das Ornamentale und die Gestalt*, Munich 1956

Hills, P., *The Light of Early Italian Painting*, New Haven and London 1987

Höfler, J., *Die Tafelmalerei der Gotik in Kärnten (1420–1500)*, Klagenfurt 1987

Holländer, H., *Hieronymus Bosch. Weltbilder und Traumwerk*, Cologne 1975

Karlowska-Kamzowa, A., 'Die gotische Malerei Mittel-Osteuropas', in *Akten des 25. Internationalen Kongresses für Kunstgeschichte*, Vienna 1983, vol. 3, Vienna, Cologne, Graz 1985

Kelberg, K., 'Bilder im Bilde. Ikonografische Details auf spätgotischen Tafelbildern', *Das Münster*, 39, 1986 (2), 144–148

Klibansky, R., Panofsky, E., Saxl, F., *Saturn and Melancholy. Studies in the History of Natural Philosophy, Religion, and Art*, London 1964

Klotz, H., *Der Stil des Neuen. Die europäische Renaissance*, Stuttgart 1977

Krüger, K., *Der frühe Bildkult des Franziskus in Italien. Gestalt- und Funktionswandel des Tafelbildes im 13. und 14. Jahrhundert*, Berlin 1992

Lanc, E., *Die mittelalterliche Wandmalerei in Wien und Niederösterreich*, Vienna 1983

Mandel, G., *Die Buchmalerei der Romanik und Gotik*, 1967

Martindale, A., *The Rise of the Artist in the Middle Ages and Early Renaissance*, New York 1972

Michler, J., Gotische Ausmalungssysteme am Bodensee', *Jahrbuch der Staatlichen Kunstsammlungen in Baden-Württemberg 23*, 1986, 32–57

Oertel, R., *Die Frühzeit der italienischen Malerei*, Stuttgart 1966

Otto-Michalowska, M., *Gotische Tafelmalerei in Polen*, Berlin 1982

Panofsky, E., *Early Netherlandish Painting*, Cambridge, Mass. 1971

Romano, S., 'Pittura ad Assisi 1260–80'. *Arte Medievale* 1985, III, 109–40

Roth, E., *Der volkreiche Kalvarienberg*, Berlin 1967

——, *Gotische Wandmalerei in Oberfranken*, Würzburg 1982

Sander, J., *Niederländische Gemälde im Städel, 1400–1550*, Mainz 1993

Schenkluhn, W., *San Francesco in Assisi – Ecclesia Specialis. Die Vision Papst Gregors IX. von einer Erneuerung der Kirche*, Darmstadt 1991

Schneider, N., *Jan van Eyck. Der Genter Altar*, Frankfurt 1993

Schrade, H., *Die Malerei des Mittelalters*, Stuttgart 1954

Souchal, G., Carli, E., Guidol, J., *Die Malerei der Gotik*, 1967

Stechow, W., *Northern Renaissance Art 1400–1600, Sources and Documents*, New York 1966

Suckale, R., *Rogier van der Weyden. Die Johannestafel*, Frankfurt, 1995

Suckale, R., 'Die Wiedergeburt der Kunst.

Von Giotto bis Lochner', in *Malerei der Welt. Eine Kunstgeschichte in 900 Bildanalysen*, ed. I. F. Walther, Cologne 1996

Thürlemann, F., *Robert Campin. Das Mérode-Triptychon*, Frankfurt 1997

Tolnay, C. de, *Hieronymus Bosch*, London 1975

Thurmann, P., *Symbolsprache und Bildstruktur. Michael Pacher, der Trinitätsgedanke und die Schriften des Nikolaus von Kues*, Frankfurt and Berne 1987

Völker, B., *Die Entwicklung des erzählenden Halbfigurenbildes in der niederländischen Malerei des 15. und 16. Jahrhunderts*, Ph. D. thesis, Göttingen 1975

BRIGITTE KURMANN-SCHWARZ
Gothic Stained Glass

Aubert, M. *et al.*, *Le vitrail français*, Paris 1958

Beck, M. *et al.*, *Königsfelden, Geschichte, Bauten, Glasgemälde, Kunstschätze*, Olten and Freiburg 1970

Becksmann, R., *Deutsche Glasmalerei des Mittelalters. Voraussetzungen. Entwicklungen. Zusammenhänge*, (Deutsche Glasmalerei des Mittelalters, 1, ed. R. Becksmann), Berlin 1995

Beer, E. J., 'Les vitraux du Moyen Age', in Blaudet, J.-C., *La cathédrale de Lausanne*, Bern 1975

Blondel, N., *Le Vitrail. Vocabulaire, typologie et technique*, Paris 1993

Brown, S., O'Connor, D., *Glass-painters*, London 1991

Castelnuovo, E., *Vetrate medievali. Officine, techniche, maestri*, Turin 1994

Caviness, M. Harrison, *Stained Glass Windows (Typologie des Sources du Moyen Âge Occidental*, 76), Turnhout 1996

Manhes-Deremble, C., *Les vitraux narratifs de la cathédrale de Chartres. Étude iconographique (Corpus Vitrearum France, Études*, 2), Paris 1993

Frodl-Kraft, E., *Die mittelalterlichen Glasgemälde in Wien (Corpus Vitrearum Medii Aevi Österreich*, 1), Graz, Vienna, Cologne 1962

Gatouillat, F., Lehni, R., *Le vitrail en Alsace (Images de Patrimoine)*, Eckbolsheim 1995

Gosse-Kischinewski, A., Gatouillat, F., *La cathédrale d'Évreux*, Évreux 1997

Grodecki, L., Brisac, C., *Le vitrail gothique au XIIIe siècle*, Fribourg 1984

Kurmann-Schwarz, B., *Französische Glasmalereien um 1450. Ein Atelier in Bourges und Riom*, Bern 1988

——, 'Les vitraux de la cathédrale de Moulins', in *Congrès archéologique de France*, 146, Le Bourbonnais, Paris (1988), 1991, 21–49

——, *Die Glasmalereien des 15.– 18. Jahrhunderts im Berner Münster (Corpus Vitrearum Medii Aevi Schweiz*, 4), Berne 1998

Lafond, J., *Les vitraux de l'église Saint-Ouen de Rouen (Corpus Vitrearum Medii Aevi France*, IV, 2, 1), Paris 1970

Leniaud, J.-M., Perrot, F., *La Sainte-Chapelle*, Paris 1991

Marks, R., *Stained Glass in England during the Middle Ages*, London 1993

Strobl, S., *Glastechnik des Mittelalters*, Stuttgart 1990

EHRENFRIED KLUCKERT
Medieval Learning and the Arts

Flasch, K., *Einführung in die Philosophie des Mittelalters*, Darmstadt 1987

——, *Das philosophische Denken im Mittelalter. Von Augustin zu Machiavelli*, Stuttgart 1986

Le Goff, J., *Intellectuals in the Middle Ages*, Cambridge, Mass. and Oxford 1993

HARALD WOLTER-VON DEM KNESEBECK
Gothic Goldwork

Angenendt, A., *Heilige und Reliquien. Die Geschichte ihres Kultes vom frühen Christentum bis zur Gegenwart*, Munich 1994

Carli, E., Il *Reliquiario del Corporale ad Orvieto*, Milan 1964

Deuchler, F., *Die Burgunderbeute. Inventar der Beutestücke aus den Schlachten von Grandson, Murten und Nancy 1476/77*, Berne 1963

Dinkler-von Schubert, E., *Der Schrein der hl. Elisabeth zu Marburg. Studien zur Schrein-Ikonographie*, Marburg 1964

Fritz, J. M., *Goldschmiedekunst der Gotik in Mitteleuropa*, Munich 1982

Das Goldene Rössl. Ein Meisterwerk der Pariser Hofkunst um 1400, exhib. cat. Bayerischen Nationalmuseums, Munich 1995, ed. R. Baumstark, Munich 1995

Karbacher, R., 'Ein unbekanntes Reliquiar im gotischen Kruzifixus des Regensburger Schottenklosters', *Jahrbuch der Bayerischen Denkmalpflege. Forschungen und Berichte*, 44, 1996, 29–33

Kötzsche, D., *Der Welfenschatz im Berliner Kunstgewerbemuseum*, Berlin 1973

Ein Schatz aus den Trümmern. Der Silberschrein von Nivelles und die europäische Hochgotik, exhib. cat., Schnütgen-Museums Cologne, 1995/1996, ed. H. Westermann-Angerhausen, Cologne 1995

Schatzkammerstücke aus der Herbstzeit des Mittelalters. Das Regensburger Emailkästchen und sein Umkreis, exhib. cat., Bayerischen Nationalmuseums München 1992, ed. R. Baumstark, Munich 1992

Steingräber, E., 'Beiträge zur gotischen Goldschmiedekunst Frankreichs', *Pantheon*, 20, 1962, 156 ff.

——, 'Emailkunst um 1400. Zwei Münchner Ausstellungen und ihre Kataloge', *Kunstchronik*, 1995, 586–602

Les Trésors des Églises de France, exhib. cat., Musée des Arts Décoratifs, Paris 1965

Wolfson, M., 'Der grosse Goldkelch Bischof Gerhards', in *Geschichte, Frömmigkeit und Kunst um 1400*, Hildesheim, Zürich, New York 1996

Index of Persons

Index of Places